ROTH FAMILY FOUNDATION

Music in America Imprint

Michael P. Roth
and Sukey Garcetti
have endowed this
imprint to honor the
memory of their parents,
Julia and Harry Roth,
whose deep love of music
they wish to share
with others.

The publisher gratefully acknowledges the generous support of the Music in America Endowment Fund of the University of California Press Foundation, which was established by a major gift from Sukey and Gil Garcetti, Michael P. Roth, and the Roth Family Foundation.

Russian Music at Home and Abroad

Russian Music at Home and Abroad

New Essays

Richard Taruskin

UNIVERSITY OF CALIFORNIA PRESS

University of California Press, one of the most distinguished university presses in the United States, enriches lives around the world by advancing scholarship in the humanities, social sciences, and natural sciences. Its activities are supported by the UC Press Foundation and by philanthropic contributions from individuals and institutions. For more information, visit www.ucpress.edu.

University of California Press
Oakland, California

© 2016 by The Regents of the University of California

Library of Congress Cataloging-in-Publication Data

Names: Taruskin, Richard, author.
Title: Russian music at home and abroad : new essays / Richard Taruskin.
Description: Oakland, California : University of California Press, [2016] | Includes bibliographical references and index.
Identifiers: LCCN 2016005529 (print) | LCCN 2016007233 (ebook) | ISBN 9780520288089 (cloth : alk. paper) | ISBN 9780520288096 (pbk. : alk. paper) | ISBN 9780520963153 (ebook)
Subjects: LCSH: Music—Russia—History and criticism. | Stravinsky, Igor, 1882–1971—Criticism and interpretation.
Classification: LCC ML300 .T385 2016 (print) | LCC ML300 (ebook) | DDC 780.947—dc23
LC record available at http://lccn.loc.gov/2016005529

25 24 23 22 21 20 19 18 17 16
10 9 8 7 6 5 4 3 2 1

To those who carry on:
Monchik, Peter, Bilchik, Anya, Olechka, Emily
And to dear Rinochka, just "because"

CONTENTS

Preface	ix
Introduction: My Wonderful World; or, Dismembering the Triad	1

PART ONE. NOT BY MIND?

1.	Non-Nationalists, and Other Nationalists	33
2.	Revenants	52
3.	Crowd, Mob, and Nation in *Boris Godunov*: What Did Musorgsky Think, and Does It Matter?	58
4.	Catching Up with Rimsky-Korsakov	78
5.	Not Modern and Loving It	120
6.	Written for Elephants: Notes on Rach 3	134
7.	Is There a "Russia Abroad" in Music?	140
8.	Turania Revisited, with Lourié My Guide	162
9.	The Ghetto and the Imperium	233
10.	Two Serendipities: Keynoting a Conference, "Music and Power"	303
11.	What's an Awful Song Like You Doing in a Nice Piece Like This? The Finale in Prokofieff's *Symphony-Concerto*, Op. 125	332
12.	The Birth of Contemporary Russia out of the Spirit of Music (Not)	348

PART TWO. REVISITING STRAVINSKY

13. Just How Russian Was Stravinsky? — *361*
14. How *The Rite* Became Possible — *366*
15. Diaghilev without Stravinsky? Stravinsky without Diaghilev? — *384*
16. Resisting *The Rite* — *395*
17. Stravinsky's *Poetics* and Russian Music — *428*
18. Did He Mean It? — *472*
19. In Stravinsky's Songs, the True Man, No Ghostwriters — *503*
20. "Un Cadeau Très Macabre" — *508*

Index — *525*

PREFACE

The essays presented here differ from their predecessors in my previous collection, *On Russian Music* (University of California Press, 2009), to which this book may seem a sequel. The contents of that book were mostly written for newspapers and magazines, general circulation publications that address current events and topical concerns. Among the current events affecting Russian music at the time were preeminently the three big skirmishes whose battlegrounds I surveyed in the earlier book's introduction and somewhat nostalgically revisit in the introduction to this one. Having done so, I do not expect to visit them again. (But, of course, one never knows.) The earlier collection included a number of book and record reviews as well, which are by definition opinion pieces and often therefore contentious.

This volume hawks a different sort of product, originating like the earlier pieces from my perch within the academy, but mainly intended for professional audiences and readerships and therefore displaying a more measured, more judicious—well, all right: a more academic—tone and style. They are products of a later phase of my scholarly career, though I shudder to think that anyone reading these calmer, longer, more intricate, and (I hope) more substantial pieces will therefore characterize them as "late" works. Yes, I am older now, and I'd like to think I'm wiser, but the difference is due more to external than to internal transmutations, except to the extent that changes within me have been responses to changes in my circumstances.

In the nineties and aughts, my invitations to write occasional pieces came from the public print media, and the eventual contents of *On Russian Music* were my response. Since then my editors at the *New York Times* and the *New Republic,* who have been aging along with me (though both James Oestreich and Leon Wieseltier are hale and healthy and still productive as I write, קינאָהאָרא), have left the posts

from which they used to commission my work. At the same time, now that my beard is grey, the frequency with which I have been invited to address scholarly conferences, often as keynoter, has greatly increased. Most of the pieces collected herein are contributions of that kind, or chapters in multiply authored scholarly books—the print version of conferences. Keynote addresses are as much an entertainment genre as a scholarly one, so I had plenty of incentive to keep the prose lively—livelier, in fact, than the versions printed here, which have been adapted for publication and as a rule amplified as well as annotated. Because most of these pieces were not previously published, they do not have receptions to report, and so I have supplied only one updating postscript of the kind that was so abundant in *On Russian Music* (it is appended to essay 4, which was, as an exception, provocative and polemical as in the old days, and has had an afterlife).

The occasions for which the chapters of this book were drafted are indicated at their beginnings. Here I extend my thanks to the many editors and conference organizers who were kind enough to solicit them and in so doing beckoned me down byways I might otherwise have missed. It was pure fortuity that led me back so often to Stravinsky: the *Rite* centennial most obviously, but also such things as the rather endearing request from the Harvard Slavists in 2009 to regale them with something about Stravinsky at Harvard. My last three assignments from the *New York Times* were also Stravinsky-related. They included essay 13, on Stravinsky's Russianness (always a touchy matter with him), which provided an apt transition to the Stravinsky items, which I have therefore gathered together as the second of the present collection's two large sections. Its status as a sort of introduction to the Stravinsky section, and the likelihood of that section's being read independently, induced me to leave a bit of material in place that also appears in essay 4. Elsewhere, redundancies have been pruned away. Whatever the reasons for it, my unexpected reengagement with the figure who preoccupied my scholarly imagination for so many years was a renewed pleasure and a continued inspiration, especially as the new occasions often took me into phases of Stravinsky's life and career that my previous work had neglected. It is especially agreeable to me that Stravinsky makes such a prominent showing in this book, since he was completely absent, except for passing references, from *On Russian Music*.

For providing me with my pretexts I happily thank Lidia Ader, Anastasia Belina-Johnson, Anna Dalos, Hermann Danuser, Gregory Freidin, Marina Frolova-Walker, Linda and Michael Hutcheon, Olga Manulkina, Rebecca Mitchell, Klára Móricz, Simon Morrison, Stephen Muir, Severine Neff, Anna Nisnevich, James Oestreich, Serhii Plokhii, Albrecht Riethmüller, Svetlana Savenko, Nathalie Sergent, Tibor Tallian, Katarina Tomašević, László Vikarius, Heidy Zimmermann, and Patrick Zuk.

Introduction

*My Wonderful World; or,
Dismembering the Triad*

> It is my deep conviction that the good and the beautiful are one for all peoples. They are one in two senses: truth and beauty are eternal companions, one and the same both in their mutual relationship and for all peoples.
> —DMITRY SERGEYEVICH LIKHACHYOV (1906–99)[1]

Between the writing of an essay and its publication comes a window during which it is available for oral delivery. So when I was honored in 2008 by the Department of Slavonic Languages and Literatures at the University of Cambridge with an invitation to deliver the sixth Dame Elizabeth Hill Memorial Lecture the next year, and my hosts asked specifically for a status report on Russian music studies with an emphasis on my own work experience, I had a piece all ready to adapt for the purpose: the introduction to my previous University of California Press collection, *On Russian Music*, which was then in press. In its published guise the introduction bears a subtitle, "Taking It Personally," that the essay you are now reading carries forward in spirit. I retitled the excerpts with which I regaled the Cambridge Slavists "Suicide Notes, Faked Memoirs, Toasts to Killers: The Wonderful World of Russian Music."[2] I still take personally the foolishness that surrounded, and still surrounds, these topics. Efforts to dispel it continue.

Those who follow the vagaries of academic musicology and its altercations will have recognized, behind the jokey allusions, a trio of composers: Chaikovsky, Shostakovich, and Prokofieff. Controversies about how and why the first met his end, about the authenticity of the bestseller *Testimony* as the edited oral memoirs of the second, and about the propriety of performing the Stalinist potboilers of the third had roused the formerly quiescent academic nook in which I had been laboring for many years, making it suddenly one of the noisiest and hottest crannies in our stately manse. I had been involved, as direct participant or voluble commentator, in all three, and in my Cambridge lecture, as in the eventual published essay, I both

deplored and celebrated them. I deplored the bad scholarship and bad faith that had blemished them all, potentially discrediting musicology as a serious scholarly pursuit. But these controversies had in their sheer clamor brought Russian music into the thick of current musicological debate and made it sexy—quite literally so in the case of Chaikovsky, the debunking of whose rumored suicide went far beyond forensic inquiry into the circumstances of his death. It encompassed the assessment of the rumor itself in light of the sociology of sexual mores, those of both his time and our own, as well as the sociology of academic scholarship and its production of knowledge. One could no longer consider the history of Chaikovsky reception without invoking gender and sexuality studies, queer theory, and the pressures that attend the formulation, propagation, and testing of hypotheses. The question of Chaikovsky's sexual orientation and its social consequences had become a crucible for societal and disciplinary self-reflection, in addition to adding an almost obligatory subtext to performances of Chaikovsky's music, and particularly stagings of his operas, in the lascivious West—or even breaking through the subtext and becoming explicit, as in Krzysztof Warlikowski's by now celebrated "Broke Back *Onegin*" at the Bayerische Staatsoper, in which the main love story in Chaikovsky's most famous opera becomes Onegin and Lensky's closeted romance and its tragic outcome.[3] Imagine the straitlaced Chaikovsky's reaction to that.

The Shostakovich and Prokofieff controversies had been a crucible for another sort of costive but necessary rumination: the burgeoning, strenuously undertaken and just as strenuously resisted probes into the impact of the Cold War on events both political and musical (hence musicopolitical, an area that had formerly not counted as a legitimate musicological domain), and its grip on the way we now study and have studied those (or any) historical events. As in the case of the Chaikovsky debates, they ramified far beyond their ostensible objects of investigation, with the result that everyone involved with musical scholarship was interested in them and sensitive to the attendant stakes. Everyone, that meant, now had a stake in Russian music and the methods and attitudes that were brought to bear on its study. Russian music, once the very archetype of a "peripheral" area in anglophone musicology, was now widely regarded as central. That new status boosted its popularity as measured in numbers of conference papers accepted and read, journal articles published, specialists engaged in academic departments, and students attracted to it as a specialization. That growth was certainly something to celebrate, no matter how much dubious battle may have fed it.

Now, seven years later, it is time—or at least there is an opportunity—for another status report. I found renewed reason for optimism, even a smidgen of self-congratulation, in the enormous fuss that attended the centennial of Stravinsky's *Sacre du printemps* in 2013. One of the longer pieces in this collection (No. 16)

is based on a talk—or actually, several related talks—that I took around the world during those festivities. What was especially cheering to me was not—or not just—all the free trips I enjoyed but the fact that talking about Stravinsky as a Russian composer, and about his work as an especially valued artifact of Russian musical culture, was no longer regarded as an unusual, let alone a controversial, stance (as once it assuredly was). I was no longer obliged to defend the idea. Outside the cloistered world of academic music theory, our version of Laputa, people accepted it, expected it, and were interested in learning more about it. That my audience in Moscow was attuned to this message was of course especially unsurprising—but the fact that there *was* a celebration in Moscow, alongside the ones in Paris and Budapest and New York and all the other places my itinerary took me that year (even Toruń, Copernicus's Polish birthplace), was a particularly gratifying wrinkle. There is now a plaque on the apartment house in St. Petersburg where Stravinsky wrote *Firebird*, his first famous work and the last work he composed on native soil, identifying him as *velikiy russkiy kompozitor* ("the great Russian composer"). So he is regarded everywhere by now. Those of us who remember not only the Russian (i.e., Soviet) objection to this characterization, but also Stravinsky's own equally vehement (anti-Soviet) objection, can appreciate in an especially specific way the changes wrought in our musical thinking by the end of the European cold war.

So is all quiet now on the western front, or the eastern? I wish it were so; and had I been writing this introduction a few years ago I might have thought it so and said as much. But there has been regression. There is still room for complaint and for improvement, and further reflection has suggested to me that in renewing my critique in the light of more recent provocations I might widen the angle the better to illuminate the reasons why disturbances on the remote Russian frontier should have had such a strong impact on the field of musicology at large. The three debates did not only apply respectively to a troika of famous names or to the proximate matters of dispute. They also touched on transcendental values: the foundations, ever since the Greeks started thinking (or, more accurately, since the Florentine humanists began interpreting their thought), of our epistemology, our morality, and our esthetics. Of course I mean the triad ἀγαθόν/ἀληθές/καλόν *(agathon/alethes/kalon)*, "the Good, the True, and the Beautiful," first formulated as such, historians of ideas inform us, by Marsilio Ficino in his commentary on Plato's *Philebus* (1464),[4] but now a firm fixture among everyone's casual cultural assumptions, as witness the epigraph above, from the great (and suitably Russian) philologist Dmitry Likhachyov. Stakes can't get much higher than that. Pretty much the whole of philosophical debate over the centuries has revolved around the mutual relationship of these terms. The three debates in which Russian music has led the way can be viewed as taking them up in turn. That is how I propose to review them now.

THE TRUE (TRAGIC)

Conditions in Russia have been especially volatile since the contested reelection of Vladimir Putin as president of the Russian Federation in March 2012. His campaign set in motion a protest movement that was met, after his victory, by a spate of repressive legislation, redoubled since the removal in February 2014 of Viktor Yanukovych as Russia-friendly president of Ukraine, which spurred the Russian Federation into Soviet-style military aggression abroad. Repercussions from these events were felt almost immediately in the arts, beginning with the arrest, on the very eve of Putin's reelection (and on a Soviet-style charge of "hooliganism"), of two members of Pussy Riot, the punk rock girl group that had staged an anti-Putin demonstration in February at Moscow's Cathedral of Christ the Savior.[5] Together with a third member of the group who was arrested somewhat later (and eventually freed before sentencing), they were convicted in August 2012 and sentenced to two years imprisonment. The two who were sent away, Mariya Alyokhina and Nadezhda Tolokonnikova, did not quite serve their full sentences, but were released in December 2013 as part of an amnesty declared as a public relations gesture to Western critics before the Winter Olympics, which were held at the Black Sea resort town of Sochi in February 2014.

By then, Russia had enacted Article 6.21 of the Code of the Russian Federation on Administrative Offenses, the so-called antigay law of 30 June 2013 prohibiting "propaganda of nontraditional sexual relations to minors."[6] This act was one of a number of measures enacted that year and the next on behalf of "traditional values," which have also included restrictions on obscenity and an antiblasphemy law, all of which have had direct repercussions on the arts.[7] Article 6.21 has specific relevance to one of the musicological controversies enumerated above, that concerning Chaikovsky's sexual orientation and its attendant rumors. Questions immediately arose as to how these matters might be handled by Russian scholars and, most immediately, whether Chaikovsky's music could be performed at public events such as the Sochi Olympics. (It was indeed coopted there regardless, though not as prominently as that of *velikiy russkiy kompozitor* Stravinsky, whose *Firebird* Suite of 1945 accompanied the lighting of the Olympic torch.)[8] Would frank discussion of Chaikovsky's homosexuality, and his actual homosexual behavior (which had been documented by 2013 on the basis of letters that had been previously—and variously—bowdlerized), be permitted? Or would that count as propaganda of nontraditional sexual relations? Might playing Chaikovsky's music, some of which was long traditional at civic exercises in Russia, now count as a violation of Article 6.21?

These questions remain as yet without definitive answers, but they are being posed with increasing urgency. Fear of reprisals has led to cautious acts of self-censorship.[9] Indirect measures seemingly related to Article 6.21 have begun to

have a stifling impact.[10] Confused and contradictory responses to the newly exacerbated gay question have provided at the very least some grim (and to Russian scholars, embarrassing) amusement. The most widely publicized of these was that of Vladimir Medinsky, the Russian minister of culture, when asked by journalists in September 2013 to comment about a Chaikovsky biopic that had reportedly been scuttled owing to concerns that it might run afoul of Article 6.21.[11] Kirill Serebrennikov, the filmmaker who had been commissioned to create the movie with government backing, complained of being unable to secure private funding to supplement his government subsidy and deplored the prurient interest that Chaikovsky's name seemed always to arouse. "Everyone is interested in this," he fumed on Facebook. "Everyone is pondering what we love him for, 'for this or not for this.' Vulgarity *[poshlost']*, vulgarity, philistine vulgarity. . . ."[12] The writer Yury Arabov confirmed that the theme of homosexuality had been written out of the screenplay, except to note that the composer was "a person without a family who was saddled with the opinion that he supposedly loves men." Finally, the minister intervened with a point-blank denial, telling the Interfax news agency that "Arabov is actually right: there is no evidence that Tchaikovsky was a homosexual."

Denial is a hard position to defend in this case. Chaikovsky's homosexuality had been widely rumored during his lifetime, had given rise at the time of his death to the widespread delusion that he had committed suicide as the alternative to exposure, and had been since his death confirmed by documentary evidence, first made public as early as 1934.[13] Acknowledgment of Chaikovsky's sexual proclivities has its own attendant dangers: they become all too easy a lens through which to view and "explain" the music, especially if one also accepts the homophobic assumption that they were an unmitigated burden to the composer. Thus, in a recent *New York Times* article based on an interview with the composer Georg Friedrich Haas, who publicizes his own sexual practices to equip listeners with what he regards as a necessary subtext to his work, the paper's classical music editor immediately reached for what he regarded as the obvious corroborating precedent: "Tchaikovsky's struggle with his homosexuality," he reminded readers, "helped create music of agonizing longing."[14] But abuse of evidence is one thing, denial quite another.

Medinsky's denial was far from unprecedented in newly benighted, or rebenighted, post-Soviet Russia. An interview had appeared in 2010 in the web journal *Novosti Koroleva* with Mikhail Ivanovich Buyanov, a distinguished member of the psychiatric profession, which in Russia has always been available for political cooption, under the headline "Russian Psychiatrists Have Proved That Chaikovsky Was Not Gay."[15] Rumors of Chaikovsky's homosexuality, Dr. Buyanov alleged, had been instigated as revenge by disappointed women whose amorous advances Chaikovsky had spurned, beginning with Alexandra Nikolayevna Purgold (1845–1929), an amateur singer who actually pursued the equally indifferent Musorgsky

for a while, and whose sister Nadezhda married Rimsky-Korsakov. (Her relationship with Chaikovsky seems to be pure fantasy.) From there Buyanov proceeded to the familiar ploy of turning the absence of evidence into evidence of absence. "To hide one's homosexuality from anyone in those days was impossible," he asserted:

> Chekhov, who was his friend, would certainly have noticed it. Yet not a single memoir of Chaikovsky contains so much as a hint of any possible "blueness." Bear in mind that the composer was a public figure who had circled the globe and frequented hotels that were crawling with fans and reporters. So if something were not quite right about him, it would have become a matter of common knowledge. Plus, people like him adored writing letters in which they recorded all their experiences. To Nadezhda von Meck alone Chaikovsky wrote three enormous volumes. I have read every letter with a psychiatrist's eye and have not found any inclination toward homosexuality.[16]

The kindest assumption would be that Dr. Buyanov had only consulted heavily expurgated Soviet-era editions of Chaikovsky's correspondence. As Alexander Poznansky's publications had long since established by the time of Buyanov's interview, Modest Chaikovsky's memoirs and his brother Pyotr's letters to him from 1876 and 1877 abound in the sort of evidence Buyanov declared nonexistent.[17] Buyanov's purpose, it is clear, was not to establish the facts about Chaikovsky's sexual orientation or behavior, but to justify his originary premise, stated as if it were his conclusion, that "Chaikovsky was asexual. Sex as such was of very little interest to him. He was concerned with higher matters. Yet hormones did from time to time claim their due, and such people would occasionally visit bordellos. I can't tell you exactly how many times Chaikovsky went there. But afterwards he would say to all and sundry that he was the vilest man alive, and anyone who did not know him personally might believe this and imagine God only knows what."[18]

The ignorance this preposterous assertion puts on display would be impossible to credit to a medical professional outside the compromised world of Russian psychiatry. It is what one expects from a politician, though; and so nobody thought it strange that President Putin's minister of culture would invoke Buyanov's assertions in the aftermath of Article 6.21. In the Western media the culture minister's comment met with ridicule, which made it necessary for his boss to weigh in. Interviewed by the Associated Press, Vladimir Putin tried to allay anxieties about the new law by assuring his interlocutors that it did not imply homophobia. "I work with these people," he said of the Russian gay community. "I sometimes award them state prizes or decorations for their achievements in various fields. We have absolutely normal relations, and I don't see anything out of the ordinary here." And then, reaching for the ultimate example, the President unwittingly—or could it have been wittingly?—echoed one of the worst old Soviet jokes, one of countless *anekdoty* about Radio Armenia, which occupied in the world of dubious

Russian humor the same place as the wise men of Chelm in Jewish humor or Poles in one tasteless strain of American humor. Asked by listeners whether Chaikovsky was homosexual, Radio Armenia answers, "Yes—but that is not the only reason why we love him."[19] And here is what Vladimir Putin told the Associated Press: "They say that Pyotr Ilyich Tchaikovsky was a homosexual. Truth be told, we don't love him because of that, but he was a great musician, and we all love his music. So what? There is no cause to make a mountain out of a molehill [in Russian, make an elephant out of a fly], nothing scary or terrible is happening here in our country."[20]

Just a comedy of errors, then? Not when there are signs that scholars or scientists continue to fall into line with the deniers, and especially not when the news from Russia encourages the suicide rumormongers, to whose nonsensical allegations it gives a renewed air of topical relevance, to come out of retirement. Svetlana Belicheva, a professor of psychology, who bears the revived Soviet-style title "honored scientific worker of the Russian Federation" *(zasluzhennïy deyatel' nauki Rossiyskoy Federatsii)*, gave a press interview that vied with Buyanov's in inanity, which the newspaper *Kul'tura* ran under the headline "Chaikovsky: Who Turned the Genius Gay?"[21] It was an attempt to dispel "the unhealthy interest in the 'dark side'" of Chaikovsky's personality, in preparation for the planned celebrations of the composer's 175th birth anniversary in May 2015. Asked the "Armenian Radio" question ("Really now, is it so important, 'was he or wasn't he?' As they say, that's not why we love Chaikovsky . . ."), Belicheva immediately resorted to the marital spat mode of argumentation ("But what about *X?*" "All you ever think about is *X!*") and followed up with the inevitable appeal to "internal evidence," that is, to matching selected musical gestures to gay stereotypes in a manner that would be appalling in a professional psychologist anywhere but Russia:

> Of course it would be absurd to discuss a composer of genius exclusively from the standpoint of sexual orientation. Even if the "facts" confirmed it, they could hardly have any bearing on the reception of his legacy. But as a psychologist I have always doubted it. Such music—harmonious, radiant, healing—could not be the work of a pervert. Homosexuality is no vice,[22] but neither is it normal. It is a sexual pathology, which—like any illness—leaves a mark on creative work so that you sense some sort of breakdown. Besides that, these rumors are an insult to Chaikovsky because they are plainly malicious and dirty.[23]

The rest of the interview is devoted to exculpation, to showing that Chaikovsky's affection for male acquaintances—his nephew Bob, his brother Modest's ward Kolya Konradi, his own manservant Alyosha—was in all cases innocent of sexual abuse, despite the libelous innuendos of "Yale professor Alexander Poznansky."[24] But Poznansky has written not only about Bob and Alyosha, but also about the explicitly sexual and anonymous one-night stands Chaikovsky described in his formerly bowdlerized correspondence.[25] There is simply no pretending anymore

that Chaikovsky was not actively homosexual, and that fact need perturb no one who is not in the grip of essentialist fantasies or living in a society that persecutes the LGBTQ community. As one to whom both of these conditions apply, Svetlana Belicheva repeats the old fib that rumors of Chaikovsky's "untraditional orientation" were entirely a figment of the postrevolutionary emigration. (She names Nina Berberova as the sensation-seeking ringleader—Berberova, who based her reports of Chaikovsky's sexual activities in part on interviews with members of the composer's family who never left Russia.)[26]

Just how far Russian scientific or scholarly culture has been backsliding can be seen in Belicheva's final sally: "It would never occur to a scholar who truly loved Chaikovsky's music to rummage through his personal life. It is more important to concentrate on delineating his refined and tragic character, and on tracing the complicated path that took Chaikovsky from obscurity and poverty to world fame."[27] The best answer to such witlessness was given more than eighty years ago by Zhdanov and Zhegin, the Soviet—not *émigré*—editors of Chaikovsky's correspondence with his patron, as referenced above in note 13. They also issued—in 1940, Chaikovsky's centennial year—a now very rare volume of the composer's family correspondence that contained the letters to Modest that Poznansky has recently restored, a volume that fell victim, only months after its issuance, to a previous wave of the "philistine vulgarity" that is now resurgent. "Chaikovsky was homosexual," they forthrightly stated, adding that the composer now "belongs to history; his life is the object of serious study, and we are obliged to disclose all the facts to scholarship, without undue concern as to the prurient curiosity of the casual reader."[28] They recognized that the composer's sex life, as part of that complicated path that took him from obscurity and poverty to world fame, was as worthy of serious study as the rest of the historical record. As I have already observed, somewhat ruefully, in *On Russian Music*, the early Soviet Union was the one place where, for a while, Chaikovsky's sexuality was treated in a frank and adult fashion. We had reason to hope that post-Soviet Russia might once again be such a place, but no.

So no, it's not funny. Least funny of all is the way this new philistinism has called forth an equal and opposite reaction from the dormant suicide squadron, chiefly based in the United Kingdom. Its new lease on life comes in response to the sense of renewed victimization that threats of LGBTQ persecution under Article 6.21 have evoked on Chaikovsky's behalf. To uphold the suicide can be seen again as serving a noble cause, uniting the good and the true, which is beautiful. Thus, when Simon Morrison of Princeton University published a report on these sad new developments—"Once more, Pyotr Tchaikovsky's sexuality has come up for debate," it began, "and once more, the discussion has nothing to do with the composer's time or place but everything to do with ours"[29]—his wise words elicited a loutish rejoinder from the squadron leader, Anthony Holden, who saw an

opportunity to rehawk his sensation-mongering Chaikovsky biography of 1995, in which, he informed readers of the *Times Literary Supplement,* Morrison "would have found . . . all the evidence he still seems to think missing from the debate over the composer's sexuality and suicide."[30] That evidence remains what it has always been, merely evidence that there was such a rumor, and that it spread. But the occupants of both mindless positions—Buyanov/Belicheva on the one side and Holden on the other—are seemingly agreed that there can be only two tenable variants: either Chaikovsky was gay and took his own life, or he wasn't and didn't (and if he wasn't, it was because he was "asexual"). It is still unimaginable to some that he could have been gay but not suicidal, indeed reasonably well adjusted to his condition; yet that is where all the evidence continues to point. By the time I published *On Russian Music* I thought I would not have to point this out again. How depressing it is to have to launch once more unto this boring breach that keeps reopening like a sinkhole.

THE TRUE (COMIC)

There is a farcical corollary to report, also exasperating but in the end deserving of a mirthless laugh. The most exciting event of the *Sacre du printemps* centennial year was a performance of the ballet staged on the actual centennial date, 29 May 2013, on the very stage where the legendary première took place, the Théâtre des Champs-Elysées in Paris, by the Maryinsky Theater Orchestra under the ever ubiquitous Valeriy Gergiev. Two danced versions were mounted back-to-back: first Millicent Hodson's purported reconstruction of the Nijinsky original and, after intermission, the world première of a new staging by the currently red hot German choreographer Sascha Waltz. The next morning, in a smaller performance space in the same building, there was an all-day symposium at which I read an excerpt from "Resisting *The Rite,*" my centennial warhorse (chapter 16 within), alongside contributions from a team that included Stephen Walsh, Stravinsky's biographer; Robert Craft, his long-time assistant; and Pierre Boulez, whom I was meeting face-to-face for the first time.

In 2013 M. Boulez was already eighty-eight, the age to which Stravinsky had lived. He was in better shape than Stravinsky was at that age, but nevertheless frail, attended by an entourage of three: a ramrod German who introduced himself as Boulez's secretary; a rather delightful impish German who was evidently a manservant or valet, and very necessary, who helped Boulez up and down stairs and in and out of cars; and Robert Piencikowski, officially employed as a curator of music manuscripts at the Paul Sacher Foundation in Basel, Switzerland, but widely known as an authority on Boulez and spokesman for him, reminding many of the role that Robert Craft had played in Stravinsky's later life. Boulez himself was very sharp, as I of course expected, but also very polite, friendly, and benevolent, even

sweet, which made the occasion of meeting him very pleasant, but also made me wonder whether I was meeting *le vrai Boulez*, whose intransigence and superciliousness had long been legendary.

Robert Craft did not actually show up in person, much to our regret. Then five months shy of his ninetieth birthday, he sent word that his doctors had advised him against making the trip from his home in Florida, but he emailed his contribution so that the 30 May symposium could proceed as announced. The day began with a public interview at which Robert Piencikowski asked Boulez, among many other things, whether he wished to confirm or deny a famous story that had contributed to his aura of intransigence, about a whistling party that Boulez, then a student, had supposedly organized to heckle the French première of *Four Norwegian Moods*, one of Stravinsky's most innocuous works (and for that very reason abominable). "*Confirme*," said Boulez—by far the shortest answer he gave that morning. My turn followed Boulez's before lunch, and Prof. Walsh addressed us when we reconvened afterward.

We then all reassembled onstage as a panel together with the French musicologist Myriam Chimènes, who was acting as moderator. She invited Robert Piencikowski to read Mr. Craft's submission, and this is what we heard: "An exploration of this subject is long overdue, yet during the composer's life and before the death of his widow eleven years afterwards, this could not have been openly considered. It will come as a surprise to most people that in the early Diaghilev period Stravinsky was exclusively in an ambisexual phase while writing *Petrushka* and *The Rite of Spring*."

Indeed, it did come as a surprise. By the time we had heard even this much I was sitting openmouthed. I was of course skeptical: Stravinsky was perhaps the most uxorious of the great composers, and his letters and writings (including those ghosted by Robert Craft) abound in unkind and unfunny innuendos and slurs at gay men (on the order of "Aunt Britten and Uncle Pears").[31] But mainly, I was amazed at the incoherence of Craft's formulation: why the coy and recondite "ambisexual" (even if a coy and recondite vocabulary had been among the most consistent distinguishing features of the six books of Stravinsky/Craft conversations)? And could Craft not see that "exclusively" contradicted "ambi-"? What could this gibberish mean?

Things went south from there. Craft specifically alleged that, in addition to his many heterosexual liaisons, Stravinsky had been amorously involved with at least three men: Andrey Rimsky-Korsakov, his teacher's son; the Belgian composer Maurice Delage; and Maurice Ravel. The relationship with the first of these predated the specified period of "ambisexuality," but Craft did not stop to take note of that discrepancy. The basis for his surmise was a letter sent from Beaulieu in southern France in the summer of 1910, first published in a Soviet collection of Stravinskiana in 1973, in which, wheedling Andrey, a lazy correspondent, both for a letter and for a couple of songs that eventually went into the first scene of *Petrushka*,

Stravinsky wrote, "You know, of course, that I have long been in love with you and if you were a woman (which of course could never be, as our late Gurevich used to say), then . . . I couldn't vouch [for what I'd do] . . ."³² The evidence in the case of Delage was a letter from Stravinsky (14 October 1912) in which he says he misses the time spent at home with Delage, "who, without being aware of it, takes away all of the filth of the Grand Saison des Ballets Russes," and one from Delage (23 March 1915) that ends with "kisses from your Maurice."³³ The case for Ravel is based on a story, well known to readers of Stravinsky/Craft, of their excursion in 1913 to the northern Italian town of Varese to buy music paper. "The town was very crowded," according to the version published in 1959, "and we could not find two hotel rooms or even two beds, so we slept together in one."³⁴ In 2013, Craft added this: "Routinely questioned on this subject—'How was it?'—Stravinsky would reply, 'You will have to ask Ravel.'" To this Craft added, without any further documentation, that "Ravel and Stravinsky . . . were time-to-time lovers in the early Diaghilev years and it is conceivable that Stravinsky attended more than one of the infamous parties by the all-male group called the 'Apaches,' since he recalled that Ravel had dressed as a ballerina complete with tutu and falsies."

While Robert Piencikowski was reading this drivel, I shot sidelong glances at Boulez, and—sure enough—he was seething. At the end, Myriam Chimènes asked whether any of the panelists wished to respond to Craft's paper before she opened the floor to a general Q and A. Boulez reached for the microphone and fulminated at length about *"ces sottises . . . ces bêtises . . . ces stupidités . . . ,"* at which I thought, elated, *Enfin, du vrai Boulez!* Afterward, Boulez approached Stephen Walsh and me and, once again the sweet old man, apologized to us for his outburst. "You will understand, I hope; it just makes me angry." Why yes, we said. We understood.

Harder to understand is how Craft could have perpetrated this muddled thing, and why. Versions of it have been twice published by now: as an essay in the *Times Literary Supplement* and as a book chapter.³⁵ In the *TLS* version, another male lover was added to the list:

> At one of the *Firebird* rehearsals, Ravel introduced the Russian to his pupil, the epicene Maurice Delage, who became Stravinsky's lover . . . ; a letter from [Stravinsky] informs the unidentified recipient that "Delage is with me every day." . . . Delage's letters to Stravinsky are embellished with "kisses and hugs." *When Delage refers to Stravinsky being "in the arms of that fiend Diaghilev," the reader may understand it literally and wonder about those early years when Diaghilev treated Stravinsky as a minion on the way up.* The Delage connection terminated with the *Rite* and Stravinsky's resumption of both his family life in Switzerland and his hyperactive heterosexual philandering.³⁶

The reception these publications have predictably elicited provides a clue, perhaps, to Craft's purpose in issuing them. "Percolating through the worlds of

music and dance," according to the *New York Times*, they were widely reported in the press and in the blogosphere.³⁷ Both the *New York Times* and the *Los Angeles Times* ran accounts in which arts reporters queried relevant authorities as well as Mr. Craft himself, whose follow-up comments only made matters more mysterious. He readily acknowledged that he did not hear of any such liaisons directly from Stravinsky, even volunteering to the Los Angeles reporter that "Stravinsky forbade sexual gossip at his dinner table" (the reason being that "you do not know unless you were holding their legs").³⁸ To the same interviewer he confided, quite absurdly, that "a primary source" of information for his allegations had been "the now popular Benjamin Ivry book on Ravel"—absurdly, because Ivry's very prurient book, based almost exclusively on secondary sources, relied for its information about Stravinsky almost wholly on Craft's publications, particularly of Stravinsky's correspondence, about which Ivry had irresponsibly speculated exactly the way Craft has now done.³⁹

Academic commentators pointed out, as politely as they could, that Craft's interpretations of his evidence were bewilderingly obtuse. As Stephen Walsh told the Los Angeles reporter, the epistolary effusions of Stravinsky, Andrey Rimsky-Korsakov, and Maurice Delage were "just the usual over-affectionate greetings, which were more or less conventional" at the time, and remain so in Europe. Having received letters from Russian correspondents, he knew that "Russians habitually sign off with 'obnimayu,' meaning 'I embrace [you];'" or just as commonly, I'll add, with *tseluyu*, "I kiss you." "And of course," Walsh continued, "the French, too, were always embracing and kissing at the end of their letters, and no doubt in person as well, without necessarily jumping into bed with every correspondent." It is to me inconceivable that Craft did not know this: indeed, there is a widely shown and excerpted film in which Stravinsky, at home in Hollywood, is seen exchanging kisses with Pierre Boulez, and Craft is in the room looking on.⁴⁰ Nor can I imagine Craft not noticing that Delage's epistolary kisses—"*Je vous embrasse*"—use the formal second person mode. To put it very mildly, this strongly counterindicates a relationship of physical intimacy such as Craft has alleged.⁴¹

Obtuse to the point of quaintness is Craft's evident confusion of sexuality with gender. The Delage letters, he confidently asserted, would be a "bombshell" in Stravinsky studies because they showed that "Stravinsky's principal bisexual experience occurred during *The Rite of Spring*, widely regarded as the epitome of masculinity in music, comparable to Wagner." As we have already seen in the case of Chaikovsky, this confusion is all too widely shared, even among academics engaged in LGBTQ advocacy, who seek perhaps to kill two birds with one stone. The one academic voice in support of Craft's position when queried was that of Nadine Hubbs, a professor of women's studies at the University of Michigan and the author of an important book about gay American composers.⁴² Agreeing that modernism was essentially macho and that "the preferred story for a long, long

time is that all of our great artists are the manliest of men and that's what makes them geniuses," Prof. Hubbs expressed the opinion that Craft's revelations "raise the stakes and up the ante in ways that affect our understanding of modernism."[43] Are we in for a "Broke Back *Sacre*"? Nonacademic members of the musical and (especially) dance worlds maintained a visceral skepticism. "The Ballets Russes and that circle was a furnace of gossip, and many, many people have published biographies and memoirs who were there at that time, after Diaghilev and Stravinsky were dead," Joan Acocella, the *New Yorker*'s dance critic, told the *New York Times* reporter. "Somehow I feel that if Stravinsky had had an out-and-out affair with Maurice Delage, I would have known it."

Robert Craft could hardly have been surprised to find his allegations all but universally rejected by the knowledgeable. He was himself perfectly well equipped to dismiss them. The question thus becomes one of identifying an agenda rather than exposing a fallacy. Pierre Boulez was of the opinion that Craft, long used to sharing the limelight with Stravinsky, was merely making a crass bid for attention. Internet trolls predictably suspected venality. I had a somewhat different impression. When a member of the audience in Paris put me on the spot by asking what I thought Craft was seeking to accomplish, I said that he was probably trying to keep Stravinsky relevant by attaching him to matters of current topical concern. Craft seemed to corroborate the thought by telling the *New York Times* reporter, who had asked why he waited so long to advertise Stravinsky's ambisexual escapades, that he was "not trying to make any kind of sensation out of it at all," but that "the age has come. The world has changed so much." Stravinsky, he seemed to have thought, had better change to keep pace.

Once again I am moved to summon the late Simon Karlinsky's wisdom to put things in perspective. The three topics on which, he used to say, every fool has an opinion remain the same: music, sex, and Russia. Simon used to follow that by saying, "Just imagine what the Chaikovsky literature is like." I had thought the remark, which I quoted in *On Russian Music*, possibly superseded, and my optimism is reflected in the absence, in the body of this book, of any essays or polemics touching on Chaikovsky's sexuality. I now see that optimism was premature. Not only has the bad literature on Chaikovsky continued to proliferate and even worsen in recent years, but the Stravinsky literature is beginning to compete with it, and that is something no one could have expected in 2009. The loss of Simon Karlinsky's learned and funny voice on the side of reason leaves me feeling lonely.

THE BEAUTIFUL

Karlinsky's interventions in the matter of *Testimony*, Solomon Volkov's faked Shostakovich memoirs, have, alongside those of Laurel Fay, proved dispositive.[44] Only diehards are still touting the book, and only incorrigibly lazy writers are still

quoting it.[45] The end of the European cold war had more to do with the marginalization of the formerly aggressive party that, aping Marxist lingo, had called itself revisionist with respect to Soviet music than the efforts of particular scholars in debate. But among these individuals, Simon Karlinsky ranked near the top in sheer effectiveness. That dying down of fruitless controversy is one of the reasons there is no essay in the present collection specifically devoted to Shostakovich. A more interesting reason is that Shostakovich is treated *passim* as a member of various cohorts, not as an exceptional individual figure. This is in keeping with one of the most salutary developments in recent musicology, away from what I have long been calling the poietic fallacy (with its exclusive focus on the unique characteristics of individual works and accounts of their making by uniquely individualistic composers) toward a broader consideration of the social and historical conditions that shape the music created and enjoyed by people within specific environments. It is a variant or adaptation of the theory of affordances promulgated by ecological psychologists and widely applied over the last several decades by sociologists, conspicuously including sociologists of culture and the arts.[46] In a very broad sense it is symptomatic of the mutually beneficial convergence now under way between ethnomusicology and its unprefixed older sibling.[47]

Shostakovich figures in this book only in group photographs, so to speak; and this metaphor seems right not only because Shostakovich was a member of the group we refer to by the adjective Soviet, but also because he is seen within that group from two very different perspectives, as if snapped by different photographers in differing light or from different angles. In essays 9 and 10 he is in the background, seen only in relation to typically Soviet figures usually neglected or disdained by non-Russian writers—figures like Khrennikov, Kabalevsky, and Weinberg (although Weinberg has been getting more attention of late, of a problematic "revisionist" kind that used to be lavished on Shostakovich alone). And in essays 7, 8, and 17 he is viewed from abroad by Russians, these essays being devoted to a cohort that has received very little attention indeed, that of the Russian postrevolutionary emigration or diaspora. In essays 7 and 8 Shostakovich is seen through the eyes of Arthur Vincent Lourié, who when discussed at all by music historians is discussed as a member of that little-discussed group; but in essay 17, Shostakovich is seen through the eyes of Stravinsky, who is almost never described as a member of any group, being regarded as an emblematically potent poietic figure in history—did he not write *The Poetics of Music?*—whose originality, being precious, needs defense against any inclination to lump him with his inferiors (i.e., with anyone).

That, of course, is precisely the way Shostakovich and Prokofieff are normally treated among Soviet composers—as exceptional and, in various ways, exempted. So it is one of the missions of this book to see them, and Stravinsky too, in perspective, which means in context, which means precisely not as exceptional. As nor-

mally viewed, Prokofieff is as exceptional within the diaspora community as he was later within the Soviet. Seeing him, for a change, as typical within both groups (and seeing Stravinsky as typical within the émigré group) will mean seeing him newly. The new image will not, and should not, supplant the old. But it does provide an illuminating supplement that corrects, and thus exposes, the romantic biases to which many adhere without necessarily regarding themselves as romantics.

It was such a bias—not even an entirely unwitting one—that allowed David Schiff, a composer and knowledgeable writer on music who studied with Elliott Carter and teaches at Reed College, cheerfully to side with Volkov and *Testimony* in assessing the "Shostakovich Wars" for the *Times Literary Supplement* in 2005, his essay there being the last respectable endorsement the old hoax received and therefore worthy of some comment. While "American, British and Russian scholars take turns bayoneting *Testimony* and its defenders," Schiff noted with a snicker, "in concert halls, at least American ones, Volkov seems triumphant," and this because "performances of any Shostakovich work are routinely preceded by actors impersonating the composer and his nemesis, Stalin—or are they Luke Skywalker and Darth Vader?"[48]

What amazed me when I read this was that Schiff reserved his contempt not for the Skywalker impersonators but for the scholars. "Volkov," he was prepared to admit, "is a romantic myth-maker, not a historian," but his story was beautiful; those of the historians were not; and as the poet averred, *Beauty is truth, truth beauty*. In preferring the myth to the reality Schiff echoed Tolstoy, who wrote *War and Peace* as a novel rather than as history, he said, precisely so as to avoid being "guided by historical documents rather than the truth."[49] But Volkov, seemingly unnoticed by Schiff, was claiming to have produced not a truth-guided work of art but an actual historical document. Complacently evaluating two nearly simultaneous publications, Volkov's follow-up volume *Shostakovich and Stalin* and Malcolm H. Brown's *A Shostakovich Casebook*, which, among other things, made available to musicological readers Laurel Fay's original exposure of Volkov's deceptions,[50] Schiff advised that

> the sources and powers of music are mysterious, and composers have been turning into myths ever since Orpheus. Ghosted memoirs are also nothing new: Stravinsky "wrote" most of his books with a little help from his friends, and the two-volume memoir of Aaron Copland assembled by Vivian Perlis in the 1980s mixed older published material with what seemed like new accounts, never acknowledging, moreover, the fact that Copland was suffering from Alzheimer's disease. The contrasting views of the *Casebook* and Volkov's latest volume remind me in some ways of the schizoid *New Grove Wagner* of 1984. In the first half of that book, John Deathridge demonstrated that Wagner's autobiography, *Mein Leben*, was a "tendentious dramaturgy" of misinformation; in the second half, Carl Dahlhaus, a musicologist of

unrivalled intellectual refinement, argued that the factual lies were interpretative truths: Wagner bent the facts to explain his music. Much of the music world has reached a similar view in respect of Shostakovich: that while *Testimony* may be a fraudulent document it nonetheless provides a convincing assessment of the music.

Where to begin? Perhaps with the difference between Stravinsky, who solicited the help of ghost writers in an effort to control his reception and manage his reputation, and Shostakovich, who was victimized by a ventriloquist after his death. (Copland, too, was a willing party to his collaboration with Vivian Perlis, which began before he became impaired.) Or perhaps with "the schizoid *New Grove Wagner*," in which John Deathridge meticulously but (in Schiff's view) tiresomely documented Wagner's autobiographical lies, while Carl Dahlhaus triumphantly revealed the higher truths about Wagner's creative output that his lies embodied. Yes, Wagner's lies are revealing of his beliefs and goals, and do shed light on his works. The same can be said of Stravinsky's. It is true of many autobiographers, perhaps most. But Volkov's *Testimony* was not autobiography. His lies are not Shostakovich's but his own, and so reveal not Shostakovich's but only Volkov's beliefs and goals. Volkov is to be compared neither with Wagner nor with Dahlhaus, but at best with Clifford Irving, the pseudo-autobiographer of Howard Hughes.[51] The light his book purported to shed on Shostakovich was a calculated, now superseded Cold War glare that gratified and exploited the wishes of impressionable readers and listeners who wanted a hero with whom they could identify or—at the very least—wanted to flatter themselves as insiders to a *double entendre*. Irony—always available as a way of reading anything—sets up, in the wise words of Patricia Williams, "a winking hierarchy" between two audiences: "one who supposedly hears but doesn't understand, plus another, superior audience that not only catches that extra quantum of more-than-meets-the-ear but also sees the other's incomprehension and is amused."[52] Myth, the higher truth, will beat facts any day in the world of spin.

In the world of scholarship, by contrast, the lowly facts are precious and the endless unglamorous and unromantic winnowing process goes on. Eventually, as the history of Shostakovich's homeland attests, lies give way. They may occasionally struggle back into a semblance of life, as in the case of Chaikovsky's asserted asexuality, but pertinacious, vigilant resistance will keep them at bay if we're willing to make the effort.

The point—the only point—about Solomon Volkov's *Testimony* that is relevant to the debate over Shostakovich's legacy is that it has been conclusively exposed as fraudulent. As in the case of other fraudulent assertions, such as those alleging Stravinsky's homosexuality or denying Chaikovsky's, their significance is to be sought in the light they throw, not on their ostensible subjects, but on their perpetrators. True statements may serve particular agendas, but they do not originate

there. Their proponents are not their inventors. On that fundamental distinction scholars must insist. That is another reason why I continue to maintain, as I put it years ago in another context, that "we should be wary of a scholar [or a critic] who thinks he is an artist."[53]

THE GOOD

Except to romantic poets, then, what is beautiful or gratifying is not *eo ipso* true. Is it good? Now we have reached the third transcendental principle, and also the third domain in my wonderful world: the toasts to killers. It was because it had "abstract musical worth—formalist integrity, if you will"—in a word, because it had beauty—that John Rockwell objected to my objection to performing Prokofieff's *Zdravitsa*, his sixtieth-birthday toast to Iosif Stalin, before audiences of well-fed, well-heeled, and (by their obliviousness) well-insulated American music lovers at Lincoln Center.[54] Performing beautiful music, he maintained, was inherently virtuous, and to cavil with that virtuous act was "misguided puritanism." My answer at the time was that if the music was indeed abstractly beautiful, one might then perform it abstractly—i.e., wordlessly. But of course I knew that no one would dare do that. It smacked all too clearly of Soviet ways, being precisely how sacred music had to be presented under Communist rule.[55] Somewhat tauntingly, I pointed that out. What I should have done was propose a serious alternative.

A better deterrent, of course, would be to insist on translating the text so that it could not so easily be ignored. Impeding their insulation might heighten listeners' awareness of the dissonance between the beautiful form and the obnoxious content, and lessen the chances of persuading them that the former redeemed the latter. But do I really wish to deter performances? I do not. In the spirit, perhaps, of Frederick the Great, who, according to Kant, loved to say, "Argue as much as you please, but obey!"[56] I say, Perform away, but keep the mind engaged! Let the performance be a path to moral awareness, not away from it.

That may be asking too much of entertainers, for whom someone like me will always look like an academic scold who wants to turn the concert hall into a classroom. But I would also caution fellow scolders that the conflict here is not between right and wrong, but between two rights: the moral rightness (or righteousness) of forbearance and the right or freedom to perform. Neither right is absolutely anterior or superior to the other. Neither would we willingly sacrifice, but either choice—to perform or not to perform—entails a sacrifice. That is why there is a problem. To ignore one of the horns of a dilemma does not resolve the dilemma but merely hides it. The hiding is what I have objected to, and still object.

Another flaw in my original approach to this problem has been exposed by more recent manifestations of it. Grumbling about those performances of

Zdravitsa at Lincoln Center, I remarked that were we dealing with a toast to Hitler rather than Stalin there would have been no need for argument because there would have been no performance. I was taking note of a double standard that has been in place since the Second World War, when Hitler was our enemy (and a loser) and Stalin our ally (and a winner). Not even the Cold War, I thought, had wholly effaced that distinction. And yet recent events have proven me wrong about that—and wrong, I regretfully add, in the wrong way. In March 2015, an orchestral composition called *March to Oblivion* (or rather, *Marsh u nebuttya* in untranslated Ukrainian) by Jonas Tarm, a young Estonian-born composer, then a student at the New England Conservatory, had been scheduled for performance at Carnegie Hall by the New York Youth Symphony, an orchestra comprising musicians between the ages of twelve and twenty-two. At rehearsal, some of the players noticed something the conductor had not noticed: that Tarm's composition quoted at length the "Horst Wessel Lied," a Nazi anthem. They asked the composer to corroborate, but it went no further at the time. The Youth Symphony went on to give the work its public première, in February, at a less prestigious venue. But then they received a letter of protest from an anonymous "Nazi survivor" who had heard that performance, and decided to cancel the one at Carnegie Hall.[57]

So far things were going as I might have predicted: once the Nazi cat was out of the bag, there was no performance. But, as I perhaps should have expected but didn't, there was still an argument, and it took a depressingly familiar shape. Spokespersons for the orchestra, clearly embarrassed at the prospect of being accused of censorship, were evasive about the reasons for the cancellation. The reasons reported in the *New York Times* included a very unconvincing "aesthetic" argument involving the originality of a piece that "incorporated significant portions of music written by others." The orchestra's executive director also reminded the *Times* reporter, irrelevantly, that performing the Horst Wessel Lied was illegal in Germany. Less implausibly, the management maintained that under the circumstances the piece was "inappropriate for a youth orchestra," but did not say why. That, plus their having received the letter of complaint, suggested that the Youth Symphony's reason for canceling Mr. Tarm's composition was similar to the reason for the Boston Symphony Orchestra's notorious cancellation, in the aftermath of the World Trade Center attacks in 2001, of choruses from the Peter Sellars opera *The Death of Klinghoffer*, which depicted an act of jihadist terrorism.[58] The BSO offered discretion, the wish to "err on the side of being sensitive," as the reason for canceling the performance. That seemed to be the tacit reason for the Youth Orchestra's decision as well.

They were not thanked for it. Like the BSO, they were excoriated for committing an act of suppression. Svetlana Mintcheva, identified as the director of programs for the National Coalition against Censorship, issued a statement averring that "attempts to sanitize contemporary art do not protect young people or survivors of oppressive regimes; they can only succeed in suppressing the voice and

violating the vision of creative artists, as well as in impoverishing public conversation about important, though disturbing, issues." Although "some audience members may have painful memories associated with the official music of oppressive regimes," she further advised, "that should not mean that any work that references this music must be silenced." The composer himself eagerly piled on, very much the way John Adams, who wrote the music for *The Death of Klinghoffer*, had piled on the Boston Symphony Orchestra in 2001. "I was devastated," Mr. Tarm told the *Times*. "It's one thing to have a concert canceled because of weather, or financial issues; that's kind of like death by natural causes. But canceling because of something that it's saying—it feels almost like murder to me."

These reactions were ill-considered in exactly the way I have tried to describe in the case of Prokofiev's *Zdravitsa*. The cases were not precisely analogous. Mr. Tarm's piece was not a toast to Hitler; no one suspected it of promoting the Nazi leader, let alone Nazism, the way Prokofieff's had promoted Stalin. But the effect of the performances, not the intention behind the compositions, was the point at issue; and in both cases the offender's defenders set up a fallacious contest of right and wrong where in fact two rights collided. Quite obviously, the cancellation of the Carnegie Hall performance of *March to Oblivion* both protected young people and survivors of oppressive regimes *and* suppressed the voice of a creative artist; but only the rights of the creative artist are recognized as such by those who complain of censorship. The sensibilities of Holocaust survivors are not self-evidently of lesser value—and yet there is a fair likelihood that you, dear reader, will conclude that by saying this I have in my philistinism denigrated the creative freedom of Jonas Tarm, whereas in fact I, too, think his freedom worthy of defense. Both sides of this dispute are defensible; and that, precisely, is what makes it a dilemma. One cannot choose sides here without offending against someone's legitimate concern. Those of us who comment from the sidelines have the luxury of endless debate. We can be content to describe the dilemma. Prospective performers must choose a course of action and take the consequences. I believe that the managers of the New York Youth Symphony, which had already given the piece a performance and learned from an affronted member of the audience something about the piece that the composer had withheld from them, made the right decision when they chose to respect the sensibilities of its future audiences over the claims of an artist who had, I think it fair to conclude, sought a collision that embarrassed them.

I say this not out of any general principle that audiences deserve greater respect than artists. There can be no coherent defense of such a principle, or of the opposite principle, even though Zachary Woolfe, the *New York Times* classical music editor, seemed to invoke such an absolute standard in an article decrying the orchestra's "misguided, mishandled decision," which, he predicted, would leave "a blot on the reputation of the youth symphony." An orchestra that has made it a policy to commission new works by young composers for performance by

young instrumentalists, he wrote, "should be particularly protective of artists and the ways they choose to express themselves." Mr. Woolfe had no hesitation in writing off the competing claim. "It is pernicious," he admonished his readers, "to cloak censorship in the guise of child protection." Quoting in derision from the executive director's public statement, Mr. Woolfe asserted that "if 'Marsh u Nebuttya' is playable by any orchestra, it should be playable by an orchestra 'such as ours.'"[59]

That "if" was curious. It seemed to leave room for the idea that the work was *not* playable by any orchestra. Mr. Woolfe cited precedents in rebuttal. There was Karlheinz Stockhausen, who included the Horst Wessel Lied among the dozens of political and patriotic songs that, as advertised by its title, make up the substance of his *Hymnen*. There was the Swedish composer Carl-Olof Anderberg, who quoted it among other songs in a movement from a piano concerto composed in 1968 to memorialize the Prague Spring. There was the British composer Orlando Gough, who in an opera of 2007 juxtaposed the Horst Wessel Lied with statements by Donald H. Rumsfeld, evidently to make a point about the Iraq war. And there was Pavel Haas, an actual victim of the Nazis, who died at Auschwitz after internment at Terezin and who left an unfinished symphony that quotes the Nazi anthem. If they could do it, why not Jonas Tarm? Mr. Tarm himself cited Chaikovsky's "1812" Overture, with its citations of *La Marseillaise*, as precedent.

The difference is that unlike the composers Mr. Woolfe invoked, Jonas Tarm proceeded by stealth, apparently intending to take listeners by surprise (as indeed he did); and unlike *La Marseillaise*, the tune he quoted evoked far more than a long-settled military conflict. The distress he caused the "Nazi survivor" who suddenly recognized the Horst Wessel Lied was premeditated, the resort to surprise an act of aggression. The program note he supplied to the orchestra was the opposite of informative. It identified *March to Oblivion* as having been "dedicated to the victims of hunger and fire," rather than political oppression. Otherwise the note consisted entirely of a short, enigmatic quotation from T. S. Eliot's poem *The Hollow Men*: "Between the conception / And the creation / Between the emotion / And the response / Falls the Shadow."[60] Even after the orchestra had received the listener's complaint and asked about it, the composer, according to the *Times*, "declined to discuss what his piece was about." "I strongly believe in Gustav Mahler's quote," he told the *Times* reporter, "that if a composer could say what he wanted to say in words, he wouldn't bother writing the music."[61] To maintain this after his use of an associative trigger had been exposed was sheer stonewalling.

This "lack of transparency," according to the orchestra's executive director, was what finally led to cancellation.[62] Mr. Woolfe again reacted as if there were not two sides to the question. "I respect and even admire the composer's choice not to answer these questions directly," he wrote, meanwhile deriding the demand for

transparency along with all calls (remember Tipper Gore's?) for "'trigger warnings,' explicit alerts that the material people are about to read or see—in a classroom or concert hall—might upset them."[63] The equation of classroom and concert hall was typical of Mr. Woolfe's unwillingness to make distinctions. As I've already implied, I too would like the concert hall to perform an educative task; but that task demands good faith and transparency all around, a demand that the composer, in this case, had pusillanimously rejected. Mr. Tarm, a very young man, still has lessons to learn. One important lesson is that while composers, like everyone else, should enjoy the right to freedom of expression (that is, the freedom to write as they please without fear of reprisal), no one has the right to a performance in Carnegie Hall. One gains access to prestigious venues not by right but through negotiation. Learning how to negotiate is part of the maturing process. Critics ought to help composers mature rather than indulge the spoiled-brat behavior that romantic esthetics has prescribed for them.

Almost needless to say, Mr. Woolfe's next sentence disparaged those, like me, who in their "excessive literalism" continued to question the evenhandedness of *The Death of Klinghoffer*. "It is not the role of an arts institution to spare audiences from history that might upset them," he declared. "Quite the contrary," he went on, implying that gratuitous upset is part of art's remit. That is indeed what artists have long been taught, and are still taught by upholders of the late, late romantic standard. The dogma that artists must define their calling in opposition to social norms, *pour épater les bourgeois*, is getting tired, though. It's so . . . well, twentieth century. Even its proponents have begun to see its knee-jerk assertion as counterproductive, demoralizing, even frivolous. In the aftermath of cancellation, Mr. Tarm finally deigned to own up to what had always been obvious, that his piece was about something for which words could after all be found. "It's about conflict, it's about totalitarianism, it's about polarizing nationalism," he now said. This prompted Mr. Woolfe to ask, "Why couldn't he have just said something like that in a program note, and perhaps avoided this whole mess?"

Why indeed? Was it not because a truly explanatory note would have shown respect to those whom the composer had been taught to despise? Again, *The Death of Klinghoffer* furnishes an ineluctable precedent. For accepting that the Boston Symphony acted out of an honorable impulse in canceling its post-9/11 performances of choruses from that opera, I was cast along with the BSO as a censor. But in fact I did not—and do not—object to performing the work; nor have I urged anyone to boycott it. I only expressed approval of the orchestra's discretion in the immediate circumstances, and recommended that we all exercise a bit of self-control in our mutual interactions. Many were the writers who caricatured the discretion I endorsed as "self-censorship"—that is, a preemptive act in anticipation of coercion—rather than considerate self-control.[64] By that standard, all courtesy and kindness is up for derision by esthetic snobs.

But that is an old story. Centuries old. Max Beerbohm satirized it perfectly in his immortal tiny essay "An Infamous Brigade,"[65] about his attempt to get a team of firemen to desist in their efforts to put out a beautiful blaze merely for the sake of restoring prosaic safety to the inhabitants of the building whose conflagration had produced "a strange glamour in the sky." Hilariously misconstruing both the collision of rights and the utilitarian principle, he vows not to rest "until the public has been thoroughly aroused on the general question of its right to the unspoilt enjoyment of fires! The sentimentalist may prattle of life-saving, but we must think, rather, of the greatest happiness of the greatest number." He then promises to form "an Artists' Corps whose aim will be to harass the members of the fire brigade on all occasions. I am maturing an elaborate system of false alarms, and I shall train my recruits to waylay the enemy in their onrush, seize the bridles of their horses, cut their reins.... We shall go about our work in a quiet, gentlemanly manner: servants, not tyrants, of the public.... Each one of us will trail a sinuous hose. It will not be filled with water. It will be filled with oil."

For, he concludes, "nothing is easier than to be incendiary. All one needs is a box of matches and a sense of beauty." Beerbohm was aping the Wildes and Whistlers. His words have not lost their edge in the age of Tarm and Woolfe, who are doing art no favors by continuing to insist on giving priority to esthetics over ethics.

. . .

So the epigraph that stands above this introduction, by a justly revered figure in recent Russian cultural history, is beautiful; but alas, like all inspirational utterances, it is far from true. Beauty is not truth, nor truth beauty. Nor is beauty redemptive. Neither the true nor the good will always gratify our esthetic sense, and that which gratifies us should not on that account be trusted. That, dear reader, is what I have learned on earth. It is not all we need to know. We will never know all we need to know. But we must try not to believe all we need to believe.

While I love the good and enjoy the beautiful, I am professionally concerned with the true, and responsible for (and to) it alone. That is the essence of *skepsis*, which defines the scholarly endeavor and gives us who practice it our special identity and (which amounts to the same thing) our *raison d'être*. Without it we are nothing. And so we chain ourselves to the mast and try our best to resist the blandishments of beauty when it tries to seduce us from the true (which we define, modestly, as merely that which has not yet been shown to be false) and let no virtuous commitment override the ethics of our vocation. If there is to be a Hippocratic Oath for scholars, that should be it; for if our actions do not distinguish us from advocates and politicians and hucksters, we perform no necessary or desirable function at all.

And with that I conclude the polemical portion of this volume.

NOTES

1. "По моему глубокому убеждению, добро и красота едины для всех народов. Едины—в двух смыслах: правда и красота—вечные спутники, они едины между собой и одинаковы для всех народов.." D. S. Likhachyov, "Pis'ma o dobrom i prekrasnom" (Letters on the Good and the Beautiful, 1985), preface to the Japanese edition; quoted by G. A. Dubrovskaya in the editorial preface to the second Russian edition (Moscow: Detskaya literatura, 1988), available online at www.e-reading.club /chapter.php/34608/0/Lihachev_-_Pis%27ma_o_dobrom_i_prekrasnom.html.

2. Delivered at Cambridge, 26 November 2009. It was Thanksgiving Day. Many thanks to John Rink, the American-born Professor of Musical Performance Studies at Cambridge, who kindly brought me a turkey sandwich.

3. First performed in October 2007, it has been regularly revived. See Ilana Walder-Biesanz, " *Eugene Onegin* meets *Brokeback Mountain* in Munich," https://bachtrack.com/review-eugene-onegin-warlikowski-opolais-munich-may-2015; Zachary Woolfe, "Hitting All the High Notes in Munich," *New York Times*, 1 August 2015, C1–2. A suitably provocative trailer can be found at www.youtube.com /watch?v=y7M-UgDd8As. (Unless otherwise noted, all URLs cited this chapter were accessed December 21, 2015).

4. See Marsilio Ficino, *The Philebus Commentary*, trans. and ed. Michael J. B. Allen (Berkeley: University of California Press, 1975), esp. 78–79: "*Ad finem igitur aliquem actio mentis dirigitur. Nam quod intelligit finis eius est veritas, quod vult finis est bonum, quod peragit finis pulchrum*" (So the action of intelligence is directed to some end. For in so far as it understands, its end is the truth; in so far as it wills, its end is the good; in so far as it acts, its end is the beautiful); 110–11: "*Ut est actus omnium roboratque, bonum dicitur. Ut vivificate, lenit, mulcet et excitat, pulchrum. . . . Ut in cognoscente potentia eam applicat cognito, veritas*" (As the act of all and as it strengthens, [the first act] is called the good. As it gives life, assuages, smooths, and stimulates, it is called the beautiful. . . . As it is in a cognitive power and joins it to the known object it is called truth); 238–39: "*Profecto ex Timaeo Platonis colligitur mentem ipsam divinam, quam Seraphin Hebraei nuncupant, tria quaedam habere officia*" (Certainly you can learn from Plato's Timaeus that the divine intelligence itself, which the Hebrews call the Seraphim, has some three offices).

5. The text of the obscene mock-liturgical song they sang, "Bogoroditsa, devo, Putina progoni" (Mother of God, Drive Putin Out), can be found at http://russmus.net/song/11998, and a performance by the group is available at www.youtube.com/watch?v=lPDkjJbTQRCY. The trial and its aftermath are recounted in Masha Gessen, *Words Will Break Cement: The Passion of Pussy Riot* (New York: Riverhead Books, 2014).

6. The law defines propaganda as "the act of distributing information among minors that 1) is aimed at the creating nontraditional sexual attitudes, 2) makes nontraditional sexual relations attractive, 3) equates the social value of traditional and nontraditional sexual relations, or 4) creates an interest in nontraditional sexual relations" (http://mic.com/articles/58649/russia-s-anti-gay-law-spelled-out-in-plain-english).

7. See Neil MacFarquhar and Sophia Kishkovsky, "Russian Theater Director Fired for Offending Christians," *New York Times*, 20 March 2015, A4, which describes the firing by the Russian culture minister of the director of a Siberian opera house over a production of Wagner's *Tannhäuser* that portrayed Jesus Christ rather than the title character as dallying with Venus, and that displayed a poster showing a crucifix between a pair of naked female thighs.

8. David Ng, "Sochi Olympics: Tchaikovsky's 'Swan Lake,' Stravinsky Abound," *Los Angeles Times*, 10 February 2014, www.latimes.com/entertainment/arts/culture/la-et-cm-sochi-olympics-swan-lake-stravinsky-20140210-story.html.

9. A playwright, Ivan Vyrypaev, who preemptively cut curse words from the text of one of his plays, commented to a *New York Times* reporter that "of course my plays lost something, but my artistic life

hasn't been ruined." See Rachel Donadio, "Russian Artists Face a Choice: Censor Themselves, or Else," *New York Times*, 2 April 2015, C1.

10. Cases in point include the cancellation of a production in Moscow of *Gross Indecency: The Three Trials of Oscar Wilde*, a play by Moisés Kaufman, first produced in New York in 1997, owing to an edict barring the Moscow New Drama Theater "from accepting foreign funds for artistic productions," which prohibition was interpreted by the performers as having been provoked by the subject of the play. See Michael Paulson and Sophia Kishkovsky, "Play about Oscar Wilde Runs Afoul of Kremlin," *New York Times*, 22 June 2015, C1.

11. My account of this episode, including quotes from the filmmakers and from government officials, is assembled from various news reports: "Putin: Tchaikovsky Was Gay but Russians Love Him Anyway," www.reuters.com/article/2013/09/04/us-russia-gay-rights-putin-idUSBRE9830XL20130904; "Tchaikovsky Was Gay but Russians Love Him, Says Vladimir Putin as David Cameron to Raise Concerns over Russia's Controversial Policies," *Independent*, 4 September 2013; Zack Ford, "Putin: Russia Isn't Homophobic because We Like Tchaikovsky's Music," http://thinkprogress.org/lgbt/2013/09/04/2569041/putin-russia-homophobic; Sara C. Nelson, "'Tchaikovsky Was Not Gay,' Insists Russian Culture Minister Vladimir Medinsky (but Putin Says He Was)," *Huffington Post*, 19 September 2013; Claire Bigg, "Proposed Tchaikovsky Film's Director Slams Debate over Composer's Sexual Orientation," Radio Free Europe/Radio Liberty, 19 September 2013, www.rferl.org/content/russia-tchaikovsky-film-gay/25111468.html.

12. "Все размышляют, за что мы его любим—'за это или не за это.' Пошлость, пошлость, обывательская пошлость . . . " (http://grani.ru/Culture/Cinema/m.219171.html).

13. In the editorial introduction to P. I. Chaikovsky, *Perepiska s N. F. von-Mekk*, vol. 1, ed. V. A. Zhdanov and N. T. Zhegin (Moscow-Leningrad: Academia, 1934), where previously suppressed passages in letters from Chaikovsky to his brother Modest were cited in support.

14. Zachary Woolfe, "A Composer and His Wife: Creativity through Kink," *New York Times*, Arts and Leisure, 23 February 2016. Mr. Haas himself was even cruder. Comparing his own optimistic music, born of sexual satisfaction, not only with Chaikovsky's but also with Schubert's less fortunate sex lives, he told Mr. Woolfe that "what you perceive," over and above "the fact that they desired men," is "the sadness about the impossibility to make love a reality." Over and above the sheer quaintness of this prejudice about homosexual men and their lonely lives, to assert this as a "fact" about Schubert is, to put it gently, outdated. It relies on a long-debunked reading of a single Schubert letter by Maynard Solomon that was in the musicological news in the late 1980s and early '90s. See Maynard Solomon, "Franz Schubert and the Peacocks of Benvenuto Cellini," *19th-Century Music* 12 (1988–89): 193–206, and a long subsequent literature of rebuttal and controversy, in which the decisive contribution was Rita Steblin, "The Peacock's Tale: Schubert's Sexuality Reconsidered," *19th-Century Music* 17 (1993–94): 5–35—an article that was much maligned on account of the sheer effectiveness that eventually put an end to the matter, at least where facts were concerned.

15. Yeva Merkacheva, "Rossiyskiye psikhiatrï dokazali, chto Chaikovskiy ne bïl geyem," 5 November 2010, http://korolevnews.ru/news/?id=857. M. I. Buyanov (1939–2012) is identified by Russian Wikipedia as a child psychiatrist and an instructor at the Central Finishing Institute for Doctors (Tsentral'nïy institut usovershenstvovaniya vrachey) in Moscow, who in 1992 founded an organization called the Moscow Psychotherapeutic Academy, which he headed as president until his death. A former member of the Union of Soviet Journalists, he belonged in post-Soviet times to the Russian Society of Physician Writers (Rossiyskoye obshchestvo medikov-literatorov).

16. "Вообще утаить от кого бы то ни было свои гомосексуальные наклонности в то время было невозможно. Да тот же Чехов, который был его другом, сразу бы заметил это. Но ни в одних воспоминания нет даже намека на возможную «голубизну» Чайковского. Заметьте, что композитор был фигурой публичной, объехал полсвета, подолгу жил в гостиницах, где его допекали поклонники и корреспонденты. И если бы с ним что-то было не так, это тут же стало

бы достоянием общественности. Плюс люди такого типа, как он, обожают писать письма, в которых сообщают все свои переживания. Чайковский написал одной только Надежде Фон Мекк столько, что они вошли в громадный трехтомник. Глазами психиатра я изучил каждое письмо и никакой склонности к гомосексуализму не нашел" (http://korolevnews.ru/news/?id=857).

17. See Alexander Poznansky, "Tchaikovsky: The Man behind the Myth," *Musical Times* 4 (1995): 175–82; *Tchaikovsky's Last Days: A Documentary Study* (Oxford: Clarendon Press, 1996), intro.; "Unknown Tchaikovsky: A Reconstruction of Previously Censored Letters to His Brothers (1875–1879)," in *Tchaikovsky and His World*, ed. Leslie Kearney (Princeton, NJ: Princeton University Press, 1998), 55–96.

Anton Chekhov could not be described as a friend of the composer. He sent Chaikovsky a fan letter; Chaikovsky paid him a visit at which they seem to have discussed in vague terms a possible opera on the subject of Lermontov's *Geroy nashego vremeni* (A Hero of Our Time); Chekhov dedicated his third collection of stories, *Khmurïye lyudi* (Gloomy People, 1890), to Chaikovsky and inscribed a copy to him, hopefully, as "your future collaborator." See *Anton Chekhov's Life and Thought: Selected Letters and Commentaries*, trans. Michael Henry Heim, ed. and annotated by Simon Karlinsky (Berkeley: University of California Press, 1975), 147–48.

18. "Чайковский был асексуалом—секс как такой его интересовал очень мало, его занимали более высокие материи. Однако гормоны все равно время от времени брали свое, потому такие люди эпизодически посещают бордели. Не могу сказать, как часто конкретно Чайковский там бывал. Но после таких похождений композитор во всеуслышание заявлял, что он самый порочный человек на свете. И ведь любой не знающий его характера мог поверить в это и представить себе бог знает что" (http://korolevnews.ru/news/?id=857).

19. I heard this joke many times during my year as an exchange student in Moscow (1971–72). A search on Google.ru turned up this version: "Армянскому радио задают вопрос: «Правда ли, что Чайковский был гомосексуалистом?» Армянское радио отвечает: «Возможно, правда, но мы любим его не только за это»" (http://starybarin.ru/index.php%3Foption%3Dcom_content%26view%3Darticle%26id%3D37%26Itemid%3D11).

20. "Я вас уверяю, что я работаю с такими людьми, я их иногда награждаю государственными медалями и орденами за их достижения в тех или иных сферах. У нас абсолютно нормальные отношения, и я не вижу здесь ничего особенного. Вот говорят, что Петр Ильич Чайковский был гомосексуалистом. Правда, мы любим его не за это, но он был великий музыкант, и мы все любим его музыку. Ну и что? Не надо делать из мухи слона, ничего страшного здесь, у нас в стране, и ужасного не происходит" ("Putin: Govoryat, Chaikovskiy bïl gomoseksualistom, no mï lyubim ego ne za èto," http://ria.ru/politics/20130904/960605375.html#ixzz3fAmtI241).

21. Dar'ya Yefremova, "Chaykovskiy: Kto prevratil geniya v geya?" *Gazeta "Kul'tura,"* no. 85 (5 November 2014). The website of Mikhail Buyanov's Moscow Psychotherapeutic Academy (www.mospsy.ru/belka.html) identifies Svetlana Afanas'yevna Belicheva as the founder and president of the Russian Consortium for Public Health, a professor at the Lenin State Pedagogical University in Moscow, and the editor-in-chief of the journal *Vestnik psykhosotsial'nogo i korrektsionnogo raboti* (Psychosocial and Correctional Newsletter).

22. A variation on the title of a famous comedy by Alexander Ostrovsky, *Bednost' ne porok* (Poverty Is No Vice, 1853), which has become proverbial.

23. **Культура**: В самом деле, так ли важно, «был»—«не был»? Как говорится, мы ведь любим Чайковского не за это . . .

Беличева: Конечно, обсуждать гениального композитора исключительно в ключе сексуальной ориентации—абсурд. Даже если бы «факты» подтвердились, едва ли это могло повлиять на восприятие его наследия. Но как психолог я всегда сомневалась. Такую музыку—гармоничную, светлую, исцеляющую—не мог написать изломанный человек. Гомосексуализм

хоть и не порок, но и не норма. Это сексопатология, которая, как и любая болезнь, накладывает отпечаток на творчество—должен чувствоваться какой-то надлом. За Чайковского обидно еще и потому, что в этих слухах много откровенно компрометирующего, скабрезного (http://portal-kultura.ru/articles/sensatsiya/68938-chaykovskiy-kto-prevratil-geniya-v-geya/).

24. About Poznansky (actually a librarian at Yale rather than a professor), Belicheva let drop a clump of libelous innuendos of her own: "In psychology we have a concept called addiction, in which one's understanding of things is dependent on previous experience; it determines one's undertakings, the motivations of one's actions, one's convictions. Not knowing Poznansky personally I cannot speak of his experience. But when it comes to his values, they show through. An employee of Yale University, an emigrant, Poznansky constructs his book on an artificial dichotomy: Western truth vs. Soviet lies. Legalization of same-sex marriage, multiple parenthood, propagandizing homosexual relations [in Russia today a prosecutable offense] all seem to be ideas close to this researcher's heart" (В психологии есть такое понятие—аддикция. Это зависимость восприятия от предшествующего опыта, стоящих [sic] перед человеком задач, мотивов деятельности, убеждений. Не зная лично Познанского, мы не можем говорить о его опыте. Но, что касается ценностей, они просматриваются. Сотрудник Йельского университета, эмигрант, Познанский строит книгу на искусственной дихотомии «правдивого западного» и «лживого советского». Идеи узаконивания однополых браков, пронумерованных родителей, пропаганды гомосексуальных отношений исследователю, похоже, очень близки).

25. See the publications referenced in note 17, especially the last and most detailed, "Unknown Tchaikovsky."

26. Berberova's main work on Chaikovsky was a *biographie romancée* called *Chaikovskii: Istoriya odinokoy zhizni* (Chaikovsky: The Story of a Lonely Life) (Berlin: Petropolis, 1936). Berberova later published a follow-up essay as the preface to a French translation of her book, *Tchaïkovski: Biographie* (Paris: Actes Sud, 1987; paperback reprint 2004); the preface also appeared in English, translated by Vincent Giroud, as "Looking Back at Tchaikovsky," *Yale Review* 80, no. 3 (July 1992): 60–73.

27. "Исследователю, по-настоящему любящему музыку Чайковского, не пришло бы в голову копаться в личной жизни композитора. Важнее сосредоточиться на характеристике его натуры, тонкой и трагедийной. И на том непростом пути, который прошел Чайковский—от безвестности и бедности к мировой славе" (Belicheva, "Chaykovskiy: Kto prevratil geniya v geya").

28. Chaikovsky, *Perepiska s N. F. von-Mekk,* quoted in R. Taruskin, "Pathetic Symphonist: Chaikovsky, Russia, Sexuality, and the Study of Music," in Taruskin, *On Russian Music* (Berkeley: University of California Press, 2009), 83.

29. Simon Morrison, "Waist-deep," *Times Literary Supplement,* 1 May 2015, 14–15.

30. Letters to the Editor, *Times Literary Supplement,* 15 May 2015, 6. I wrote in to defend Prof. Morrison, and Mr. Holden replied; a couple of unimportant rounds ensued in the *TLS* letters column (27 May, 19 June, 24 June).

31. From a letter to Nicolas Nabokov, 15 December 1949, published in Robert Craft, ed., *Stravinsky: Selected Correspondence,* vol. 2 (New York: Alfred A. Knopf, 1984), 376.

32. "Ты ведь знаешь, я давно влюблен в тебя и если бы ты был женщиной (что быть не может, как говорил покойный Гуревич), то . . . я не руча . . . " (Igor Blazhkov, ed., "Pis'ma I. F. Stravinskogo," in *I. F. Stravinsky, Stat'i i materialï,* ed. L. S. D'yachkova and B. M. Yarustovsky [Moscow: Sovetskiy kompozitor, 1973], 453). (The fact that this passage passed the Soviet censors already refutes Craft's interpretation.) Yakov Grigor'yevich Gurevich (1844–1906) was the headmaster of the St. Petersburg *gimnaziya* where Stravinsky and Andrey Rimsky-Korsakov had been classmates. More recently the letter has been published in I. F. Stravinsky, *Perepiska s russkimi korrespondentami,* ed. Viktor Varunts, vol. 1 (Moscow: Kompozitor, 1997), 260–61.

33. See Robert Craft, ed., *Stravinsky: Selected Correspondence,* vol. 1 (New York: Alfred A. Knopf, 1982), 23, 37.

34. Igor Stravinsky and Robert Craft, *Conversations with Igor Stravinsky* (Garden City, NY: Doubleday, 1959), 67.

35. Robert Craft, "100 Years On: Igor Stravinsky on The Rite of Spring," *Times Literary Supplement*, 19 June 2013; "Amorous Augmentations," in Robert Craft, *Stravinsky: Discoveries and Memories* (Naxos Books, 2013), 66–87.

36. Craft, "100 Years On"; emphasis added.

37. Zachary Woolfe, "Doubts Greet Claims about Stravinsky's Sexuality," *New York Times*, 17 July 2013.

38. Rick Schultz, "Robert Craft Explains Writing about Stravinsky's Homosexual Affairs," *Los Angeles Times*, 18 July 2013.

39. See Benjamin Ivry, *Maurice Ravel: A Life* (New York: Welcome Rain, 2000), 78–80. Ivry's main exhibit is what he calls a "slightly flirtatious" letter from Ravel to Stravinsky, written during the time when Ravel was renting a suite in the Hotel Splendide, across the street from Stravinsky's residence, the pension Les Tilleuls, in Clarens, Switzerland, where the two of them were working on the impending Diaghilev production of Musorgsky's *Khovanshchina*: "[My] second room," Ravel wrote, "looks out on the avenue Carnot. I could leap into your apartment from my balcony, though I would not take advantage of this possibility. From morning on—about 12:30—we could exchange flatteries in our pajamas" (Robert Craft, ed., *Stravinsky; Selected Correspondence*, vol. 3 [New York: Alfred A. Knopf, 1985], 16).

40. The relevant moment may be seen, for example, in *Pierre Boulez: Inheriting the Future of Music*, a documentary about his master class at the Lucerne Festival Academy (EuroArts DVD, 2010).

41. With Andrey Rimsky-Korsakov Stravinsky used the familiar second person, but that is because they had been school chums. Once Russians are on *tutoyer* terms, they remain so for life, whatever the vicissitudes of their relationship. The last item in Stravinsky's correspondence with Andrey was a letter, written almost twenty years after their explosive falling-out, in which Rimsky-Korsakov *fils* asked Stravinsky (then resident in Paris) for a tribute to be published in a memorial volume marking the twenty-fifth anniversary of the death of Rimsky-Korsakov *père*. An exceedingly stiff and proper formal request, written in French, the letter begins "Cher Maître," never addresses Stravinsky by name, but ends, incongruously, "Reçois, cher Maître, les cordiales et respectueuses salutations de ton fidèle ami et sincère admirateur' (quoted in R. Taruskin, *Stravinsky and the Russian Traditions: A Biography of the Works through* Mavra [Berkeley: University of California Press, 1996], 978n22). Anglophone scholars do not always realize that they need training in the mores governing the second person in languages that distinguish the two forms (i.e., most languages).

42. Nadine Hubbs, *The Queer Composition of America's Sound: Gay Modernists, American Music, and National Identity* (Berkeley: University of California Press, 2004).

43. Brian Wise, "Was Stravinsky Bisexual? If He Was, So What?" 25 July 2013, www.wqxr.org/#!/story/301048-was-stravinsky-bisexual-if-he-was-so-what. The linkage between manliness and the concept of genius derives from an influential study by Christine Battersby, *Gender and Genius: Towards a Feminist Aesthetics* (Bloomington: Indiana University Press, 1990).

44. They have been collected, along with his writings on Chaikovsky, Stravinsky, and much else, in Robert P. Hughes, Thomas A. Koster, and Richard Taruskin, eds., *Freedom from Violence and Lies: Essays on Russian Poetry and Music by Simon Karlinsky* (Boston: Academic Studies Press, 2013).

45. Two of Volkov's strongest proponents have been muted by their publishers. Ian Macdonald's *The New Shostakovich* of 1990, which purported to vindicate the veracity of *Testimony* as a guarantee of its authenticity by mounting a scathing attack on the credibility of doubters, has been posthumously reissued minus most of the invective, leaving the implausible speculations undefended by bluster. See Ian Macdonald, The *New Shostakovich*, 2nd ed., ed. Raymond Clarke, with a new introduction by Vladimir Ashkenazy (London: Pimlico, 2006). The fate of Allan B. Ho and Dmitry Feofanov, eds., *Shostakovich Reconsidered* (London: Toccata Press, 1998), a compilation of material in support of Volkov's claims, has

been similar. The first edition remains in print, but only because the second edition, in which the compilers answered their critics with redoubled recklessness and vituperation, was rejected by the publisher and is self-published online as *The Shostakovich Wars*, www.siue.edu/~aho/ShostakovichWars/SW.pdf.

The lingering effect of Volkov's mischief can be felt in the way Shostakovich continues to be marketed in the West. The first series of recordings undertaken by the Boston Symphony Orchestra under its new director, Andris Nelsons (born in the Latvian SSR in 1978), is a Shostakovich symphony cycle. (The first installment, issued in July 2015, pairs the Tenth Symphony with the Passacaglia entr'acte from *The Lady Macbeth of the Mtsensk District*.) It is long overdue, Nelsons's predecessor, James Levine, having spurned Shostakovich for all the old Cold War reasons; but it is being hawked under the Volkovian rubric "Shostakovich: Under Stalin's Shadow," and the accompanying note, by Harlow Robinson, an old Volkov supporter, maintains the line promoted by *Testimony* and subsequent writings by Volkov, that Shostakovich's work between 1936 and 1953 is uniformly "about" Shostakovich's relationship with the dictator and "their personal creative competition, the struggle between two egos." Nevertheless, neither Volkov nor *Testimony* are cited as authorities, even when the discussion turns to the second movement of the Tenth, the subject of one of *Testimony*'s most news-making allegations. Now we read that it "may or may not have been intended as a musical portrait of Stalin" (Booklet accompanying Deutsche Grammophon CD 479 5059). These meaningless weasel words could be applied to any composition by Shostakovich or by any of his contemporaries.

46. The clearest, most concise introduction to this approach is still the original statement: James J. Gibson, "The Theory of Affordances," in *Perceiving, Acting, and Knowing: Toward an Ecological Psychology*, ed. Robert Shaw and John Bransford (Hillsdale, NJ: Lawrence Erlbaum Associates, 1977), 67–82. The strongest application so far to music is Charles O. Nussbaum, *The Musical Representation: Meaning, Ontology, and Emotion* (Cambridge, MA: MIT Press, 2007), and the strongest application to historical musicology is Bonnie C. Wade, *Composing Japanese Musical Modernity* (Chicago: University of Chicago Press, 2014).

47. Wade's *Composing Japanese Musical Modernity* is an especially crisp example, being a study of music history focusing on a literate tradition and on named composers with individual styles, but written by an ethnomusicologist using the tools of her own trade in a manner that I, a historical musicologist, have found instructive.

48. All quotations from Schiff come from "Fruit of the Poison Tree," *Times Literary Supplement*, 6 May 2005, 3–6.

49. *War and Peace*, Draft One, quoted in Andrei Zorin, "Tolstoy's Sand Clock: The Flow of History in *War and Peace*," *Times Literary Supplement*, 20 March 2015, 15.

50. Solomon Volkov, *Shostakovich and Stalin: The Extraordinary Relationship between the Great Composer and the Brutal Dictator* (New York: Alfred A. Knopf, 2004); Malcolm H. Brown, ed., *A Shostakovich Casebook* (Bloomington: Indiana University Press, 2005).

51. Alex Ross got this right; see his "Unauthorized: The Final Betrayal of Dmitri Shostakovich," *New Yorker*, 6 September 2004, www.newyorker.com/magazine/2004/09/06/unauthorized. As if directly answering Schiff (who actually advanced the argument somewhat later), Ross wrote, "Some have shrugged their shoulders over the entire affair, saying that, yes, some hanky-panky went on, but that it doesn't matter in the end, because Volkov told little lies in order to convey a larger truth about Soviet music." And then, admirably, he continued: "I don't buy that argument. It isn't enough for the memoirs of a major artist to have an ambience of authenticity. A book that subjected Picasso or Joyce to such manipulations would never have made it to publication. For some reason, though, music is treated as a childish realm in which fables serve as well as facts. Russian composers seem especially vulnerable to urban legends, as if facts mattered even less behind the old Iron Curtain." What is particularly admirable is that to make this assessment, Ross had to acknowledge that he had formerly been a proponent of what he was now exposing.

52. Patricia J. Williams, "Cruelty, Irony, and Evasion," *The Nation*, 11/18 January 2016, 10.

53. See R. Taruskin, *Text and Act* (New York: Oxford University Press, 1995), 27. The issue then was the not unrelated matter of certainty, to which scholars, unlike artists (or religious zealots), cannot aspire.

54. Rockwell made his comment in the program book for the 1996 Lincoln Center Festival, of which he was the director, answering a piece I had published in the *New York Times* ("Prokofiev, Hail—and Farewell?") in 1991 on the centenary of Prokofieff's birth. See also R. Taruskin, "Stalin Lives On in the Concert Hall, but Why?" *New York Times*, 25 August 1996; reprinted with an update in *On Russian Music*, 277–82.

55. See Pauline Fairclough, "Don't Sing it on a Feast Day: The Reception and Performance of Western Sacred Music in Soviet Russia, 1917–1953," *Journal of the American Musicological Society* 65 (2012): 67–111.

56. Immanuel Kant, "Answering the Question: What Is Enlightenment?" (1784), available at www.columbia.edu/acis/ets/CCREAD/etscc/kant.html.

57. Information about this incident, and quotations in this paragraph and following ones, come, unless otherwise attributed, from Michael Cooper, "Youth Symphony Cancels Program That Quotes 'Horst Wessel' Song," *New York Times*, 4 March 2015, www.nytimes.com/2015/03/05/arts/music/youth-symphony-cancels-program-that-quotes-horst-wessel-song.html.

58. For an account of the controversy surrounding that cancellation, see R. Taruskin, "The Danger of Music and the Case for Control," first published in the *New York Times* on 9 December 2001, and reprinted with an update in idem, *The Danger of Music and Other Anti-Utopian Essays* (Berkeley: University of California Press, 2009), 168–80.

59. Zachary Woolfe, "Making the Case to Hear Nazi Song," *New York Times*, 7 March 2015, C1; available online under the title "An Argument for Hearing a Work with a Nazi Reference," at www.nytimes.com/2015/03/07/arts/music/an-argument-for-hearing-a-work-with-a-nazi-reference.html.

60. The note was reprinted on 6 March 2015 in Norman Lebrecht's blog, *Slipped Disc*, under the heading "The Composer Who Got Cancelled at Carnegie Hall," http://slippedisc.com/2015/03/the-composer-who-got-cancelled-at-carnegie-hall.

61. This is a paraphrase of a sentence from a famous letter from Mahler to his friend Max Marschalk about his Second Symphony and his ambivalence about supplying a program note that would explain the music the way he had just explained it to Marschalk: *"Ich weiß für mich, daß ich, solang ich mein Erlebnis in Worten zusammenfassen kann, gewiß keine Musik hierüber machen würde"* (I know, where I am concerned, that so long as I can sum up my experience in words, I would never write any music about it) (Letter of 26 March 1896, trans. Piero Weiss, in Piero Weiss and Richard Taruskin, *Music in the Western World: A History in Documents*, 2nd ed. [Belmont, CA: Thomson/Schirmer, 2008], 351.) The version quoted by Jonas Tarm evidently comes from Wikiquote: https://en.wikiquote.org/wiki/Gustav_Mahler.

62. Cooper, "Youth Symphony Cancels Program."

63. Woolfe, "Making the Case."

64. See, for example, Guy Dammann, "Through a Glass, Darkly," *Times Literary Supplement*, 23 March 2012, where my essay (referenced in note 58) is boiled down to a demand that "the work should be boycotted (or subject to 'self-censorship')." For an example of genuine self-censorship, see note 9 above.

65. First published in the collection *More* (1899) and endlessly reprinted, most recently in Philip Lopate, ed., *The Prince of Minor Writers: The Selected Essays of Max Beerbohm* (New York: New York Review Books, 2015), 206–9.

PART ONE

Not by Mind?

Умом Россию не понять,
Аршином общим не измерить:
У ней особенная стать—
В Россию можно только верить.

Russia will not be grasped by mind,
Nor measured by the common stick:
She's of her own peculiar kind—
For Russia faith must do the trick.
—FYODOR IVANOVICH TYUTCHEV,
"UMOM ROSSIYU NE PONYAT'" (1866)

And yet we try.

1

Non-Nationalists, and Other Nationalists

You don't have to be Russian to love Tchaikovsky.
—RALPH P. LOCKE[1]

Here's an old story I must have heard a hundred times growing up in a family of Yiddish-speaking émigrés from the Russian empire, many of whom had been members of radical organizations in the old country and joined similar organizations in America. My family had both Socialist and Communist members, and as you must know, Socialists and Communists hated one another far more than they hated capitalists. I had relatives on both sides when Socialists and Communists would try to break up each other's meetings with heckling that often ended up in brawls. According to the old story, told with relish from both perspectives, the police were breaking up one such brawl; a cop had his nightstick poised above the head of one of the brawlers, who looked up and said, "But officer, I'm an anti-Communist." "I don't care what kind of Communist you are," said the officer as the billy club came down.

That's how I feel about "non-nationalist" Russian music. I don't care what kind of nationalist you are; as long as we see nationalism as the issue dividing Russian musicians, we are still in the ghetto that nationalist discourse has created for us. The ghetto is especially evident here because we have chosen to speak only about Russian opera at this conference, and that means that our question is still "How Russian is it?"—the baleful question that I identified, and tried to shake, a decade and a half ago in *Defining Russia Musically*.[2] That book, of course, did not succeed in shaking the baleful question, because it, too, was almost wholly devoted to

Originally delivered as a keynote address at a conference, "Non-Nationalist Russian Opera," organized around a performance of Sergey Taneyev's *Oresteia*, at the University of Leeds, 17 November 2010.

music by Russian composers and therefore succeeded, at best, in merely adding a new wing to the ghetto.

In the *Oxford History of Western Music* I tried to shake it by spreading Russian composers as evenly as I could through the volumes devoted to the nineteenth and twentieth centuries. Russia makes its debut, it is true, in a chapter called "Nations, States, and Peoples," which sounds suspiciously like a euphemism for the old ghetto of "nationalism." But Russia's company in that chapter consisted of Germany and France, and my purpose was to show that nationalism spread to Russia with westernization. In the next chapter, on virtuosos, I gave a lengthy description of Liszt's first recital in St. Petersburg, replete with comments from Glinka, as related by Stasov, together with a retort to Glinka from another St. Petersburger, quoted by Stasov (and by me) in the original—that is, in French.[3] The purpose was to make Russia (or at least St. Petersburg) seem a normal—which is to say, an unmarked—venue for European music-making.

In the chapter given in part to Chopin, Russia figured as the oppressor nation against which Chopin's nationalist sentiments were directed, and in a chapter called "Slavs as Subjects and Citizens" Russia was contrasted with the Czech and Moravian lands, with Smetana and Balakirev as the protagonists. The purpose there was chiefly to show how national character is assigned to music—by audiences as well as composers, sometimes in the presence of folklore, but sometimes without its benefit. In the chapter following those on Wagner and Verdi, called "Cutting Things Down to Size," Russian realism, exemplified by Musorgsky's *Boris Godunov* and Chaikovsky's *Eugene Onegin,* is juxtaposed with French *opéra lyrique,* verismo, and operetta. In the last chapter of the nineteenth-century volume, symphonies by Borodin and Chaikovsky are discussed alongside symphonies by Bruckner, Dvořák, Amy Beach, César Franck, Saint-Saëns, Elgar, Vaughan Williams, and Sibelius. One thing I knew I would do from the moment I conceived the book, before I even sat down to write the medieval chapters, was to make Alexander Serov one of the main spokesmen of the New German School. I admit that I was delighted to give myself a pretext for sneaking into the text a picture of the man to whom I devoted most of my doctoral dissertation, and in full consciousness that mine would surely be the only English-language general history of music in which Serov's name would even appear in the index.[4]

But the larger purpose, I hope, is clear: it is, to use a term that feminist historians coined, to "mainstream" Russian music and musicians into the general narrative. Serov, like Anton Rubinstein, was accepted during his lifetime as a cosmopolitan figure abroad (though for a Russian the term "cosmopolitan" is never without complications); and he was considered an authentic spokesman for the progressive faction in European musical politics at midcentury. That made him a terrific vehicle for mainstreaming. And yet, as you may know from other parts of the *Oxford History,* I have been critical of some of the mainstreaming efforts that have been

mounted on behalf of women composers, since representing them disproportionately can distort the historical picture in a fashion that actually weakens the main political point of feminist scholarship: namely, that women have been not merely excluded from the historical account but denied the access and opportunities that would have enabled them to earn their place within it.[5]

But that is hardly the case with Russian music, which since the days of Rubinstein in the nineteenth century, and Sergey Diaghilev in the twentieth, has been extremely prominent in the European and American performing repertoire even as it has been minimized and ghettoized in historiography. Of course that minimization-cum-ghettoization is a legitimate and necessary part of the story one has to tell, but so is the prominence, amounting at times to veritable crazes. For example, in *Modern Composers of Europe*, a survey published in 1904, Arthur Elson (1873–1940), a Harvard-educated writer who eventually succeeded his father, Louis C. Elson, as music critic of the *Boston Advertiser*, but who at the time was working as a math and science teacher at a prep school, proclaimed, in the topic sentence of the book's final paragraph: "There seems little doubt that Russia is to-day the leader of the world of music." He then proceeded to justify the claim by disposing of possible rivals one by one:

> While Wagner to some extent checked development in Germany, because his great achievements were difficult to equal, the national school in Russia, working along similar lines, has made an advance that is shared in by all her composers, and that is leading to continually new progress. The wealth of her folk-lore and poetic legends is an added incentive, and the material has all the charm of novelty for the nations of Western Europe. Germany still has much to say, but it is not so entirely new; France has gone astray for the moment in a maze of weird harmonic effects; Italy, but just awakened from a long sleep, has hardly mastered the new musical language; England and the Netherlands are almost too civilized for the best results; Bohemia has lost some of her greatest leaders, while in Norway Grieg belongs almost to a past generation. Russia, however, is at the height of her activity, and in the next few years the Western world, already familiar with some of her triumphs, will probably be forced to grant her the homage due to the most musical nation in the world.[6]

By the time Elson wrote these words, "Russomania" had been growing for decades in England and America, "having taken off in the 1880s," Tamsin Alexander tells us, "when left-leaning literary circles became enamoured by the elusive 'Russian Soul' via the novels of Tolstoy and Dostoevsky."[7] And while that enthusiasm for Russian culture and its mystique reached music and theater a little later than it did literature, owing to the greater weight, and consequent inertia, of the infrastructure that needed to be mobilized on behalf of the performing arts, it unquestionably achieved the proportions of a frenzy by the time Diaghilev and his Ballets Russes began their industrial-strength export campaign.

Minimization came with the professionalization of Anglophone musicology at the hands of the German Jewish refugees who poured into the United

Kingdom and the United States with the rise of National Socialism (or, in some cases, like that of my own Professor Paul Henry Lang, who was neither German nor Jewish but emphatically *mitteleuropäisch,* slightly in advance of it). Their loyalty to German culture was only intensified by exile, which fostered the conviction (altogether congruent with that felt and expressed by Arthur Lourié on behalf of *russkoye zarubezh'ye,* the Russian cultural diaspora, in chapter 7 of this book) that they, rather than the thugs who had expelled them, were the bearers of the fatherland's "true" or "pure" culture, whence the zeal with which they set about rebuilding their institutional environment on Anglophone turf and communicating its mores, a nervous overemphasis on canonicity prominent among them, to a new cohort of pupils and disciples—a task that included the construction of the ghetto for "other" musics in which we were once confined.[8] But here I will stop pressing my attempts to counter the old habits of my profession, happily no longer as firmly entrenched as they once were. As you can imagine, the account of twentieth-century music in the Oxford History, replete with Stravinsky and Shostakovich, Rachmaninoff and Prokofieff, Schnittke and Gubaidulina, offered manifold opportunities for mainstreaming, but to go on offering my own work as an example may, if it gives an impression of self-interest, lessen the effectiveness of the argument. Nevertheless, the example is relevant to my point that we need to look for other contexts into which to place Russian music if we want to accord it an appropriate position within the historical narrative and counter the essentialist assumptions that have demeaned it—above all, the dogma that the authenticity or legitimacy of Russian music depends on its Russianness, however that quality is defined.

There are so many other contexts, after all, into which Taneyev's *Oresteia*—the centerpiece around which the present conference has been built—might have been inserted. We could have had a conference on operas after Aeschylus, or after Greek drama generally. In that case, Taneyev would have taken his place in a distinguished lineage that might have gone all the way back to the Florentine *camerata.* (Of course, I would not have been invited to that conference.) It could have been a conference on mythological opera, in which case the Wagnerians would have invaded, so I can understand why we didn't go that route. How about a conference on opera in the decade after Wagner? There would have been many prominent Russian works to feature alongside those by Germans, Frenchmen, and Italians. How about a conference about leitmotifs in and out of opera? Or on one-opera composers? (Taneyev would have fared pretty well against Franck and Schumann, but then there'd be Beethoven.) How about operas published by Belyayev? (In that case Taneyev would be in counterpoint with Rimsky-Korsakov and Borodin, thus crosscutting the factitious divide between nationalists and "non-nationalists.") By now I'm reaching, obviously, but I hope you will agree with me that the old factitious divide didn't do Russian music any good.

Not that I don't sympathize with the effort to give "non-nationalists" their due. There is only one thing worse than being confined to a ghetto, after all, and that is being judged a bad ghetto citizen, which is how Chaikovsky is usually portrayed in non-Russian textbooks, to say nothing of Rubinstein or other "cosmopolitan" figures. In the most recent such textbook published in America, which, following recent trends in textbook publication, has very little continuous text but consists in the main of bite-sized verbal clumps, there is an opening that presents, on facing pages, a lightly annotated listing of "Major Composers of the 19th Century," grouped by countries. Although the breakdown thus emphasizes nations, the issue of national character is explicitly raised in only three of the nine groups: Spain, Russia, and the United States (not Scandinavia, not Great Britain, not even Bohemia). And only in the paragraph devoted to Russia is the matter presented as contentious. I'll quote approximately the first half of the paragraph, silently omitting parenthetical information like dates or cross-references. It reads:

> Mikhail Glinka was one of the first Russian composers to gain international fame. While studying in Italy as a young man, he experienced "musical homesickness," the desire to hear music that was distinctively Russian. His two great operas, *A Life for the Czar* and *Ruslan and Ludmila*, inspired several subsequent generations of Russian composers, including the group known as "The Five": Mily Balakirev, César Cui, Alexander Borodin, Modeste Mussorgsky, and Nikolai Rimsky-Korsakov. Many Russian composers considered Tchaikovsky too foreign in training and outlook to belong to this group of nationalists.[9]

Only a Russian composer, in this as in every such book, makes news by *not* fetishizing his nationality. In the more extended verbal clump that provides a "Composer Profile" for Chaikovsky, we read that he "embraced his Russian heritage but did not make a display of it, unlike some of his contemporaries, who made a point of writing explicitly nationalistic music."[10] One could easily multiply assertions of this kind to illustrate the degree to which being "explicitly nationalistic" has become a normative or default assumption about Russian composers. Notice in this case, for example, that Chaikovsky has to be explicitly pardoned for his deviance from the norm with the assurance that despite everything he "embraced his Russian heritage" after all. I really have no idea what the author meant by that; it makes sense only as a preemptive defense against some kind of implied McCarthyite or Zhdanovite attack (so I guess I do understand it at that); but it strangely parallels the statement one paragraph earlier that Chaikovsky "acknowledged his homosexuality privately but otherwise kept it concealed for fear of public condemnation." It was something else about which one could say that Chaikovsky "embraced" it but "did not make a display of it."

My favorite illustrations of the spurious newsworthiness of non-nationalism in a Russian composer are two. One is Robert P. Morgan's remark that "curiously,

Skryabin was not himself nationalist in orientation."[11] (I just love that "curiously"!) The other concerns the protagonist of our conference, Sergey Taneyev, and it is something I'll never forget because it gave me my first impulse to topple the national question from its privileged position in Russian music studies, more than a quarter of a century ago. At a meeting of the Society for Music Theory, the reader of a paper on Taneyev's treatise of 1909, *Podvizhnoy kontrapunkt strogogo pis'ma* (Invertible Counterpoint in the Strict Style), went out of his way to inform the audience that Taneyev's compositions were "without conspicuous nationalistic elements."[12] When I asked him why he felt it necessary to state this negative "fact," especially in the context of a strict counterpoint text, he replied that it answered "a natural question" about a Russian composer. Natural. That got me thinking seriously, for the first time, about the pitfalls of essentialism.

But if we want to fix the blame for this situation, the name that should head the bill of indictment will not be that of any feckless Western textbook writer, but a name revered in Russia to this day. Any Russian will know that I am about to summon Vladimir Vasil'yevich Stasov to the dock. It is he, more than anyone else, who made the distinction between nationalist and non-nationalist in Russian music not only factitious and contentious, but also invidious. It is to his writings that we must look first to isolate the bacillus we need to extirpate. He wrote so voluminously that sampling his rhetoric could be an endless endeavor, so I will limit myself for the most part to his last testament, the grand summation called *The Art of the Nineteenth Century (Iskusstvo XIX-ogo veka)*, first published in abridged form in 1901 as a supplement to the arts journal *Niva* and reissued in full five years later (very shortly before Stasov's death) in the fourth volume of his collected works. I will be quoting from the text as given in the third and last volume of the lavish edition of Stasov's *Selected Works* that was issued by the Soviet publishing unit *Iskusstvo* in 1952, in the wake of the so-called *Zhdanovshchina*, when Stasov's writings were recanonized because they were seen to favor the xenophobic arts policies of the Soviet government in the early years of the Cold War.

This huge final survey, *The Art of the Nineteenth Century*, sums up the seventy-seven-year-old Stasov's sublimely inflexible views at their final stage of cementedness, and at a point where he could portray the whole century whose art he had witnessed as if it were a single static and highly polarized entity. Its second great advantage is that it was Stasov's universal synopsis, uniting his views on Russian and European art and placing the former, the Russian, within the context of the latter, the European. And of course the place to look, in order to see the polarization of Russian and non-Russian within the Russian milieu, will be Stasov's farewell characterizations of his perennial *bêtes noires*, Rubinstein and Chaikovsky.

The linkage of names was not just a matter of Stasovian rhetoric. Rubinstein had been Chaikovsky's mentor, and what brought them together, hence what they had most in common, was their affiliation with the St. Petersburg Conservatory,

Rubinstein as its founder and first director, Chaikovsky as a member of its first graduating class. This is our signal that the issue of nationalism was inextricably tangled up, both conceptually and strategically, and especially in the mind of Stasov, with the issues of education and professionalization. Indeed, during their lifetimes, Chaikovsky and Rubinstein would never have cast their differences with the composers now thought of as the Russian nationalists in any other terms than those of professionalism, and this was true of their antagonists as well.

We know this now above all from their letters. There is the now-famous letter from Chaikovsky to his patron, Nadezhda von Meck, sent from Italy late in 1877 (or early 1878, N.S.),[13] in which, at her request, he cast a withering eye over the whole *moguchaya kuchka*, the Mighty Bunch whom Stasov had christened as such a decade before. "All the newest Petersburg composers are very gifted persons," he allowed, "but they are all infected to the marrow with the worst sort of conceitedness and with a purely dilettantist confidence in their superiority over all the rest of the musical world." Immediately he excepted Rimsky-Korsakov from this generalization, because Rimsky-Korsakov was, in Chaikovsky's words, "the only one among them to whom it occurred, five years ago, that the ideas propagated by the circle had really no foundation, that their contempt for schooling, for classical music, their hatred of authorities and standards were nothing more than ignorance." We all know why this happened to Rimsky-Korsakov: he had been appointed to the faculty of the hated conservatory (something about which you can learn only with the greatest difficulty if Stasov is your source). As for the rest, Cui, in Chaikovsky's description, "cannot compose otherwise than by improvising and picking out on the piano little themelets supplied with little chords *[melodiyki, snabzhyonnïye akkordikami]*." Borodin's "technique is so weak he cannot write a line without outside help." Musorgsky actually "shows off his illiteracy, is proud of his ignorance, slops along any old way, blindly believing in the infallibility of his own genius." As for Balakirev, who at the time Chaikovsky was writing was in a period of withdrawal, Chaikovsky admitted that "he has enormous gifts, but," he then had to add, "they are lost because of some fateful circumstances that have made a saintly prig out of him."[14]

As we see, "How Russian is it?" was not Chaikovsky's question. And neither was it Musorgsky's question when he wrote equally disparagingly to Stasov, almost exactly four years earlier, about a visit from "the worshipers of absolute musical beauty," which left him with "a strange *feeling of emptiness*." This is the letter in which Musorgsky keeps referring to Chaikovsky as Sadyk-Pasha, the *nom de plume* of his namesake, the Polish (some say Ukrainian) patriot and orientalist writer Michal Czajkowski (1804–86). Chaikovsky and Musorgsky met at Cui's apartment while Chaikovsky was visiting St. Petersburg in connection with staging his opera *The Oprichnik*. Chaikovsky listened to a medley of pieces by Cui and Musorgsky, including recently composed items from the revised *Boris Godunov*. He responded, according to Musorgsky, with some patronizing advice: "a strong

talent ... but dissipated ... would be useful to work on ... a symphony ... (*en forme*, of course)."[15]

The link between the matter that actually divided Chaikovsky and the *kuchkisty*, on the one hand, and the spurious question of nationalism that has dominated the discourse of Russian music since their time, on the other, was again provided by Stasov, originally in an article opposing the establishment of the St. Petersburg Conservatory, which appeared in 1861 in a reactionary, xenophobic newspaper called the *Northern Bee (Severnaya pchela)*, an organ of bilious merchant-class opinion, which would have been a strange place for a liberal *intelligent* like Stasov to be writing on any other subject. His opposition had been provoked, along with that of Balakirev and even Alexander Serov, by some rash comments made by Anton Rubinstein during his campaign to mobilize support for the institution, among them tactless comments on the failure of Russia to produce any significant composers, this at a time when Glinka and Dargomïzhsky, who were then still alive, had produced between them three operas that had succeeded on the stage, and in which Russian musicians could take justifiable pride, and when Glinka, at least, had made an international reputation.[16] This gave the opposition a pretext to cast Rubinstein's activities as unpatriotic, a charge that resonated easily with Rubinstein's dubious ethnicity. Although there were many aspects to his anti-conservatory tirade that were out of Stasovian character, he never retreated a step from it over the course of his career. (Retreat would have been more out of character for him than anything else.) He reprinted large extracts from it in his most famous essay on Russian music, namely the fourth chapter of his 1882 survey *Twenty-Five Years of Russian Art*; and he recycled the odious charges a full forty years later in *The Art of the Nineteenth Century*, where he wrote:

> Not long before the opening of the St. Petersburg Conservatory voices were raised in the press *against* the necessity of such institutions at the present time generally, and in Russia particularly. For Russia it would be sufficient, said the protesters, to follow the example of Glinka and Dargomïzhsky with regard to composition. Neither of them had ever gone to musical schools; they had developed independently, apart from the traditions and customs of European musical guilds. It would have been better if all the musicians of Russia went in their footsteps. These voices were Serov's and mine, and it would seem that in these protesting opinions there was a measure of truth, because in a few years the results given by our conservatories turned out to be the same as those always given by all conservatories: an inclination toward workaday musicianship on the part of performers and composers alike; the forgetting of the main, essential tasks of musical artistry and its transformation into a mere livelihood; the proliferation of external, pretentious technical display to the detriment of art; in sum, the decline of robust feeling and common sense, the deterioration of taste, and base submission to tradition and authority.[17]

Stasov went on for a while in this familiar vein, and then came the modulation that interests us here:

Having made himself the director of our main conservatory, the Petersburg one, Anton Rubinstein brought to it, first of all, all his personal artistic tastes and ideas and, in the second place, all the tastes and ideas of the German conservatories he knew. He believed blindly in them, and beyond their horizon he knew nothing and saw nothing. He was a pianist of genius, amazing, profound in spirit and in poetry, than whom no one stood higher except, of course, his comrade and contemporary Liszt, whose like the world in all probability will not soon see again. But Rubinstein's tastes and ideas were very narrow and circumscribed. By nature he was an ardent Mendelssohnian and somewhat retreated from this cult only in his late years, not so much out of inner conviction as in response to the later opinion of Mendelssohn that took hold in most of Germany.... His own compositions, extraordinarily prolific, revealed a very middling and unoriginal talent, ... and although he had an enormous success in Russia with his *Demon,* a rather weak opera (apart from its colorful oriental dances) and a few mediocre romances (which included, however, the truly delightful "Persian Songs"), still, in the final analysis, his works never aroused any significant response anywhere. The national tendency he did not admit and did not like. All his ideas and tastes he implanted in his conservatory. In it they reigned eternal with majestic force, and reign there to a significant degree to this day.[18]

The conservatory having been associated through Rubinstein with opposition to "the national tendency," the stage has been set for Chaikovsky, who, Stasov wrote, "was born with a great and rare talent, but who unfortunately was trained at the St. Petersburg Conservatory in its earliest, that is, its most inauspicious time, during the unlimited dominion and spell of Anton Rubinstein." This was bad not only for Chaikovsky but for Russia:

> Chaikovsky's musical career lasted more than a quarter of a century. For practically all this time he went from success to success and was soon recognized, both at home and abroad, as the greatest musical talent in Russia, a talent equal to Glinka, and in the opinion of many, even higher than Glinka. That opinion was mainly conditioned by the fact that Chaikovsky, although a sincere patriot and a zealous devotee of all things Russian, did not carry in his musical nature the "national" element and was from head to toe a cosmopolitan and eclectic.[19]

The pages that follow are fascinating to read, as Stasov piles up evidence that contradicts his assertions (some of it from letters to von Meck that had been published only in the few years since Chaikovsky's death), only to sweep it all away with mantra-like repetitions of his claims. Anyone who knows Stasov's writings knows that they give new meaning to the word "closed-minded," but his performance here reaches peaks probably unequaled in his own output, or in anyone's. Stasov's ideas about what constitutes "the 'national' element" remain in this last testamentary piece what they were before, as laid out in *Twenty-Five Years of Russian Art* in the form of four points: (1) the absence of preconception and blind faith; (2) the use of folklore as source material; (3) the oriental element; (4) an

extreme inclination toward program music.[20] From this one could easily divine the list of exceptional Chaikovsky works that Stasov cites (just as one could have guessed the two exceptions noted in his brief unsympathetic survey of Rubinstein's output, in both cases "oriental"). Since *The Art of the Nineteenth Century* was written more than seven years after Chaikovsky's death, the list here is the most complete one that Stasov ever drew up. It includes the *Scherzo à la russe* for piano, the finale of the Second Symphony, the andante of the "third" [*recte:* first] quartet, the choruses in the first act of *Eugene Onegin* "and parts of the wetnurse's role in that opera," the finale of the Fourth Symphony, "and perhaps some other things." And that, Stasov concludes, was the secret of Chaikovsky's success. It was a matter of pandering collusion with the critic's other perennial whipping-boy, the lazy and ignorant Russian public:

> The Russian public, long since corrupted in its musical tastes by the Italian opera and other pernicious and banal elements, were sorely burdened by the New Russian School and its creations. And when Chaikovsky appeared in the arena, a talented cosmopolitan and eclectic, who did not threaten to drag anybody toward anything particularly "national," everyone was gladdened and contented. Past the Verzhbolovsky station [i.e., the Polish border] there was even less demand for the national. Chaikovsky suited Europe to a T.[21]

Lucky bastard! These complaints weren't even true at the time Stasov composed his self-pitying grumble, and his grumbles became ever less pertinent as time went on. But leaving that contradiction unrefuted for the moment, let us press on to some even bigger contradictions. In all of Stasov's vast output, he mentions our own Sergey Ivanovich Taneyev, to my knowledge, only once, and that single mention comes toward the end of *The Art of the Nineteenth Century*, where Stasov strains for a proper valediction. Surveying the present scene as of 1901, Stasov finds some good words for everyone, even if they contradict the gloom and doom of his fulminations only a few pages earlier. Thus:

> The number of musical figures who have received their education at the St. Petersburg and Moscow conservatories has been very considerable. From both have emerged several good pianists from the classrooms of the great Russian artists Anton Rubinstein (in St. Petersburg) and his brother Nikolai (in Moscow), and they have become the pedagogues and propagators of the Russian pianoforte school. There have also emerged from these conservatories many teachers and performers, both vocalists and instrumentalists, so that in the course of the past quarter century all of our choruses and orchestras have been basically staffed with Russian singers and musicians—and that is one of the best and most significant results of the conservatories' operation. The Moscow Conservatory has produced from its midst several musicians of remarkable talent and influence, at once composers, performers, and pedagogues. Such, in particular, are Taneyev, Scriabin, and Rachmaninoff. Among the works of Taneyev that are distinguished by great technical mastery, energy, ele-

gance, and superb expressivity are the opera *Oresteia* (1894), two quartets, and a symphony.²²

That is all Stasov ever had to say about Taneyev. After a similarly skimpy and dutiful recital of the merits of Scriabin and Rachmaninoff, Stasov turns northward and, despite the direction of his gaze, grows warmer. "But the advantage, both in terms of quantity and, at times, also in quality has always been on the side of the St. Petersburg Conservatory. Without doubt, this has depended above all on the fact that at the head of its musical faculty there stood such a great and independent artist as Rimsky-Korsakov." After a glowing rundown of Rimsky-Korsakov's *curriculum vitae*, Stasov begins handing out accolades to Rimsky's offspring: "Many of the best pupils of this great teacher have themselves subsequently become not only remarkable composers, but also conductors and teachers. Thus the benign tradition of the independent Russian school has been wholly preserved. Chief among them are Akimov, Antipov, Arensky, Artsïbushev, Blumenfeld, Wihtol, Grechaninov, Ippolitov-Ivanov, Sokolov, Cherepnin, and others." Following this list of greats there is a colossal paragraph in which each of them is provided with a résumé and a list of works.

To sort out all the double standards whereby these protégés of Rimsky-Korsakov (or more accurately, protégés of Mitrofan Belyayev, the timber-magnate Maecenas thanks to whom their works were published and performed) could be described as preservers of "the independent Russian school" and its four-point checklist of characteristics (particularly the first of them, that is, skepticism of academic routine) would be tediously anticlimactic, and of course it's been done.²³ But Stasov is just getting started. The next major subdivision of *The Art of the Nineteenth Century* is devoted to the work of Lyadov and Glazunov, whom Stasov describes without evident qualm as "the most important artists and composers of the most recent period"—and remember, the survey from which I am quoting had not only Russia but all of Europe as its purview.²⁴ A survey that had begun boldly, eighty large-format pages back in the edition from which I am quoting, with Beethoven, and with Stasov's assertion that "architecture and music are the two arts that have blossomed more robustly, richly, and extensively than all the rest in the course of the nineteenth century[, and] music has surpassed even architecture in the strength and breadth of its flight and the mightiness of the means it has attained,"²⁵ has culminated in Lyadov and Glazunov, and with a renewed affirmation that "music has done and achieved the most of all" the arts in the nineteenth century, because it was the youngest of the arts and had only in the nineteenth century managed to hit its stride.²⁶

Stasov is left with Lyadov and Glazunov as the greatest of the great because the rest of Europe had in his unhappy view become enmeshed in decadence. That is the main reason why he had to make his peace with the conservatories, whose sins

by century's end had come to seem to him to be lesser evils. The way in which his mammoth survey fizzles amid dizzy proclamations of triumph is in its tragicomic way an effective epitaph to the New Russian School and to the century in which it flourished; and yet Stasov managed to bequeath his prejudices about Russian music to the twentieth century, both in and out of Russia. This is a story very much worth telling, and I will outline it here as far as I am able at this point to detect its outlines.

In the first instance, Stasov bequeathed his prejudices to the West through his disciples, notably Rosa Newmarch, who carried them to an Anglophone readership at the exact moment when the arts of Russia began their steep ascent in popularity. In his recent, very interesting study of Newmarch, Philip Ross Bullock strives hard to vindicate her contribution to the literature on Russian music against what he correctly sees as my "comprehensive attempt to challenge the dominance of the writings of Vladimir Stasov,"[27] an attempt of which this essay is obviously a component. Bullock seeks to vindicate Newmarch by challenging my contention that her writings transmit Stasov's doctrinaire and intransigent views without significant change, and that one of those views that she helped significantly to propagate was the view that Russian composers were to be divided into the very unequally valued camps of "nationalist" and "non-nationalist."

Bullock focuses his defense of Newmarch on the matter of Chaikovsky, a composer for whom Newmarch certainly did evince a greater sympathy than did Stasov. After all, she undertook to abridge and translate Modest Chaikovsky's giant biography of his brother as *The Life and Letters of Peter Ilich Tchaikovsky* in 1906, the year of Stasov's death at the then very venerable age of eighty-two. Bullock quotes a letter in which Stasov, still frantically active at the very end of his life, congratulates Newmarch on the book's appearance but reminds her that in his opinion Chaikovsky "never has been, or will be, one of the *great men* of art" and apologizes for frankly expressing "these views if they do not coincide with your own."[28] But in noting what he calls the "context of reception"—that is, in noting that Newmarch wrote for an audience whose expectations did not match Stasov's—Bullock accounts sufficiently for their differing estimates of Chaikovsky's ultimate importance (and I fully agree that time has vindicated Newmarch rather than Stasov with respect to Chaikovsky).[29] The questions remain, however, whether Newmarch's actual description of Chaikovsky differed from Stasov's, and whether it helped spread Stasov's views on the nature and importance of nationalism in Russian art.

I think the answer to the first question is No, Newmarch's description did not differ in any significant way from Stasov's; and the answer to the second question is Yes, Newmarch did indeed spread the view that the main factor distinguishing Chaikovsky and a host of other composers in his historiographical orbit from those whom Stasov would have described as the "great men of art" was indubitably the matter of nationalism as defined preeminently by Stasov. I would go fur-

ther still and propose that Newmarch was the main carrier of this notion into the twentieth-century discourse of music history and that we are still laboring in her wake, even those of us who wish to vindicate the "non-nationalists."

First of all, Stasov never called Chaikovsky a bad or an unimportant composer, so Newmarch's interest in him did not in itself contravene the Stasovian canon. If you will forgive me for yet one more quotation from *The Art of the Nineteenth Century*, immediately after all the caveats and reservations Stasov leveled at Chaikovsky and his reputation, he added this:

> But be all that as it may, the huge dissemination and fame of Chaikovsky were in many ways completely justified and legitimate. He was so talented, so strongly endowed with the ability to fill his music with grace and beauty, and withal so strongly equipped to affect the listener with his mastery of form and the subtle qualities of his colorful and elegant instrumentation, that he could not help having an uncommonly strong and charismatic influence on great masses of listeners.[30]

If there is irony here, it is directed at the listeners, not at Chaikovsky. Now here is the beginning of the chapter on Chaikovsky in *The Russian Opera*, Rosa Newmarch's most important work on Russian music:

> Typically Russian by temperament and in his whole attitude to life; cosmopolitan in his academic training and in his ready acceptance of Western ideals; Tchaikovsky, although the period of his activity coincided with that of Balakirev, Cui, and Rimsky-Korsakov, cannot be included amongst the representatives of the national Russian school. His ideals were more diffused, and his ambitions reached out towards more universal appreciation. Nor had he any of the communal instincts which brought together and cemented in a long fellowship the circle of Balakirev. He belonged in many respects to an older generation, the "Byroniacs," the incurable pessimists of Lermontov's day, to whom life appeared as "a journey made in the night time." He was separated from the nationalists, too, by an influence which had been gradually becoming obliterated in Russian music since the time of Glinka—I allude to the influence of Italian opera.[31]

The very first sentence in Newmarch's chapter thus insists on Stasov's factitious and invidious distinction; and the rest does not matter, so far as we are today concerned. We may disagree over the nature of Chaikovsky's Western affinities. For Stasov, the implication was that Chaikovsky was German in orientation owing to his conservatory training at the hands of Rubinstein. Newmarch cites the Italian opera—surprisingly, since she knew many of his letters intimately, having translated them, letters that affirm over and over again that his main enthusiasm was for contemporary French music (the music of Gounod, Saint-Saëns, Bizet, Delibes), the influence of which shouts loudly from virtually all his works.

And was Newmarch's take on Chaikovsky quite as "adoring" as (following Stasov himself in a grumpy letter to an even grumpier Balakirev) Dr. Bullock

implies it to have been?[32] This is from the last paragraph in the same chapter from Newmarch's *The Russian Opera:*

> Tchaikovsky's nature was undoubtedly too emotional and self-centred for dramatic uses. To say this, is not to deny his genius; it is merely an attempt to show its qualities and its limitations. Tchaikovsky had genius, as Shelley, as Byron, as Heine, as Lermontov had genius; not as Shakespeare, as Goethe, as Wagner had it. As Byron could never have conceived "Julius Caesar" or "Twelfth Night," so Tchaikovsky could never have composed such an opera as "Die Meistersinger."[33]

Oh well, two can play this game. Let's imagine *Eugene Onegin* by Wagner. Now we can snicker. But in saying that "opera is the one form of musical art in which the objective outlook is indispensable," and that "Tchaikovsky had great difficulty in escaping from his intensely emotional personality, and in viewing life through any eyes but his own," Newmarch was again distinguishing him invidiously from his nationalist confreres, who, like Shakespeare, could reflect in their art not only themselves but "humanity" at large.[34] Her view of Chaikovsky self-evidently continued to inform that of Chaikovsky's wordiest biographer, David Brown.[35]

Of course Stasov was not alone in his characterization of Chaikovsky, nor was Newmarch the first to bring the notion west. There was also César Cui, a musical politician as partisan as Stasov and far less principled, who in his book *La musique en Russie,* which had begun as a series of articles published beginning in 1878 in the Paris journal *Revue et gazette musicale,* brought to French readers the prejudices of the New Russian School (which Cui had named as such, just as Stasov had somewhat later christened it the Mighty Kuchka). From Cui the French learned that "Chaikovsky is far from being a partisan of the New Russian School; he is sooner its antagonist."[36] But that is only because Chaikovsky was for Cui just a chip off of Rubinstein, and therefore an embodiment of conservatory cosmopolitanism—the antagonism, in other words, went the other way, from Cui and Co. to Chaikovsky, not from him to them. Remarkably, the ever clear-eyed Gerald Abraham, writing near the beginning of his career in collaboration with his mentor, Michel-Dmitri Calvocoressi, got this right. "The Conservatoire," he wrote,

> staffed entirely by teachers of foreign blood, had given [Chaikovsky] a sound education, a hearty contempt for those who had not had a sound education, and a warm dislike of people who were constantly attacking "Germans" and "Jews." His idol was a German Jew and his bosom-friend a German-Russian. Added to this he was always quick to suspect hostility to his own work even where none existed, and Cui, the journalistic mouthpiece of the "handful," had dismissed his [graduation] cantata with contemptuous sarcasm. It is not unnatural that although he had never met any of the "handful," [Chaikovsky] regarded them as a hostile group, while, according to Rimsky-Korsakof, they on their side considered him "a mere child of the Conservatoire."[37]

The divine Gerry wrote that in 1936! How we have regressed since.

Unlike Stasov, moreover, Cui was a competitor, happy to concede to Chaikovsky the realms of chamber music and symphony, so long as it was clear that Chaikovsky could never compete with Cui as a composer for the stage. Bear in mind, of course, that as of Cui's writing Chaikovsky had actually produced only two operas that had been staged, *The Oprichnik* and *Vakula the Smith* (the earlier version of what became *Cherevichki*). But who was Cui to be making such a judgment? At the time of writing he had had three operas produced: *William Ratcliff*, after Heine; *Angelo*, after Victor Hugo (a subject that would later serve as the basis for Ponchielli's *La Gioconda*); and the insignificant one-act operetta *The Mandarin's Son*. Between him and Chaikovsky, with operas to his credit on subjects from Russian history and Little-Russian fakelore, who was the cosmopolitan? We know, from a late memoir by Cui that has achieved wide exposure in America thanks to its incorporation into the music history text by Grout as revised by Palisca (and now by Burkholder),[38] that as far as Cui was concerned the preoccupations of the New Russian School were far removed from what is usually thought of as nationalism. ("We carried on heated debates," Cui recalled, "in the course of which we would down as many as four or five glasses of tea with jam, we discussed musical form, program music, vocal music, and especially operatic form.")[39] Not only that, but as Cui perversely loved to admit, he was ethnically half-French and half-Lithuanian, "without a drop of Russian blood."[40]

Nevertheless, Cui launched his book with a chapter on Russian folk song, giving a pair of examples that would have been quite out of place in his own music (though perfectly at home in Chaikovsky's *Vakula*), and ended that introductory chapter by stipulating that "it is in these national songs that most Russian composers have taken their principal inspiration, impregnating themselves with the spirit that reigns within them, or else using the melodies of national songs as themes in their vocal and instrumental works."[41] This utterly hypocritical remark was strictly for the benefit of his French readers, for whom the likeliest appeal of the music Cui was trying to sell them was an exotic one that excluded Chaikovsky (as well as Cui himself, but he was assured of acceptance in France as a *"mi-français"*). And his calculation hit the mark, as we can see from the response of Alfred Bruneau, one of the most sympathetic of all French musicians toward the music of Russia, partly because he, too, was obsessed with questions of operatic form in his now forgotten settings of prose libretti by Zola. Having taken Cui's bait, Bruneau was perhaps the first of the many Western writers who have dismissed Chaikovsky point blank for not being Russian enough: "Devoid of the Russian character that pleases and attracts us in the music of the New Slavonic school," he wrote, "developed to hollow and empty excess in a bloated and faceless style, his works astonish without overly interesting us."[42] Without an exotic group identity, which is to say a ghetto identity, a Russian composer could possess no identity at all. Without a folkloristic or oriental mask, he was, as Bruneau says, "'faceless."

Bruneau noted that Rubinstein and Chaikovsky remained popular in Russia, and thought this inexplicable. Diaghilev thought inexplicable the resistance to Chaikovsky in France and England, thanks to which he almost lost his shirt in 1921, when he produced *The Sleeping Beauty* in London, where (thanks to his then unappreciated spadework) it would later be so popular. To me it seems inexplicable that the relationship between "nationalism" (in quotes) and exoticism (sans quotes) was not obvious to these observers, let alone the fact that it depended on the angle of observation.

But oughtn't it be obvious to us by now? A while ago I cited Gerald Abraham in 1936, with a more sophisticated take on the national question and the social divisions that produced it than we have come since to expect. Why have we been backsliding?

One reason remains the Diaghilev reason—let's call it *Diaghilevshchina*—which persists. Russian music is still valued abroad for its exotic Russianness. Russian music is still purveyed by orchestras abroad in special Russian programs, Russian festivals, Russian seasons. When Shostakovich's quartets are heard, except for the eighth, it is almost always in a cycle. But as I noted once when asked to write a program essay for a double cycle of Shostakovich and Beethoven, when the Shostakovich and Beethoven quartets are performed in a single sequence, Beethoven is the one who contributes the Russian folk songs.[43] When will the individual Shostakovich quartets (I mean the ones that don't ask to be decoded verbally the way the eighth one does) be as commonly programmed as the Bartók quartets, which used to be programmed only in cycles, and still occasionally are, but which have long since begun leading their own independent lives in concert programs.

What is the antidote to Diaghilevshchina? Gergievshchina! Since the Soviet collapse legions of Russian musicians, with Generalissimo Valeriy Gergiev at their head, have invaded the West; and while at first they mainly brought their special repertoire with them (and that was great for me, since Gergiev's San Francisco performances of Prokofieff and Rimsky-Korsakov gave me a lot of preview work), by now they are bringing us Verdi and Wagner and Beethoven and Mahler. And Chaikovsky.

But Diaghilevshchina has never been *just* Diaghilevshchina. The reason Russia has remained so stubbornly exotic has also had to do with its political and cultural isolation in the twentieth century. So Diaghilevshchina is really another Zhdanovshchina. As long as Russia remained a riddle wrapped in a mystery inside an enigma, its arts needed to seem mysterious and enigmatic in order to seem authentic, or at least worthy of attention. "Everywhere, secrets," John Updike's character Henry Bech muses upon realizing that the weird Russian writing above the elevator door in his Moscow hotel merely reproduces the word *étage*. "French hidden beneath the Cyrillic."[44] What is Shostakovich *really* saying, we automatically wonder, assuming that to Russian ears the subtexts we struggle with are crys-

tal clear. (So why, then, did he end his life a Hero of Socialist Labor rather than a *zek?*)[45] What is Chaikovsky *really* saying, we automatically wonder, assuming that what delights our children every Christmastime at the ballet would corrupt them if they only knew. David Brown quotes Stasov's preposterous claim that the big "Slav'sya" chorus at the end of *A Life for the Tsar* is "a melody composed entirely in the character of our ancient Russian and Greek church melodies, harmonized with the plagal cadence of the middle ages," and assumes that Stasov's Russian ears "really heard it this way."[46]

Americans like me, brought up during the Cold War, have a hard time regarding Russia as a normal place—and lately it's become hard again. Behind its closed doors were unspeakable, unimaginable doings that made us constantly curious but also constantly guarded. Take away the veil, peek behind the curtain, see the place as normal, and what would remain of any interest to us? And yet at the same time, we who know Russia desperately wish that she would become less, well, *interesting* (as the Chinese say when they curse their enemies, "May you live in interesting times"). "A Russia in which Musorgsky no longer looks like a prophet is the Russia we all long to see"—those were the last words in my book on Musorgsky, published over two decades ago.[47] They were written in the bright dawn following the Soviet collapse, when that bland and beautiful fate seemed a possibility. It hasn't happened yet. The last two decades of Russian history again have the makings of a great Musorgsky opera: *Khodorkovshchina? Songs and Dances of Debt? Crimea and Punishment?* Russia is still an object of morbid curiosity, and that is still good for business when it comes to selling books, or music.

But a Russia that looms not as a big Other but as a part of the common stash might turn out to be even better. Let Gergiev continue to play Mahler and Verdi until it no longer looks odd, let more Bullocks, Steven Muirs, Peter Schmelzes, and Simon Morrisons write the future's books on Russian music, and maybe we won't have to have any more conferences like this one.

NOTES

1. Ralph P. Locke, *Musical Exoticism: Images and Reflections* (Cambridge: Cambridge University Press, 2009), 17.

2. R. Taruskin, *Defining Russia Musically* (Princeton, NJ: Princeton University Press, 1997), xvii.

3. R. Taruskin, *Music in the Nineteenth Century*, Oxford History of Western Music, vol. 3 (New York: Oxford University Press, 2009), 288.

4. For the (autographed) picture of Serov, originally a gift from my dear friend Mike Beckerman, see ibid., 438.

5. R. Taruskin, *Music in the Seventeenth and Eighteenth Centuries*, Oxford History of Western Music, vol. 2 (New York: Oxford University Press, 2009), 78–83 ("Women in Music: A Historians' Dilemma").

6. Arthur Elson, *Modern Composers of Europe: Being an Account of the Most Recent Musical Progress in the Various European Nations, with Some Notes on Their History, and Critical and Biographical Sketches*

of the Contemporary Musical Leaders in Each Country (Boston: L. C. Page, 1904), 282–83. In the paragraph immediately preceding this one, Elson gives an interesting justification for his opinion: "Under the strict censorship of its corrupt government bureaucracy, free speech is repressed, and free thought even discouraged. The Russians, however, are a race gifted with imagination and feeling, and this must find its expression in some way. If literary freedom is checked, the people may turn to music with redoubled intensity." Compare Nietzsche: "Music reaches its high water mark only among men who have not the ability or the right to argue" (*The Wanderer and His Shadow*, § 167).

7. Tamsin Alexander, "Tchaikovsky's Yevgeny Onegin in Britain, 1892 and 1906: Slipping between High and Low, Future and Past, East and West," *MusikTheorie* 33 (2015): 223–34 at 224.

8. See David Josephson, "The German Musical Exile and the Course of American Musicology," *Current Musicology*, nos. 79 & 80 (2005): 9–53. For a most egregious example of ghettoization, see Alfred Einstein's *Music in the Romantic Era* (New York: W. W. Norton, 1947), chap. 17 ("Nationalism"), with its blatantly racist comparison of the Russian musicians of the nineteenth century with "a savage people which comes into contact with European civilization and suddenly is placed in the position of using the achievements of a civilization it has not created, such as guns and 'fire-water'" (302–3).

9. Mark Evan Bonds, *A History of Music in Western Culture*, 3rd ed. (Upper Saddle River, NJ: Prentice Hall, 2010), 489.

10. Ibid., 471.

11. Robert P. Morgan, *Twentieth-Century Music* (New York: W. W. Norton, 1991), 55.

12. Gordon D. McQuere, "The Development of Music Theory in Russia: Sergei Taneev," *AMS/CMS/SEM/SMT Abstracts* (Vancouver, 1985), 39; cf. Taruskin, *Defining Russia Musically*, 48n.

13. That is, "New Style," or according to the Gregorian calendar, by then in use everywhere in Europe except Russia.

14. Passages from Chaikovsky's letter (24 December 1877/5 January 1878), trans. Vera Lateiner, in *Letters of Composers through Six Centuries*, ed. Piero Weiss (Philadelphia: Chilton Books, 1967), 362–64.

15. Letter of 28 December 1872, in M. P. Musorgsky, *Literaturnoye naslediye*, ed. Alexandra Orlova and Mikhail Pekelis, vol. 1 (Moscow: Muzïka, 1971), 142.

16. About this stage of the controversy, see R. Taruskin, "How the Acorn Took Root: A Tale of Russia," *19th-Century Music* 6 (1982–83): 189–212; reprinted in *Defining Russia Musically*, 113–51.

17. V. V. Stasov, *Izbrannïye sochineniya* (Moscow: Iskusstvo, 1952), 3:744.

18. Ibid., 745.

19. Ibid., 745–46.

20. For a translation of this portion of *Twenty-Five Years of Russian Art*, see Piero Weiss and Richard Taruskin, eds., *Music in the Western World: A History in Documents*, 2nd ed. (Belmont CA: Thomson/Schirmer, 2007), 333–36.

21. Stasov, *Izbrannïye sochineniya*, 3:746.

22. Ibid., 750.

23. See, inter alia, R. Taruskin, *Stravinsky and the Russian Traditions* (Berkeley: University of California Press, 1996), chap. 1 ("Russia and How It Got That Way").

24. Quotations in this paragraph to this point are from Stasov, *Izbrannïye sochineniya*, 3:750–51.

25. Ibid., 673.

26. Ibid., 755.

27. Philip Ross Bullock, *Rosa Newmarch and Russian Music in Late Nineteenth- and Early Twentieth-Century England*, Royal Musical Association Monographs 18 (Farnham, U.K.: Ashgate, 2009), 2.

28. Ibid., 43.

29. Ibid., 3, 43.

30. Stasov, *Izbrannïye sochineniya*, 3:747.

31. Rosa Newmarch, *The Russian Opera* (New York: E. P. Dutton, n.d. [1914]), 334.
32. Bullock, *Rosa Newmarch*, 43.
33. Newmarch, *Russian Opera*, 361.
34. Ibid., 360–61.
35. In his four-volume *Tchaikovsky: A Biographical and Critical Study*—vol. 1: *The Early Years (1840–1874)* (London: Gollancz, 1978), vol. 2: *The Crisis Years (1874–1878)* (London: Gollancz, 1982), vol. 3: *The Years of Wandering (1878–1885)* (London: Gollancz, 1986), vol. 4: *The Final Years (1885–1893)* (London: Gollancz, 1991); paperback ed. (2 vols.) includes minor corrections and updated Work List (London: Gollancz, 1992). The books were issued in the United States by W. W. Norton. For an evaluation, see R. Taruskin, "Pathetic Symphonist: Chaikovsky, Russia, Sexuality, and the Study of Music," *New Republic*, 6 February 1995, 26–40; reprinted in idem, *On Russian Music* (Berkeley: University of California Press, 2008), 76–104.
36. "Tchaïkowsky est loin d'être partisan de la nouvelle école russe; il est bien plutôt son antagoniste" (César Cui, *La musique en Russie* [Paris: Fischbacher, 1880], 119).
37. M.-D. Calvocoressi and Gerald Abraham, *Masters of Russian Music* (1936; New York: Tudor Publishing Co., 1944), 266 (chapter "Peter Tchaikovsky," signed G.A.). The "German-Russian" to whom Abraham referred was the critic Herman (or Gherman) Avgustovich Laroche, one of Chaikovsky's closest friends in addition to being his champion in the press.
38. J. Peter Burkholder, Donald Jay Grout, and Claude V. Palisca, *A History of Western Music*, 9th ed. (New York: W. W. Norton, 2014).
39. "Pervïye kompozitorskiye shagi Ts. A. Kyui," in César Cui, *Izbrannïye stat'i* (Leningrad: Muzgiz, 1952), 544.
40. See Calvocoressi and Abraham, *Masters of Russian Music*, 147.
41. Cui, *La musique en Russie*, 10.
42. Alfred Bruneau, *Musiques de Russie et musiciens de France* (Paris: Bibliothèque Charpentier, 1903), 27–28.
43. R. Taruskin, "Hearing Cycles," Aldeburgh program book, June 2000; reprinted in *On Russian Music*, 340–56, at 348.
44. John Updike, *Bech: A Book* (New York: Alfred A. Knopf, 1970), 192.
45. "Zek" (formed from the abbreviation zeh-KA [z-k] for *zaklyuchyonnïy* ["locked-up person" or inmate]) was Soviet slang for a Gulag prisoner.
46. David Brown, *Mikhail Glinka: A Biographical and Critical Study* (London: Oxford University Press, 1974), 134.
47. R. Taruskin, *Musorgsky: Eight Essays and an Epilogue* (Princeton, NJ: Princeton University Press, 1993), 407.

2

Revenants

Bewitching Russian Opera: The Tsarina from State to Stage. By Inna Naroditskaya. New York: Oxford University Press, 2012. [xvi, 401 pp. ISBN 978-0-19-534058-7. $74.] Music examples, tables, bibliography, index.

Inna Naroditskaya's delightful essay in revisionism departs from the premise that students of Russian opera face a major task of forgetting. We have to forget the first fact we ever learned: viz., that Russian opera begins with Glinka. Even those of us who think we have become sophisticated on the matter of nationalism, who have refined the notion of Glinka's primacy to acknowledge the reality of his predecessors, and who define his significance in terms of genre (the first *real* operas—that is, sung straight through) and reception (performed and admired abroad!)—even we, the author insists, are still blinded by a discourse that is the unholy ahistorical issue of utopian nationalism and masculinist revenge. The much touted fact that Glinka's contemporaries immediately recognized his work as "a wonderful beginning" (to quote Gogol yet again) merely locates the source of that ahistorical discourse in the need for nineteenth-century Russians to forget that their country had been ruled in the eighteenth century by women, and that the one among those women who mattered the most to the histories both of Russia and of opera was a foreigner to boot. So we must now remember what they forgot and forget what they would have us remember. And if we manage to do all that we will put Catherine II, known as the Great, in place of Glinka in the founder's seat. Then, and only then, will we be able to see the history of Russian opera as a single continuous development and understand both how it got going and how it became what it became in the years of its greatest fame.

Does it seem odd to put a noncomposer in such a place? Such a thesis comes with less strain to an ethnomusicologist, which is what Prof. Naroditskaya is by

Originally published in *Music Library Association NOTES* 70 (2012): 423–26.

training and self-description. But as the work of scholars such as Ellen Rosand and Martha Feldman has shown, even unprefixed musicologists are getting used to the idea that, when it comes to charting their histories, artistic genres are better viewed as social practices than as collections of works. The empresses who ruled Russia from 1725 to 1796 (but for three tiny interregna totaling less than four years) were the ones who brought opera to the St. Petersburg court. There were four of them; but as it was the second, Anne, who first imported the genre from Italy, one tends to think of them in this connection as a trio. Catherine the Great was the last, and she did more than patronize the genre. She also contributed to it as librettist, composing (with the assistance of literary secretaries) the Russian texts to five comic operas and one historical pageant with music. The composers who set them were an assortment of Italians and locals who sometimes collaborated (so the pageant, *The Early Reign of Oleg*, for example, had music by two Italians, Giuseppe Sarti and Carlo Cannobio, and one Russian, Vasily Pashkevich, who also set one of the comic librettos).

Catherine's activity was never a secret to historians of Russian opera (even though aristocratic mores did not permit her name to appear on the works she authored until they were posthumously published or reprinted), but it was never taken seriously. Her spoken comedies have fared better with historians. (There is even a literary scholar, Lurana O'Malley, who specializes in the works of Catherine the Great.) But the present book contains the most extensive treatment her operas have ever received in any language. Naroditskaya's book has only one noteworthy predecessor: *Russkaya opera do Glinki* (Russian Opera before Glinka), a monograph published in 1948 by the Soviet musicologist Alexander Rabinovich. The very title of the book, with its suggestion of prehistory, reinforces the influence of the old narrative; and whereas some of the music by Catherine's composers (especially the native ones who hailed from the lower social echelons) is praised, Catherine's contributions are never actually discussed, only insulted: "The libretto of *Fevey*," we read of one, "sets a veritable record for feebleness and tastelessness." Another is dismissed with jarring, and memorable, crudeness: its text, we are told, is *na redkost' glup*, "as dumb as it gets."

Well, what is a Soviet writer supposed to say about the work of a tsarina (or a Russian about a foreigner, or a man about a woman)? And yet, animus apart, Rabinovich's treatment of Catherine's operas is not so different from the treatment one expected to find in pre-Feldman writings on *opera seria*, in which it was always the music that got the detailed description, not the texts that controlled the music in every way. We understand now that the composer of an eighteenth-century opera was closer to the bottom than the top of the food chain, after the poet and the singers and the impresario; and when push came to shove, even the poet and singers and impresario were subordinate to the ruler in whose honor and at whose expense the performance was mounted. That is all that Naroditskaya is claiming

for Catherine: not literary genius, but an all-important shaping role as the one who not only conceived the scenarios and wrote the words but also chose the composers and directors and paid them. It is as "Empress(ario)," as Naroditskaya puts it with characteristic charm, that she needs to be reckoned with.

That is the task accomplished in the first half of the book, and that much, as we say at the seder, would have been enough. Naroditskaya's treatment of opera as celebratory court ceremonial (chapter 1, "Russian Minervas Staging Empire") and as site of social interaction and role-reversal (chapter 2, "The Play of Possibilities: Serfs Enacting Aristocrats; Countesses Playing Peasants") follows and significantly extends the groundbreaking example of Richard Wortman's *Scenarios of Power: Myth and Ceremony in Russian Monarchy* (1995). And her informative descriptions, in chapters 3 and 4, of Catherine's operatic activities and productions altogether supersede not only Rabinovich's slurs but every previous treatment of the subject; for even Marina Ritzarev's *Eighteenth-Century Russian Music* (2006), the most comprehensive monographic account of that repertory in any language, adheres to the old composer-centric model, so that the figure of Catherine, diffused into a multitude of scattered references, never emerges as a historical force. The first half of Naroditskaya's book achieves some very important correctives and brings the study of early Russian opera within the newly integrated, interdisciplinary purview of musicology as it is increasingly practiced today.

But it is the second half of the book that will give students and lovers of Russian opera the really spicy food for thought. For here the author selects five test cases from the active performing repertory of Russian operatic masterworks—by Glinka (*Ruslan and Lyudmila*), Dargomïzhsky (*Rusalka*), Rimsky-Korsakov (*Mlada* and *Sadko*), and Chaikovsky (*The Queen of Spades*)—and reads them in the light of the genre's eighteenth-century courtly origins. And since most of these operas had literary prototypes, we are dealing with poets as well (indeed, a supremely great poet, Pushkin, in three cases out of five). Unlike the operas of Catherine II and her literary and musical minions, these are authors and works that matter greatly to students and listeners today; interest in them is not only historical but esthetic. So most readers will experience a quickening of interest as they embark on the second half of the book—but also the raising of their guard, for the ground has shifted from social history to hermeneutics.

This is familiar territory for students of the Russian arts, laden as they have always been with subtext and symbol—or, to use the word Naroditskaya prefers, *inoskazanie* (literally, "an other-telling"). *Inoskazanie* is a fairly unusual word in Russian, and the author did well to leave it untranslated. It can refer specifically, and technically, to allegory, but in the present context its meaning is broader. In general terms, *inoskazanie* is whatever must be read between the lines, or decoded. Since the mid-nineteenth century, the standard Russian term for that has been "Aesopian" language. Inasmuch as the Russians had a word for it, there is no doubt

they practiced it both as writers and as readers under tsar and commissar alike. Indeed, there was no other way to speak or write publicly in Russia about many things.

Both the use of Aesopian discourse and its interpretation are fraught with notorious pitfalls. Authors are never in full control of the range of meanings their words (or notes) might embody or convey, nor are readers (who have their own agendas) always equipped to recognize a code. Works always say both more and less than authors consciously intend, and there is always the possibility that it is the reader rather than the writer who is doing the coding as well as the decoding, in which case we are dealing not with *inoskazanie* but—if I may coin a Russian word—*inochtenie* ("other-reading"). Is there an infallible way to distinguish *inoskazanie* from *inochtenie*? Of course not. Nothing in the realm of scholarship is infallible; if certainty is what you want, you need religion, preferably old-time. Decodings always run the risk of tendentious fallacy. The scholar's hardest, well-nigh impossible analytical and historical task is to establish that messages received are indeed messages sent. Over this point of procedure many battles have been fought, even whole religious wars (re Shostakovich, for example). It is Naroditskaya's contention that the social history expounded in the first half of her book provides a key to the interpretation of the famous operas she addresses in the second half—and not only them, for they all have numerous counterparts amounting in the aggregate to practically the whole repertoire.

Here is one test: Does the proposed reading answer a question raised by someone other than the decoders themselves? (This is the test that the Shostakovich revisionists, for example, notably failed.) In the case now under consideration, I was reminded of a lengthy omnibus review of Russian opera recordings by a connoisseur named Conrad L. Osborne, who wrote for *High Fidelity* magazine back when I was just getting started as a student of the repertory. It came out in two parts in 1974–75, and I clipped it, so I was able to verify my recollection that among the many jokes this very snarky (but also very astute) critic cracked was this one, about Prokofieff's *Love for Three Oranges*: "With this luminescent *pasticcio* Prokofiev set two compositional records: 1) Largest number of operas by a Russian composer to be written in New York and premiered in Chicago (one); 2) largest number of operas by a Russian composer dealing with neither Ivan the Terrible nor water nymphs (three)."

This was the culmination of a running gag that went through the whole essay about the frequent reappearance, in opera after opera, of what, long before the quoted passage, Osborne had taken to calling "the obligatory water nymphs." The Russian word for a water nymph (and the Czech one too, as lovers of Dvořák know very well) is *rusalka,* which is also the title of Dargomïzhsky's opera in the list of those for which Naroditskaya offers exegeses. There are indeed very many *rusalka* operas by nineteenth-century Russian composers; and if you generalize from

rusalkas to powerful supernatural females in general, the number multiplies further; if you add powerful exotic women the number grows even higher; and if you add exotic historical women you end up with practically the whole repertoire in your list (including *Love for Three Oranges*, by the way, with its spell-casting Fata Morgana and even the titular oranges, which contain magical princesses).

Naroditskaya's contention, as the reader will no doubt have guessed, is that all these magical or fabulous females are revenants: that (to quote from the book's introduction) "as power and ownership shifted, the image of bygone empresses underwent metamorphosis; after their demise, tsarinas returned in the guise of enticing dangerous supernatural operatic heroines" (xiv). They are, "if examined in their historical and intertextual context," a collective "manifestation of Russia's nineteenth-century nationalist ethos—or its psychosis" (xiv). Generalizing still further, that psychosis was brought about by the same gender anxiety that beset nineteenth-century males everywhere, but (owing to the peculiarities of its dynastic history) in Russia more than anywhere else, because of "its recent past as a female kingdom" (148). All of a sudden *Rusalka* and *Carmen* are sinister sisters.

This is of course playing with fire, and Naroditskaya knows it. Her rhetoric is sharply honed but modestly articulated, and her gentle humor is what finally wins one over. Like anyone arguing a new and likely controversial thesis, Naroditskaya indulges at times in calculated overstatement—what the Russians call "bending the stick too far." But she just as knowingly and elaborately pulls back now and then with a wink, ultimately recognizing that she is not uncovering a strict (read: thin) deterministic causality that would have amounted in the present case to a genetic fallacy, but only exposing one of the many strands in the tangled skein that overdetermined the development of Russian opera and made it the peculiar thing it was. That overdetermination is what makes it possible to accept Naroditskaya's point about the provenance of all those *rusalka* operas even if we know that the Dnepr *rusalki* who inhabit Russian operas had swum over from the Danube, where they had been featured in Austrian singspiels about *Donauweibchen* that Russian theatergoers knew very well—and even if we recall that women have been enticing and ruining clueless men in song and story ever since Adam and Eve. Naroditskaya's book is a contribution to the thick description of one particular complex cultural phenomenon and, if accepted in that spirit, has real explanatory value.

Catherine II, after all, haunted nineteenth-century opera overtly as well as covertly. She "appears" as herself at the end of the second act of *The Queen of Spades* (or rather, her arrival is hailed just before the curtain comes down so that the law against showing her royal person onstage would not be violated; nowadays a dolled- and coiffed-up supernumerary in a hundred-pound gown usually steps out and waves), and she also appears as a character in the Gogol story from which both Rimsky-Korsakov's *Christmas Eve* and Chaikovsky's *Cherevichki* were derived. (In the operas she is disguised in male drag as an unnamed "Svetleyshiy,"

meaning "His Radiance"—not "His Lightness" as Naroditskaya translates it in a rare lapse—but her presence is an open secret.) Naroditskaya exhorts us not to be literalistic but to accept the Countess in *The Queen of Spades,* who is killed for her card-playing secret in act 2 and comes back as a ghost (that is, literally as a revenant) in act 3, as the "real" Catherine-surrogate in that opera, or at least in the Pushkin story on which it is based (and so in the opera just the same). And because Catherine's operas included the first folk-tale operas and the first operas about mythical Russian knights and heroes, all the many nineteenth-century operas in those genres are also revenants—for "the more they [i.e., Russian artists of the nineteenth century] aimed to escape from the female century, the more they relied on and expanded its tropes" (187).

On balance, making allowance for all the bent sticks, this feels right. Seeing the famous works of the nineteenth century in this new light does give Russian opera the longer history that Naroditskaya seeks to restore, and sensing Catherine's presence in the work of her subjects' descendants does contribute to our sense that the history of Russian opera unfolded within a dynastic regime and the culture that it spawned, very far not only from our contemporary reality, but even from that of the Russians' nineteenth-century "western" contemporaries, who produced and consumed operas within an entrepreneurial culture that had very different incentives and risks. I'm sure that if Rimsky-Korsakov or Chaikovsky had chanced to read Naroditskaya's chapters about their works, they would have reacted with the same asperity Stravinsky showed in response to Boris Asafyev's *Book about Stravinsky,* scrawling "What is all this deep-thinking nonsense?" in the margin. But unless we are willing, or feel the need, to limit our own understanding of a cultural phenomenon to the consciously formulated thoughts and purposes of its agents (and there was a time, not so long ago, when most musicologists willingly, and even militantly, accepted that limitation), a book such as Naroditskaya's, like the general convergence of ethno- and unprefixed musicology of which it is the fruit, opens the door to many novel and stimulating impressions from works we thought we knew.

3

Crowd, Mob, and Nation in *Boris Godunov*

What Did Musorgsky Think, and Does It Matter?

I

Russians, and we who study them, should not complain. The national question has been good to us. It was our ticket of admission into music history. It led at times to fads and crazes we could exploit. Nevertheless, one resists. Celebrations of nation, affirmations of self, declarations of solidarity with one's own kind, "playing the identity card" and suchlike exercises, have done, on balance, much more harm than good, and have often led musicology astray.[1] It is quite a while now since I emitted my *cri de coeur*: "If 'How Russian is it?' is your critical question, then however the question is answered, and however the answer is valued, you have consigned Russian composers to a ghetto."[2] Isn't there something else of interest about Russia besides how Russian she is? Something of interest about Grieg other than how Norwegian he was? And yet, protest though I may, there is nothing one can possibly say, at a conference convened under the rubric "Opera and Nation," that will be construed in any other way. Thus framed, Russians, and we who study them, will remain confined to the ghetto, resist though we may. To claim of Chaikovsky (who never insisted on it), or of Taneyev (who did), that they were "nonnationalists" is only to affirm that nationality is the standard against which all shall be measured, and that Chaikovsky and Taneyev have compounded the offense of living in a ghetto by being unworthy denizens. No one escapes, not even poor Sergey Diaghilev, who thought that he could ride the crest of Russian exoticism

Originally published as "Crowd, Mob, and Nation in *Boris Godunov*: What Did Musorgsky Think, and Does It Matter?" *Journal of Musicology* 28 (2011): 143–65.

(which is to say, Russian nationalism viewed from the outside) to world conquest and then, after the Great War, renounce or transcend it by putting Stravinsky to work on *Pulcinella* or getting Poulenc to write *Les biches*. When Poulenc ran into Diaghilev one evening in Monte Carlo and told the impresario that he was on his way to see *Pétrouchka*, Diaghilev made a face and cried, *"Mais quel ennui!"*[3] But of course the moral of the story is that he was still performing *Pétrouchka* after the war—and *Firebird*, and *Shéhérazade*, and *Le Festin*, and even a newly commissioned *Nuit sur la Mont Chauve*—and needed to do so in order to keep his enterprise afloat.

So what else is new? If it is true, according to everybody's favorite Walter Benjamin quote, that there is no document of culture which is not at the same time a document of barbarism, so there is no enabling factor that is not at the same time a constraint. But some paradoxes are reversible, and it is equally the case that there is no constraint that is not at the same time an enabler.

Thus, simultaneously enabled and constrained, I will take the opportunity neither merely to rail at the national question nor merely to exploit it but rather to complicate it. Complication is what Susan McClary seems to rule out in her simple celebration of Grieg and his identity card, with which she strongly (and sentimentally) identifies, even claiming that the only alternative to simple celebration is "a fastidious refusal to raise the issue of Difference [that] leaves the mainstream unchallenged, its hegemony unquestioned."[4] I think we can do better. The question that interests me is not whether opera is implicated in the construction of nationhood (answer: It is), or whether it can be divorced from the construction of nationhood (answer: Not unless it can be performed somewhere other than in a nation), but how that implication is played out over time. The relationship of opera—or of individual operas—and nation may be inevitable, but it is also unstable, and I would like to pursue that inevitable instability with reference to an opera whose national significance has never been in the slightest doubt: Musorgsky's *Boris Godunov*.

II

This is an opera that relates to nation even without reference to its own nation. As Joseph Kerman wrote long ago in *Opera and Drama*, a book that seems to have had as its purpose the elimination of as many famous operas from the canon as possible, *Boris* makes the grade because "unlike *Turandot*" by the ineffable Puccini, "*Boris Godunov* is really about something: kingship, the relation between ruler and ruled."[5] Putting it a bit more abstractly, it is about legitimacy, which means that it was not only a historical drama, but a drama that participated, like several other Russian operas of its time, in some of the most pressing questions then being debated by the historical profession. Not that this is in any way

surprising. In Russia, as everywhere else in Europe, the nineteenth century was the great century of historiography as well as the great century of nationalism—which is merely two ways of making the same point, for the two were symbiotic. What is also unsurprising is that many of the foundational works of the Russian operatic repertory (including most of the serious historical operas) were written, or at least begun, during the reign of Tsar Alexander II, the emancipator tsar. (Musorgsky's whole career, in fact, unfolded during this reign, for the composer died only two weeks after Alexander's assassination.) During that relatively liberal time, the Russian literary scene blossomed forth as never before, and particularly its historiographical wing, because even the censor stood back briefly and let a hundred schools of historical thought contend.

Well, that was a slight exaggeration. There were three main contenders, as follows:

- the old school of dynastic historians, established by Nikolai Mikhailovich Karamzin (1766–1826), the "Official Historiographer" appointed by Alexander I, whose monumental *History of the Russian State* appeared in twelve volumes beginning in 1818 (the last published posthumously) and lay the foundations for the Official Nationalism proclaimed in 1835 on behalf of Alexander's younger brother and successor, Nikolai I, according to which nationhood *(narodnost')* rested on the twin pillars of orthodoxy *(pravoslaviye)* and autocracy *(samoderzhaviye)*;[6]
- a neo-Hegelian "statist" school, most prominently represented by Sergey Solovyov (1820–79), whose unfinished twenty-nine-volume *History of Russia from the Earliest Times,* the most comprehensive history of Russia ever attempted by a single author and a deliberate attempt to supersede Karamzin, began appearing in 1851 and had reached the year 1774 when it was interrupted by the author's death. Its view of historical agency was as top-down as that of dynastic historians, but it was also rigorously teleological, a strong and centralized state being the goal toward which all progressive thought and action tended, the "great man . . . always and everywhere satisf[ying] the needs of the nation in a certain time";[7]
- a short-lived "populist" school, which could only exist for the duration of the little window Alexander II's relaxed censorship had suffered to open, which promulgated a bottom-up theory of historical agency, and whose primary exponent was Nikolai Kostomarov (1817–85), who is known to all scholars of Russian music for having declared of *Boris Godunov* that it was an authentic "page of history."[8]

The historian's interest in contemporary opera was symptomatic of the time—and of the nation. *Boris Godunov,* based on a play by Pushkin that had until 1870 been banned from the stage (though not from publication), was also a product of

that little window. The composer was an enthusiastic student of history, and in his next (unfinished) historical opera, *Khovanshchina,* he took the unprecedented step of fashioning a libretto directly from primary documentary sources rather than availing himself of a preexisting literary treatment. In that positivistic and optimistic moment in Russian intellectual history, operas could be taken quite seriously by the theatergoing public and its intellectual preceptors as contributions to the national historiography. The very first issue of the *European Courier,* one of the thickest of the famous Russian "thick journals" of historiography and liberal opinion, contained a learned exchange between Kostomarov and the arts publicist Vladimir Stasov (a professional librarian) on the historical verisimilitude of an operatic production, that of *Rogneda,* an opera by Alexander Serov set in tenth-century Kiev. The editor of the journal, Mikhaíl Stasyulevich, gave their colloquy an introduction that could stand atop this essay as an epigraph:

> Perhaps a few of our readers will be surprised that in our "Historical Chronicle" section we speak of the theater and of scenic productions, even though the journal is devoted specifically to historical scholarship. But such doubts will not visit those who, like us, think of the theater not as an idle amusement but accord it a high significance among the organs that motivate and develop the intellectual life of man and, consequently, have an influence on the history of societies.[9]

That's so Russian! And indeed, all three of the historical schools in question had important operatic embodiments in the 1870s. Any opera that was based on a play by one of the many writers who used Karamzin as a source was willy-nilly a mouthpiece for the dynastic view. Chaikovsky's early opera *The Oprichnik* (1870–72) is the classic example. It is based on a tragedy by Ivan Lazhechnikov (1792–1869) about a young nobleman who joins the *oprichniki,* Ivan the Terrible's personal militia, to avenge his mother, who turns around and disowns him for what she takes to be his class perfidy; he then petitions for release in order to marry, and thus dooms mother, bride, and self alike for having tempted Ivan's arbitrary, bloodthirsty cruelty. The play, and consequently the opera, reflect Karamzin's harsh judgment of Ivan (a verdict meant to reflect glory on the Romanov dynasty, the Official Historiographer's employer, which had succeeded the tyrant):

> Amid other sore trials of Fate, beyond the misfortune of the feudal system, beyond the Mongolian yoke, Russia had also to endure the terror of an Autocrat-Torturer. She withstood it with love for the autocracy, for she believed that God sends plagues, earthquakes, and tyrants alike; she did not break the iron scepter in Ivan's hands but bore with her tormentor for twenty-four years, armed only with prayer and patience, in order to have, in better times, Peter the Great and Catherine the second (History does not like to name the living).[10]

The statist view was embodied preeminently in Rimsky-Korsakov's opera *The Maid of Pskov* (1873), based on a play by the poet Lev Alexandrovich Mey (1822–62).[11]

In keeping with the positivist impulse of the age, the play had proposed an answer to an actual historical riddle: why did Ivan the Terrible, who destroyed the republican Hanseatic port of Novgorod to enforce the unification of Russia under his autocratic rule, nevertheless spare Pskov, Novgorod's republican sister city? In a series of soliloquies, Ivan, who seems to have read both Karamzin and Solovyov, ponders his various historiographical images. In one speech he summarizes the popular Karamzinian view of his character and reign: "A bloodthirsty blackguard, persecutor of the boyars and his zealous servants, a torturer, a killer, a monster!"[12] But in another, a famous address to his son (quite obviously modeled on Boris Godunov's farewell to his son in Pushkin's play), which Rimsky-Korsakov turned into a monologue, Mey's Ivan gives his reasons:

> Only that kingdom is strong and great,
> Where the people know they have
> A single ruler, as in a single flock
> There is a single shepherd. . . . Let the shepherd
> Grant the herd boys their will—and the whole flock perishes!
> Never mind the wolves; they themselves will do the killing
> And lay the blame to the dogs. . . .
> No! I would like to rule so that
> Rus' will be bound by law, like armor,
> But will God grant me the insight and the strength?

"How comical is this Ivan Vasil'yevich, discoursing on his theories of government just like Mr. Solovyov, . . . almost a sweet and tenderhearted Ivan Vasil'yevich, this," was the assessment of Apollon Grigoryev, a rival poet and playwright.[13] But Mey's embodiment of ongoing historiographical controversy was seen as progressive by progressives, including musical progressives like Rimsky-Korsakov and the roommate who shared his bachelor quarters at the time he was finishing *The Maid of Pskov*, one who was then at work on a historical—or rather, historiographical—opera of his own.

In the fall of 1871, Musorgsky was between versions of *Boris Godunov*. The opera as composed in 1869–70 had been submitted to the Imperial Theaters directorate, whose opera committee notoriously rejected it in February 1871 on the grounds that it contained no prima donna role. But the changes that Musorgsky made in revising the opera went so much further than anything required by the committee that one can only conclude the main impetus toward rethinking his opera lay elsewhere.[14] One of the biggest changes that had nothing to do with the Imperial Theaters' demands was the replacement of one crowd scene by another. The change embodies far more than a musical or dramaturgical revision; it represents a 180-degree shift from Karamzin's top-down conception of history to the bottom-up view only lately propounded by Kostomarov. In effect, the two versions of *Boris* directly contend with one another in keeping with contemporaneous debates in

the realm of historical scholarship—testimony to the uniqueness of the moment in Russian intellectual history.

The Karamzinian view had come to Musorgsky straight from Pushkin. The original version of the opera was composed at a time when the composer was entertaining very strict "realist" views as to the relationship between operatic and spoken theater. In the wake of a famous experiment by Alexander Dargomïzhsky—that "great teacher of musical truth," as Musorgsky called him on two separate occasions[15]—who set the text of Pushkin's *The Stone Guest* (one of four "little tragedies" of 1830) almost exactly as it stood, without any specially prepared libretto, Musorgsky had written an even more radically realistic opera, a setting of several scenes from the first act of Gogol's farce *Marriage*, as an "experiment in dramatic music in prose" that would make absolutely no compromise with the criteria of spoken drama.

The original libretto of *Boris Godunov* was a non-libretto of this type. Virtually all of its words came directly from Pushkin's original text, although, since *Boris Godunov* was a full-evening play rather than a one-acter like *The Stone Guest*, it had to be whittled down for musical treatment, musical tempos being generally so much slower than spoken ones. Musorgsky's solution, calculated on the presumed familiarity of the historical plot to his audience, was to cherry-pick. The two scenes that together made up the first act—the monastery "Cell Scene" that launches the career of the Pretender, or False Dmitry, and the "Scene at the Lithuanian Border" that shows its progress—were evidently chosen because they embodied a stark Shakespearean contrast that would give Musorgsky's radical methods an ideal proving ground. The Cell Scene was famous for its lofty idealization and its beautiful, much-memorized iambic-pentameter verses, while the Scene at the Border was a comic scene in prose. The one could be set à la *The Stone Guest* and the other à la *Marriage*. For the rest, apart from the opening scene that shows the crowd in forced supplication to the Tsar-elect, conflating lines from the second and third scenes of Pushkin's first act, Musorgsky simply threw out all the scenes in which the title character failed to appear, leaving a total not of twenty-three but only six from which to adapt his text—a text in which the guilty ruler looms much larger than he did in Pushkin's play, which chiefly concerns the progress of the Pretender (and thus belongs to a genre known to literary historians as the "Demetrius play," descending from the Spanish and English theaters of the early seventeenth century).[16]

One (and only one) of these scenes brought Boris into confrontation with the crowd. Pushkin's scene 19 (Square in Front of the Cathedral in Moscow) corresponds to the sixth (penultimate) scene of the opera in its 1869 version, designated "Square before the Shrine of the Blessed Basil," i.e. Red Square. Pushkin had based it on a passage in Karamzin that concerned not the rise of the False Dmitry but rather the death of Boris's own first-born son in 1588, ten years before he became tsar.

Godunov, ... having at the time only one infant son, took him recklessly with him, though the boy was sick, to the church of St. Basil the Blessed, paying his doctors no heed. The infant died. At the time there was in Moscow a fool in God [*yurodivïy*], esteemed for his real or imaginary holiness. Walking naked through the streets in bitter cold, his hair hanging long and wild, he foretold calamities and solemnly calumniated Boris. But Boris held his peace and dared not do him the smallest harm, whether out of fear of the populace or because he believed in the man's holiness. Such *yurodivïye*, or blessed simpletons, appeared frequently in the capital wearing chains of penance called *verigi*. They were privileged to reproach anyone, no matter how important, right in the eye, if their conduct was bad. And they could take whatever they wanted from shops without paying. The merchants would thank them for it as if for a great favor.[17]

As Pushkin adapted it, Boris orders a church service so as to pronounce an anathema on the Pretender. On his way out he is accosted by the *yurodivïy*, who complains to Boris that some boys have stolen a penny from him and that the tsar should have them killed, the way he had had the lawful tsarevich killed. Boris asks the holy man to pray for him but is rebuffed. The scene opens with some mutterings from the crowd, which show them ignorant and apathetic:

First Man: Will the Tsar soon come out of the cathedral?
Another: The mass is ended; now the Te Deum is going on.
First Man: What! Have they already cursed *him*?
Second Man: I stood in the porch and heard how the deacon cried out:—Grishka Otrepyev [i.e., the False Dmitry] is anathema!
First Man: Let them curse to their heart's content; the Tsarevich has nothing to do with Otrepyev.
Second Man: But they are now singing mass for the repose of the soul of the Tsarevich.
First Man: What? A mass for the dead sung for a living man? They'll suffer for it, the godless wretches!
Third Man: Hist! A noise. Is it not the Tsar?
Fourth Man: No, it is the *yurodivïy*.[18]

With some little modifications, Musorgsky set these lines as "realistic" choral recitative. Then comes the episode of the *yurodivïy* and the thieving boys, following which the crowd cries out, "The Tsar! The Tsar is coming." As Boris and his entourage file out of the church, the crowd accompanies their procession with a few lines that Musorgsky cobbled himself:

> Our provider, Little Father, give for Christ's sake!
> Our father, Lord, for Christ's sake!
> Tsar, our Lord, for Christ's sake!
> Our provider, Little Father, send aid for Christ's sake!
> Bread! Bread! Give to the hungry!
> Bread! Bread! Give us bread! Little Father, for Christ's sake!

Musorgsky set these plain lines beautifully, in a folkloric lyric style rather than as recitative, and in so doing emphasized that it was very much Karamzin's crowd that he was showing us: a submissive, passive, powerless lot, conscious only of its bodily needs and looking trustingly to their Tsar, heaven's emissary, for salvation. They are shown in the act of withstanding adversity, as Karamzin would say, with love for the autocracy. The crowd does not participate in the blistering confrontation with the *yurodivïy;* on the contrary, when the holy fool accuses the "Tsar-Herod" of murder, the crowd—according to Musorgsky's stage direction, not Pushkin's—disperses in horror.

III

> Before his departure from Petrograd I went to see him and experienced something extraordinary. This something is none other than a milestone in Korsinka's talent. He has realized the dramatic essence of musical drama. He, that is Korsinka, has concocted some magnificent history with the choruses in the *veche*—just as it should be: I actually burst out laughing with delight.[19]

Korsinka was Rimsky-Korsakov, and the *veche* was the scene in *The Maid of Pskov* that showed the Pskov republican council, or *veche,* in panicky session, attempting to cope with the prospect of Ivan the Terrible's likely attack. The scene ends with a schism and the secession of a gang of rebels, who (unlike the accommodating governors) will meet a violent fate. It was the internal dissension, and Rimsky-Korsakov's success in finding a way of rendering it musically, that captured Musorgsky's imagination. At the end of the scene, the rebels march off singing a genuine (transcribed) folk song; the governors implore them to reconsider in impassioned recitative, the town tocsin sounds an alarm, and the dread Tsar's leitmotif looms over all. This contrapuntal tour-de-force, montaging three "natural" or life-drawn artifacts—virtually unretouched folk song, speech-mimicking recitative, and mimetic orchestral effect—was the very epitome of realist ideals as then conceived by the reform-minded composers of the New Russian School (known informally in English-speaking countries as the Mighty Five), and César Cui, the member of the group whose music is most irretrievably forgotten but who was at the time its most famous member because he was a big tough critic as well as a composer, greeted it with what for him was an orgy of praise:

> You forget that before you is a stage, and on it choristers performing a more or less skillfully constructed crowd scene. Before you is reality, the living people, and all of it accompanied by matchless, meaty music from beginning to end. A crowd scene like this has never appeared in any existing opera. Even if everything else in *The Maid of Pskov* had been completely worthless, this *veche* scene alone would have been enough to give the opera significance in the history of art and a prominent place among the most remarkable of operas, and its author a place among the best operatic composers.[20]

Musorgsky must have been fairly itching to emulate this scene, and must have welcomed the rejection of the earlier version of Boris Godunov for the pretext it gave him to do so. He had a particularly bemusing experience with the St. Basil's scene in July 1870, a month after expressing his enthusiasm for Rimsky's *veche*. At a gathering at Stasov's dacha outside St. Petersburg, Musorgsky played the first version of the opera, then in limbo between completion and rejection, and found to his bewilderment that even such a sympathetic, hand-picked audience could mistake the opera's genre and tone, hence its meaning. "As regards the peasants in *Boris*," he wrote to Rimsky, "some found them to be *bouffe*(!), while others saw tragedy."[21] Perceiving that in the eyes—or ears—of his audience the prose recitative of his choral scenes ineluctably spelled "comedy," its traditional medium, Musorgsky had to acknowledge a formerly unrecognized problem for realist art. From this moment, perhaps, and not from the eventual rejection, dated his first impulse to revise his opera. The needed revision was one that would clarify the opera's genre by making decisive the contrast between what was *"bouffe"* and what was not, and by elevating the tone of the opera to a level appropriate to tragedy.

In place of the realist, Pushkin-derived prose recitative in the St. Basil's scene, Musorgsky wrote himself a text that contained all the elements Rimsky had deployed in his *veche*: naturalistic recitative, to be sure (including choral recitative), but also sweeping orchestral music, some of it mimetic of the stage action, and choral folk song adapted from various genres including wedding songs and epic narratives, or *bïlinï*. Musorgsky also wrote verses for a "revolutionary" chorus (*Razgulyalas' udal' molodetskaya,* "Bold insolence has run wild") that would provide a more extended and developed continuous number than anything in Rimsky's setting. The whole would end with the Pretender's arrival on the scene, to be greeted by the crowd and followed offstage to victory, leaving the *yurodivïy* (salvaged from St. Basil's along with the little episode of kopeck-stealing) to lament the Time of Troubles.

The trouble was that Pushkin, who had no conception of such collective popular agency, had not furnished material for such a scene. The closest to the sort of unruly crowd scene Mey had provided for Rimsky to set comes in Pushkin's penultimate scene, when the crowd, having been incited to riot by a tirade uttered by the poet's namesake, the boyar Pushkin, rushes off toward the palace now occupied by Boris's helpless son, shouting, "Bind him, drown him! Hail Dmitry! Crush the race of Godunov!"—an episode that comes straight from Karamzin, and could have gone straight into Musorgsky. A tiny hint of post-Karamzinian crowd behavior may lurk in Pushkin's immediately preceding scene, when the boyar Pushkin, conferring with the boyar Basmanov (a fellow defector to the Pretender's cause), confidently predicts victory:

> ... Basmanov, dost thou know
> Wherein our true strength lies? Not in the army,
> Nor yet in Polish aid, but in opinion—

> Yes, popular opinion. Dost remember
> The triumph of Dimitry, dost remember
> His peaceful conquests, when, without a blow
> The docile towns surrendered, and the mob
> Bound the recalcitrant leaders?[22]

But that is all one finds in Pushkin—just a hint, and no words on which to base a libretto. The first actual spark of the eventual scene that Musorgsky wrote to replace St. Basil's may have been touched off by a couple of lines on the Pretender's progress, which Musorgsky himself inserted into the text of that very scene: "He's already got as far as Kromy, they say.—He's coming with his troops to Moscow. —He's blasting Boris's troops to smithereens." Even this, however, is a long way from the eventual "Scene at Kromy" *(stsena pod Kromami)* or "revolution scene" on which Musorgsky embarked in November 1871, while sharing quarters with Rimsky-Korsakov (who was at that very moment orchestrating the *veche*, so its strains were probably resounding on the communal piano every day). The inserted lines refer to the siege and pitched battle of 1605 described in detail by Karamzin, at which the False Dmitry's Polish troops were joined by several hundred Don Cossacks. It was these Cossacks who had bound and taken prisoner the boyar Khrushchev (whose name had to be omitted from Russian programs, whether of the play or of the opera, between 1956 and 1964 while his namesake ruled the Soviet Union), whom Boris had sent to lead them against the Pretender. They presented Khrushchev to Dmitry as a trophy at Kromy, a town near Oryol, about 220 miles south-southwest of Moscow. According to Karamzin, this was the turning point in the Pretender's campaign.

But was Karamzin's account Musorgsky's source? In his obituary, Stasov claimed it was, and that he and Musorgsky had planned the scene together. Indeed, there are a few footnote references to the Official Historiographer in the earliest printed libretto of Musorgsky's Kromy scene. But Alexandra Orlova and Maria Shneerson, who tried to run the citations down, concluded that they were fictitious references to mislead the censor, and have reached the same conclusion as have I, after a thorough perusal of Karamzin, that "revolt is not even mentioned in [his] history"—as indeed one would not expect it to be.[23] The closest Karamzin ever comes to admitting that "the people" *(narod)* had any active role in the downfall of Godunov is a single caustic remark:

> In the cities, the villages, and along the highways, proclamations of Dmitry to the inhabitants of Russia were circulated, containing news that he was alive and would soon be among them. The people were astonished, not knowing whether to believe it. But the tramps, the good-for-nothings, the robbers long since inhabiting the northern regions, rejoiced: their time was coming. Some came running to the Pretender in Galicia; others ran to Kiev, where ... a banner had been set out to rally a militia.[24]

Musorgsky surely read this passage and was impressed, for in his correspondence he always referred to the Kromy scene as "the tramps" *(brodyagi)*. But Karamzin did nothing more than name them; his tramps were an anarchic element to be harshly judged and explicitly distinguished from "the people":

> It was not a host that assembled against Boris, but a scum. An entirely insignificant portion of the [Polish] nobility, in deference to their king, ... or else flattering themselves with the thought of deeds of derring-do with the exiled tsarevich, showed up in Sambor and Lvov. Also there hurried thither all manner of tramps, hungry and half-naked, demanding arms not for victorious battle but for plunder and favors, which Mniszek [the Pretender's sponsor and father-in-law] granted generously in hopes for the future.[25]

Musorgsky could not have drawn his inspiration from the riffraff Karamzin describes. Although he, too, harshly judged the revolting mob (which furnished, in its credulity, the revised opera's tragic hero), he needed a historian who drew the kind of unambiguous connection that Karamzin was unwilling to draw between the famine-inspired lawlessness in the Russian countryside and the progress of the False Dmitry. In order to find a reliable historiographical sanction for a choral scene to match Rimsky's *veche*, Musorgsky needed a historian who viewed the people as an authentic agent in the events of the Time of Troubles between the Russian dynasties, not a mere reactor to them, as portrayed both by aristocratic historians like Karamzin and by "statists" like Solovyov.

In short, he needed Kostomarov, and eventually he found his man. Kostomarov's idealization of the peasantry made it inevitable that he should specialize in the chronicling of popular uprisings. His first big success was *Stenka Razin's Revolt* (*Bunt Stenki Razina*, 1859), one of the first fruits of the liberalized censorship under Alexander II. Its popularity was phenomenal and made its author a hero. In the early sixties his lectures were so appealing to the St. Petersburg University students who crowded his auditorium that more than once Kostomarov was carried out on their shoulders.[26]

Kostomarov's magnum opus was *The Time of Troubles of the Muscovite State in the Beginning of the Seventeenth Century* (*Smutnoye vremya moskovskogo gosudarstva v nachale XVII-ogo stoletiya*), first published serially in the *European Courier* in 1866. It was the most recent authoritative word on the subject when Musorgsky came to revise *Boris*. Its narrative began in 1604, the year of the False Dmitry's victory over the forces of Boris Godunov. In the scene-setting introduction to the main account, Kostomarov wrote an extended paragraph that directly related the unrest caused by famine to the progress of the Pretender, thereby setting out the conceptual kernel of Musorgsky's Kromy scene:

> If old-timers couldn't remember such a horrible famine in Russia, neither would they remember such vagrancy *[brodyazhnichestvo]* as then was rife. Lords had turned out

their servants when it became excessively dear to feed them, and later, when the price of bread had fallen, wanted to get them back. But their former serfs, if they had managed to survive the famine, were living with other masters or else had developed a taste for wandering—and did not wish to turn themselves in. Lawsuits and prosecutions multiplied. Hunted fugitives gathered in gangs. To these tramps were added a multitude of serfs who had belonged to fallen boyars. Boris had forbidden taking them as serfs, and this had been just as hard on them as the prohibition on transfers had been on the peasants. Having been indentured to one master, it was a rare serf who wanted to leave the status of serf altogether; practically all ran away to find another place. These "fallen" serfs gathered at that time by the thousands. Deprived of the right to roam from court to court, they attached themselves to the robber gangs, which sprang up everywhere in varying numbers. Most serfs had no other way of feeding themselves. The only exceptions were those who knew some trade. There were a multitude of fugitives from noble courts, from monasteries, from outlying settlements. They ran wild during the famine, and later, when they were sought by their former masters, they couldn't buy themselves off, especially since so many died in the famine. On the survivors a huge tax was declared before they could be free of their obligations. And so they ran, cursing the extortion, the injustice of the bailiffs and elders, the violent measures of their henchmen. Some ran off to Siberia, others to the Don, still others to the Dnepr. Many settled on the Ukrainian plains and there evaded their state-imposed obligations. The fact that the northern Ukraine had happily been spared the worst of the famine was the reason for an extreme concentration of people in that region. The government began to take measures for the return of the fugitives, and they for their part were prepared to resist. This whole fugitive population was naturally unhappy with the Moscow authorities. They were prepared to throw themselves with joy at whoever would lead them against Boris, at whoever would promise them an advantage. This was not a matter of aspiring to this or that political or social order; the huge crowd of sufferers easily attached itself to a new face in the hope that under a new regime things would be better than under the old.[27]

Not a scum, then, but a mass of insulted and injured, with whom one can (and the historian does) sympathize. As to the people as an active force that, when aroused, can threaten tsars, consider Kostomarov's description of the gang of Khlopka Kosolapïy (and substitute the name Khrushchev for Basmanov):

Khlopka did not limit himself to attacking travelers on the highway; with an enormous gang he went straight to Moscow, threatening to annihilate the throne, the boyars, and all that was sanctioned by authority, powerful, rich, and oppressive in Russia. In October 1603, Boris sent troops to destroy this gang, under the leadership of the *okol'nichiy* Ivan Fyodorovich Basmanov. They had not gotten far from Moscow when suddenly "thieves" fell upon Basmanov. They attacked the tsar's troops on a path that cut through the underbrush. Basmanov was killed.[28]

As for Khrushchev himself, the story of his capture by the Don Cossacks and his acceptance of the False Dmitry (which last is part of the action in Musorgsky's

Kromy scene) is related by Kostomarov in much greater detail than any previous historian had done:

> Here [on the left bank of the Dnepr near Kiev], there came again to Dmitry emissaries from the Don Cossacks with representations of the willingness of the whole independent population of the Don basin to serve the miraculously spared tsarevich. As an earnest of their fidelity they lay at their feet the nobleman Pyotr Khrushchev, who had been sent by Boris to incite them against Dmitry. The prisoner, brought before him in shackles, no sooner caught sight of the Pretender than he fell at his feet and said, "Now I see that you are the natural-born, true tsarevich. Your face resembles that of your father, the sovereign Tsar Ivan Vasil'yevich [the Terrible]. Forgive us, Lord, and show us mercy. In our ignorance we served Boris, but when they see you, all will recognize you."[29]

Finally, Kostomarov narrates several incidents that furnished Musorgsky with the model for the chorus of mockery in his Kromy scene. They relate, actually, to the period immediately following Boris's death, when his son and family were routed from the palace. Here are two:

> Meanwhile, on the other side of the river there were still those who, having sworn loyalty to Boris's widow and son, wished to remain true to their vows and persuaded others in the name of church and duty not to turn traitor. They reviled Dmitry, proclaiming, "Long live the children of Boris Fyodorovich!" Then Korela shouted: "Beat them, beat them, not with swords, not with sticks, but with poles; beat them and say 'There you are, there you are! Don't you be picking fights with us!'" This appealed to the assembled troops, especially the ones from Ryazan. The Godunovites were turned loose, and the Dmitryites chased them with laughter and beat them, some with whips, some with sticks, and some with fists.[30]

> [The supporters of Boris] were robbed and plundered without any mercy, from those marked by the people's hatred even the clothing was ripped, and many were seen that day—so eyewitnesses report—covering their nakedness as Adam did, with leaves. The mob, who had suffered long and much, who had been so long humiliated, rejoiced in this day, amused themselves at the expense of the noble and wealthy, paid them back for their former humiliation. Even those who had not sided with the Godunovs suffered on that day; it was enough to have been rich. And the general plunder and drunkenness continued until nightfall, when all slept like the dead.[31]

So when Kostomarov said of Musorgsky's *Boris* that it was "a page of history," one understands what he meant—it was a page of *his* history. That he was referring to Kromy, the scene that concluded the revised version in the original production, can go without saying. The difference between Kromy and the rest of the opera was precisely the difference between Karamzin and Kostomarov.

But was that difference indicative of Musorgsky's political views? One of his intimates, Alexandra Molas (née Purgold), Rimsky-Korsakov's sister-in-law and a

singer to whom Musorgsky had dedicated several songs in the 1860s, much later told the young Boris Asafyev that "the Kromy Forest scene arose in connection with the fact that Musorgsky recast the denouement of his tragedy in keeping with the burgeoning populist [narodnicheskiye] tendencies" of the time.[32] That much is true, but Asafyev, by then the sanctioned voice of the Soviet musicological establishment, added tendentiously that "precisely what Nikolai I's regime did not permit Pushkin to do was done here by Musorgsky."[33] That is nonsense. Musorgsky's scene followed a historiographical line that did not so much as exist in Pushkin's time, nor indeed until the 1860s. Kostomarov's interpretation of events was as much a denial of Solovyov's "statism" as the latter had been of Karamzin's absolutism, the source of Pushkin's view of the Time of Troubles and, at first, of Musorgsky's as well.

Nevertheless, it would be facile to claim that the Kromy scene is a direct expression, or even evidence, of Musorgsky's own changed ideological commitment, however palatable to liberal opinion (to say nothing of Soviet opinion, asserted as dogma against occasional questioners).[34] When the conductor of the première production, Eduard Nápravník, cut the scene to ribbons in rehearsal, Musorgsky acquiesced and even thanked him. (Stasov railed to his daughter in a letter that he couldn't understand how the composer could have been "so cowardly, so shallow and small.")[35] Two and a half years later, in October 1876, the Maryinsky Theater dropped the scene from the opera altogether (without reinstating its predecessor, it goes without saying, which had never been rehearsed or put into production). Stasov shrieked in protest that the theater had "castrated" the opera, and in his obituary essay for the composer he would claim that the removal of the Kromy scene had mortally offended the composer and even hastened his death.[36] Another close friend of the composer, Count Arseniy Golenishchev-Kutuzov, reported in his memoirs that, on the contrary, "Musorgsky not only approved this cut, he was particularly pleased with it." Surprised at this, Golenishchev-Kutuzov argued in favor of the scene; whereupon Musorgsky "heatedly asserted that its complete omission was demanded not only by the plot of the drama and the demands of the stage but also by his author's conscience." "'In this act,'" he went on, "'and for the only time in my life, I lied about the Russian people. The people's mockery of the boyar [Khrushchev]—that's untrue, that is an un-Russian trait. An infuriated people may kill, may execute, but they do not mock their victim.'"[37]

So which was it? Did Musorgsky agree with Kostomarov or with Karamzin? How did he himself regard the Time of Troubles or the question of Boris's legitimacy? The evidence, which consists mostly of claims by rival memoirists, does not permit a conclusive answer. Indeed, the opera's creative history, as we have already seen, points toward a musical and a dramaturgical rather than a political stimulus toward revision. The substitution of the Kromy scene for the one at St. Basil was motivated less by any principled commitment to populism (unlikely, after all, in a

member of the gentry class who had been impoverished by Alexander II's emancipation of the serfs) than by a wish to clarify the opera's tragic genre and a keen admiration for Rimsky-Korsakov's choral dramaturgy in that quintessentially "statist" opera *The Maid of Pskov*. In keeping with statist principles, Mey's (and Rimsky's) rebels had come to a bad end. Mob action comes (implicitly) to a bad end in *Boris Godunov* as well. After Kostomarov's unruly crowd of rebels follow the Pretender and his Polish retinue offstage, Pushkin's *yurodivïy*, transferred to Kromy from the discarded St. Basil's scene, is left alone to croon his crazed prophecy of Russia's downfall: *Gore, gore Rusi, / plach', plach', russkiy lyud, / golodnïy lyud!* ... (Woe, woe to Rus', / weep, weep, Russian folk, / hungry folk! ...)

IV

By transferring the role of the *yurodivïy* from St. Basil's to Kromy, Musorgsky made sure that the two scenes could not be performed in a single sequence. One was definitely intended to replace the other. (In fact, they were both intended to occupy the same—penultimate—position in the sequence of scenes, before Boris's death, until Musorgsky—or rather, his historian friend Vladimir Nikolsky—had the inspired idea of ending the opera with Kromy and the *yurodivïy*'s heartbreaking lament.) Whatever his political or historiographical convictions, Musorgsky could not have been unaware that the two scenes were as incompatible ideologically as they were textually and musically redundant.

For a long time no one was tempted to conflate them, for the simple reason that the St. Basil's scene lay unpublished and forgotten in Musorgsky's archive at the St. Petersburg Imperial (later State) Public Library. Not counting an imprecise and ambiguous passing reference to it in Nikolai Rimsky-Korsakov's memoirs, first published (posthumously) in 1909,[38] the scene was first brought to public attention by Andrey Nikolayevich Rimsky-Korsakov, the composer's musicologist son, who had succeeded Stasov as curator of musical manuscripts at the library, in an article that appeared in 1917 (not an auspicious year for Russian musicology) in a scholarly journal of small circulation that the younger Rimsky-Korsakov was then editing.[39] Nine years later, in 1926, Oskar von Riesemann, an Estonian-born musicologist living in Germany, finally published the St. Basil's scene, in his own error-filled transcription, as an appendix to his biography of Musorgsky. Two years after that, the whole first version of the opera was published in Pavel Lamm's edition and performed in Leningrad, and won for itself a cult following among Russian operatic cognoscenti.

The first public performance of the scene at St. Basil's had taken place a little earlier, on 18 January 1927, when the Moscow Bolshoy Theater, at the instigation of the conductor Ariy Moiseyevich Pazovsky (1887–1953), revived *Boris* in a production that added the newly discovered scene to the Rimsky-Korsakov version of

the opera, falsely billing it as having been "omitted earlier at the behest of the censor." An orchestration of the scene in the brilliant style of Rimsky-Korsakov was commissioned from Mikhaíl Mikhailovich Ippolitov-Ivanov (1859–1935), a former pupil of Rimsky-Korsakov who was then on the theater's conducting staff, after Alexander Glazunov (Rimsky-Korsakov's most eminent former pupil then still living in Russia) had refused.[40] Whether that production included Kromy alongside St. Basil's is not clear. The next year, as Robert W. Oldani relates, "the Stanislavsky Opera Theater apparently rehearsed both the Kromy scene and the St. Basil scene for a single production, though so-called 'technical considerations' ultimately forced the omission of Kromy since an extended intermission before the work's end would have made the opera too long."[41]

The familiar version with both scenes (St. Basil in Ippolitov-Ivanov's version) flanking the death of Boris became canonical in the USSR beginning in 1939, when a gala new production of *Boris Godunov* was mounted at the Bolshoy in honor of the composer's birth centennial. Their positioning on either side of what was originally to have been the opera's last scene somewhat mitigated their redundancy—but only somewhat. There is every reason to suppose that the decision to include them both was motivated by a Stalinist view of the opera's role as a political commentary on the illegitimacy of tsarist rule, each scene contributing its mite to that propagandistic task. There was no way one could logically justify the conflation, which Musorgsky had never envisaged, and actually made impossible—or so he thought.

And yet both scenes are searingly effective musical and dramatic achievements. Both bring tears to the eyes of the audience, and the reprise of the *yurodiviy*'s lament (which is not a reprise unless both of the scenes are included) is perhaps the crowning stroke of musicodramatic genius. No wonder the version of the opera concocted in Moscow possibly for political purposes became standard in the Soviet Union, achieved popularity abroad thanks to recordings and a widely shown film (in which the part of the *yurodiviy* in both scenes was unforgettably sung by Ivan Kozlovsky),[42] and has remained viable not only in post-Soviet Russia but in Europe and America as well. Among productions I have seen, both the Metropolitan Opera production of 1973, which reinstated Musorgsky's own orchestration on the basis of David Lloyd-Jones's then brand-new Oxford University Press edition and touted itself as unprecedentedly authentic for that reason, and a San Francisco Opera production of 1992 retained both St. Basil and Kromy and used them to flank the scene of Boris's death just as the Bolshoy had done (and continues to do). A 2010 production by Andrey Konchalovsky, the famous movie director, at the Teatro Regio of Torino, retained both scenes while (in keeping with today's aggressively interventionist staging practices) introducing even more extreme departures from the canonical scenario. And, as reported in the *New York Times* (13 October 2010), a new production at the Metropolitan Opera under Valery Gergiev also flanked the death scene with both crowd scenes.

Audiences (and directors) have become used to seeing them both and have found it perfectly possible to overlook redundancies and contradictions.

And they are right. Although unforeseen and seemingly disallowed by the author (even though it uses only material he composed), it is, I believe, a greater work than either of the two authorial versions. And if that is musicological heresy, make the most of it.[43]

And yet if, as I claim, the "supersaturated" redaction of Boris is greater than either of the two authorial versions, the question must inevitably arise: greater on what basis? If you measure greatness the modernist or academic way, in terms of internal unity and elegant form, it is a travesty.[44] If you measure greatness the way audiences measure greatness, in terms of what it does to them, it is a masterpiece. Modernists (and academic critics, who by and large still follow modernist principles by default), for whom the very first principle of art is "the customer is always wrong," cannot be expected to respect such a definition of greatness, and that is exactly where I differ with them (though the decision whether to call that difference premodern or postmodern I gladly leave to others). My sympathy, as a member of the audience, is finally with my own kind. Does an evil message (say, the Stalinism to which I have already called attention, or the antisemitism of Bach's *St. John Passion,* or the German chauvinism of Wagner's *Die Meistersinger*) prevent a work of art from achieving the status of a masterpiece? Only by the sort of tautological critical fiat that declares evil masterpieces to be a contradiction in terms that must be resolved either by proving that they are not evil or by proving that they are not masterpieces.

But even though my preference may seem to contradict the composer's, in another sense I am in solidarity with him. For Musorgsky's seeming ideological or historiographical change of heart in revising *Boris Godunov* had its origin, as I have argued, not in a considered historiographical analysis of the events the opera depicts, but in an esthetic and stylistic crisis. Whatever political or ideological messages Musorgsky's contrasting versions may appear to espouse are thus byproducts rather than premises of his artistic performance. For him, the Kromy mob was less a historical agent than a musicodramatic device (a *priyom,* as Russian formalists would say). Its purpose was not to secure a truthful representation of historical events but to "realize the dramatic essence of musical drama" and "concoct some magnificent history," the way Rimsky-Korsakov had done in *The Maid of Pskov.* Effective "concoction" was the end. The crowds, the mobs, and the national historians—the means.

NOTES

1. The allusion within the quotation marks is to Susan McClary's "Playing the Identity Card: Of Grieg, Indians, and Women," *19th-Century Music* 31 (2007–8): 217–27. Like her article, which originated as a keynote address to a conference, "Music and Identity," that took place as part of the centennial

celebration *Grieg 2007!* in Bergen, Norway, the present article originated as a keynote address to a conference, "Opera and Nation," that took place in Budapest in October 2010 as part of the celebrations marking the bicentennial of the birth of Ferenc Erkel and a new production at the Hungarian National Opera of his best-known work, *Bank Ban*. Where McClary endorsed the spirit of the occasion in which she was invited to participate, I chose to challenge the premises under which the Budapest conference was convened. My essay was inspired in part as a reply to hers and to what I take to be its regressive romanticism.

2. Richard Taruskin, *Defining Russia Musically: Historical and Hermeneutical Essays* (Princeton: Princeton University Press, 1997), xvii.

3. Francis Poulenc, *My Friends and Myself: Conversations Assembled by Stéphane Audel*, trans. James Harding (London: Dennis Dobson, 1978), 127.

4. McClary, "Playing the Identity Card," 226.

5. Joseph Kerman, *Opera as Drama* (New York: Vintage Books, 1956), 256.

6. See Nicholas Riasanovsky, *Nicholas I and Official Nationality in Russia, 1825–1855* (Berkeley: University of California Press, 1959).

7. Sergey Solovyov, *Istoriya Rossii s drevneyshikh vremyon*, vol. 3 (containing the original vols. 5 and 6 [Moscow: K. Soldatenkov]) (Moscow: Izdatel'stvo Moskovskogo Universiteta, 1963), 704.

8. The remark appears twice in the writings of Vladimir Stasov, who overheard (or, possibly, elicited) it: first, in Stasov's 1881 obituary for Musorgsky (Vladimir Vasil'yevich Stasov, *Izbrannïye sochineniya* [Moscow: Iskusstvo, 1952], 2:199); and, somewhat differently worded, in "Pamyati Musorgskogo," an essay marking the fifth anniversary of the composer's death (ibid., 3:34).

9. *Vestnik Yevropï* 1, no. 1 (1866): 84.

10. Nikolai Karamzin, *Istoriya gosudarstva rossiyskogo* (St. Petersburg: Izdatel'stvo Yevgeniya Yevdokimova, 1892), 9:273–74.

11. Mey wrote three plays in all: two on episodes in the life of Ivan the Terrible—*The Tsar's Bride* (*Tsarskaya nevesta*, 1849) and *The Maid of Pskov* (*Pskovityanka*, 1859)—and one, *Servilia* (1853), that takes place in ancient Rome. All three were turned into operas by Rimsky-Korsakov.

12. *Pskovityanka*, act 5, scene 10, in L. A. Mey, *Dramï* (Moscow: Sovetskiy pisatel', 1961), 194.

13. *Sochineniya Ap. Grivor'yeva*, vol. 1 (St. Petersburg, 1876), 515.

14. A comprehensive treatment of the revision in all its overdetermined aspects is attempted in R. Taruskin, "Musorgsky versus Musorgsky: The Versions of *Boris Godunov*," *19th-Century Music* 8 (1984–85): 91–118, 245–72; reprinted in idem, *Musorgsky: Eight Essays and an Epilogue* (Princeton, NJ: Princeton University Press, 1993), 201–99. For a more comprehensive examination of the relationship between Russian historiography and Russian historical opera, see R. Taruskin, "The Present in the Past: Russian Opera and Russian Historiography, circa 1870," in *Russian and Soviet Music: Essays for Boris Schwarz*, ed. Malcolm H. Brown (Ann Arbor: UMI Research Press, 1984), 77–146; reprinted in idem, *Musorgsky: Eight Essays and an Epilogue*, 123–200.

15. In the dedications of his songs "Kolïbel'naya Yeryomushki" (Jeremy's Cradle Song, 1867) and "S nyaney" (With Nanny, 1868), the first of the *Detskaya* (Nursery) cycle.

16. Examples include *El Gran Duque de Moscovia y Emperador Perseguido* by Lope de Vega and John Fletcher's *The Loyal Subject*. See Erwin C. Brody, *The Demetrius Legend and Its Literary Treatment in the Age of the Baroque* (Rutherford, NJ: Fairleigh Dickinson University Press, 1972). A later example, contemporaneous with Pushkin but unknown to him, was Schiller's unfinished *Demetrius*.

17. Karamzin, *Istoriya gosudarstva rossiyskogo*, 10:169.

18. Slightly adapted from the translation by Alfred Hayes in *The Poems, Prose, and Plays of Pushkin*, ed. Avrahm Yarmolinsky (New York: Modern Library, 1936), 394.

19. Musorgsky to Nadezhda and Alexandra Purgold, 18 June 1870, in Musorgsky, *Literaturnoye naslediye*, vol. 1, ed. Alexandra Orlova and Mikhaïl Pekelis (Moscow: Muzïka, 1971), 110.

20. César Antonovich Cui, *Izbrannïye stat'i* (Leningrad: Muzgiz, 1952), 221.
21. Musorgsky, *Literaturnoye naslediye*, 1:117.
22. *Poems, Prose, and Plays of Pushkin*, 406–7.
23. Alexandra Orlova and Maria Shneerson, "After Pushkin and Karamzin," in *Musorgsky: In Memoriam 1881–1981*, ed. Malcolm H. Brown (Ann Arbor: UMI Research Press, 1982), 253.
24. Karamzin, *Istoriya gosudarstva rossiiskogo*, 11:85.
25. Ibid., 84.
26. Oblique testimony to Kostomarov's status can be found in Stasov's hysterical letter of 17 May 1863 to Balakirev on Serov's *Judith*, an opera by his worst enemy: "Immediately, from the very first note Serov became the idol of St. Petersburg, just such an idol as Kostomarov was recently" (M. A. Balakirev and V. V. Stasov, *Perepiska*, vol. 1, ed. Anastasiya Sergeyevna Liapunova [Moscow; Muzïka, 1970], 199).
27. *Sochineniya N. I. Kostomarova*, vol. 3 (St. Petersburg: Tipografiya M. M. Stasyulevicha, 1903), 42–43.
28. Ibid., 43.
29. Ibid., 83.
30. Ibid., 117.
31. Ibid., 127–28.
32. Boris Asafyev, "'Boris Godunov' Musorgskogo, kak muzïkal'nïy spektakl' iz Pushkina," in idem, *Izbrannïye trudï*, vol. 3 (Moscow: Akademiya nauk SSSR, 1954), 132.
33. Ibid., 137.
34. See Yury Nikolayevich Tyulin, Alexey Ivanovich Kandinsky et al., "K izucheniyu naslediya M. P. Musorgskogo: Stsena 'pod Kromami' v dramaturgii 'Borisa Godunova,'" *Sovetskaya muzïka*, no. 3 (1970): 90–114.
35. Letter of 2 February 1874, in V. V. Stasov, *Pis'ma k rodnïm*, vol. 1, pt. 2 (Moscow: Muzgiz, 1953), 209.
36. V. V. Stasov, "Urezki v 'Borise Godunove' Musorgskogo (Pis'mo v redaktsiyu)," *Novoye vremya* 239 (27 October 1876); reprinted in V. V. Stasov, *Izbrannïye sochineniya* (Moscow: Iskusstvo, 1952), 1:278–79, 2:199.
37. M. V. Ivanov-Boretsky, ed., *Muzïkal'noye nasledstvo: Sbornik matierialov po istorii musïkal'my kul'turï v Rossii* (Moscow: Ogiz & Musgiz, 1935), 20.
38. See Nikolai Rimsky-Korsakov, *My Musical Life*, trans. Judah A. Joffe (London: Eulenburg Books, 1974), 110.
39. See Andrey Nikolayevich Rimsky-Korsakov, "'Boris Godunov' M. P. Musorgskogo," *Muzïkal'nïy sovremennik*, nos. 5–6 (January–February 1917): 108–67.
40. See M. M. Ippolitov-Ivanov, *50 let russkoy muzïki v moikh vospominaniyakh* (Moscow: Muzgiz, 1934), 146.
41. Information kindly provided by Prof. Oldani in a private communication.
42. Mosfilm, 1954, dir. Vera Stroyeva.
43. Somebody already has. Responding to my essay in the Torino program book, from which I took the idea at the heart of this paper, an angry Italian blogger whose moniker, Proslambanomenos, indicates that he is well and possibly professionally informed about music history, made this rejoinder:

> There is one point, at least, that should be held to firmly: namely, *the incompatibility between Saint Basil and Kromy*. The *technical procedure* that Musorgsky employed to construct the second version saw to that: he not only eliminated Saint Basil but also salvaged from it what struck him as useful (the episode with the Holy Fool) in the construction of Kromy. This is proof positive of the impossibility of retaining both scenes. And the beautiful thing is that—in theory—this fact has been recognized by eminent scholars, such as Prof. *Richard Taruskin*, one of whose articles opens the program book of the Sala Regio. Too bad that, as soon as he has

recognized the validity of this logic, our man loses no time declaring himself in favor of the coexistence of the two scenes. And why? Because *the public likes it* that way! The grandiosity of this affirmation is matched by its crankiness. Because if you pursue this logic, as long as it would please the public, one might perform infinite different versions of the symphonies of Beethoven, constructed from the mountain of sketches, notes, and ideas that the genius of Bonn left behind. *What idiocy.* You have to have a chair in Berkeley to come up with ideas like this . . .

[Invece ci sarebbe un punto (almeno uno) da tenere ben fermo, poiché di una chiarezza incontestabile: *l'incompatibilità fra San Basilio e Kromy.* Certificata proprio dal *procedimento tecnico* che Musorgski impiegò per costruire la sua seconda versione: eliminare San Basilio e recuperare da esso ciò che gli tornava utile (la scenetta dell'Idiota) nella costruzione di Kromy. Ciò è la più chiara e convincente dimostrazione dell'impossibilità di coesistenza dei due quadri. E il bello è che—in teoria—ciò viene riconosciuto anche da eminenti studiosi, come il prof. *Richard Taruskin,* un cui scritto apre il volumetto del programma di sala del Regio. Peccato che, subito dopo aver riconosciuto la validità dell'assunto logico, il nostro si affretta a dichiararsi entusiasta della convivenza fra i due quadri. E in base a quale ragionamento? Che la cosa *piace al pubblico!* Grandiosa davvero, questa affermazione, pari alla sua bizzarrìa. Chè allora, visto che sicuramente al pubblico piacerebbero, si potrebbero presentare infinite versioni delle *sinfonie di Beethoven,* costruite recuperando la montagna di schizzi, appunti e idee che il genio di Bonn ci ha lasciato in eredità. *Rob de matt,* bisogna avere una cattedra a Berkeley per sfornare simili idee . . .] (http://proslambanomenos.blogspot.com/2010/10/lurca-boris-torino.html)

Yet I, for one, would be quite interested in hearing those new Beethoven symphonies, and I don't exclude the possibility that any one of them might be a keeper. (Thanks to Mary Ann Smart for help with the translation.)

44. And so I myself argued, quite puritanically, a quarter century ago (in "Musorgsky vs. Musorgsky"; see note 14 above), before I had the nerve (and the job security) to argue on behalf of my actual convictions.

4

Catching Up with Rimsky-Korsakov

I

In the part of the world I inhabit, the works of Rimsky-Korsakov may be divided into two groups: the unknown and the overplayed. They are not of equal size. The overplayed category consists, by my count, of exactly five pieces. Two of them are so familiar that many who whistle them probably do not know that they are by Rimsky-Korsakov. One—for virtuoso whistlers only—is "The Flight of the Bumblebee," which is known not as an entr'acte from the opera *The Tale of Tsar Saltan*, as Rimsky-Korsakov knew it, but as an encore piece for every conceivable instrument. I have heard it on tuba, banjo, and mouth organ; you can find it on YouTube played on the Russian accordion, on electric guitar, and as sung by the Swingle Singers;[1] and I played it myself, as arranged by Joachim Stutschewsky, when I was an aspiring cellist. Much later, when I was studying the viola da gamba, which (unlike the cello) I played professionally for a while, my teacher gave me a month of free lessons in return for arranging Stutschewsky's arrangement for viola da gamba and harpsichord, so that she could use it in recital. (She never did, but I still have the score if anybody is interested.)

The other is "Song of India," a piece one is (or was) likeliest to hear in restaurants and hotel lobbies as blandly arranged instrumental background music. It was popularized in America by the bandleader Tommy Dorsey in a recording made in

Originally delivered as a keynote address at a conference, "N. A. Rimsky-Korsakov and His Heritage in Historical Perspective," held at the Rimsky-Korsakov home-museum, 28 Zagorodnïy Prospekt, St. Petersburg, 20 March 2010, and first published in *Music Theory Spectrum* 33, no. 2 (Fall 2011): 169–85, 229 (response to rebuttals).

1937, and it was recorded by the popular tenor Mario Lanza in 1953 with words by the American songwriter and lyricist Johnny Mercer. That's how I first heard it:

> And still the snowy Himalayas rise
> In ancient majesty before our eyes,
> Beyond the plains, above the pines . . .[2]

This item also comes from an opera, *Sadko*, but that fact is irrelevant to its popularity, as is its Russian title (*Pesnya indiyskogo gostya*, "The Song of the Hindu Trader"), because that title only has relevance within the action of the opera. The remaining overplayed items, however, are well known to all classical concertgoers as works by Rimsky-Korsakov. Hardly a season goes by without one of them showing up in the programs of any orchestra. (I checked the 2010–11 programs— just announced at the time of writing—of my local orchestra, the San Francisco Symphony, and found two of them.) They are the three orchestral scores that Rimsky-Korsakov wrote in a clump, one right after the other, in 1887 and 1888, the exact midpoint (although he couldn't know that) of his career: *Capriccio espagnol (Kaprichchio na ispanskiye temï)*, op. 34; the symphonic suite *Sheherazade*, op. 35; and the piece known to English speakers as the *Russian Easter* Overture, which Russians know today as *Svetlïy prazdnik* (Bright Holiday), although the original title was *Voskresnaya uvertyura na temï iz Obikhoda* (Easter Overture on Themes from the Book of Common Orthodox Chants), op. 36. They are popular classics (all of them recorded and rerecorded, for example, by the Boston Pops Orchestra), and that status has rubbed off on the composer's reputation.

For, as the foreigners at our conference know very well but the Russian participants may be shocked to learn, Rimsky-Korsakov is not taken very seriously by musicians and music scholars in the West. Even though he wrote one of the great nineteenth-century autobiographies (musical or not), there is still is no scholarly biography of Rimsky-Korsakov in any Western European language, or even translated into one, which puts Rimsky-Korsakov in a category within the Mighty Kuchka with César Cui alone, since even Balakirev received a full length scholarly treatment, by the British musicologist Edward Garden, as long ago as 1967.[3] Musicians to the west of Russia could never quite forgive Rimsky-Korsakov for his redaction of his friend Musorgsky's *Boris Godunov*, which so scandalized French modernists that it became the subject of what is surely the most sustained and unwarranted invective ever aimed at a single deed by a single musician: a book called *En marge de Boris Godounof* by Robert Godet, a close friend of Debussy, for whom Musorgsky was "something of a god in music."[4] It is worth noting by the way that this book, although written in French by a Frenchman, was issued by an English firm, the music publisher J. & W. Chester, which at the time was also hawking a reprint of the Bessel vocal score of Musorgsky's original version of the opera. Godet's book was part of their advertising campaign.

Compared with the mythic, tortured figure of the uncouth, untutored, and unmarried Musorgsky, dead of alcoholism at the age of forty-two (or, for that matter, Chaikovsky with his tantalizing sexual *mystères*), the all too respectable Rimsky-Korsakov—the stern professor, the straitlaced paterfamilias, the serene and tolerant bourgeois liberal (albeit the scion of an ancient aristocratic family long distinguished in arms)—did seem for many to be the very antithesis of a great artist. But it was only the romantic stereotype of the suffering artist to which Rimsky-Korsakov was antithetical. Long before Stravinsky and other modernists took up the refrain after the Great War, Rimsky-Korsakov espoused a wholly unillusioned, antiromantic view of his calling. The artist depended, to his mind, not on inspiration but on know-how; music expressed not the immediate feelings of the artist but, rather, that which the artist knew how to express; there was no contradiction between originality and correct style; for Rimsky-Korsakov, the former did not excuse the want of the latter; regularity of habits and adherence to conventional standards of morals and hygiene were beneficial to artists as to all people. Thus Rimsky-Korsakov forbade his dissolute former pupil Arensky, who drank like Musorgsky and was a gambler to boot, from attending his musical gatherings. And despite his being a professed atheist, Rimsky-Korsakov could nevertheless give heart-rending expression to religious sentiments he did not share in *The Legend of the Invisible City of Kitezh*.[5]

It was Musorgsky who epitomized for foreigners the romantic genius in Russian music, and the whole reception history of Russian music in Western Europe and America has been the history of an implied and invidious comparison between Musorgsky and Rimsky-Korsakov, a comparison rooted in their contrasting lifestyles. Gerald Abraham, the scholar to whom all of us Anglophone writers on Russian music trace our line, gave the old cliché its most elegant formulation, made all the more exasperating by its polite condescension. At the end of an article comparing the earliest version of Rimsky-Korsakov's first opera, *Pskovityanka*, with its final revision, Professor Abraham wrote: "Rimsky Korsakov was as right to make a better job of his own early score as he was wrong in performing exactly the same operation on his friend's *Boris*. *Boris Godunov* is a work of another man's genius; the original *Pskovityanka* was a work of his own great talent. He raised one and reduced the other to nearly the same level."[6]

Amazingly enough, Hollywood did make Rimsky-Korsakov the subject of a biopic. Inevitably, it is called "The Song of Scheherazade."[7] Its action takes place during "Nicky" Rimsky-Korsakov's youthful naval career, on board the battleship *Almaz* and in Tangiers, where he falls in love with a dancing girl played by the sexy Yvonne de Carlo. As one reviewer put it, "The character played by Jean-Pierre Aumont and the real Rimsky-Korsakov only share the same name," and any resemblance between the events portrayed in the movie and the life of the actual composer was pure coincidence.[8] But it certainly underscores how firmly

the name Rimsky-Korsakov has always been associated, outside of Russia, with orientalist kitsch.

And that explains why, where I come from, music historians who didn't ignore Rimsky-Korsakov altogether often went far out of their way to disparage him. The example that will always loom largest in my mind comes from *Music in Western Civilization* by Paul Henry Lang—a book first published in 1941, but still very much in print, and still influential. It was written by a man who, much later, was my own professional mentor, so you can imagine the mixture of feelings with which I now quote to you his considered opinion of the composer whom we are gathered here to commemorate:

> Rimsky's soul was not occupied by the somber and fateful shadows of the tragedy of his people; the eternal and mysterious *active* forces that are at the bottom of the Russian soul and which agitated a Moussorgsky or Dostoyevsky were unknown to him, who leaned rather toward the passive, storytelling nature of the Russian, always colorful, but always devoid of problems. This type of imagination, which does not find its inspiration in true life, which perhaps is afraid of it because it knows that it could not respond to its exigencies, always flees into the world of the fabulous. All the color, pomp, and lulling intoxication of the Slavic fairy world return in the scintillating, phosphorescent, often sensuously opulent orchestral and operatic works of Rimsky-Korsakov, but the color and élan is that of the picture books which grownups read with such pleasure to their children, but which without the enraptured listeners lose their spell. What paucity of ideas and feelings, aside from the folk tunes [!], in the most fetching of his orchestral poems, *Scheherazade*—it reminded Debussy "more of a bazaar than the Orient"—what grand opera pose and trick in *Coq d'Or!* And if the beguiling apparatus of the storyteller, the orchestra, is taken away there is a complete collapse. Rimsky's chamber music and other works for intimate ensembles or solo instruments are not within the realm of serious music; they might be taken for the works of an unpromising beginner.[9]

I don't propose to parse or to unpack this spew, except to point out that what will certainly strike us now as its offensive essentialism—the certainty as to what is truly and exclusively Russian and the insistence upon it as a mark of authenticity, the banal appeal to the eternal and mysterious Russian soul—is not something invoked merely to portray what is Russian as alien or of a lower order. Essentialism of this kind was a direct inheritance from German romanticism, and it characterized every description in Lang's work of music from any particular time or particular place. I first read this passage at the age of sixteen, a few months before enrolling at Columbia University, Lang's institution, as a college freshman. I had been given his book by one of my high school teachers as a graduation present. Even by the time I read it, however, I knew that Lang's description of Rimsky-Korsakov, though it claimed to encompass the composer's work in all media, orchestral, operatic, and even chamber, was in fact the work of a writer who did not know the

Rimsky-Korsakov that you all know here in Russia, and that I, thanks to relatives in Moscow who sent me many presents including phonograph records, was already getting to know—and that was the Rimsky-Korsakov of the operas besides *Coq d'Or*. Lang obviously did not know *Pskovityanka*, or *May Night (Maiskaya noch')*, or *The Snow Maiden (Snegurochka)*, or *Kashchey the Deathless (Kashchey bessmertnïy)*, or—especially—*Kitezh*. I did. And it became my mission to bring the news to Professor Lang, and to everyone else, about what they were missing.

There was someone who could have dispelled opinionated ignorance about Rimsky-Korsakov far better than I, but who preferred to exploit it—and that of course was Stravinsky, Rimsky-Korsakov's most famous pupil, whose feelings about Rimsky-Korsakov were even more complicated than my feelings about Professor Lang. In his autobiography, *Chroniques de ma vie* (ghostwritten by Walter Nouvel), a grateful Stravinsky still professed filial piety toward the man he called his *cher maître*, while at the same time emphasizing the split within the world of Russian art during the time of his apprenticeship between the progressives with whom he would eventually associate and the academic world represented by his teacher. Still, "in justice to Rimsky-Korsakov," Stravinsky admitted, he "had sufficient courage and finesse not to make a sweeping condemnation of everything serious and appreciable that modern art had to offer." His teacher, Stravinsky wrote, "had my deep affection and I was genuinely attached to him."[10] Only a few years later, though, in the chapter (ghostwritten by Pyotr Suvchinsky) on Russian music in his Harvard lectures, later published as *La poétique musicale*, Stravinsky spoke of Rimsky-Korsakov only as a member of the so-called Five—"ces slavophiles d'espèce populiste"—from whom he distanced himself with great distaste. "I was able to enjoy for myself the benefits of his sober and forceful pedagogic gifts," Stravinsky told his audience in 1940, but by the time Stravinsky knew him, Stravinsky went on, Rimsky-Korsakov was the doyen of the "Belyaev Circle," composers who "under cover of concern for the most serious of professional techniques ... gave evidence of the alarming symptoms of a new academicism."[11]

By the time Stravinsky had turned to memoir-dictating on an industrial scale, even the value of Rimsky-Korsakov's teaching had to be denied. Rimsky was "shockingly shallow in his artistic aims." His knowledge of composition "was not all it should have been." His "modernism" was "based on a few flimsy enharmonic devices." Summing up, Stravinsky patronized his teacher wickedly: "I am grateful to Rimsky for many things, and I do not wish to blame him for what he did not know; nevertheless, the most important tools of my art I had to discover for myself."[12]

These mean remarks are only too easily seen through. Beyond any question of *amour-propre*, or of public relations, there was the deep and lasting resentment Stravinsky bore Rimsky-Korsakov's survivors (his widow and his sons), who

rejected and reviled Stravinsky after his teacher's death because of his association with Diaghilev's enterprises. They thought of Stravinsky as a renegade, and he in turn felt betrayed by them. His authority, however, was absolute in the musical world of the mid-twentieth century, and while it lasted there could be no question of revising Rimsky-Korsakov's reputation. Instead, it became fashionable to flatter Stravinsky with gratuitously invidious comparisons to his teacher, as when Charles Rosen, always ready to give a fresh and witty turn to a tired conventional judgment, after remarking that "Schoenberg sounds best when his music is played as if it were by Brahms," adds for no reason (except the reason about which I am writing) that "Stravinsky, on the contrary, does not benefit by trying to make his music sound as if it were by Rimsky-Korsakov."[13]

II

I've been recalling all these ancient calumnies, right here in Rimsky-Korsakov's own house, not merely to register a trite complaint, or to infuriate you, but to set the scene for the story I mean to tell. That story begins in 1963, fifty-five years after Rimsky-Korsakov's death, when the American composer Arthur Berger, the co-editor of a then new journal called *Perspectives of New Music,* published an article in its third issue called "Problems of Pitch Organization in Stravinsky."[14] This is a very famous article among Anglophone musicologists; indeed, it marked a watershed, not only in Stravinsky studies, but in that of music theory and analysis generally, setting the cornerstone to what Berger himself, in the article's last sentence, greeted as "a new branch of theory" (154). That branch would address what Berger, in the article's first sentence, called "twentieth-century music that is centric (i.e., organized in terms of tone center) but not tonally functional" in that it is not "defined by those functional relations postulated by the structure of the major scale" (123).

The part of the article that has given it this larger significance is the part initiated by a discussion of a theme from Stravinsky's choral ballet *Svadebka,* known outside of Russia as *Les noces* (ex. 4.1).

Despairing of accounting for the pitch content of this passage by referring to diatonic scales (though he flirted briefly with the harmonic minor), and unwilling to attempt any *a priori* differentiation of what was "structural" from what was "ornamental" in the musical texture, Berger looked for other evidence to account for its consistency, and found it in the (then) surprising fact that when the passage recurred, so that the first sung note was C rather than E-flat, and recurred again with A in the corresponding position, the total pitch content ("with a few exceptions so marginal as scarcely to require mention," 132) did not change. Abstracting the unchanging pitches from the three passages and ordering them as a scale, Berger discovered that the notes of this scale formed a recurrent pattern

EXAMPLE 4.1. Mothers' duet from Stravinsky's *Svadebka* (third tableau) as given (as Example 5) in Arthur Berger's "Problems of Pitch Organization in Stravinsky" (1963).

of alternating tones and semitones (fig. 4.1). Because the scale comprised eight elements, Berger christened it "octatonic"—a term that, although arguably misspelled, you will now find in any English-language music dictionary or music textbook, whether of theory, of history, or even of music appreciation.[15] This was its first appearance. To Arthur Berger, then, goes the credit of having contributed a universally adopted term to the English-language technical vocabulary of music (and an internet search will turn up plenty of references to *la gamme octatonique* and *die oktatonische Tonleiter* as well).

Berger made a number of preliminary observations about his octatonic scale, beginning with the fact that Olivier Messiaen had listed it among his "modes of limited transposition" in *Technique de mon langage musical,* his treatise of 1944. Berger noted that Messiaen had reported Stravinsky's use of the scale, thus acknowledging that he had not actually discovered or invented the scale he had named. But he was still the first to note some very striking applications of the scale in Stravinsky's music, and forever changed perceptions of it. He immediately noticed, for example, that the famous *Petrushka*-chord, superimposing triads on C and F-sharp, which had previously been the foundation for a great deal of speculation about Stravinsky's "bitonality," could be referred to the octatonic scale, thus accounting for it within a single, rather than a dual, tonality (or "referential order," as he very cautiously put it). The *Petrushka*-chord actually illustrated one of the scale's most salient properties, namely, that each of its members has a tritone-related counterpart. The *Petrushka*-chord was the inevitable outcome of this property: if the notes of one triad are extracted from the scale, the remainder will include that triad's tritone-complement.

From there, Berger went on to observe that the *Jeu de rapt (Igra umïkaniya)* from *Le sacre du printemps* doubles up on the *Petrushka*-chord through a harmonic texture that adds triads on A and E-flat to the C-plus-F-sharp complex, thus demonstrating another way in which harmonic relations could be derived

	i	ii	iii	iv	v	vi	vii	viii	(i)
	a	B♭	c	D♭	e♭	E	f♯	G	(a)
pitch numbers:	0	1	3	4	6	7	9	10	(1)
intervals:		1	2	1	2	1	2	1	(2)

A formal approach to this scale (hereafter referred to as "octatonic") would calculate the structure and enumerate the properties at once.[8]

FIGURE 4.1. The analytical chart showing the derivation of the scale from the theme. The surrounding text is historic: it shows the earliest occurrence of the now-standard term "octatonic."

from the octatonic scale. The diminished-seventh chord is composed entirely out of minor thirds (which are half a tritone, as the tritone is half an octave); any tone in the octatonic scale will thus have not only a tritone-complement but a complement (or, actually, two complements) at the minor third as well; hence, as Berger put it, "the *Jeu de rapt* is a veritable primer of the ways in which the octatonic scale may be arranged into four major triads or seventh chords" (139). If it seems a little odd that Berger deduced the minor third complementation from the tritone-complementation rather than the other way around, it was a result of his determination to proceed entirely by inference rather than through what he dismissively called "the proverbial historical search for correspondences" (126). That phrase and the bias it implies is something to which I will return, but for now we may note that an ahistorical bias did not prevent Berger from making observations that were pregnant with historical implications. The way he compared the harmony in *Petrushka* with the more complex harmony in *Le sacre du printemps* was one of these. It certainly alerted me, when the time came, to the progressive quality of Stravinsky's harmonic evolution—in the literal rather than the stale, politicized meaning of the word "progressive."

Next, Berger showed something quite surprising—namely, that the theme of the Variations movement in Stravinsky's *Octuor* of 1923 was also drawn from the same octatonic scale he had identified in *Svadebka*, *Petrushka*, and *Le sacre*, even though the *Octuor* was considered the foundational work of Stravinsky's neoclassical manner, hitherto regarded as an extreme departure (even the repudiation) of the "Russian" period that preceded it. This was tangible evidence of the continuity that underlay Stravinsky's many stylistic metamorphoses—something previously sensed and declared, but only as enthusiastic propaganda, not as the fruit of technical analysis.

The example from the *Octuor* was marked by irony (a prime "neoclassic" marker) in that the theme was harmonized by chords referable to the key of D minor, whose tonic was not a part of the octatonic scale to which Berger referred the melody. This brought Berger to his concluding clump of observations, in which

he noted some of the many ways in which octatonic and diatonic scales and harmonic devices interacted in such works as *Histoire du soldat* (1918), the *Symphonies of Wind Instruments* (1920), the *Symphony of Psalms* (1930), the *Concerto per due pianoforte soli* (1935), the *Symphony in Three Movements* (1946), and *The Rake's Progress* (1951)—which took the discussion almost up to what was the present at the time of writing (while Stravinsky was still very much alive and still composing). Even though many of the details both of Berger's analyses and of the conclusions he drew about the octatonic scale and its properties have been superseded by subsequent research, and although the purview of his investigation had peculiar limitations, I think it is fair to say that Berger's article stands as the most important single contribution to understanding Stravinsky's composing technique, and as the foundation of all subsequent analytical work on Stravinsky's music.

The next big step toward turning Berger's insights into "a new branch of theory" was taken a dozen years later by Pieter van den Toorn, whose very long article "Some Characteristics of Stravinsky's Diatonic Music" was split between two issues of the same journal, *Perspectives of New Music*, beginning in the fall of 1975 (four years after Stravinsky's death), and later expanded into a substantial book.[16] Rejecting Berger's proviso that representations of the octatonic scale, properly so-called, must begin with the half-step rather than the whole step so as to emphasize its distinctness from the diatonic scale, Van den Toorn showed that the two versions of the scale had different properties, and that Stravinsky had exploited both. The version of the scale beginning with the whole step, when bisected, yields two minor tetrachords. Following the rule about tritone-complementation within the octatonic collection, these tetrachords stand a tritone apart, which made this ordering of the scale an appropriate resource for producing radical harmonizations of diatonic folk-like tunes such as one finds in *Le sacre* or *Svadebka*. Van den Toorn also showed that the octatonic ordering beginning with the half-step, which yields triadic material at four transpositions, returned to prominence in Stravinsky's "neoclassical" music, now with an emphasis on chords containing both major and minor thirds over a given root (also referable to the scale). Stravinsky's career, in other words, could be parsed into phases corresponding with changing octatonic usages, and this provided an even more effective gauge than Berger had provided for assessing the continuities that underlay Stravinsky's apparently radical changes of style over the course of his career.

In his article, Van den Toorn showed even less interest than Berger in the origin of the octatonic scale. Like Berger, he noted its presence in Messiaen's list of modes of limited transposition, but he did not report even as much as Messiaen had reported about its occurrences before Stravinsky. Both Berger and Van den Toorn were content to regard the scale as Stravinsky's virtual invention; and for this reason they had little defense against skeptics who argued that their analyses were arbitrary, hence factitious or opportunistic, segmentations of Stravinsky's musical

surfaces. As Van den Toorn admitted, "Stravinsky was of no assistance in this matter," never having mentioned the octatonic collection or its scalar representations in any of his writings or dictated memoirs, even though "his commentary was not always of a nontechnical nature." He could do no better in defending his analyses against his critics than to protest that "given the evidence [of the scores themselves] it seems inconceivable that [Stravinsky] could somehow have been unaware of the collection as a cohesive frame of reference, or of its very considerable role in his music as a constructive or referential factor."[17] Not surprisingly, then, most of the American theorists who had worked on Stravinsky's music—John Rahn, Joseph Straus, Allen Forte, and several others—felt justified in ignoring or actually dismissing his work along with Berger's.[18]

III

There was one reader, however, who did not ignore or dismiss but who accepted Van den Toorn's work with joy and gratitude, and that reader was I. That is because by the time I read Van den Toorn—and reread Berger—in the fall of 1979 I had begun investigating the early music of Stravinsky from an historical rather than purely inferential perspective, and I knew what everyone here already knows: namely, that the octatonic scale was widely known among Russian musicians in the years of Stravinsky's training, and that it was known in Russia not only as the *gamma ton-poluton* (the "tone-semitone scale") but also as the *korsakovskaya gamma* (the "Rimsky-Korsakov scale"). I knew that in his *Chronicle of My Musical Life* (a book long available in English and read by many), Rimsky-Korsakov had acknowledged discovering the scale in Liszt's first symphonic poem (the so-called Mountain Symphony), and further acknowledged, in what turned out to be a colossal understatement, that the scale had "subsequently played an important part in many of my compositions."[19] I knew that Rimsky-Korsakov had described the scale in a letter to Balakirev as early as 1867, and even told Balakirev where it first occurred in his own works, in the symphonic poem *Sadko*.[20] I knew that the last chapter of Rimsky-Korsakov's harmony textbook guides the student, under the rubric "false progressions along the circle of minor thirds," to discover the octatonic scale in the form in which Rimsky-Korsakov had found it in Liszt, that is, as a descending bass.[21] I knew that Rimsky-Korsakov often discussed the scale with his Boswell, Vasiliy Yastrebtsev, who in his now-celebrated diary of his daily meetings with Rimsky-Korsakov reported its occurrences in several of Rimsky's compositions. I knew that Yastrebtsev had published an article naming the "tone-semitone scale" in 1900 (the earliest public reference to it that I know, and one that predated Stravinsky's apprenticeship), and he also reported discussions of the scale between Rimsky-Korsakov and several of his pupils, including Lyadov and Maximilian Shteynberg (Stravinsky's contemporary).[22] At one of these discussions,

EXAMPLE 4.2. Sketch by Rimsky-Korsakov for *Tsar Saltan* (1899) showing the two forms of the octatonic scale.

EXAMPLE 4.3. Sketch by Rimsky-Korsakov for *Heaven and Earth*, showing "*Petrushka* chords" *avant la lettre*.

Shteynberg illustrated the scale by playing a passage from Stravinsky's just-completed *Scherzo fantastique*.[23]

And from there, of course, I turned to the scores, where both the extent of Rimsky-Korsakov's deployment of the scale and the resourceful variety with which he exploited it were abundantly revealed. By scores I mean not only the published works but also Rimsky-Korsakov's sketchbooks, which had been transcribed and issued, as the last volume of his collected literary works and correspondence, in 1970. There his systematic investigations of the scale and its various properties and possibilities were laid out especially clearly, often with explicit verbal annotations, and elaborated into compositional technique.[24]

Rimsky-Korsakov, it turned out, was fully aware of both forms of the scale, as promulgated by Van den Toorn in 1975, and of their differing properties, leading to differing suitabilities. There is a telling sketch for *The Tale of Tsar Saltan*, made in 1899, that shows the two forms of the scale side by side proceeding from the same pitch, labeled "the one scale" *(odna gamma)* and "the other scale" *(drugaya gamma)* (ex. 4.2). These became for him what I dubbed the melody scale and the harmony scale; and when they worked in tandem they could encompass the full chromatic spectrum within an octatonic purview.[25]

In another sketch, which juxtaposed triads on F major and B major (equivalent to the *Petrushka*-chord a half-step down), Rimsky wrote a reminder to himself to transpose "the same rising sequences [to] the interstices D minor and G-sharp minor," the complementary harmonies that would exhaust the octatonic collection of reference (ex. 4.3). When Van den Toorn discovered the *Petrushka*-chord similarly transposed (to a superimposed A and E-flat) to accompany Petrushka's appearance in the third tableau of Stravinsky's ballet, he touted it as evidence of Stravinsky's "in-the-act" or *a priori* awareness of the octatonic scale as a collection of reference.[26] Rimsky-Korsakov possessed the same awareness.

In fact, there is nothing in Stravinsky's octatonic usages up to *Petrushka* that does not have a direct precedent in the work of his teacher; and his subsequent usages—in *Le sacre du printemps*, in *Svadebka*, and on into the later phases of his career—are solidly and logically based on deductions from his earlier practice, which is to say the practice of his teacher. What Berger and Van den Toorn had accomplished actually amounted, remarkably enough, to catching up with Rimsky-Korsakov, who in the second half of the nineteenth century had, in his practical work, already been striking out into Berger's "new branch of theory" and passing it along to his pupils, and his pupils' pupils, in the form of "*Gebrauchs*-formulas," as Lazare Saminsky, a pupil both of Rimsky-Korsakov and of his pupils at the St. Petersburg Conservatory, put it after his emigration to America.[27] Saminsky's idiosyncratic term means, precisely, "usages." That, rather than "theory," is what composers learn and teach, at least in conservatories.

This had not been entirely unsuspected. Messiaen, who had evidently read Rimsky-Korsakov's *Chronicle of My Musical Life*, listed him, along with Scriabin, Ravel, and Stravinsky, among those who had stumbled upon his second mode of limited transposition. Following the account in Rimsky's memoirs, Messiaen mentioned *Sadko*—and only *Sadko*, suggesting that he had looked no further. Having examined only Rimsky-Korsakov's first experiment with the octatonic scale (where it appears only *as* a scale, descending, and functions as a leitmotif evidently portraying the merchant seaman Sadko's underwater plunge), Messiaen felt justified in writing it off as a "timid sketch."[28] Even before Messiaen, the eagle-eyed Gerald Abraham had spotted the scale in the music Rimsky had composed for the *tsevnitsï* or panpipes in the Cleopatra scene from *Mlada*—music that "sounds so genuinely exotic," Abraham wrote, but "is based not on some oriental scale, but on the artificial one of alternate tones and semitones invented by Rimsky-Korsakov himself," which suggests that Prof. Abraham had forgotten the passage in Rimsky-Korsakov's memoirs that Messiaen remembered.[29]

But if all of this had been suspected, it was nevertheless neglected, or resolutely minimized. In a curious memoir delivered as a lecture in 1998 and published four years later, when he was ninety years of age, Arthur Berger let it be known that when writing his seminal article on pitch organization in Stravinsky, "I vaguely

remembered having seen some mention of a succession of whole- and half-steps in, of all unexpected places (to me at least), Rimsky-Korsakov's *My Musical Life* many years earlier. Perhaps I should have looked up the passage but my approach was not historical."[30] I'll say it wasn't! To find unexpected Stravinsky's own teacher's influence on his pupil's pitch organization seems about as unhistorical as an approach can get. In his full-length treatment of 1983, Van den Toorn, while noting that "the origin of the octatonic collection remains obscure," nevertheless conceded that "Stravinsky undoubtedly inherited it from his teacher, Rimsky-Korsakov," and gave a single example, drawn—inevitably—from *Sadko*, the one piece Messiaen had cited long ago.[31]

Van den Toorn saw no reason to investigate the case any further, except unwittingly: Messiaen not having specified the *Sadko* to which he was referring, Van den Toorn took his example from the opera of 1897 rather than the symphonic poem of 1867, the piece Messiaen must surely have had in mind, since that is the piece Rimsky-Korsakov himself had named in his memoirs. Had he noticed his apparent error, Van den Toorn would have realized that he had documented Rimsky-Korsakov's involvement with the scale over a period of thirty years, and this might have deterred him from claiming that Rimsky-Korsakov's involvement with the octatonic collection amounted to nothing more than "brief and scattered passages," or that it was for Rimsky-Korsakov "never more than a colorful 'device.'"[32] The only Anglophone writer as of the early 1980s who was moved to look further into Rimsky-Korsakov's work for possible links to Stravinsky was the American composer Robert Moevs (1920–2007), a pupil of Walter Piston and Nadia Boulanger, who perused Rimsky-Korsakov's orchestration textbook (in which all the examples were drawn from Rimsky's own works) and came up with a number of very intriguing specimens, which he cited in a review of Allen Forte's monograph on *Le sacre du printemps*.[33]

Moevs may have been somewhat carried away when he claimed that "perhaps ninety percent of *[Le sacre]* can be referred directly to a matrix of alternate half and whole-tone steps," although any such evaluation depends on what one means by "referred," or by "directly," or by "matrix." His claim certainly stimulated my exertions, though, as, with mounting excitement, I went about the task of uncovering the missing evidence I was sure Berger, Van den Toorn, and the rest would welcome as to the origins and evolution of the octatonic scale and its attendant usages on the way from Schubert (as I eventually discovered) to Stravinsky. My sense of mission was much boosted by the prospect that they would find as much encouragement as I had found in the happy convergence of inferential and historical investigations on a single technical perspective. A sturdy bridge between history and theory was under construction, and I was thrilled to be among its architects.

I won't give a recital here of all the wonderful things I found. I have published my findings at length—very great length indeed—both in my Stravinsky mono-

graph and in the preliminary article that, after substantial revision, became the monograph's fourth chapter.[34] Let it suffice for now to describe the nature of the evidence I found: (1) that both the whole-tone scale and the octatonic scale were outgrowths of Romantic experimentation with mediant cycles (the whole-tone scale arising as a descending bass out of sequential extensions of the flat submediant progression into a closed circle of major thirds, with the octatonic scale arising by analogy out of descents by minor thirds, both usages documented in the work of Schubert who is provisionally credited with their invention); (2) that the composer who most enthusiastically pursued the implications of Schubert's example was Liszt, especially in his symphonic poems and programmatic symphonies, but also in concertos and piano pieces; (3) that Rimsky-Korsakov—who, as he admitted, first encountered the octatonic scale in Liszt (as he had first encountered the whole-tone scale in Glinka)—was driven by a spirit of positivistic inquiry into further investigations involving many new partitions and deductions from both scales; and (4) that Rimsky-Korsakov had imparted these discoveries as *Gebrauchs*-formulas to all his pupils. My original article only cited Stravinsky's opus 1 and opus 2 (the Symphony in E-flat and the orchestral song cycle *Faun and Shepherdess*), but set them in a context of common practice alongside works not only by Rimsky-Korsakov (with examples from eight compositions, plus sketches) but also by Glazunov, Lyadov, Nikolai Cherepnin, and Shteynberg. The subsequent chapters in the monograph emphasized the many imaginative and inventive changes Stravinsky continued to ring on the octatonic *Gebrauchs*-formulas he had inherited from Rimsky-Korsakov to the end of his so-called Russian period; and Van den Toorn's book continued the story to the end of Stravinsky's career. What a fabulous joint enterprise we had managed to achieve, I thought. Surely this was an advance in Stravinsky studies in which all who participated would take pride, and it might assist in the long-desired (at least by me) dissolution of the artificial walls dividing the domain of musicology into historical and theoretical wings.

An education awaited me, beginning with the response of my comrade-in-arms, Pieter van den Toorn. Already in his monograph he had shown signs of squeamishness, or at the very least a peculiar eagerness to distance Stravinsky's octatonic ways from those of his teacher. As a result of our correspondence, which had begun immediately after I had discovered his article and written in feverish enthusiasm about the convergence of our differently motivated research, he knew some of the examples I would adduce in my as yet unpublished work, and cited an example I had found that showed Rimsky-Korsakov to have been, in Van den Toorn's words, "conscious of the octatonic collection as a cohesive frame reference" and to have "followed through with its full (0, 3, 6, 9) symmetrically defined potential *unimpaired*." (What this meant was that Rimsky-Korsakov had written music that deployed without interference or intermixture the full cycle of minor-third triadic transpositions that an octatonic collection could provide.) "But," Van

EXAMPLE 4.4. Unadvertised *"Petrushka* chord" as it appears in Igor Strawinsky *[sic]*, *L'Oiseau [sic] de feu*, Partition de piano (Mainz: Schott, n.d.), 6 (top system).

den Toorn hastened to insist, "Rimsky did not superimpose; nor did he juxtapose or oscillate back and forth accordionlike *à la Stravinsky*."[35] In other words, the bold usages—beginning with the *Petrushka*-chord, which marked Stravinsky as a modernist giant—were beyond Rimsky-Korsakov's imagining, and this unbridgeable gap relieved Stravinsky of any embarrassing burden of debt to his teacher.

But as I've already hinted, it turned out that Rimsky-Korsakov had bridged the unbridgeable gap. In sketches he had made, shortly before his death, for *Heaven and Earth (Zemlya i nebo)*, a projected opera on a subject borrowed from an unfinished play by Lord Byron, Rimsky-Korsakov had superimposed tritone-related triads exactly as Stravinsky would do in *Petrushka*. (I have already shown that sketch in example 4.3; let me also note parenthetically that, even without this precedent in Rimsky-Korsakov's work, Stravinsky's *Petrushka*-chord would not have been a first. There are similar superimpositions in Strauss's *Elektra* [1908] and in Ravel's *Jeux d'eau*, composed as early as 1901. There is even an unheralded and mostly unnoticed *Petrushka*-chord in the twelfth measure of the Introduction to Stravinsky's own *Firebird* of 1910—and as long as Stravinsky saw fit to chide his teacher for his "flimsy enharmonic devices," have a look at how that chord is spelled [ex. 4.4].)

As I've said, I first became aware of Rimsky-Korsakov's sketches for *Zemlya i nebo* when I encountered them in his published sketchbook.[36] Stravinsky encountered them much earlier, because Maximilian Shteynberg incorporated them into his *Prélude symphonique*, op. 7, in memory of Rimsky-Korsakov, which was performed at a memorial concert that Stravinsky attended along with the rest of Rimsky-Korsakov's surviving pupils (ex. 4.5).

To repeat: there is nothing in Stravinsky up to the time of *Petrushka*, insofar as technique is concerned, that is not also in Rimsky-Korsakov (and many unacknowledged borrowings besides). Van den Toorn briefly took this idea on board. In his Berkeley doctoral dissertation of 1985, published two years later as *Stravinsky and "The Rite of Spring": The Beginnings of a Musical Language*, he cited Shteynberg's *Prélude*, with its amazing quotations, and admitted that "the technique of superimposition, however closely identified with Stravinsky's music, is by no means without precedent." He concluded that "without question, the octatonic vocabu-

EXAMPLE 4.5. Maximilian Steinberg [sic], *Prélude symphonique*, op. 7, Klavierauszug (Leipzig: M. P. Belaïeff, 1909), mm. 100–102.

lary of Rimsky and his school, however radically transformed by techniques of superimposition and by [Stravinsky's] rhythmic-metric innovations . . . , remains a fundamental part of the harmonic and melodic design of *The Rite*."[37] This comradely agreement was short-lived as music theorists mobilized in resistance to the historical contextualization of Stravinsky's achievement.

IV

Van den Toorn quickly joined them, returning to his earlier false conclusion about Stravinsky's relationship to Rimsky-Korsakov and turning it into a dogma. In 1987 he wrote that, with respect to Stravinsky's inheritance from his teacher, "I must confess . . . that my own hearing and understanding of Stravinsky's octatonicism remains unaffected by these disclosures. This is possibly because the weight of the octatonic evidence in his early music is already so conclusive. Beginning with pieces such as *Zvezdolikii* and *The Rite of Spring*, octatonic construction, by way of techniques of superimposition and rhythmic displacement, takes on a radically different complexion. The passages by Liszt and Rimsky seem tame and remote in comparison, as if conceived in a different age."[38]

Why "as if"? They *were* conceived in a different age. But Van den Toorn was no longer willing to allow the connections between the two ages to affect his "hearing and understanding." Or rather, he allowed it, but only in one direction: "While it is unlikely," he continued, "that the music of Liszt and Rimsky can shed much light on Stravinsky, a study of the latter's octatonic practices could well . . . spur an interest in Liszt and Rimsky." The reason, as he goes on to relate, is that "we are

interested, above all, in what it is that distinguishes the music of Stravinsky from that of [other composers] and in what distinguishes individual compositions."[39] Too much comparison, he implies, can compromise that distinction. Seeing what Stravinsky has in common with others (or—for another example of knowledge better shed than sought—what Stravinsky may have appropriated from genuine folklore) is according to Van den Toorn uninformative. But I cannot really believe he believes that. Rather, I think he means that the information thus obtained is unwelcome in that it somehow diminishes Stravinsky. By the year 2000 he was ready to endorse the contention of Chilean-American composer Claudio Spies, whose analytical studies of Stravinsky's late serial music strongly assert its status as the crowning phase of his career, that "Rimsky's music [was] too uninteresting ... to have served even the young Stravinsky as an important source of ideas and techniques."[40] Denying what he had formerly acknowledged, Van den Toorn reasserted his erroneous contention that Rimsky-Korsakov had stopped short of the *superimpositions* that distinguished Stravinsky's octatonic usages. Reaching back to his monograph of 1983 (thus bypassing his admissions of 1985–87), he once again insisted that

> in *Petrushka*'s second tableau, the tritone-related triads ... no longer succeed one another (as they do, harmlessly, in Rimsky's *Sadko* or *The Firebird*). They are now imposed *simultaneously*. And the "bite" of this invention, from which the most startling implications were to accrue in pitch organization (and, as a consequence, in melodic, formal, instrumental, and rhythmic-metric design as well), opens up a new universe, a new dimension in octatonic thought, one that Stravinsky was to render peculiarly his own. The distance separating Rimsky's passage [in *Sadko*] from *Petrushka* suddenly becomes enormous.[41]

Why did Van den Toorn now affect to forget what he had formerly acknowledged? The answer seems to lie in a panicked reaction following a reading of Steven Baur's article "Ravel's 'Russian' Period: Octatonicism in His Early Works, 1893–1908,"[42] which summarized the work of Berger, Taruskin, and Van den Toorn himself, to which Van den Toorn now responded with a (to me) shockingly dismissive rhetorical question: "What do we really gain by Russianizing Stravinsky to the bone?" Along with the person and music of Rimsky-Korsakov, all sense of place must now be cleansed from our "hearing and understanding" of Stravinsky. And all sense of time as well, for Van den Toorn's next question was "What do we gain by pushing that much more of his music into the nineteenth century?" His answers were very suggestive: "I for one see little advantage in joining even Russian-period works such as *The Rite of Spring* (1913), *Les Noces* (1917–23), and *The Soldier's Tale* (1918) with Rimsky-Korsakov's operas and symphonic poems. The musical sense of one of these repertories has too little to do with the other. And, apart from the issue of lineage, comparing the octatonicism of these Russian-

period works to that of Rimsky, with the latter used as a foil, yields too little of substance."⁴³

Resistance to Rimsky-Korsakov has opened out into determined resistance to Russia, and Van den Toorn's candid use of the word "advantage" shows the resistance to be of a tactical nature. It is a common attitude, indeed a commonplace one, and would seem to arise out of various traditional prejudices and loyalties. There is, of course, loyalty to the older Stravinsky, who always insisted that "the musicians of my generation and I myself owe the most to Debussy" and, more specifically, that "*Le Sacre* owes more to Debussy than to anyone else except myself," a French modernist master being a preferable creditor, in terms of prestige, to a Russian nationalist.⁴⁴ Proponents of this view have always been hostile toward attempts like mine to demonstrate Stravinsky's prior, far more formative, and (in view of Occam's razor) far likelier debt to his immediate environment. Thus Martin H. Geyer, a professor of history at the University of Munich, who thinks himself well versed in musical as well as political history, dismisses my 1,747 pages on Stravinsky and the Russian traditions with a contemptuous snort:

> That a serious musicologist tries to tell me that, due to a few vague allusions to traditional folk tunes, [*Le sacre du printemps*] is a pure product of the Russian musical tradition. Please! No doubt, it is work of genius, a great dark musical vision, but, conceding that in its spirit it is an "authentic" Russian composition, in its composing strategies it owes Debussy and Ravel much more than any Russian composer. Frankly, I don't understand why Taruskin tries so hard to hide this vital influence on Stravinsky in this book. Though Stravinsky emancipated [himself] from these influences in later years, the impact on his early ballet music was tremendous. And Stravinsky was the last one to deny it.⁴⁵

Indeed—as I've been saying, he insisted on it. But why should Stravinsky's testimony be accorded such credence? Normal scholarly procedure, founded on empirical skepticism, treats (and tests) all testimony alike (as it is treated, at least in theory, in court) through interrogation and contextualization, with due attention to interests and motives. (A moment's reflection will suffice to raise *a priori* doubts against the veracity of anyone's memoirs, it being safe to assume that the chief motivation for writing memoirs in the first place is self-interest; or, to put it the way I like to put it in the seminar room, the only reason to write a memoir is to lie.) But composers who have written memoirs are often treated by musicologists, and even more often by music theorists, as oracles rather than witnesses. Van den Toorn angrily decries the "relentlessly trigger-happy approach when confronting Stravinsky and his published conversations."⁴⁶ Another music theorist, Kofi Agawu, registered an implicit objection to all attempts at contextualizing Stravinsky by complaining that to "claim that the extensive use of the octatonic scale indexes a Russian compositional sensibility" is not only inconclusive, but may also "have the effect of depriving Stravinsky

of what might be called his hard-won cosmopolitanism."[47] This is what is known in America as playing the victim card.

But telling scholars to back off in favor of respecting the right of self-description or self-determination, while of ethical weight when dealing with living informants, particularly those in positions of "subaltern" economic or social status (and therefore with good reason a lively and cogent issue in contemporary ethnomusicology), seems merely subscholarly or anti-intellectual when transferred to the realm of history. In Agawu's case the transfer from the one domain to the other is especially easy to deduce since he works in both domains, having done ethnomusicological research in West Africa and music-theoretical work on European music while living in England and America. The invocation of ethnomusicological restraint seems in the case of Stravinsky to be an excuse to impose one's own preferences by identifying them with the composer.

So phobic have some writers become about Stravinsky's debt to his Russian heritage that they have sought for him, as if answering Agawu's call, an alternative route to the octatonic scale. Such a route has actually been proposed by Sylvia Kahan in her recent monograph *In Search of New Scales*, a study of a man she identifies in her subtitle as "Prince Edmond de Polignac, Octatonic Explorer." This book has made a minor sensation in American music-theory circles, for it reveals the existence of a French theorist of octatonicism, completely independent of Rimsky-Korsakov's example or that of any Russian. The Prince de Polignac (1834–1901), a French aristocrat and patron and an amateur composer, began experimenting with the scale of alternating tones and semitones in the 1870s, and wrote a treatise on it in 1879, a year before Rimsky-Korsakov published the first edition of his harmony textbook with its proto-octatonic "false progressions." Polignac's music, while occasionally performed, was never published, and the treatise remained entirely unknown until after its author's death.

Late in life, the impoverished prince made a marriage of convenience with Winnaretta Singer, the heiress to an American sewing machine fortune, who became his third wife in 1893. She outlived him by forty-two years, and in the 1920s and '30s became an important Parisian arts patron with a special interest in music, commissioning for her salon works by Erik Satie, Manuel de Falla, members of Les Six, and of course Stravinsky. This nexus allows some gratifying speculations. "It is tantalizing to imagine that Winnaretta discussed her husband's 'chromatico-diatonic' scales with the brilliant young Russian," Kahan writes (though under no illusions that Stravinsky would have learned anything new, having by then written nearly all the music now identified as belonging to his "Russian" period).[48] Nevertheless, it has enabled some of us to imagine that if a dilettante like Edmond de Polignac could have found his way to the octatonic scale without assistance from Rimsky or Russia, then so could a genius like Stravinsky. At the least, it has rid the octatonic scale, in the minds of the reluctant, from any necessary taint of Russia.

But once you start foreclosing areas of research in the name of one's prejudices, one's own preserves are inevitably placed in jeopardy. Van den Toorn has learned this the hard way. It was only a matter of time before those who sought to save Stravinsky from Rimsky-Korsakov, thence from Russia, would also seek to save him from the octatonic scale despite Berger's and Van den Toorn's voluminous demonstrations. Dmitri Tymoczko has mounted the most vigorous challenge along these lines, arguing that many passages in Stravinsky that are referable to the octatonic scale may also be referred to other scales (including the whole-tone scale, the ascending melodic minor, and the harmonic minor), singly or in various combinations; and, conversely, that superimpositions like the *Petrushka*-chord, while referable to the octatonic scale, are not necessarily therefore derived from that scale.[49] The contradictory aspect of the argument—at times invoking, at times refuting the principle of referability—is symptomatic of its opportunism.[50]

But arguments based solely on "referability" are silly arguments. The octatonic scale, as we know, may be parsed into four triads (either major or minor), four dominant seventh chords, four minor seventh chords, four half-diminished seventh chords, two diminished seventh chords, two French-sixth chords, and so on. This means that any composition by Mozart or Haydn, the occasional augmented triad apart, could be given an octatonic "analysis," as could any composition by Bach or Handel, Wagner or Brahms, even Monteverdi or Josquin des Prez.[51] Why are they not given such analyses? Because we all recognize that there is no connection between octatonic theory and what Fred Lerdahl would call "the compositional grammars" of these composers.[52] Whether we wish it or not, or admit it or not, that is an historical determination, not an inferential one. Anyone who undertakes octatonic analyses based on referability alone without establishing historical connections is condemned to inconsequence. The sheerest examples have been studies by Allen Forte, who refers three- or even two-note segments extracted from Debussy or even Webern to this or that octatonic scale as if any piece by any composer could not yield equally valid results under pressure of such a procedure.[53]

Tymoczko's resistance is less a matter of rescuing Stravinsky from Russia than an attempt to establish (or restore) a different image of the composer—"as [a] pluralist, a *bricoleur* who used a variety of materials possessing no systematic unity"—positing an eclectic compositional technique so as to justify a similarly eclectic analytical technique.[54] The chief tactical gain, on this view, is the removal of any historical constraint that might limit anyone's analytical approach, keeping the game open to all players. According to Tymoczko, to portray Stravinsky as preoccupied with the octatonic scale imprisons him in a conceptual cage, falsely depicting him as "a systematic rationalist, exploring with Schoenbergian rigor the implications of a single musical idea."[55] Whether that is even a fair description of Schoenberg is not my present concern; but clearly, by Tymoczko's lights

historical descriptions of Stravinsky's heritage are not merely dubious but wickedly confining. Like Agawu, Tymoczko is out to liberate him from the clutches of historians, which means, first of all, liberating him from the clutches of Rimsky-Korsakov.

V

These objections, as I say, are commonplace in the academy, where turf is always at issue. The weight of historical evidence is regarded by many analysts as oppressive, and historians as intellectual tyrants, in response to perceived imbalances of institutional power. Arnold Whittall put the thought as diplomatically as he could at the end of his review of my study, *Stravinsky and the Russian Traditions*, but the issue he raises is indeed contentious. Indeed, it is the principal issue dividing musicologists who identify themselves as historians from musicologists who identify themselves as theorists, and one that demands a serious response of a sort that is coming now not only from historians, but also from the younger generation of theorists, who are perhaps less burdened with the need to shore up disciplinary walls. Whittall cites an enthusiastic comment by Stephen Walsh, the author of a magnificently detailed recent biography of Stravinsky, who in an earlier study of Stravinsky's music found in the *Symphony in Three Movements* (1946) "a miraculous balancing act between the implied continuities of classical tonality and gesture and the architectural non-continuities with which Stravinsky had worked in his Russian period."[56] "It may be," Whittall wrote, "that we get too little sense of that 'miraculous balancing act' from Taruskin's ... narrative of the absorption of traditions, since their transformation—their role in a Stravinskianism that is multifarious, beyond allegiance to any single strain, national, cultural, or aesthetic—is not the topic that concerns him. With an impassioned advocacy embodying his principled commitment to the task in hand, Taruskin may appear to rush to judgment on issues fraught with the kind of tensions that tempt other musicologists to leave them endlessly open to alternative interpretations."[57]

A book of nearly 1,800 pages seems a mighty slow rush, but it is the judgment, not the rush, to which Whittall is offering his courteous objections. It is closure that, like Tymoczko, he chiefly fears. Less diplomatic was Allen Forte's response to the same historical judgment and its implied challenge to what I called Forte's "phenomenological virginity," the stance that impelled Forte's search for a method of maximum conceptual neutrality (he calls it objectivity) and abstraction, eventually laid out in his influential manual of 1973, *The Structure of Atonal Music*.[58] In response to my suggestion that his method lacked a criterion of relevance to justify its procedures or its findings, and that historical contextualization might help analysts arrive at such a criterion, Forte put forth a remarkably categorical dissent from what he called my "extreme historicism." It is worth quoting at some length

for its forthright crystallization of the issues that have motivated this essay, and that I intend to ponder in conclusion. "A knowledge of history," Forte declared,

> is totally inadequate for understanding musical documents, including musical scores as well as treatises on music. It is only now, with the development of contemporary modes of theoretical thought, that scholars are beginning to understand more fully many of the classic documents of music theory. And, in the case of modern music, such as the modern music of Stravinsky's "Russian" period, we see the corresponding development of analytical modes, which certainly are not dependent in any sense upon historicism in its most extreme form. . . .
>
> If history were "self-contained" there would be little, if any, music theory or analysis—or for that matter, real musicology. Each epoch would carry with it its own cultural kit: the total of information required to understand its music, including the cultural background of that music. As I write this I am aware of the fact that an older school of musicologists took exactly that position, a position that, in my opinion and in my personal experience, proved detrimental to the development of new modes of thought.
>
> To repeat, in my opinion, extreme historicism is potentially negative in its effect upon music theory and analysis. If I were to approach the study of a new repertory of music, one quite unfamiliar to me, I would adopt as an epistemusicological strategy a stance of "phenomenological virginity," as Taruskin wittily puts it, not merely because virginity of any kind is such a rare commodity these days, but because it is often the best way to start out. The *tabula rasa* has not yet outlived its usefulness, just because it still offers, insofar as possible, a clean slate upon which to draft new ideas.[59]

But is Stravinsky's music really "a new repertory of music, one quite unfamiliar"? Does anyone really imagine that we can achieve the full possession of knowledge of any epoch's "cultural kit," even our own? And is Forte's method, despite its abstraction and purported objectivity, really a *tabula rasa,* or—like any other method—does it come with its own cultural kit in the form of philosophical commitments that have their own historical context? What Forte's declaration succeeds in declaring is that the actual achievement of dehistoricizing analysts is not the rescue of composers from historians, but rather the rescue of scores from composers. He makes it clear that his interest lies not in Stravinsky's composing but in the composition—the musical document. The detachment of the work from the author has a considerable history, and an honorable one, in criticism. It is the basis of the so-called intentional fallacy, and it has borne nutritious fruit in literary studies—and in musical ones, too, insofar as it has discouraged, for example, reductive biographical interpretations. But Forte—and here he speaks for a consensus among music analysts today—wants to go further. He wants to approach musical documents as if they were natural objects like rocks or ferns or coelacanths or subatomic particles—God's creations. But of course they are not God's creations; they are creations of God's creatures, who since the expulsion from the

Garden of Eden have lived in history. Their creations are not only products of history but also products of culture, coded with human values, expressive of human volition, agents of human communication, individually as well as in the aggregate.

Thus, the debate between theorists and historians, when conducted on such categorical terms, actually becomes a debate between creationists and evolutionists. What evolutionists like me hope to achieve by means of analysis is not merely a taxonomy of musical configurations (misrepresented as "structure"), as one might dissect a fern or a coelacanth, but insight into practice—methods, routines, *Gebrauchs-formulas*, devices of composition, including flimsy enharmonic ones. In the case of Stravinsky, Rimsky-Korsakov (love him or hate him) offers an indispensable source of information to evolutionists, and the impulse to ignore him, which often disguises itself as lofty disdain, is in fact the horror of creationists at the prospect that the cultural artifacts they worship bear traces of evolutionary history, and that it is precisely in those traces that actual musical meaning—whatever it is that music communicates to its hearers—can be identified. The resistance to Rimsky and Russia as factors in Stravinsky's musical patrimony seems to me to be of a piece with the resistance of creationists to the prospect that mankind may have descended from lower primates, or that the species *Homo sapiens* may have originated in Africa.

Stravinsky did his best to aid and abet the creationist view of his own work. Most of us can probably recite by heart the concluding words of his eightieth-birthday-year memoir of *Le sacre du printemps*: "I was guided by no system whatever in *Le Sacre du printemps*. When I think of the other composers of that time who interest me [i.e., the composers of the 'Second Viennese School'], how much more theoretical their music seems than *Le Sacre*; and these composers were supported by a great tradition, whereas very little immediate tradition lies behind *Le Sacre du printemps*. I had only my ear to help me. I heard and I wrote what I heard. I am the vessel through which *Le Sacre* passed."[60]

What historian would not take that as a challenge? The fact that for such a long time no one rose to it probably has to do with the political and linguistic consequences of Russia's twentieth-century isolation, but it also has to do with the perverse ideology I am in the process of describing. Who could really believe now that Stravinsky had no theoretical assumptions or common practice to guide him as he wrote his masterpiece? The same ones, no doubt, who still believe what Stravinsky told a Paris journalist in 1920—that *Le sacre* was, despite its scenario and its well-known creative history, *un oeuvre architectonique et non anecdotique*, and that it was in essence a piece of abstract symphonic music.[61] In music as in cosmology, creationism is a doctrine of faith, professed by those who are committed to believing what is unbelievable, and who declare with Tertullian, *Credo quia absurdum*—"I believe because it is absurd."[62] In religion, the remark makes perfect sense. We do not need faith to believe that of which sense and reason persuade us. Our faith is tested by what reason rejects.

Does such faith have a place in scholarship? Not unless we wish to change the definition of our calling, which has traditionally been the precious redoubt of *skepsis*, productive doubt. It is only doubt that induces the itch to acquire knowledge. When I read Tymoczko, Whittall, or Forte I am taken back to my earliest impressions of Stravinsky, whose music seemed to me, when I first encountered it in my early teens, to be utterly different from all other music, hence the most perfectly original music ever. How, I wondered, could a composer create such a powerful new style absolutely from scratch? But even by the time I first read to myself the famous words of Stravinsky's that I have just quoted, I knew they could not be true, although I could not then counter them. That is what set me on the course that produced my monograph, why I felt such joy on reading Berger and Van den Toorn, why I found Yastrebtsev's diary of his days with Rimsky-Korsakov so thrilling, and why I found myself so disgusted on reading Forte's book-length treatment of *Le sacre* that I took it as a mission to discredit his approach, which as I saw it was an elaborate ploy to forestall informative investigation and perpetuate the *absurdum* of creationism.

VI

Thus I suggest that at the end of this paper we are closing in on what I would propose as a theory of theory: that is, a criterion, or a set of criteria, for what makes music theory and its analytical toolkit culturally relevant and potentially illuminating. In his typically pithy and reflective little treatise, *Analyse und Werturteil* (1970), Carl Dahlhaus distinguished in his wonted binary way between analysis that uncovers technique of composition and analysis that uncovers form.[63] He asserts no preference between them, but I have no hesitation in declaring my preference for the former, which describes a real historical act rather than a fiction produced by a set of premises that only become "real" when historically contextualized. Only what is historically real can be said to be uncovered. The fictive is not uncovered but constructed. It has no reality beyond the historical conditions that give rise to its premises—and which can be uncovered by means of historical research. To conceive of form—or of harmonic functions, or of coherence based on the recurrence of pitch-class sets—as something "real" that analysis "uncovers" is to adopt an uncritical attitude toward premises scholars should be interrogating. To insist on the objective reality of cultural fictions is to engage in propaganda. Are these the words of a tyrant? No, they are merely the words of a confirmed evolutionist.

There are signs that music theorists are becoming aware of the pitfalls of creationism and acting on that awareness. I take particular encouragement from Robert O. Gjerdingen's recent treatise, *Music in the Galant Style,* whose subtitle, delightfully emulating the style it treats, identifies it as "An Essay on Various

Schemata Characteristic of Eighteenth-Century Music for Courtly Chambers, Chapels, and Theaters, Including Tasteful Passages of Music Drawn from Most Excellent Chapel Masters in the Employ of Noble and Noteworthy Personages, Said Music All Collected for the Reader's Delectation on the World Wide Web."[64] Gjerdingen's study is a rich combination of what used to be called style criticism and history. It takes style to be not an idea or an entity, hence not something to be objectified, but rather a set of communicative behaviors, and investigates the manner in which such behavior is imparted and assimilated. Its basic premise is that Bach was not born Bach nor Mozart Mozart. Rather, Bach learned to be Bach and Mozart learned to be Mozart, as all composers learn their trade, and the chief instrument is example. It is thus primarily a book about pedagogy, and it has contributed a new term to the active theoretical and critical vocabulary of academic musicians: *partimento*, basically a thoroughbass exercise, or, more particularly, an "instructional bass from which an apprentice was expected to re-create complete compositions at the keyboard," as Gjerdingen has defined it.[65] It is the sort of exercise composers learned from as long as textbooks were written to instruct composers in current, as opposed to obsolete or *stile antico*, idioms, and what one learns from such exercises are what Gjerdingen calls *schemata*, which are nothing other than what Lazare Saminsky called *Gebrauchs*-formulas. One of the latest textbooks to use exercises of this kind to instruct composers in current practices was Rimsky-Korsakov's, where I found the exercises—the latter-day *partimenti*—from which the pupils at the St. Petersburg Conservatory, as well as Stravinsky, studying *extra muros*, educed the octatonic scale—not as a concept, but as the outcome or resultant of a set of procedures. Stravinsky learned to be Stravinsky the way Mozart learned to be Mozart—just as every mediocrity of Stravinsky's or Mozart's time learned to be mediocrities. The difference between the genius and the mediocrity was a difference in the excellence and the resource with which they applied the principles of their common patrimony and built upon it. Studying the common patrimony at its source, Gjerdingen implies (and of course I enthusiastically agree), is the way one apprehends the ground from which unique genius sprouts, and provides the yardstick by which one can take its measure *sans mystique*.

Why *sans mystique*? Because Gjerdingen's mode of analysis explicates not "how the music works," but how composers worked. Real historical agents in the act. That is how I sought to portray Stravinsky, and before Stravinsky, how I sought to portray his teacher. Gjerdingen's emphasis on practical instruction is utterly in the spirit of Rimsky-Korsakov, who, when asked by Yastrebtsev the name of a strange chord in the second act of *Le coq d'or*, said, "I actually don't know what sort of chord this is exactly; I only know that it has three resolutions: to F minor, to C-sharp minor, and to A minor."[66] Anyone familiar with Rimsky-Korsakov's *Gebrauchs*-formulas will know from this that the chord was a whole-tone chord. But merely naming it tells you nothing. Giving names (labeling chords, numbering pitch-class sets) is the way

of *mystique*. It is an exorcism rather than an explanation of the new. For Rimsky-Korsakov, the whole-tone scale was not a thing but a set of procedures, and so was the octatonic scale. Anyone who knows Stravinsky's music in context knows that Stravinsky thought the same way about theoretical concepts. For him, as for Rimsky, *znat'* meant *umet'*: to know was to know how; knowledge was know-how. This was not the attitude of a *bricoleur*. Nor was it that of a systematic rationalist. Tymoczko confronts us with a false dichotomy and demands that we choose. But as with most creative artists, at least the ones who matter, Stravinsky's attitude was that of a professional, deploying a magnificently mastered technique, or set of techniques.

Another theorist whose work encourages me is Lawrence Zbikowski, whose treatise *Conceptualizing Music: Cognitive Structure, Theory, and Analysis* comes at music from the other side: from the side of the conceptualizing listener rather than the practicing composer.[67] But the listener Zbikowski studies, like the composer Gjerdingen studies, is a real historical agent—or perhaps in this case I should say an historical patient. Zbikowski's book, like Gjerdingen's, is an implied protest against a music theory—the kind I call creationist, which Zbikowski describes as "built on quicksand"—that describes as phenomena, or observable facts, *a posteriori* constructs that are part neither of the composer's conceptualization nor of the listener's.[68] Such concepts include the Schenkerian Ursatz, the Fortean set complex, and other such premises that purport to model "how the music works." Zbikowski wants to investigate how the music works *on listeners*, which means, how musicians work on listeners. And there is the meeting point between his approach and Gjerdingen's. Gjerdingen explores the behaviors that together create compositional style; but his working assumption, and the motivation for his project, is that composerly behaviors are meant to elicit behaviors on the part of the listener, as stimulus begets a response.

To put it in terms of the once-fashionable tripartition that Jean-Jacques Nattiez imported from linguistics to musicology, Gjerdingen's and Zbikowski's work together seek, from their opposing vantage points, to put the *poietic* (the maker's perspective) directly in contact with the *esthesic* (the receiver's perspective), bypassing (hence eliminating) the so-called neutral level—that of "the message (or the music) itself"—that for far too long has preoccupied the theory of music. That level is the fictive one, the standpoint of the omniscient observer—God's standpoint. Zbikowski's work, like Gjerdingen's, returns music theory to the arena of human transactions, to what Zbikowski calls "the cultural or historical context for musical utterances, or the complex networks of social interaction that give rise to musical behavior."[69]

It is no accident, of course, that both Gjerdingen and Zbikowski have taken inspiration (Gjerdingen through formal study, Zbikowski informally) from the work of Leonard B. Meyer (1918–2007), the great pragmatic exception among the founders of American music theory, who based his music-theoretical ideas on

messy psychological premises rather than tidy mathematical systems, and who never lost sight of real worlds—the phenomenal world, the social world—and the place of music within them. The emphasis that his pupils and disciples are placing on pedagogy and social transaction does him honor, and may yet rescue music theory from the creationists.

And that is why I have seen an opportunity here, and why I have taken my discussion so seemingly far afield from our beloved Nikolai Andreyevich. For nowhere is the creationist bias in contemporary music theory and academic criticism more glaringly evident than in the desperate ambivalence with which so many writers have treated the news about Stravinsky's octatonicism; and the only way to explain it—at least, the only way I can hope to explain it—is in the way the octatonic has, in the wake of Berger and Van den Toorn, but far more explicitly in the wake of my own avowedly evolutionist research, become a metonym for the threatening shade of Rimsky-Korsakov. We have seen how Van den Toorn reacted to the threat, suppressing the memory of Rimsky-Korsakov's octatonic superimpositions, retreating to a superseded stance of nescience in an effort to preserve the pristine originality of Stravinsky's mature style and its independence of all tradition. But as the new denial of Rimsky-Korsakov's octatonic superimpositions can no longer betoken ignorance of them, it must portend a dogmatic rejection. Eventually every party to the line of inferential research that first gave evidence of the tradition to which Stravinsky was heir has moved toward recantation, and I use that word in full consciousness of its Galilean and Inquisitorial ring. It is the price that disciplinary purity always exacts from communicants.

My closing exhibit is at once amusing and bemusing. Reviewing my monograph in the *Times Literary Supplement* shortly after its publication in 1996, Robert Craft remarked that my disclosure of the extent of Stravinsky's debt to his teacher had "greatly and permanently magnified" Rimsky-Korsakov's historical stature.[70] Five months later, as he reports in his autobiography, Craft lectured about Stravinsky at the New England Conservatory. "On entering the room," he writes, "I recognized three old friends in the second row: the composers Arthur Berger, Leon Kirchner and Harold Shapero." During the symposium that followed the lecture, as Craft recalled, "I remarked that I found the vogue of octatonic analysis tiresome," whereupon "Arthur [Berger], the acknowledged discoverer of Stravinsky's use of the device, chimed in with 'So do I. I wish I had never mentioned it.'"[71]

This is a dispiriting way to come full circle, but I think it shows better than anything I could possibly say on his behalf how and why Rimsky-Korsakov's historical stature has been enhanced. He now stands for everything that musicology in the German Romantic tradition has tried to ward off. By now it is a losing battle, and that is what chiefly accounts for its stridency. Arthur Berger, having found a key to a new room in the mansion of music theory, opened the door, took fright at what he saw lurking within, and, like Bluebeard's bride, tried to lock it up again.

But the spirit of Rimsky-Korsakov had escaped its confinement and gone out into the world. By now the impact of Rimsky's work not only on Stravinsky, and not only on Scriabin, and not only on Ravel (gratefully recognized, for once, bless him), but also as a link in the chain from Liszt to Bartók, is widely, perhaps universally, acknowledged by evolutionists, and it has permanently troubled the sleep of creationists. All of which merely vindicates his pupil Lazare Saminsky's assertion, made almost eighty years ago, that "to Rimsky-Korsakov alone falls the honor of being the true fountainhead and Alma Mater of the tonal newness that has played so great a part in the tonal reform of the last three decades."[72]

Crediting Rimsky-Korsakov "alone" is of course the usual propaganda—as false when indulged by Russians on behalf of Rimsky-Korsakov as it is when indulged by Germans on behalf of the usual suspects. But so deafening and intimidating has been the roar from the German side, and so thoroughly has the Russian patrimony of twentieth-century music been shouted down outside of Russia, that one can hardly resist the impulse to endorse Saminsky's claim, at least today, at least in St. Petersburg, at least at no. 28, Zagorodnïy Prospect. Here it seems only right, and only fair, to bid the world at last catch up with Rimsky-Korsakov.

POSTSCRIPT, 2015: *DIE ALTEN, BÖSEN LIEDER . . .*

I did not really expect the official organ of the Society for Music Theory to accept this essay for publication, since its subject matter and its viewpoint were pretty far off the Society's beaten path, and not likely to appeal to many of its members. So I was pleasantly surprised that the editor, Severine Neff (then newly on the job), agreed with me that *Music Theory Spectrum* did not always live up to the promise of its name as a forum for diverse opinion, and that a bit of debate might enliven its pages. It didn't hurt, I guess, that Sev and I were old acquaintances. As a result of our overlapping stints as graduate students and junior faculty members at Columbia University in the 1970s and '80s, we had bonded, you might say, in adversity. Unlike some of my interlocutors, then, she did not regard me as an antagonist. My critique of the behavior of some music theorists did not amount, in her eyes, to an attack on the discipline of music theory from an alien and unfriendly perspective, such as was often ascribed to me, but rather as an opportunity for interaction not only between the rival subdisciplines of academic music study but also within the community of theorists, of which she graciously accepted me as a member (and not only because I pay my dues to the Society every year). To egg the dialogue on, she invited several of my *dramatis personae* to comment on my piece, along with a couple of others who were strongly identified with Stravinsky research. In alphabetical order, as printed immediately following my piece in the fall 2011 issue (where interested readers can find them), the responses came from Kofi Agawu, Robert O. Gjerdingen, Marianne Kielian-Gilbert, Lynne Rogers, Dmitri

Tymoczko, Pieter van den Toorn, Arnold Whittall, and Lawrence Zbikowski. In the aggregate they occupied more than twice the space of the article to which they were appended, so I will not try to summarize them all; but they raised some points that do merit some further discussion—and some that don't.

Reading them gave me a warm rush—or more accurately, perhaps, a hot flush—of nostalgia. They took me back a quarter century, to the 1986 national meeting of the American Musicological Society, which took place in Cleveland on November 6–9. That was the site of the first face-off between the serried ranks of theorists and one lone historian (me) on the subject of Stravinsky and "octatonicism." The program committee, headed by Douglas Johnson of Rutgers University, asked several commentators to react as a panel to "Chernomor to Kashchei," the *JAMS* article referenced in note 34, just the way Severine Neff asked for reactions to "Catching Up With Rimsky-Korsakov." One of the reactors, Pieter van den Toorn, was asked both times; the other panelists in 1986 were Allen Forte, Elliott Antokoletz, and Lawrence Gushee. The moderator was Don Randel; the exemplary tact he exhibited at that session was no doubt the reason why he was subsequently appointed president of the University of Chicago.

Reading the 2011 responses with reference to the one article while recalling the 1986 discussion of the other was *déjà vu* all over again. Everyone (with the shining exception of Gjerdingen, as will be seen) was still singing the same bad old songs. Yet, though disappointed, I was not surprised. Intransigence, this time around, was my chief complaint, the virtual subject of the piece, and the responses confirmed it, indeed illustrated it. My essay was an attempt to understand the stalled positions that the new responses continued to exemplify, and so they were welcome insofar as they gave me more material for analysis toward (one hopes) a better understanding.

My flashback went beyond the octatonicism roast at the Cleveland meeting to encompass another session that took place the next day, at which Allen Forte presented a paper called "Liszt's Experimental Music in Contemporary Perspective," of which a version was published the next year in *19th-Centrury Music*, where it may now be easily located and read.[73] Here is the first sentence of its abstract as presented in 1986: "Throughout his creative lifetime Liszt composed two kinds of music: the more normal music with which his public persona is usually associated, and the type of music which I will call 'experimental,' music which was not in accord with the grammatical norms of the time but which established its own rules of progression, continuity, and contrast." And here is the last sentence: "The analytical procedures employed in the paper derive from contemporary reductive methods, the results of which are interpreted with respect to a comprehensive system of pitch relations that is not dependent upon a traditional tonal orientation."[74]

The "comprehensive system" to which the abstract alludes was, of course, Forte's method of pitch-class set tabulation, devised so as to achieve through abstraction a

maximum degree of procedural neutrality. The range of its proper application had given rise to controversy from the start. But the discussion that followed Forte's paper at the Cleveland AMS was short. Kofi Agawu stood up to query one of Forte's examples, namely the opening theme of the *Faust-Symphonie* (the famous series of arpeggiated augmented triads descending by semitones), which Forte had described as "atonal" but which Agawu thought was related, by virtue of its triadic morphology, to the common practice and therefore (although I do not think Agawu used such an artless term) "tonal," if not (to use Forte's even more artless term) "normal." Forte's answer consisted of three words: "We're at loggerheads." End of discussion.

That refusal to engage shocked me at the time. It seemed flagrantly unscholarly; but no one pursued the matter, evidently assuming (no doubt correctly) that there would be no point in doing so; and there were no more questions. Looking back, I would call it a perfect example of what in "Catching Up with Rimsky-Korsakov" I called the creationist position, and it is well adumbrated in Forte's abstract: first, by positing two radically different "kinds of music," albeit composed by the same person, which are then held to be utterly incommensurable (a judgment that can only be made on essentialist assumptions), and second, by declaring that the difference is revealed by the use of an equally radical and incommensurable difference in analytical approach. The decision regarding which approach to employ is taken *a priori*, with the result that the method is entirely circular. (That, I will venture to guess, was the substance of Agawu's objection.) Once taken, the decision becomes a law: Thou shalt not compare; thou shalt not sully the purity of the strains. Thus assumptions and procedures are both insulated from scrutiny.

That is no way to proceed; and that refusal to engage—much more than the ostensible, fairly trifling, topic of dispute—was the real point at issue in my essay. Willingness to engage in debate is, to me, the scholarly *sine qua non*. It is that willingness which differentiates scholarly knowledge from other kinds of knowledge—e.g., knowledge imparted by revelation, or passed on by unchallenged or unchallengeable tradition, or dictated by authority. Knowledge safeguarded by faith or by decree can be certain knowledge. Scholarly knowledge is, and can only be, provisional. What scholars call a fact is only an opinion—that is, something believed. But belief in it is based on cited empirical evidence (things observed) and rational inference, and is subject to challenge, contradiction, and counterexample. Thus a scholarly fact is nothing more than an opinion that is as yet uncontradicted by opinions similarly grounded and rationalized.

While it is an opinion, then, it is not "just" an opinion, no better or worse than any other. It differs in kind from opinions founded on authority or intuition or personal preference. The special status it enjoys within the scholarly discipline is not a mere privilege, but is tantamount to a definition of knowledge within the terms of the discipline, which holds as its most unyielding tenet that its opinions

be in principle refutable. Unless the grounds of its potential refutation are statable within the same terms as its formulation—that is, unless one can state what sort of evidence might refute it—it cannot count as knowledge, only as belief. Refutation—what Karl Popper notoriously called "falsification" to counter the erroneous notion that science is built upon verification—is thus always impending and always to be expected. One must always be prepared to find one's opinions rendered untenable by subsequent discovery or deduction. In fact, if one is being a good little positivist, one looks forward to that happening, because that is the way science and scholarship progress.[75] Most of us admittedly fall short of loving the process of refutation when we are on the receiving end, but we do think it meet and just.

For only that process accounts for the real difference between evolutionism and creationism, and that is why my invoking the latter was inevitably (and intentionally) so provocative. Creationism—not only the actual biblical-fundamentalist variety but also the softer, pseudoscholarly, scare-quoted version I identified with the position of my scholarly adversaries—cannot be reconciled with the practice of any scholarly discipline. Evolutionism is a hypothesis subject to continual testing, while the other is a dogma sanctioned by scripture. Either (or neither) might be correct; we can never know with certainty (and that is why the enemies of science tirelessly remind us that evolution, like creationism, is "just a theory"). The difference between them is not the difference between correct knowledge and incorrect, but between opinions arrived at through observation and inference, and therefore eternally challengeable, and opinions accepted from unchallengeable authority. If we are content humbly to accept authority, we can be content with creationism, and that contentment, many think, is fair compensation for renouncing reason. If we arrogantly insist that knowledge justify itself to our senses and our reasoning faculty, then we will insist on evolutionism, and will never be content. The kicker: "arrogant" evolutionists know that they may be wrong; "humble" creationists are sure that they are right. People who know with certainty that they are right are not open to persuasion. They see no point in engaging in debate, and often think that debate, insofar as it challenges revealed truth, is necessarily maleficent, if not malevolent. When scholars refuse to engage in debate, therefore, they are adopting an essentially religious attitude and in so doing deny the foundation of their (our) profession. For that they deserve rebuke as well as refutation.

Rebuke is usually more effectively delivered when coupled with humor, and that is another reason why I—playfully or mischievously, depending on my readers' various perspectives—invoked the analogy of creationism. As a dogmatic alternative to biological science creationism is proverbially disreputable within the academy, so the epithet was, I admit, belligerent, and potentially insulting, although no one could seriously think I was accusing my opponents of believing in the "inerrancy" (to use the preferred evangelical word) of the Bible's account of

creation.⁷⁶ Nevertheless, I meant the analogy quite seriously as a heuristic parallel, because the scholars whose positions I was caricaturing in this way were indeed purveying dogma disguised as inquiry. That posture is not limited to music theorists, and so I do not necessarily regard the difference between my "creationists" and my "evolutionists" as being one of disciplinary allegiance. It is, more accurately, a difference of attitude and procedure. Practitioners of either kind can and do turn up on either side of the increasingly permeable disciplinary divide. I regret the sally only to the extent that it may have enraged some of my opponents and thus occasionally blinded them to the issues I meant to raise.

Not everyone took offense, however. Two of my interlocutors, including one of my opponents in debate, were sophisticated enough, and secure enough, to see the point of the analogy and were willing to engage with it. To them I offer thanks, and happily exempt them from the critique I am in process of clarifying. Pieter van den Toorn, unafraid of the term and its implications, sought helpfully to define the latter. "My perspective here is 'creationist,'" he frankly averred, albeit "within the framework of the concerns of history or 'evolution.'" My distinction, he went on to elaborate,

> between the currents of creationism in theory and evolutionism in music history (the first of these centered on the individual creation, the second on the communal aspect from the standpoint of a common practice), is, in my view, a question of focus and hence ultimately of degree. I associate the term *creation* with the particular or individual aspects of a given piece, composer, or idiom, *evolution* with the collective from which, in turn, the particular may emerge. Evolutionary processes presuppose the notion of one thing leading to another, with the former often called upon to explain the latter.⁷⁷

Van den Toorn then goes on (properly, in my view) to "question the number of true creationists in our midst, believers, presumably, in compositional or aesthetic vacuums, music composition or creation (or understanding) without a past, present, or anticipated future." I would not insist that musicological creationists exist as a pure strain. I did not mean my use of the term to identify an actual belief so much as a kind of behavior, which does indeed exist and often flourishes, as Van den Toorn goes on to acknowledge—even naming a few names of his own, most prominently Benjamin Boretz, whose *Meta-Variations: Studies in the Foundations of Musical Thought* (first submitted as his Princeton PhD dissertation in 1969, then published serially in *Perspectives of New Music* in 1969–70, and reissued in book form as recently as 1995)⁷⁸ represented in his view the ultimate expression of individualism in musical theorizing. So whereas no one really believes that artifacts exist literally outside of history, Van den Toorn seems to assert, there may be advantage in acting as if they did. It is in that sense that he embraces the mantle of "creationism." Fair enough. Let us judge cases, and performances, on their merits.

Lawrence Zbikowski rather winningly describes creationists as those who "refuse to believe that the exquisite order of the world could be other than it is." That happy pantheistic acceptance of things as they are, he proposes, inhibits the impulse to inquire into the origin and history of things and sets music theorists irrevocably apart from "music historians, [who] by contrast are evolutionists: rather than accepting the exquisite order of the world as a given they struggle to understand both how this order emerged over time and the various forces which shaped that which we now behold."[79] Synchronic description of individual artifacts suffices in order to show, as he puts it, "how the cognitive capacities of humans make possible the creation of uniquely communicative utterances." But I share Pieter van den Toorn's doubts that this happy pantheist really exists in our vale of tears; for Zbikowski immediately paraphrases the thought in a manner that actually contradicts it: "Put another way," he writes, "music theorists have the skills and perspective to address the question of how music, as a product of human beings and human beings only, has come to be organized in the various ways that it has."[80] *Coming to be* is evolution, no?

Van den Toorn offers, from his avowed creationist standpoint, a corrective to the characterization I offered of Stravinsky's esthetic predilections in an essay called "Stravinsky and Us," where I drew parallels between the performance practice that Stravinsky preached (in his *Poetics of Music* and elsewhere) and practiced in his actual performances as preserved in recordings, on the one hand, and, on the other, the right-wing politics of the post–World War I decades, to which he was strongly attracted.[81] I have, Van den Toorn suggests, put the cart before the horse. After a stimulating analysis of a passage from *Renard* (1917), in which a repeated motive is subjected, in Stravinsky's habitual manner, to a variety of ingenious rhythmic-metric displacements, he notes that this characteristic Stravinskian effect, which exerts such a strong attraction on all of us who have been drawn to studying his work, already harbors drastic implications for performance style:

> When repeated, . . . the features of this *Renard* fragment are not embellished, varied, or developed, but are left intact in order that they might serve as a foil for what does change, namely, alignment. Similarly, in performance, if metrical alignment and realignment are to be highlighted, a strict beat is required. Rubato or *espressivo* timing must be kept to a minimum if the point of the invention is to make itself felt.
>
> Stravinsky's strict performance style begins here, in fact *[sic]*, not with philosophy or an "objectivist aesthetic," not as a kind of "dehumanization" or "Modernist" fad, but rather as something springing directly from the invention as a necessary condition thereof. (If anything, these roles should be reversed; far more readily, both the strict style and the composer's formalist esthetics fall into place as effects of the musical processes alluded to above, not as causes or instigators thereof.) No less than with the expressive modifications that may accompany performances of, say, the Beethoven piano sonatas, the drastic reduction in the use of such modifications in performances of Stravinsky's music is *structural* in origin. Just as with the slight

ritardandi and *accelerandi* that can serve to clarify the boundaries of phrases and larger groupings in Beethoven's piano sonatas, the reduction in the use of such devices can help to expose metrical placement and displacement.

In this regard, it is essential that the musical motivation behind the need for a relatively "straight" reading of Stravinsky's music be felt by listeners and performers. By having a *structural* and, by extension, expressive purpose, a crisp, *secco* approach in the articulation of his music can be sustained without forcing listeners, conductors, or performers to imagine themselves victims of a kind of metrical tyranny. The strict beat can be maintained sympathetically, rather than mechanically or submissively.[82]

The last pair of sentences allude to T. W. Adorno's famous claim, in *Philosophie der neuen Musik* (1948), that Stravinsky's regressive esthetics exercised an actual nefarious, literally fascistic, dehumanizing influence on listeners and performers, a stricture that vastly exceeds any claim of mine. Van den Toorn is one of many who have paired me with the gloomy Frankfurter, and offered us a joint corrective. His argument is avowedly creationist in the exact sense described by Zbikowski. It takes Stravinsky's rhythmic strictness as a given, an essential attribute, for which the analyst neither posits nor seeks an origin. It is simply an aspect of "the exquisite order of [Stravinsky's] world." But although it is without an origin, hence not an effect of any cause, it can nevertheless be a cause that produces effects, among which Van den Toorn (apparently unwilling to give up the idea of causality in favor of correlation) counts the politically tinted esthetic attitudes that, according to him, I have wrongly postulated as causes. Van den Toorn's is a serious argument, based on a perceptive hearing of Stravinsky's actual music. Although, like any creationist argument, it holds its truths to be self-evident (as evinced by the charming "in fact," *sic*'d above), it can nevertheless be tested by counterclaims. It can be engaged with; and therefore falls productively, if only willy-nilly, within the purview of what I take to be scholarly discourse.

So let us engage. My first counterclaim entails the universality of the model Van den Toorn asserts. It is of course true that many characteristically Stravinskian textures require, as the passage from *Renard* certainly does, a steady beat for its effective realization. But not all of Stravinsky's music is of this type. The very first performance direction in *Le sacre du printemps,* as it happens, is *Lento, tempo rubato.* Even Renard has passages (e.g. at figs. [16] and [18] in the score) where the voices go through *rallentandi* and *accelerandi* galore, which the conductor and instrumentalists must follow *colla parte.* It is true that rhythmic strictness in Stravinsky becomes more pronounced in his music of the 1920s and after, and his performances also become more regular in the later phases of his career, a process that Robert Fink has meticulously documented in an article provocatively titled "'Rigoroso (♪ = 126)': 'The Rite of Spring' and the Forging of a Modernist Performing Style."[83] In other words, Stravinsky's wonted strictness has a history—

which already calls into question the priority that Van den Toorn asserts for it over the explicitly expressed "interwar" esthetic attitudes. Moreover, when Stravinsky began preaching rhythmic regularity as well as practicing it, he did not prescribe it only for his own music (or that portion of it which seems to demand it according to Van den Toorn's persuasive claim), but prescribed it for—and practiced it in—virtually all music, including music that had never previously been thought hospitable to such an approach. Here the most telling document is Stravinsky's famously (and, in the opinion of many, perversely) unyielding performance, together with his son Soulima, of Mozart's C minor fugue for two pianos, K. 426 (1783).[84] So Stravinsky's performance practice had an origin worth investigating; it was not necessarily (or even probably) a straightforward, unproblematical outgrowth of his compositional habits.

There is no evidence that would suggest, let alone compel, the adoption of a simple, linear cause-and-effect model to account for Stravinsky's esthetic or political attitudes vis-à-vis his compositional praxis, hence no reason to assert one. Neither need be posited as the "cause" of the other. Most historians would reject such a model as inadequate for the explanation of cultural phenomena, which are multiply determined and arise out of a complex dialectic of agency and circumstance. I would rather regard both Stravinsky's compositional praxis and his esthetic attitudes as responses to multiple stimuli, and stimuli in their turn to multiple responses in the work both of Stravinsky and of many others. Causes and effects, in any case, exist in an endless chain. To take the compositional or performance practice as the (or even a) cause of the esthetic stance without seeking its own causes is to take the latter to be a first principle—creationism as the dictionary itself would define it. But if we are dealing with culture rather than nature, such a thing is literally inconceivable. Van den Toorn is showing symptoms of the same object-envy—the same preference for rocks and ferns over artifacts (man-made by definition, and products of the historical flux)—as have the other, less reasonable, creationists whose work I have critiqued. Let us agree to leave the *primum movens* to cosmology.

Nor is there any reason to call Stravinsky's performance practice "structural," as Van den Toorn does twice (signaled by my italics) in the passage extracted above, except that "structural" is a sanctified word, an amulet that removes whatever it modifies from flux and contingency and renders it immanent. The word is so common in our musicological discourse—in music-theoretical discourse above all—that we all need to be reminded now and again that it is a metaphor, as it is in any description of an artwork that occupies time rather than space. We could all do with a fresh look at Lessing.[85] Having looked, we might be inclined to speak of rhetoric rather than structure, which would remind us in turn that the impulse to dichotomize structure and expression, like its sister impulse to dichotomize form and content, is an evasive tactic.

So if, predictably enough, I end by rejecting Van den Toorn's proposition as untenable, it is nevertheless respectable. Its promulgator may not have meant to engage with my evolutionist alternative, but it nevertheless can so engage, quite profitably. It is an argument advanced in good faith, and does not seek to foreclose investigation and discussion. It does not frustrate the way Allen Forte's rebuff frustrated Kofi Agawu that November day in Cleveland so long ago. More is the sorrow, therefore, to report that some of the other responses my essay elicited do refuse engagement, and none more flagrantly than Kofi Agawu's. Mere petulance, as displayed by Tymoczko (whose quibbles did prompt me to introduce a qualification with respect to augmented triads into the text of my essay, for which I thank him) or Whittall (who confined himself to giving me a lesson in etiquette), may be innocuous enough. Agawu's convoluted performance, by contrast, seems as though actually designed to subvert the scholarly endeavor.

He does this by continually, and tacitly, changing the subject in search of straw men to demolish. The fundamental premise of my essay, returned to at its conclusion (where it is framed according to a dichotomy proposed by Dahlhaus),[86] is that while there can be no predicting a given listener's response to a given musical stimulus (and no point trying to rationalize responses by "theorizing" them), matters of compositional practice may be deduced from documents. My claim addresses only the poietic side of the semiological partition, not the esthesic. So when Agawu writes that "for better or worse, not all of us 'think octatonic' when we hear the 'Petrushka' chord," and offers this as a refutation of my claim that Stravinsky consciously employed it as a subset of the octatonic collection, he propounds an irrelevancy.[87] His further claim, that I am trying to force listeners to hear the *Petrushka*-chord in terms of its octatonic derivation (which "takes us into a different realm altogether, one of ideology"), is worse than an irrelevancy; it is a false imputation.

Agawu affects to chide me for my failure to engage with Carol L. Krumhansl's "empirical attempt to ascertain the [octatonic] scale's audibility," as if exposing some sort of coverup—but this is just another red herring. Krumhansl's experiment involved the perception of the *Petrushka*-chord, not the octatonic scale, which was brought in only as a "probe"—that is, only to test whether the chord would help subjects predict the scale.[88] That her subjects were more inclined to hear the chord in terms of its triadic components was unsurprising: that is everybody's naive response to the chord, and the basis of its expressive significance within the composition. It has no bearing whatever on the question of its composer's conceptualization, and Agawu must surely realize this. His persistent attempts to muddy the waters degrade our profession.

Meanwhile, Agawu never engages the single point I raised in relation to him (his "victim card"), except obliquely when he accuses me of seeing in the use of octatonically motivated *Gebrauchs*-formulas "a sort of DNA of Russianness,"[89]

whereas my claim was just the opposite. I discuss only behavior, never biology. The essentialist assumption, here and elsewhere, is made only by Agawu. For the rest, his response remains fixated, like Tymoczko's, at the stage of the discussion that followed the earliest publications of Van den Toorn, when the referability of this or that passage in Stravinsky to the octatonic collection was seen as the only relevant issue. Agawu's defensive restatement of well-known outmoded positions amounts in the end to an assertion of the right to think and believe as one wishes, whatever the evidence. Can one blame me for thinking of creationists?

And can we not do better? We certainly can, as Robert O. Gjerdingen's contribution to the symposium hearteningly attests. It actually advances the argument rather than trying to impede it. Extending the purview of his study of the galant style into the late-nineteenth-century Russian domain, he adduces actual *partimenti* by Arensky (who knew?) as corroborative evidence that Stravinsky was trained in the use of *Gebrauchs*-formulas. He also analyzes according to his own terminology what he calls "a joint improvisation by Arensky, Rachmaninoff, Glazunov and Taneyev, 1896."[90] The piece is not, however, what is usually called an improvisation. It is the product of a parlor game in which one composer mentally composed a phrase for piano, jotted it down, and sent it around the table, where it was continued and completed by the other players, phrase by phrase. Four such pieces, begun by each player respectively, were thus composed simultaneously. The fact that Arensky and his companions "could play this game at such a high level" is what tipped Gjerdingen off that *partimento*-training had to be involved. This facility, of course, has been lost by composers trained under the modernist dispensation. Stravinsky (and such other, somewhat younger Russian conservatory-trained émigrés as Vernon Duke and, for a while, Prokofieff) were among the last of this "artisanal" line. Gjerdingen implies that the loss to composers and their public has been great, and quotes in conclusion a similarly elegiac remark, paraphrasing Jacques Maritain, by Ernest Ansermet, one of Stravinsky's most enthusiastic promoters: "The fault of academic instruction is to be theoretical and speculative instead of being operational."[91] If I had remembered that quote I would have made it my epigraph, for it applies to so much of what passes for music theory and analysis today.

NOTES

1. www.youtube.com/watch?v=NVbuIZ-5-80; www.youtube.com/watch?v=muqflDqEEp8; www.youtube.com/watch?v=CZ01_BDn8Ew.

2. The rest of the words can be found on the "Lyrics Forum" web site (www.allthelyrics.com/forum/lyrics-request/14491-mario-lanza-song-of-india.html).

3. See E. Garden, *Balakirev: A Critical Study of his Life and Music* (London: Faber & Faber, 1967). The only monographic treatments of Rimsky-Korsakov in English are Gerald Abraham's 124-page brochure, *Rimsky-Korsakov: A Short Biography* (London: Duckworth, 1945), commissioned for a series called "Great Lives" in which it was no. 91; and a book by John P. Roach Jr. called *The Mighty Kuchka: Biographical Novel of Nikolai Rimsky-Korsakov, Member of the Russian Five of St. Petersburg*, printed by

an American vanity press called AuthorHouse in 2009. In French, there is a short life by the serial biographer Michel-Rostislav Hofmann: *Rimski Korsakov: Sa vie, son oeuvre* (Paris: Flammarion, 1958). There also exists a German translation of a popular biography by Iosif Filippovich Kunin: *Rimskiy-Korsakov*, Zhizn' zamechatel'nikh lyudey, Seriya biografiy (Moscow, 1964); trans. Florian Köchl (Berlin: Verlag Neues Musik, 1979).

4. R. Godet, *En marge de Boris Godounof* (Paris and London: J. & W. Chester, 1926). For the Debussy quote, see Malcolm Brown, ed., *Musorgsky: In Memoriam, 1881–1981* (Ann Arbor: UMI Research Press, 1982), 7.

5. See R. Taruskin, "Kitezh: Religious Art of an Atheist," *New York Times*, 26 February 1995; reprinted in idem, *On Russian Music* (Berkeley: University of California Press, 2010), 179–83.

6. Gerald Abraham, "*Pskovityanka*: The Original Version of Rimsky-Korsakov's First Opera," *Musical Quarterly* 54 (1968): 73.

7. Dir. Walter Reisch, Universal Studios, 1947.

8. Amazon.com customer review, accessed 5 February 2010 (www.amazon.com/Song-Scheherazade-VHS-Yvonne-Carlo/product-reviews/0783227728/ref=cm_cr_dp_synop?ie=UTF8&showViewpoints=0 &sortBy=bySubmissionDateDescending#RVGZUIR0ZQ1AE).

9. Paul Henry Lang, *Music in Western Civilization* (New York: W. W. Norton, 1941), 952. (N.B.: There are no folk tunes in *Scheherazade*.) By way of extreme contrast, compare Arthur Elson's survey of 1904 (cited in chapter 1, n. 6), in which Russia is proclaimed "the leader of the world in music." In the discussion leading up to that summation, we are informed that "the greatest of the five national composers is by all odds Nicolai Andrejevitch Rimsky-Korsakoff," who is characterized by means of a long quotation from an encomium by the French critic Jean Marnold (1859–1935) that had appeared in the journal *Mercure de France* in April 1902: "Of all the Slav composers, he is the most notable, the most charming in his music. He has not been equaled by any of his countryment in his skill in handling orchestral colour, an art for which the Russians have long been noted. . . . His inspiration is something exquisite, and the inexhaustible transformation of his themes is most skillful and interesting. Like other Russians, he sins through lack of cohesion and unity, and especially through a want of true polyphony. . . . But the descriptive, dramatic intention is realized with unusual surety, and the ease of construction, the breadth and well-ordered progression of combinations, show a mastery and originality that are rarely found among Northern composers, and that no other of the great Five ever possessed" (Arthur Elson, *Modern Composers of Europe* . . . [Boston: L. C. Page, 1904], 261, 266). A portrait of Rimsky-Korsakov serves as the Elson book's frontispiece.

10. Igor Stravinsky, *An Autobiography* (anonymous translation of *Chroniques de ma vie* [1936]) (New York: W. W. Norton, 1962), 18, 23.

11. Igor Stravinsky, *Poetics of Music in the Form of Six Lessons*, trans. Arthur Knodel and Ingolf Dahl, bilingual ed. (Cambridge, MA: Harvard University Press, 1970), 122, 125.

12. Igor Stravinsky and Robert Craft, *Memories and Commentaries* (Garden City, NY: Doubleday, 1960), 52, 55, 57.

13. Charles Rosen, "Freedom of Interpretation in Twentieth-Century Music," in *Composition—Performance—Reception: Studies in the Creative Process in Music*, ed. Wyndham Thomas (Aldershot, UK: Ashgate, 1998), 72–73.

14. Arthur Berger, "Problems of Pitch Organization in Stravinsky," *Perspectives of New Music* 2, no. 1 (Fall–Winter 1963): 11–42. Further references to this article will be to its reprinting in Benjamin Boretz and Edward T. Cone, eds., *Perspectives on Schoenberg and Stravinsky* (Princeton: Princeton University Press, 1968), 123–54, with citations provided in the main text.

15. Dutch musicologists, for whom the scale was long known as the Pijper scale owing to its conspicuous use by the composer Willem Pijper, have corrected Berger's spelling when adapting his term to their language (as *octotonie*, meaning "octatonicism"). That is why the English translation of Louis

Andriessen and Elmer Schönberger's marvelous book *Het apollonisch uurwerk: Over Stravinsky* (Amsterdam: Bezige Bij, 1983) uniquely uses the spelling that, as I would tend to agree, Berger should have used: octotonic; see *The Apollonian Clockwork: On Stravinsky*, trans. Jeff Hamburg (Oxford: Oxford University Press, 1989).

16. Pieter C. van den Toorn, "Some Characteristics of Stravinsky's Diatonic Music," *Perspectives of New Music* 14, no. 1 (Fall–Winter 1975): 104–38 and 15, no. 2 (Spring–Summer 1977): 58–96; idem, *The Music of Igor Stravinsky* (New Haven, CT: Yale University Press, 1983).

17. Van den Toorn, *Music of Igor Stravinsky*, 42.

18. See, for example, Allen Forte, *The Harmonic Organization of "The Rite of Spring"* (New Haven, CT: Yale University Press, 1978); John Rahn, *Basic Atonal Theory* (New York: Longman, 1980); Joseph N. Straus, "A Theory of Harmony and Voice Leading in the Music of Igor Stravinsky" (PhD diss., Yale University, 1981); idem, "Stravinsky's Tonal Axis," *Journal of Music Theory* 26 (1982): 261–90; idem, Review of Van den Toorn, The Music of Igor Stravinsky, in the *Journal of Music Theory* 28 (1984): 129–34. Straus is still determined to circumvent the octatonic as a tool for analyzing Stravinsky's music: see his "Three Stravinsky Analyses: *Petrushka*, Scene 1 (to Rehearsal No. 8); *The Rake's Progress*, Act III, Scene 3 ('In a foolish dream'); *Requiem Canticles*, 'Exaudi,'" *Music Theory Spectrum* 18, no. 4 (December 2012) at www.mtosmt.org/issues/mto.12.18.4/mto.12.18.4.straus.html; and also his "Harmony and Voice Leading in the Music of Stravinsky," *Music Theory Spectrum* 36 (2014): 1–33.

19. Nikolai Rimsky-Korsakov, *My Musical Life*, trans. Judah A. Joffe, ed. Carl Van Vechten (London: Eulenburg Books, 1974), 78.

20. Sergey Mikhailovich Liapunov, ed., "Perepiska M. A. Balakireva i N. A. Rimskogo-Korsakova (1862–1898gg.)," *Muzïkal'nïy sovremennik* 7 (March 1916): 92.

21. N. A. Rimsky-Korsakov, *Polnoye sobraniye sochinenii: Literaturnïye proizvedeniya i perepiska*, vol. 4: *Uchebnik garmonii* (Moscow: Muzgiz, 1960), 222–24.

22. Vasiliy Vasiliyevich Yastrebtsev, *Nikolai Andreyevich Rimskiy-Korsakov: Vospominaniya, 1886–1908*, ed. A. V. Ossovsky, 2 vols. (Leningrad: Muzïka, 1959–60); idem, "N. A. Rimskiy-Korsakov: Yego biografiya. Yego znacheniye v istorii russkoy muzïki," *Russkaya muzïkal'naya gazeta* 7, no. 51 (17 December 1900): col. 1269.

23. Yastrebtsev, *Vospominaniya* 2:495 (entry for 12 April 1908).

24. N. A. Rimsky-Korsakov, *Polnoye sobraniye sochinenii: Literaturnïye proizvedeniya i perepiska*, vol. 4 suppl.: *Notnïye zapisnïye knizhki* (Moscow: Muzïka, 1970).

25. Ibid., 101.

26. Ibid., 277.

27. Lazare Saminsky, *Music of Our Day: Essentials and Prophecies*, 2nd ed. ([1932] New York: Thomas Y. Crowell Co., 1939), 240.

28. Olivier Messaien, *The Technique of My Musical Language*, trans. John Satterfield, vol. 1 (Paris: Leduc, 1957), 59.

29. Gerald Abraham, "Rimsky-Korsakov's 'Mlada'" (1934), in idem, *On Russian Music* (London: William Reeves, 1939), 120–21.

30. Arthur Berger, "The Octatonic Scale," in idem, *Reflections of an American Composer* (Berkeley: University of California Press, 2002), 187.

31. Van den Toorn, *Music of Igor Stravinsky*, 20–21.

32. Ibid., 21.

33. Robert Moevs, Review of *The Harmonic Organization of "The Rite of Spring"* by Allen Forte, *Journal of Music Theory* 24 (1980): 97–107.

34. R. Taruskin, *Stravinsky and the Russian Traditions: A Biography of the Works through "Mavra"* (Berkeley: University of California Press, 1996); idem, "Chernomor to Kashchei: Harmonic Sorcery; or, Stravinsky's 'Angle,'" *Journal of the American Musicological Society* 38 (1985): 72–142.

35. Van den Toorn, *Music of Igor Stravinsky*, 329.
36. Rimsky-Korsakov, *Notnïye zapisnïye knizhki*, 277.
37. Pieter van den Toorn, *Stravinsky and "The Rite of Spring": The Beginnings of a Musical Language* (Berkeley: University of California Press, 1987), 126–27.
38. Pieter C. van den Toorn, "Taruskin's Angle," *In Theory Only* 10, no. 3 (October 1987): 30.
39. Ibid., 31.
40. Pieter C. van den Toorn, "Will Stravinsky Survive Postmodernism?" *Music Theory Spectrum* 20 (2000): 108; the reference is to Claudio Spies's article "Conundrums, Conjectures, Construals; or, 5 vs. 3: The Influence of Russian Composers on Stravinsky," in *Stravinsky Retrospectives*, ed. Ethan Haimo and Paul Johnson (Lincoln: University of Nebraska Press, 1987), 76–140. This essay reaches extraordinary peaks—or depths—of invective in its effort to exorcise the demon spirit of Rimsky-Korsakov from his pupil's musical patrimony. Some samples: "the larger—or largest—questions are bound to concern both the extent to which Stravinsky may have seen through the gimcrack surfaces of Rimsky's music and the time at which he came to realize consciously how poor that music was" (86); "one is led to wonder what palpably beneficial consequences such a model might have produced for Stravinsky's emerging compositional practice" (ibid.); "it is easier to understand Stravinsky's usage as an effort to do the very opposite of Rimsky-Korsakov, and for the best of reasons, to boot" (93); "In assessing its overall effect on Stravinsky, Rimsky-Korsakov's music may be more accurately judged a deterrent, rather than an encouragement, to emulative efforts" (104).
41. Van den Toorn, *Music of Igor Stravinsky*, 37; quoted in idem, "Communication," *Journal of the American Musicological Society* 53 (2000): 446.
42. *Journal of the American Musicological Society* 52 (1999): 531–92.
43. Van den Toorn, "Communication," 448.
44. Igor Stravinsky and Robert Craft, *Conversations with Igor Stravinsky* (Garden City, NY: Doubleday, 1959), 49; idem, *Expositions and Developments* (Garden City, NY: Doubleday, 1962), 163.
45. www.amazon.com/Stravinsky-Russian-Traditions-Biography-Two/dp/0520070992/ref=sr_1_12?ie=UTF8&s=books&qid=1265952304&sr=1–12. Also germane is Jeremy Noble, "Debussy and Stravinsky," *Musical Times* 108 (1967): 22–25.
46. Van den Toorn, "Taruskin's Angle," 29.
47. Review of Christopher Hatch and David Bernstein, eds., *Music Theory and the Exploration of the Past*, in *Music Theory Spectrum* 17 (1995): 272.
48. Sylvia Kahan, *In Search of New Scales: Prince Edmond de Polignac, Octatonic Explorer* (Rochester, NY: University of Rochester Press, 2009), 111.
49. Dmitri Tymoczko, "Stravinsky and the Octatonic: A Reconsideration," *Music Theory Spectrum* 24 (2002): 68–102.
50. Van den Toorn has replied at length to Tymoczko; his response, together with Tymoczko's brief surrebuttal, occupies thirty-six pages and, to my considerable relief and satisfaction, incorporates a guarded reassertion of solidarity with me, and with historical investigation generally. See Pieter C. van den Toorn and Dmitri Tymoczko, "Colloquy: Stravinsky and the Octatonic—The Sounds of Stravinsky," *Music Theory Spectrum* 25, no. 1 (Spring 2003): 167–202.
51. The clause about augmented triads is added in this version of the piece in response to Tymoczko's pugilistically titled response to its initial publication. See Dmitri Tymoczko, "Round Three," *Music Theory Spectrum* 33 (2011): 211–15, at 213. Tymoczko also points out that major-major seventh chords cannot be referred to the octatonic scale. Neither point makes any difference to my argument, since (as I pointed out decades ago in "'Chez Pétrouchka': Harmony and Tonality *chez* Stravinsky," *19th-Century Music* 10 [1986–87]: 265–86), any tonality, including an octatonic one, must by definition allow for departures and returns and for "chromaticism." So (again) total referability, the only criterion Tymoczko invokes, is a red herring, not a serious objection.

52. Cf. Fred Lerdahl, "Cognitive Constraints on Compositional Systems," *Contemporary Music Review* 6 (1992): 97–121, esp. 99ff.

53. See Allen Forte, "Debussy and the Octatonic," *Music Analysis* 10 (1991): 125–169; idem, "An Octatonic Essay by Webern: No. 1 of the *Six Bagatelles for String Quartet*, Op. 9," *Music Theory Spectrum* 16 (1994): 171–95.

54. Tymoczko, "Stravinsky and the Octatonic," 100.

55. Ibid., 68.

56. Stephen Walsh, *The Music of Stravinsky* (London: Routledge, 1988), 198; quoted in Arnold Whittall, Review of R. Taruskin, *Stravinsky and the Russian Traditions*, in the *Journal of the American Musicological Society* 50 (1997): 519–29, at 529.

57. Whittall, Review of Taruskin, *Stravinsky and the Russian Traditions*, 529.

58. Allen Forte, *The Structure of Atonal Music* (New Haven, CT: Yale University Press, 1973).

59. Allen Forte, "Making Stravinsky Soup and Other Epistemusicological Pursuits: A Hymenopteran Response (Letter to the Editor in Reply to Richard Taruskin)," *Music Analysis* 5 (1986): 321–37, at 335.

60. Stravinsky and Craft, *Expositions and Developments*, 169.

61. Michel Georges-Michel, "Les deux Sacres du printemps," *Comoedia*, December 11, 1920; reprinted in François Lesure, *"Le sacre du printemps": Dossier de presse* (Geneva: Editions Minkoff, 1980), 53.

62. The phrase, made famous by Freud, who invoked it in several essays including "Civilization and Its Discontents" and *Moses and Monotheism*, is also occasionally cited in a "corrected" version: *credo quia absurdum est*. Freud's original phrase (without "est"), endlessly recycled in existentialist literature, was the product of faulty memory: what Tertullian actually wrote (in *De carne Christi*) was *credibile est, quia ineptum est* (it—that is, the fleshly resurrection of Christ—is credible because it is unreasonable). See James Strachey's annotation in his translation of *The Future of an Illusion*, rev. ed. ([1961] New York: W. W. Norton & Company, 1989), 35.

63. Carl Dahlhaus, *Analysis and Value Judgment*, trans. Siegmund Levarie (New York: Pendragon Press, 1983), 53.

64. Robert O. Gjerdingen, *Music in the Galant Style* (New York: Oxford University Press, 2007).

65. Robert O. Gjerdingen, "Partimento, que me veux-tu?" *Journal of Music Theory* 51 (2007): 85–135, at 85.

66. Yastrebtsev, *Vospominaniya* 2:468 (23 January 1908).

67. Lawrence M. Zbikowski, *Conceptualizing Music: Cognitive Structure, Theory, and Analysis* (New York: Oxford University Press, 2002).

68. Lawrence M. Zbikowski, "Cognitive Science, Music Theory, and Music Analysis," in *Musiktheorie im Kontext*, ed. Jan Philipp Sprick, Reinhard Bahr, and Michael von Troschke (Berlin: Weidler Buchverlag, 2008), 447–63, at 447.

69. Zbikowski, *Conceptualizing Music*, ix–x.

70. Robert Craft, "Prince Igor's Dance," *Times Literary Supplement*, 13 September 1996, 3.

71. Robert Craft, *An Improbable Life* (Nashville, TN: Vanderbilt University Press, 2002), 393.

72. Saminsky, *Music of Our Day*, p. 225.

73. Allen Forte, "Liszt's Experimental Idiom and Music of the Early Twentieth Century," *19th-Century Music* 10 (1986–87): 209–28.

74. Douglas Johnson, ed., *Abstracts of Papers Read at the Fifty-Second Annual Meeting of the American Musicological Society, November 6–9, 1986* (Cleveland: American Musicological Society, 1986), 52–53.

75. For an especially clear, and relatively compact, statement of Popperian principles, see Karl R. Popper, "Truth, Rationality, and the Growth of Scientific Knowledge," in *Conjectures and Refutations: The Growth of Scientific Knowledge* (London: Routledge & Kegan Paul, 1963), 291–340.

76. See "The Chicago Statement on Biblical Inerrancy" (1978), at www.etsjets.org/files/documents/Chicago_Statement.pdf.

77. Pieter C. van den Toorn, "Catching Up with Taruskin" (reply to Taruskin, "Catching Up with Rimsky-Korsakov"), *Music Theory Spectrum* 33 (2011): 216. The second sentence in the extract was as originally printed a footnote appended to the first.

78. Red Hook, NY: Open Space, 1995.

79. Lawrence M. Zbikowski, "Music Theory, Music History, and Quicksand" (reply to Taruskin, "Catching Up with Rimsky-Korsakov"), *Music Theory Spectrum* 33 (2011): 226.

80. Ibid., 227.

81. R. Taruskin, "Stravinsky and Us," in *The Cambridge Companion to Stravinsky*, ed. Jonathan Cross (Cambridge: Cambridge University Press, 2003), 260–84; reprinted in idem, *The Danger of Music and Other Anti-Utopian Essays* (Berkeley: University of California Press, 2008), 420–46.

82. Van den Toorn, "Catching Up with Taruskin," 218–19. Italics added, except in the case of Italian music terminology.

83. Robert Fink, "'Rigoroso (♪= 126)': 'The Rite of Spring' and the Forging of a Modernist Performing Style," *Journal of the American Musicological Society* 52 (1999): 299–362.

84. Recorded in 1938, reissued several times on CD, and available on YouTube (www.youtube.com/watch?v=lPoLj41Kjno). On the performance, see R. Taruskin, *Text and Act* (New York: Oxford University Press, 1995), 131–32; also "Did He Mean It?" in the present collection.

85. I.e., the treatise *Laokoön, oder über die Grenzen der Malerei und Poesie* (1766); for a useful modern adaptation, see Daniel Albright, *Untwisting the Serpent: Modernism in Music, Literature, and the Other Arts* (Chicago: University of Chicago Press, 2000).

86. In her contribution to the *Spectrum* symposium, Lynne Rogers observes that my paraphrase of Dahlhaus distorts his meaning by removing it from its original context—a misreading that, as she tactfully speculates, "may underline the intensity of [my] opinion" (Lynne Rogers, "The Joy of Analysis," *Music Theory Spectrum* 33 [2011]: 208–10, at 208). I take the point: in the passage in question (*Analysis and Value Judgment*, 53), Dahlhaus was not proposing two analytical approaches, but rather, and more modestly, two ways of interpreting the oft-asserted contradiction between Schoenberg's novel pitch organization and his traditional rhythmic writing. Nevertheless, Dahlhaus's alternatives did stimulate my thinking toward what still seems to me a fruitful way of framing my "theory of theory."

87. Kofi Agawu, "Taruskin's Problem(s)," *Music Theory Spectrum* 33 (2011): 186–90, at 189.

88. See Carol L. Krumhansl, *Cognitive Foundations of Musical Pitch* (New York: Oxford University Press, 1990), 226–39; Agawu's reference is in "Taruskin's Problem(s)," 187.

89. "Taruskin's Problem(s)," 186.

90. For the *partimenti*, see Robert O. Gjerdingen, "*Gebrauchs*-Formulas," *Music Theory Spectrum* 33 (2011): 191–99, at 194; the "improvisation" is printed at 192, and the analysis at 198.

91. "Le tort de l'enseignement académique est d'être théorique et spéculatif au lieu d'être opératif" (Ernest Ansermet, "L'oeuvre d'Igor Strawinsky," *La revue musicale* 2, no. 9 [1921]: 16; quoted in Gjerdingen, "*Gebrauchs*-Formulas," 198).

5

Not Modern and Loving It

When I was a lad I received a present from my mother, who was a piano teacher (but not *my* piano teacher; she knew better than that). It was a set of sepia-toned lithographed portraits from G. Schirmer, the main American music publisher of standard and pedagogical piano literature. The portfolio was titled "The Great Composers," and it started, perhaps needless to say, with J. S. Bach. The other Bs then passed in review, along with Mozart, Haydn, Schubert, Schumann, Chopin, Wagner, Verdi—the whole crowd. What was surprising was the end-point: the only composer in ordinary modern dress, beardless, wigless, short-haired, altogether contemporary and therefore quite exotic in such surroundings. It was Rachmaninoff, of course, the only composer who was still alive at the time the set was issued. Rachmaninoff, the portrait set quietly insisted, was the last of the Great Composers, the only one left. That made quite an impression on me.

I remembered that ancient gift and the impression it made when it came time, perhaps fifty years later, to frame my account of Rachmaninoff in the *Oxford History of Western Music*—my attempt, in only six volumes and a mere one and a half million words, to put everything about classical music into a single perspective. As a historian, I saw my task as reportage, not evaluation, still believing that a neutral

Written for and delivered orally at the conference "Music, Memory, and Nostalgia: Rediscovering the Music of Rachmaninoff," Pittsburgh, 4 April 2009; previously published in Russian translation, "Несовременен—тому и рад," in Alexander Dolinin, Ilya Doronchenkov, Lyudmila Kovnatskaya, and Nataliya Mazour, *(Ne)muzïkal'noye prinosheniye, ili Allegro affetuoso: Sbornik statei k 65-letiyu Borisa Aronovicha Katsa* [An (Un)musical Offering, or Allegro affetuoso: Festschrift for the 65th Birthday of Boris Aronovich Katz] (St. Petersburg: Izdatel'stvo Yevropeiskogo Universiteta, 2012), 16–24.

point of view, if not actually achievable, is nevertheless the thing toward which, asymptotically, one strives. Whether I myself agreed with the value G. Schirmer had claimed for Rachmaninoff was, I assumed, of no interest to my readers, who would be seeking from me the information they would need to reach their own informed judgments. As a reader I always cherished this right and resented historians who tried to usurp it. What the historian owes the reader is a just account of historical significance, an account that should originate in observation, not predilection. For me to say "Rachmaninoff was the last of the great composers" would have been absurd; and it would have been equally absurd for me to say that he was not. And yet, needless to say, reportage and evaluation are not so neatly separable. The act of selection—of choosing what shall be reported—is implicitly, and inescapably, evaluative; and evaluation is implicitly, and inescapably, contentious.

My solution to this dilemma, or at least the criterion of relevance I sought to apply to the task of selection, was to ask myself always what was the necessary contribution of this figure or that fact to the story as a whole. And here is where that old set of sepia prints gave me the answer. "There were many," I wrote, "during the 1920s and 1930s, who regarded [Rachmaninoff] as the greatest living composer, precisely because he was the only one who seemed capable of successfully maintaining the familiar and prestigious style of the nineteenth-century 'classics' into the twentieth century." I congratulated myself when I came up with that sentence, because it reported the fact that Rachmaninoff was widely regarded as great, and it also signaled his unusualness within the stylistic spectrum of his day, even hinting that his role was an embattled one. Rachmaninoff, I concluded, was "the most effective antimodernist standard bearer." The fact that he was both antimodernist and successful, I continued, "and that his style was as distinctive as any contemporary's, could be used to refute the modernist argument that traditional styles had been exhausted."[1]

And that, I thought, was a job worth doing, because what I called "the modernist argument" had long since stopped being an argument and become a dogma—which is to say a fact held to be irrefutable, a truth held to be self-evident, or a judgment to be taken on faith—in the textbook histories of the twentieth century, even as Rachmaninoff's reputation with music lovers had held firm, as it still does. That reputation gave him an enormous historical significance that went unrecognized by historians, who as a rule either ignored him or dismissed him as unimportant, thus widening the embarrassing gap between the academic canon and the performing repertory that made academic historical writing on music seem ever more irrelevant to the actual musical life of our time. It was precisely to reclaim the relevance of historiography, the genre I practiced, and earn the respect of my readers that impelled me to combat the modernist discourse—not modernist music or modernist composers, who were also figures of self-evident historical significance

in need of characterization, but the implicitly modernist historians who were shirking the first task of historical understanding, which necessarily entailed taking stock of their own position in intellectual history.

"Rachmaninoff's piano concertos," I wrote,

> particularly the Second (1901) and the Third (1909), were repertory items at a time when the works of Schoenberg, Stravinsky, Bartók, and all the other modernists were considered specialty items at best; and his *Rhapsody on a Theme of Paganini* for piano and orchestra (1934), a set of variations on the theme of Paganini's Twenty-Fourth Caprice—which had already served Liszt and Brahms as a basis for virtuoso variations—might be called the very latest contribution to the standard (as opposed to the "modern") concert repertory. Modernists derided him: Virgil Thomson, the American composer who in the 1940s was the country's most influential music critic, called Rachmaninoff's music "mainly an evocation of adolescence," and "no part of our intellectual life." But Rachmaninoff's stature was commanding; and his reputation was not only undamaged but, in the eyes of his admirers, even enhanced by modernist abuse.[2]

I hoped that this paragraph would suffice to show that neither the modernists nor their antagonists had, or would ever have, the last word in this contention, or the unequivocal upper hand, and that both positions needed to be understood historically and comprehended dialectically—that is, as a pair of orientations that mutually conditioned and defined one another and must be described in tandem. Standing alone, as it usually does, the standard modernist account is an account of one hand clapping, and that deserves no applause.

But—of course—I failed to achieve the dialectical parity I sought. The asymptote prevailed as usual, because the deck is stacked in favor of the one clapping hand in a way that no historian can hope entirely to evade. Freud once described the difficulties of psychoanalysis in a way that illuminates the historian's problem as well. He compared the roles of the analyst and the analysand to those of two passengers in a train, only one of whom can see out the window. "Act as though . . . you were a traveler sitting next to the window of a railway carriage and describing to someone inside the carriage the changing views which you see outside," he directed analysands; and, further, admonished them "never [to] forget that you have promised to be absolutely honest and never leave anything out because for some reason or other it is unpleasant to tell it."[3]

Practicing analysts report, however, as one has told me, that unpleasantness is not the real threat to free association. To return to Freud's metaphor, the one looking out the window begins: "Oh, there's a barn; there's a cow; there's a tree; there's a telephone pole; there's a cornfield; another telephone pole; another telephone pole; ooh, a chicken; a telephone pole, telephone pole, telephone pole, another barn, a swimming hole, more telephone poles, more trees, telephone poles, telephone poles, telephone poles, trees, telephone poles, telephone poles, telephone

poles, telephone poles...." To the analysand, the only possible outcomes seem to be two: either the passenger receiving the description (that is, the analyst) says, "That's okay, I think I'll get some sleep now," or else the one doing the describing (that is, the analysand) starts censoring out the trees and telephone poles so as to maintain interest.

What this parable tells us, when transferred to the sphere of historiography, is how easily the historian's attention, and the reader's as well, are captured by novelty or innovation. A good analyst learns to live with boredom and a good analysand can perhaps be convinced that it is precisely the repetitive aspects of the story that are of greatest clinical interest. But a historian's readers are not getting paid, and the historian is therefore bound, all caveats notwithstanding, and despite the sincerest intentions to report comprehensively, eventually to lend his story, by suppressing the telephone poles, what willy-nilly amounts to a modernist proclivity.

That invidious tendency will come out at least quantitatively no matter what the historian's qualitative judgments may be. We can see this most clearly if we compare Rachmaninoff not with Schoenberg, Stravinsky, or Bartók, but with Scriabin, a composer very close to him both temporally and geographically. Indeed, Rachmaninoff and Scriabin were classmates at the Moscow Conservatory, class of 1892, and one can still see their names side by side on the conservatory's gold and marble honor plaque (Rachmaninoff with the great gold medal that year and Scriabin with the small). They were both virtuosos as well as composers, and could be said to have started their careers from the exact same place. But the great gold medal winner gets a total of eight pages of discussion in my *History*, divided between two chapters and encompassing two musical examples, while the small medal winner gets thirty-two pages—four times as many!—and twenty-three examples, almost twelve times as many.

Do I think Scriabin a more important composer than Rachmaninoff? Not necessarily. There are measures, including frequency of performance, range of dissemination, and stature within an established tradition, by which Rachmaninoff's work looms far larger than Scriabin's; and there are measures, including novelty of style and expressive purpose, the amount of explanation required to elucidate its evolution, and immediate influence on younger composers, by which Scriabin's work comes out ahead. Yet relative space in a canon-defining work like a general history weighs very heavily in Scriabin's favor, disavow the impression though I may. The book speaks louder than its author; as Satie once said, "Ravel rejects the Legion of Honor, but all his music accepts it."[4] Protest though I may that I never meant to belittle Rachmaninoff, the book contradicts me in the eyes of its readers. A thorough airing of this problem would be a worthwhile endeavor, for it would elucidate the subtle yet crucial nuance that differentiates importance from prestige. And while I don't expect to do full justice to that larger question, continued attention to Rachmaninoff's historical reputation will take us far enough for now.

Rachmaninoff was sensitive to that nuance. Of course it bothered him, and it may even have stunted his output. In the twenty-six years from the date of his emigration from revolutionary Russia in 1917 to his death in Beverly Hills in 1943, he completed only six of his forty-five works with opus numbers. Another factor, needless to say, was the demands of his performing career, which (as in the case of Stravinsky, among others) only became a necessity to his livelihood after the revolution, when the Bolsheviks seized his family property. (That may explain the hatred for the Soviets that exploded on 12 January 1931 in a famous letter to the *New York Times* indicting the "Communist oppressors of Russia," which put his music under a temporary cloud in his homeland.)[5] From 1918 to 1933, a period that witnessed the creation of only one major original work (the relatively unsuccessful Fourth Piano Concerto), Rachmaninoff devoted most of his creative energies to fashioning the brilliant arrangements—from Bizet, Musorgsky, Kreisler, Schubert, Rimsky-Korsakov, Mendelssohn, and Bach (plus "The Star-Spangled Banner")—that served him till the end as encore material.

There are other poignant indications that, despite his eminence and success, Rachmaninoff felt discouraged by the reception his music was getting from tastemakers. When asked in 1941 by David Ewen, a leading music journalist of the day, to describe his musical aims in an interview for the *Étude*, a piano teachers' magazine whose readership idolized him, Rachmaninoff nevertheless felt the need to look over his shoulder at his detractors while answering. "I have no sympathy with the composer who produces works according to preconceived formulas or preconceived theories, or with the composer who writes in a certain style because it is the fashion to do so," he told his interlocutor, caricaturing modernists as carelessly as they caricatured him. "Great music has never been produced in that way—and I dare say it never will. Music should, in the final analysis, be the expression of a composer's complex personality. . . . A composer's music should express the country of his birth, his love affairs, his religion, the books which have influenced him, the pictures he loves. It should be the product of the sum total of a composer's experience."[6]

References to preconceived theories and formulas were usually aimed at twelve-tone composers or "atonalists," but when Rachmaninoff scoffed at fashion, and especially when he got into his list of what music *should* do ("express the country of his birth, his love affairs," and all that), he was butting heads with his countryman Stravinsky, who a few years earlier, in a ghostwritten autobiography, had put many noses out of joint by asserting that "music is, by its very nature, essentially powerless to *express* anything at all."[7] Although they maintained civil relations (and had at least one congenial dinner in 1942 during which they exchanged grimaces at Shostakovich's "Leningrad" Symphony and sob stories about unpaid royalties),[8] Rachmaninoff disdained his younger colleague—not so much for his music (although, *Firebird* apart, it was hardly to his taste) as for his esthetic and social

pretensions. His correspondents were always eager to regale him with malicious stories like the letter I am about to quote, from his close friend and fellow exile Nikolai Medtner—another, somewhat younger, Moscow Conservatory graduate and a greatly gifted pianist-composer, whom in a moment of indiscretion I once called the poor man's Rachmaninoff when I should have called Rachmaninoff the platinum card-holder's Medtner.

Medtner revered the same Russian musical traditions as Rachmaninoff, and clung to them with the same tenacity. Like Rachmaninoff, he specialized in romantic concertos that fueled his own, somewhat less spectacular and far less lucrative, postrevolutionary performing career. So the world première of Stravinsky's piano concerto, an in-your-face demonstration of music's inability to express anything at all, scored for a very percussive piano and an orchestra of deliberately clunky winds and brasses, sickened Medtner, who chanced to witness it at a Paris concert in 1924. He immediately sat down to share his pain with Rachmaninoff. The first item on the program was Stravinsky's *Firebird* Suite. Medtner found, to his surprise, that he liked it.

> But then the composer appeared with his new concerto and gave me such a box on the ear for my silly sentimentality that I couldn't bear to stay until the end of *The Rite of Spring*, the more so as it showed its stuff right from the start. I walked out. But the public, who had filled the Paris Grand Opera to overflowing, this public who takes it as an insult if someone should appear in its midst in anything but tails or a smoking jacket (for which reason I had to hide myself and my little grey coat in the highest loges)—this public steadfastly withstood every slap in the face and every humiliation, and what is more, rewarded the author with deafening applause. What is all this?![9]

What it was, Medtner later decided, in a book called *Muza i moda*, was "the fashion for fashion," his definition of modernism. And in reference to the Parisian Stravinsky, that's not too bad a definition. Stravinsky, fresh from his affair with Coco Chanel, had learned that in order to be a major *couturier* one needed not to follow fashion but to set it. Medtner and Rachmaninoff heartily disapproved.

Here's another report of Stravinskian antics, this time from a nonmusician friend of Rachmaninoff's, his occasional secretary Yevgeniy Ivanovich Somov, writing from New York to Rachmaninoff, then touring in Europe, a few days after a radio concert on 3 February 1935 at which Stravinsky, touring America with his violinist partner Samuel Dushkin, was called upon to do something hitherto unprecedented:

> Stravinsky was invited by Ford [Somov wrote; actually, it was General Motors] to conduct his broadcast orchestra.... Before beginning the program, Stravinsky made a little speech something like, "Ladies and gentlemen, I am very glad to have the opportunity to conduct for you today works by the great Russian composers Glinka

and Chaikovsky, the direct descendant of whom I consider myself to be." I swear to God, that's literally what he said: [switching into English] "Of whom I consider myself as direct descendent [sic]." How do you like that![10]

According to Stephen Walsh, Stravinsky's most recent, and most thorough, biographer, this was both the first time Stravinsky had publicly conducted works by composers other than himself and the first time he had spoken English in public, and what he actually, "literally" said was "the great Russian composers from whom I consider myself descending in some ways directly."[11]

One can imagine Rachmaninoff's mixed mirth and indignation at reading this when one recalls that, unlike Stravinsky, he had as a conservatory star enjoyed the personal friendship and protection of Chaikovsky, who declared the nineteen-year-old Rachmaninoff to be his creative heir. All Russians knew this (ergo, Stravinsky knew this), and it was something neither Rachmaninoff nor his countrymen ever forgot. The official communiqué with which the Union of Soviet Composers had meant to greet the by-then-forgiven Rachmaninoff on his seventieth birthday (a document signed by Reinhold Glière, Nikolai Myaskovsky, Prokofieff, Shostakovich, Khachaturyan, Kabalevsky, the soon-to-be-disgraced Muradeli, Shebalin, Khrennikov, Shaporin, and three others, in that order) conveyed "cordial greetings to you, renowned master of Russian musical art, glorious continuer of the great traditions of Glinka and Chaikovsky, creator of works that are dear and close to the hearts of the Russian people and all progressive humanity."[12] Except for the last phrase, routine Communist jargon, this description surely approximated Rachmaninoff's self-image, and it is a pity he never received the telegram, for the planned celebration of his birthday had turned five days earlier into mourning his unexpected death from a long-undiagnosed cancer.

But note that Rachmaninoff's supporters and his detractors saw things in the same stark either-or terms—either you were a modernist and despised Rachmaninoff or you were a traditionalist and despised Stravinsky. Such attitudes are hard to change because they entail more than taste. Intellectual and social commitments are also at stake.

That is why the growing academic reclamation of Rachmaninoff (in the ecumenical spirit of what used to be called postmodernism) so often veers off on the wrong track. The worst move is to try to reclaim him by denying there's a difference that needs investigating or a bias that needs revising. Like efforts to reclaim Handel's operas by finding a Wagner in him, or to tout Milton Babbitt's music for its sensuous appeal—and both of these tacks have been tried!—efforts to find the modernist in Rachmaninoff can only reinforce invidious preconceptions. Metooism, which tacitly accepts the bias, is always futile.

A case in point: in the spring 2008 issue of *Nineteenth-Century Music,* a leading academic journal, Charles Fisk, a pianist and scholar who occupies chairs in both

musicology and performance at Wellesley College, defended our hero in an article called "Nineteenth-Century Music? The Case of Rachmaninov." The position he wanted to counter was the familiar one that Rachmaninoff, in Fisk's words, was "fundamentally a blinkered nineteenth-century composer, a holdover from the past, who was able to achieve spectacular success far and wide with audiences who shared his reluctance to advance musically into the twentieth century."[13] But look how much ground this description concedes to the other side: that there is something wrong with the nineteenth century, for one thing, and that it is the business both of composers and of audiences to advance. Fisk cites a few typical opinions, including a predictably patronizing one from Orlando Figes, a popular historian of Russian culture, that Rachmaninoff was "trapped in the late Romantic mode of the nineteenth century," and a truly snobbish one from Francis Maes, a popular historian of Russian music, that Rachmaninoff's music "gave expression to the sentiments and musical values of the lower strata of the [Russian] aristocracy."[14]

Fisk's third quoted miscreant—you've been waiting for this, of course—is me. He quotes the same sentence from my *Oxford History* that I quoted myself above, about "maintaining the familiar and prestigious style of the nineteenth-century 'classics' into the twentieth century," without quoting the first part of the sentence, in which I pointed out that for this very reason "there were many, during the 1920s and 1930s, who regarded [Rachmaninoff] as the greatest living composer." That omission, I guess, is what enabled Fisk to call my characterization "quite simpl[e]," and invidious, since in his view my "assessment ... offers no grounds for contention with Virgil Thomson's assertion,"[15] which I have also quoted, that Rachmaninoff's music has no intellectual distinction. Again it would seem that Fisk is endorsing a commonplace modernist verdict on the nineteenth century, something I would not have expected a Schubert specialist to do.

Fisk showed his awareness of the me-too trap by repeatedly forswearing it, going so far at one point as to assert that "it does Rachmaninov a disservice to claim that his musical evolution brought him closer to a modernist aesthetic."[16] He interprets Virgil Thomson's "implication" to be that "Rachmaninov in his obliviousness to contemporary trends contributed nothing of lasting significance to the development of music as an art form."[17] One could attempt refutation in two ways. One could argue that Rachmaninoff's conservatism did not preclude a contribution of lasting significance. Fisk chooses the other way: to argue that, appearances to the contrary notwithstanding, Rachmaninoff was not conservative. To defend Rachmaninoff in this way is not necessarily to identify Rachmaninoff as a confirmed modernist, but it does so identify his defender.

Fisk's strategy is to isolate passages in Rachmaninoff's later music in which the writing, as Fisk analyzes it, "takes certain musical parameters ... beyond late nineteenth-century norms."[18] At one point he even trots out that most hackneyed of modernist claims, that certain harmonic progressions in Rachmaninoff are

"virtually unanalyzable by traditional harmonic methods," this because "although chromatic progressions prevail in much late tonal music, very little of that earlier music is so fully saturated with dissonant or nonfunctional sonorities as in these examples," taken mainly from the Paganini Rhapsody, Rachmaninoff's last concerted composition.[19] The upshot, the very last words in the article, is this: Rachmaninoff was "a composer who responded to every new discovery by adapting it to the musical language he had learned in his homeland at the end of the nineteenth century; but one whose music not only was written but could only have been written in the twentieth."[20]

Fine, but how does that make it better? And if it does not make it better, then why take the trouble to write and publish this very insistent article? We are in the twenty-first century now. Neither the nineteenth nor the twentieth century is contemporary anymore. Why make such an issue out of being with the times, when neither Stravinsky nor Thomson (nor Schoenberg nor Webern nor even Boulez or Stockhausen) is any more with it by now than Rachmaninoff? The reason, as I see it, has to do with the very limited way in which so many writers have construed and applied the term "modernism."

Take Virgil Thomson's "implication," according to Fisk, that only by being with it can one make a contribution of lasting significance to the development of music as an art form. The essential modernist idea here is not the obligation to be with it, but rather the obligation to make a contribution of lasting significance to the development of the art. That, rather than communicating with (let alone "pleasing") an audience, is the task modernism assigns its votaries, as romanticism, its progenitor, had done before it. It is only since the later, post-Beethoven phases of musical romanticism, beginning in the mid–nineteenth century with the exhortations of the so-called New German School (essentially Liszt and Wagner, with a reluctant Berlioz roped into service as *bon père*), that the merits of composers have been computed according to that historicist calculus. (Which, by the way, is why it was so marvelously witty of Leonard Meyer, some years ago, to define modernism as the "late, late romantic" period.)[21] Only since then have composers regarded their primary duty as one they owe not to their pubic or patrons but to their art.

The alternative duty or debt, the one to public and patrons, is unrecognized by romantics or modernists, at least in theory, and that was the real issue that divided Rachmaninoff from the modernist consensus. That may seem paradoxical, since Rachmaninoff is in conventional parlance the quintessential, cryogenically preserved romantic. The true romantic view, however, was born of the great nineteenth-century divide between composers and performers, symbolized by Beethoven's withdrawal, on account of his deafness, from real-time music into an unseen empyrean domain from which henceforth emanated his artistic utterances and commands. Rachmaninoff, composer and performer in equal measure (like Medtner, and of course like Mozart) was a rare survivor, or atavism, from the

preromantic era when a complete musician united the roles that late romanticism put asunder. To conclude these remarks, then, I want to turn from Rachmaninoff the composer to Rachmaninoff the performer, and suggest that the latter's attitudes toward his audience were also the former's.

Unlike Stravinsky, unlike all modernists, Rachmaninoff had no wish to slap the public's face (as Medtner put it) or humiliate them. Like all great performers, he respected and considered those who paid to hear him. He matter-of-factly confided, in a letter to Medtner, that he let the coughing in the hall regulate the length of his Variations on a Theme of Corelli. "When the coughing increases," he wrote, "I leave out the next variation. If there is no coughing, I play them in order. At one small-town concert, I forget where, they coughed so, that I only played 10 variations out of 20. The record so far is 18 variations, in New York."[22] Even the man Stravinsky derided as "a six-and-a-half-foot-tall scowl" believed in, and lived by, Jules Renard's old precept that "art is no excuse for boring people."[23]

And like any other prelapsarian compleat musician, Rachmaninoff did not value the composer over the performer, either within himself or in the world beyond. I'm sure he would have disagreed as emphatically as I do with Joseph Horowitz, whose pessimistic history of classical music in America—its title, *Classical Music in America: A History of Its Rise and Fall,* already tells the whole story—is in essence a set of variations on a theme finally stated plain at the beginning of the penultimate chapter: "In the proper scheme of things musical, creators outrank re-creators."[24] Horowitz states this as if it were a Jane Austenly truth universally acknowledged, but it is a Utopian prescription. The religiously inflected terminology Horowitz invokes, moreover, tips us off that the truth he wishes to enforce is in fact of very recent vintage. It arises out of German romanticism, and was propagated by a line of German romantics that culminated in Theodor Wiesengrund Adorno, Horowitz's smugly acknowledged preceptor. In America, the line goes back to the heavily Teutonicized Boston Brahmins and other New England transcendentalists, notably John Sullivan Dwight, and their numerous progeny, of whom Joseph Horowitz has cast himself quite consciously as the present-day representative. For Adorno, Dwight, and Horowitz, America, with its commercial culture and egalitarian politics ("populism," in the vocabulary of scoffers), has been a great corruptor of art, and Horowitz blames America for Rachmaninoff's decline.

Very portentously, he announces that Rachmaninoff "capitulated to the American hierarchy: performance first" and cites as proof the fact that "the first solo recital of his career took place in Northampton, Massachusetts, on November 4, 1909."[25] Shame! But Rachmaninoff had already been touring for years as a concerto soloist, and afterward he went back to Russia for eight years, and gave many more solo recitals before emigrating.

His philosophy of performance can be deduced from his performances, and again Rachmaninoff comes down at the opposite extreme from the modernist

ideal. That ideal was given its strongest and most succinct enunciation in the sixth and last "lesson" from Stravinsky's *Poetics of Music*, his Harvard University lectures of 1939, and it is indeed an academic ideal. "The idea of execution," Stravinsky wrote, "implies the strict putting into effect of an explicit will that contains nothing beyond what it specifically commands," while "interpretation" implies the intrusion of the performer's own will between the music and its receivers; and as Stravinsky warns, interpretation "is at the root of all the errors, all the sins, all the misunderstandings that interpose themselves between the musical work and the listener and prevent a faithful transmission of its message."[26]

These words of Stravinsky's, and nothing earlier, have provided the intellectual foundation for the so-called Early Music movement with its spurious cult of authenticity, and prescribe the extreme literalism that still reigns over the performance of classical music today, which is why classical performances so often transgress against the principle enunciated by Jules Renard. Can we wonder that classical music is losing ground with audiences today? Meanwhile, listening to any recording by Rachmaninoff will show that Rachmaninoff utterly rejected Stravinsky's dogmatic dichotomy. He came down firmly on the side of all the errors, all the sins, and all the misunderstandings. Like most pianists of his generation, he rarely played Bach from authentic texts,[27] preferring adapted ones, including adaptations of his own. And what marvelous adaptations they are! A transcription like Rachmaninoff's of the Prelude from Bach's E-major violin partita is no mere transmission. It is a witty commentary, flattering both to the composer and to the performer—and equally flattering to the audience, who is presumed capable of getting all the jokes.

Or consider Rachmaninoff's recording of the opening variations movement from Mozart's piano sonata in A major, K. 331. Rachmaninoff plays only Mozart's notes (albeit not all of them, because a 78 RPM disc imposed severe limitations on time), but enacts an overall acceleration of tempo that gives the music an irresistible undertow that Mozart had not planned. At the Juilliard School's conference "Performing Mozart's Music," held in May 1991 in celebration of Mozart's bicentennial, Malcolm Bilson, who has made a career out of mocking his predecessors, put on this recording just to deride it. Marius Flothuis, an erudite and sharp-witted composer/scholar from the Netherlands (and a man whom I admired tremendously), shouted from the back of the house, "Rachmaninoff, hub' rachmones!" which means "Rachmaninoff, have mercy" in Yiddish—and Flothuis wasn't Jewish! (I asked him.)

We all laughed merrily, but I couldn't help thinking of Gulliver and the Lilliputians. I also thought about Glenn Gould and Jacques Hétu's *Variations pour piano* (1967). According to an anecdote much better known than the piece, the composer was shocked when he heard Gould's recording, in which all the tempos were completely at variance with his markings. Gould, in his liner notes, insisted that his performance was correct, implying that the reason Hétu didn't think so was that he hadn't analyzed his own music properly.[28] I can almost imagine Rachmaninoff

telling Mozart the same thing, except that Rachmaninoff, not being a modernist like Gould, would not have assumed there was only one correct way of performing this or any composition, as we can tell from his endlessly recycled remark, on being told that Benno Moiseiwitsch's recordings of his music outsold his own, that "Moiseiwitsch must be the better Rachmaninoff pianist."[29]

The best-known instance of Rachmaninoff as an interpreter rather than an executant is his very—and justly—famous recording of Chopin's second piano sonata, in which he plays the second movement, the celebrated Funeral March, with dynamics that often diametrically contradict the composer's, because he envisioned the piece as a procession approaching and then receding on opposite sides of the Trio in the middle. He was following the example of Anton Rubinstein, another charismatic performing composer; and some editors (Arthur Friedheim, for one) actually changed the score to conform to the tradition thus introduced.[30] I'm not necessarily advocating such measures; but the fact that they were taken shows our contemporary esthetic of submissive textual literalism to be a modern prejudice, not a universal verity. Rather than a self-evident virtue, it seems to me just another manifestation of modern existential anxiety.

The interesting thing to me is that Joseph Horowitz manages to rationalize a justification for this performance, despite its blatant flouting of his "proper scheme of things musical." He writes that "the vicelike [a Freudian slip, Mr. H—you meant 'viselike'] grip of this pianist's musical intelligence partners Romanticized freedom and passion."[31] Why the special dispensation? I'm guessing it's because Rachmaninoff was after all a composer, and a composer gets to be a decider. That's why Joseph Horowitz has always been so hard on his namesake Vladimir Horowitz, who was Rachmaninoff's equal as a pianist, particularly in color and voicing, non-quantifiable "parameters" that modernists despise, but did not write as many notes down on paper, so that he now attracts, from Joseph Horowitz and other critics like Tim Page, the modernist aggression that the older man's forbidding creative majesty deterred. It's just a prejudice, a thing of the mind, not the ears.[32]

So why do I enjoy Rachmaninoff? He is a symbol to me of something lost—and if that is nostalgia, make the most of it. Modernist prejudice on the one hand and commercial interests on the other have long split the world of classical music into a destructive dichotomy: the Three Tenors on the one side and academic austerities on the other. I'll gladly exchange either for Rachmaninoff in the golden middle.

NOTES

1. R. Taruskin, *The Oxford History of Western Music* (New York: Oxford University Press, 2005), 4:553.

2. Ibid. The quotation from Thomson comes from his essay "On Being Discovered" (1965), in *A Virgil Thomson Reader*, ed. John Rockwell (Boston: Houghton Mifflin, 1981), 410.

3. Sigmund Freud, "On Beginning the Treatment (Further Recommendations on the Technique of Psychoanalysis I)" (1913), in *The Standard Edition of the Complete Psychological Works of Sigmund Freud*, vol. 12, trans. James Strachey et al. (London: Hogarth Press, 1958), 121–144, at 135.

4. "Ravel refuse la Légion d'honneur, mais toute sa musique l'accepte" (*Le Coq* 1 [1 May 1920]: 1).

5. Though never a ban, as has been often claimed. In her recent study of the evolving classical repertory in the early decades of the Soviet regime, Pauline Fairclough has meticulously documented Rachmaninoff's place in it. His *Orthodox Vespers* were removed from the repertory of the Glinka Capella in 1928, but this was a general proscription on Orthodox sacred music. After the appearance of the letter in the *Times*, the Russian Association of Proletarian Musicians (RAPM) lobbied for the removal of Rachmaninoff's works from programs, with some success in the two years that remained to the organization's existence, but after the dissolution of RAPM in 1932 Rachmaninoff began a comeback, with the Second Symphony, performed by the Leningrad Philharmonic in February 1933, and the Fourth Piano Concerto (composed abroad), performed in Moscow under Albert Coates (the prerevolutionary Maryinsky conductor) in 1935. During the war, when Rachmaninoff's natural and elective homelands were allies, he was fully canonized. See Pauline Fairclough, "The 'Rehabilitation' of Rakhmaninov," in idem, *Classics for the Masses: Shaping Soviet Musical Identity under Lenin and Stalin* (New Haven: Yale University Press, 2016), 185–91.

6. Quoted in Sergei Bertensson and Jay Leyda, *Sergei Rachmaninoff: A Lifetime in Music* (Bloomington: Indiana University Press, 2001), 368.

7. *Stravinsky: An Autobiography* (New York: Simon & Schuster, 1936), 83.

8. See Bertensson and Leyda, *Sergei Rachmaninoff*, 374.

9. Nikolai Karlovich Medtner, *Pis'ma*, ed. Z. A. Apetyan (Moscow: Sovetskiy kompozitor, 1973), 271.

10. Sergey Vasil'yevich Rachmaninoff, *Literaturnoye naslediye*, vol. 3 (Moscow: Sovetskiy kompozitor, 1980), 261.

11. Stephen Walsh, *Stravinsky: The Second Exile—France and America, 1934-71* (New York: Alfred A. Knopf, 2006), 8.

12. Rachmaninoff, *Literaturnoye naslediye*, 3:393.

13. Charles Fisk, "Nineteenth-Century Music? The Case of Rachmaninov," *19th-Century Music* 31 (2007–8): 245.

14. Both quoted ibid., 248.

15. Ibid.

16. Ibid., 258.

17. Ibid., 248.

18. Ibid., 254.

19. Ibid., 251.

20. Ibid., 265.

21. Leonard B. Meyer, "A Pride of Prejudices; or, Delight in Diversity," *Music Theory Spectrum* 13 (1991): 241.

22. Letter of 21 December 1931, in S. V. Rachmaninoff, *Literaturynoye naslediye*, vol. 2 (Moscow: Sovetskiy kompozitor, 1980), 321–22.

23. Igor Stravinsky and Robert Craft, *Conversations with Igor Stravinsky* (Garden City, NY: Doubleday, 1959), 42; *The Journals of Jules Renard*, trans. Louise Bogan and Elizabeth Roget (New York: George Braziller, 1964), 85.

24. Joseph Horowitz, *Classical Music in America: A History of Its Rise and Fall* (New York: W. W. Norton, 2005), 433.

25. Ibid., 328.

26. Igor Stravinsky, *Poetics of Music in the Form of Six Lessons*, trans. Arthur Knodel and Ingolf Dahl (bilingual edition) (Cambridge, MA: Harvard University Press, 1970), 163.

27. According to Francis Crociata, at one time or another Rachmaninoff programmed the following by Bach: English Suite No. 2 (BWV 807), French Suite No. 6 (BWV 817), the Italian Concerto, the Sarabande from Partita No. 5 (BWV 828), and the D-minor Prelude from the Well-Tempered Clavier, Book 1. (He also recorded the Sarabande.) My thanks to Gregor Benko for supplying the list.

28. See Jacques Hétu, "Variations and Variants," www.musiccentre.ca/node/61136.

29. For a version of it, as related by Alexander Greiner, the artists' representative of the Steinway piano company, see Victor Alexander, "Moiseiwitsch: Portrait of an Artist," *HiFi/Stereo Review*, May 1962, 36.

30. See Rose Rosengard Subotnik, "On Grounding Chopin," in *Music and Society*, ed. Richard Leppert and Susan McClary (Cambridge: Cambridge University Press, 1987), 111.

31. Horowitz, *Classical Music in America*, 329.

32. See R. Taruskin, "Why Do They All Hate Horowitz?" *New York Times*, 28 November 1993; reprinted with an update in idem, *The Danger of Music and Other Anti-Utopian Essays* (Berkeley: University of California Press, 2009), 30–36.

6

Written for Elephants

Notes on Rach 3

"I wrote it for elephants," Sergei Rachmaninoff told Vladimir Horowitz, according to Horowitz, after hearing the younger pianist storm through his Third Piano Concerto, to his utter amazement ("He swallowed it whole!"), in the famous basement warehouse of the Steinway piano firm in 1928, right before Horowitz's American debut (playing the First Concerto of Chaikovsky, who was to Rachmaninoff what Rachmaninoff was to Horowitz: model, god, and patron).[1]

In English, Rachmaninoff's comment sounds as though he were genially mocking his masterpiece, the way composers will. Stravinsky once told Vladimir Ussachevsky, a younger Russian composer in America, that he wrote *The Rite of Spring* "with an axe."[2] Yes, we know Rach 3 is heavy; yes, we know *The Rite* is crude—and in both cases, if that's all you hear you are hearing nothing. But of course Rachmaninoff was speaking Russian, and in Russian the word for elephant (*slon*) has a different set of resonances. It conveys not ungainly heaviness but *weightiness*, which is a sort of grandeur. To say "I wrote it for elephants," in Russian, is to say "I wrote it for heavyweights"; or better, "I wrote it for champs."

The first champ for whom Rachmaninoff intended his concerto was of course himself. He wrote it at the very height of his powers and—for him a crucial matter—the peak of self-confidence as pianist and composer. And conductor, too, although that is not one of the talents posterity remembers; but in his day the young Rachmaninoff was a major orchestra director. He was a staff conductor at the Moscow Bolshoy Theater from 1904 to 1906, and among the operas he led there were a pair of his own, *Francesca da Rimini* (after Dante by way of Modest Chaikovsky) and *The Miserly Knight* (after Pushkin), in a double bill. He was offered the directorship of the Boston Symphony Orchestra during his first

American tour in 1909–10. When he declined the job it went back to the German conductor Karl Muck, who had held it previously and who lived to regret his second tour of duty when, during the First World War, he was forced to wait out the hostilities in an internment camp for enemy aliens.

It was for that American tour that Rachmaninoff composed the Third Concerto, starting work on it almost immediately after the première of his symphonic poem *The Isle of the Dead* in May 1909, and finishing it by early fall. It had its first performance in New York, on 28 November 1909 (repeated 30 November), with the New York Symphony Orchestra under Walter Damrosch; on 16 January 1910 Rachmaninoff was back in New York to play the concerto again, this time in Carnegie Hall with New York's other orchestra, that of the Philharmonic Society, under its then permanent conductor, Gustav Mahler. Besides the concerto, the program included Mahler's "Bach Suite," reorchestrated from two of Bach's originals; the "Prelude and Liebestod" from Wagner's *Tristan und Isolde*; and the overture to Smetana's *The Bartered Bride*. After reminding readers that the concerto "was given its initial performance anywhere" only a few weeks before, an anonymous reviewer reported in the next day's *New York Times* that

> on this occasion the favorable impression it had made when it was played before was deepened. It is more mature, more finished, more interesting in its structure, and more effective than Rachmaninoff's other compositions in this form. The first theme of the first movement, very Russian in its spirit, is extremely beautiful, and the finale is inspiring, with its succession of nervous rhythms and its noble coda. It was felt by many yesterday, that many another pianist could play it better than the composer. However, Rachmaninoff gave it a sympathetic reading, if lacking some of the brilliancy which parts of the work demand.[3]

The champ may have had a nerve-ridden off night, to judge by the surprising last two sentences. Perhaps the reviewer was thinking longingly of Josef Hofmann, Rachmaninoff's friendly rival (a fellow Russian despite his name), to whom the concerto was dedicated. But the *Times*'s description of the concerto jibes well with its subsequent reputation. It has never been Rachmaninoff's most popular concerto. That was always, and remains, the Second, with its hit-tune finale. The Third is not for everybody. Certainly not for every pianist—just ask David Helfgott, the protagonist of the movie *Shine*, whose famous filmed and fictionalized encounter with the fearsome piece brought it briefly into the maelstrom of popular culture, giving critics a brand new reason to deride Rach 3 on top of all the old ones that had, almost from the beginning, beset its reception.

The *Times* reviewer put his finger on the problem when he called attention to the concerto's "interesting structure." Its departures from the conventions of sonata form, as commonly found in the standard concertos, have often been held against it. The reviewer had it right, though. The formal eccentricities are what give the

concerto its wonderfully special character. They reflect the ebullient high spirits Rachmaninoff must have felt when composing it, despite having to work "like a convict" (as he put it in a letter to a friend)[4] in order to finish it in time for his tour—an ebullience one feels despite the outwardly melancholy character that Rachmaninoff so avidly cultivated as a trademark, especially in fashioning his long, drooping melodies, so instantly recognizable as his. The first movement deploys the famous, very quiet opening theme with superb originality. It both begins the movement and ends it, and comes in the middle to mark what the textbook would call the beginning of the development section. But what the theme's recurrences really mark are the onset and completion of two enormous waves that reach ecstatic peaks, which mirror on the compositional level what Rachmaninoff always averred as a performer: that there is *one place* toward which everything in a composition converges (he called it the *tochka*, "the spot"), and it is the performer's job to find it and bring it to fruition.[5]

It is not difficult to find the climaxes in Rach 3, but only a champ can put them in the proper perspective. The first climax is accompanied by the full orchestra and is followed by a marvelously sustained and graded subsidence (over more than sixty measures) that only a composer schooled to past-mastery in counterpoint could have devised. The second climax manages to surpass it, however—and does so without the help of the orchestra, in the course of the most heroic cadenza Rachmaninoff (or, it would seem, anybody) ever composed, clearly recalling, but just as clearly outstripping, the one in the first movement of Chaikovsky's great big First Concerto. It brings the quiet first theme to a delirious acme in the major key before the wind instruments enter one by one to waft the piano down from cloud nine. It is a shape unique among concertos, and the concerto thus owes its shape to its reliance on "elephants." That prerequisite of high ebullient virtuosity is always bait for critics, the paid puritans of the press, dependably virtuosophobic even as they make a fetish of difficulty, because true virtuosity—the virtuosity of champs—makes light of difficulty and in doing so commits, in their eyes, the seventh of the deadly sins.

But as the *Times* reviewer rightly reported, the first movement's grandeur is surpassed by the "noble coda" in the finale, in which a theme first heard as a heavy rhythmic pounding that merely seems to mark time between more salient themes is brought to what seems an endlessly mounting zenith through an exciting harmonic progression (derived, it almost seems, from the one in Wagner's "Liebestod," which shared the program with it under Mahler in 1910) that continually announces, and continually defers, the final cadence. In keeping with the history of the concerto form, the first movement is almost always the weightiest one, with the finale, if successful at all, succeeding through such contrasting virtues as lightness or wit. Rachmaninoff's are among the few concertos that are truly end-weighted. That, of course, is another hurdle that only champs, with their elephantine stamina, can clear, and another reason why they elicit such rapture from audiences along with the paid puritans' unfailing reproach.

Rachmaninoff enhanced the weight of the Third Concerto's finale by recycling the first movement's themes, the way composers often did in serious late-nineteenth-century symphonies such as Franck's D Minor or Dvořák's *New World* or, a little in advance of them, the Fifth by the worshiped Chaikovsky. Rachmaninoff had done it himself in his Second Symphony. But neither Chaikovsky nor Rachmaninoff had previously applied the device to a concerto, usually deemed a slighter, shallower genre. Recycling themes was one of the ways in which Rachmaninoff reserved his Third for champs. It coexists with a device that Rachmaninoff did adopt from Chaikovsky's First Concerto, a fleeting fast section that seemed to sandwich a scherzo within the slow second movement to imply a full symphonic four. Rachmaninoff chose this moment to recycle the first movement's opening theme, but did it subtly. It is usually not until the second or third hearing that listeners notice the muted, rhythmically altered reminiscence in the wind instruments during that interpolated scherzo. The moment of recognition, whenever it comes, elicits an unforgettable *frisson*.

Alongside the interesting structure, the *Times* reviewer singled out the "extremely beautiful" opening theme, which is made to bear so much of the concerto's structural weight despite its calculated quietness. Many have noticed what the reviewer called the theme's "very Russian" spirit; and thereby hangs one last tale about Rach 3. An organist and musicologist named Joseph Yasser, who had studied at the Moscow Conservatory a couple of decades after Rachmaninoff's time there, and who after the revolution joined Rachmaninoff in emigration (working for many years as organist and choirmaster at various reformed-Jewish synagogues in New York, including Temple Emanuel), thought he detected a resemblance between the famous opening theme and a particular liturgical chant sung at the Cave Monastery in Kiev. He wrote to Rachmaninoff in 1935 asking him whether he (1) had quoted the medieval tune outright, (2) had deliberately modeled a theme of his own on the style of Orthodox chants, or (3) was unconsciously influenced by such chants when writing his theme.[6] Yasser, you will notice, left no room for Rachmaninoff to disavow the influence; and this, no doubt, is why Rachmaninoff so categorically did disavow it, writing to Yasser from his villa on Lake Lucerne:

> You are right to say that Russian folk song and Orthodox church chants have had an influence on the work of Russian composers. I would only add, "on *some* Russian composers"! As far as whether the influence is "conscious" or "unconscious" (the latter being in your view the "more substantial" possibility)—that's a hard one to answer. This is a dark matter! ... The first theme of my Third Concerto is borrowed neither from folk song nor from ecclesiastical sources. It just "got written"! You will probably ascribe this to "unconscious" influence! If I had any intention at all when writing this theme, it was simply a matter of its sound. I wanted to "sing" a melody on the piano the way singers sing, and to find an appropriate orchestral accompaniment for it, or more precisely, one that would not drown this "singing" out. That's all![7]

Rachmaninoff further pointed out a technical feature that, as far as he was concerned, precluded the derivation that Yasser proposed. Although he agreed that his theme had "taken on, without my intending it, a songlike or liturgical character," still, if he were actually employing a theme from the medieval liturgy, "I would probably have deliberately kept to the notes of the old modal scale and not admitted a [modern, 'tonal'] C-sharp, but rather C-natural." There were, he added in conclusion, no early drafts for the theme that differed in any significant way from its final form.[8]

Yasser, perhaps needless to say, would not take no for an answer. In a second letter, he seized upon the small concession the composer had made and asked whether he agreed, therefore, that the chantlike, liturgical character might yet indicate an unconscious derivation from an actual chant. This time he included musical examples demonstrating the relationship he believed he had uncovered, and asserted his conviction that the resemblance could not have been a coincidence.[9] Rachmaninoff did not answer.

Years later, still unfazed, and long after Rachmaninoff was safely dead, Yasser published his side of the story in a rather preposterous article wherein he insisted that, even though he himself had found the chant in question in a published book, Rachmaninoff must have heard it *in situ*. Finding that Rachmaninoff had indeed spent a week in Kiev in 1893, only sixteen years before writing the concerto, he decided that that was when Rachmaninoff heard the monks of the Cave Monastery sing it. The many rehearsals and performances the composer-pianist admittedly had to attend to that week "no doubt left him little time for any diversion, but it could hardly have prevented him from visiting the famous Lavra (monastery) which was only a half-hour trolley ride from the theater."[10] Q.E.D.

It is unlikely that anyone now will find Yasser's argument plausible (especially anyone who has actually read his laborious "proof," in which the two melodies are atomized into fragments so small that they could establish a relationship between any theme and any chant). But scarcely more plausible is Rachmaninoff's unwillingness to acknowledge his theme's "very Russian spirit," especially when you compare it with the themes of his other concertos, or the other themes in the Third, which would never have prompted such a phrase from the *New York Times*'s critic in 1909, or induced Yasser to pose his questions in 1935.

There is another point to consider: the fact that Rachmaninoff wrote his concerto for performance in America. It was always when writing for foreign consumption that Russian composers of Rachmaninoff's or younger generations were at their most Russian-sounding. Was this a "conscious" or "unconscious" calculation? In the case of Stravinsky's ballets we have ample documentation of how conscious a decision it was. It was a business decision, and it was made by Diaghilev, the impresario of the Ballets Russes. Without wishing to incite the paid puritans to renewed attacks, I would suggest that Rachmaninoff's decision to make his Third

Concerto more Russian-sounding than his Second was likewise a business decision made with the American audience in mind—not that this need in any way detract from the famous theme's undeniable and, in the trustworthy words of the *New York Times,* extreme beauty.

NOTES

1. David Dubal, *Evenings with Horowitz* (Portland, OR: Amadeus Press, 2004), 177; Vladimir Horowitz interviewed by Abram Chasins on National Public Radio, New York, 27 February 1980, quoted in Glenn Plaskin, *Horowitz: A Biography of Vladimir Horowitz* (New York: William Morrow, 1983), 107 ("swallowed it whole").

2. Vladimir Ussachevsky, "My Saint Stravinsky," *Perspectives of New Music* 9, no. 2–10, no. 1 (1972): 37.

3. "The Philharmonic Again: Sunday Afternoon Concert in Carnegie Hall with Rachmaninoff as Soloist," *New York Times,* 17 January 1910.

4. To Matvey Leont'yevich Presman, 2 October (O.S.) 1909, in S. V. Rachmaninoff, *Literaturnoye naslediye,* ed. Zaruya Apetovna Apetyan, 3 vols. (Moscow: Sovetskiy kompozitor, 1978–80), 1:483.

5. Marietta Shaginian, "Vospominaniya o S. V. Rakhmaninove," in *Vospominaniya o Rakhmaninove,* ed. Z. A. Apetyan (Moscow: Muzïka, 1974), 2:162.

6. Letter of 15 April 1935, in Rachmaninoff, *Literaturnoye naslediye,* 3:267.

7. Letter of 30 April 1935, ibid., 49.

8. Ibid., 49–50.

9. Letter of 22 May 1935, ibid., 268.

10. Joseph Yasser, "The Opening Theme of Rachmaninoff's Third Piano Concerto and Its Liturgical Prototype," *Musical Quarterly* 55 (1969): 313–28, at 327.

7
Is There a "Russia Abroad" in Music?

I

In 1931, the Russian émigré composer Arthur Lourié[1] was asked by Henry Prunières, the editor of the Parisian journal *La revue musicale*, to write a survey of contemporary Russian music for a special issue to be designated "Géographie musicale 1931, ou essai sur la situation de la musique en tous pays." The *Géographie* appeared as the summer issue that year, with Lourié's contribution in a translation by Henriette de Gourko (herself a member of a very distinguished émigré family) under the title "Perspectives de l'École Russe."[2]

Most items in the special issue were straightforward and innocuous and, as one might have expected, focused on composers, their influences, and their techniques. The news from Germany, as reported by Armand Machabey (the medievalist musicologist), was twelve-tone technique, *Gebrauchsmusik,* and "*Gebrauchsmusik* jazziforme" (Kurt Weill, as described on p. 86). Arthur Hoerée managed to bring in a survey of Belgian composers (89-96) that was longer than Machabey's German survey. *Res ipsa loquitur.* Prunières, the editor, contributed seven pages under the title "Tendances de la jeune école française." The big issue there, predictably, was polytonality. Suzanne Demarquez, a French composer best known as a biographer of Falla, began her British survey by marveling that it was even possible to write one (105). The title of the Hungarian survey, by Emile Haraszti, then an attaché at the Hungarian embassy in Paris, allowed a little familiar

Originally delivered as a keynote address at the conference "Russian and Soviet Music: Reappraisal and Rediscovery," University of Durham (UK), 12 July 2011.

ideology to peep through its title: "Racines et renouveau de la musique hongroise" (119–28). Guido M. Gatti, the editor of the *Rivista musicale italiana*, contributed "Quelques notes sur la musique italienne moderne," which mainly celebrated "la volonté absolue d'une musique libérée du mélodrame vériste" (130) and, in an act of negative bravado, never mentioned a single opera or composer of opera.

A few little countries—the Netherlands, the Nordic lands (treated collectively)—received little surveys. The appraisal of "La jeune musique polonaise" by Mateusz Glinski, the founder of the Polish section of the ISCM, has the distinction of touting most insistently the necessity of creating a national style (not unexpectedly, given that the country in question was then only thirteen years old), naming as major talents names that—at least for me—have since sunk back into obscurity: Maklakiewicz, Kondracki, Perkowski, Labunski, Wiechowicz, Kassern, and others of similar renown. The shortest piece by far was "De la musique roumaine" by (who else?) Georges Enesco. Although laid out across a spread (158–59), it really amounts to only a single page of type, and I can make it even shorter by juxtaposing the first sentence with the last (the rest being easily inferred): "Le paysan roumain porte la musique en lui. . . . Et tous nous travaillons avec ardeur, ayant tous l'ambition de voir un jour l'école musicale roumaine figurer dignement à côté des autres écoles ses soeurs."

Lourié's article comes next, followed by surveys of Czech music since the war (signed "Probus"); of American music (by Marion Bauer), the longest of all, already preoccupied by the high/low dichotomy and by European preconceptions: "On s'imagine en Europe que, pour être américaine, la musique doit faire penser au jazz ou aux Indiens" (183); on Brazil (by Renée de Saussine, a biographer of Paganini who is perhaps better known as a youthful correspondent of Antoine de Saint-Exupéry), which is for some reason the only article with musical examples; and on Spanish America (by Julieta Telles de Menezes, a Brazilian singer then in Paris to study with Ninon Vallin). Lourié's piece stands out from the rest as the most complicated and insistently ideological of all. Although disguised as a survey, it was in fact a political manifesto.

Its thesis was that Russian music had left Russia, and that what was being written back home was no longer Russian music. To sell this idea, Lourié was required (unlike most other contributors to the *Revue musicale*'s survey) to tell his story from its envisaged beginning. And in the beginning, per Lourié, there were "three elements in [European] music culture: the German, the Latin and the Slav" (160/519).[3] These elements were in perpetual contention, with the German, of course, in the ascendancy. The only challengers to its hegemony were France, representing the Latin (a strange slight, this, to Italy), and Russia, on behalf of the Slav (519). Within Russia, German hegemony could be challenged from either of two traditional perspectives. One could oppose it as a "Westernizer" *(zapadnik)* à la Chaikovsky, "whose notion was to develop national characteristics by means of

the technical methods of the West;... but to the German canon he clearly preferred the French, in the form it assumed towards the middle of the nineteenth century" (520).[4] "This," Lourié asserted, "brought [Chaikovsky] into collision with those Russian musical circles which considered the connection of Russian music with the German as something that could be neither contested nor altered." "Those circles" meant Anton Rubinstein and his conservatory, but also Rimsky-Korsakov, insofar as the quondam kuchkist eventually found his place at the head of that Germanizing institution. (In most tellings Rimsky-Korsakov transformed the institution; but in Lourié's telling, and in that of another, more famous Paris-based Russian composer with whom Lourié was at the time closely associated, and whose inescapable eminence obviates the necessity of naming him, the transformation went decisively the other way.)

Or—and this was the other traditional perspective—one could oppose German hegemony as a pure Slav, à la Musorgsky, Chaikovsky's "antithesis" (520). As Lourié described him, Musorgsky "broke decisively and categorically with Western canons of any kind; his principles from the Western point of view were anarchical. He believed that a specifically national musical culture, absolutely independent of any foreign influences, was indispensable to Russia" (520).

To achieve this autochthonous ethos, Musorgsky traveled what Lourié calls the "Scythian" route: "He sought to incarnate the crude folk-element, which he assumed to be the only organic expression of Russia" (521). For this he was rewarded in his time with nothing but rebuff, until the French, with "Debussy and the impressionists" at their head, discovered him. Thus Russian music had two fructifying encounters with French culture: the one that created Chaikovsky's style and the one that facilitated Musorgsky's reception. In the twentieth century, the Chaikovsky and Musorgsky lines could thus be hybridized and jointly opposed to the German.

Lourié then proceeded to sort subsequent Russian composers into the boxes his account had built, with quite predictable, increasingly tendentious results. Into the German box went anyone tainted with a conservatory education or a cosmopolitan orientation. Glazunov, Medtner, Rachmaninoff, even Scriabin are tossed in willy-nilly: Glazunov for being the "direct successor and dependent of Rimsky-Korsakov" (520), Medtner for being "fed entirely on German music" (521), Scriabin for having submitted to "the allurements of other worlds, into which music did not enter, [which] led him to regard the problem of Russian music as of secondary importance in comparison with those eschatological visions wherewith his music was nourished" (521). Thus, incidentally but quite significantly, Lourié noted that "Skryabin on the extreme left and Medtner on the extreme right" could nonetheless find themselves united on the most important question facing Russian musicians. Style, accordingly, was not a composer's most decisive defining aspect. In this Lourié was quite unusual and (I would like to say) conceptually ahead of his time. (As for Rachmaninoff, Lourié seems to have forgotten about him while

writing this essay. That was a feat of absent-mindedness, but not, I think, an anomaly. I doubt whether anyone would imagine Rachmaninoff anywhere but alongside Medtner, wherever that might be.)

With all the important figures born between the 1850s and the 1870s comfortably within the Germanic box, the actual Germans, Lourié admitted, were at the beginning of the twentieth century quite justified in the "conclusion that German music had exhausted the world's musical resources" and so "continued to look upon the Russian branch of the art merely as a province of their empire." If the "Frenchmen of the modernist period" disagreed, they had to await the coming of a new standard-bearer for the "Scythian" position hitherto occupied by Musorgsky alone (522).

No prizes for guessing who that would be. "Against this background," Lourié declared, "Stravinsky made his appearance, and a living bond between Russian and French music became an accomplished fact.... He became a brilliant exponent of Musorgsky's 'Scythian' problem, which he handled with the utmost vigour and determination. Those concerned with this problem ... adopted *Le Sacre du printemps* as their banner [for] in it Stravinsky affirmed the Asiatic spirit of Russia, breaking with everything hostile to that spirit, not only in the West but also in Russia" (522).

With that last sentence, about Asia, Lourié broke through into a new terrain, both geographical and ideological. We will come back to it. But for the moment let's see how Lourié disposed of a couple of glaring contradictions. In the first place, Stravinsky, no less than Glazunov, had been a pupil of the Germanizing Rimsky-Korsakov. He had been saved from this fatal lineage by his timely removal to Paris; but that very removal had given rise to the second contradiction. Was Stravinsky's recent "desertion from the Scythian steppes to the banks of Europe ... to international shores" any less grave a "treachery to nationalism" than Scriabin's? "From my point of view, certainly not," Lourié averred (523). This time, however, the saving difference came not from the events of Stravinsky's life but from events in the life of his country. With *Le sacre du printemps,*

> the Scythian problem had been developed to its full extent, and further progress in this direction was impossible.... In forsaking the national plane for the universal, Stravinsky broke away from the line on this particular question. The radical change in his style was conditioned by the alteration in the ideological problem.... It is curious that this change in his style coincided historically with the political and social changes in contemporary Russia, where the national consciousness developed into a supernational consciousness and an aspiration toward universal union. Though politically opposed to the Russia of today, Stravinsky gave musical expression, as it were, to new departures similar to those prompted by the new ideology prevailing in that country, but on different grounds: the rôle of Karl Marx is played by Bach. (523)

But if Stravinsky abroad had "rejected musical nationalism ... and turned towards the formal canons of the West," contemporary Russia had experienced an

even greater rupture, "not merely with the West but with every branch of human culture: Russia is faced with the task of creating an entirely new culture, not national but universal" (523). Thus Stravinsky's neoclassical turn was analogous to Russia's Bolshevik turn. Both were turns away from the national toward the cosmopolitan or universal: universalist esthetics on the one hand and universalist politics on the other. Yet where Stravinsky's turn had been wholly propitious, Russia's had led into a ruinous cul-de-sac. "In the early days of the upheaval," Lourié asserted (those days being, one may recall, the days of his own active presence on the scene as a musical commissar under Lunacharsky), "there was no contact between art and politics, and the social and political life of the country developed in one direction, and its culture and art in another" (524).[5] But then (after Commissar Lourié had left the scene) "side by side with the political and economic fronts in the U.S.S.R. a cultural front was announced. Drama, literature and painting were brought into contact with Marxist doctrine far more quickly than music," and that for a reason once considered obvious: the literary and visual arts "can be more easily and speedily adapted to external purposes, and worked up for the express benefit of the ideology connected with any new movement," but "the mere attachment of superficial labels, or of literary programs and explanations hurriedly tacked on, makes no difference to the nature of the music itself, which undergoes no modification just because it is coupled with a capitalist or a communist subject" (525).

Withal, Soviet music had not been immune from harm. "The terrible isolation of the musicians of Soviet Russia from present-day life in the West" had caused their music, already of doubtful authenticity owing to German domination, to fall into a backward state, as a result of which "Russian music has once more returned to the provincial position it formerly occupied when it crawled along in the rear of Western music" (525). A way out of the cul-de-sac is "possible only if great and individual creative powers are forthcoming" (526)—only, that is, if a Soviet Stravinsky were somehow to emerge. "But here," Lourié warned, "we strike against the fundamental tenets of the U.S.S.R., in so far as the established methods of dialectical materialism employed in dealing with both culture and economics officially exclude any toleration of the individualist element" (526).

The most characteristic Soviet composers, therefore, were the Moscow "Proletarians," as Lourié termed them, meaning the composers associated with such organizations as RAPM (Russian Association of Proletarian Musicians) or ProKoll (the *Proizvodstvenniy kollektiv* or production co-op of Moscow Conservatory students). They, Lourié conceded, had been trying to make a virtue of their isolation and the collective mandate: "They think to proclaim a direct and definite contact between musical creation and communism," which forced them to "restrict their equipment to demagogic methods of a purely agitational order" (527). According to Lourié, "they have no professional grounding and seem to be essentially

amateurs," while "the work they are doing has no artistic value, from whatever point of view it may be regarded." Nevertheless, theirs was the only tendency in Soviet music that possibly had a future. No matter what it turned out to be, though, it could never be "Russian music," because "proletarian art by its very nature precludes the establishment of nationalism" (527).

For the elite professional composers of Soviet Russia, Lourié held out even less hope. Their art was moribund, under actual sentence of death. "Modernist degeneration" would only worsen "the profundity of the abyss which has been created in that country between music and life," with life undergoing revolutionary transformation while music remained mired in a now useless esthetic, "pouring out . . . an incessant stream of . . . scholastic pianoforte sonata[s]" (526). Who is he talking about? "In Moscow: Myaskovsky, Alexandrov [evidently Anatoly, b. 1888], A[lexander] Krein, Mosolov, Oborin [yes, Lev Oborin, remembered now only as a pianist, who had published a piano sonata in 1930, just in time for Lourié to complain about it], Polovinkin, [Sergey] Protopopov, Roslavets, Feinberg, and Shebalin; in Leningrad: Shestakovich [*sic*; "Chestacovitch" in the original French version], Popov, Shcherbachov, [Pyotr Borisovich] Ryazánov [a name new to me, but a composer who had come out with a piano sonata in 1925], Deshevov" (526). Lourié touted this list—obviously a chance assortment of composers whose piano sonatas he happened to have collected—as a roll call of futility. Having indicted these figures, Lourié pronounced his verdict, with the assurance of one stating an obvious fact: "Russian music as a school has ceased to exist in the U.S.S.R." (527).

Providentially, however, there was another list: his *"extra muros"* list, or "Western group," as Lourié named them, which "consists of the following composers: Stravinsky, Prokofiev, Lourié, Dukelsky, Nabokoff, and Markevich. Also Lopatnikov, Tcherepnin (Alexander), Berezovsky [i.e., Nikolai Tikhonovich Berezowsky, who had been an American citizen since 1928, but who was at the time of Lourié's writing living briefly in Paris, where he had just had his first symphony premièred by Koussevitzky], Yulian Grigor'yevich Krein [a nephew of the Krein in the first list, who at the time of Lourié's writing was studying in Paris at the École normale de musique under Paul Dukas, but who moved back to Moscow in 1934 and lived there until his death in 1996], Obukhov and Vishnegradsky" (527). "Is this group representatively Russian?" Lourié asked rhetorically, so that he could then trumpet in response:

> It seems to me so evident, that I should not ask the question were it not frequently raised in Russian émigré circles with regard to Russian literature. But literature is in another position, since a rupture with the national territory is almost a rupture with the national language upon which literature subsists. This is not so with music, since the language of music is not necessarily connected with any country [this sentence included only in the English version]. . . . As I have already remarked, Stravinsky found an outlet from the national plane to the universal, and therefore, thanks to

him, the new Russian music in the West has entered the international arena. It has not forfeited its national character, but a distinguishing peculiarity of our Western group of composers is that the "exotics" which Europe used to consider an indispensable national attribute of the Russian style have been eliminated. The young men of the West are already following what might be termed the Stravinsky tradition, and treading the path which leads towards the solution of general, and not restricted and specifically national, problems. (527–28)

On what basis, then, other than a flagrant double standard, can the Western group be considered the truly representative Russian school, if they have forsaken the national for the general and the specific for the universal? "Our justification for regarding the Paris group as representing the evolution and continuing the work of the Russian school," Lourié writes, "is based on the fact that the language employed—the Russian musical language—is common to both" (528). And now a sentence that must elicit a groan: "I cannot here dwell on the nature and meaning of this language and must limit myself to a mere statement of the fact" (528). In the immortal words of Ring Lardner, "Shut up he explained."[6]

It was indeed a double standard, a flagrant one, that motivated this disingenuous article, which, like all propaganda, seeks not to inform but to sway the reader, not to describe what is but to bring about what it describes. The argument was more strategic than eccentric: In characterizing all of Soviet Russian music as having descended stylistically either from Scriabin, in the case of "radicals," or, in the case of conservatives, from Nikolai Medtner (so far an epigone of German romanticism as to have "fallen out of Russian music" altogether), Lourié was able to assert that Russian music, properly so-called, had—to continue his metaphor—quite literally fallen out of Russia. The true Russian heritage now informed only the music being composed *extra muros* by the émigrés, while Soviet composers were under the irrevocable sway of the West. As Lourié argued in a never-finished monograph on Stravinsky that began to appear piecemeal in émigré journals in 1926, the raid through which the emigration had abducted the true spirit of Russian music was preeminently Stravinsky's doing, precisely by virtue of the stylistic renunciations Stravinsky had carried out when making his sharp right turn toward neoclassicism, thanks to which he had spectacularly reasserted the supremacy of the diatonic scale.

Lourié entered a mild complaint that several of his exiled Russians "out of political grudges or sentimentality have begun to flaunt a reactionary style, vintage 1830, just as arbitrary as the attempts at Marxist adjustment their colleagues on the other side are making in Leningrad."[7] He was thinking, no doubt, of pieces like Nicolas Nabokov's *Ode* or Vladimir Dukelsky's *Zéphyr et Flore*, both of them ballets Diaghilev had produced very late in his career. "But," Lourié announced in conclusion, "this is only a phase. With Stravinsky the European and Prokofieff the Russian our young school is on the move—not without detours, perhaps, but

without any doubt. The spirit of competition animates its progress. The old traditions of fraternity will smooth the way."[8]

Reaffirmation of the "supremacy of the diatonic scale," then, is the appropriate stylistic lens through which to view the music of Lourié's "Western group." If Soviet Russia was (in the words of Pierre Souvtchinsky) "the new 'West,'" the music of the Russian diaspora was the new music of Russia.[9]

If diatonic revivalism is the key, one has to wonder what Obukhov and Wyschnegradsky (the former a post-Scriabinist mystic, the latter a quarter-toner) were doing in Lourié's list. But then, in the widely quoted words of one of our American senators recently caught in a flagrant lie, Lourié's article was "not intended to be a factual statement."[10] There is no need for a tedious factual corrective. Still, one of its gaffes is worth some attention. In the list of Soviet composers, the most famous name is misspelled. "Chestacovitch," however, is not a typo. The next year, 1932, the same error, newly transliterated, survived (as "Shestakovich") into the English text. Anyone who speaks Russian, or studied Russian formally at a university, will know how to account for this peculiarity. Lourié was reflexively bringing a now thrice-familiar but rather odd name, of Polish derivation, into conformity with the normal rules of Russian spelling. (Recall the married name of Glinka's sister Lyudmila, who married a general with the fairly common surname Shestakov and became "Shestakova" in the historical literature.) It is a very telling sign of the precise time at which Lourié was writing—before Shostakovich's lasting international fame (which came with *Lady Macbeth of the Mtsensk District*) and after Prokofieff's emigration, when Myaskovsky (rather than Shostakovich) could be called, as Lourié calls him, the "chef incontesté" (165) of Russia-at-home, that is, of Soviet music.[11]

II

Its very tendentiousness, its very preposterousness, are what make Lourié's article an important document. Its outlandish theses not only reflected but united and helped constitute the community whose attitudes it purported to disseminate. That community, the Russian cultural diaspora, is now, after the title of an influential book by Marc Raeff, often called "Russia Abroad."[12]

The most radical version of Russia Abroad attitudes was the one known as *Yevraziystvo*, or Eurasianism. It was given its earliest enunciations by Prince Nikolai Sergeyevich Trubetskoy, a linguist specializing in the phonology of Turkic languages, and Pyotr Nikolayevich Savitsky, a geographer whose specialty was the so-called Turan steppe, the huge landmass north of the Black Sea that stretched from the Carpathians to the Pacific and which was therefore roughly coterminous with the old, contiguous Russian empire. Out of their joint interest in Central Asia, a territory added to that empire in its latest (nineteenth-century) phase, Trubetskoy and Savitsky evolved a view of Russia that had never actually existed in

Russia, one that saw Russians as akin not to brother Slavs to the west or south, as in earlier Russian nationalistic movements, but rather to the non-Slavic peoples of the Russian empire, located to the east. It was precisely because Trubetskoy and Savitsky, along with thousands of their most educated countrymen, were stranded against their will in western Europe that they were attracted to a view of Russia that rejected Europe. If Russia were to reclaim its true Turan heritage, it would offer the world an alternative to what Trubetskoy called the panromanogermanic hegemony that had lately plunged the world into chaos and misery.

Lourié's article carries a strong whiff of Eurasianism in its emphases, first, on Stravinsky's affirmation of the "Asiatic [or 'Scythian'] spirit of Russia," which Lourié, exaggerating wildly, generalized into the common bond uniting his "Western group" in opposition to the Soviet composers who were still enslaved by the panromanogermanic heritage of nineteenth-century Russia; and, second, on Stravinsky's salvific mission (also generalized without warrant or restraint) as the bearer of a "supernational consciousness and an aspiration toward universal union."

Lourié was well positioned to make these claims. Along with Pyotr Petrovich Suvchinsky (better known to musicians, thanks to Stravinsky's memoirs and Robert Craft's diaries, as Pierre Souvtchinsky), who was the principal bankroller of the Eurasianist press at its inception, and did more than anyone else to popularize Eurasianist ideas among uprooted Russians, Lourié was a close associate of Stravinsky in the years surrounding 1930. He was the one musician who actively participated in Eurasianist politics, writing for many of the Eurasianist publications that Suvchinsky edited or subsidized, and was actually on the masthead of the last of them, a weekly called *Yevraziya* that appeared (not always on schedule) in 1928 and '29. Thus Lourié was a nexus between Stravinsky and the Eurasians, and I found that nexus extremely stimulating when interpreting Stravinsky's unique position within Russian music, the task to which my monograph *Stravinsky and the Russian Traditions* was devoted. While I never made the claim that Stravinsky was actually associated with the movement (although many of my critics thought or asserted that I did), I nevertheless did find, and do find, Eurasianist ideas—as eventually crystallized in the writings of Souvtchinsky, Karsavin, Trubetskoy, and others that appeared in the 1920s—to be an indispensible key to understanding his work. And now that it has been established (chiefly owing to the efforts of the Belgian scholar Valérie Dufour) that Souvtchinsky was not only the ghostwriter of the fifth lesson of Stravinsky's *Poétique musicale*, but the *éminence grise* behind Stravinsky's Harvard lectures as a whole, that book now stands as a major musical document of Eurasianism.[13]

Among the questions that I mean to raise here is the degree to which one can generalize from Stravinsky or from Eurasianism about the musicians of the Russian diaspora. Even Lourié had to admit that Stravinsky was *hors du concours*: "européen comme seul un russe peut l'être [Dostoyevskian notion!], en marge de

l'école" (164). Stravinsky, in fact, can be an impediment to studying the Russian musical diaspora. Like Vladimir Nabokov in literature, he looms monstrously, casting surrounding figures in his shadow. One cannot regard so colossal a figure as typical of any group. And yet, biographically and geographically, he certainly had much in common with other émigrés, and to put him in their context must surely produce some mutual illumination. The problem is greater for music than it is for literature, since Nabokov's great international fame only came to him in America in the 1950s, after he had established himself as a writer in English. When he was writing in Russian as "V. Sirin" in Berlin and Paris he did not stand out so starkly from the group, and so he is regularly included in studies of Russia Abroad, whereas Stravinsky is not.

But then, are there any existing studies of Russia Abroad from a musical point of view? There is only one such comprehensive study, to my knowledge: Igor Vishnevetsky's *Yevraziyskoye ukloneniye v muzïke 1920–1930-x godov: stat'i i materialï, istoriya voprosa* (The Eurasian Turn in the Music of the 1920s and 1930s), to which reference has already been made[14] and which treats (or asserts) quite exhaustively the Eurasianist connections of what could be described as a subset of Lourié's "Western group": Lourié himself, plus Stravinsky, Prokofieff, Dukelsky, and Markevitch (with the noncomposing Souvtchinsky as a necessary supplement). The trouble is that Vishnevetsky has not posed the question of Eurasianism as a common bond among Russian musicians abroad but rather assumed it as a premise. His handling of the matter begs the crucial question, namely, whether the other members of the group—or more modestly, whether any others—are as fruitfully characterized from a Eurasianist perspective as Stravinsky seems to be. And so his work cannot answer the question. Although it is a goldmine of relevant texts and information, it is hardly less tendentious than Lourié's own writings on the subject.

Let us, as a way of approaching the question, frame it even more modestly: Without embracing a Eurasianist bias *a priori*, and without limiting ourselves to charting personal relationships like those binding Stravinsky with Lourié or with Souvtchinsky, can one profitably view the musicians of the Russian interwar diaspora as a group, and if so, on what basis? This leads to the question that furnished me with my title: can one speak collectively of "Russia Abroad" when speaking of music, or only of various Russians abroad?

Since Marc Raeff coined the phrase, we might as well begin with his definition—a progressively refined definition—of Russia Abroad. In the first place, Russia Abroad consisted simply of "all the Russians who escaped the victorious Red Army, who chose not to live under the Bolshevik regime, or who were expelled by the Soviet authorities."[15] At first, then, they were a community of refugees, who mostly regarded their separation from their homeland as temporary. And let me specify another criterion that Raeff does not specify, because it did not occur to him to do so: they were a community of Russian-speaking refugees.

I say this as a descendant of a different population of refugees from the Russian empire, a group whose everyday language was not Russian but Yiddish. The Yiddish-speaking cohort (into which, incidentally, Lourié had been born, but which he left behind) did not think of their separation as temporary, and they did not constitute a part of Russia Abroad—which is not by any means to say that Russia Abroad did not or could not comprise Jews. There were, by the time of the Bolshevik coup and civil war, plenty of Russian-speaking Jews who thought of themselves as Russians. My ancestors, however, who hailed from the Jewish Pale of Settlement (territories no longer located within the borders of the present-day Russian Federation), were not among them. About them one could not say what Raeff goes on to say about Russia Abroad, that "in a most literal sense they did not 'unpack' their suitcases; they sat on their trunks. Quite naturally, too, they did not think of melding into the host societies, even when assimilation might have been relatively easy, as for example in the Kingdom of Serbs, Croats, and Slovenes (the future Yugoslavia), in contrast to the unreceptive attitudes of Germany and France." In these circumstances, he continues, "exile or emigration . . . entailed a sense of mission, . . . to preserve the values and traditions of Russian culture and to continue its creative efforts for the benefit and ongoing spiritual progress of the homeland" (4).

By the time it became clear that the Bolshevik regime was there to stay—Raeff puts it around 1927 or 1928—the émigrés constituting Russia Abroad had surrounded themselves with the material and institutional means to maintain themselves as an enclave, an insular society within a host society. "What made the Russian emigration of the 1920s and 1930s into a society and not merely a group of people who had exiled themselves for political reasons?" he asks (5). In the first place, he answers, it was because "most social classes of prerevolutionary Russia were represented abroad, although not quite in the same proportions." It was a diverse group rather than "homogeneous in its religious, ethnic, educational, and economic makeup." Nevertheless, in the second place, Raeff emphasizes that "the émigrés were committed to carrying on a meaningful *Russian* life. They were determined to act, work, and create as part and parcel of *Russia*, even in a foreign environment. They needed 'producers' and 'consumers' of cultural 'goods' and values maintained in exile. Russia Abroad was a society by virtue of its firm intention to go on living as 'Russia,' to be the truest and culturally most creative of the two Russias that political circumstances had brought into being" (5).

There we have the mutually validating nexus between Raeff's theoretical generalizations and Lourié's exemplification. We have seen that spirit of competition at work in Lourié's description of "the Russian School," that sense that Russia Abroad justified its existence by believing itself to be the real Russia. Indeed, it was inevitable that we would find an optimal test of Raeff's thesis in the writings of a creative musician, because according to the thesis itself, as Raeff goes on to say, the main theater of operations for Russia Abroad, its main existential validator, lay in

cultural rather than political life. As Raeff puts it, for Russians abroad, culture was the "essential aspect of their national identity, of their identity as educated" (and therefore self-conscious) "Russian people" (10). One further corollary of Raeff's thesis that encourages the present project, which deals with the high-prestige repertory of "art music," is his contention that in this context "culture" means "all those manifestations of what at times, erroneously I think, is called 'high' culture: the literary, artistic, and scientific or scholarly creations of the nation, which are promulgated by such institutions as church, school, theater, books and journals, informal clubs, societies, and organizations" (10).

I should enter a caveat here: I am far less sure than Raeff seems to be that the national identity of the Russian diaspora—or, to be more precise, its national self-identification—is to be sought only in high, rather than popular, culture. His restriction seems perhaps more a product of the academic environment in which he was writing, more than twenty years ago, than of the cultural environment he sought to observe and describe. What about nursery rhymes, school songs, proverbs, lullabies, social dance, cuisine, sports and games, or the many other artifacts of expressive culture that are transmitted in ways other than through writing? The assumption, popularized to the point of doctrine by Benedict Anderson's perhaps too influential book, that national identity is primarily the by-product of literacy, is true only of certain, admittedly culturally dominant, social classes.[16] And while it is true that the Russian émigré community was characterized, in per capita terms, by a much higher literacy rate than the indigenous population of Russia owing to its overwhelmingly urban origin (Raeff includes peasants in his breakdown only because he classifies Cossacks as peasants), and there is a strong correlation between literate social groups and what is loosely meant by "cultured" social groups, nevertheless literate and urban people also have an oral culture. Whether oral or literate culture is the more determinate of national self-identification is not a question I will presume to decide, but I do think it should be proposed and considered.[17] It is not a question crucial to my present purpose, however; what Raeff proposes is at the very least applicable to the attitude that Lourié propounds in his seminal article, and validates it. Whether it is or is not the primary carrier, high culture is definitely a major fount of national self-identification, and we do expect to find evidence of social cohesion among Russian émigrés in high cultural products.

What Lourié's essay does not substantiate is what seems the most commonsensical aspect of Raeff's theory of the Russian diaspora as a self-conscious and self-constituting social group, and something that I too have often taken for granted, namely its primary dependence for its cohesion on language. "For a number of reasons," Raeff writes,

> the predominant expression of modern Russian cultural creativity, roughly since the reign of Peter I, had been in the form of literature. In its manifold modes, the word

was the mainstay of Russian cultural identity and the most prominent element in the consciousness of its intelligentsia. In emigration, literature became even more crucial to the émigrés' collective identity, for language is the most obvious sign of belonging to a specific group. The Russian language, both written and oral, bound the émigrés together despite their geographic dispersion. For this reason, too, the cultural life and creativity of Russia Abroad was preeminently, if not exclusively, verbal. Other artistic and intellectual expressions of culture for which a national linguistic form was not essential could [be], and frequently were, integrated and assimilated by the international or host cultures. (10–11)

In what can only seem at first blush a downright perverse assessment, Lourié takes the exactly contrary view. "More fortunate than literature," he writes, which is "always tied to the language and the climate of a single country, music can retain its national characteristics even far from its homeland." And therefore "the young Russian musicians, most of whom have chosen to reside in Paris, are taking a direct part in the evolution of music in Europe, and have, in contrast to the intra-muros school [i.e., the musicians back home in Soviet Russia], have no provincial accent" (165). Again the paradox: their music retains its national characteristics and yet it has no regional accent to marginalize it or mark it as inferior. So what are these national characteristics? The Russian language is something everyone can recognize, and so Russian literature is recognizable anywhere as a distinguishable entity. Can we similarly distinguish the national characteristics of Lourié's young Russian musicians in Paris and define them *sans mystique*?

Of course we can't. Mystique has always been a necessary component of nationalist discourse. And yet Lourié offers a partial corrective to Raeff nevertheless, because he reminds us that even if Stravinsky magnificently exemplifies Raeff's seemingly commensensical point as a practitioner of an art form "for which a national linguistic form was not essential," and whose works had indeed been "integrated and assimilated by the international or host culture" to a degree that no Russian writer had achieved or would ever achieve (that is, to the point of virtual dominion within his host culture), and even though it is possible to attempt an account of Stravinsky's émigré style in terms of its residual Russianness (indeed, I devoted an entire book to that attempt), there remain a host of counterexamples—musicians who did not achieve successful integration and assimilation despite their apparently sharing all of Stravinsky's advantages—and they included one who sported a name almost as prominent as his.[18]

III

Of course I mean Prokofieff, and the question of Russia Abroad gives us a new context in which to consider an old problem.

To Lourié's contention that music abroad had an advantage over literature abroad in its freedom from linguistic limitation and its consequent potentially universal appeal, one obvious objection would be that it was precisely the segregating property of the Russian language within a foreign milieu that provided Russian literature with its institutional armature. Most Russian writers abroad wrote within the exile community for readers who were likewise within that community, and this was true even of those writers who (as Greta Slobin reminds us) did engage creatively with the literature of their host countries.[19] Lourié himself, when writing words rather than music, was one of them. Everything he wrote before his second emigration, to America, was written in Russian and published in Russian, even if in a few cases (such as the article I have been discussing) the original pretext came from outside the community and (in that one case) its first publication was in translation.[20] Lourié's other writings in French, German, or English—including his most famous and influential piece, "Neogothic and Neoclassic," the first extended dialectical juxtaposition of Schoenberg and Stravinsky, and the acorn from which a monstrous oak of tendentious criticism would sprout—were translations from the Russian ("Neogothic and Neoclassic" being a short section, translated by the ubiquitous Pring, from a huge article on Stravinsky that graced the maiden issue of *Vyorstï*, the most lavish of all the Eurasianist periodicals).[21]

Lourié's co-workers in the Eurasianist press included a number of very well known émigré writers, whose literary activities conformed (like Lourié's own) to Raeff's paradigm of a self-sustaining literary enclave. His fellows on the editorial board of *Yevraziya*, for example, included Lev Platonovich Karsavin, the religious philosopher and historian (and brother of Tamara Karsavina, Diaghilev's first prima ballerina); Prince Dmitri Sviatopolk-Mirsky, the great literary critic and historian (who wrote impeccable English, but only about Russian literature); and Sergey Efron (who, although best remembered now as the husband of Marina Tsvetayeva and as an NKVD double agent, was also an active Russian poet while living abroad). The article from which I have been quoting so extensively, when it was finally published in Russian in 1933, came out in another Parisian émigré periodical, *Chisla* (Numbers, or Dates), a lavishly illustrated journal edited by the poet Nikolai Avdeyevich Otsup. The biggest of these journals in terms of capaciousness, prestige, and durability were *Sovremennïye zapiski* (Contemporary Notes) in Paris and *Volya Rossii* (The Russian Will) in Prague. There were also daily Russian newspapers published in Paris, the longest lived and best remembered being *Poslednïye novosti* (Latest News), the organ of the Kadet (or Constitutional Democratic) Party in exile. It lasted from 1920 to 1940, when it was closed down by the German occupation.

It was because of these outlets, and the community of readers to whom they gave access and who, having thus been "interpellated," created the necessary demand (although the writers themselves, and today's historians of their activities,

all ritually exclaim, in chagrin or in wonder, that the readers were far too few), that there could be a thriving colony of self-identified Russian writers abroad. Their numbers are legion and many of their names are famous: Ivan Bunin, who won the Nobel Prize for literature in 1933; Alexey Remizov; Vladislav Khodasevich and his wife, Nina Berberova; Georgii Ivanov; Boris Poplavsky; and the aforementioned V. Sirin, whom everyone knows today by his family name. All it takes to maintain the activity of such a group is a printing press, a supply of paper and ink, and a distribution mechanism (or, to cite Slobin's less tendentiously minimal list: "churches, schools, professional societies, publishers, and bookstores").[22]

Composers need a lot more than that in order to find an audience. This was driven home to me while writing the article on Russia for the *New Grove Dictionary of Opera* in the early 1990s. When it came to the twentieth century, I found myself writing this introductory paragraph: "As in the case of literature, the wave of emigration that followed the Revolution and the Bolshevik coup in 1917 divided Russian musical culture into 'Russia at home' and 'Russia abroad.' Yet it is obvious that the émigré community could hardly support opera, which demands major institutional backing, the way it could support literature; and so Russian composers abroad found it necessary to assimilate into their host communities far more than the writers did, or else come home. There were prominent examples of both manoeuvres."[23]

Once again, the names that followed were, and could only have been, Stravinsky and Prokofieff. At the time of Lourié's writing, Prokofieff belonged to his Western group, but not for long. The reasons for his return to Russia, greatly illuminated if not definitively settled by Simon Morrison in his splendid study of the composer's Soviet years,[24] were obviously complex and overdetermined; but I would maintain that prominent among them was the disappointment Prokofieff suffered on account of his opera *The Fiery Angel*, which he regarded as his masterpiece but which he could not get staged, although he offered it to opera houses on both sides of the Atlantic. Literary authors did not have to rely on so much subsidy, infrastructure, and collaboration. And although it is easy to scoff that there was even less chance of getting *The Fiery Angel* staged in the Soviet Union, and of course Prokofieff found that out if he didn't realize it to begin with, the fact remains that he wrote his masterpiece to a Russian libretto based on a Russian *roman à clef* whose referents were as well known within the émigré community as they were arcane outside of it.[25] What Prokofieff learned from his debacle was that the diaspora could nurture ambitious writers but not ambitious composers.

And Russian words, and Russian listeners, were what he needed. I have never seen this stated as a fact before, but a fact it is that, although Prokofieff spoke several foreign languages fluently, he never set a word of any other language than Russian to music (except "Valse, valse, mesdames" in the first act of *War and Peace*). Both of the operas he wrote during his diaspora years had Russian texts, even

though the first of them, *The Love for Three Oranges*, was commissioned by an American company and had to be translated for its première (into French, not English, but that's another story). Stravinsky never set another word of Russian to music after *Mavra*, a little sketch of an *opéra bouffe* that was written for a Paris émigré cabaret, Le Théâtre de la Chauve-Souris de Moscou, in 1922. (To dispose of apparent counterexamples: for the Russian church in Paris Stravinsky did some settings of the Slavonic liturgy, but that's not Russian; and in his California years he did some arrangements of his Russian songs for performance at the Evenings on the Roof or Monday Evening Concerts, but they were not new compositions.) Prokofieff seemed to be in the position Khodasevich or Remizov might have faced had there been no Cyrillic type fonts abroad. Granted, some of the writers, including some whom I've mentioned, also went home, and usually to crueler fates than composers suffered. But that is yet another reason why Russian writers abroad were more securely a group than were musicians: they had more to fear, or felt they did, from the Bolsheviks.

There were, of course, outlets for publication and performance of music by Russian composers abroad. Outlets of both kinds were provided by a single great Maecenas, Sergey Alexandrovich Koussevitzky, whose *Rossiiskoye muzïkal'noye izdatel'stvo* (alias *Russischer Musikverlag*, alias *Édition russe de musique*) published works by eight of the twelve composers in Lourié's Western group and, with his own orchestra in Paris, or later with the Boston Symphony Orchestra, performed these eight, plus two more: Alexander Nikolayevich Tcherepnin, who was published by another émigré firm, Belyayev, having inherited his connection there from his father, also a composer; and Nikolai Borisovich Obouhov (for whom Koussevitzky led the single performance ever of parts of his magnum opus, *Kniga zhizni*, or *Le Livre de la vie*). Koussevitzky also gave the single performance Prokofieff ever heard of selections from *The Fiery Angel*, amounting to somewhat less than a single act, the second (leaving out what Prokofieff surely thought the best part, namely the conjuring music for strings playing glissando, eventually salvaged as the scherzo of his Third Symphony). In one of Prokofieff's letters to Myaskovsky, he tells how after this performance "[Leonid] Sabaneyev [a critic known for his hostility to all modern music not composed by Scriabin] and [Alexander] Gretchaninoff [born in 1864, the most venerable composer in the postrevolutionary diaspora] came up to me and started to praise Act II to the skies; I was embarrassed and decided that maybe the work was not so good after all."[26]

As usual, with his lively literary talent Prokofieff conjures up a vivid scene, and the scene he conjures shows the Concerts Koussevitzky as a musical meeting place for Russia Abroad: the work of an émigré, published by an émigré and performed by the same émigré, before an audience containing more émigrés. (Prokofieff also mentions members of the Russian ballet in the audience, there mainly to scoff at the proceedings as they did at all operas; and he also mentions the ineluctable

presence of Pierre Souvtchinsky.) My first prescription, then, for a focal point to a study of musical Russia Abroad with an eye toward measuring its extent and testing its reality would be a study not of any composer, or of composers collectively, but one that would take Koussevitzky—not an author but a mediator—as the crucial figure, focused (as studies of Koussevitzky have not been up to now, Lourié's own bought-and-paid-for authorized biography included)[27] on his Maecenas activities, the interrelationship between those activities and his performing career, and his switch from being a modernist Belyayev to the Russians abroad to becoming the American Belyayev from his perch in Boston, favoring Copland, Harris, Hanson, and others of that cohort in addition to—and eventually in preference to—his fellow émigrés.[28]

Of course, not everyone in Koussevitzky's audience was Russian; and Raeff is certainly right to stipulate that music crossed international frontiers more easily than literature, so that concerts were rarely the sort of insular affair that a literary reading had to be. The legendary success of the Ballets Russes, which was another important performance venue for Russia Abroad, with five of Lourié's names—about half the *extra muros* group—figuring on its programs, is more evidence of the advantage that musical performances had over literature, along with the visual arts as represented by the costumes and décor. The Ballets Russes, the *ne plus ultra* of chic in Paris and London, conferred a prestige on those whose work it presented that no publisher or competing performing agency could match. But that prestige was shared from the beginning with composers from the host countries; and they had come to dominate the programs, or at least the roster of novelties, by the time the organization met its untimely end with Diaghilev's death in 1929. That progressive dilution was symptomatic. By the end of the thirties Russia Abroad had by and large disappeared from the musical scene; those who were going to assimilate had assimilated, those who were going home had gone home. Those who could neither assimilate nor go home—they included Lourié himself, as well as Obouhov—quite literally disappeared.

So: a few preliminary conclusions. Comparing the musical and literary scenes, and keeping Raeff's theses in mind, it would appear that music had a short-term advantage over literature, especially (or at least) when it came to individual reputations. With the equivocal exception of Vladimir Nabokov, who had the advantage of being able to write brilliantly in English, no Russian writer in exile ever achieved the fame and prestige of Stravinsky or Prokofieff. But Stravinsky, like Nabokov, came to be an equivocal representative of Russian identity in the West. And Russian literature, thanks to its more modest institutional and, so to speak, infrastructural requirements, proved the hardier growth. Cabaret and church apart,[29] there were few musical equivalents to the quite numerous serious literary writers who were able to maintain their careers catering to a Russian readership abroad, often supplementing their income from publication by teaching, and sometimes

achieving prominence in the Western academy as professors of Russian literature. To return to Lourié's list, Nikolai Lopatnikoff became a professor of music at Carnegie Mellon University in Pittsburgh, but not a professor of Russian music; Nicolas Nabokov taught for a while at St. John's College, Annapolis, but not even as a professor of music, just a general tutor. Neither of them were counterparts to Joseph Brodsky, or especially to Andrey Sinyavsky, whom I single out as a particularly crisp example of a kind of career that was not open to Russian composers abroad. Asked by an interviewer to describe his life in the West, Sinyavsky focused on his professorship at the Sorbonne. "I live in a Russian world," he said. He taught at the Sorbonne, but only Russian literature, to students who understood the language. "'It's the easiest way I have of earning a living,' he explained, 'but if I were not paid, I would not do it.'"[30]

Be that as it may, Sinyavsky in Paris and Brodsky in Ann Arbor had, along with countless little Pnins—to recall Nabokov's endearing character, surrogate for many Russian writers turned professors in the west—a sort of job that no Russian composer could have *as* a Russian composer. There have been a few lucky émigré scholars who found employment teaching Russian music in the west—Margarita Mazo, Izaly Zemtsovsky, Marina Frolova-Walker—but only Zemtsovsky has continued to write in Russian. (His Western employment has not been steady, and he maintains a residence in St. Petersburg, where he spends part of every year.) One should also mention, in confirmation of the general rule, the continuing output in Russian—for consumption in Russia, but on American music—of the musicologist Elena Dubinets, a graduate of the Moscow Conservatory who emigrated more than twenty years ago and now works not in an academic job but in the management of the Seattle Symphony Orchestra.

Mentioning the living and the recently deceased is a reminder that there have been large waves of Russian emigration since the one that brought Lourié's cohort out of Russia—first the mainly Jewish (but Russian-speaking) wave dating from the early 1970s and associated with Nixon-Brezhnev Soviet-American détente, and finally the wave associated with the collapse of the Communist regime and the dissolution of the Soviet empire. Both waves have borne their share of musicians. Do these newer émigrés constitute a new Russia Abroad, or are their members only Russians abroad? Schnittke, Gubaidulina, Volkonsky, Finko, Smirnov, Firsova, Korndorf, Ivashkin, Mazo, Dubinets, Frolova-Walker—do these names delineate a community? I would say no, they do not, even as the older cohort, Lourié's cohort, *were*—albeit briefly, and ultimately unsuccessfully—a community.

Elena Dubinets, both a member of the group and its most avid student, having compiled an exhaustive set of interviews with twenty-one contemporary Russian musicians abroad, agrees.[31] Indeed, she prefers to call her cohort an "anti-community," not only because of their intense post-Soviet individualism, but also because they have not embraced a high self-consciousness of themselves as exiles, owing

to "globalization"—which is to say the ease of instant communication in the age of email and Facebook and Skype, which make one's physical location on the map a matter of relative indifference—and to the fact that the Russian border is now open. It is possible to carry multiple passports, and musicians cross over freely in both directions and identify with multiple homelands. They leave Russia now to seek their fortune rather than their freedom. And so the musicians in Dubinets's sample have no shared sense of trauma, hence no cause to feel or to claim the sort of "joint affinity or comradeship" that Arthur Lourié touted so fervently in 1931, or breathe the "bitter air of exile," to recall the title of Simon Karlinsky and Alfred Appel's famous anthology, which itself recalled a verse of Anna Akhmatova.[32] "Nor," Dubinets adds, is there any "joint infrastructure to represent their interests or provide advantages and protections." All deal as individuals with their careers, in terms of commissions and performances. They are, she concludes, all "trying to establish themselves by creating independent individual identities that embrace both their past experiences and their new situations." They use "the same global music infrastructure as their foreign and Russia-based colleagues and they are no longer required to submit to the nation-defining principles of their native or newly adopted states."

And so another romantic dream bites the dust of modernity. To answer our titular question: The history of the twentieth century, and now the twenty-first, has assured a steady stream of Russian musical émigrés, but a school they aren't—and perhaps never were, save in the imagination of Arthur Lourié.

NOTES

1. One of the many fascinating marginal men of twentieth-century music, Lourié (1892–1966) was born Naum Izrayilevich Luria in Propoysk, a town now located in Belarus. Twice he changed his name, first Russianizing it to Artur Sergeyevich Lur'ye, and then Gallicizing it to Arthur Vincent Lourié. These changes followed the geographical vagaries of his career, which took him first to St. Petersburg, where he became prominent among the composers of the prerevolutionary avant-garde—and, after St. Petersburg became Petrograd, the first Soviet commissar for music—and later, having defected, to Berlin and eventually Paris, where he became a close associate of Igor Stravinsky. Later still he emigrated again, to the United States, and died in obscurity in Princeton, New Jersey, in a house belonging to the philosopher Jacques Maritain.

2. Arthur Lourié, "Perspectives de l'École Russe," *La revue musicale* 12, nos. 117–18 (July–August 1931): 160–65.

3. Lourié's essay is here given a double pagination because it was published the next year in an English translation: Arthur Lourié, "The Russian School," trans. S. W. Pring, *Musical Quarterly* 18 (1932): 519–29. Further text citations are from Pring's version.

4. In Lourié's original Russian text, unpublished until 1933, in place of "French" there was "Italo-French" *(italo-frantsuzskiy)*; reprinted in Igor Vishnevetsky, *Yevraziyskoye ukloneniye v muzïke 1920–1930-kh godov: Stat'i i materialï. Istoriya voprosa* (Moscow: Novoye literaturnoye obozreniye, 2005), 259–69, at 260.

5. Half a century later, in a letter to his friend Kyril FitzLyon (né Zinovieff, a member of the aristocratic Russian diaspora living in Great Britain), Sir Isaiah Berlin (another member of the same community, though not an aristocrat by birth) made a characteristically well judged, ironic yet indulgent, comment on this conceit, conceding that the young artists who remained in Russia in the immediate aftermath of the revolution "were certainly fresher and more alive during those few years before the guillotine fell than were the rather tired older writers, whether they remained in Russia or not," and when his émigré friends (naming a group of names that included Lourié) "talked to me about how exciting those few early years were, I was prepared to believe it—it was all summer lightning, brief and unreal perhaps, but it occurred" (5 November 1980; Isaiah Berlin, *Affirming: Letters 1975–1997*, ed. Henry Hardy and Mark Pottle [London: Chatto & Windus, 2015], 142).

6. Ring Lardner, *The Young Immigrunts* (Indianapolis: Bobs-Merrill, 1920), 78.

7. Quoted (in translation) from the French version at 165; in the English translation (528) this passage, sans reference to Marx or Leningrad, came out in two wordy sentences as follows: "On the negative side, the rupture with Russia has created among some of the younger members a decadent ideology and a kind of reactionary aestheticism; they nourish their creative powers on memories of the old Russian culture, which has already accomplished its course and to which there can be no return. Particularly characteristic of them in this sense is a musical aesthetic based on the stylization of the 1830s, which, we hope, will be overcome, as it often causes their efforts to create a new culture to result in mere feeble reproduction of the past."

8. Again quoted from the French version, at 165. In English the peroration reads: "Brotherly cooperation and an inward sense of responsibility to one another have always been the watchwords of the Russian school; spiritual solidarity, and not the disintegration and indifference so characteristic of the Western Europe of to-day. So long as this principle of national cohesion—not for self but for Russia—exists, so long will the school endure" (529).

9. See P. Suvchinsky, "Novïy 'zapad'" (The New 'West'), *Yevraziya: Yezhenedel'nik po voprosam kul'turï i politiki* 2 (1928): 1–2; reprinted in Vishnevetsky, *Yevraziyskoye ukloneniye v muzïke*, 324–27. Soviet Russia had become the "new 'West'" because it was now in the eyes of Europe what Europe, before the revolution, had been in Russian eyes: the part of the world that seemed to be "easily and simply following its course" and "going effortlessly from one triumph to another and painlessly unraveling all of life's knots."

10. Sen. John Kyl of Arizona; see www.washingtonmonthly.com/archives/individual/2011_04/028869.php.

11. In response to this paper, when it was given orally at the Durham conference in July 2011, the St. Petersburg musicologist Lidia Ader noted from the floor that Shostakovich's name was frequently "corrected" to "Shestakovich" in early St. Petersburg Conservatory records.

12. Marc Raeff, *Russia Abroad: A Cultural History of the Russian Emigration, 1919–1939* (New York: Oxford University Press, 1990). Raeff's titular phrase was perhaps prompted by two similar phrases in Russian—*russkoye zarubezh'ye* or *zarubezhnaya Rossiya*—that the literary historian Gleb Struve had coined (or rather, adopted from his father, Pyotr Struve, a famous political exile) in his *Russkaya literatura v izgnanii* (Russian Literature in Exile) (New York: Izdatel'stvo imeni Chekhova, 1956). An exact translation of "Russia abroad" into Russian, however, would be *Rossiya za rubezhom* (or *za granitsey*). *Russkoye zarubezh'ye*, not precisely translatable into English, connotes something like "the Russian colony abroad" or "the Russian diaspora," and *zarubezhnaya Rossiya*, while closer to Raeff's formulation, translates literally as "foreign Russia."

13. See Valérie Dufour, *Stravinski et ses exégètes* (Brussels: Éditions de l'Université de Bruxelles, 2006), as well as the new French edition of the lectures: Igor Strawinsky, *Poétique musicale, sous forme de six leçons*, édition établie, présentée et annotée par Myriam Soumagnac (Paris: Harmonique Flammarion, 2000); also Svetlana Savenko, "P. P. Suvchinskii i 'Muzïkal'naya poètika' I. F. Stravinskogo," in

Pyotr Suvchinskiy i ego vremya, ed. Alla Bretanitskaya (Moscow: Kompozitor, 1999), 273–83; and idem, "Zametki Stravinskogo dlya 'Muzïkal'noy poètiki,'" in Igor' Stravinskiy, *Khronika, poètika*, trans. L. V. Yakovleva-Shaporina, E. A. Ashpis, and E. D. Krivitskaya, ed. Svetlana Il'yinichna Savenko (Moscow: Rosspèn, 2004), 255–62.

14. See note 4.

15. Raeff, *Russia Abroad*, 4. Further in-text citations are from this source.

16. See Benedict Anderson, *Imagined Communities: Reflections on the Origin and Spread of Nationalism* (London: Verso, 1983).

17. Many have done so: one who did it delightfully was Vsevolod Vyacheslavovich Khomitsky (1902–80), an émigré actor and playwright, and the author of a one-act comedy, *Russkaya kul'tura*, which I happened to have the pleasure of seeing as a Columbia College sophomore in December 1962, during my very first term of Russian language study, when I was in my initial happy throes of calf-love with *russkiy yazïk*. It concerns an earnest young American student of Russian language and literature named Stanley Crabtree (played, in the amateur production I saw, by Mark Simpson, then my classmate, later a professional Slavist), who pompously torments his Russian girlfriend and her mother with their ignorance of Russian (high) culture and history until they turn the tables on him and expose his ignorance of the *bytovaya kul'tura* (everyday popular culture, nursery rhymes, children's stories, household phrases) that constitute the "real" cultural patrimony of the nation. See Vsevolod Homitzky, *15 izbrannïkh odnoaktnïkh p'yes* (New York: Izdatel'stvo Peredvizhnogo Russkogo Teatra, 1964), 24–45.

18. And even Stravinsky could look marginal at various points in his life, notably the 1940s, after his removal to America. Here are Aaron Copland's impressions after an evening spent with Stravinsky in Hollywood in 1943: "I've come to the conclusion that Stravinsky is the Henry James of composers. Same 'exile' psychology, same exquisite perfection, same hold on certain temperaments, same lack of immediacy of contact with the world around him." With regard to the newly completed Symphony in C, which Stravinsky played him from a broadcast recording, Copland wrote: "I don't think he's in a very good period. He copies himself unashamedly, and therefore one rarely comes upon a really fresh page—for him, I mean" (Aaron Copland to Arthur Berger, 10 April 1943, in Gertrude Norman and Miriam Lubell Shrifte, *Letters of Composers* [New York: Alfred A. Knopf, 1946], 404).

19. Slobin proposed amending Raeff's two-stage model (consisting of the "exile" stage, when Russians abroad expected to return, and the "diaspora" stage, when they expected to live out their lives abroad) by adding a third stage, at least in literary history, when younger writers no longer thought of themselves primarily as bearers of a precious traditional culture, or as the "true" alternative to the inauthentic culture of the Soviet Union, but as members of the international community of writers, particularly of modernist writers; see Greta N. Slobin, *Russians Abroad: Literary and Cultural Politics of Diaspora (1919–1939)* (Boston: Academic Studies Press, 2013), 31ff. And yet, as long as they wrote in Russian, they remained ineluctably isolated, at least in terms of their reach, from the authors of their host countries.

20. And, as noted above, this was true of Vladimir Nabokov as well, to cite the one Russian émigré author who could be said to have rivaled Stravinsky in his universality of appeal. He wrote almost exclusively in Russian until his second exile, to America, when he began writing in English.

21. Arthur Lourié, "Neogothic and Neoclassic," *Modern Music*, March–April 1928, excerpted from "Muzïka Stravinskogo," *Vyorstï* 1 (1926): 119–35.

22. Slobin, *Russians Abroad*, 23.

23. R. Taruskin, "Russia," in *The New Grove Dictionary of Opera* (London: Macmillan; New York: Grove's Dictionaries of Music, 1992), 4:101.

24. Simon Morrison, *The People's Artist: Prokofiev's Soviet Years* (New York: Oxford University Press, 2008).

25. See R. Taruskin, "To Cross That Sacred Edge: Notes on a Fiery Angel," in *On Russian Music* (Berkeley: University of California Press, 2010), 223–32.

26. *Selected Letters of Sergei Prokofiev*, ed. Harlow Robinson (Boston: Northeastern University Press, 1998), 274.

27. Arthur Lourié, *Sergei Koussevitzky and His Epoch*, trans. [as ever] S. W. Pring (New York: Alfred A. Knopf, 1931).

28. This latter phase of Koussevitzky's legacy was comprehensively covered by Hugo Leichtentritt in *Serge Koussevitzky: The Boston Symphony Orchestra and the New American Music* (Cambridge, MA: Harvard University Press, 1947).

29. See Natalie K. Zelensky, "Music in Exile: Constructing the Russian Diaspora in New York through Russian Popular and Sacred Music," Ph.D. diss., Northwestern University, 2009.

30. Alan Riding, "Andrei Sinyavsky Lives in France, but His Soul Remains in Russia," *New York Times*, 21 December 1989.

31. Elena Dubinets, *"Motsart otechestva ne vïbirayet": O muzïke sovremennogo russkogo zarubezh'ya* ("Mozart Does Not Choose a Homeland": On the Music of the Contemporary Russian Diaspora; Moscow: Muzizdat, 2016). Quotations drawn from the Introduction ("Russkaya kompozitorskaya shkola za predelami Rossii"), pp. 9–43.

32. Simon Karlinsky and Alfred Appel, *The Bitter Air of Exile: Russian Writers in the West*, rev. ed. (Berkeley: University of California Press, 1977). Cf. Akhmatova, "Epilogue," from *Poem without a Hero* (ll. 715–20): *А веселое слово—дома—/Никому теперь незнакомо,/Все в чужое глядят окно./Кто в Ташкенте, а кто в Нью-Йорке,/И изгнания воздух горький —/Как отравленное вино* (But the happy word—home—has become unknown to all of us, who peer through foreign windows, whether in Tashkent or New York, and the bitter air of exile is like poisoned wine).

8

Turania Revisited, with Lourié My Guide

At night, as I read Khlebnikov, youthful memories surged and wafted over me like a wind out of Asia. How I loved this wind in former times! All that is European in me is dead, decadent, schism, disintegration, doubt, skepticism and weakness of will. All that is Asian is alive, authentically vital, joyous and bright. What a strange vision: Christ in Asia!
—ARTHUR VINCENT LOURIÉ, DIARY ENTRY, 8 MARCH 1949[1]

I

"As for me, never in my life have I seen or heard a single line of Lourié's music," wrote Stravinsky to Pierre Souvtchinsky on 17 January 1967, after belatedly getting news, via *Le monde*, of the death of his old publicist, factotum, and famulus, whom he hadn't seen or exchanged a word with in nearly thirty years.[2] Not even Robert Craft, who fulfilled exactly those roles during a later phase of Stravinsky's life, could buy such a whopper. "This cannot be true," he wrote, in a book otherwise devoted to maintaining many time-honored components of the Stravinsky legend.[3] And indeed, there were at least two works of Lourié's—the *Concerto spirituale* (1929) and the *Sinfonia dialectica* (1930)—that Stravinsky not only knew intimately, but also discussed with the composer and recommended to conductors.[4] They are indispensably part of the context surrounding the *Symphony of Psalms*. Indeed, it is hard to imagine Stravinsky conceiving that masterpiece were Lourié not already engaged in writing the *Concerto*, which like Stravinsky's symphony recasts a classical instrumental genre as a choral setting of texts selected from the Latin psalter.

Craft, who understandably recognized in Lourié a forerunner to himself, may have exaggerated the factotum's influence on the boss in certain respects. It is true

First published, somewhat abridged, in Klára Móricz and Simon Morrison, eds., *Funeral Games in Honor of Arthur Vincent Lourié* (New York: Oxford University Press, 2014), 63–120.

that Lourié was an ardent Catholic convert, a friend and disciple of Jacques Maritain (in whose Princeton house he lived his last years), and that he liked to quote French Catholic writers in his musical essays. He managed to work references to and quotations from Pascal, whose *Pensées* furnished the epigraph to the *Sinfonia dialectica*, into discussions not only of Stravinsky's *Oedipus Rex*, where they might have been expected, but of his *Sonate* for piano as well.[5] His letters to Stravinsky, now published in full and admirably annotated by Victor Varunts (see note 2) are full of religious exhortation, often dated according to the church calendar and ending with an ecclesiastical valedictory like *Khristos s vami* (Christ be with you). In one of them, Lourié compared Stravinsky to St. Ignatius of Loyola,[6] and in another urged Stravinsky to emulate Maritain's Christian humility.[7] But to attribute to Lourié's influence "the formulation of Stravinsky's 'homo faber' philosophy" is at once to overstate Lourié's role in its transmission and Stravinsky's role in its formulation. By now it has been well established that the strong flavor of Maritain's Thomism in Stravinsky's Harvard lectures, which became *La poétique musicale*,[8] was chiefly the contribution of Stravinsky's ghostwriter Alexis Roland-Manuel, who may have been guided to Maritain by a then recent monograph of Domenico de Paoli,[9] and who was in any case chiefly instructed in esthetic theory by Paul Valéry.[10]

But Craft was entirely right to note what may have been an even greater debt, albeit a somewhat dubious one, that Stravinsky—or perhaps I should write "Stravinsky," meaning the composer's public image and reputation—owed to Lourié. "Perhaps Lourié did more than any other critic before Theodor W. Adorno," Craft wrote, "to establish the notion of Schoenberg and Stravinsky as thesis and antithesis, and Lourié's 'Neogothic and Neoclassic' (*Modern Music*, March–April, 1928) was profoundly influential in this regard."[11] There is considerable irony in Craft's juxtaposition of the names Lourié and Adorno, because Adorno's comparison, in *Philosophie der neuen Musik* (1948), was entirely invidious with respect to Stravinsky, while Lourié's judgment went just as decisively the other way. But it was indeed Lourié who first proposed that Schoenberg vs. Stravinsky was the fatal choice confronting musicians after the Great War. For that reason his article, which was derived in part from a longer essay published in France (but in Russian) two years earlier,[12] must be adjudged the most influential critical evaluation of Stravinsky as of its time and up to the time of Adorno's. Adorno's reversed evaluation was as telling a sign of *its* time (the aftermath of the next great war) as Lourié's interwar postulate had been. Our first order of business, then, will be to contextualize and explicate "Neogothic and Neoclassic" in an effort to recapture its original impact, which (as Craft correctly testifies) was easily as great in its day as Adorno's has been in ours.[13]

For Lourié, Schoenberg was the thesis and Stravinsky the antithesis because Schoenberg represented the anachronistic survival of something long outmoded. Lourié called it "neogothic" not, as he put it, because there was anything medieval

about it, but because he equated Gothic with Teutonic and saw in Schoenberg the high emotional temperature and the solipsistic self-absorption of the German Romantics as brought to its acme by German expressionism. By now this is a cliché; but it must have come as a shock to Schoenberg's followers, who saw him as the most radical of modernists, to find the inventor of the twelve-tone method baited as old-fashioned, the most lethal epithet one could hurl at a modernist. Nor did Lourié construe "neoclassic" in ordinary terms of stylistic retrospection, which, as a loyal modernist, he dutifully denigrated.[14] For him, rather, the term "neoclassic" surprisingly denoted "plastic realism" in the recognizably Stravinskian sense that it implied a judicious conformity to the limitations of its medium.[15] It traded not in expression but in "the purely musical idea," and therein lay its greater novelty vis-à-vis the neogothic as well as its greater validity. It was the opposite of egocentric. It was based not on contrast, or on a dynamic sense of unfolding and growth with which inflated egos could identify, but with the so-old-they're-new scholastic virtues of stasis, clarity, and unity.[16]

The ideas Lourié propounded in "Neogothic and Neoclassic" were obviously related to the notions of subjective and objective time that Stravinsky propounded in a famous passage from the *Poétique* that was based not on Maritain but (indirectly) on Bergson. The dialectical opposition of Schoenberg and Stravinsky was also obviously related to the contrast of vital (dynamic) and geometrical (static) art on which Wilhelm Worringer had founded his theory of the abstract and empathic poles between which the pendulum of art history perpetually swung—a theory that had already been elaborated by T. E. Hulme into a theory of neoclassicism that had as wide a repercussion within the literary realm (for example, on T. S. Eliot) as Lourié's formulations had in music.[17] This much is now widely recognized and often cited as part of the background to Stravinsky's neoclassicism, among other musical manifestations of modernity.[18]

Far less widely recognized as yet is the subtext that made kindred spirits of Lourié and Stravinsky. The immediate link between their ideas—a link that can be traced in their music as well as their verbal expressions—was bound up with Pierre Souvtchinsky, the man to whom Stravinsky addressed the exasperated words quoted at the beginning of this essay. It broke the surface of Lourié's prose when he made explicit the contrast between the Schoenbergian thesis—egocentrism, "art-fétichisme," rationalization—and the Stravinskian antithesis (or, perhaps better, antidote), to be found in the subordination of the ego to "superior and eternal values," a renunciation that will at last defeat the temptations of art fetishism and enable art once again to assume its "normal function" in life.[19]

The idea at the heart of Lourié's aesthetic, the idea he promoted as the essential attribute of the neoclassic, is thus the principle of ego-subordination. It was an idea that was even more pressingly debated in the post–World War I political arena (which for Russians meant the postrevolutionary arena) than it was in

the aesthetic domain. And the only place where Russians could by then publicly debate such things was outside Russia. It was the postrevolutionary Russian emigration, the crucial common circumstance that shaped the existence of Stravinsky, Lourié, and Souvtchinsky alike, that provided the most relevant context for Lourié's aesthetic dialectic, hence for his influential definition of Stravinsky's neoclassicism. Through Lourié the concerns of the Russian diaspora became general concerns for musicians in Europe and America. They gave rise to the slogan, first enunciated in "Neogothic and Neoclassic" and later, famously, proclaimed in *La poétique musicale*, that "revolution inevitably leads to anarchy."[20]

As for Souvtchinsky, he is best known to Stravinskians as the author of the article from which Stravinsky avowedly drew his Bergsonian distinction, already alluded to, between subjective (psychological) and objective (ontological) time in the *Poétique*.[21] The fact that, alone among his sources, Stravinsky did Souvtchinsky the courtesy of acknowledgment had to do not only with their close personal relationship, but also with Souvtchinsky's now recognized status as the true architect of the lectures that Roland-Manuel would eventually draft.[22] But Souvtchinsky's theory of time, like Lourié's theory of neoclassicism, was a special application of general principles deriving from a cultural and political orientation for which Souvtchinsky served as focal point, thanks in part to his intellectual leadership but also, and in greater part, to his intermittent financial sponsorship. That orientation was the one known among the Russian émigrés as Y*evraziystvo,* or "Eurasianism."

II

The basic idea of Eurasianism is implicit in the movement's name. Russia was not Europe; nor was it Asia. This seemingly simple perception was elaborated into a multifaceted cultural and intellectual movement with political aspirations, mainly through the efforts of a pair of young émigrés who had left Russia by way of Turkey and met in Sofia, Bulgaria, in 1920. Prince Nikolai Sergeyevich Trubetskoy (1890–1938) was a linguist specializing in the phonology of the Turkic languages. Pyotr Nikolayevich Savitsky (1895–1968) was a geographer. The former argued, in a ferocious tract titled *Yevropa i chelovechestvo* (Europe and Humanity), published in that same year and same city, "that the Romano-German culture (Western) was not the only culture that existed in the world and that, in particular, the Russian culture was a value in itself, which had to be distinguished from and contrasted with European culture." It was perhaps the first salvo in the anticolonialist campaign against a self-defined, self-asserted, universalizing Western European mainstream that reached its literary pinnacle nearly six decades later in Edward Said's *Orientalism* (1978), although Said gave no sign of having heard of Trubetskoy or Eurasianism. Savitsky, for his part, argued "that Russia was indeed a special world from the geographical point of view. By this he meant natural conditions, natural

riches, cultural-ecological and social conditions, and cultural-economic and political self-sufficiency."

These quoted paraphrases come from the deposition given to the Soviet authorities by Lev Platonovich Karsavin (1882–1952), a philosopher and Orthodox theologian who had joined Trubetskoy and Savitsky's movement in Paris later in the 1920s, and who had taught since the thirties at the University of Kaunas in independent Lithuania, where he had been arrested following the Soviet postwar reannexation. His pithy deposition happens to be one of the best short summaries of the movement.[23] With reference to another programmatic essay by Trubetskoy, Karsavin observed that the "seeds of Eurasianism" were contained in the argument that "the unique Russian culture was historically tied with Asia no less than with Europe and Byzantium, and in particular that the Russian empire was the heir of the Central Asian empire of Genghis Khan."[24]

From this one can see how radically Eurasianism differed from earlier Russian nationalistic movements, whether Slavophile or Panslavist: it declared Russian solidarity not with brother Slavs to the west or south, but rather with the non-Slavic peoples of the Russian empire, located to the east. The fundamental original idea of the movement was not that Russia was a dialectical synthesis of Europe and Asia, but more nearly the opposite: that the Russia lands and their inhabitants were to be drastically distinguished from Europeans and Asians alike. Nevertheless, this separatist and essentialist idea—often reasserted as the "true" Eurasianism against deviations, to little avail—was often confused, both within the movement and without, and from the very beginning, with its synthetic counterpart (in two variants: one that saw Russia as a blend of Europe and Asia, and another that allied Russia with Asia in opposition to Europe). One finds this confusion in the writings of every Eurasianist, even the founders; and it is already evident in the quotation from Lourié's diary that stands atop this chapter as an epigraph, its late date proclaiming his virtually lifelong adherence to Eurasianist notions.

These ideas were not wholly new; nor, at first, were they even Russian. Until the eighteenth century—and this is as clearly reflected in music historiography as in any other kind—the primary conceptual division of Europe was between north and south. Musicologists conventionally associate the musical Renaissance with a gradual migration, over the course of the fifteenth and sixteenth centuries, of the center of musical gravity and stylistic innovation southward across the Alps, a movement that also, and inevitably, reflected the relocation of economic wealth; and the next two centuries, the period we conventionally (and perversely) persist in calling Baroque, would be far better described as the period of Italian, or southern European, hegemony. Until considerably past the middle of the eighteenth century, European travelers habitually referred to countries like Poland and Russia as northern, not eastern. It was "the intellectual work of the Enlightenment," Larry Wolff writes, "to bring about that modern reorientation of the continent which

produced Western Europe and Eastern Europe," so that "Poland and Russia would be mentally detached from Sweden and Denmark, and associated instead with Hungary and Bohemia, the Balkan lands of Ottoman Europe, and even the Crimea on the Black Sea."[25]

Association with the Ottomans meant association with Asia. Accordingly, even as Peter the Great sought to strengthen Russia's ties with Europe, Enlightened opinion did the opposite. Partly for this reason, Europeans did not uniformly welcome Peter's overtures. Voltaire extolled him extravagantly, asserting that before Peter "the Muscovites were less civilized than the Mexicans when they were discovered by Cortes."[26] But such praise of Peter only succeeded in alienating Frederick the Great, who wrote to Voltaire, "Tell me, I pray you, what made you think of writing the history of the wolves and bears of Siberia? ... I will not read the life of these barbarians; I even wish I could ignore the fact that they live in our hemisphere," and, with that, broke off their correspondence.[27] Maria Theresa of Austria opposed the acquisition of former Ottoman territories in Eastern Europe as part of the Polish partition, calling them "provinces unhealthy, depopulated, or inhabited by treacherous and ill-intentioned Greeks."[28] Prejudices born of the new east/west division persisted into the nineteenth century and beyond, and they remain a cliché of musical reception. In 1894, having asserted that "Brahms is the greatest living composer," the editor of the *Outlook,* the organ of the Christian Union, a charitable organization based in New York, asked on behalf of whom such an allegation might be challenged: "Dvořák or Rubinstein? Possibly. But these composers, though doubtless very distinguished, reproduce too much of what is semi-barbaric in their nationalities to rival Brahms in the estimation of people of musical culture."[29] Three years later, a British critic dismissed Dvořák, "the little Hungarian composer," for an excess of "Slav naïveté" that in his case "degenerates into sheer brainlessness."[30]

When Russians reacted to this sort of invidious lumping with an invidious lumping of their own, the seeds of Eurasianism were planted. The first such attempt—touted by one of the chief historians of the movement as "the one nineteenth-century work which Eurasianism resembled the most"[31]—was a book by Nikolai Yakovlevich Danilevsky (1822–85), by profession a botanist but with strong Panslavist leanings, titled *Russia and Europe: A Look at the Cultural and Political Relations of the Slavic World to the Germano-Roman World (Rossiya i Yevropya: Vzglyad na kul'turnïye i politicheskiye otnosheniya slavyanskogo mira k germano-romanskomu),* which appeared first serially in 1869, was published as a monograph two years later, and reappeared in many editions to the end of the nineteenth century and beyond. The "relationship" posited within, if that is the word, was one of utter incompatibility, expressed above all in what Danilevsky called the *psikhicheskiy stroy*—the mental structure, or what we would now call the mindset—of Slavs and Europeans respectively. The European mindset was one

of intolerance, characterized by aggression (*nasil'stvennost'*, a coinage connoting a tendency toward force, violence, or rape, which Danilevsky sought to clarify by association with the German *Gewaltsamkeit*). *Nasil'stvennost'*, he writes, is

> common to all peoples of the Romano-Germanic type. Such aggression is in turn nothing but an excessively developed sense of personality, of individuality, according to which a person possessing it places his mode of thought, his interests, so high that any other mode of thought or interest must necessarily give way to it, willy-nilly, as inferior. Such an imposition of one's own thoughts upon others, such a subordination of everything to one's own interests, does not even seem, from the point of view of such an excessively developed individualism, such an excessive sense of one's own worthiness, to be in any way unjust. It appears to be the natural subordination of inferior to superior, even in a certain sense a benefit to the inferior. Such a mentality leads . . . to the rejection of all authority.[32]

This passage from Danilevsky's famous book so closely parallels the basic thesis of Trubetskoy's equally famous *Europe and Humanity* of 1920, often cited as the founding document of Eurasianism, as to seem a paraphrase—which establishes Danilevsky as a primary source of inspiration for Trubetskoy, who appropriated from Danilevsky the locution "Romano-Germanic" as a synonym for "European" or "Western" (though Danilevsky interchanges it, as Trubetskoy does not, with "Germano-Romanic," and Trubetskoy often adds the prefix *pan-* to the term).[33]

Thus the invidious lumping of diverse lands and peoples into a single conceptual domain was a mutual or reciprocal process, and it was not without benefit to the inferior partner, as Danilevsky suggested, since the arts of Eastern Europe, valued as exotic, were as often the object of cults and crazes in the West as of denigration. But although "Asiatic" Russia as an exoticist or primitivist fantasy could make for good box office in Western Europe (as Diaghilev above all could attest), it nevertheless traduced Russia's own Romantic vision of itself as a land straddling the continental divide and to all intents and purposes a continent unto itself, as distinct from Asia as it was from Europe. This variant on the east/west idea seems to have been first proposed to Russians by Vladimir Ivanovich Lamansky (1833–1914), a professor of history and philology at the University of St. Petersburg, in 1892, in a lecture titled "Tri mira aziysko-yevropeyskogo materika" (The Three Worlds of the Asiatic-European Continent), later published in the almanac *Slavyanskiy sbornik* (The Slavic Omnibus).[34] On its way to soi-disant *yevraziystvo*, Lamansky's idea was cross-bred with a somewhat earlier one, first proposed by an exiled Polish ethnographer, Rev. Franciszek Duchiński (1817–93), in a book published in French in 1864: *Peuples Aryâs et Tourans, agriculteurs et nomades*, the purpose of which was to repudiate the ethnic brotherhood of Russians and Poles as advanced by Pan-Slavists. As summarized by Norman Davies in his history of Poland, Duchiński's argument was that "the origins of peoples cannot be reduced

to simple factors such as Language or Religion, but can only be determined by reference to twenty-eight points of differentiation varying from Hydrography and Pedology to Epidemiology, Nutrition, Folklore, and the status of women. On this basis, [Duchiński] argued that the origins of the Great Russians lay not with the Indo-European Slavs but rather with the Finnic and Hunnic peoples of Asia."[35]

The Finns and Hungarians, along with the Turks and Mongols, belonged to a language group (Ural-Altaic) that in the nineteenth century was known as Turanian, hence the title of Duchiński's tract. Of course, his argument was motivated by politically inspired hatred of the Russians, whom (in the words of a British reviewer) the author "endeavours to reduce to the moral and intellectual level of niggers."[36] But Duchiński's idea could serve other agendas as well, and it was taken up by an arch-conservative Russian philosopher, Konstantin Nikolayevich Leont'yev (1831–96), who became a Eurasianist saint.[37] Horrified by the egalitarian and utilitarian ideas that were invading Russia from the liberal West, Leont'yev sought to emphasize his homeland's ties to the East. So Duchiński's attempt at "othering" Russia vis-à-vis Europe became Leont'yev's attempt at othering Europe with respect to Russia. In an explosive essay of 1875, "Vizantizm i slavyanstvo" (Byzantinism and Slavdom), later reprinted in a volume called *Vostok, Rossiya i slavyanstvo* (*The East, Russia, and Slavdom*, 1885–86), he introduced Duchiński's "Turanian" argument to Russia under the guise of "Byzantinism" *(Vizantizm)*.[38]

Next to borrow the term was Prince Trubetskoy, who as a linguist specializing in the phonology of Turkic languages was especially familiar with matters Turanian. The word being derived from Turan, the name of the East European/Central Asian steppe north of the Black Sea that straddles the Eurasian landmass, Trubetskoy thought, in appropriating it to pinpoint Russia's unique identity, to divest it of its former linguistic (and some of its ethnographic) associations and apply it instead to the landmass itself and its inhabitants, which could then symbolize Russia's unique but also encompassing geographical (whence cultural and psychological) identity. Eurasianism was an attempt imaginatively to recreate, which is to say invent, that separate, totalized, monolithic Turanian Russia in a manner true to its envisaged autochthonous conditions and mentality. It was in effect an attempt to undo the work of Peter the Great, regarded by the nineteenth-century Slavophiles and their collateral Eurasianist heirs in the twentieth century as the Betrayer-Tsar, if not the Antichrist himself, and forever close his window on the West.

In my own study of Stravinsky, I took Trubetskoy's idea a step further by coining an imaginary geographic designation, Turania, to denote not terrestrial Russia, however ancient or pure, or any existing land mass, but rather the imaginary utopian ur-Russia of the Eurasian imagination.[39] I choose to revive it here because it offers a no less useful reference point for considering the cultural orientation that Lourié embodied both in his writings and in his musical compositions of the 1920s and '30s. Its meaning for interpreting Lourié's work is somewhat different from the

meaning I drew from it, or the purposes it served, when applied to Stravinsky. For Stravinsky, "Turania" served as a metaphor for the anti-European stance his music exuded during his so-called Swiss (that is, First-World-Wartime) period and for a short time thereafter. Stravinsky wrote, for a while, in what (for me, at any rate) is advantageously regarded as a Turanian style. For Lourié, who wrote quite prolifically about music and its esthetic issues, Turania had no particular musical style, but it had an exigent social theory, to which all its composers found ways—ways that variously but crucially affected their styles—of submitting.

What Western civilization represented in Eurasianist eyes was the rationalized Roman law under which Europe (but not Russia!) had been unified in late antiquity. The Roman law gave rise to the individualistic, legalistic "Romano-Germanic" spirit of Europe, a spirit that had been imported willy-nilly to Russia along with the Western technology through which Peter the Great had sought to modernize his nation, and that had infected Russia with its alien ideology. All Western liberalism, insofar as it partook of the spirit of Rome or its latter-day embodiments like the Code Napoléon—or, most recently, the social democratic theory that underwrote the Russian Revolution—was responsible in Eurasianist thinking for the decline and ineluctable destruction of Russia. Salvation could come only from rededication to the principle of acquiescence. "Unquestioning submission," wrote Trubetskoy, "is the foundation of Turanian statehood; it is consistent, and extends in concept even to the highest ruler, who automatically thinks in terms of unquestioning submission to whatever higher principles may reign in the life of each subject."[40]

Trubetskoy's language here is almost precisely that of Lourié's description of Stravinsky's neoclassicism in contradistinction to Schoenberg's egocentric expressionism, which in his insistently dualistic view stood in for the rationalized individualism of Romano-Germanic society. Like Turanian ethics, neoclassical esthetics sought its freedom in submission and sought not diversity but always, and everywhere, unity. In the words of Lev Karsavin, who was not only an eventual votary of the Eurasianist movement but also, as a religious philosopher, one of its important forerunners (and whose sister Tamara, Diaghilev's first prima ballerina, created the roles of the Firebird and the Ballerina in *Petrushka*), the essential "Russian idea" was *vseyedinstvo,* all-encompassing unity, and the principal mission of the émigré guardians of the autochthonous Russian flame was "to reinstitute the unity that Western tendencies have checked."[41] Compare Lourié on the neogothic and neoclassic: "The first, always egocentric, . . . ends only in an affirmation of self or the personal principle. The second seeks to affirm unity and unalterable substance."[42] And compare Stravinsky, in the *Poétique,* on the eternal principle of contrast vs. similarity: "La similitude naît d'une tendance à l'unité. Le besoin de varier est parfaitement légitime, mais il ne faut pas oublier que l'un précède le multiple."[43]

Thus, precisely because Eurasianism was *au fond* a religious impulse, Eurasianists opposed the blasphemy of sacralized art. (In Schoenberg's music, according

to "Neogothic and Neoclassic," "esthetic experience takes the place of religious, art becomes a kind of substitute for religion.")[44] According to the correct view, art served religion; it was not religion itself. And for Russian mystics religion was expressed in "endeavors to grasp unity, and more directly, to grasp *the one*. Even the dualism of the ego and the non-ego is to be transcended."[45]

It followed of course that Eurasianists fiercely opposed democracy, which could only degenerate into chaos and destruction, the law of the jungle. Their ideal was "ideocracy" (Trubetskoy's word); or, to put it as Karsavin did in an article called "The Foundations of Politics," it was a "symphonic society," incorporating not a polity of individuals in the blasphemous Western sense, but instead the "higher symphonic personality" or "symphonic subject."[46] If one were to nominate a Eurasianist sine qua non, it would have to be this idea: that culture, politics, and religion were all united in a single "symphonic" social order. That is why it is footless to claim that Eurasianist thought, Stravinsky's or anyone's, could "figur[e] as the cultural alternative to the futile political reaction of the Bolsheviks" or wonder whether Eurasianism was, in essence, "mainly cultural or political."[47]

Such claims and questions are the product of resistance, to which idealizers are inevitably prone, called forth by the obvious parallels between Eurasianist thinking and modes of thought now irrevocably tainted as totalitarian. As we look back upon them from our perch in the twenty-first century, the histories of both communism and fascism are fouled and bloodied beyond redemption. During the heyday of Eurasianism, by contrast, its connections with both utopias were frequently assessed with equanimity and still-viable hope. One of the most eminent Eurasianists, the literary critic "D. S. Mirsky" (as he was known to his Anglophone readers; to Russians he was Prince Dmitry Petrovich Sviatopolk-Mirsky), touting the virtues of "ideocracy" (i.e., "society . . . subject to an Idea)," wrote that the members of his movement

> visualize it as exercised by a unique party united by one idea, but an idea accepted by the symphonic personality of the People. Here again Communism and Fascism have to be regarded as rough approximations to a perfect ideocratic state. The insufficiency of Fascism lies in the essential jejuneness of its ruling idea, which has little content apart from the mere will to organise. The insufficiency of Communism lies in the only too obvious contradiction between a policy that is ideocratic in practice, and the materialist philosophy it is based on which denies the reality of ideas, and reduces all history to processes of necessity.[48]

Mirsky here suggests the reason why Eurasianists were able to entertain their "intrinsically unrealistic" dream of co-opting and thus wresting the monopoly on political power in Russia from the Soviet Communist Party.[49] As preposterous as the notion may now appear, "the Eurasianists proclaimed themselves ready to replace the Communists in the government of the U.S.S.R.," and that is what

sustained the movement and caused it to spread among the émigré communities of Paris, Berlin, and Prague.[50] According to documents now held at the Central State Archive of the October Revolution (TsGAOR) and recently released to scholarly scrutiny, Souvtchinsky entertained madcap hopes, in the late 1920s, of seizing power in the process of "the USSR's rapid transformation into a nationalistic corporate dictatorship," in which he would serve as ideologist.[51] Through their efforts, the Eurasianists believed, Russia was destined to become symphonic.

III

Karsavin had appropriated the word *simfoniya* not from the Western musical tradition but from the hymn-writers *(kanonisti)* of the Byzantine church, for whom *simfoniya*, in the original Greek, meant concinnity *(soglasovaniye)* and coordinated activity *(soglasovannaya deyatel'nost')*. The Stravinskian resonance is clear as a bell. In his *Symphonies d'instruments à vent*—Symphonies of (not for!) Wind Instruments of 1920, composed as a memorial for Claude Debussy, the title of which has often puzzled musicians because of its curious use of the plural—Stravinsky also intended a Byzantine-Greek appropriation of the term. The idea of *soglasovannaya deyaltel'nost'* is especially relevant to a piece in which the music constantly shifts among three precisely calibrated proportional tempos. The work was first published in 1926, but only in a piano transcription that until 1952 was the only score in print. The transcriber, of course, was Arthur Lourié.

These were not coincidences. The Eurasianist writings quoted in the foregoing discussion all appeared in journals, or were issued by publishing houses, that were bankrolled by Souvtchinsky, who as heir to a sugar fortune had already played the role of Maecenas to musicians in Russia, and who would continue to play at patronage in Paris to the end of his days. (He was an early sponsor of Pierre Boulez, and a principal backer of the *Domaine musical*, Boulez's concert society of the 1950s and '60s.) Lourié's most extensive and comprehensive early writings on Stravinsky were all published in Souvtchinsky's Eurasianist journals. They were intended for a book on Stravinsky that Lourié was planning to publish through Souvtchinsky's *Yevraziyskoye knigoizdatel'stvo* (Eurasian Publishing House), which was also Trubetskoy and Karsavin's principal outlet. "Neogothic and Neoclassic," published in America, might seem an exception; but the article from which it was drawn, "Muzïka Stravinskogo" (The Music of Stravinsky), was in fact the introduction to the intended monograph. It graced the maiden issue of *Vyorstï* (Versts, or mileposts), Souvtchinsky's most richly appointed Eurasianist journal, now celebrated as "one of the most enduring literary monuments of the prewar Russian emigration."[52] It was here that Lourié first expounded, for a reading public that would have grasped its full range of subtexts, the dialectic on which his Schoenberg/Stravinsky dichotomy would be founded.

Here, for example, in their original form and somewhat literalistically translated for the sake of the resonances thus gained, are the two paragraphs that—altered, abridged, and recast—became the first three paragraphs of "Neogothic and neoclassic":

> For those who create the living experience of our day, commitment to emotion is obviously being replaced by commitment to consciousness. The collision of these two forces has given rise to a new style. On the one hand there is the new Gothic. By this I do not mean a medieval style, but rather the striving for expressivity, which has become an end in itself, manifested through the sphere of personality, subjectivity, contingency rather than rule. This, albeit superficially renovated, is the same old individualism (a direct, atavistic link with the nineteenth century), and the emotional extremes of expressionism are its natural consequence. On the other hand there *is geometrical thinking* (purely musical), the true expression of which is *material realism [plasticheskiy realizm]*.[53] To put it more precisely, a neoromantic, which is to say revolutionary, *sensibility* is giving way to a classical or religious *consciousness*.
>
> These two basic ideologies of our day are antipodal. They are mutually exclusive. The first way is forever egocentric, whether narrowly or broadly. It is fatally connected with merely "calendrical" time and leads to mere self-assertion, whether on the part of the individual or of the mass. The other way is theocentric. It leads to the affirmation of what is unwavering and to unity. Its meaning lies in the escape from "calendrical" time into the *concept of musical time*.[54]

Schoenberg is for the moment unnamed, but the association of Stravinsky—and of Lourié—with Turanian principles is already implicit (replete with theocratic references that were excised from the version submitted for American consumption), along with the theory of time that Souvtchinsky, a decade or more later, would reappropriate in turn and then, as it were, donate back to Stravinsky for recycling in the *Poétique*. The paragraphs quoted from the original article in *Vyorstï* are its fourth and fifth. The opening three, dropped from the version published in *Modern Music,* which would have constituted the preamble of the intended book, embody a veritable musical paraphrase of the Eurasianist political program:

> The demon of boredom has taken possession of contemporary music. What we have been accustomed for the last ten or fifteen years to calling "modernism" has actually turned out to be the devastation of musical art. This footless little word has become a mark of disintegration. Jolly disorder has grown up alongside the warping of musical invention. In recent years things have reached the point of complete anarchy. Like any anarchy it has above all else enveloped us all in a horrific boredom.
>
> A giant spider sits in the contemporary concert hall and holds audience and performers alike fast in its web of boredom. French music is in an incessant struggle with boredom, while German music is doomed to boredom and resigned to it. Stravinsky is transforming the concert hall and summons our active engagement.

Our musical age proceeds under the auspices of this artist. He belongs to that small number who in various walks of life effectively express the qualities that define the present. In a formal sense, and today more than ever, Stravinsky is *a call to order*. A mighty shout amid the decay in which music languishes. He is a dictator, but in essence his dictatorship is a symbol of living consciousness. His is a new dogma and an authentic contemporary *Weltanschauung*.

The way of being in the world that shaped the art of the last century has vanished. The new arises to take its place with enormous effort. The nineteenth century was a difficult century, and the whole first quarter of the twentieth has been devoted to overcoming it. In music, wherever the traditions of the recent past hold sway one sees confusion and instability: either listless obsolescence or innocent pipe-dreams. Decadent modernism holes up in a shell of pseudo-innovation and "daring come what may," but it no longer tempts anyone. What only recently beguiled us with the charms of a seemingly pure aesthetic has by now become perhaps the most vulgar merchandise on display in the art bazaar.[55]

A few years later Lourié summed it up in a single phrase. In his authorized biography of Koussevitzky he referred to Stravinsky as the "dictator of the reaction against the anarchy into which modernism degenerated."[56] As for Stravinsky himself, beginning around 1925 he loved to shock reporters with claims that "Modernists Have Ruined Modern Music," to quote the headline that ran above one such interview, given on arrival in the United States for a concert tour (his first visit to America).[57] The main thrust of Lourié's article, the eminently Eurasianist thesis that was to have launched his monograph on Stravinsky, was that Stravinsky had transformed himself from a "Russian" composer into "universal" one. He achieved this status, in the first place, by successfully jettisoning all that was covertly European or "panromanogermanic" in his ostensibly nationalist style (which is to say, all that he had inherited from his teacher, to the enduring chagrin and consequent enmity of Rimsky-Korsakov's survivors). And, in the second place, by divesting his music of all residual traces of Russian folklore, so that, while conforming to a rigorously non-European, Turanian mentality, his music no longer sounded indicatively "Russian" according to the expectations of Westerners. "In Russia *The Nightingale* already evoked a howl of despair," Lourié declared (possibly on the basis of firsthand experience, for *The Nightingale* was one of the last Stravinsky scores to be heard in Russia before his music was shut out of the Soviet performing repertoire), "so completely did it withdraw from the Korsakovian pseudonational opera that had risen from a German yeast."[58] The composers of the Mighty Kuchka had "poured Russian wine into German bottles," which made them mere purveyors of exotica.[59] It had fallen to Stravinsky to "break the ties that connected Russia with Western Europe," as a result of which "for the first time Russian music lost its 'provincial,' 'exotic' quality and . . . has become a thing of capital significance, at the very prow of world music."[60]

This characteristic whiff of Russian messianism returns in more explicit guise at the essay's peroration: "Beginning with Glinka and up to the most recent past, the experience of Russian music has merely been a repetition and an idiosyncratic reflection of European experience. In our day a Russian musician, Stravinsky, is himself creating the universal experience, and European musical consciousness is drawn into his wake."[61] To juxtapose the article's conclusion with its premise, as expressed in the opening paragraphs, is to see how Lourié has cast Stravinsky as the savior of European music just as Eurasianists were wishfully casting Russia itself, reinvented as Turania, as the savior of Europe. What clinches the association between Lourié's musical interpretations and the general Eurasianist program is the superficially paradoxical idea that it was only when he stopped basing his work on Russian folklore that Stravinsky was able *as a Russian composer* to achieve truly universal European significance. His Russianness, something that went much deeper than style, conditioned the cultural turn that Europeans interpreted, and followed, as neoclassicism. That cultural turn, for Eurasians, had ineluctable social and political ramifications even as it projected esthetic purity. The ramifications were precisely what made it an irresistible force, and rendered Stravinsky a dictator.

As if fixated on the Eurasianist-tinctured narrative he had concocted in this first attempt to account for Stravinsky's significance, Lourié recapitulated and embellished the account of Stravinsky's emergence and import in subsequent articles that were neither devoted exclusively to Stravinsky nor addressed to a Russian readership. In an essay entitled "Puti russkoy shkoli" (The Course of the Russian School), written in Russian but first published in French in the *Revue musicale* and (in expanded form) in an English translation by the ever-ready Pring in the *Musical Quarterly*, Lourié once again proclaimed what we might now be tempted to call the globalization of Russian music:

> But for Stravinsky, the fate of Russian music in the West would probably have been quite different by now. As I have already remarked, Stravinsky found an outlet from the national plane to the universal, and therefore, thanks to him, the new Russian music in the West has entered the international arena. It has not forfeited its national character, but a distinguishing peculiarity of our Western group of [Russian émigré] composers is that the "exotica" which Europe used to consider an indispensable national attribute of the Russian style have been eliminated. The young men of the West are already following what might be termed the Stravinsky tradition, and treading the path which leads towards the solution of general, and not restricted and specifically national, problems.[62]

This, of course, is propaganda: writing that seeks less to inform than to influence the reader, writing that attempts less to describe what is than to bring about what it describes. The vision of Russian music conquering, and thus saving, the world is at the heart of Lourié's message. Having identified it, one is justified in

identifying Lourié as the Eurasianist musical politician par excellence. But what sort of politics is Eurasianist politics?

IV

Knowing Stravinsky's political predilections during the heyday of Eurasianism, I once wrote confidently that in casting him as the dictator of reaction Lourié had depicted him as "the Mussolini of music, who wanted to do for modern music what the Duce promised to do for modern Europe."[63] I have no doubt that that was how Stravinsky wished to see himself cast, and that Lourié knew it, but I would not insist that Lourié had meant to advance that particular political program when writing thus about Stravinsky. Although Eurasianists were united in seeing liberal democracy as a degenerative disease infecting whatever panromanogermanic thought had infiltrated, including contemporary music, they differed in the antidotes they prescribed, although anything prescribed as an antidote had to be viewed as indigenous to "Turania," the ur-Russian utopia of their fantasies. All Eurasianists envisioned the Turanian utopia as a political monolith, as it indeed had to be in order to qualify as salvific, and as an esthetically imagined entity could only be. Unlike Turania, however, Eurasianism existed in the real world, and was no monolith. From the beginning there were factions, and what chiefly distinguished the factions was their attitude toward Soviet Russia.

Many Eurasianists took a simple "white émigré" view of Bolshevism, seeing it as the ultimate rationalistic travesty of their homeland, tainted with Jewishness to boot. Such a one was Trubetskoy; another was Karsavin, who regularly professed his enthusiasm for Mussolini in articles and book reviews in the Eurasianist press, his only reservation being that Italian fascism was a wholly secular movement operating within a Catholic country and therefore unable to promote symphonic society in all its fullness.[64] In 1927, a year after the authoritarian anti-Bolshevist Smetona government took power through a coup d'état in Lithuania, Karsavin took up a post at the University of Kaunas, which he held until the Soviet occupation in 1940, when he transferred to the University of Vilnius, newly rejoined to the country of which it was the old capital. He held this post throughout the German occupation of 1941–44 and was finally arrested by the Soviets in 1949. He died in a labor camp three years later.[65] Still, for Karsavin, even the Bolsheviks were preferable to constitutional liberals.[66]

Ambivalence toward Bolshevism was more pronounced among the so-called left Eurasians, the faction that included Souvtchinsky, whose writings, apparently motivated by his ill-judged political ambitions, occasionally approached apologetics on behalf of the Soviet state. At a time when all émigré organizations were subject to infiltration by Soviet agents, he was occasionally suspected, precisely because he was the movement's chief enabler, of being a provocateur.[67] In the

mid-thirties, by which time the movement had splintered, Souvtchinsky seemed to be playing a remarkably wide field, politically. It was he who assembled the texts from Marx, Engels, Lenin, and Stalin for Prokofieff's massive *Cantata for the 20th Anniversary of the October Revolution,* a work that, contrary to previous assumptions, was entirely Prokofieff's idea and was planned and partially sketched prior to his return to Soviet Russia;[68] but it was also Souvtchinsky who ghosted the fanatically anti-Soviet fifth *leçon* ("Les avatares de la musique russe") in Stravinsky' *Poétique*. Clearly, by the late 1930s Souvtchinsky was available for collaboration on behalf of any and all of his friends.

More significant enunciations of principles that led Eurasianists toward reconciliation with Bolshevism included an article by Mirsky, "The Ambience of Death in Prerevolutionary literature" ("Veyaniye smerti v predrevolyutsionnoy literature"), originally delivered as a lecture before a scandalized émigré audience in Paris.[69] At its peroration, Mirsky resorted to a surgical metaphor to equate what he took to be the salubrious change in postrevolutionary literature with the revolution itself. Russian literature had been dominated by a "decomposition of the spirit," manifested in "mystical eroticism," and even more serious symptoms, such as "subterranean necrophilia, pathophilia, and a love for non-existence." These were afterward replaced by

> formalism, futurism, and acmeism. The significance of all three lay in their amputation of the spirit, which was so far gone in decomposition that it could not be healed. But *ferrum sanat* [the knife heals],[70] and to save the organism the decomposing spirit was removed. This operation may not have saved us, but had it not happened, it would have been impossible for us to be saved. (Thus, the Revolution itself was a crisis that could have been followed by either death or recovery, but without it recovery was impossible.)[71]

What makes this statement significant is its congruence with Souvtchinsky's own diagnosis of modernism, in all media and all countries, as having replaced "dematerialized art, descriptive images, and topical expressivity"—the legacy of egotism—with an extreme formalism in which "material has ceased to be a means of revealing creative processes, [but rather] has converged with these processes into one creative form."[72] Accordingly, as Sergei Glebov summarizes Souvtchinsky's thesis, "the dominant method of modern art is constructivist and compositionist, and successful products of art are not those that are maximally beautiful in given conditions, but those that better reflect the internal laws of composition and overcoming of space, time and material."[73] This much may be regarded as boilerplate neoclassicism; what makes it specifically Eurasianist is Souvtchinsky's further insistence that the new drive toward formalism is "connected with the search for religious foundations," a search that arises out of a need to "break away from the differentiating" toward "a common psychic answer to life phenomena."[74]

The congruence of all of this with Bolshevism was made clearest in the unsigned editorial that appeared in the second issue of *Yevraziya*, a short-lived weekly that Souvtchinsky founded and funded, and Mirsky edited, in 1928–29. The article was titled "The New 'West,'" and the reason for the scare quotes around "West" was the fact that the new West turned out to be Russia. The article's thesis was that the Russian Revolution had radically reversed the political and cultural perspective that had previously governed relations between Russia and Europe.

> In Russian consciousness, Europe had always been considered *the land where problems were solved*. At a time when Russia was frantically writhing in place, it seemed that the West, easily and simply following its course, was going effortlessly from one triumph to another and painlessly unraveling all of life's knots. It is a matter for historical investigation to establish the extent to which such an evaluation of Europe in relation to Russia corresponded at various times to the actual state of affairs. What matters is that such a myth existed, and both Russia and the West lived by its lights. But what matters even more is that faith in this myth *has now been shattered* for all to see, and it was the Russian revolution that shattered it, far more than the world war with all its hopeless consequences. Under the looming difficulties of its social problems and political predicaments the ceiling has lowered immeasurably over Europe in the last decades. But above all, the troubles at the heart of Western culture have made themselves known. The very structure and fabric of life in classical Europe, all that constitutes its traditions and strengths, all that it had regarded as legitimate and absolute, has begun to exasperate and enervate a considerably larger number of people in Europe itself than meets the eye.[75]

The cause of this enervation and irritation will come as no surprise to anyone who knows Lourié's music criticism:

> The principle of personal freedoms and individual self-determination, promulgated by every European revolution, has in the course of time turned into a harsh social indifference, in the face of which no one's social situation finds any guarantee beyond himself. And even one's civil rights must be in essence *won* by each for himself, under conditions of general ruthless competition, which must weary and embitter not only the laggards, the dropouts and the losers. It is natural that amid incessant existential alarms and fruitless social strivings a thirst for social stability and a quest for another way of life should arise among the broad masses, one in which the personal fate of each human being is somehow *guaranteed* by some objective and mandatory authority.

The author (whether Souvtchinsky or Mirsky) here describes in social terms the sort of debilitating anarchy we have seen Lourié repeatedly describing in cultural or esthetic terms. Europe faced a crossroads. On one side lay the principle of *free inequality* (to borrow the article's italic megaphone for a moment) that had brought panromanogermanic society and culture to an impasse. On the other lay the capacious principle of *constrained equality*[76]—the Russian way, as applicable to Soviet communism as it was to Eurasianist symphonic society. That is how the

author sought to explain the wrong turn Russia had taken. The revolution had been right to overthrow the tsarist autocracy, which had become infected over the course of the nineteenth century with liberalism, starting with the disastrous reign of Alexander II, the Emancipator Tsar. Thus, in the author's view, Eurasianism shared with Bolshevism considerable common ground: the collectivist principle, the need for a "*new type* of state" (italics again original) "that might be called, in contradistinction to the neutral, irresponsible polity of Western democracies, an *insurance state [gosudarstvo strakhovoye]*," defined as the social and ethical constituent of an ideal Eurasianst ideocracy. Regardless of all shortfalls, the Soviet experiment was thus a down payment on the Eurasianist ideal.

> It was altogether unexpected that the Russian revolution, ignited by 1880s-style communism, for which the supreme principle is merely the hedonistic principle of the just distribution of goods, has in its depths suddenly revealed a "common philosophical cause" with us. A certain possibility of approaching, by means of revolution, a solution to the fundamental problem of our time—the problem of a new polity—has immeasurably raised the ceiling over Russia vis-à-vis the European level and makes the territory of the Russian revolution the place where the problems of the twentieth century will be, if not solved, then at least posed in a way that can lead to solution, while the West, in the process of defending its bourgeois foundations, has not only not posed them, but has lost its ability even to understand them.

Thus the Russian Revolution—because it was the *Russian* Revolution—was still and all, Bolshevism or no Bolshevism, the hope of mankind. The tables had turned: "Once upon a time it was the West that with its light and airy *ocean wind* attracted troubled Russian souls, suffocating under the low roof of Russia. Will not the time come, when that wind, subsiding more and more in Europe, will arise over the continent of Eurasia, and will that continent not soon become for new European generations what 'oceanic' Europe once was for Russian 'runners' and seekers of truth—a new ocean, where breathing is easy: *a new 'West.'*"[77]

Almost forty years later, Lourié was still echoing this line. The British actor Robert Speaight, a close friend of Maritain, interviewed Lourié in 1966 for *Blackfriars* magazine and reported that "like so many Russian exiles, [Lourié] has a charity towards the Revolution whatever they may think of its deviations. They see beyond it to a messianic vocation of universal brotherhood, of which they believe Russia to be the destined standard-bearer. Lourié seems even to imagine a kind of theocratic socialism. It was not communism but commerce which created the ugliness and vulgarity that he condemned."[78]

But the question inevitably arises: given their investment of optimism in Soviet Russia, what were Souvtchinsky, Mirsky, Lourié, and the other Eurasianist "runners" doing in Europe, now that the winds had changed? This became *the* existential question for Eurasianists, some of whom actually did go back to Soviet Russia, mostly to a bitter fate. (The best known were Mirsky and Efron.) "Left"

Eurasianists who stayed in the West often rationalized their decision by calling it a cultural rather than political choice, creative freedom despite inequality being a decisive factor for artists. But at the least it should be clear that it is inaccurate to characterize Souvtchinsky as "hostile to all things Soviet,"[79] even if he did try to talk Prokofieff and his wife out of returning from exile, pointing to the tribulations to which Shostakovich was subjected in 1936, and even if he later ghostwrote for Stravinsky the chapter that remained unpublishable in the USSR, even when the rest of the *Poétique* was translated and printed there in honor of Stravinsky's eightieth-birthday-year visit (when the Soviet government was somewhat naively trying to woo the great composer back to his long-forsaken homeland in time to bury him there).

Yet having recognized the possibility of common ground, and even common cause, between Eurasianists and Bolsheviks, one must guard against the assumption that such an affinity in any way mitigated the ties already observed between Eurasianism and the political right, even within the mind of a single individual, who would not have thought his mind in any way divided. Common antipathy to permissive and "irresponsible" bourgeois democracy, as well as to capitalism, united all of these factions, whether of the left or the right as we now retrospectively, and anachronistically, define them.[80]

V

Locating Lourié within the Eurasianist ideological spectrum is not something one can do with great precision. As is already evident, the Eurasianists, far from a militant or disciplined faction, were a loose and dreamy association of the vaguely like-minded. Except for those who applied the word to themselves in print, is it hard to determine "membership" in the group. Nevertheless, it seems fair to call Lourié a member, even if the movement issued no card to carry, for he not only published many of his articles in the Eurasianist press, but also joined the masthead of *Yevraziya*, the weekly review, bankrolled as always by Souvtchinsky, that appeared in 1928–29.[81] That publication, as we have seen, was very much of the "left"—so much so that the two original Eurasianists, Trubetskoy and Savitsky, in a long letter to the editor of another émigré newspaper (later published as a pamphlet), denounced it as a Marxist, pro-Soviet deviation from the authentic Eurasianist line.[82] There was no such official line, however. There was, instead, an internal schism between the proprietary claims of the founders and the later enterprises of the more energetic members, which eventually splintered the movement. That Lourié's name was firmly associated with the movement while it lasted is clear enough. A letter from Maxim Gorky, then an émigré, to a correspondent in Moscow, evaluating the first issue of *Vyorstï*, noted that it seemed (on account of its being edited by Mirsky) a "princely affair," but that "the Eurasians are in here

too—Lev Shestov, Arthur Lourié, and, of course, Marina Tsvetayeva and [Alexey] Remizov."[83] Was Lourié "right" or "left"? Despite the testimony he gave Speaight in 1966, recollecting his turbulent life from the nostalgic security of his final home in Princeton, this is a difficult question to answer within the context of the émigré twenties and thirties, when Lourié had a Bolshevik past to live down yet needed to maintain credibility with, among others, the rigidly "white" Stravinsky.

He was enough of a Communist in the eyes of the French government to warrant deportation after his first attempt to establish French residence in 1924. To some Russian émigrés, he was irrevocably suspect. In November 1926, after Lourié had succeeded in clearing his name with the authorities and resettled in Paris, Vladimir Dukelsky (the later Vernon Duke) wrote from there to his brother in America that Stravinsky was "surrounded by suspicious and worthless gentlemen like the retired Bolshevik Lourié."[84] After the first issue of *Vyorstï* was published, carrying Lourié's most extensive and programmatic Stravinskian essay (which probably provoked Dukelsky's complaint), Lourié wrote to Stravinsky to protest the hostile reception the journal had suffered in what he called "the 'liberal' émigré press," his scare quotes conveying the disdain for liberalism that united Eurasianists of all stripes.[85] He was evidently referring to a gripe that the poet Vladislav Khodasevich (1886–1939) printed in the émigré newspaper *Sovremennïye zapiski* that *Vyorstï* was receiving a subsidy from the Soviet government and that among its contributors "there is a genuine Communist: Arthur Lourié, the former head of the music section of the Soviet commisariat of education. Here he is something of an overseer *[khozyaiskiy glaz]* or a plant [*svadebnïy general*, literally 'wedding general,' invited to add class to an otherwise undistinguished guest list]."[86] In the aftermath of this denunciation, Lourié was moved, or required, to write to Souvtchinsky in a manner presaging similar declarations from Americans during the years of Joseph McCarthy's ascendency: "I consider it necessary formally to state that I have never had anything to do with the Communist Party, because when I was the head of the Music Section [within the Commissariat of Education in Petrograd in 1918–21] my job required that I be in close touch with [Anatoly Vasil'yevich] Lunacharsky [the Commissar of Education] and other people of that sort. In fact I was never a Communist."[87]

Whatever the circumstances that motivated this disclaimer, it is plausible enough. A memoir by Nikolai Nikolayevich Punin (1888–1953), written in 1921, when memories were fresh and Lourié not yet anathema, tells how he and Lourié became members of the fledgling Bolshevik arts administration. An art historian, Punin is now best remembered for his relationship, sometimes described as a civil union or common-law marriage, with Anna Akhmatova, the great poet on whose coattails Lourié has also ridden on occasion to notoriety in the West. (In the catty opinion of one British Slavist, Lourié was "most famous [as] another man besides Boris Anrep whom Akhmatova refused to follow into emigration."[88] Lourié and

Punin had gone to the Winter Palace very shortly after the Bolshevik coup to seek permission to put on a play by the futurist poet Velimir Khlebnikov (1885–1922), whose name graces the epigraph atop this chapter. They were met by Lunacharsky, the commissar himself, which surprised and impressed them (above all as an indication of "the loneliness of the Bolsheviks in the first few months"). As Punin recalled the meeting, Lunacharsky "willingly and at length talked to us of art, of the tasks of the Communist Party and the position of the intelligentsia. Soon our little project of staging in the Hermitage theatre was left far behind. The question under discussion was of the organization of a new administrative apparatus in all fields of art."[89]

At the end of the meeting Punin found himself a member of the Petrograd collegium of IZO (*Otdel izobretatel'nïkh iskusstv* or visual arts section) and Lourié found himself appointed to MUZO (*Muzïkal'nïy otdel* or music section), of which he would soon be named the head. Their appointment was not evidence of political zeal. (Indeed, Punin's career was marked by constant political conflict and repeated arrests; he died in the Siberian labor camp at Vorkuta.) Their appointment sooner "reflects the fact," in the canny words of Amy Nelson, "that initially only artistic radicals were willing to work with Lunacharsky."[90] It also reflects Lunacharsky's assumption, characteristic of pre-Stalinist Soviet policy, that—as he put it to Prokofieff when the latter announced his intention to emigrate—"you are a revolutionary in music, we are revolutionaries in life. We ought to work together."[91]

All the same, denials made under political pressure cannot be taken as read (though Lourié's ardent Catholicism would eventually have made him hard for the Soviets to accept no matter what he thought of them, and might help explain his need, finally, to defect). Explicit declarations like the one Lourié made to Souvtchinsky have to be balanced against the implications of his writings, as they do in the case of Souvtchinsky himself.

With Stravinsky the pressure was different. By the 1920s, he was a dyed-in-the-wool "white," a zealous anti-Bolshevik who would never have accepted Lourié's friendship if he suspected him of pro-Soviet attitudes. (And this might already explain Lourié's need to so emphasize, and even exaggerate, his religious side in writing to Stravinsky, whose religiosity was also, to some extent, an anti-Soviet posture.) The compulsion coming from Stravinsky, in any case, was as much economic as political. The relationship between Stravinsky and Lourié was in part (and began wholly as) a business relationship. Stravinsky was a source of remunerative work, at first chiefly via Koussevitzky's publishing house, which commissioned from Lourié first the piano reduction of the Octet for winds in 1924 and then the Symphonies of Wind Instruments the next year.[92]

These brilliantly executed transcriptions were surely what won Lourié his entrée into Stravinsky's inner circle. They show a remarkable technical grasp of a sort that would win any composer's respect, particularly one who would aver, like

Stravinsky, that "up to a point technique and talent are the same," and that "if I hear of a new composer's 'technical mastery' I am always interested in the composer."[93] There was also a previous business relationship of sorts between them dating from the days when Lourié, as the chief musical functionary of the fledgling Soviet government, offered material assistance to Stravinsky's mother (who reciprocated by allowing the young commissar, who lacked a heated apartment, to take shelter in her residence the next winter). That no doubt eased Lourié's initial contact with Stravinsky, as did his close relationship with Olga Glebova-Sudeykina, the future Vera Stravinsky's predecessor as a wife of the painter Serge Soudeikine. Apparently Olga, Vera, Serge, and Lourié lived for a while as a virtual *ménage a quatre* in Soudeikine's splendid apartment on the Fontanka, St. Petersburg's Park Avenue.[94]

But these fortuitous personal links could scarcely have vouchsafed the musical trust Stravinsky invested in Lourié, to the amazement of his other friends. "What I do not understand," Souvtchinsky told Craft on their first meeting in 1956, "is how Lourié could have had Stravinsky's musical esteem. But he *did* have it, was in fact the first person to be shown each new work up to the time of *Perséphone*," which is to say 1934.[95] Their relationship was indeed a close one, and the best proof of that is all the backbiting and belittling Lourié has attracted from jealous memoirists and supercilious biographers (of exactly the kind that would dog, and continues to dog, Robert Craft). To Stephen Walsh, Lourié was an "office boy."[96] To Souvtchinsky, he was a *valet de chambre*.[97] To Nicolas Nabokov, in an especially catty memoir, he was "Stravinsky's shadow."[98] But what he was, or aspired to be, was Stravinsky's mouthpiece.[99]

The extensive Lourié-Stravinsky correspondence, which mainly survives on Lourié's side (Stravinsky having been a lifelong conserver of letters), actually begins with a missive from Stravinsky in Carantec, Brittany, to Lourié in Petrograd dated 2 September 1920 (also preserved by the sender, in his *Copie de lettres*, rather than by the recipient), in which, addressing the then Soviet bureaucrat as "Dear Comrade" *(Dorogoy tovarishch)*, he asks for help in liquidating such of his own property as remained in the old family apartment so as to pay the requisite fees for his mother's emigration.[100] Victor Varunts, the editor of Stravinsky's Russian correspondence, notes that the salutation "Dear Comrade" "is absolutely out of character" for Stravinsky. "One may suppose," he writes, "that Igor Fyodorovich pondered for a considerable time before arriving at a suitable salutation for so exalted an echelon in Lenin's government. But doesn't a certain irony also show through here?"[101] Surely not! The last thing Stravinsky would have wished was to condescend to, and risk antagonizing, the man on whose uncoerceable good offices his mother's fate depended. He must indeed have pondered, and that very fact precludes trifling of the sort Varunts imagined.

And yet Lourié appears to have been unable to secure Anna Kirillovna Stravinskaya's exit visa; she did not manage to emigrate until October 1922, by which time

Lourié himself had become a "runner." This shows that, despite the official title that has caused many others after Stravinsky to assume he had wielded a great deal of personal power in revolutionary Petrograd, Lourié in fact did not occupy such an exalted echelon in Lenin's government. Far from a policy-maker, he was a midlevel executive whose actual job as titular head of the MUZO within the Narkompros *(Narodnoye komissarstvo prosveshcheniya)*, or People's Commissariat of Education, was confined to such managerial and administrative tasks as organizing concerts, implementing the nationalization of property and institutions, regulating copyrights, and carrying out what we now call outreach or audience-building projects. These were assignments befitting Lourié's actual standing in the artistic and political communities at whose nexus he—"a twenty-five-year-old composer and self-proclaimed futurist with no administrative experience or broad-based authority in the musical community," in the well-weighed words of Amy Nelson—rather improbably stood.[102]

The main body of the surviving correspondence consists of fifty-seven letters from Lourié dating between 14 February 1924 (about a month after Vera Sudeykina introduced him to Stravinsky)[103] and 18 June 1939 (Stravinsky's fifty-seventh birthday, which took place at a time of great upheaval in his life owing to the deaths of his mother, wife, and daughter, in the course of which his relationship with Lourié—and with many others—had foundered).[104] The letters chiefly chronicle, on the one hand, Lourié's activities on Stravinsky's behalf and, on the other, the religious enthusiasms that solidified their bond (though his exhortations that Stravinsky compose an Orthodox Mass fell on deaf ears).[105] Several letters give evidence (*pace* Walsh and others) of Lourié's genuine intimacy not only with Stravinsky but with his family as well.[106] In several letters Lourié discusses his own compositions (*Concerto spirituale, Pir vo vremya chumï* [A Feast during the Plague, after Pushkin], *Sinfonia dialectica*) with a correspondent who obviously knew them, conclusively belying the assertion to Souvtchinsky from which this essay took its departure.[107]

There is one letter that demands a closer look, because it sheds light on Lourié's own artistic convictions, and on this essay's major themes. On 8 and 13 December 1927, Arnold Schoenberg made two appearances in Paris, conducting his own music at the then brand new Salle Pleyel. Stravinsky was away at the time with his wife and daughters in Nice. Lourié wrote to him the day after the first of these concerts, at which Schoenberg conducted his tone poem *Pelléas et Mélisande*, some excerpts from *Gurrelieder*, his transcription of two Bach chorale preludes, and *Pierrot lunaire*. Lourié's reaction to this concert provided the immediate subtext and possibly the pretext for extracting and separately publishing the section from his long essay "Muzïka Stravinskogo" that became "Neogothic and Neoclasic," his most influential article, which appeared in America four months later. These are the impressions he set down in his letter, when memory was fresh:

Schoenberg has literally taken over everything: symphony concerts, chamber music evenings, salons, and even a *causerie* on the subject of *"conviction et connaissances* [knowledge and belief]." Yesterday I was at his concert in the Salle Pleyel. It was a full house and everyone was keyed up. The music made a horrible impression, at least on me. I think he is a typical representative of the dark forces, armed to the teeth and asserting only his own self with mind-boggling insistence. He is always trying to be frightening, but all he elicits is anger. The masons, of course, are exulting. [Henry] Prunières [editor of the *Revue musicale*] is giving a banquet, to which we are invited "pour rencontrer Arnold Schönberg." Needless to say, I wouldn't dream of going to such a bacchanale.[108]

Many years later, Stravinsky would tell Robert Craft how sorry he was to have missed these seminal concerts of Schoenberg's,[109] but clearly Lourié was expecting (and at the time surely elicited) his concurrence, antisemitic insinuations and all.[110] The signal point in Lourié's reaction to the concert was his revulsion against what, in "Neogothic and Neoclassic," he called Schoenberg's egocentrism. That arbitrary and socially divisive self-assertion was the original neogothic sin that the neoclassic was meant to redeem. This was the sense in which Stravinsky could be said to have created his art "in reaction to Schoenberg," whose music he hardly knew.[111] But it was also the sense in which Lourié ultimately parted company with Stravinsky, because it gives evidence of a social conscience Stravinsky made a career of defying.

VI

From here on, then, we shall consider Lourié not as an extension of Stravinsky, or as his mouthpiece, but as a musical and sociocultural thinker in his own right, and as a representative voice of Eurasianism. His contributions to *Yevraziya*, the journal in which his name appeared on the masthead, will serve us as a touchstone to furnish a perspective on writings that both predate and postdate the Eurasian movement as such. Conversely, in the light of these earlier and later pieces, Lourié's Eurasianist phase will take its place within the broader evolution of his thought.

One does not need to be a paid-up Eurasianist to be obsessed with Russia's relationship to the West. All urban, educated Russians shared—and share—this obsession, which has fostered a wide and unpredictable range of opinion. So it comes as no surprise that Lourié was already expressing strong views on the matter even before he went to work for the Bolsheviks, during his bohemian days as a Petrograd "futurist." It was in an explicit "futurist" manifesto, in fact, that Lourié showed the first sign of proto-Eurasianist thinking.

Its title was *Mï i zapad* (We and the West), and it was a broadside riposte to Filippo Tommaso Marinetti, the author of the first Futurist manifesto, who had visited St. Petersburg in 1914 and insulted his hosts after his return by calling them

"false Futurists, who distort the true meaning of the great religion for the renewal of the world."[112] Teaming up with the painter Georgiy Yakulov (the future constructivist whose success at the Paris Art Deco exhibition of 1925 would inspire Prokofieff's *Le pas d'acier*) and the poet Benedict Livshits, Lourié hurled the affront right back in Marinetti's teeth:

> A crisis has overtaken Europe in its creative quests (there have been no achievements!), expressed outwardly in a turn eastward. IT IS NOT WITHIN THE POWER OF THE WEST TO COMPREHEND THE EAST, for the former has lost any conception of the limits of art (having confused questions of philosophy and aesthetics with methods of artistic embodiment). EUROPEAN ART IS ARCHAIC, AND THERE IS NO NEW ART IN EUROPE, NOR CAN THERE BE, because the latter is built on COSMIC elements. Nevertheless, Western art is TERRITORIAL. The only country so far lacking any territorial art is Russia. The whole endeavor of the West is directed at FORMAL GROUNDING in the achievements of old art (old aesthetics). Nevertheless, the West's attempts to construct a new aesthetic, since they are *a priori* rather than *a posteriori*, have been FATALLY CATASTROPHIC: a new aesthetic must follow upon new art, and not the other way around. Acknowledging the operative difference between Western and Eastern art (Western art is the embodiment of a geometric worldview, proceeding from object to subject, while Eastern art is the embodiment of an algebraic worldview, directed from the subject to the object), we affirm the following as principles COMMON to painting, poetry and music:
>
> 1) Arbitrary spectrum,
> 2) Arbitrary depth,
> 3) The independence of tempos, as a means of embodiment, and rhythms, which are immutable;
>
> and as SPECIAL principles:
>
> FOR PAINTING
> 1) Rejection of conical construction along with trigonometric perspective;
> 2) Dissonances.
> —GEORGIY YAKULOV
>
> FOR POETRY
> 1) The unbrokenness of the individual verbal mass;
> 2) Differentiation of masses of varying degrees of resolution: lithoid, fluid, phosphoid;
> 3) Overcoming the accidentalist approach
> —BENEDICT LIVSHITS
>
> FOR MUSIC
> 1) Overcoming linearity (architectonics) by means of inner perspective (synthesis-primitivism);
> 2) Elemental substantiality.
> —ARTHUR-VINCENT LOURIÉ[113]

In a speech he read before an audience of young artists in Baku in April 1917, during the revolutionary spring that followed the tsar's abdication but preceded Lenin's coup, Lourié returned to the themes of the manifesto, declaring that "evolution has led the West by successive, progressive degrees into a creative catastrophe, to utter spiritual bankruptcy, and in the person of its individually most significant artists and thinkers the West itself now presents us with the clearest example of exodus toward the primeval, holistic cultures of the East; for here, at the font of primeval wholeness and purity of artistic contemplation, one envisions salvation and freedom." The culprit responsible for the catastrophic bankruptcy of the West was its commitment to "reason" and "linearity" of thought. In terms of Russian history, this translates into a familiar scenario: "From the time of Alexey Mikhailovich, the 'Pacific' Tsar, the last preserver and expresser of the Asiatic spirit of our land, in the life of Russia the exodus from Asia has gone on for an agonizingly long time, beginning with Peter, who turned the ship of Russian state, along with Russian art and religion, toward 'foreign shores.'" It took the world war to right this centuries-old wrong: "Russia is at the present moment the country to which all Western eyes must turn, as to a source of healing, for in contradistinction to the West, Russia's strength is in its future."[114]

There may not be anything in this exhortation that is expressly and exclusively attributable to Eurasianism, or ineluctably predictive of it, just as it is not in itself a sign of Eurasianism to characterize *Le sacre du printemps,* as Lourié would later do, as "an affirmation of the Asiatic spirit of Russia."[115] In itself such an assessment was a common reaction to Stravinsky's (and not only Stravinsky's) neoprimitivism, especially among those for whom it was an exotic treat. But it was out of just such a synthesis of futurism and Slavophilism as the one Lourié advanced in Baku that Eurasianism eventually emerged; and as Igor Vishnevetsky has pointed out, Lourié's homily could easily be read as a partial, prescient paraphrase of Souvtchinsky's "The "New 'West,'" one of the crucially programmatic Eurasian texts.[116]

Which brings us to Lourié's own most programmatic statement: a fairly extended essay, published serially in *Yevraziya,* called "Krizis iskusstva" ("The Crisis of Art" or "Art in Crisis").[117] This piece, which postdates all of his essays devoted wholly to Stravinsky, is an outwardly pessimistic yet stubbornly utopian screed that will remind anyone who has read them of Souvtchinsky's political tirades, and removes all doubt as to Lourié's place, as of this moment (which was also the moment of his most significant creative work), within the Eurasianist faction. The musical world it adumbrates is precisely that of Turania, and his own masterworks, the two symphonies and the *Concerto spirituale,* were in this sense as authentic an expression of Turanian esthetics as the Stravinskian creations Lourié had been propagating as a critic.

The crisis of which Lourié complains in this essay is the familiar calamity of corrupting egotism. In the modern art of Europe, he asserts, "the power of creative and spiritual genius has gone astray and given itself up to the phantom of

false self-assertion," just as misguided individualism has corrupted the politics and economy of Europe. As a result, the old ideal of "art for art's sake" *(iskusstvo dlya iskusstva)* has been perverted into "art without art" *(iskusstvo bez iskusstva)*. The proximate cause of perversion was the original romantic sin—already decried in "Neogothic and Neoclassic," but also (eventually) in the *Poétique musicale* and in the writings of Karsavin and Souvtchinsky—of making art an ersatz religion, "substitut[ing] esthetic for spiritual experience." But the art that now stands in place of religion had been created under a materialist dispensation (capitalist or Marxist, depending where) and is no longer "subordinate to a higher principle." In the West it has become mere "manufactured goods"; in Russia it has become "propaganda in esthetic form." In Russia and the West alike, art has been "subjugated to a ruling class" rather than freely serving society as a whole (239–40).

Lourié's sarcasm sometimes hits the mark. Contemporary art-without-art is not only misguided, he declares, but also unsuccessful. "The esthetic of production in Russia is recognized as serving the interests of the proletariat, while the esthetic of production in Europe sooner serves the bourgeoisie," he observes uncontroversially. "But," he continues, "the esthetically untutored proletariat obviously prefers bourgeois production in art, while the surfeited bourgeoisie lusts after the proletarian." So the proletarian and the bourgeois, contrary to Marxist teaching, are not in a true dialectical relationship. Proletarian art, which in Russia exists only as "a dogmatic premise," does not provide a true thesis. Nor can bourgeois art, cut loose from spiritual experience, provide a true antithesis. "Thus, deprived of its thesis, proletarian art is at the same time unable to arise in reaction to its antithesis. What might in mutual struggle have given rise to new authentic values, amounts only to a sterile draw" (240).

The shining exceptions to the bleak picture Lourié paints were Picasso and, predictably, Stravinsky, but only to the extent that these two had lately "entered into conflict with modernity." Both had rejected their own pasts (in the case of Picasso, what Lourié calls his "formal and emotional exaggerations"; in Stravinsky's case, his *"sturm und drang"*).

> Picasso, having broken pictorial nature down practically to its constituent atoms, has brought it to an organized and organic unity. Stravinsky, having laid bare the essence of music, has reined in chaos, clamping it with a steel bit. Both, having begun with ideally expressed disequilibrium and disorder, have brought their musical and painterly equipment into an ideal state of order, returning to visual and auditory material a durable equilibrium and the regularity of a new causality. Both, departing from a revolutionary dynamic of extreme emancipation, have come to the stasis of submissive contemplation. (242)

In both cases, the public wants what the artist has rejected, and so the artists have become alienated. But what is alienated within a diseased environment is *ipso facto* healthy and nourishing. So, far from a retreat from contemporary life,

Stravinsky's music and Picasso's painting are a documentary witness to the historical events of their time, in all aspects be they esthetic, ethical, political, or social. Picasso's designs have not been a mere backward glance on the past with an eye toward restoration. He has created a new set of relationships that parallel old painting but do not seek to resurrect it. Picasso's formal method, while serving his structural purpose, has at the same time established an equivalence between what has newly arisen and what is past. Picasso's painterly nature, being a concrete reflection of the present, at the same time finds itself in sympathetic agreement with every authentic pictorial-constructive epoch of the past, whether the barbarian archaic or the geometrical thinking of the early Italian Renaissance. Stravinsky has turned away from the present with a feeling of nausea. He has, for reasons other than Picasso's, gone back to the past, where he brings back to life that which he finds resonant not so much with the contemporary canon as with his own personal sensibility. His excursions into the past are conditioned less by formal-constructive principles like Picasso's than by formal and ethical principles. But both of them persistently return to bygone cultures, summoning a whole set of values from the past to renewed existence under the conditions of our contemporary existence. (243)

To the extent that Picasso and Stravinsky have succeeded in pulling other artists into their orbit, "all individualistic procedures in contemporary art are for the moment located outside the effective field of vision." Theirs, being a "formal-objective art," was "supra-individual, impersonal, and supra-emotional" (244), thus embodying the solid virtues of Turanian symphonic society.

But then, so did a lot of art that Stravinsky or Picasso would not have endorsed. One has to wonder, for example, whether the readers of *Yevraziya* were any less surprised than Igor Vishnevetsky, the compiler of the indispensable anthology *Yevraziyskoye ukloneniye v muzïke* (The Eurasian Turn in Music), to find in the journal's pages a warm appreciation of Rachmaninoff as both pianist and composer, following a Paris recital at which the great unregenerate romantic performed Mozart's D major sonata, K. 576; Chopin's B-flat minor sonata and G minor ballade; Liszt's *Sonetto 104 del Petrarca*; and a selection of his own pieces (a *Moment musical*; the G major prelude, op. 32, no. 5; and the transcription of Kreisler's *Liebesfreud*).[118] One suspects that readers were indeed surprised, and that Lourié intended the surprise, because his review starts right off with a pseudo-apology: "I will say it outright, without reservation: I love Rachmaninoff: his strength, his old-fashionedness, all that is homely about his music and about himself."[119] The adjective that Lourié used, and that is translated here as "homely," was *bïtovoye,* a very difficult word to render in English in predicative form. Its literal meaning is, roughly, "pertaining to everyday life," and its most familiar musical use is in the term *bïtovoy romans,* often translated as "domestic" or "household" romance, meaning the kind of old-fashioned parlor song on which, for example, Chaikovsky based the musical idiom of his opera *Yevgeniy Onegin.* It means something familiar, something from home,

something encountered as part of one's taken-for-granted environment, a component of one's unreflected-upon consciousness.[120] Such a consciousness is not idiosyncratic, not peculiar to a single individual, but rather something that informs a collective subjectivity. Therein lies its affinity with Lourié's Eurasianist theorizing, and the reason, presumably, he sought an outlet for his Rachmaninoff-inspired reflections in the Eurasianist press. "The fact that he is accessible to the masses, that his works and his playing make exceptional and immediate contact with the crowd, the 'democratic' quality of his artistic nature—all that constitutes one of Rachmaninoff's highest merits. Herein lies the 'humanistic' aspect of his art, or rather its simple humanity, and to that he owes his worldwide acclaim"[121] (245).

Vishnevetsky suggests that Lourié's unexpected praise of Rachmaninoff "should be considered in the context of the overall Eurasianist pursuit of alternatives to the Western modernist project."[122] But that is merely a negative criterion, and there is a considerable difference between the antimodernism that Lourié attributes to Stravinsky and Picasso, who are both antimodern and intensely (hence, influentially) contemporary, and the old-fashioned antimodernism of Rachmaninoff. The one stance implies renunciation, the other mere indifference or rejection. The latter is a matter of taste, the former of principle. Lourié's antimodernism, like Stravinsky's, was a principled renunciation, and principles require a positive commitment. Toward Rachmaninoff's actual style Lourié remains negative even here: "Rachmaninoff was always, and remains, an outsider to advanced or progressive music," he writes; and that is the reason for what Lourié calls the "justified opposition" to him.[123] Implying a direct comparison with Stravinsky, he adds, even more damningly:

> Having stood apart from everyone, this exceptionally gifted Russian musician still seemed to be predestined for great and serious achievements.... But now, when modernism has shouted its last and died down, it has become clear that unfortunately nothing has come of this predestination. It is strange to speak like this in the face of Rachmaninoff's enormous fame; but that changes nothing, for fame is just fame, and the achievements that should have transpired, and to which he seemed entitled, have not materialized. Rachmaninoff's antagonism to modernity has turned into a stubborn and mistakenly academic conservatism. He has shown no instinct for the move that is now afoot, nor any signs of a contemporary musical consciousness.[124]

But what Rachmaninoff did possess, overriding any anachronism, was the "classical" quality that Lourié, as ever, upheld over its implied antithesis, the egocentric or neogothic. His playing, Lourié avers, "is vivid and always transmits a cool, clear and undecorated design, never introducing any element that is foreign to pianoplaying. In this sense Rachmaninoff's technique should rightly be considered classical. It is the highest development of the concert-salon style of the nineteenth century, and retains a living connection with the great tradition of this style."[125]

Anyone who knows the sixth *leçon* in the *Poétique musicale* will know that this is high praise indeed. The fact that Lourié lavishes it on a figure from whom Stravinsky would have withheld it, and on behalf of a century against which Stravinsky was in revolt, argues for the greater consistency of his philosophical commitments. Stravinsky—and surely Stravinskians—would have seen a contradiction here; Eurasianists would not. That also helps explain why Lourié could write favorably about Bartók in the pages of *Yevraziya* at a time when Stravinsky disparaged all composers who still traded, as he once did, in folklore.[126] After his own articles on Stravinsky, which made universalist claims within the context of Eurasianism, Lourié was committed to severing the old romantic nexus between folklore and "authentic" national character. The way he finessed this issue on behalf of Bartók, whose creative authenticity he recognized and promoted, is noteworthy for its singular mixture of acuity and absurdity. Bartók's was a divided nature, in Lourié's diagnosis, for he descended not from one pure line, but from two contradictory lines: the German line, by way of Liszt and Strauss (and recognizing Liszt in the German line was a feat of acuity), headed ineluctably for "atonality"; and the Hungarian line, by way of folklore. Thus Bartók's music,

> arising on unstable soil, bears marks of collision between, on the one hand, abstract formal thinking in the instrumental sphere, and on the other, the concrete lyric nature of the Hungarian folklore from which he took nourishment. Herein lies the most distinctive feature of his music, which harbors a collision of opposing, organically alien forces. His violent, willful effort to force these urges into agreement has determined the whole development of his mastery. This process, in my view, is what gives his music its peculiarity *[lyubopïtstvo]*; otherwise it is less interesting. Bartók is a superb musician, but uncommonly dry. He loves and writes a dry music, like dry wine, but the emotional moisture that is inherent in all folklore (but Magyar in particular) impedes the attainment of the degree of dryness he seeks.[127]

VII

Lourié continued to worry the issue of nationality in art in a series of writings on Russian music, each representing a new stab at an elusive all-embracing view. The two main conspectuses were "The Course of the Russian School" ("Puti russkoy shkolï"; lit., *puti* means "the paths") from which a passage has already been quoted, written in Russian in 1931–32 but published in French (as "Perspectives de l'École Russe," trans. H. Gourko; see chapter 7) and English (as "The Russian School," trans. S. W. Pring; see note 62) before appearing in the original in 1933,[128] and "The Evolutionary Lines of Russian Music" ("Linii èvolyutsii russkoy muzïki"), which appeared in 1944 in the New York–based *Novïy zhurnal* (or *New Review*), founded in 1942 by Mikhaíl Osipovich Tsetlin and Mark Alexandrovich Aldanov (Landau), which lasted long enough to bill itself as "the oldest literary magazine of the

Russian diaspora."[129] These pieces were unusual in their day because they took the story up to what was then the present, but did so from Lourié's perspective as an émigré, meaning that the postrevolutionary period was viewed as effectively bifurcated into Russia-at-home (i.e., Soviet music) and Russia abroad. His accounts of their mutual relations were full of fascinating contradictions and ambivalences.[130] In addition, there were two major pieces on individual Russian composers, both published in 1943: an essay on Musorgsky, which appeared in *Novoselye* (New Home), a literary magazine edited by the poet Sophie Pregel, who, like Lourié, had become a double émigré, having been forced out of Europe by the rise of fascism; and an essay for *Novïy zhurnal* on Shostakovich's Seventh Symphony, following its sensational radio première under Toscanini.

The magazines for which Lourié wrote in America were no longer Eurasianist journals; the movement as such did not survive into the 1940s and never took hold in the New World. Lourié's outlook, however, was still identifiable with the tenets expressed in his Parisian articles on Stravinsky. The two crucial points were, first, that Russian music had achieved its full significance in the act of transcending the indicatively "Russian" and embracing a universalist perspective; but, second, that in so doing it did not give up its national character, which was expressed less through style than through a collectivist social orientation. The first of these principles turns out to be the unexpected ground upon which the two contemporary Russias met. Taking Stravinsky as the focal point of "Russia abroad," Lourié called attention, in "The Russian School," to Stravinsky's rejection of "the folk-element as primary basis" of musical Russianness, and in this lay his paradoxical kinship with the Soviet music he despised:

> In forsaking the national plane for the universal, Stravinsky broke away from the line on this particular question. The radical change in his style was conditioned by the alteration in the ideological problem, which in its turn was due to the modification of the entire formal process of his musical thinking. It is curious that this change in his style coincided historically with the political and social changes in contemporary Russia, where the national consciousness developed into a supernational consciousness and an aspiration toward universal union. Though politically opposed to the Russia of today, Stravinsky gave musical expression, as it were, to new departures similar to those prompted by the new ideology prevailing in that country, but on different grounds: the role of Karl Marx is played by Bach.[131]

As to the second point, here is the same article's ringing final paragraph: "Brotherly cooperation and an inward sense of responsibility to one another have always been the watchwords of the Russian school; spiritual solidarity, and not the disintegration and indifference so characteristic of the Western Europe of today. So long as this principle of national cohesion—not for self but for Russia—exists, so long will the school endure."[132]

Special interest attaches, inevitably, to one of the essay's least informative passages, Lourié's quite incoherent discussion of the early Soviet years, when (although he gives no hint of it) he was the plenipotentiary in charge of music. It is his single public reference to that time, and his squeamishness ("I was never a Communist; I have never had anything to do with the Communist Party") is palpable:

> In the early days of the upheaval there was no contact between art and politics, and the social and political life of the country developed in one direction, and its culture and art in another, almost independent of political circumstances. During this period, art occupied an aristocratic, privileged position. The musical life of Russia was restricted to its professional plane. That the revolution brought about change was due simply to the fact that, when the masses of the people were attracted to the arts, conditions had altered for the worse. This affected performers and teachers only; musical creation was untouched by politics. It continued to utilize its own aesthetic processes which had existed prior to the revolution. The political workers were not concerned with music, and the musicians shut their eyes to politics and tried their utmost to maintain the "art for art's sake" position, which was essentially a thing of the past. Later on, when the political power had grown stronger and the revolution more deeply rooted, side by side with the political and economic fronts in the U.S.S.R. a cultural front was announced. The drama, literature and painting were brought into contact with the Marxist doctrine far more quickly than music.[133]

In the essay on Musorgsky, Lourié gives an interesting Eurasianist twist to one of the central clichés of Musorgsky criticism, namely his relationship to Rimsky-Korsakov and the familiar harsh evaluation of the latter's editorial work. Lourié identifies Musorgsky with "the Russian mythos," thence with "Russia herself," by aligning him with a series of conservative or Slavophile religious thinkers, all possessing good Eurasianist credentials—

> In historical perspective the author of *Khovanshchina* and *Boris* is related to our conception of the Russian mythos. He is the single musician to have participated during the nineteenth century in establishing it. This mythos about Russia herself, and its relationship to him, touches immediately on all the fateful questions: on the Russian people and its fate, on the opposition of East and West, Europe and Asia, Christianity and paganism, Orthodoxy, Catholicism, socialism, aesthetics and morals, and so forth and so on. In a word, all the problems that we have long known about from [the work of] Vladimir Solovyov, Konstantin Leontiev, Dostoyevsky, Gogol, [Alexey] Khomyakov, [Sergey] Aksakov, [Fyodor] Tyutchev, [Vasiliy] Rozanov, and even [Lev] Shestov. Musorgsky by right belongs to this family, and his blood tie with it is becoming the main ontological meaning of his persona. You won't capture Musorgsky by logic. He is ontological, like Russia herself.[134]

—and then juxtaposing him with Rimsky-Korsakov, who is characterized in "The Russian School" as "loyal . . . to the formal methods of the Germans,"[135] as if contrasting panromanogermanic culture itself with the ur-Russian: "Musorgsky

exploded the rationalistic basis of musical thought. He reduced to rubble the structures of mechanical musical practice, built on worked-out schemata, formulas and pre-established technical devices. In this soil there bloomed like a brazen flower the legend of Musorgsky's musical ignorance and illiteracy. Rimsky-Korsakov was the main author of this legend. He at that time possessed sufficient authority to command belief. He was believed also in the matter of the necessary editing and 'correcting' of Musorgsky's manuscripts."[136]

These hackneyed judgments oddly contradict a passage—an equally Eurasianist passage, one should note—in the 1944 conspectus of Russian music, where Lourié adduces as evidence of the Russian school's touted "spiritual solidarity" the many examples of collective endeavor (e.g., the unfinished *Mlada* ballet project of 1870, to which each of the members of the Mighty Kuchka save Balakirev contributed an act) and shared editorial labor: "All were united," he now averred, "by their national self-awareness. Their relationship to art was not personal, not individual. What one failed to complete, another would continue. Borodin's *Prince Igor* was brought into order, completed, and orchestrated by Glazunov and Rimsky-Korsakov. The works of Musorgsky were revised by Rimsky-Korsakov and other musicians practically in their entirety."[137]

Nor is that the only contradiction one finds in this relatively late essay. It was composed after the break with Stravinsky, and that fact may be obliquely registered in a strangely spiteful reevaluation. Whereas formerly Stravinsky's universalism had been touted as the ultimate triumph of the Russian spirit in music, Lourié now writes: "The work of Stravinsky still possessed enormous significance in the very recent past, and his compositions even now remain in the foreground of contemporary musical life. But the esthetic and the ideology of his art, proclaimed as an article of faith, are in open contradiction to the Russian spirit."[138]

Stravinsky's esthetic, formerly contrasted with the "neogothic" (read: Teutonic), is now equated with that of Hanslick—and, among Russians, with that of Anton Rubinstein, "the first pioneer of the professional movement in Russia and the ardent opponent of nationalists," who frankly described music as taught in his conservatory as "a German art."[139] "This theory of 'the musically beautiful' (as Hanslick called it) was sent to the archive until the modernists revived it," Lourié now observed. "To the extent that Stravinsky professes this theory, he is right when he says that he no longer considers himself a Russian musician, but just a musician."[140]

But then he wheels around and asserts a fundamental incongruity "between what [Stravinsky] preaches and what he creates," finding that "his temperament remains Russian and betrays itself in his compositions' every *intonatsiya*." I leave that final word untranslated, assuming it to be a knowing reference to Asafyev's idiosyncratic usage, in which "intonation" is actually something like what linguists call a morpheme, a minimal meaningful or communicative lexical unit, or like what music analysts following Leonard Ratner call a "topic," a musical turn that

makes extroversive reference to recognizable, preexisting musical genres, presumably (or hopefully) within the listener's range of experience.[141] Just so, Lourié explains, Stravinsky "prefers to utilize preexisting material, readymade and, consequently, neutral and faceless, rather than create new material. That is why most of his works are pastiches. Having renounced his past and broken his ties with Russia, Stravinsky now occupies the very center of Western European musical thought, which he has developed critically. Thus he was one of the first to discover the impasses that musical modernism now confronts."[142]

So whereas in 1929, when Lourié published the second half of "Art in Crisis," Stravinsky (with Picasso) had been the key to art's redemption, now, in 1944, Stravinsky himself provides Lourié's crowning example of "art without art." The first half of "Art in Crisis," the screed to which the second half prescribed the Stravinskian antidote, had ended with an italicized shriek—*"An art driven only by method is an art without art!"*—and a somewhat anticlimactic elaboration: "Method devours art. Art without art is just the same as 'art for art's sake,' but in a new configuration, namely utter devastation. Formerly spiritual experience had been replaced by esthetic experience; now it is formal experience that replaces creative experience. The living flesh of art, its matter, its very substance, is being replaced by aimless formal arrangement."[143]

Here now is the peroration, fifteen years later, of "The Evolutionary Lines of Russian Music":

> It was not professionalism and not theory that called Russian music to life. Its foundation was faith in the people and an organic bond with them: the conviction that in music there will be emptiness where the human being is absent, supplanted by technique. Technique is indispensable, but it must not become an end in itself.
>
> One of the contradictions in music is that technique must be rational, while at the same time the spirit of music is irrational. Some have striven to subordinate technical rationalization to creative imagination (such cases are rare: Musorgsky and Scriabin in Russia, Chopin and Debussy in Europe), while others have wished to make the rational the very essence of music—such are the majority of European musicians of the nineteenth century, as well as those Russians who followed them: Rimsky-Korsakov and Stravinsky. For these last the task was relatively easy: it comes down to craft alone, they produce goods for better or worse.
>
> The problem that torments the former group is the necessity of capturing and reproducing their inner world. But in the musical hierarchy the greatest are those who reach the highest levels of spiritual ascent through what we may call the near immateriality of sounds.[144]

Stravinsky's precipitous fall is surely in large part to be read as the falling-out of former friends. The extent to which this passage contradicts everything Lourié had previously said about Stravinsky is most evident in the comparison with Rimsky-Korsakov, to whose Germanic influence Stravinsky had hitherto been the splendid

remedy. But the new Stravinsky is not merely an inverse Stravinsky. Lourié's fresh take on his old comrade reveals a genuine evolution in his thinking—or perhaps a reversion to inclinations formerly checked. It not only illuminates his critical persona but will find echo in his music as well.

In the light of Lourié's new Stravinsky one can even take in stride his friendly assessment of Shostakovich's Seventh, a notorious political football that Stravinsky (having listened to the broadcast) made sure to revile, in step with the vast majority of composers and critics not subject at the time to Communist discipline.[145] Vladimir Nabokov, having read Lourié's review, refused a proposal to collaborate on an opera based on Dostoyevsky's *The Idiot*, writing to the painter Mstislav Dobuzhinsky, who had served as go-between, that "nothing will come of *The Idiot*, unfortunately; in the first place, because I can't stand Dostoyevsky, and in the second, because, judging by his article on music in the *Novïy Zhurnal*, Lourié's and my outlooks on art are utterly at odds."[146] Igor Vishnevetsky finds it "altogether impossible to understand what so exercised Nabokov in Lourié's article," adding that "if the writer actually read the article through (as he tells Dobuzhinsky), then he understood absolutely nothing in it."[147] But surely Nabokov understood all too well the following reverberation from "Art in Crisis":

> The most cultured and serious of American critics, after the first [broadcast] performance of the Seventh Symphony, reacted to it with hostility. The sense of his assertions was that the symphony's patriotism in no way compels one to acknowledge its artistic significance, that it will be found wanting in the scales of history, and so on. But the constant repetition of the same opinion in different variants came across as anxious insecurity. His arguments amounted to the notion that this music is all right "for the Soviet masses, but not for 'connoisseurs.'" From his point of view the critic was perhaps correct, and courage was needed to oppose the current. But his evaluation was a blunder, precisely on account of an ideological error. What he appeals to was once called "art for art's sake." But that criterion has long been outdated. On its basis nothing valuable has been accomplished for a long time. We are witnessing today the complete liquidation of esthetics, which we might call "art without art." What will take its place? Who knows? We are now at the tipping point. In Russia a new ideological dispensation is in progress. We are accustomed to thinking that art with an ideological content is the lowest form of art, but when the initial stages are past it is possible that even ideology itself will be transformed and deepened. At the present moment it is in the incipient phase, and Shostakovich's Seventh Symphony is only one token of a musical process that is still undergoing development.[148]

Something else is echoing here besides "Art in Crisis": namely, Souvtchinsky's "The New 'West,'" published in the same Eurasianist journal and in the same year. Like Soviet Russia itself as described there, Shostakovich in Lourié's description was a harbinger, holding out the possibility of renewal to an exhausted modernity. Lourié rehearses the story of Shostakovich's denunciation in 1936, but from

a standpoint that as scandalously "opposed the current" as anything American reviewers had to say about the Seventh Symphony:

> After the crisis he endured, which was much commented on at the time, after accusations of "left deformation" and "formalism" and ties with European "degenerate ideology" and so forth, he was dislodged from his habitual routine, typical of a modernist of those days. Grievance against the force and pressure of official doctrine might have arisen within him, and then the only thing left for him would have been to clam up and be silent. Yet he did not go that route, but submitted, which is far more significant. From that moment a new experiment began for him. He accepted the official esthetic as a dogma, something not up for discussion. From then on the development of his musical thinking was regulated by that dogma, which meant that his personal concerns were subordinated to it. The individual, free consciousness of an artist he would exchange for a collective consciousness. But Shostakovich could not confine himself to blind subordination. Before him as a musician stood tasks that arose out of this collective experience, and he solved them on his own. The first of them was extreme simplification of technique so as to make his musical language accessible and expressive to one and all. The second was the acquisition of new sonic material, close to the masses of listeners, found in the very thick of those masses and becoming their common property.[149]

But this is precisely the Eurasianist prescription, as enunciated above all by Karsavin in the movement's halcyon days: the transcendence of the merely personal and idiosyncratic (already called for in "Neogothic and Neoclassic") and the submergence of the individual consciousness in the "symphonic" consciousness of collective subjectivity. From this standpoint, Lourié could pronounce Shostakovich's Seventh "not merely a quest but already an achievement." Thanks to this achievement Shostakovich's musical materials were "far less reliant on the eclecticism of the general European sounds" of conventional modernism. That made his music more, not less, original. "Shostakovich's melos is becoming more and more Soviet. Where he is original his intonational system is founded on the humblest, most elementary melodic idiom. His melos derives not from folklore, nor from a peasant style, but from the Soviet urban style—a working-class, proletarian style. His Russian roots are in *chastushki*, and not in the lyrics and chants of Russian antiquity."[150]

Lourié rates the Seventh Symphony higher, in fact, than its two predecessors by Shostakovich: "If the Fifth and Sixth Symphonies went to the masses by way of popularization, in the Seventh there is a dual tendency: both an approach to the masses and an attempt to get the masses to approach the music. The tendency toward pure music manifests itself thus far, as it were, in a cloaked manner: those moments in which Shostakovich gives his musical imagination free rein are the most valuable ones. In them there is both a series of formal explorations and a sharp purely musical inventiveness."[151]

Lourié's inventory of these moments gives evidence of very attentive listening (which cannot be said of the reviews referenced in note 145). The part that really demands quoting is the passage devoted to the all but universally condemned "main theme of the first movement," as Lourié terms it, or what is now usually referred to as the "invasion" episode:

> Unquestionably valuable is the whole exposition of the main theme in the first movement.... A whole parade of critics considers it an open duplication of Ravel's *Boléro*. But Shostakovich took from Ravel not the music of his *Boléro*, or even the form of the piece, but only the mannerism of repeating the whole time a single musical period, developing it in a dynamic progression. The whole time the same motive repeats, and builds without interruption.... Shostakovich does not repeat his motive mechanically, like Ravel in *Boléro*. He varies its phrase structure asymmetrically as well as the role within it of the melodic cadence. The trivial, deliberately stupid motive first appears as if whistled through the teeth, over a background of light rapping by the drummer. This motive sounds ironic, as if a mask. Shostakovich has taken "the first thing that popped into his mind." Any Soviet passerby might whistle such a little tune. There is something in it of Zoshchenko's characters. And this motive resolves itself in stormy bursts that achieve a dramatic and threatening character....[152]

Shostakovich's affinity for the deadpan satirist Mikhail Zoshchenko (1895–1958), a close personal friend, is now a critical cliché, but Lourié was by a wide margin the first to discern it, apparently without knowledge of Shostakovich's personal circumstances, all of which makes the quoted passage a *tour de force* of critical empathy. And if the closing remarks—

> The Seventh Symphony wins us over with its sincerity, its tension, and its inner modesty, which places it in the company of the significant works of our time. We won't guess at its future, but for the present it offers a musical portrait of our long-suffering motherland.[153]

—seem conventional by comparison (and even rather close to the praises that political hacks were singing), it is obvious that Lourié found his own very special way to an appreciation of a work that so many of his counterparts despised. He continued to mull the questions Shostakovich's improbable triumph had stimulated, or restimulated, in him in a wider-ranging piece, "The Approach to the Masses," published (seemingly in his own English) in *Modern Music* the next year, the last full year of the war. Beginning with a final rehearsal of his pet dualism (Art for art's sake vs. Art without art), he finds himself no longer able to endorse the former at the expense of the latter on mere grounds of creative freedom, seeking instead a dialectical solution to the problem. "Revolutions, wars, historic cataclysms," he writes, "interrupt the flow of the eternal verities that are beyond time, confronting us with immediate necessities, temporal and practical."[154] "There is only one really creative solution," he asserts: "it lies in the sphere of music itself":

The necessity of establishing a new rapport between the individual will of the artist and the collective state of culture is one of the great difficulties which must still be overcome.

There is naturally a great temptation to establish an immediate connection between historic events and art, but such a connection cannot be forced. No event can change the secret meaning of art, which is its whole value. The artist must preserve his integrity through any historical event whatsoever. No one can deny him that. *Nolite perturbare circulos meos.* It is true that Archimedes paid with his life for these words, but at the same time he established the independence of the artist over the world around him.

It is not as an "expression of the times" that populism can be justified in our eyes. And since we have already excluded it from the esthetic problem it remains in the end a rather tiresome question. To do more than merely pose it is to invite the soldier of Syracuse to help Archimedes draw his circles.[155]

Lourié's quoting Archimedes in Latin rather than Greek leads us back to his evident *locus classicus*, a famous passage near the beginning of Kierkegaard's *Philosophical Fragments:*

> It is not given to everyone to have his private tasks of meditation and reflection so happily coincident with the public interest that it becomes difficult to judge how far he serves merely himself and how far the public good. Consider the example of Archimedes, who sat unperturbed in the contemplation of his circles while Syracuse was being sacked, and the beautiful words he spoke to the Roman soldier who slew him: *nolite perturbare circulos meos* [Don't spoil my circles]. Let him who is not so fortunate look about him for another example.[156]

Shostakovich was one of the lucky few, as Lourié wished to be. The artist's task was not to ignore the soldier but to engage with him, to achieve the mutual attraction Lourié envied in Shostakovich's Seventh, which both went out to meet the masses and drew the masses toward itself. This is the task Lourié, perhaps quixotically, sought to accomplish in his large-scale musical works beginning in the late 1920s and the '30s, the time of his greatest involvement with the Eurasian faction.

VIII

To appreciate the musical style of the works Lourié composed during his period of association with Eurasianism, and in light of that involvement, one needs to view the music (as one views the movement) in terms of dogmatic rejections and ascetic renunciations. One has to view Lourié, in other words, the way he viewed Shostakovich in 1942; and that affinity, surely, was the source of his surprising sympathy for the modishly reviled "Leningrad" Symphony. Lourié, like "his" Shostakovich, allowed the development of his musical thinking to be regulated by a dogma, subordinating his personal concerns to it and exchanging the "free consciousness of an artist" for "a collective consciousness." This exchange demanded an extreme

simplification of technique and the "acquisition of new sonic material" based on what the composer and his envisaged audience prized in common. But of course for Lourié, a composer of the Russian diaspora, that did not mean *chastushki*.

As Igor Vishnevetsky correctly emphasizes, in the first place these renunciations demanded the repudiation of rationalized modernism, preeminently exemplified by Scriabin, the very composer on whom Lourié, in common with most of his composing compatriots, had leaned most heavily before his emigration.[157] The disowning was explicit. Its first signs appeared as early as Lourié's stint as official representative of Narkompros. In a speech, "Scriabin and Russian Music," delivered in Moscow in April 1920 to mark the fifth anniversary of Scriabin's death, and issued as a pamphlet the next year, Lourié, by then the composer of "Nash marsh" (Our March), a Bolshevik rouser on words by Mayakovsky, rebuked and even insulted the majority of his colleagues and rivals by becoming one of the first of many to declare that Scriabin's "much-touted ultrachromaticism has brought forth a 'literature' that is perhaps of importance to 'theorists,' but which has little to do with [the practice of] art."[158]

Take that, Roslavets! Take that, Matyushin! But above all, take that, Lourié! Of greatest interest in Lourié's lecture is the implied repudiation of his own musical past, both as a composer and as a "theorist"—the very theorist who in 1915 had published a tiny (three-page) treatise in an avant-garde almanac called *Strelets* (Sagittarius), titled "Toward a Music of Higher Chromaticism," which proposed a system of notation for quarter-tones in an effort to surpass the ultrachromaticism from which he was now retreating, and even supplied a "practical" example in the form of a prelude composed for an as-yet-uninvented piano "avec le chromatisme supérieur."[159] What Lourié so often said of Stravinsky—that in his creative work of the 1920s he renounced his past—he could have said even more aptly of himself.

But not until he had joined the emigration did Lourié go so far as to call Scriabin un-Russian; and in this accusation one catches a frank Eurasianist resonance. In the long article published first in French (1931), then in English (1932), and finally in Russian (1933), from which various extracts have already been discussed, Lourié asserted that Scriabin had emerged "from the bosom of the Russian national school" with his First Symphony, but, "carried away into 'extramusical' worlds, he regarded the national question regarding Russian music as being somehow altogether secondary and insignificant compared with those eschatological reveries that nourished his muse. In the period of his ripest works he left all the traditions of the Russian school once and for all and became as much an absolutist of westernization as Musorgsky had been a nationalist."[160]

This judgment was as strategic as it was eccentric. In characterizing all of Soviet Russian music as having descended stylistically either from Scriabin (in the case of "radicals") or, in the case of conservatives, from Nikolai Medtner (so far an epigone of German romanticism as to have "fallen out of Russian music"

altogether), Lourié was able to assert that Russian music, properly so-called, had—to continue his metaphor—fallen out of Russia altogether, in the literal sense that its true legacy now informed only the music being composed by "Russia abroad"—the émigrés—while Soviet composers were under the sway of the West. As Lourié argued in his unfinished monograph on Stravinsky, that raid through which the emigration had abducted the true spirit of Russian music was preeminently Stravinsky's doing, precisely by virtue of the stylistic renunciations Stravinsky had carried out in making his sharp right turn toward neoclassicism, thanks to which he had spectacularly reasserted the supremacy of the diatonic scale. This, then, is the appropriate light in which to view the newly (or re-)Russianized and diatonicized music of Lourié's Paris years. If Soviet Russia was "the new 'West,'" the music of the Russian diaspora in the West was the new music of Russia.

With that posture in mind, it seems odd that no previous discussion of Lourié's most famous composition, the *Concerto spirituale pour piano solo, choeurs, cuivres, contrebasses, timbales et orgue*, has ever noted the fact—salient to the point of obviousness to anyone who knows Russian musical terminology—that the polyglot title contains a translation into ersatz Italian of *dukhovnïy kontsert*, the usual name given to indigenous Russian or Ukrainian a cappella compositions for the Orthodox church beginning in the middle of the seventeenth century. These compositions, thoroughly westernized (at first, Venetian) in style, were pioneered by composers like Nikolai Diletsky and Vasiliy Titov.[161] They adopted the term "concerto" as it was used by Gabrieli and Schütz, possibly mediated by Polish church composers such as Mikołaj Zieleński or Marcin Mielczewski. In this usage, concerto implied a mixed vocal-instrumental composition with basso continuo and perhaps an obbligato instrument or ensemble as well, written to a Latin text for service use.

When imitated by composers for the Eastern Church, not only did the liturgical texts have to be translated into Slavonic, but the instrumental music had to be eliminated in accordance with the restrictions imposed by Orthodox custom. Nevertheless, the style of the music remained indebted to the continuo textures of the original Catholic genre. In the eighteenth century, orthodox *dukhovnïye kontsertï* were composed by actual Italians such as Giuseppe Sarti or Baldessare Galuppi, who had been brought in by the St. Petersburg court primarily to write operas, and the genre passed from them to their pupils and their pupils' pupils: Bortnyansky, Berezovsky, Vedel'. Although *kontsert* was obviously a loan word, the full term *dukhovnïy kontsert* was exclusively a Russian coinage and referred only to Orthodox a cappella compositions in Old Slavonic. *Concerto spirituale*, though not unknown, was never standard terminology in Italian.[162] Thus one may conclude that Lourié made his back-translation from the Russian expressly to evoke and exploit a specific set of cross-cultural resonances or implications.

One of these, surely, was the sad fact that the *dukhovnïy kontsert*, as a living genre, had fallen victim to the Russian Revolution. The late nineteenth and early twentieth

centuries had witnessed a great flowering of Russian liturgical composition. Besides the great names of international repute (Chaikovsky, Rachmaninoff) and other composers of at least local fame who wrote for the church alongside their work in secular genres (Gretchaninoff, Ippolitov-Ivanov), there was a whole school of specialist composers for Orthodox choirs: Alexander Andreyevich Arkhangelsky (1846–1924), Alexander Dmitriyevich Kastalsky (1856–1926), Pavel Grigoryevich Chesnokov (1877–1944), and many others. With the coming of the Soviet regime, their activities were severely restricted. Some, including Gretchaninoff and Arkhangelsky, emigrated; others, like Kastalsky, switched over to secular genres; still others, notably Chesnokov, lapsed into silence. To write a *dukhovnïy kontsert* for Western concert performance in Latin was at once to demonstrate that the "real" Russian music had fallen out of Russia and to show that that music had now achieved, precisely through its martyrdom and relocation, a universal significance.

But at the same time that it exemplified or symbolized Russian universalism, Lourié's Concerto retained conspicuous features of the modern concerto genre: most obviously a virtuoso concertante part for a pianist, replete with cadenza. That, of course, made the work *sui generis*: a unique hybrid that, like "Turania," wholly belonged neither to the actual Russia nor to the actual West. And—as has likely already occurred to the reader—Lourié's particular hybrid did for "Concerto" what Stravinsky's *Symphonies d'instruments à vent* had done for "Symphony": invest a standard Western genre with demonstratively nonstandard associations—associations, in both cases, of an Orthodox, or at least ecclesiastical, nature.[163] (Stravinsky's *Symphonie de psaumes* also comes to mind, of course, the more so in that it was, like Lourié's Concerto, a setting of texts from the Vulgate Psalter. It was not yet planned when Lourié began writing his composition, but followed soon thereafter, when Stravinsky received a commission for a symphony from the Boston Symphony Orchestra. It is by no means farfetched to surmise that Lourié's hybrid concept prompted Stravinsky's.)

Moreover, just as the word *Symphonies* in the title of Stravinsky's wind piece resonates both with Byzantine hymnody and with Karsavin's "symphonic" sociality,[164] so do the rigorously, even obsessively homorhythmic or homophonic textures of Lourié's choral and brass writing. They testify to another sort of ascetic or dogmatic renunciation: the back turned, as it were, on a thousand-year cultivation of elaborate polyphony in the West to match the equally conspicuous rejection of chromatic harmony in favor of a wholly invented, but obviously archaizing, faux-modality. (The choral textures, too, are invented and archaizing—and extremely imaginative, including at least one effect later adopted by Stravinsky: the accompaniment of a sung soprano line with spoken text in the remaining voices. Stravinsky used it in the "Libera me" from his *Requiem Canticles* of 1966, his last major composition.)

But although its title evokes an old Russian genre by evident design, Lourié's *Concerto spirituale* is more than a *dukhovnïy kontsert*. Like *Le sacre du printemps* or

Les noces (or, by implication, the *Symphonies*, which follows the form of a Russian memorial or requiem service), it simulates an enacted ritual. The texts are drawn from the liturgy of the Paschal Vigil as recited on the eve of Easter Sunday, marking (in keeping with an antecedent Jewish practice) the beginning of the Easter season. It begins with the Service of Light, otherwise known (as in Lourié's score) as the Blessing of the Fire *(Bénédiction du feu)*. When performed as an actual service, a large candle, symbolizing the *Lumen Christi* (Light of Christ) is brought into the darkened church, having been kindled from a "new fire" ignited outside by natural means (sunlight through a lens or flint and steel) earlier in the day (i.e., Holy Saturday). From the initial candle other candles will take their flames until the building is fully illuminated. A celebrant or deacon then pronounces the *Praeconium Paschale* or Easter Proclamation, known after its incipit as the *Exsultet*. After a reading of the opening chapters of the Book of Genesis (which narrate the creation of light) and the singing of some canticles and a litany, the service proceeds to the Blessing of Water for Baptism, otherwise known (as in Lourié's score) as the Blessing of the Fonts *(Bénédiction des fonts)*. All of the preceding action is timed to conclude at midnight, when the Easter Mass can begin. Lourié's score is headed by an epigraph from the Counter-Reformation mystic San Juan de la Cruz (St. John of the Cross, 1542–91), to whom the work is dedicated. It refers metaphorically to the baptismal font: *Qué bien sé yo la fonte que mana y corre, aunque es de noche!* (How well I know that spring, which surges forth and swiftly flows though darkness lie over all!)

The first part of the *Concerto spirituale*, designated *Prologue: Bénédiction du feu*, is in fact a setting of the actual traditional chant of the *Exsultet* for a unison chorus of between six and twelve voices (tenors, baritones, and basses in varying combinations depending on range and desired volume) and an eight-part brass choir consisting of four trumpets, three trombones, and tuba.[165] The only departure from the original chant melody is a transposition, evidently prompted by the structure of the original. As printed in the *Liber usualis*, after three strophes there is a middle section, sung to the same threefold repetition of the melody but printed in a single block of type, labeled "the deacon's personal and humble prayer." At this point Lourié transposes the Phrygian melodic formula up a major third, so that its final is no longer E but G-sharp, and the performing choir shifts from a group of basses and baritones to one of baritones and tenors. At the concluding verse Lourié maintains the higher pitch, but has the basses, now singing at the top of their range, rejoin the ensemble for a sonorous peroration. It is perhaps worth pointing out that Stravinsky's *Symphonies d'instruments à vent*, with which Lourié's name is firmly associated as arranger, takes its overall shape from a similar transposition of repeated material, albeit downward.[166]

The harmonic idiom of the brass choir in Lourié's Prologue is not very different from that of harmonized, organ-accompanied plainchant as normally heard in

the French churches of the time: diatonic and functional, with liberal admixture of sevenths and ninths. It, too, bears a suggestive relationship with the *Symphonies d'instruments à vent,* the final section of which (sometimes referred to as the "chorale") gradually sheds the chromatic, octatonically derived harmonies that characterize most of the piece and approaches a pure diatony for its final cadence. Often described as a "clarification," the effect can be described with equal aptness as a gradual renunciation. At the very end, then, Stravinsky's *Symphonies* reaches the point from which Lourié's demonstratively ascetic harmonization of the *Exsultet* departs. (Was this the composer's conscious thought? Impossible to say, of course; but his work on the *Symphonies* preceded the beginning of his work on his own Concerto by a matter of months at most.) But where the achievement of a diatonic idiom in the *Symphonies* is matched by a subsidence in tempo and volume, Lourié's brass writing, in keeping with the character of the *Praeconium* that it accompanies, is often proclamatory in the manner of a fanfare, replete with *pavillons en l'air.* The overall effect, withal, is contemplative, static, and impersonal; Vishnevetsky plausibly supposes that "the composer, as it were, turns the minds of his performers and listeners—and herein lies the meaning of his *revolutio*—toward a time preceding the flowering of individualism in modern European music."[167]

The much longer second part of the *Concerto spirituale,* the concerto proper (completed before the Prologue was composed), is designated *Concerto: Bénédiction des fonts* and consists, like most classical concertos, of three large movements, the cadenza coming between the first and the second. Here the full panoply of triple choir, concertante piano (plus a simpler *ad libitum* part for a "piano obligato" to reinforce the sound), brass, double basses, timpani, and organ comes into play at various times (the brass returning only in the third movement and the organ reserved for the final tutti), and the textures and harmonic idiom become idiosyncratic and distinctive, no longer obviously archaistic. Again a Stravinsky parallel is too obvious to ignore: the orchestra of the *Symphonie des psaumes,* likewise devoid of upper strings (though it retains cellos)—more evidence, perhaps, of creative exchange between Stravinsky and the man who was at the time among his closest confidants. The use of the solo piano also requires comment in light of obvious Stravinskian antecedents *(Les noces)* and consequents *(Symphonie des psaumes)*. But in *Les noces,* the pianos (but for a single measure in the fourth tableau) are always subordinate to the voices; and in the *Symphonie des psaumes,* the piano is not a soloist but just a foot soldier in the percussion section. Lourié's pianist is a real concerto protagonist, and that seems to be something unique in a work derived from liturgy. Another unique feature is Lourié's use of the double basses and timpani in conjunction to emphasize the bass line. Possibly recalling the mammoth orchestra of Berlioz's *Requiem,* he calls for no fewer than seven drums, arranged in a scale. But unlike Berlioz's scale of timpani, Lourié's is frequently retuned, necessitating the use of pedal instruments unavailable to

Berlioz. Lourié remained partial to this idiosyncratic deployment of timpani in both of his symphonies, so that one might actually speak of a distinctive "Lourié orchestra."

This second part of the *Concerto spirituale* consists of a gigantic, though oddly incomplete, setting, in three movements plus cadenza as noted, of Psalm 41 according to the Vulgate ("As the hart panteth after the water brooks" in the King James version, where it is Ps. 42). Verses 2–4 from this psalm form the canticle as actually sung at the *Bénédiction des fonts* during the Paschal Vigil on Easter eve, the service from which the Concerto's text is drawn; but Lourié's setting encompasses the text from verse 2 to the middle of verse 8 (out of twelve), breaking off most strangely thereafter in the middle of a sentence.

The first movement is a tripartite setting of verse 2 through the middle of verse 6:

[2] Quemadmodum desiderat cervus ad fontes aquarum
 ita desiderat anima mea ad te Deus
[3] Sitivit anima mea ad Deum fortem vivum
 quando veniam et parebo ante faciem Dei
[4] Fuerunt mihi lachrymae meae panes die ac nocte
 dum dicitur mihi quotidie ubi est Deus tuus
[5] Haec recordatus sum et effudi in me animam meam
 quoniam transibo in loco tabernaculi admirabilis usque ad domum Dei
 in voce exultationis et confessionis sonus epulantis
[6] Quare tristis es anima mea et quare conturbas me? . . .

 2. As the hart panteth after the water brooks,
 So my soul desireth thee, O God.
 3. My soul thirsteth for God, for the living God:
 when shall I come and appear before God?
 4. My tears have been my meat day and night,
 while they continually say unto me, Where *is* thy God?
 5. When I remember these things, I pour out my soul in me
 for I had gone with the multitude,
 I went with them to the house of God,
 with the voice of joy and praise,
 with a multitude that kept holyday.
 6. Why art thou cast down, O my soul?
 And *why* art thou disquieted in me?
(King James version)

Lourié's setting of this text is faithful to the precepts of "Neogothic and Neoclassic." Hieratic rather than expressive, it represents the exalted mood of the occasion rather than the emotional states to which the text refers. The representation of exaltation is far from static, however. Animated and varied, it abounds in sudden

contrasts in tonality and texture. The effect of the concertante piano in counterpoint with the austerely chanting choirs is uncanny and evocative. For an idea of what it has evoked, consider the reaction of the Dutch-born conductor and music journalist Frederik Goldbeck (1902–81), who heard the Concerto at its Paris première in 1936. Having compared the brass accompanying the *Exsultet* to the gold setting of a Byzantine icon, he wrote of the concerto proper that

> this is no longer a Byzantine aureole, but rather the technique of [El Greco's] *Burial of Count Orgaz*, superimposing in a single composition a terrestrial act and a celestial one. The effect of the combination goes beyond matters of technique: the piano part, as it were, responds in poignant, human terms to the disembodied gravity of the voices. "What El Greco painted over their heads, they see not with their eyes but with their souls," Barrès said of the figures in this celebrated picture. Just so, the piano says, with all the means of modern virtuosity, that which, "over its head," the choirs sing in archaizing melopoeia.[168]

The movement's overall ternary form *(Tempo maestoso—Tempo di ballata—Tempo primo)* is divided unequally. The first section, comprising verses 2–4 (corresponding, whether by accident or design, to the part of the psalm that is actually recited at the Paschal Vigil as part of the liturgy), is by far the longest. Verses 2–3 are set for two of the mixed choirs, each containing forty voices (ten to a part). They declaim the text in the strictest homorhythm and fairly strict white-key diatony. The piano, along with the double basses and timpani, provides a sonorous reinforcement, banging out the same harmonies in double notes. At verse 4, the texture is altogether transformed, coinciding with a sudden lurch into the E major scale. All three choirs (the third a smaller group of coryphées, four to a part) now sing in overlapping antiphony; at the ends of lines the singers in the larger choirs are directed to sustain their final pitch *bouches fermées*, humming in the background to let the smaller third choir occupy the foreground. Meanwhile, despite the dark mood depicted in the text, the piano part is at its brightest and most virtuosic, giving out fast divisions that will remind any properly attuned listener of a long tradition of Russian glory-music evocative of bell-ringing (*Boris Godunov*'s coronation, Rachmaninoff's *Kolokola* after Balmont's Poe, Rimsky-Korsakov's *Russian Easter*, and the list goes on).

This sonorous outburst suddenly gives way to chiaroscuro for the middle section, corresponding to the long fifth verse of the psalm, marked *Tempo di ballata*, evidently because it shifts into a triple meter that is fairly consistently maintained. The third choir is again silent, and the other two now sing pianissimo, *molto espressivo e cantabile*. The second choir is entirely given over, for the first half of the verse, to *bouches fermées* humming, while in the first choir, which enunciates the words, only the sopranos sing. The rest of the choir speaks the text (*parlato*, marked with x-shaped note heads on the space beneath the staff) in homorhythm

with the sung part. Even the double basses are infected for the moment with lyricism, playing legato, in four-part harmony and in high positions that double alto and tenor voices. The solo piano starts in a like vein *(legato, espressivo ma molto tranquillo)*, but soon begins eddying back into rhythmic divisions, stirring the music toward the texture of the second half of the verse, in which the two choirs begin a conventional texted antiphony that ends in open-mouthed melismas.

The return to *Tempo primo* is matched by a return to the tonality and melodic formulas of the opening section. Now the third choir is in the foreground, the larger vocal groups confined to short disjointed notes that reinforce the rhythmic beats along with the basses, timpani, and piano. The fifth verse is repeated: at "admirabilis," the three choirs begin singing in a uniform homorhythm—the richest choral sound heard thus far, made even grander at "sonus epulantis," when the brass rejoin the texture, trumpets first, with the trombones and tuba held in reserve for a final explosion of "joy and praise." The beginning of the sixth verse is set as a hushed coda for the tenors and basses of choir three, accompanied by the first two choirs, *bouches fermées*.

Inasmuch as the text of the first movement breaks off, after the first hemistich of verse 6, on a disconsolate question (*Quare tristis es anima mea* / Why art thou cast down, O my soul), it is tempting to regard the extended, ruminative piano cadenza that follows (marked *Tempo rubato* and about equal in length to the whole first movement) as a meditation or homily on penitence, the nadir from which the remainder of the Concerto will rise toward the light. Although it ends with a *da capo* that reestablishes the opening key (B major) and ties the whole into a neat tripartite package, the cadenza makes a strophic impression because its middle section is based on variants of the same brief tune that repetitively informs the outer ones. That tune is fashioned to resemble monotonous plainsong melodies, and it lies—except for what sounds like a brief angelic interlude in the middle—in a baritone register convenient for "Gregorian" singing. In effect, then, the cadenza is a muted chant without words, to be matched, at the opposite end of a steep emotive ascent, by a powerful wordless *jubilus* for fifty-six wide-open-mouthed choristers at the Concerto's conclusion.

The second movement of the concerto proper is the slow movement, *Tempo moderato e molto cantabile*. Its text takes up the sixth verse where the first movement had left off, and continues through the seventh:

> . . . *spera in Deo quoniam confitebor illi salutare vultus mei*
> [7] *Deus meus ad me ipsum anima mea conturbata est*
> *propterea memor ero tui de terra Iordanis et Hermoniim a monte modico*
>
> . . . Hope thou in God: for I shall yet praise him for the help of His countenance.

> 7. O my God, my soul is cast down within me: therefore I will remember Thee from the land of Jordan, and the land of the Hermonites, from the hill Mizar.
> (King James version)

The fastest-moving melodic part at first is the piano, so that the movement sounds at first like a continuation of the cadenza with choral accompaniment. Only the singers of the third chorus enunciate words; the others hum as before with closed mouths. Curiously, Lourié sets the first words of verse 7, "Deus meus," as if they were the concluding words of verse 6. At the words "ad me," the texture is scaled down to its smallest complement: a solo baritone carries the text, the other singers (minus all basses) backing him up with closed-mouthed humming. Of instruments only the solo piano is heard, softly. At "propterea," the baritones and basses of the third choir take up the text in unison against continued soft, nocturne-like piano playing. The whole seventh verse is repeated with a tenor solo taking the place of the baritone, and then repeated yet again, this time set to a recapitulation of the *Tempo di ballata* from the first movement, transposed to a higher pitch.

Recalling the beginning of the final tableau of Stravinsky's *Svadebka (Les noces)*, which breaks in on the score's quietest moment, the last movement *(Tempo risoluto)* of *Concerto spirituale* breaks out in an explosion of sound to the turbulent words of the eighth psalm verse's opening hemistich, which describes a cataract:

> [8] *Abyssus ad abyssum invocat in voce cataractarum tuarum* . . .

> 8. Deep calleth unto deep at the noise of thy waterspouts . . .
> (King James version)

Lourié sets it as a virtual timpani cadenza, the voice parts mounting against the drumbeats in a virtual shouting match of antiphonal clamor, punctuated by the full brass. The hemistich is thrice repeated, with "cataractarum tuarum" thrice repeated each time; and then, instead of completing the verse, the singers and instruments, now including the organ, let loose in a wordless culmination, *Tempo appassionato e finale*. This loudest and simplest section consists of fifteen huge choral chords of varying lengths, each given a pickup of similarly varying lengths, supported homorhythmically by the brass and organ, while the piano, the double basses, and the timpani accentuate every pulse. The chords, like those at the end of the *Symphonies d'instruments à vent*, undergo clarification, beginning with a full budget of sevenths and ninths and ending in a blaze of unalloyed D major, voiced with the soprano high A at the top. The effect foreshadows the religious ecstasies of Messiaen.

In its combination of austere *style dépouillé* and dionysiac intensity, the *Concerto spirituale* makes an impression that many, often to their surprise, have found powerful. Even Lourié's worst detractors have praised it. Nicolas Slonimsky, a jealous rival for the affections of Koussevitzky, tried to cut Lourié down in an article for

the *Boston Evening Transcript* titled "The Strange Case of Arthur Vincent Lourié: His Record and Music from a Revolutionary Past to a Religious Present." Judgment is summary: "Be it said at once," we read in the second paragraph, "he does not possess a degree of creative power which would entitle him to the dignity of an individual composer."¹⁶⁹ And yet the last two paragraphs of the purported dismissal show the extent to which the *Concerto spirituale* had gotten under Slonimsky's skin:

> It is very difficult to estimate the artistic deserts of Lourié's musical works. Being an indefatigable dialectician, he can temporarily create an impression of reality. He lacks talent, but he possesses a constructive mind capable of producing excellent imitations. Furthermore, being Stravinsky's intimate, he bears a certain weight with the musical world. In some respects he may exert an influence on the master himself; certainly he can supply argument in defence of Stravinsky's courses. And at times he gets ahead of Stravinsky in works such as the "Concerto Spirituale," produced by the Schola Cantorum of New York on March 26, 1930.
>
> In fact it is his only work . . . that deserves serious consideration. It is scored for a double [*recte* triple]-chorus, piano, brass and six [*recte* ten] double basses. The Prologue for Solo Baritone [*sic*] accompanied by three [*recte* four] trumpets, two [*recte* three] trombones and tuba, is impressive, and the piano-cadenza is "just as good as Stravinsky." The idiom is necessarily diatonic (as opposed to chromatic and ultrachromatic infatuations of his youth); the writing is done according to the rules of mediaeval counterpoint, with all its futile clumsiness. The key of C major and its modal ramifications prevail. Of melodic invention there is, however, not a question. The general impression from one hearing is that of an austere, deliberately colorless work, to be performed at solemn occasions. A religious fanatic such as the strange Nicolas Obouhov, hurling sounds and shouts out of the abundance of his heart, may be justified in the eyes of the world, for his is a natural aberration. Arthur Lourié knows no such ecstasies. His heart is empty.¹⁷⁰

The New York première of the *Concerto spirituale,* at which Slonimsky had his chance to hear the work performed by one of the city's leading performing groups (the Schola Cantorum under its founder, Hugh Ross), was a big event—big enough to be heralded by a feature article in the *New York Times* the Sunday before, by Olin Downes, the paper's chief music critic. It conveys considerable misinformation, some perhaps based on inattention (including, despite Downes's claim that he had been studying the score, a manifoldly inaccurate listing of the performing forces, which Slonimsky obviously copied in his *Transcript* piece), but also some misinformation that seems to have come from the composer, including the highly significant misinformation that "he goes back to plain chant as the basis of his score, not to Gregorian chant of the sixth century and after, but to the Ambrosian chant, the earliest Christian chant extant, which antedated the Georgian [*sic*], and which has probably even a closer relation with old rites and music of the East than the liturgical melodies which Gregory expounded and systematized."¹⁷¹ The Latin

text notwithstanding, Lourié was making sure that his Concerto would be taken as a vision of "Christ in Asia."

IX

The elegant *Sinfonia dialectica* has a title that begs to be misunderstood by those who routinely equate its second term with what is "dialectical in the Hegelian sense of the word."[172] Lourié referred to dialectics and "the dialectical" on many occasions, as we have had ample opportunity to observe when investigating his historical and esthetic views. But dialectics are vastly older than Hegel, and invoking thesis and antithesis does not in itself a dialectician make. If Lourié cast the Schoenbergian Neogothic as a thesis to Stravinsky's Neoclassic antithesis, there is no reason to assume that he was doing anything more than countless writers do who summon ready terms of art that readers can be counted on to vaguely comprehend. (And please note that in that famous discussion Lourié proposed no synthesis.) More idiosyncratic is Lourié's use of such terms in narrower musical applications, as (for a notable instance) when discussing the "instrumental dialectic" in Stravinsky's *Sonate* for piano. But his usage there, and probably always, was loose and informal, adapted from the sort of binary discourse that is customary, for example, when discussing "sonata form."

In accounting for what he called Stravinsky's "dialectical method" in the *Sonate*, Lourié distinguished between "structural time," defined as "the musical dimension in which elements are transformed," and "structural space," defined as "the musical dimension in which, as in mechanics, elements succeed one another." The former defined the dialectic of the classical sonata; the latter, that of Stravinsky's, whose *Sonate*, Lourié contended, existed in space, not time, like a geometrical surface, while preserving its unity within (or rather, despite) time through the conspicuous use of isochronous note values in the outer movements, thanks to which "meter and rhythm achieve the highest degree of synthesis."[173] This talk of space replacing time as a musical medium recalls Stravinsky's famous manifesto on his Octet for winds, which had appeared a year earlier, in which he spoke of the work as a material object having an architecture realized through a "play of volumes." The resonances continue: Lourié writes that, in *facture*, Stravinsky's *Sonate* is restrained: "The pianistic coloration and the foundations of the musical fabric are constructed exclusively on *legato* and *staccato*; in dynamics only two dimensions are in evidence: *forte* and *piano*." Stravinsky: "I have excluded all nuances between the *forte* and the *piano*; I have left only the *forte* and the *piano*."[174]

These "dialectics," which concern musical contrast and unity, are without benefit (or impediment) of Hegelian philosophies of natural or historical evolution. On the contrary, they seem rather to describe unchanging essences, and are for that reason the virtual opposite of what is normally meant by dialectical proc-

ess.[175] They have everything to do with Eurasianism, however, which, as Ekaterini Levidou puts it, was all about "the perception of the world in terms of entities [and] organic totalities."[176] Elsewhere she writes of the congruence between Lourié's (and Stravinsky's) Eurasianism and the structuralist formalism of the Prague school, with its "holistic rhetoric that described the world in terms of structures that constitute harmonious entities, organic totalities."[177] Quite so, and what could be less dialectical? Understood this way, rather than as a calculus to grapple with an endless flux, Lourié's "dialectics" provide some useful tools for investigating the *Sinfonia dialectica*.

In conversation with the San Francisco conductor Giovanni Camajani, Lourié seemed to define dialectics in terms of its etymology (from the Greek *dialektos*, "talk" or "conversation," deriving in turn from dialegesthai "converse with each other" or, more literally, "to speak across").[178] "Dialectics," said Lourié, "is the talk of the soul with itself."[179] This was perhaps an echo of Jacques Maritain's comment that, as embodied in Lourié's *Sinfonia*, dialectics "articulates an interior dialogue through which we converse with ourselves or with God."[180] A clue to the subject of the symphony's particular conversation comes in the form of an epigraph: *Memoria hospitis unius diei praetereuntis*, a verse from the Vulgate Apocrypha (*Liber sapientiae [Wisdom of Solomon]*, V:15) that, in the King James version, reads, "The Remembrance of a Guest of one Day that passeth by." Pascal had quoted it in his famous "Wager," which is where Lourié discovered it.[181] It provoked Pascal into a meditation on the transience of human terrestrial life, and one can probably infer that Lourié, in appropriating the Latin phrase, also meant to appropriate the attendant meditation and make it the subject of his own.

The symphony is cast as a single uninterrupted movement in many short sections, bringing to mind Lourié's description of Stravinsky's "instrumental dialectic," a variegated surface or mosaic in which elements succeed one another without undergoing transformation. On the title page there is something like a roadmap for conductors, in which the many short sections are grouped into five larger units, as follows:

Allegro I: Moderato [mm. 1–247]
Allegro II: Scherzoso [mm. 248–367]
Allegro III: Stringendo alla cadenza [mm. 368–431]
Adagio I: Quasi récitativo *[sic]* [mm. 432–463]
Adagio II: Arioso [mm. 464–523]

With the exception of the first Adagio (and, tautologically, the first Allegro), these larger sections are not delineated as such in the score; the measure numbers are supplied on the basis of a thematic analysis by the composer that is preserved among his papers in the Arthur Lourié Collection at the New York Public

Library.[182] Following Lourié's roadmap one is led through the thicket of surface contrasts to what Lourié would likely have described as an underlying unity, not so far, really, from a conventional or "textbook" sonata form. Allegro I introduces two big themes in contrasting keys, giving it the character of an exposition—in retrospect, at any rate, when the first theme is loudly recapitulated in Allegro III. The intervening section, in which previously heard material is accompanied by a woodwind filigree and a climax is reached, fulfills some of the expectations of a development. Tonality, however, is progressive. The first theme is sounded initially against an A major–seventh harmony and almost immediately repeated a step higher, against a chord rooted on B. Its restatement in Allegro III, pitched on C, continues the progression, and the final cadence, which comes to rest on a D major–seventh chord, may be said to complete it. The first of the two Adagios, which together have the character of an extended coda, embodies a second climax initiated by a group of solo strings (probably the reason for the designation *récitativo*), while the second *(arioso)* consists of a long subsidence comprising a series of accompanied solos and duos for low winds, beginning with the rare contrabass clarinet and ending with the contrabassoon. The emphasis on low ranges accords with the heavy general sound of Lourié's orchestra, with its insistent timpani-reinforced bass.

The incipit of the second theme in Allegro I, fortuitously or not, coincides with that of the opening theme in the *Concerto spirituale*. Putting the two side by side will allow a sampling of their respective idioms, as both are thoroughly representative (ex. 8.1a–b). The extract from the Concerto is the chaste beginning of the *Bénédiction des fonts*, up to the first accidental. The *Sinfonia* theme is considerably more traditional in harmony. Its "modality," which admits the use of secondary dominants, is reminiscent of the Russian music of the nineteenth century, as is the varying meter, which varies only in the numerator, never the denominator. One can easily imagine such a tune slipping unnoticed into Rimsky-Korsakov's *Russian Easter* Overture, or—perhaps more to the point—Borodin's *Central Asia*. Elsewhere in the score the succession of meters takes on a more Stravinskian aspect, as measures of 3/8 or 5/8 alternate with 3/4 or 4/4, and must be coordinated according to a subtactile pulse. Also Stravinskian is the use of the piano alongside the timpani in the percussion section. From the point of view of the immediate (if not intended) "Western" audience, the *Sinfonia* sounds emphatically, throughout, like the "Russian music" for which that audience had a long-standing predilection, while the resolutely universalizing Concerto, with its celestial (thus nation-transcending) evocations, invokes an indicatively "Russian" idiom only vaguely and sporadically, and only if one is on the lookout for its signifiers.

. . .

Lourié's Second Symphony, completed in 1939, is scored for a much bigger orchestra than its predecessor: sixteen winds, fourteen brass, and strings to match, plus a

EXAMPLE 8.1

a. Opening theme of Lourié's *Concerto spiritual*.

b. Lourié, *Sinfonia dialectica,* incipit of second theme.

full battery of percussion (cymbals, tamtam, bass drum, xylophone, celesta etc.) to complement the ubiquitous set of seven timpani. Where the *Sinfonia dialectica* is lithe and shapely, the Second makes a massive, ungainly effect, even though, at around fifteen minutes' duration, it is no lengthier, and is put together similarly out of a succession of short episodes.

Like the *Sinfonia dialectica* it has an epigraph and a title. The former is from Michelangelo: *Ricordati che vivi, e cammina!* (Remember that thou livest, and walk!). These are the words that, according to a venerable anecdote, Michelangelo said to his marble statue of Moses when it proved to be too big to be transported into the Roman basilica of San Pietro in Vincoli (St. Peter in Chains).[183] This exhortation, emblematic of artist as life-giver or demiurge, had a history in Russian letters. Vyacheslav Ivanovich Ivanov (1866–1949), the Russian philosopher and symbolist poet, had used it as the epigraph to one of his most famous poems, *Tvorchestvo* (Creation), a manifesto of symbolist doctrine: art as prophecy.[184] There can be little doubt that Ivanov's epigraph was the source of Lourié's, for Lourié copied it just as it appeared in the book where he found it, down to the source citation, which he translated exactly from Russian to French.[185] Even were this not the case, there would be strong evidence that Ivanov was Lourié's source and inspiration, because the book where Lourié found the epigraph was Ivanov's first book of poetry, published in 1903. Its title was *Kormchiye zvyozdï*, usually translated "Lodestars"; and the title Lourié gave his Second Symphony, the one by which it is best known, was (in his French-style transliteration) *Kórmtchaïa*.

The Russian adjective *kormchiy* is derived from *kormá*, the stern or aft of a ship, where the rudder is mounted. The adjective pertains, therefore, to steering, more generally to guidance (hence *kormchiye zvyozdï*, "stars to steer by"). When used as a substantive, *kormchiy* means pilot or helmsman. (Both Stalin and Mao Zedong were apostrophized in their day as *velikiy kormchiy*, "great helmsman.") The most distinguished literary use of the term was in the title of the *Kormchaya kniga*, a thirteenth-century Slavonic translation, by Savva, the first archbishop of Serbia, of the Byzantine *nomocanon* or book of ecclesiastical law. Known simply as the *Kormchaya* (as in Lourié's title), it was adopted by all the Slavic Orthodox churches and remained canon law until the eighteenth century. The title means, literally, *Book of the Helmsman,* but the term came to mean, simply, "The Guidebook," and *kormchiy* or *kormchaya* could refer to any guide (masculine or feminine as the case may be).

Lourié's title is feminine, which might simply be out of agreement with the noun *simfoniya*. But a dedication following the title page in his autograph score takes the form of a verse from the Votive Canon to the Most Holy Virgin *(Kanon molebnïy ko Presvatoy Bogoroditse)*, attributed to the ninth-century martyr Theostirikt (or Theoktirist), abbott of the Peliktion Monastery in what is now Turkey.[186] In this

prayer, designated "to be sung upon any occasion of spiritual grief" *(poyemïy vo vsyakoy skorbi dushevnoy i obstoyaniyi)*, the Virgin Herself is addressed as *kormchaya:*

> *Strastey moikh smushcheniye, kormchiyu rozhdshaya Gospoda, i buryu utishi moikh pregresheniy, Bogonevestnaya.*
>
> Pacify, O guide who bore the Lord, the ignominy of my passions and the storm of my transgressions, Bride of God.

The canon, or ninefold ode, from which this verse comes, popularly known as the Canon of Repentance, is one of the most widely recited, and widely memorized, texts in the Slavonic liturgy. Lourié, though born a Jew and Roman Catholic by personal conviction, evidently knew the verse in that informal way (perhaps from hearing others perform it), for he quoted it inaccurately and misidentified it.[187] It is the evident source, however, not only of the poetic content of the music, as the composer conceived it, but also of its form, its ten sections corresponding to the nine odes *(pesni)* within the Kanon, plus the prefatory *Tropar' Bogoroditse* or Hymn to the Virgin. The music is incantatory throughout, with a constant percussive beat reminiscent of the *ostinati* in *Le sacre du printemps*, turning the whole symphony into what, in the language of *Le sacre*, could be called a continuous *Action rituelle* in ten gestures:

I: Tempo I (quarter note = 96)
II: L'istesso tempo
III: Ostinato I, quasi fantastico
IV: Tempo mosso di Marcia (meno mosso recitando ma non rubato)
V: Ostinato II, in tempo di marcia
VI: Presto, in tempo appassionato
VII: Tempo primo
VIII: Introduzione del finale: Tempo di cavatina
IX: Finale: Allegro
X: Postlude: Arioso, poi ostinato III

The sequence is not as diverse as a bare listing might suggest. All of the sections employ rhythmic *ostinati* (the actual use of the term merely denoting sections that consist of virtually nothing but percussive pulsation, with section V quite unambiguously recalling the "Action rituelle des ancêtres" from *Le sacre*), and the designation *Tempo di Marcia* might well be applied to the whole symphony, which might thus more simply be described as an extended march or procession *(shestviye)*, reminiscent of many earlier processions in what the Russians would call the *zolotoy fond* or mother lode of Russian music ("of the Nobles" *[shestviye boyar]* in Rimsky-Korsakov's *Mlada*, "of the Sardar" *[shestviye sardara]* in Ippolitov-Ivanov's *Caucasian Sketches*, and so on, not to mention "of the

Oldest-and-Wisest" *[shestviye stareyshego-mudreyshego]* in *Le sacre*). But there is a specifically Eurasian resonance as well. The perpetual marching or lumbering effect is obviously related to the epigraph and its exhortation, "Cammina!" But the constant on-the-wayness of a procession also puts one in mind of the old Eurasianist tracts—*Iskhod k vostoku* (Exodus to the East), *Na putyakh* (Under Way)—that figured so prominently in the preliminary sections of this essay. *Na putyakh*, it may be remembered, was the source of Souvtchinsky's theorizing about the religiously founded formalism that had constituted Eurasianism's esthetic ideal (cf. n. 72). That ideal had reached an early musical peak in Stravinsky's *Symphonies d'instruments à vent* (a piece that Lourié knew as only one can know who has written out its every note), the final section of which, shedding its octatonically based chromaticism as it approached its purely "modal" final phrases, had become for Lourié an ideal, inspiring him as *Apollon musagète* would later inspire Balanchine ("It seemed to tell me . . . that I, too, could eliminate").[188]

The trouble was that Stravinsky, with whom Lourié had broken personally, had turned his back on the ascetic, hieratic manner that had inspired so much Eurasianist praise and emulation. By the late 1930s he had thoroughly Europeanized and secularized his style, nowhere more so than in a pair of works that were exactly contemporaneous with Lourié's *Kórmtchaïa*, namely the "Dumbarton Oaks" Concerto and the Symphony in C. At the basis of both works lay motivic cells that conspicuously—one might almost say demonstratively—featured resolving leading tones in the European manner (in terms of "fixed doh" or Paris Conservatory solfège: sol-si-ut in the case of the Concerto, si-ut-sol in the Symphony; see ex. 8.2a for an illustration from the Concerto, of the two Stravinsky compositions the one that Lourié would have known at the time). Perhaps, then, it was in reaction or even protest that Lourié founded his *Kórmtchaïa* on a cell of similar contour (re-fa-sol or mi-sol-la) that just as conspicuously or ostentatiously avoided the leading tone, remaining true to the anhemitonic wellsprings of the anti-Europe we have been calling Turania, as if striving, against the new cosmopolitan tide, to keep alive in music the spirit of Khlebnikov (ex. 8.2b–c). This putative "correction" of Stravinsky's excessively westernizing turn accords perfectly with the somewhat later judgment of Stravinsky recorded in Lourié's 1944 essay on the evolution of Russian music.[189]

Kórmtchaïa follows a progressive tonal trajectory similar to that of the *Sinfonia dialectica*. It begins with a fortississimo tutti on an augmented triad, (A♭/C/E, from which a long diminuendo is made, the bass A♭ quickly dropping out to leave the dyad C-E sounding long enough to establish a sense of tonic repose. (Finally the E also drops out, leaving C alone as a tonic pedal to accompany ex. 8.2b, identifying the degrees of its motivic cell as fifth, [flat] seventh, and tonic.) The whole gesture, temporally condensed, is repeated at the end of the symphony, but transposed up a fourth, so that the apparent ending tonic is F (shadowed faintly

EXAMPLE 8.2

a. Stravinsky, "Dumbarton Oaks" Concerto, I, m. 21.

b. Lourié, *Kormtchaïa*, anhemitonic cell.

c. Lourié, *Kormtchaïa*, ending.

in the double basses by D♭). Just at the end, though, there is a whispered reprise of ex. 8.2b at its original pitch, lending a nostalgic whiff of bitonality, vintage 1925, to the music (ex. 8.2c).

There are many other such backward glances—glances not only backward but, equally unfashionably for the date, toward an imagined East. Example 8.3 contains a sampling of the symphony's themes, section by section. Some of them incorporate the modal/archaic motivic cell identified in ex. 8.2b, while others construct another sort of exotic archaism. The most interesting theme is the one from section IV, with its unique combination of accompanying march beat *(non rubato)* and "recitando," i.e., rhythmically and tonally erratic hymnody. Clearly it is meant as a kind of invented (read: Turanian) chanted liturgy. (It is reprised in section VII, with massive doubling, including an ear-splitting high piccolo.) Another such

EXAMPLE 8.3. Lourié, *Kormtchaïa*, themes.

hymn, both non-European and non-folkloric in style, is the concluding Arioso (section X). Section VI, meanwhile, which follows an obvious gesture toward *Le sacre*, gestures toward it as well, recalling the "Évocation des ancêtres" that actually precedes the "Action rituelle" in Stravinsky's score, the model for the section that it follows in Lourié's.

To emulate *Le sacre* in 1939 was, of course, anything but progressive or up-to-date. Nor was it any longer a gesture of solidarity with Stravinsky but more nearly the opposite. (Not that Stravinsky himself was immune, at the end of the thirties, from ambivalence or contradiction: at the very moment his music was most rigorously Europeanizing itself, the composer was delivering his Harvard lectures, perhaps the prime musical document of Eurasianism, thanks to Pierre Souvtchinsky's pervasive input, by no means confined, as formerly thought, to the fifth lesson ("Les avatars de la musique russe").[190] As Brahms's First Symphony sought to correct a wrong turn Beethoven had taken in his Ninth, Lourié's *Kórmtchaïa* (as Adorno would one day say of Webern in relation to Bach) "remained faithful by being unfaithful, . . . identif[ying] that heritage's content by recreating it for itself."[191] Lourié was unfaithful to what he regarded as Stravinsky's infidelity to the old Eurasianist faith. Marginalized by his fidelity to an outmoded ideal, he became a martyr to his faith, sacrificing what had been the beginnings of a strong European (or at least Parisian) reputation to the bleak obscurity of his American years. Doubly an unperson, in the Soviet and Stravinsky literatures alike, Arthur Vincent Lourié is now best known for being unknown. Few are the musicians today who cannot truthfully affirm what Stravinsky asserted as a lie at the beginning of this chapter.

NOTES

1. Transcribed in Lyudmila Korabel'nikova, "Tam, za okeanom . . . ," in Ernst Zaltsberg and Mikhail Parkhomovsky, eds., *Russkiye evreyi v Amerike*, Bk. 1 (*Russkoye evreystvo v zarubezh'ye*, vol. 12) (Jerusalem/Toronto/Moscow: Gesharim/Mostï kul'turï, 2005), 135.

2. Victor Varunts, ed., *Igor Stravinskii: Perepiska s russkimi korrespondentami. Materialï k biografii*, vol. 3: *1923–39* (Moscow: Kompozitor, 2003), 375 (hereafter cited as *PRK*).

3. Robert Craft and Vera Stravinsky, *Stravinsky in Pictures and Documents* (New York: Simon & Schuster, 1978), 291 (hereafter cited as *SPD*).

4. See, for example, a letter from Lourié to Ernest Ansermet (25 December 1929), first cited in Ekaterini Levidou, "The Encounter of Neoclassicism with Eurasianism in Interwar Paris: Stravinsky, Suvchinsky, and Lourié" (DPhil diss., University of Oxford, 2008), 156–57. The letter describes Stravinsky as studying the score of the *Concerto* and encouraging Lourié to follow up with a symphony.

5. Artur Lur'ye, "Dve operï Stravinskogo," *Vyorstï* (Paris) 3 (1928): 109–26 (also trans. Boris de S[chloezer] as Arthur Lourié, "Œdipus-Rex," *Revue musicale* 8, no. 8 [August 1927]: 240–53); Arthur Lourié, "La Sonate pour piano de Strawinsky," trans. R. Vandelle, *Revue musicale* 6, no. 10 [October 1925]:100–104, at 104. Both articles may be found in Russian in Igor Vishnevetsky, *Yevraziyskoye ukloneniye v muzïke 1920–1930-kh godov: Stat'i i materialï. Istoriya voprosa* (Moscow: Novoye literaturnoye obozreniye, 2005), 205–16 and 220–24 (hereafter cited as *YUM*).

6. Letter of 1 September 1924 (*PRK* 3:78–9; Craft [*SPD* 220] misdates it 1 November): "I am with great enthusiasm reading Loyola's '*Exercitia spiritualia*' and think it an extraordinarily sound and accurate work of theology, fashioned with the sort of dry heat that, except in your music, is nowhere to be found today."

7. Letter of 24 November 1926 (*PRK* 3:210): "[Maritain's] home is a real nest of godliness—filled with kindness for all, meekness and simple sincerity."

8. Maritain's presence there is traced in greatest detail, with parallel passages, in the second and third subsections ("*Art et Scolastique*" and "A *Summa Theologica* of Music") of the sixteenth chapter ("*Poétique musicale*") in Louis Andriessen and Elmer Schönberger, *The Apollonian Clockwork: On Stravinsky,* trans. Jeff Hamburg (Oxford: Oxford University Press, 1989), 86–96.

9. D. de'Paoli, *Strawinsky (da "L'Oiseau de Feu" a "Persefone")* (Turin: G. B. Paravia, 1934); see Valérie Dufour, *Stravinski et ses exégètes* (Brussels: Éditions de l'Université de Bruxelles, 2006), 204–5.

10. See Dufour, *Stravinski et ses exégètes,* as well as the new French edition of the lectures: Igor Strawinsky, *Poétique musicale, sous forme de six leçons,* édition établie, présentée et annotée par Myriam Soumagnac (Paris: Harmonique Flammarion, 2000); also Svetlana Savenko, "P. P. Suvchinskii i 'Muzïkal'naya poètika' I. F. Stravinskogo," in *Pyotr Suvchinskiy i ego vremya,* ed. Alla Bretanitskaya (Moscow: Kompozitor, 1999), 273–83 (hereafter cited as *PSV*); and idem, "Zametki Stravinskogo dlya 'Muzïkal'noy poètiki,'" in Igor' Stravinskiy, *Khronika, Poètika,* trans. L. V. Yakovleva-Shaporina, E. A. Ashpis, and E. D. Krivitskaya, ed. Svetlana Il'yinichna Savenko (Moscow: Rosspèn, 2004), 255–62. These publications decisively supersede Robert Craft's account of the genesis of the *Poétique,* "Roland-Manuel and the 'Poetics of Music,'" *Perspectives of New Music* 21 (1982–83): 487–505; revised as "Roland-Manuel and *La poétique musicale,*" in *Stravinsky: Selected Correspondence,* ed. R. Craft, vol. 2 (New York: Alfred A. Knopf, 1984), 503–17 (hereafter cited as *SSC*).

11. *SPD*, 221.

12. Artur Lur'ye, "Muzïka Stravinskogo," *Vyorstï* 1 (1926): 119–35.

13. Thus it was perplexing to find Lourié's article excluded—that is, *not* to find it—in Carol Oja's assemblage of writings on Stravinsky in *Modern Music,* Minna Lederman's journal of reportage and opinion, where Lourié's piece appeared in a translation by the ubiquitous S. W. Pring, translator of countless writings on Russian music in the 1920s and '30s. In the appendix where she lists the relatively few articles she chose to omit, Oja describes Lourié's discussion, not inaccurately, as "ponderous," which may have been the reason for its exclusion. See Carol J. Oja, *Stravinsky in "Modern Music" (1924–1946)* (New York: Da Capo Press, 1982), 168.

14. "Following the command recently issued to go back to Bach (and by the same token to the eighteenth century), only two or three years were needed for the wholesale imitation and production of old and outworn formulas. All in the name of neoclassicism, music was turned out in the manner of Czerny and even of Clementi" ("Neogothic and Neoclassic," trans. S. W. Pring, *Modern Music* 5 [1928]: 6).

15. The word "plastic" as it appears here (in Pring's translation), unidiomatic in English, is taken over as a faux-cognate from the French *plastique,* the modeling of forms in space, or the assumption of the shape of a container.

16. Lourié's brief 1925 article about the *Sonate* for piano in the *Revue musicale,* his first Stravinskian essay, likewise refrains from attributing to the work a retrospective idiom. Rather, as he explains (in a fashion echoed by Stravinsky a decade later in his *Chroniques de ma vie*), Stravinsky sought "un retour aux formes musicales originelles," that is, to a strictly etymological construal of the word "sonata" (as derived from *sonare,* to play an instrument), divested of its subsequent association with particular musical forms (e.g. "sonata allegro"). Nevertheless, as Valérie Dufour has ingeniously proposed, Lourié's insistence that Stravinsky had made a *retour* as opposed to a *régression,* together with his ascription to Stravinsky's writing of a "force et d'une logique qui font penser à Bach," might have prompted "a synthetic reading [producing] the formula 'Retour à Bach,' which would thereafter define this phase of Stravinsky's output"

(*Stravinski et ses exégètes*, 92–93). The suggestion is surprising but also plausible inasmuch as the article that did the most to put the catchphrase on the map, Charles Koechlin's "Le 'Retour à Bach,'" appeared in the same journal only a few months later (*Revue musicale*, November 1926, 1–12).

17. See Wilhelm Worringer, *Abstraktion und Einfühlung* (Munich: Piper Verlag, 1908), with portions translated in Francis Frascina and Charles Harrison, eds., *Modern Art and Modernism: A Critical Anthology* (New York: Harper & Row, 1982), 150–64; T. E. Hulme, *Speculations: Essays on Humanism and the Philosophy of Art*, ed. Herbert Read (London: Routledge, 1924) esp. the essays "Romanticism and Classicism" and "Modern Art and Its Philosophy."

18. For an application to the problem of musical performance practice, see R. Taruskin, "The Pastness of the Present and the Presence of the Past," in *Early Music and Authenticity*, ed. Nicholas Kenyon (Oxford: Oxford University Press, 1988), 137–210; reprinted in R. Taruskin, *Text and Act* (New York: Oxford University Press, 1995), 90–154.

19. Lourié, "Neogothic and Neoclassic," 6.

20. Ibid., 5.

21. Pierre Souvtchinsky, "La notion du temps et la musique (Réflexions sur la typologie de la création musicale)," *Revue musicale*, no. 191 (1939): 70–80. Stravinsky's gloss is found in the second *leçon*, "Du phénomène musicale"; see Igor Stravinsky, *Poetics of Music in the Form of Six Lessons*, bilingual ed. (Cambridge, MA: Harvard University Press, 1970), 38–43.

22. See the work by Dufour and Savenko cited in note 10 above, but especially Valérie Dufour, "La *Poétique musicale* de Stravinsky: Un manuscrit inédit de Souvtchinsky," *Revue de musicologie* 89 (2003): 373–92; also idem, "Strawinsky vers Souvtchinsky: Thème et variations sur la *Poétique musicale*," *Mitteilungen der Paul Sacher Stiftung* 17 (March 2004): 17–23.

23. See "From the Protocol of the Interrogation of L. P. Karsavin," an appendix to S. S. Khoruzhii, "Karsavin, Eurasianism, and the All-Union Communist Party," *Russian Studies in Philosophy: A Journal of Translations* 34 (1995–96): 10–25 (originally published in Russian as "Karsavin, yevraziystvo i VKP," *Voprosï filosofii*, no. 2 [1992]: 78–87). The appendix is on pp. 21–24.

24. Ibid., 21.

25. Larry Wolff, *Inventing Eastern Europe: The Map of Civilization on the Mind of the Enlightenment* (Stanford: Stanford University Press, 1994), 5. Wolff notes as his latest example of the earlier conceptualization a book by William Coxe titled *Travels into Poland, Russia, Sweden, and Denmark* (London, 1785), in the preface of which the author generalizes about his "travels through the Northern kingdoms of Europe."

26. Voltaire, *Histoire de Charles XII* (Paris: Garnier-Flammarion, 1968), 44; quoted in Wolff, *Inventing Eastern Europe*, 90.

27. Georges Gusdorf, *Les principes de la pensée au siècle des lumières* (Paris: Payot, 1971), 128; cited in Wolff, *Inventing Eastern Europe*, 170.

28. Letter to the Comte de Mercy-Argenteau, 31 July 1777, quoted in Matthew Head, *Orientalism, Masquerade, and Mozart's Turkish Music*, RMA Monographs 9 (London: Royal Musical Association, 2000), 73.

29. Quoted in the *American Brahms Society Newsletter* 6, no. 1 (Spring 1988): 1.

30. John F. Runciman, "Tschaikowsky and His 'Pathetic' Symphony," *The Dome: A Quarterly Containing Examples of All the Arts* 1 (1897): 114, 110.

31. Nicholas V. Riasanovsky, "Afterword: The Emergence of Eurasianism," in *Exodus to the East: Forbodings and Events, an Affirmation of the Eurasians*, ed. Ilya Vinkovetsky and Charles Schlacks Jr. (Idyllwild, CA: Charles Schlacks Jr., 1996), 129.

32. Nikolai Yakovlevich Danilevsky, *Rossiya I Yevropya: Vzglyad na kul'turnïye i politicheskiye otnosheniya Slavyanskogo mira k Germano-Romanskomu*, 3rd ed., ed. Nikolai Strakhov (St. Petersburg: Tip. Brat. Panteleyevïkh, 1888), 191.

33. See Kn. Nikolai Sergeyevich Trubetskoy, *Yevropa i chelovechestvo* (Sofia: Rossiysko-Bolgarskoye knigoizdatel'stvo, 1920), passim.

34. Marlène Laruelle, "La question du 'touranisme' des Russes," *Cahiers du monde russe* 45 (2004): 241–66 (accessed online at www.cairn.info/article_p.php?ID_ARTICLE=CMR_451_0241, 30 December 30, 2010) at n. 65.

35. Norman Davies, *God's Playground: A History of Poland*, vol. 2: *1795 to the Present* (New York: Columbia University Press, 2005), 18–19. A French writer, Henri Martin, quickly took up Duchiński's theory and popularized it in France. See Stephan Wiederkehr, "Eurasianism as a Reaction to Pan-Turkism," in *Russia between East and West: Scholarly Debates on Eurasianism*, ed. Dmitry Shlapentokh (Leiden: Brill Academic Publishers, 2006), 55n8.

36. Henry Sutherland Edwards, *The Russians at Home, and the Russians Abroad: Sketches, Unpolitical and Political, of Russian Life under Alexander II*, vol. 2 (London: Wm. H. Allen, 1879), 196.

37. His name turns up in a list of proto-Eurasianist thinkers, along with those of Vladimir Solovyov, Vasiliy Rozanov, Nikolai Berdyayev, Nikolai Fyodorov, and Victor Nesmelov in the fifth chapter ("Les avatares de la musique russe") of *La poétique musicale*, the chapter that was (as established by Savenko and Dufour) entirely written by Souvtchinsky.

38. See Marlène Laruelle, "Existe-t-il des précurseurs au mouvement eurasiste? L'obsession russe pour l'Asie à la fin du XIXe siècle," *Revue des études slaves*, nos. 3–4 (2004): 437–54.

39. R. Taruskin, *Stravinsky and the Russian Traditions: A Biography of the Works through "Mavra"* (Berkeley: University of California Press, 1996), 1126–36 (hereafter cited as *SRT*). Thus when, in an attempted rebuttal, Ekaterini Levidou ("Encounter of Neoclassicism with Eurasianism," 26) announces that "'Turania' is Taruskin's invention," she discloses only that she has read carelessly.

40. N. S. Trubetskoy, "O turanskom elemente v russkoy kul'ture," *Yevraziyskiy vremennik* 4 (1925): 371; reprinted in N. S. Trubetskoy, *K probleme russkogo samopoznaniya: Sbornik statei* (Paris: Yevraziyskoye knigoizdatel'stvo, 1927), 49.

41. L. P. Karsavin, *Vostok, zapad i russkaya ideya* (Petrograd: Academia, 1922), 74.

42. Lourié, "Neogothic and Neoclassic," 3.

43. Arthur Knodel and Ingolf Dahl, recognizing the thought as inherently religious, translate as follows: "Similarity is born of a striving for unity. The need to seek variety is perfectly legitimate, but we should not forget that the One precedes the Many" (*Poetics of Music*, bilingual ed., 42–43).

44. Lourié, "Neogothic and Neoclassic," 6.

45. Thomas Garrigue Masaryk, *The Spirit of Russia: Studies in History, Literature, and Philosophy*, trans. E. and C. Paul (London: George Allen & Unwin, 1919), 2:259.

46. L. P. Karsavin, "Osnovï politiki," *Yevraziyskiy vremennik* 5 (1927): 188.

47. Levidou, "Encounter of Neoclassicism with Eurasianism," 98, 152.

48. D. S. Mirsky, "The Eurasian Movement," *Slavonic Review* 6 (1927); reprinted in idem, *Uncollected Writings on Russian Literature*, ed. G. S. Smith (Berkeley, CA: Berkeley Slavic Specialties, 1989), 244. At least one Eurasianist, a certain Sergey V. Dmitriyevsky, managed to praise both Hitler and Stalin, recognizing the latter as "an emerging Russian Fascist leader" (see Dmitry V. Shlapentokh, "Eurasianism Past and Present," *Communist and Post-Communist Studies* 30 [1997]: 145).

49. The phrase in quotation marks is G. S. Smith's; see *D. S. Mirsky: A Russian-English Life, 1890–1939* (Oxford: Oxford University Press, 2000), 171. Also N. V. Riasanovsky, "Afterword: The Emergence of Eurasianism," in Vinkovetsky and Schlacks (eds.), *Exodus to the East*, 120: "Communist Russia and Fascist Italy were ideocracies, weakened, however, by the fact that their master ideas had no ultimate spiritual and religious sanction. Eurasianism was to become the successful ideocracy of Eurasia." For Lourié's agreement in principle, see the letter referenced in note 85 below.

50. Riasanovsky, "Afterword: Emergence of Eurasianism," 123.

51. Shlapentokh, "Eurasianism Past and Present," 136. The archive also contains an anonymous denunciation of Souvtchinsky that depicts him as engaging, beginning in 1929, in "meetings with agents of the Communist government and went so far as to see the Consul General of the USSR" (ibid., 143).

52. Smith, *D. S. Mirsky,* 148–49.

53. The Russian word *plasticheskiy* (related to the French *plastique*) is notoriously difficult to render in English. The meaning is closest to the term "plasticity" as used in physics, which pertains to the shaping of physical material in response to external forces (as applied here, the shaping of the musical material in response to the composer's creative thinking). Cf. note 15 above.

54. Lur'ye, "Muzïka Stravinskogo," 120.

55. Ibid., 119–20. Lourié's invocation of the "call to order" is striking. Cocteau's manifesto, *Le rappel à l'ordre,* also glorifying Stravinsky, appeared the same year.

56. Arthur Lourié, *Serge Koussevitzky and His Epoch* (New York: Alfred A. Knopf, 1931), 196.

57. Henrietta Malkiel, "Modernists Have Ruined Modern Music, Stravinsky Says," *Musical America,* 10 January 1925, 9.

58. Lur'ye, "Muzïka Stravinskogo," 124.

59. Ibid., 126. Here Lourié was no doubt paying back Andrey Nikolayevich Rimsky-Korsakov, Stravinsky's former bosom friend, for his famous sally that in *Petrushka* "our raw Russian moonshine *[sivukha]* has been too obviously larded with French perfume" (A. N. Rimsky-Korsakov, "7-y simfonicheskiy kontsert S. Kusevitskogo," *Russkaya molva,* 45 [25 January/7 February] 1913).

60. Lur'ye, "Muzïka Stravinskogo," 134.

61. Lourié's substantiation of this provocative thesis was not devoid of blunders. As a concrete example of Stravinsky's universalism he juxtaposes a tune from the fourth tableau of *Petrushka* with a Gregorian antiphon, not recognizing Stravinsky's tune as the Russian folk song "A mï maslenu dozhidayem" (As We Await the Shrovetide) ("Muzïka Stravinskogo," 127; *YUM,* 189–90).

62. Arthur Lourié, "The Russian School," trans. S. W. Pring, *Musical Quarterly* 18 (1932): 528. Lourié lists his "Western group" as follows: "Stravinsky, Prokofiev, Lourié, Dukelsky, Nabokov, and Markevich. Also Lopatnikov, Tcherepnin (Alexander), Berezovsky, Obukhov, and Vishnegradsky" (ibid., 527). See the preceding essay ("Is There a 'Russia Abroad' in Music?") in this collection.

63. R. Taruskin, *Defining Russia Musically: Historical and Hermeneutical Essays* (Princeton: Princeton University Press, 1997), 452 (hereafter cited as *DRM*). Details of Stravinsky's flirtation with fascism and Mussolini can be found there, as well as in Robert Craft, "Stravinsky's Politics: Left, Right, Left," in *SPD,* 547–58.

64. See L. P. Karsavin, Review of Giovanni Gentile, *Che cosa è il fascism: Discorsi e polemiche, Yevraziyskaya khronika* 8 (1927), 55; also *DRM,* 450.

65. Information on Karsavin's career is from Françoise Lesourd, "Karsavin and the Eurasian Movement," trans. Jack Pier, in Shlapentokh (ed.), *Russia between East and West,* 68–69.

66. "Speaking for the nation in the sobbing voice of a provincial tragedian, no Kerensky [i.e., Alexander Fyodorovich Kerensky (1881–1970), head of the liberal Provisional Government from February to October 1917] ever expressed anything national, whereas Lenin, oppressing the Russian people in the name of the International, did manage to express something, as did General Kornilov [i.e., Lavr Georgiyevich Kornilov (1870–1918), commander in chief of the Provisional Government's armed forces until his arrest by Kerensky for sedition] from the other side" (Karsavin, "Fenomenologiya revolyutsii," *Yevraziyskiy vremennik* 5 [1927]: 44).

67. Even by Stravinsky, it seems, on occasion. Robert Craft went so far in a recent self-interview as to allege that "a file containing Souvtchinsky's record as a Soviet spy was accidentally uncovered during Isaiah Berlin's wartime work in Washington" ("Conversations with Robert Craft: Restoring Stravinsky,"

Areté 24 [Winter 2007]: 44). Surely this is a garbled version—the word of one notorious gossip as retailed by another—of denunciations such as that referenced in note 51 above. As to infiltration, according to Françoise Lesourd's summary of Karsavin's deposition to the Soviets in 1950 (see note 23 above), "during 1924–25, the heads of the Eurasian movement (Savitskii, Trubetzkoi, Souvtchinskii, Arapov, and Malevskii-Malevitch) met a certain Langovoi in Berlin who was thought to be close to [Soviet] government circles and at the same time a sympathizer with regard to the Eurasians" ("Karsavin and the Eurasian Movement," in Shlapentokh [ed.], *Russia between East and West*, 92). Alexander Alexeyevich Langovoy (d. 1964) was indeed a Soviet agent, a *chekist* (that is, an officer in the Soviet secret police, which from 1923 to 1934 was called OGPU [*Ob'yedinyonnoye Gosudarstvennoye Politicheskoye Upravleniye* or Joint State Political Administration], the forerunner of the later NKVD and KGB) working through an organization called *Trest* ("The Trust"), "allegedly an underground anticommunist resistance group, but, in fact, a bogus organization set up by the OGPU to control and manipulate the Russian emigration," according to G. M. Hamburg and Randall A. Poole, who characterize *Trest* as "the decisive stimulus in shifting Eurasianism's focus from philosophical ideas to political deeds" (*A History of Russian Philosophy 1830–1930* [Cambridge: Cambridge University Press, 2010], 368). *Trest* is best known for being the bait in some of the most famous stories of counterespionage and political abduction in the 1920s, including those of Sidney Reilly—the "Ace of Spies" of television fame—and the White general Alexander Kutyopov. Langovoy's main purpose in infiltrating émigré groups was to persuade their members to return, his greatest catch being Sergey Efron (see Alain Brossat, *Agents de Moscou: Le Stalinisme et son ombre* [Paris: Éditions Gallimard, 1988], 180ff.). For more details on Langovoy's interactions with Eurasianists, see Sergey Lvovich Voytsekhovsky, *Trest: Vospominaniya i dokumentï* (London, Ont.: Zarya, 1974), a memoir by a former Trest agent who had defected to Canada. Isaiah Berlin was not close enough to the Eurasianists to parse them into factions. For him, "the general movement of Eurasia, Suvchinsky, etc., . . . gravitated in that direction," i.e., toward the pro-Soviet (letter to G. S. Smith, 20 March 1996, quoted in Smith, *D. S. Mirsky*, 145).

68. Simon Morrison and Nelly Kravetz, "The Cantata for the Twentieth Anniversary of October, or How the Specter of Communism Haunted Prokofiev," *Journal of Musicology* 23, no. 2 (2006): 227–62; see also Simon Morrison, *The People's Artist: Prokofiev's Soviet Years* (New York: Oxford University Press, 2009), 54–66; and *YUM*, 337–42.

69. The occasion is described in Smith, *D. S. Mirsky*, 150–51. The lecture was introduced by Souvtchinsky; the audience included "many famous figures who after it were to become Mirsky's implacable enemies."

70. A reference to a Latin translation of an aphorism by Hippocrates, *Quae non medicamenta sanant, ferrum sanat, quae ferrum non sanat, ignis sanat, quae vero ignis non sanat, oportet insanabilia reputari* (What drugs do not heal, the knife heals; what the knife does not heal, fire heals; but what fire does not heal must be considered incurable), best known to the literary from its use as an epigraph in Schiller's *Die Räuber*.

71. *Vyorstï* 2 (1927): 247–54, at 254; quoted in Smith, *D. S. Mirsky*, 151.

72. P. Souvtchinsky, "Vechnïy ustoy" (An Eternal Foundation), in *Na putyakh: Utverzhdeniye yevraziytsev* (Under Way: An Affirmation of the Eurasianists), 2:99–133, at 114–15; quoted in Sergei Glebov, "Science, Culture, and Empire: Eurasianism as a Modernist Movement," in *Russian and East European Books and Manuscripts in the United States: Proceedings of a Conference in Honor of the Fiftieth Anniversary of the Bakhmeteff Archive of Russian and East European History and Culture*, ed. Tanya Chebotarev and Jared S. Ingersoll (New York: Haworth Information Press, 2003), 22.

73. Glebov, "Science, Culture, and Empire," 22.

74. Souvtchinsky, "Vechnïy ustoy," 115, quoted in Glebov, "Science, Culture, and Empire," 22..

75. All quotations from "The New 'West'" ("Novïy 'zapad'"), which originally appeared in *Yevraziya: Yezhenedel'nik po voprosam kul'turï I politiki* 2 (1928): 1–2, are cited from its reprint in *YUM*, 324–27.

76. The binarism works better as a slogan in Russian, where both terms can form negatives with a single prefix: *svobodnoye neravenstvo* vs. *nesvobodnoye ravenstvo* (free inequality vs. unfree equality).

77. The word "runner"—*begun,* accented on the second syllable, with a long *u*—means a runner in a race. As a wry equivalent of *émigrant,* it was trendy in the Eurasianist journals, possibly for its resonance with *beglets,* also derived from the verb "to run," which means a "runaway" or deserter.

78. Robert Speaight, "Arthur Lourié: A Study in the Artistic Conscience," *New Blackfriars* 48, no. 557 (27 October 1966): 32.

79. Morrison, *People's Artist,* 41. In a later article, "Pax Eurasiana" (*Yevraziya,* no. 10 [1929]: 1–2; rpt. *YUM,* 327–30), Souvtchinsky went further in what amounted to an apologia for the recent policies of the Soviet government at the inception of the first Five-Year Plan and the expulsion of Trotsky: "For all its excesses, revolutionary statism has correctly defined the style of Russia's assertive state policies as a *pax eurasiana.*" Any counterrevolutionary backsliding, he insists, is expressly to be condemned as "politico-economic degradation that must inevitably be accompanied by a new bout of cultural kowtowing to Europe, which will irrevocably detach Russia from its true historical path." Russia, he concludes, must not try to rival America as an "individualistic, hypercapitalistic" society; rather it must provide an alternative to America in three ways: "the *primarily religious cultural substance* of the Russo-Eurasian peoples; *revolution* as an aggregate of ideas and processes that will lead to the creation of Russia's contemporary identity; and a system of revolutionary consequences, expressed formally in Soviet federalism and economic statism" (*YUM,* 329). The issue of *Yevraziya* in which this editorial appeared, it may be worth noting, was the first issue in which Lourié's name appeared on the masthead.

80. I feel it necessary to emphasize this caveat because Igor Vishnevetsky, in his volume devoted to musical Eurasianism, surely the most comprehensive and useful treatment the subject has received up to now, makes so many unnecessary and squeamish disclaimers on this score, possibly out of misplaced advocacy, and definitely out of an insufficiently nuanced appreciation of the complexity of interwar politics, as if a sympathetic attitude toward Mussolini in the 1920s were tantamount to a sympathetic attitude toward Hitler in the 1940s. His sensitivity may be due in part to the resurgence of a faction that calls itself Eurasianist on the contemporary Russian political right, and its claim of continuity with the Eurasianism of the émigré twenties and thirties. (On its rise and claims, see Marlène Laruelle, *Russian Eurasianism: An Ideology of Empire,* trans. Mischa Gabowitsch [Washington, DC: Woodrow Wilson Center Press/Baltimore: Johns Hopkins University Press, 2008].) Practically assuming Trubetskoy's own voice and diction, Vishnevetsky scoffs that in calling attention in my writings on Stravinsky to the right-wing politics that attracted many Eurasianists I "criticize Eurasianism from the most vulnerable liberal-democratic position" (*YUM,* 26). He regards the title of the section in *DRM* devoted to Stravinsky—"Stravinsky and the Subhuman"—as a slur on Eurasianism that casts doubt on the book's integrity, but the adjective was intended there to characterize not Eusasianism but rather the earlier neoprimitivism of *Le sacre du printemps.* "With the obvious polemical overreach that is unfortunately characteristic of his interesting books," writes Vishnevetsky, "Taruskin . . . for some reason launches a discussion of 'fascism'" in connection with Lourié's description of Stravinsky as the dictator of the reaction against musical anarchy, as if that characterization were incompatible with Lourié's or Souvtchinsky's "leftism" *(levizna)* (*YUM,* 157). (Moreover, as reported above, Lourié made the implied comparison with Mussolini not in "Neogothic and Neoclassic," as Vishnevetsky erroneously asserts, but in his biography of Koussevitzky, dating from 1931. See *YUM,* 157n1.) He attributes my discussion of the Eurasianists' fascist affinities to an uncritical acceptance of Prince Svyatopolk-Mirsky's "notorious self-flagellation" in his "repentant" essay "The Story of an Emancipation" ("Istoriya odnogo osvobozhdeniya"), made in 1931 on the eve of his ill-fated return to Stalinist Russia, in which he characterized Eurasianism as "Russian Gandhi-ism" and, as such, "a form of fascism, Gandhi-ism being in any case nothing more than bourgeois fascism" (quoted in *YUM,* 157n1). My source for Mirsky's views, however, was "The Eurasian Movement," an article that he published in the British journal *Slavonic and East*

European Review in 1927, when the movement was still relatively united and its press, including *Vyorstï*, was going strong. In that article Mirsky related Karsavin's concepts of "symphonic society" and "the higher symphonic personality" to early theories of fascist corporatism (for a summary, see *SRT*, 1134). Vishnevetsky is also exercised over my allusion to the affinities between Trubetskoy's romantic philologism and what, citing James Billington, I called "Nazism in its early 'runic' stages" (see Billington, *The Icon and the Axe* [New York: Alfred A. Knopf, 1966], 760; *SRT*, 1134). Contrary to Vishnevetsky's assumptions, and possibly the reader's, Billington's reference (and consequently mine) was not to Hitler or the period of his reign, but to Guido von List (1848–1919), whose *Das Geheimnis der Runen* was a foundational text of the "Ariosophy" and pagan revivalism that attended the birth of the Nazi Party, founded in Munich in January 1919, a few months before List's death. (Hitler joined later that year.) The immediate post–World War I period was one in which romantic philologism was politicized both in Germany and among the Russian émigrés. Trubetskoy's *Yevropa i chelovechestvo*, the Eurasianist foundational tract, was a product of this period and trend. For a fuller discussion of the importance of Italian fascist theorizing, as well as the example of the early fascist state in Italy, to the theory of Eurasianism, see *DRM*, 450–54.

81. Lyudmila Korabel'nikova, "'Tam' i 'zdes', 'tam' i 'tam': Po stranitsam pisem," in *PSV*, 166. Lourié joined the editorial board beginning with the tenth issue (26 January 1929). His fellow board members included Karsavin, Svyatopolk-Mirsky, and Efron.

82. N. S. Trubetskoy, P[yotr] N[ikolayevich] Savitsky et al., *O gazete "Yevraziya" (Gazeta "Yevraziya" ne yest' yevraziyskiy organ)* (On the Newspaper *Yevraziya* [The Newspaper *Yevraziya* Is Not an Organ of Eurasianism]) (Paris, 1929); see Ilya Vinkovetsky, "Eurasianism in Its Time: A Bibliography," in Vinkovetsky and Schlacks (eds.), *Exodus to the East*, 144.

83. Quoted in Smith, *D. S. Mirsky*, 165.

84. Letter of 2 June 1925, quoted in *YUM*, 217. In later decades, when they were both living in America, Lourié and Dukelsky became close friends. Their correspondence is preserved at the Library of Congress.

85. 10 November 1926, *PRK* 3:209.

86. G. S. Smith, ed., *The Letters of D. S. Mirsky to P. P. Suvchinskii, 1922–31*, Birmingham Slavonic Monographs, No. 26 (Birmingham: Department of Russian Languages and Literature, University of Birmingham, 1995), 193. The editors of *Vyorstï* jointly wrote to *Sovremennïye zapiski* to deny the allegation of a Soviet subsidy, and Lourié wrote to deny that he had ever been a member of the Party. In the extract given here the term *Muzo* is translated as "music section" and *Narkompros* as "Soviet commissariat of education." They will be more precisely defined below.

87. Letter of 16 December 1926, published in facsimile in *PSV*, 127 (first page only), and quoted in *PRK* 2:479.

88. Smith, *D. S. Mirsky*, 343n84. Boris Anrep (1883–1969) was a St. Petersburg–born painter who emigrated to England in 1917 and became famous for his mosaics.

89. N. Punin, "V dni krasnogo oktyabrya," *Zhizn' iskusstva*, no. 816 (1921), 8 November, quoted in Sheila Fitzpatrick, *The Commissariat of Enlightenment: Soviet Organization of Education and the Arts under Lunacharsky, October 1917–1921* (Cambridge: Cambridge University Press, 1970), 122; as Fitzpatrick remarks, "Punin's account suggests that before their arrival, time had been hanging heavy on Lunacharsky's hands."

90. Amy Nelson, *Music for the Revolution: Musicians and Power in Early Soviet Russia* (State College: Pennsylvania State University Press, 2004), 21.

91. Sergei Prokofiev, *Autbiography*, in *Sergei Prokofiev: Autobiography, Articles, Reminiscence*, ed. S. Shlifshteyn, trans. Rose Prokofieva (Moscow: Foreign Languages Publishing House, 1960), 50.

92. Stravinsky also put him to work proofreading works published by other houses, including *Histoire du soldat*, the Suites for chamber orchestra, and *Svadebka* (all published by J. and W. Chester), the

last-named a notoriously bad job of proofing, and recommended him in the summer of 1924 to Wilhelm Hansen Verlag for the job of transcribing the *Concertino* for string quartet (1920) for solo piano (see Lourié to Stravinsky, 16 August 1924, *PRK* 3:74, in which Lourié thanks Stravinsky for "remembering me in Copenhagen" and informs him that "I have done the work for Hansen and sent it off to him"; for some reason, Varunts fails to connect these remarks with the *Concertino* in his commentary in *PRK*, possibly because Lourié's arrangement was not published until 1926).

93. Igor Stravinsky and Robert Craft, *Conversations with Igor Stravinsky* (Garden City, NY: Doubleday, 1959), 26.

94. Stephen Walsh, *Stravinsky: A Creative Spring—Russia and France 1882–1934* (New York: Alfred A. Knopf, 1999), 457.

95. Robert Craft, *Stravinsky: Chronicle of a Friendship, 1948–1971* (New York: Alfred A. Knopf, 1972), 63. Recollections at a remove of two decades that included World War II always come with a caveat, of course; and recollections that come by way of Souvtchinsky need a stronger one, for Souvtchinsky could compete with Stravinsky in deviousness. In the same conversation, as recorded by Craft, Souvtchinsky says that "the lecture in the *Poétique Musicale* on music in the U.S.S.R. convinces me that the fear of communism would eventually have driven [Sravinsky] into the arms of the occupier." That chapter, as Craft could not then have known but Souvtchinsky surely remembered, was written by Souvtchinsky himself (see Savenko, "P. P. Suvchinskii i 'Muzïkal'naya poètika' I. F. Stravinskogo," cited in note 10 above).

96. *Stravinsky: A Creative Spring*, 384. Putting the phrase in Walsh's own context suggests another reason why Lourié has been so often disparaged: "As for Stravinsky, it was typical of him to be more interested in the Jewish Lourié's practical value as an office boy and, perhaps, as an articulator of ideas." It is strange that Lourié's adopted Catholicism should have been good enough for Stravinsky but not for Walsh.

97. Craft, *Stravinsky: Chronicle of a Friendship*, 62.

98. Nicolas Nabokov, *Bagazh* (New York: Atheneum, 1975), 166. The envy shows through especially clearly in this passage:

> In 1930 I had been commissioned by the Maison Pleyel to write a piece for the new harpsichord they were putting on the market, and given a studio with a harpsichord in it. Suddenly there was a knock at the door of my studio, and before I could say *"Entrez,"* Stravinsky and his shadow, Arthur Lourié, had come in. "Did you know we are neighbors?" Stravinsky said. And he pointed to a door on the opposite side of the dark corridor that ran between two rows of studios. "Come to my place." Lourié unlocked Stravinsky's door and we walked into his studio. From that morning on through the three or four weeks of Stravinsky's stay in Paris, my life was concentrated on being with Stravinsky, waiting for Stravinsky, and spending all the time I possibly could muster at his side. (166–67)

99. At times, one must admit, in a manner fairly, and unbecomingly, servile, which lends a bit of credence to the complaints of onlookers. In one of his letters to Stravinsky (20 November 1929, in *PRK* 3:367), he asks that Stravinsky send him Boris de Schloezer's recent book (*Igor Stravinsky* [Paris: Éditions Claude Aveline, 1929]), which he had not yet seen, so that he could "correct its errors" according to "your [i.e., Stravinsky's] markings." This article or review does not seem to have been written. The closest Lourié ever came in print to acting as an official spokesman was in "A propos de l'*Apollon* d'Igor Strawinsky" (*Musique: Revue mensuelle de critique, d'histoire, d'esthétique et d'information musicales*, 1, no. 3 [15 December 1927]: 117–19). This article took the form of an open letter to Robert Lyon, the magazine's publisher, and, just as Robert Craft would often do in later years, gives an advance look at a work that was still in progress.

100. *PRK*, vol. 2: *1913–22* (Moscow: Kompozitor, 2000), 478–79.

101. *PRK* 2:480n2.

102. Nelson, *Music for the Revolution,* 21.

103. The meeting is recorded in Vera Sudeykina's diary; see Walsh, *Stravinsky: A Creative Spring,* 384.

104. Again, Vera Sudeykina appears to have been involved. According to Robert Craft (*Stravinsky: Chronicle of a Friendship,* 63), Stravinsky cut off relations with Lourié in 1939 because the latter "intrigued against V. before her marriage to I.S., which is the reason why the name is never mentioned in the I.S. household." Lourié's side of the story, so far as it is reflected in public documents, is confined to a laconic passage within a lengthy diary entry made in America, titled "My Contemporaries" ("Moï sovremenniki"), possibly intended as notes toward an essay, which carries the date 5–7 July 1946: "In Paris: Stravinsky. Later Maritain. Real intimacy was only with Stravinsky. It was agonizing, all attractions and repulsions. It ended in a breakup, forever. A reconciliation we have not had and will never have" (transcribed in Korabel'nikova, "Tam, za okeanom . . . " [see note 1 above], 140).

105. 17 May 1924, in *PRK* 3:58.

106. These letters, which appear to mark the warmest phase in their relationship, mainly concern Stravinsky's children, on whom Lourié reports to their father (away on tours) with something approaching parental concern, even though the "children" were nearing, or past, their majority. On 18 November 1929 (*PRK* 3:365–66) he describes the nineteen-year-old Soulima's musical and intellectual growth; in a trio of letters, all written between 8 and 15 March 1930 (*PRK* 3:383–85), he expresses worry about Fedik (Théodore, Stravinsky's older son) and his "intimate affairs" ("I don't think he's really in love, just strangely attached," nothing that a little "psychology and self-analysis" couldn't cure; "he'll get through it with God's help"). At this point I believe it is fair to call Lourié "a virtual member of Stravinsky's household," despite Walsh's objection (to *SRT,* 1587) and his suggestion that if Lourié was a member of a household, it was Vera Sudeykina's, not her future husband's, to which he properly belonged. In two separate letters, the Russian-born Swiss musicologist Jacques Handschin sends Stravinsky family greetings, and includes "Artur Sergeyevich" along with Stravinsky's wife Yekaterina Gavrilovna and his daughter (presumably Lyudmila) (*PRK* 3:420, 536).

107. 2 January 1930 (*PRK* 3:374–75), 28 July 1930 (396), 29 August 1930 (399–400), 1 October 1930 (406–9), 6 June 1931 (434), 14 October 1931 (451).

108. Lourié to Stravinsky, 9 December 1927, in *PRK* 3:256.

109. Igor Stravinsky and Robert Craft, *Expositions and Developments* (Garden City, NY: Doubleday, 1962), 93.

110. Prunières, like Schoenberg, was born a Jew. The Masons were, and remain, standard proxies for Jews in antisemitic discourse, especially in France and Russia.

111. Cf. Walsh, *Stravinsky: A Creative Spring,* 462.

112. *Russkoye slovo* (Moscow), no. 84; quoted in Camilla Grey, *The Russian Experiment in Art, 1863–1922* (London: Thames & Hudson, 1962), 94.

113. The single surviving copy of this broadside is now in the National Library of Russia (formerly Saltïkov Shchedrin State Public Library) in St. Petersburg; reprinted in Vladimir Markov, ed., *Manifestï i programmï russkikh futuristov* (Munich: Wilhelm Fink Verlag, 1965), thence in *YUM,* 161. It was reprinted in French translation (as "Nous et l'Occident") in *Mercure de France* with a response from Guillaume Apollinaire, and in Russian in the newspaper *Russkoye slovo,* 21 October 1916.

114. Arthur Lourié, *Rech' k yunosham-artistam Kavkaza* (Baku: Tipografskoye tovarishchestvo, 1917); reprinted in *YUM,* 166–67.

115. Lur'ye, "Muzïka Stravinskogo," 124.

116. *YUM,* 168; cf. note 75 above.

117. Arthur Lourié, "Krizis iskusstva," *Yevraziya,* no. 4 (1928): 8; no. 8 (1929): 8; reprinted in *YUM,* 239–44.

118. Program listed in Z. A. Apetyan, ed., *S. Rakhmaninov: Literaturnoye naslediye*, vol. 2 (Moscow: Sovetskiy kompozitor, 1980), 504n6.

119. Arthur Lourié, "O Rakhmaninove," *Yevraziya*, no. 4 (1928): 8; reprinted in *YUM*, 245–48 at 245.

120. Lourié makes this point explicitly with regard to Rachmaninoff's most ubiquitous work: "At present there could scarcely be in any country a house where there is a piano but not the famous Prelude in C sharp minor" (ibid., 246).

121. Ibid., 245.

122. Ibid., 247n.

123. Ibid., 245.

124. Ibid., 246.

125. Ibid., 247.

126. See "Bela Bartok," *Yevraziya*, no. 18 (1929): 8; reprinted in *YUM*, 248–50. Another attraction (at least for the journal, if not for Lourié) was the fact that as a Magyar composer Bartók hailed from a language group within the older "Turanian" classification from which Trubetskoy had derived the catchword for the movement. Stravinsky's patronizing final word on Bartók, in his first book of dictated memoirs, is one of his sorriest, albeit grimly amusing, hypocrisies: "I never could share his lifelong gusto for his native folklore. This devotion was certainly real and touching, but I couldn't help regretting it in the great musician" (Stravinsky and Craft, *Conversations with Igor Stravinsky*, 82).

127. *YUM*, 249. On 28 September 1945, Lourié was among the ten mourners at Bartók's funeral.

128. The Russian original appeared in *Chisla* (vol. 7/8 [1933]: 218–29), a lavishly illustrated journal published in Paris under the editorship of the poet Nikolai Avdeyevich Otsup and the theosophist I. V. de Manziarly. In what follows, quotes are from S. W. Pring's translation in the *Musical Quarterly* (see note 62).

129. Arthur Lourié, "Linii èvolutsii russkoy muzïki," *Novïy zhurnal* 9 (1944): 257–75; reprinted in *YUM*, 299–315.

130. For an analysis, see the preceding essay ("Is There a 'Russia Abroad' in Music?") in this collection.

131. Lourié, "The Russian School," 523.

132. Ibid., 529.

133. Ibid., 524.

134. Lourié, "Na temu o Musorgskom," *Novosel'ye: Yezhemesyachnïy literaturno-kyudozhestvennïy zhurnal* 1 (1943); reprinted in *YUM*, 283. Note the many overlaps between the honor roll nominated in this paragraph and the litany of Eurasianist saints that Souvtchinsky inserted into the fifth lesson of the *Poétique musicale* (names surely bafflingly unfamiliar to the original Harvard audience in 1940): Leontiev, Solovyov, Rozanov, [Nikolai Alexandrovich] Berdyayev, [Nikolai Fyodorovich] Fyodorov, and [Victor Ivanovich] Nesmelov (see *Poetics of Music*, bilingual ed., 129, 131). The last pair of sentences in the extract parodies a famous quatrain by Fyodor Ivanovich Tyutchev (1803–73): *Umom Rossiyu ne ponyat', / Arshinom obshchim ne izmerit': / U ney osobennaya stat'— / V Rossiyu mozhno tol'ko verit'* (You won't capture Russia with the mind, / Or measure her by a common yardstick: / She has her own peculiar form— / In Russia one can only believe).

135. Lourié, "The Russian School," trans. Pring, 520.

136. "Na temu o Musorgskom," *YUM*, 286.

137. "Linii èvolyutsii russkoy muzïki," *Novïy zhurnal* 9 (1944): 257–75; reprinted in *YUM*, 299–315, at 302.

138. Ibid., 314.

139. For the quote, see Anton Rubinstein, *Muzïka i yeyo predstaviteli* (Moscow: P. Jurgenson, 1891), 40.

140. "Linii èvolyutsii," *YUM*, 314.

141. For the Asafyev concept, see *Intonatsiya* (second volume of *Muzïkal'naya forma kak protsess*) (Moscow: Muzgiz, 1947), trans. James Robert Tull as "B. V. Asafev's *Musical Form as a Process:*

Translation and Commentary" (PhD diss., Ohio State University, 1976) and explicated in Gordon McQuere, "Boris Asafiev and *Musical Form as Process*," in *Russian Theoretical Thought in Music*, ed. G. D. McQuere (Ann Arbor: UMI Research Press, 1983), 217–52; for Ratner's, see Leonard G. Ratner, *Classic Music: Expression, Form, and Style* (New York: Schirmer Books, 1985). Asafyev was an old associate of Souvtchinsky, who before bankrolling the Eurasian press subsidized two Russian musical journals with which Asafyev was connected: *Muzïkal'nïy sovremennik* (The Musical Contemporary), published 1915–17 with Andrey Rimsky-Korsakov (son of Nikolai) as editor, from which Souvtchinsky and Asafyev bolted (over a dispute concerning Stravinsky, as it happens) to found a short-lived journal of their own called *Melos*, which lasted for all of two issues in revolutionary Petrograd. See *SRT*, 1121–25.

142. *YUM*, 314.
143. "Krizis iskusstva" (1928–29), in *YUM*, 239–45, at 241.
144. "Linii èvolyutsii," *YUM*, 315.
145. Famous dismissals of Shostakovich's Seventh include Virgil Thomson's in the *New York Herald Tribune*, 18 October 1942 (reprinted in Thomson, *The Musical Scene* [New York: Alfred A. Knopf, 1945], 101–4, and abridged in Piero Weiss and Richard Taruskin, *Music in the Western World: A History in Documents*, 2nd ed. [Belmont, CA: Thomson/Schirmer, 2007], 425–26) and B. H. Haggin's in the *Nation*, 15 August 1942 (reprinted in Haggin, *Music in the Nation* [New York: William Sloane Associates, 1949], 108–11).
146. Letter of May 1943, in V. Stark, ed., "Perepiska Vladimira Nabokova s M. V. Dobuzhinskim," *Zvezda*, no. 11 (1996): 92–108, at 101; quoted in *YUM*, 293.
147. *YUM*, 293.
148. Ibid., 288. It seems clear that the review to which Lourié here retorts is Thomson's.
149. Ibid., 289.
150. Ibid., 290. *Chastushki* are little satirical verses like limericks that are usually sung, with balalaika or accordion accompaniment, to stock melodic formulas. The genre, popular in cities as well as the countryside, is often bawdy or seditious. It is usually ranked as a very low form of folklore when weighed against the rural genres to which Lourié here compares it. The best-known Soviet concert works based avowedly on the idiom of *chastushki* are by Rodion Konstantinovich Shchedrin (b. 1932), especially his Concerto No. 1 for Orchestra (1963), subtitled "Ozornïye chastushki" (variously translated "Mischievous Melodies" or "Naughty Limericks" in Anglophone publications and recordings), which exists as well in arrangements for solo piano and for piano trio.
151. *YUM*, 291.
152. Ibid., 292.
153. Ibid.
154. Arthur Lourié, "Approach to the Masses," *Modern Music* 21 (1944): 203–7, at 205 (*YUM*, 296).
155. Ibid., 207 (*YUM*, 298).
156. Søren Kierkegaard, *Philosophical Fragments*, trans. David F. Swenson (Princeton, NJ: Princeton University Press, 1936), 5.
157. See *YUM*, 23.
158. *Skryabin i russkaya muzïka* (Petrograd: Gosudarstvennaya izdatel'stvo, 1921), 16; in *YUM*, 176.
159. "K muzïke vïsshego khromatizma," in *Strelets*, ed. Alexander Belenson (Petrograd, 1915), 81–83; in *YUM*, 162–64.
160. "Puti russkoy shkolï," Russian variant (*Chisla*, 1933); in *YUM*, 259–69, at 261.
161. See Claudia R. Jensen, *Musical Cultures in Seventeenth-Century Russia* (Bloomington: Indiana University Press, 2009), 33ff.
162. A search of *Grove Music Online* (19 March 2011) turned up two very minor Italian masters—Agostino Facchi (d. 1682) and Francesco Maria Marini (fl. 1637; actually a citizen of the Republic of San Marino)—who published books of *concerti spirituali*. Alessandro Scarlatti published a book of *concerti sacri*, and of course there is the famous *Cento concerti ecclesiastichi* of 1602 by Ludovico Grosso da

Viadana. Schütz's coinage, *geistliche Konzert*, is without a direct Italian antecedent: Italians earlier than Schütz preferred the term *sacrae symphoniae* (as did Schütz himself). The Italian term *concerto spirituale*, when it was used before the twentieth century, more frequently specified an occasion (cf. *concert spirituel*) than a composition. Besides Lourié's, the only twentieth-century *concerto spirituale* that I have succeeded in tracing is a setting by Giorgio Federico Ghedini (1892–1965) of a poem, "De l'Incarnazione del Verbo Divino," by Jacopone da Todi for two sopranos or a chorus of sopranos and chamber orchestra. It was composed in 1943, and may well have been named with Lourié's composition (his most widely publicized piece, then at the height of its notoriety) in mind.

163. On Stravinsky's Symphonies, see *SRT*, 1486–99.

164. See *DRM*, 405. This point has been disputed: for example, by Vishnevetsky (*YUM*, 50–51).

165. The authenticity of Lourié's melody may be verified by consulting any edition of the *Liber usualis*, where the complete text is found and the incipit is given in musical notation. (In the version with Latin and English texts [*Mass and Vespers* (Paris and Tournai: Desclée et Cie., 1957)], the *Exsultet* is found on p. 630.) A complete rendition of the *Exsultet* in English, which may be easily followed from Lourié's score, can be heard online at www.domcentral.org/life/exsultet.htm (accessed 20 March 2011).

166. Compare the chords in m. 4ff. and the top of p. 12 in Lourié's arrangement (Paris: Édition russe de musique, 1926).

167. *YUM*, 53. The continuation of this passage, associating Lourié's invocation of fire with every heliotropic Russian symbolist or futurist who wrote of flame or blaze or "Victory over the Sun," seems by contrast entirely misguided.

168. Fred. Goldbeck, "Arthur Lourié: Concerto spirituale," *La revue musicale*, no. 167 (July–August 1936): 47. Goldbeck also conjectured, quite plausibly, that the idea for a concerto combining solo piano and chorus may have stemmed in part from Busoni, whose concerto (op. 39, 1904) ends with an invisible male chorus singing lines from the verse drama *Aladdin* by Adam Gottlieb Oehlenschläger. (Other precedents for combining a concertante piano with chorus include Beethoven's *Choral Fantasy*, op. 80, as well as a concerto by Daniel Stiebelt that was first performed in St. Petersburg in 1820.) Lourié's acquaintance with Busoni in Berlin in 1921 is sometimes cited as one of the factors leading to his defection from Soviet Russia.

169. 3 January 1931, reprinted in Nicolas Slonimsky, *Writings on Music*, ed. Electra Slonimsky Yourke, vol. 1 (New York and London: Routledge, 2004), 97.

170. Ibid., 99.

171. Olin Downes, "A New 'Spiritual Concerto,'" *New York Times*, 23 March 1930. As reported three days later (idem, "Schola Cantorum Gives Novelties," *New York Times*, 26 March 1930), the performance was bedeviled by problems of balance, leading the disappointed critic to pronounce a negative judgment on the work, in which "passages of exquisite conception" were overwhelmed by "much inept writing." The most successful performance of the Concerto took place in Paris in 1936 at the Salle Pleyel under the direction of Charles Munch, with Yvonne Lefébure (1898–1986) at the piano. It was greeted by the rapturous article in *La revue musicale* by Goldbeck, already quoted, who pronounced it "one of the rarest musical masterpieces of our time" ("Arthur Lourié: Concerto Spirituale," 48; Goldbeck did not mention the fact that he and Lefébure were companions of long standing; they were married in 1947). Years later, the Concerto was recalled reverently by Vernon Duke, who attended the concert (as Vladimir Dukelsky) and found the Concerto to be "heavy with music and replete with religious fervor" (Duke, *Passport to Paris* [Boston: Little, Brown, 1955], 334).

172. Levidou, "Encounter of Neoclassicism with Eurasianism," 158. Further on, despite her Hegelian assumption, Levidou persuasively debunks Vishnevetsky's strained attempt to coordinate scattered writings by Lourié (and the *Concerto spirituale* into the bargain) with the strictly schematic neo-Hegelian dialectics of Alexey Fyodorovich Losev (ibid., pp. 160–69).

173. "La Sonate pour piano de Strawinsky," *La revue musicale* 6 (1925): 103. Lourié calls it "rythme monométrique," a term he reapplied to Stravinsky in his article on *Oedipus Rex* two years later (*La*

revue musicale 8 [1927]: 241, 246–47). It went back to Stravinsky himself, who sketched a set of "Cinq pièces monométriques" in a notebook he used in 1919–22 (in which sketches for the *Sonate* can also be found). For a reference, see R. Taruskin, *Text and Act* (New York: Oxford University Press, 1995), 117.

174. Stravinsky, "Some Ideas about My Octuor," *The Chesterian*, 1924; reprinted in Piero Weiss and Richard Taruskin, *Music in the Western World: A History in Documents*, 2nd ed. (Belmont, CA: Thomson/Schirmer, 2008), 389. The parallel passages from Lourié are from "La Sonate pour piano de Strawinsky," 103.

175. After making a considerable effort at finding a Hegelian in Lourié, Levidou ("Encounter of Neoclassicism with Eurasianism," 176) seems to concede this point, concluding that "he often resorts to the terms 'dialectics' and 'dialectical' mainly to denote that the music in question fulfils his ideals of balance, unity and organicism.".

176. Ibid., 177.

177. Ibid., 245.

178. Definitions from *Online Etymology Dictionary*, www.etymonline.com/index.php?search=dialect&searchmode=none (accessed 22 March 2011).

179. Giovanni Camajani, "The Music of Lourié," *Ramparts*, January–February 1965, 35. Camajani (1905–86), who led the University of San Francisco Schola Cantorum, was best known for having given, in 1954, the first American performance of Orff's *Carmina burana*.

180. Maritain, "Le clef des chants," *La nouvelle revue française*, no. 260 (1 May 1935): 696; quoted in Levidou, "Encounter of Neoclassicism with Eurasianism," 178.

181. The citation in the score reads: "Pascal (Lib. Sap. V-15)."

182. "Sinfonia dialectica: Sketches," reproduced piecemeal over the course of Levidou's analysis of the *Sinfonia* in "Encounter of Neoclassicism with Eurasianism," 184–95.

183. This legend has many variants; the most popular (a favorite with Roman tour guides) is that when he completed the statue, Michelangelo, reacting in Pygmalion-like fashion, was so stunned at its lifelikeness that he bade it speak, and when it remained silent, struck it on the knee with his hammer, leaving a mark that may be seen to this day.

184. Pamela Davidson, "Viacheslav Ivanov's Idea of the Artist as Prophet: From Theory to Practice," *Europa Orientalis* 21 (2002): 157–202, at 163.

185. Ivanov: *Slova Mikel' Andzhelo mramoru* "*Moise*" / Lourié: *Michelangelo (paroles pour le marbre "Moïse")* (both: "Words of Michelangelo to his marble 'Moses'").

186. For the full Slavonic text, see www.molitvoslov.com/text4.htm.

187. His version reads: *Strastey smushcheniye, Kormchaya rozhdshaya Gospoda, i buryu utishi pregresheniy, Bogonevestnaya*. The main error concerns the word "Kormchaya" itself, which in the correct text is cast in the archaic vocative case *(kormchiyu)*, which Lourié evidently did not recognize as such and therefore "corrected." Since it addresses the Virgin Mary, Lourié incorrectly assumed it must have come from what he called the "Hymne Acathistos," referring to the famous sixth-century Byzantine hymn to the Virgin that is sung standing (i.e., not-sitting, *a-cathizo*).

188. George Balanchine, "The Dance Element in Stravinsky's Music," in *Stravinsky in the Theatre*, ed. Minna Lederman (New York: Da Capo, 1975), 81.

189. See note 137 above.

190. On this point see three important publications by Valérie Dufour: "La *Poétique musicale* de Stravinsky: Un manuscript inédit de Souvtchinsky," *Revue de musicologie* 89 (2003): 373–392; "Strawinsky vers Souvtchinsky: Thème et variations sur la *Poétique musicale*," *Mitteilungen der Paul Sacher Stiftung* 17 (March 2004): 17–23; *Stravinski et ses exégètes* (see note 9).

191. Theodor W. Adorno, "Bach gegen seiner Liebhaber verteidigt" (*Prismen*), quoted in Michael Marissen, "Hindemith, Bach, and the Melancholy of Obligation," in *Bach Perspectives*, vol. 3: *Creative Responses to Bach from Mozart to Hindemith*, ed. Michael Marissen (Lincoln: University of Nebraska Press, 1998), 147.

9

The Ghetto and the Imperium

1. *FATTA L'ITALIA, BISOGNA FARE GLI ITALIANI*

On 17 March 1861, Vittorio Emanuele II of the House of Savoy, ruler of Sardinia and Piedmont—having convened an all-Italian parliament in Turin following the French victory over Austria (which had liberated Lombardy) and Garibaldi's campaign against the Kingdom of Naples and the Two Sicilies (which had succeeded thanks to Vittorio Emanuele's intervention)—was proclaimed, by the parliament he had appointed, king of a united Italy.

The kingdom he ruled was still in part a fiction: its nominal capital, Rome, was still under papal rule, and Venetia was still held by the Austrians. (The fully united peninsula, achieved in July 1871, was the collateral product of Prussian military aggression: Venetia was annexed as a result of Austria's defeat in 1866, and Rome followed with the defeat of the pope's protector, Napoleon III, in the Franco-Prussian War of 1870.) But even half formed, the new state, being an expansion of an existing sovereign dynastic realm, was immediately recognized as legitimate, so that when the Sardinian—now Italian—prime minister, Camillo Benso, count of Cavour, lay dying only months after the March proclamation, he could take leave of his associates with the confident words "Non temete, l'Italia è fatta" (Fear not, Italy is made)[1]—on hearing which his predecessor and rival, Massimo d'Azeglio, is supposed to have rejoined, "Fatta l'Italia, bisogna fare gli italiani" (Italy is made; now we must make Italians). A brilliant comment, it broached the crucial

Delivered (in part) as a keynote address at the conference "Nationalism in Music in the Totalitarian State," at the Musicological Institute of the Hungarian Academy of Sciences, Budapest, 24 January 2015.

difference between a state and a nation, hence between patriotism and nationalism: the one a political entity that inspires political allegiance, the other sociocultural; the one a matter of statute, the other of consciousness; the one a thing of maps, the other of minds.

D'Azeglio surely wished he'd made this brilliant comment, but he never did.[2] What he did write, in his posthumously published memoirs, was this: "To do its duty, . . . Italy's first need is the formation of Italians who know how to fulfill their duty, which means the formation of lofty and strong characters."[3] And this: "We need to make Italians if we want to have Italy, and once they are made, *Italy will make itself.*"[4] D'Azeglio's italics indicated his acknowledgment that he was quoting an old Risorgimento slogan, most recently popularized in a speech by d'Azeglio's old employer, King Carlo Alberto of Piedmont-Sardinia, the father of the future king of Italy.[5] The assurance that Italy would evolve "naturally" toward nationhood served the king's successful monarchist counterrevolution in 1848, the main instrument of which, the constitution known as the Statuto Albertino, would remain nominally in force throughout the history of the Italian kingdom—that is, until shortly after the Second World War. And that was why Friedrich Engels called Carlo Alberto "the arch-enemy of Italian liberty," who deceived the people by posing as their champion.[6]

D'Azeglio's two approximations of the famous words eventually attributed to him are in contradiction. The one puts Italy first, the other Italians.[7] Yet whether making Italy will produce Italians ("of lofty and strong character") or making robust and noble Italians will produce Italy, the meaning of the distinction remains the same. Until there were Italians, imbued with a sense of common membership not only in a purely legal and diplomatic entity known as Italy, but also in what is now often called (after Benedict Anderson) an imagined kinship community,[8] there could be no nation, only a state—and a state riven, moreover, with conflicting allegiances and identities breeding mutual suspicion and contempt: north vs. south, rich vs. poor, industrial vs. agrarian, even Europe vs. "Africa." It was the task of patriotism to transcend these divisions, or rather sublate them, by providing an object to which all could pledge their loyalty—a common allegiance that would shade, with time, into a mutual one. Only then would Italy be a nation.

The man who wrote the book about this process, long before Benedict Anderson, was Jean-Jacques Rousseau. In *Considérations sur le gouvernement de Pologne*, his last political tract, written in 1771–72 and published (posthumously) only after the state whose sovereignty the essay was intended to bolster had already been partitioned and obliterated, Rousseau posed the problem of saving the state as one of creating the nation—or, as he put it, of "establishing the republic in the Poles' own hearts, so that it will live on in them despite anything your oppressors may do."[9] This can only be accomplished, Rousseau with striking prescience advised, on

the basis of distinctiveness. "See to it," Rousseau exhorted the Polish patriots who had solicited his advice, "that every Pole is incapable of becoming a Russian, and I answer for it that Russia will never subjugate Poland" (11).

Poland never had a chance of implementing this advice, but other countries would later do so with a vengeance; for in this prescription, with its shift in emphasis from the "Enlightened" celebration of human universality to the celebration and cultivation of human difference, Rousseau had planted the seed of modern Romantic nationalism. Like many if not most radical thinkers, Rousseau cloaked his innovations in a pretended revival of ancient ways:

> *National* institutions: That is what gives form to the genius, the character, the tastes, and the customs of a people, what causes it to be itself rather than some other people; founded upon habits of mind impossible to uproot; what makes unbearably tedious for its citizens every moment spent away from home—even when they find themselves surrounded by delights that are denied them in their own country. Remember the Spartan at the court of the Great King; they chided him when, sated with sensual pleasures he hungered for the taste of black broth. "Ah!" he sighed to the satrap, "I know your pleasures, but you do not know ours!"
>
> Say what you like, there is no such thing nowadays as Frenchmen, Germans, Spaniards, or even Englishmen—only Europeans. All have the same tastes, the same passions, the same customs, and for good reason: Not one of them has ever been formed *nationally*, by distinctive legislation. Put them in the same circumstances and, man for man, they will do exactly the same things. . . . Give a different bent to the passions of the Poles; in doing so, you will shape their minds and hearts in a national pattern that will set them apart from other peoples, that will keep them from being absorbed by other peoples, or finding contentment among them, or allying themselves with them. . . . They will love their fatherland; they will serve it zealously and with all their hearts. Where love of fatherland prevails, even a bad legislation would produce good citizens. And nothing except good citizens will ever make the state powerful and prosperous. (11–12)[10]

To achieve this love of fatherland, Rousseau prescribes, more than two centuries *avant la lettre*, what Eric Hobsbawm and Terence Ranger and their legions of followers would call "invented traditions":[11]

> You must maintain or revive (as the case may be) your ancient customs and introduce suitable new ones that will also be purely Polish. Let these new customs be neither here nor there as far as good and bad are concerned; let them even have their bad points; they would, unless bad in principle, still afford this advantage: they would endear Poland to its citizens and develop in them an instinctive distaste for mingling with the peoples of other countries. I deem it all to the good, for example, that the Poles have a distinctive mode of dress; you must take care to preserve this asset—by doing precisely what a certain czar, whose praises we often hear, did not do. See to it

that your king, your senators, everyone in public life, never wear anything but distinctively Polish clothing, and that no Pole shall dare to present himself at court dressed like a Frenchman.... You must create games, festivities, and ceremonials, all peculiar to your court to such an extent that one will encounter nothing like them in any other. Life in Poland must be more fun than life in any other country, but not the same kind of fun. This is to say: you must turn a certain execrable proverb upside-down, and bring each Pole to say from the bottom of his heart: *Ubi patria, ibi bene* [Where my homeland is, there I am at ease]. (14)[12]

These customs, Rousseau emphasized, must rely primarily on expressive and symbolic artifacts: national monuments, commemorative holidays, honorifics, and the avoidance of "any invective against the Russians, or even any mention of them; [for] that would be to honor them too much" (13). The great instrument of inculcation would be primary education, to which Rousseau devotes the next chapter of his tract, thus tying his treatise on Polish nationhood to one of his overriding themes. The instilling of national pride in the citizenry must begin with "the games they play as children, through institutions that, though a superficial man would deem them pointless, develop habits that abide and attachments that nothing can dissolve" (4):

> The newly-born infant, upon first opening his eyes, must gaze upon the fatherland, and until his dying day should behold nothing else.... When the Pole reaches the age of twenty, he must be a Pole, not some other kind of man. I should wish him to learn to read by reading literature written in his own country. I should wish him, at ten, to be familiar with everything Poland has produced; at twelve, to know all its provinces, all its roads, all its towns; at fifteen, to have mastered his country's entire history, and at sixteen, all its laws; let his mind and heart be full of every noble deed, every illustrious man, that ever was in Poland, so that he can tell you about them at a moment's notice. (19–20)

All of which will replicate in plural that sentiment of unique being—in a word, of authenticity—that Rousseau had celebrated in his *Confessions,* when he insisted that "I know men" and therefore "venture to believe that I am not made like any of those who are in existence. If I am not better, at least I am different"—and therefore noteworthy and valuable.[13] The big "I" of Romanticism begot the big "we" of nationalism. Rousseau left no doubt that the big we, on one level a distinguishing sentiment of being, is on another an all-encompassing one. "Let none of the things I have mentioned be reserved for the rich and powerful," he warned. "Rather let there be frequent open-air spectacles in which different ranks would be carefully distinguished, but in which, as in ancient times, all the people would take part" (14–15).[14] Thus, farsightedly perceiving the social task that nationalism would have to perform, Rousseau explicitly designed his vision of nationhood and its associated symbols and rituals to transcend and counteract—though not to efface—divisions of class.

2. FRATELLI D'ITALIA, L'ITALIA S'È DESTA, / DELL'ELMO DI SCIPIO S'È CINTA LA TESTA

Among the symbols and rituals imparting a sense of national belonging music has always been conspicuous. Its role as a community builder was recognized, long before there were modern nations, in the creation and maintenance of religious fellowship. Fifteen hundred years before Rousseau or d'Azeglio pondered what it would take to produce Poles or Italians, St. Basil wrote that singing psalms "forms friendships, unites those separated, conciliates those at enmity, ... so that psalmody, bringing about choral singing, a bond, as it were, toward unity, and joining the people into a harmonious union of one choir, produces also the greatest of blessings, charity."[15] In short, it produced Christians. Say what you like, to echo Rousseau, the parallels between ecclesiastical and political rites, Enlightened insistence on *laïcité* notwithstanding, were always salient, indeed calculated. Music was meant to transfer the effects of religious fellowship to the secular fellowship of nationality, nowhere more so than in zealously anticlerical revolutionary France.[16]

That modern nationhood has (or is) a liturgy is reflected in the names given its musical components in all the European languages: not just songs but hymns and anthems—the first term adapted from the Greek ὕμνος *(humnos)* to mean (in the words of St. Augustine) "a song with praise of God";[17] the second the modernized form of an old English corruption (with cognates in other languages) of the Latin *antefana*, derived from the Greek ἀντίφωνον *(antiphonon)*, which in its most proximate (Christian) meaning denoted an introductory or alternating verse sung to adorn a psalm. Some national anthems—including the very famous British one, evidently the first of its kind—are cast as actual prayers.

The actual use of national anthems in public ceremonies only slightly predates Rousseau's call for "games, festivities, and ceremonials" to foster the sentiment of national being. Here, as in so much that pertains to modern nationalism, England was out in front. "God Save the King," as it was then sung, in an arrangement by Thomas Arne, was ritually performed at two London theaters in September 1745 in patriotic response, as it happens, to military adversity: the defeat of King George II's army by one loyal to the Old Pretender in the second Jacobite Rising.[18] Although in keeping with the tradition of the unwritten constitution the song has never been officially adopted as the British national anthem, it has had de facto recognition as such ever since, both inside and outside the British Isles. It was a reliable signifier for Beethoven in *Wellington's Victory* (1813), even though by then the tune had been appropriated by several other countries for patriotic use, including Russia, where it carried the words "Bozhe, tsarya khrani" (the incipit being a direct translation of the original English text), until Alexey Fyodorovich Lvov's melody (familiar from its use in Chaikovsky's *Marche slave* and "1812" Overture) was adapted to it in 1833.

By the time of Italy's unification, national anthems had become as much the norm as national flags, and Italy was thus one of the earlier nations to have an anthem from the very beginning: namely, the "Marcia reale d'ordinanza" (Royal March of Ordinance, or Royal Fanfare), a wordless composition for military band, which the new state inherited along with its ruling dynasty, the House of Savoy, which had ruled Sardinia and the Piedmont since 1718. Commissioned by King Carlo Alberto in 1831 from Giuseppe Gabetti (1796–1862), his regimental bandleader, it remained the official Italian anthem as long as there was a Savoy king in Italy, that is, until 1946.[19]

But the new Italian kingdom's musical debut as a "regenerated nation" before the world spurned the "Marcia reale" in favor of another anthem, the choice of which reflected a considered preference, to recall d'Azeglio, for *gli Italiani* over *l'Italia*.[20] In 1861, the year of unification, Giuseppe Verdi, newly elected a deputy to the first Italian parliament, received a commission from the Society of Arts in London to compose a triumphal march, for full orchestra, to be performed at an international exposition to be held in the British capital in 1862. The exposition had originally been planned for 1861, to mark the decennial of the Great Exhibition of the Works of Industry of All Nations, known as the Crystal Palace Exhibition of 1851, and to establish a precedent for holding such events at ten-year intervals in perpetuity. It had been postponed expressly to await the outcome of the Italian War of 1859, in which France and Britain had pledged moral support for unification under the Savoy crown and France had lent actual military support to Sardinia in its struggle to liberate Lombardia-Venetia from the Austrian Empire. The invitation to Verdi went out alongside others: to Daniel-François Auber to represent France with a march for military band; to Giacomo Meyerbeer, long resident in Paris, to (somewhat equivocally) represent Germany with an accompanied anthem; and to William Sterndale Bennett to represent Great Britain with an unaccompanied chorus (or "chorale," to quote the official *Report of the Commissioners*).[21] Verdi was actually the Society's second choice to represent Italy, after the venerable, long-retired Rossini, who had begged off out of "what was by that time congenital laziness." [22] Both for that reason and because of his low regard for *pezzi d'occasioni*, Verdi was slow to accept the commission; but he was brought round when reminded of the honor that it represented, not only to him personally but to his regenerated nation, which would appear as one of a veritable Big Four of European musical powers. Representing his country at this prestigious affair would allow him "to fulfill a role in facilitating the making of the new Italy."[23]

He did not, however, write the piece he was asked to write, nor did any of the other commissionees. Meyerbeer, pleading ignorance of English, opted for an overture; Sterndale Bennett composed what Meyerbeer was supposed to have furnished, an accompanied anthem; Auber chose to write his march for full orchestra, thus usurping the role assigned Verdi. When Verdi learned of this (directly from

Auber, whom he chanced to meet in Paris), he decided to set a text that had been submitted to him by Arrigo Boito, whom he had not previously met, and thus embark on what would be a most distinguished series of collaborations, and use the resulting cantata (or "Cantica," as Verdi called it), composed for solo tenor, mixed chorus, and orchestra, as his submission to the London exposition. When he offered it to the London commissioners, he offered as an inducement the services of the famous tenor Enrico Tamberlik, who was then preparing to "create" the role of Alvaro in Verdi's latest opera, *La forza del destino.*

Boito's "Cantica" celebrates the arts as the fruit of peace, contrasting the joyous occasion of its performance with a day now past when war brought furious "clanging of arms, a clashing of swords, / a pounding of carts and horses . . . / a shout of triumph, . . . and a howling cry!" But now, "where in the field were / cruel adversaries, today there are / only brothers in art." As the text unfolds, the references become more and more specific, until at the end it is clear that the poem's subject is the War of 1859, and that its object is to render thanks to the allies whose support had enabled united Italy to emerge triumphant:

Salve, Inghilterra, Regina de' mari,	Hail, England, queen of the seas,
Vessillo antico di libertà! . . . Oh Francia!	ancient emblem of liberty! O France!
Tu, che spargesti il generosi sangue	You, who shed your selfless blood
Per una terra incatenata, salve!	For a land enslaved, hail!
Oh Italia . . . oh patria mia! Che il cielo	Oh Italy . . . oh my country! May Heaven
Vegli su te fino a quell di che grande,	watch over you until that day when great,
Libera, ed una tu risorga al sole.	free. And united you rise again in the sun.[24]

And at this point the *Coro di popolo* launches into a complete rendition, in English, of "God Save the Queen" (as it was then sung) in tribute to the hosts of the exposition. Before the full rendition, however, the British anthem had sounded, as a kind of underscoring, where the tenor (or *Bardo,* as the poem calls him) had invoked *Inghilterra;* and comparable references to patriotic signifiers had accompanied the other invocations as well, at first seriatim and then montaged in a rough but rousing counterpoint—for which reason Verdi's Cantica is better known by its alternate title, *Inno delle nazioni* (Hymn of the Nations).

The references were comparable, but with this telling difference: "God Save the Queen" was the hymn that would have been sung in Britain at any occasion of state, which is what one ordinarily means when designating a "national anthem." That was not the case with the other cited tunes. The invocation to France was accompanied—and could only have been accompanied—by the universally recognized strains of "La Marseillaise," variously appropriated to symbolize France, or the

French revolution, or just revolution, by Beethoven, Rossini, Schumann, and Wagner, most recently by Offenbach. But in 1862 "La Marseillaise" was anything but the French national anthem. During the Second Empire of Napoleon III ("Napoléon le petit"), the official French anthem was the now-forgotten "Partant pour la Syrie," a setting, inspired by Napoleon I's Egyptian campaign, of a poem about a valiant crusader knight, originally titled "Le beau Dunois," written in 1807 by Count Alexandre de Laborde (an exile from revolutionary France who later became a close aide to Napoleon I) to a tune invented by another temporary exile, Hortense de Beauharnais, queen of Holland (and mother of Napoleon III).[25] "Partant pour la Syrie," it began, "le jeune et beau Dunois / allait prier Marie / de bénir ses exploits" (Departing for Syria, the young and handsome Dunois went to pray that the Virgin Mary would bless his exploits). "La Marseillaise," very much a republican anthem and informally adopted as the international revolutionary hymn, while by 1862 no longer actually banned (as it was during the first Bourbon restoration), nevertheless retained a whiff of the illicit in its country of origin.

And in place of the "Marcia reale," Verdi represented the new Italy by quoting the so- called "Canto degli Italiani," popularly known as the "Inno di Mameli" after the author of the words, Goffredo Mameli (1827–49), a follower of Mazzini who had lost his life, aged twenty-two, during the Roman republican insurrection. His death, while caused by an accidental wound from his own comrade's bayonet, left his name surrounded by a romantic Risorgimento aureole that kept his anthem alive alongside the official dynastic one, sung to a tune composed in 1847 by a popular songwriter named Michele Novaro (1818–85). It finally replaced the "Marcia reale" as Italy's de facto anthem for use in public ceremonies on 12 June 1946, when the last Savoy king, Umberto II, renounced the throne less than five weeks after the abdication of his father, Vittorio Emanuele III, and Italy finally became a republic. (It was only adopted legally in 2012.) "Fratelli d'Italia!" it begins, "l'Italia s'è desta, dell'elmo di Scipio s'è cinta la testa" (Brothers of Italy! Italy has awakened and bound Scipio's helmet upon her head). By invoking Publius Cornelius Scipio, the Roman commander of the third century BCE, known as Africanus after his defeat of Hannibal and celebrated for his magnanimity in refusing the life consulship that would have made him dictator, the words Verdi set invoked the pre-Imperial Roman Republic, the original *res publica*, with its elective and representative institutions.

Verdi's Cantica so exceeded the terms of the commission that the Society of Arts rejected it on the grounds that there would not be time to copy the parts and rehearse it. They put a notice in the papers that Verdi had failed to send in his piece on time; whereupon Verdi fought fire with fire, mobilizing the press to shame the commissioners. In an open letter to the *Times* of London, he admitted to having submitted more than had been bargained for; but, he wrote: "I thought that this change would not have displeased the Royal Commissioners, but, instead, they intimate that 25 days (sufficient time to learn a new opera) were not enough to

learn this small piece, and refuse to accept it. I wish to state this fact, not to give any importance to a transaction in itself of no consequence, but only in order to rectify the error that I have not sent in my composition."[26]

This maneuver did secure the Cantica a hearing, but not at the exposition. It was performed a few weeks later, as *Inno delle nazioni*, as an addendum to a performance of *The Barber of Seville* at Her Majesty's Theatre, 24 May 1862. Newspaper accounts describe a shower of bouquets and wreaths, the fervent applause of the performers when Verdi stepped out on stage, and the immediate repetition of the whole piece as an encore. The critic of record, Henry Chorley, reacted like Ebenezer Scrooge: "We must state frankly," he wrote, "that the *Cantata* appears to be no favourable specimen of Signore Verdi's peculiar manner, and beside being of a form entirely different from that in which he was invited to compose, is, in every point of taste and of art, unsuited to the occasion for which it was designed."[27] And indeed, Verdi and Boito had made a political statement out of the hymn that went beyond what either *Inghilterra* or *Francia* would have approved at the time, or even the Kingdom of Italy.

That implied republican sentiment was widely—though, apparently, wrongly—perceived as the reason why Verdi's "Hymn of the Nations" was initially rejected by Her Majesty's Society of Arts.[28] Much of the commentary in the press expressed political disapproval verging on indignation. The *Spectator* complained that the "finale," as their critic called it, "though nominally a chorus for all nations, is simply a wild Garibaldian hymn, of which the accompaniment is compounded of the Marseillaise, a so-called 'Inno Nazionale d'Italia,' and—will it be believed?—'God Save the Queen.' Even the Commissioners of the Exhibition were not equal to so gigantic a blunder as to sanction ... the close association of our national hymn of loyalty and prayer with the hateful strain of a blood-thirsty war-cry of revolution."[29]

The same critic later accused Verdi of having engineered "an ingenious piece of trickery, in order that an English audience may be led to stand up to do honour to the 'Marseillaise' and 'La Garibaldienne.'"[30] This is a fertile misapprehension: it gives us the chance to reconsider some of the political nuances any study of nationalism and its musical manifestations must confront. The offended critic for the London *Spectator* was correct: Verdi's selection of tunes did create a cognitive dissonance for those listening with politically attuned ears. Pursuing it will further sharpen the distinction we have already noted between state and nation.

If Verdi had set "God Save the Queen" alongside "Partant pour la Syrie" and the "Marcia reale"—that is, if he had put three actual national anthems in counterpoint—he would have been matching like to like and in every case invoking a political entity defined by its ruler. Dynasties determine states, not nations; and so the term "national anthem," as we habitually use it, is often a misnomer. The Russian term *gosudarstvennïy gimn*, which is the term used to designate what we would call the national anthem of the Soviet Union (the eventual subject of this

essay) and, in post-Soviet times, of the Russian Federation, is more accurate; but in English we do not normally use the term "state hymn" or anthem. One may say in general that states are far less problematically defined than nations, and their identity far less frequently contested.

One could make a case that some countries—the United Kingdom, for one—is both a state and a nation; but its identity as a state has always been far more stable than its identity as a nation. The Irish rebellion (and later civil strife fomented by the Irish Republican Army) sorely compromised the country's identity as a nation, but never its identity as a state. When the borders of the country were redrawn in 1922 to exclude most of Ireland, national integrity might be said to have been restored; but if the referendum of September 2014 had gone the other way, the borders would have had to be redrawn again to exclude Scotland and the state further contracted so as to maintain, or regain, synonymy with nationhood—at least, that is, until Wales followed suit, and then who knows what? It is only when states are of uniform or nearly uniform ethnic complexion that state and nation can become fully interchangeable concepts. The presence of significant minority populations within a state always threatens to put its national integrity in question. The national integrity of the United States was affirmed militarily in 1861–65, but it has never been accepted by the whole population without question, even if the answer to the question is, for the moment, clear enough. Statehood can be imposed; nationhood requires consent.

France in 1862 was one of the few stable nation-states on the continent of Europe, and (except for Portugal) the only nation that has looked more or less the same on the political map since the sixteenth century. But the song by which Verdi represented it in his Cantica ignores its status as a state, and for that very reason seemed out of place to the London critics. "La Marseillaise" defines the *patrie* not in terms of its ruler or its borders but in terms of resistance to invasion and tyrannical rule. In 1862 it was thought of as a politically destabilizing revolutionary song—a status that would be cemented in 1870 when it was adopted by the Paris Commune in antagonistic opposition to the actual French state. The "Canto degli Italiani," by Mameli, defines the *patria* in terms of its inhabitants, who by virtue of being "a people" united by *un'unica bandiera, una speme* ("one single flag, one hope") have become *fratelli*, "brothers"—or will become brothers if they so decide. The song is an exhortation, a plea for agreement:

Stringiamci a coorte,	Let us join in a cohort
Siam pronti alla morte	We are ready to die.
l'Italia chiamò. Si! . . .	Italy has called. Yes!
Uniamoci, amiamoci,	Let us unite, let us love one another,
l'unione e l'amore	For union and love
rivelano ai popoli	Reveal to the people
le vie del Signore.	The ways of the Lord.

This is recognizable as the romantic nationalist ideal as conceived by those who equate it with liberationist movements: a verticalized conception of society that sees all classes as united.

But what unites them? Here is where definitions become impossible, because (as I put it, throwing up my hands, in the article on nationalism that I contributed to the second edition of the *New Grove Dictionary of Music and Musicians*), different definitions serve different interests, and these differences cannot be settled in the conference hall or the seminar room. For that kind of settlement you often need a battlefield, and even then settlement can only be provisional.

Language is the most commonly cited uniter of nations. But did language unite the Czechs and the Slovaks? The Serbs and Croats? The English and the Americans? The Czechs and Serbs and English said yes, the others no. The divergence had to do with power, not linguistics. Religion is the most commonly cited divider of peoples; and yet Germany has persisted now for close to a century and a half with a religiously divided population. Germany has had its divisions since 1871— the one that lasted from 1949 to 1990 is still vivid in most of our memories—but they were not religious divisions (or not, at any rate, divisions of "confession"), and they were not self-imposed. What united the Czechs and the Slovaks from 1918 to 1992 (with a little break for bloodbaths in the middle), or what still unites the English, the Scots, the Welsh, and some of the Irish today in what many regard as a single nation, is a vertical force transcending language, religion, and economic class. What kind of a force is it? For now let's just call it force of habit.

3. *L'INTERNATIONALE SERA LE GENRE HUMAIN!*

But we are not quite finished with the *Inno delle nazioni*. After its round of occasional performances in 1862, it disappeared into Lethe, as *pezzi d'occasioni* are expected to do, and slept peacefully, awakened very occasionally by new occasions reflecting new political and military realities. These revivals were invariably associated with Arturo Toscanini, who used his fame as a conductor to facilitate political activism both within Italy and, later, from abroad. In July 1915, shortly after Italy had belatedly entered the First World War, in contravention of its prewar alliances, on the side of Britain and France, Toscanini led an orchestra and chorus numbering 1,500 performers in a *grande concerto verdiano*, billed as a *grande manifestazione artistica e patriottica*, in an outdoor arena in Milan, in which in addition to the inevitable "Va, pensiero" chorus from *Nabucco* and several numbers from *La battaglia di Legnano*, the revived *Inno delle nazioni* served as a rousing finale, the three quoted anthems as if presciently symbolizing Italy's new alignment.[31]

Nearly three decades later, on 31 January 1943, Toscanini—by then a voluntary exile from Italy, conducting the NBC Symphony in New York—disturbed its dust again to cap another *concerto verdiano*, this time ironically commemorating the

advent of the Nazi regime, to which Mussolini's Italy was then allied, ten years before. Again it shared the program with "Va, pensiero," alongside excerpts from *La forza del destino, I Lombardi alla prima croiciata, La traviata,* and *Otello.* This time Toscanini altered "The Hymn of the Nations," as it was then billed, first by inserting a word into the text of Mameli's hymn so that it now invoked "Italia, o Italia, o Patria mia *tradita!*" (my fatherland *betrayed*), and finally by appending his own arrangement of "The Star-Spangled Banner" to follow "God Save the King," symbolizing America's anticipated role in liberating Italy.

The Anglo-American invasion, which began with Sicily on the night of 9–10 July 1943, was quickly followed by the dismissal and arrest of Mussolini. On 3 September, the new Italian government headed by Pietro Badoglio signed an armistice with the Allies. On 13 October the Kingdom of Italy, changing sides, declared war on Nazi Germany. It was a messy process that led at first to a dual occupation of Italy by the Germans in the north and the Anglo-American forces in the south. But it signaled a new role for the "Hymn of the Nations," this time under the aegis of the Office of War Information, the American government propaganda agency. The Office had been negotiating with Toscanini, one of the most eminent anti-Fascist exiles, to make a propaganda film to aid the war effort. At first it was assumed that the film would feature Shostakovich's Seventh ("Leningrad") Symphony, of which Toscanini had led the American première in July 1942. But after the fall of Mussolini the conductor's son Walter Toscanini suggested that a film about Italy would be more appropriate.[32]

"The Hymn of the Nations," with Toscanini conducting the NBC Symphony Orchestra, the chorus of the Westminster Choir College, and the tenor Jan Peerce, was recorded and filmed (in two separate operations that later had to be synchronized) in December 1943. The new redaction, with the interpolated *"tradita"* and "The Star-Spangled Banner," was of course the version used—but with one more alteration: between "God Save the King" and "The Star-Spangled Banner," after a little bridge passage that Toscanini had to compose for the occasion, the national anthem of the remaining member of the alliance into which Italy had just enlisted was inserted. That country was the Union of Soviet Socialist Republics, and its anthem (unlike "The Star-Spangled Banner," which was functioning as an American patriotic song by 1862, the year of Verdi's Cantica) was an anachronism in its Verdian context, its words having been written in 1871 and its melody composed in 1888. Its name, of course, was "L'Internationale."

The author of the text, Eugène Pottier, was a designer of textiles by trade and a member of the Paris Municipal Council, the so-called Paris Commune. Pottier wrote the poem after the fall of the Commune in the attempted revolution of 1871. He intended his words to be sung to the tune of "La Marseillaise," in those days the de facto revolutionary or communard hymn, and in fact Rouget de Lisle's old melody fits the words a little better than the one specially composed for it later

EXAMPLE 9.1

a. Opening line of Pottier's "Internationale," set to the beginning of "La Marseillaise."

b. Opening line of "L'Internationale" as set by Pierre De Geyter.

"Arise, ye prisoners of starvation; Arise, ye wretched of the earth!"
(trans. Charles H. Kerr, *IWW Songbook*)

(see ex. 9.1). In 1864, Pottier had been a delegate from *the chambre syndicale des dessinateurs,* the French textile workers' union, to the founding congress, in London, of the International Workingmen's Association, known as the International, and his lyrics, sung to the tune of "La Marseillaise," were adopted by that organization and known by its name.

The tune to which it is now usually sung, the one Toscanini interpolated into "Hymn of the Nations," was composed by a Belgian-born textile worker and woodcarver named Pierre De Geyter (1848–1932), who lived in Lille, France, and sang in a local workers' chorus, La Lyre des Travailleurs, for which he made his setting of Pottier's lyrics at the request of the local Socialist Party.[33] It was almost immediately adopted as the official anthem of the Second International, the organization that succeeded the one for which Pottier had written the lyrics, formerly sung to the tune of "La Marseillaise" (see ex. 9.1b).[34] The Second International was not a workers' organization *per se* but a federation of socialist parties that included the Russian Social-Democratic Workers' Party, which took power in a coup d'état following the Russian Revolution of 1917. Lenin's Party, now the Communist Party of the Russian Soviet Federated Socialist Republic (RSFSR), adopted "The Internationale" as the anthem of the republic in 1918, and when the Soviet Union was declared in 1922, it became the anthem of the new, larger, multinational entity as well. In 1927, having learned that the composer of "The Internationale" was still alive, Iosif Stalin invited De Geyter to the celebration of the tenth anniversary of what was by then called the October Revolution. In August 1928, De Geyter was granted a Soviet pension—his sole source of income during the last four years of his life.

This is a familiar story, and the adoption of "The Internationale" as the Soviet national anthem is a familiar fact. Familiar facts can induce us to overlook anomalies unless we force ourselves to face them and appreciate their strangeness. The country in whose capital this essay originated as a conference talk, for example, was for many years a kingdom without a king, ruled by an admiral without a navy. And the Soviet Union, which always celebrated anniversaries of its October Revolution in November, had for a national anthem a song called "The Internationale," conceived as the anthem not of a country but of a political movement—one that in its inception and idealistic youth was bitterly opposed to nationalism (a "pubertal disorder of the human race")[35] and the vertically oriented social outlook that nationalism implied.

We don't have to delve very deeply into Marxist theory to see this. Slogans will do for a start, beginning with the most famous slogan of all, the one that ends the Communist Manifesto of 1848. In English it is usually rendered, "Workers of the world, unite!" But that is a free rendering that obscures the aspect of greatest significance to us. In the original German it read, *Proletarier aller Länder, vereinigt Euch!*—"Workers of all countries, unite." The Russian version, *Proletarii vsekh stran, soyedinyaites'!,* which became for the Soviet state the equivalent of the United States' national motto *E pluribus unum* on the national coat of arms and on its money, correctly rendered the German emphasis on the multiplicity of countries rather than the unitary world.

The difference is crucial. The world is natural; countries are political. To tell workers that their primary allegiance should be to their counterparts in other countries is to tell them that they owe no allegiance to the superior social classes in their own land. Nationalism or patriotism, when espoused by the working class or foisted on it, is in Marxist eyes necessarily a false consciousness (in Marxist terms, an "ideology"), because, in summoning the allegiance of the working class to a social structure that included, and necessarily benefited, their oppressors, it effectively mobilized the working class against its own economic interests. That is why Marx and Engels reserved their greatest contempt in 1848 for King Carlo Alberto, whose reputation as "la spada d'Italia" (the sword of Italy) made him their most potent ideological foe.[36] Socialism insists upon a horizontally oriented social outlook. The only social solidarity it recognizes is class solidarity. To return to the Communist Manifesto:

> The working men have no country. We cannot take from them what they have not got. Since the proletariat must first of all acquire political supremacy, must rise to be the leading class of the nation, must constitute itself the nation, it is, so far, itself national, though not in the bourgeois sense of the word. National differences and antagonism between peoples are daily more and more vanishing, owing to the development of the bourgeoisie, to freedom of commerce, to the world market, to uniformity in the mode of production and in the conditions of life corresponding

thereto. The supremacy of the proletariat will cause them to vanish still faster. United action, of the leading civilised countries at least, is one of the first conditions for the emancipation of the proletariat.[37]

As always, Marx and Engels were poor predictors, and the eventual abandonment by the Soviet state of pure socialist insistence on true internationalist consciousness is the story that this melancholy essay will tell. But the founders' optimistic faith in working-class solidarity and class consciousness is what animates the text, by Pottier, of "L'Internationale," as epitomized in the culminating couplet of its refrain: "C'est la lutte finale, / Groupons-nous, et demain; / L'Internationale / Sera le genre humain!," or in English (the way I learned to sing it as a child—from my mother): "'Tis the final conflict, Let each stand in his place; The international Party [or Soviet, if you were a Communist rather than a Socialist] Will be the human race!" In the stilted Russian version by Arkady Yakovlevich Kots (1872–1943), which became the official Soviet anthem, it went like this: "Eto yest' nash posledniy / I reshitel'nïy boy; / S Internatsionalom / Vospryanet rod lyudskoy!" (This is our final / and decisive battle; / with the International / the human race will soar!). Nations, which foster difference, are effaced. Humanity—*rod lyudskoy*—is one. That, of course, was the promise of the Enlightenment, of which Communists portrayed themselves as the ultimate redeemers.

Socialist hostility to nationalism underwrote the opposition of the Second International to the First World War, which sent socialists in many countries, including the United States, to prison. (The titular head of the American Socialist Party, Eugene V. Debs, was imprisoned in 1918 and ran for president two years later, as convict No. 9653, from the federal penitentiary in Atlanta, Georgia.)[38] And that is precisely why "The Internationale" had to stop being the Soviet anthem during the Second World War, when the country's national survival was at stake. Its frankly nationalistic replacement, the "Gosudarstvennïy gimn SSSR" (State Anthem of the USSR), whose text—a collaborative effort by Sergey Vladimirovich Mikhalkov (1913–2009), known until then primarily as an author of books for children, and the Armenian poet and *Izvestiya* war correspondent Gabriel Arkad'yevich Ureklyan (1899–1945), known by the pen name El-Registan—was set to an already-composed march by Major General Alexander Vasil'yevich Alexandrov (1883–1946), the director of what was by then called the Red-Bannered Song and Dance Ensemble of the Soviet Army (*Krasnoznamyonnïy ansambl' pesni i plyaski sovetskoy armii*, or KAPPSA). Personally commissioned by Stalin in 1942, it was first performed (by Alexandrov's ensemble) over the radio at midnight on 1 January 1944 and officially adopted on 15 March of that year. It was both in fact and in spirit a wartime anthem, which in its third stanza made direct reference to the ongoing national conflict, known in the USSR as the *velikaya otechestvennaya voyna*, the Great Patriotic War:

Mï armiyu nashu rastili v srazhen'yakh	We raised our army in battles.
Zakhvatchikov podlïkh s dorogi smetyom	We will sweep the base invaders from our path!
Mï v bitvakh reshayem sud'bu pokoleniy,	In combat we are deciding the fate of generations,
Mï k slave otchiznu svoyu povedyom!	We will lead our homeland to glory!

Note that in its last line this stanza invokes not the human race or the International Party, but rather (archaically and poetically) the *otchízna*, the threatened but inevitably victorious fatherland, called by its more modern, common name in the first line of the refrain: *Slav'sya, Otechestvo nashe svobodnoye*, "Be glorified, our fatherland free!" (Here the archaic and poetic word is the first, surely chosen for its resonance with the final patriotic chorus—known popularly as the *Slav'sya*—in Glinka's 1836 opera, *A Life for the Tsar*.) That third stanza fell away from the anthem at the conclusion of the war. The second stanza, which went like this—

Skvoz' grozï siyalo nam solntse svobodï,	Through storms the sun of freedom shined unto us
I Lenin velikiy nam put' ozaril:	And Great Lenin lighted the path for us:
Nas vïrastil Stalin—na vernost' narodu,	Stalin raised us, inspiring us to devotion to the people,
Na trud i na podvigi nas vdokhnovil!	To industry, and to great deeds!

—obviously had to go after 1956.[39] But the first stanza lasted to the end of the Soviet Union, and was the culmination of a development that encapsulates the process through which the ideals of communism and those of nationalism were reconciled.

The Soviet government adopted the new anthem after the Office of War Information film featuring Toscanini and "The Hymn of the Nations" had been shot and recorded, but before the film was released. The OWI made a half-hearted attempt to get Toscanini to reshoot the portion of the film devoted to the Russian anthem with Alexandrov's hymn replacing "The Internationale," but according to his son, who had been entrusted with the task of making the request, the conductor "refused categorically to lend himself to this opportunism of the huckster politicians *(politicanti)*, and he said that if the *Internationale*, which was the anthem of all of the proletarians and working-classes of the whole world, wasn't allowed, then they should forget distributing the entire film."[40]

Like so many nostalgics before and since, the wealthy and seigneurial Toscanini still thought of himself as a socialist.[41]

4. *VELIKAYA DRUZHBA NARODOV*

To say that the ideals of communism and those of nationalism were or could ever be reconciled, of course, is to propound a position that was controversial in the

Soviet Union until it became a dogma. It is precisely the idea that Trotsky, for one, could not tolerate. Its triumph brought about his exile from the USSR, a country that thereafter he accused of abandoning the communist ideals that were its *raison d'être*, most famously in the title of a book called *Predannaya revolyutsiya: Chto takoye SSSR i kuda on idyot?* (The Revolution Betrayed: What Is the USSR and Where Is It Going?), which he issued in 1937 from his temporary haven in Norway. In Trotsky's analysis, Stalin's regime, with its emphasis on the development of a single—and, inevitably, isolated—socialist state amid increasingly hostile (because fascist) neighbors, had resorted to the bureaucratization and eventual militarization of a society dominated by a new managerial class that, like the capitalists of old, oppressed the proletariat yet sought to secure its submission by appealing to so-called patriotic ideals that substituted the false consciousness of vertically oriented social loyalties as touted by nationalistic rhetoric on behalf of ruling classes everywhere, rather than the true, horizontally aligned "establishment of a socialist organization of society and the victory of socialism in all countries," as enunciated by Lenin in the "Declaration of the Rights of the Toiling and Exploited People."[42]

Historians today tend to call this phase of Soviet history the Great Retreat, after the title of an influential analysis by the émigré historian Nicholas Timasheff (1886–1970), who saw the new Soviet patriotism as one of a number of symptoms of retrenchment, along with emphasis on what American politicians call "family values" and the replacement of the iconoclastic avant-garde culture of the early Soviet decades, which equated (in Anatoly Lunacharsky's words) "revolution in life with revolution in art," by the new socialist-realist aesthetic that combined stylistic conservatism with monumental scale.[43] Trotsky, continuing the mock–French revolutionary rhetoric in which Lenin's "Declaration" was already couched, accused Stalin of having written the revolution's "second chapter," consisting of a "Thermidorian reaction" (as when Robespierre was overthrown by his less audacious antagonists on the ninth day of Thermidor in revolutionary year II), and replaced Marxist communism with "Bonapartism," that is to say "the suppression of the proletarian vanguard and the crushing of revolutionary internationalism by the conservative national bureaucracy."[44]

The suggestion, implicit in the phrase "Great Retreat," that it was in essence a moderating return to prerevolutionary ideas and institutions, has been discarded by most modern historians in the light of what we now view as the increasingly stringent social controls of "high Stalinism."[45] Trotsky made no such claim of temperance; on the contrary, though without actually using the word, Trotsky characterized Stalin's USSR as being in essence a fascist state, in which "the domination of the bureaucracy over the country, as well as Stalin's domination over the bureaucracy, have well-nigh attained their absolute consummation."[46] His argument against the claim that Stalinist deviations were necessary concessions to prudence and security was precisely the continued rise of fascism in the 1930s, against

which Stalinist policies could offer no protection because they were themselves effectively a co-option of fascist ideology.

Another way of putting it would be to say that, by installing a centralized, bureaucratic command structure, the USSR had replaced communism with totalitarianism—a term that had originated in fascist Italy.[47] Applying the term to the Soviet regime has become unfashionable of late; but I think it still useful for the present discussion. The objection, most influentially advanced by Sheila Fitzpatrick, is a matter of good scholarly form and as such is entirely reasonable and persuasive.[48] The term is often used as an all-purpose explainer that short-circuits analysis of social relations by tacitly assuming that governments designated "totalitarian" are omnipotent (as, no doubt, they would have liked to be), and makes further assessment or description unnecessary. Invoking the term "totalitarian" explains nothing, it is true—except, perhaps, the intents and purposes that policies so designated are meant to achieve, defined most famously by Mussolini in his oration to the citizens of Milan on 28 October 1925, the third anniversary of his March on Rome: "Our formula is this: everything within the state, nothing outside the state, nothing against the state."[49]

No government has ever achieved such total responsibility, or exercised such total control, over all aspects of its citizens' social, cultural, political, and economic activity. But several have tried, and some continue to try, and their policies and priorities can be usefully compared under that general formula. Totalitarianism, presupposing centralization and a command structure, proceeds at all times from the top down, implying vertical social organization. Thus there has never been any problem relating fascism and nationalism. The former virtually implies the latter (and, many have supposed, the latter eventually guarantees the former). But as we have already seen, the relationship between nationalism and communism did not run smooth. The stages through which that relationship was established and strengthened in the USSR are complex, and several important studies have been devoted to tracing them.[50] They will be worth a brief preliminary outline here, to furnish a framework through which we may understand the progress, if that is the word, from "The Internationale" to the "State Anthem of the USSR."

The first stage, in which Trotsky played a leading role along with Lenin, and a far more prominent one than Stalin, was the territorial reconstitution of the Russian Empire following its dissolution in the aftermath of the world war and the 1917 revolution. This reconstitution took place simultaneously with the civil war between the Red Army under Trotsky and the loyalist Tsarist regiments, which went on from 1918 to 1921. The non-Russian parts of the empire largely fell away during this period, leaving only Russia—or the Russian Soviet Federated Socialist Republic—as the new Marxist state. Both in keeping with the Marxist idea of revolution as liberation and with the national aim of securing its borders and overcoming foreign intervention, the Soviet government sought to establish its power in all

territories of the former empire. In this it was in some instances successful—in the Ukraine, for example, and in the Caucasus—and in some cases unsuccessful—in Finland and Poland, for example, as well as the former Baltic provinces, all of which declared themselves independent states and remained so past the Civil War. The Soviet Union was formed out of the recovered territories, re-annexed to the new state under terms that recognized nominal autonomy in keeping with a new theory of nationalities that replaced the old "prison house of nations" *(tyur'ma narodov)* with what the familiar Stalinist slogan eventually called "friendship of peoples" *(druzhba narodov)*.[51] The Soviet Union considered the task of reconstitution unfinished between the two world wars and made an effort to finish the job, in large part with Hitler's help, in the run-up to the second. That was one of the purposes of the 1939 Molotov-Ribbentrop Pact, which repartitioned Poland, returning western Ukraine and parts of Belorussia to the Soviet fold along with the Baltic republics. But the Soviet Union was from its inception in 1922 a reconstituted imperium, under the de facto domination of Russia. That is what *druzhba narodov* would come to mean in practice.

For a decade or so its nature was occluded behind the rhetoric, and the attendant policies, of what Lenin called *natsional'noye stroitel'stvo* or "nation-building," which gave the Soviet Union the peculiar lineaments Terry Martin wittily summarized in the title of his book *The Affirmative Action Empire*.[52] It went back, evidently, to a maxim from the Communist Manifesto, in which Marx and Engels, recognizing the fact that contemporary Europe was a political crazy-quilt, advised that revolutionary work begin at home. "Though not in substance," they cautioned, "yet in form," they admitted, "the struggle of the proletariat with the bourgeoisie is at first a national struggle. The proletariat of each country must, of course, first of all settle matters with its own bourgeoisie."[53] Accordingly, Soviet nation-building was an attempt to help the non-Russian nationalities of the USSR achieve parity with the economic and cultural level of Russia, the former imperialist power that had formerly subjected them, by encouraging their cultural autonomy even as assertions of Russian national pride were condemned as "great-power chauvinism" *(veliko-derzhavniy shovinizm)*. The double standard, based on a schematic opposition of good ("oppressed nation") nationalism and bad ("oppressor nation") nationalism that presupposed a romantically inverse correlation between economic power and moral worthiness, was justified on the theory that national differences were destined to disappear under communism. Like American affirmative action, Soviet nation-building was vulnerable to the charge of practicing racism in the name of equality. The self-proclaimed "world's first state of workers and peasants," Yuri Slezkine sharply observes, was also "the world's first state to institutionalize ethnoterritorial federalism, classify all citizens according to their biological nationalities, and formally prescribe preferential treatment of certain ethnically defined populations."[54]

And like American affirmative action, it was touted as a temporary measure that would be obviated by its own success. The objective was to gain the trust of formerly oppressed populations and make them receptive to the new gospel. National difference, like social classes, would then fall away as the state withered. As Shimon Dimanshteyn, one of the major propagandists of Soviet nation-building, put it in 1919, "We are going to help you develop your Buryat, Votyak, etc. language and culture, because in this way you will join the universal culture [obshchechelovecheskaya kul'tura], revolution and communism sooner."[55]

Implicit in this utopian formulation is a radical dichotomy of form and content both in political action and in the general culture of which politics is a constituent. The national component is the particular form in which universal, in this case revolutionary, content must be clad in order that it be conveyed to a particular linguistic or ethnic population. It is assumed to be ephemeral. Lenin put it in the form of a paradox. With the growth of trust between minority proletariats and the proletariat of the former imperial oppressor, the importance attached to matters of mere "form" would wane. Once capitalism had given way to socialism and all institutions had been fully democratized, once borders were established "according to the 'sympathies' of the population" and freedom of secession was assured, "the elimination of all national tensions and all national distrust" would inevitably follow, bringing about "an accelerated rapprochement and merger of nations." The surest way, then, to unity in content lay in (temporary) diversity of form.[56] This diversity, assuring equality but not meant to last, was what was eventually called *druzhba narodov*, the "friendship of peoples." But once it was called that, it would become an end rather than a means.

The phrase as such was one of the most widely publicized artifacts of Stalin's Thermidor. It was coined on 4 December 1935 at a Kremlin reception honoring a group of Tajik and Turkmen collective farmers who had distinguished themselves for overachievement during the cotton harvest that year. A sort of aftershock of the Stakhanovite conference held a few weeks earlier, it represented the extension of the high-productivity campaign into the "national" republics of the USSR.[57] The honored guests wore national costumes and spoke their native languages throughout (and were even addressed in the speeches of Politburo members as "comrades" in Tajik and Turkmen).[58] In his congratulatory speech, Stalin advised the farm workers that

> there is something, comrades, more valuable than cotton: namely, the friendship of the peoples of our country. Our meeting today, your speeches, your actions show that the friendship between the peoples of our country is strengthening. This is very important and worthy of note, comrades. In the old days, when the tsar, the capitalists, and the landowners ruled our land, government policy consisted of making one people—the Russian people—the rulers and all the [other] peoples subordinate and subject to oppression. This was a savage, wolfish policy. In October 1917, when our

great proletarian revolution came about, when we overthrew the tsar, the landowners, and the capitalists, the great Lenin, our teacher, our father and counselor, said that there must never again be either ruling or subordinate peoples, that peoples should be equal and free. With this he buried the old tsarist bourgeois policy and proclaimed the new Bolshevik policy—the policy of friendship, the policy of brotherhood between the peoples of our country.

Since that time eighteen years have passed. And now we can already see the auspicious results of this policy. Our meeting today is vivid proof that the former distrust between the peoples of the USSR has long since come to an end, that distrust has been replaced by full mutual trust, [and] that friendship among the peoples of the USSR is growing and becoming ever stronger. This, comrades, is the most valuable thing that the Bolshevik nationalities policy has given us.[59]

This speech—or, more precisely, the front-page report of the speech in *Pravda* (5 December 1935) under the banner "The Great Friendship" *(Velikaya druzhba)*— marked the beginning of a major transformative campaign, one of the signal turns constituting the Thermidor or Great Retreat.[60] With the benefit of hindsight, and with knowledge of the history of Stalinist policy and the ways in which it was implemented, it is possible to read the portents of impending change. The most salient, if paradoxical, signal was the declaration that a policy had been successful. This was, characteristically, a veiled announcement that the policy was now going to be altered. Another salient omen was the paternalistic language, especially as applied to the iconic figure of Lenin, who is described using terms (*nash otets i vospitatel'*, "our father and counselor") strongly redolent of the traditional epithets addressed to the tsars, especially by peasants (*batyushka, kormilets,* "little father, provider").

Another ominous declaration of success came the next year in Stalin's speech announcing the new constitution—the "Stalinskaya Konstitutsiya"—of the USSR, when he proclaimed that

> The period just past has shown beyond doubt that the experiment of forming a multinational state, created on the basis of socialism, has succeeded in full. This is an indisputable victory for Lenin's nationalities policy. . . . The character of the peoples of the USSR has fundamentally changed. The feeling among them of mutual distrust has disappeared, a feeling of mutual friendship has developed, and in this way a genuine fraternal cooperation of the peoples has been established within the system of a single unified state. As a result we now have a fully formed multinational socialist state, which has withstood all trials and whose solidity might well be envied by any national state in any part of the world.[61]

These speeches marked the beginning of the period when, in apparent paradox, Russian hegemony would be reasserted even as national "forms" of expression would stop being regarded as a stopgap and become essential and obligatory for all Soviet cultural artifacts, including Russian ones, hitherto treated as unmarked

(and not to be marked for fear of transgressing the taboo on "great-power chauvinism"). In pronouncing great-power chauvinism dead, Stalin was in effect lifting the taboo. "One aspect of the Friendship of the Peoples," Terry Martin has observed, "was the rehabilitation of Russian national culture."[62]

Moreover, under the aegis of the Great Friendship of Peoples, the celebration of national folk art, formerly thought rural and "backward" *(otstaloye)* and even suspicious, became de rigueur in Soviet cultural life, most conspicuously in the yearly ten-day festivals of "national art" *(dekadï natsional'nogo iskusstva),* a fixture of Soviet cultural life from 1936 until shortly before the outbreak of the Great Patriotic War in 1941, at which the various non-Russian populations sent delegations to the capital with musical, literary, and theatrical performances, typically culminating in ballets or operas, for which repertories had to be generated back home. The first *dekada* was Ukrainian (March 1936), followed two months later by one from Kazakhstan; Georgia was next in January 1937, followed by Uzbekistan in May.[63]

In 1939, nominally following a suggestion of Maxim Gorky, the Union of Soviet Writers launched a journal titled *Druzhba narodov,* the task of which was to publish, in Russian translation, the work of authors who wrote in the many other languages of the USSR, including those that had become literary only in Soviet times. The opera that served as the spark to ignite the musical *Zhdanovshchina* in 1948, Vano Muradeli's *Velikaya druzhba* (Great Friendship, 1947), was a chip off this particular propagandistic block. It glorifies the role of the Russian Bolsheviks in uniting the peoples of the Northern Caucasus against the revanchists (the "whites") during the postrevolutionary civil war, and in this it exemplified the reconstituted Russian hegemony that was the principal ideological objective of the *druzhba narodov* campaign: indeed, *Druzhba narodov* was the opera's alternate title. The fact that it was singled out for abuse on both political and aesthetic grounds despite its exceptionally blatant and well-advertised adherence to official policy is a particularly crisp illustration of the invisible, movable line between required orthodoxy and excessive national(ist) zeal that Soviet artists always ran the risk of transgressing, even when standing still.

5. *SOYUZ NERUSHIMÏY RESPUBLIK SVOBODNÏKH / SPLOTILA NAVEKI VELIKAYA RUS'*

The text that particularly recommends itself for parsing in our present context is an article—"Stalin i velikaya druzhba narodov" (Stalin and the Great Friendship of Peoples)—that was published in *Pravda* on 21 December 1939, a date that instantly identifies itself to connoisseurs of Soviet totalitarianism as Stalin's official sixtieth birthday, the occasion for which Prokofieff composed his *Zdravitsa,* one of the prime embodiments, both in text and in music, of socialist-realist fakelore.[64] The article was one of the more conspicuous amid the countless panegyrics that filled

the Soviet press that day. Its author, ironically enough, was Nikita Sergeyevich Khrushchev, the very one who, seventeen years later, would take it upon himself to "expose" and attempt to dismantle what, thanks to his efforts, we now look back upon as the "cult of personality" that surrounded Stalin, to which Khrushchev, in 1939 a newly elected member of the Politburo and newly appointed party chief in the Ukraine, was then making an enthusiastic contribution.[65]

Khrushchev chose the question of nationalities as his angle on Stalin's greatness, a Marxist historian might say, not by accident. For one thing, Khrushchev (ethnically and linguistically a Russian) was then the most prominent political representative of the largest of the so-called *natsional'nosti*—the non-Russian nationalities or minority populations united with Russia in the Soviet Union. (He ended the article with a toast, or *zdravitsa*, in Ukrainian.) For another, Stalin had always been closely identified with the nationalities question. It was an area in which his personal contribution to communist theory and Soviet practice gave him particular authority even before he assumed supreme power. The second (unsigned) article the twenty-five-year-old Stalin published (in his native language) in the local (illegal) Georgian Social-Democratic organ in 1904—the essay that, in the words of his most recent biographer, "essentially launched his punditry career"[66]—was called, in Stalin's habitual catechismlike manner, "How Does Social Democracy Understand the National Question?"[67] Nine years later, Lenin, recognizing that Stalin (a representative, like Khrushchev, of one of the *natsional'nosti*) had a special interest and a special stake in the matter, gave him an assignment. "We have a marvelous Georgian," he wrote to Gorky, who has "sat down and is writing us a big article, for which he has assembled *all* the Austrian and other materials."[68] Stalin wrote the piece in Vienna, where a plaque now marks the house in which he did it. It appeared as "Natsional'nïy vopros i sotsial-demokratiya" (The National Question and Social Democracy) in the newspaper *Prosveshcheniye* (Enlightenment), signed "K. Stalin." The K. stood for Koba, Iosif Jughashvili's comradely nickname. It was the first time he used the pseudonym that became his surname for the rest of his life and in history. Published as a separate pamphlet, Stalin's tract went through several editions even before the revolution, and afterward it became a scriptural text.

Khrushchev, in his birthday panegyric, paid it due tribute, drawing a direct line, as Soviet dogma had long since decreed, between Stalin's early theoretical formulations and contemporary Soviet reality. His particular choice of words, as will be seen, was peculiarly resonant: "The Bolshevik Party correctly approached the solution to the national question in Russia. Comrade Stalin made an enormous contribution toward solving it. Under the leadership of Comrade Stalin the Bolshevik Party welded together all the nationalities, all the peoples of the former Russia and on the basis of mutual trust, on the basis of the great friendship of peoples, created the Soviet state—the great Union of Soviet Socialist Republics."[69]

To reiterate in Russian (for reasons that will become evident), under Stalin's leadership the Bolshevik Party *splotila vse natsional'nosti,* "welded together all the nationalities." In 1924 Stalin found his place in the Soviet government as People's Commissar *(Narkom)* of Nationalities (his official title: *Narodnïy komissar po delam natsional'nostey),* from which post he promulgated the official Soviet Declaration of the Rights of the Peoples of Russia *(Deklaratsiya prav narodov Rossii).* This document followed the program Stalin had announced in his official report to the Tenth Congress of the Soviet Communist Party in 1921, which had laid out the goal of eradicating what Stalin was in point of fact the first to call "great-power chauvinism," so as to "help the laboring masses of non-Russian peoples catch up [economically, politically, and culturally, as previously enumerated] with central Russia."[70] This task required mutual assistance, the better endowed supplying aid to the needier. "In the Soviet Union," Khrushchev declared, "our fraternal republics are flourishing and developing. They strengthen the might of the Soviet Union and receive fraternal assistance from their elder though equal bother, the great Russian people."[71]

First—or eldest—among equals is one of the hoariest of euphemistic oxymorons—as *primus inter pares* it goes back to the Roman Senate (and the Greek version, Πρῶτος μεταξὺ ἴσων, is hoarier still)—and Khrushchev's gratuitous reference to the great Russian people *(velikiy russkiy narod,* as distinct from *velikorusskiy narod,* which would merely distinguish Russian ethnicity from Ukrainian or Belorussian) was a reminder, to those who needed one, that the actual nationalities policy of the USSR had by the end of the 1930s become one of Russification—not a fraternal system but a paternalistic one, even though the fatherly metaphor, formerly applied to Lenin, was by 1939 reserved for the now venerable object of the Cult of Personality, as Khrushchev avers when revving up toward peroration, proclaiming Stalin "the symbol of the unbreakable friendship of the great Soviet people. All peoples of the Soviet Union see in Stalin their friend, father, and leader."[72] Again a partial recapitulation in the original Russian will prove useful: Stalin, according to Khrushchev, was the symbol of *nerushimoy druzhbï velikogo sovetskogo naroda,* "the indestructible friendship of the great Soviet people."

Nor could any treatment of the nationalities question late in 1939 omit rejoicing in the fruits of the Nazi-Soviet pact. Speaking on behalf of the nationality of whose Communist Party he was then the chief, Khrushchev declared that "the Ukrainian people lovingly thank Comrade Stalin for the emancipation of their brother Ukrainians who had fallen under the yoke of the Polish overlords and capitalists. The Ukrainian people thank Comrade Stalin for the unification of the great Ukrainian nation in a single Ukrainian state."[73]

Even more chillingly, "We now have the possibility of rendering great assistance to the Finnish people in emancipating them from the yoke of imperialism," the Soviet "Winter War" of aggression against Finland having begun less than a month earlier with the invasion of 30 November 1939, on account of which the Soviet Union

had been expelled from the League of Nations a mere week before Khrushchev's article appeared.[74] In conclusion, Khrushchev issued a typically nationalistic Stalinist appeal for unity against unnamed foes, insinuating between the lines the reason behind the nationalities policy that now distinguished the Soviet state from a truly Marxist one: "In order to defend the independent existence of our state, the solidarity of our people is necessary. We have this solidarity. All the peoples of the Great Soviet Union are welded into unity. This solidarity Comrade Stalin has secured for us by means of the genius-inspired theory and practice of his nationalities policy."[75]

The word translated here as "solidarity" is *splochyonnost'*, a fairly uncommon noun derived from the past participle *splochyonnïy*, of which the short predicative form, *splochení*, also occurs in this final quote from Khrushchev, where he assures us that the peoples of the Soviet Union have been "welded into unity." So the word *splochyonnost'* literally means "weldedness," from the verb *splotit'*, as in the phrase previously quoted in Russian, stating that the Bolshevik Party had *splotila vse natsional'nosti*, "welded together all the nationalities" of the Soviet Union. The result of that welding, to requote one last time, was the *nerushimaya druzhba velikogo sovetskogo naroda*, "the indestructible friendship of the great Russian people."

And now compare the very first couplet from the text of the "State Anthem of the USSR," which, being the product of a collaboration between a Great Russian (Sergey Mikhalkov) and a member of one of the *natsional'nosti* (El-Registan), was an actual demonstration of the Stalinist nationalities policy at work, with the Russian, in whose language they were working, very much the elder brother despite his being fourteen years younger than his co-author: *Soyuz nerushimïy respublik svobodnïkh / Splotila naveki velikaya Rus'*, "An indestructible union of free republics did Great Russia forever weld together" (ex. 9.2a). Going even further than stated policy, Russia is named here not in the guise of the modern political entity known in the modern Russian language as *Rossiya*, but by its archaic, poetic, quasi-legendary name of *Rus'*, which implies much, much more than an administrative entity. Rossiya is a state; Rus' is a nation.

The text of the anthem as originally written has four stanzas, with a refrain sung between them for a total of three times. Its text—"Slav'sya, Otechestvo nashe svobodnoye"—glorifies "our free fatherland," the *nadyozhnïy oplot* or trusty bulwark of the Union's constituent peoples. Each time the refrain is sung, a single word of its text is changed to indicate what aspect or attribute of the peoples the bulwark is safeguarding. The third time it is *Slavy narodov*, "the glory of the peoples"; the second time it is *Schast'ya narodov*, "the gladness of the peoples"; but in pride of place, in the first refrain (the one actually to be sung by massed voices at public events), it is *Druzhbï narodov*, "the friendship of the peoples," for this is the variant that was proper to the official Soviet liturgy (ex. 9.2b). The Soviet national anthem, then, was a very deliberate product, expressed in a very specific coded language, of a specific concept of nationality and its relationship to political power. It

EXAMPLE 9.2

a. State anthem of the USSR *(Gosudarstvenniy gimn sovetskogo soyuza)*, first couplet.

So - yuz ne - ru - shi - mïy res - pub - lik svo - bod - nïkh splo - ti - la vo ve - ki ve - li - ka - ya Rus'!

b. State anthem of the USSR, first refrain.

Slav' - sya o - te - che - stvo na - she svo - bod - no - ye, druzh - bï na - ro - dov na - dyozh - nïy o - plot!

epitomized the transformation of Soviet ideology from some variety of Marxism to that unique thing known as Stalinism, which not only concentrated unlimited political power in the hands of a single person but also transformed Soviet communism from an internationalist to a Russocentric nationalist force.

6. *NATSIONAL'NAYA GORDOST' VELIKOROSSOV*

A fuller account of the transformation from Marxist internationalism to Soviet nationalism would have to start with the policy debate over *sotsializm v odnoy otdel'no vzyatoy strane*, "socialism in a single country." The rationale for the reconstitution of the empire had been the civil war against the remnants of the Tsarist army, and the attendant foreign interventions that required the provision of an ever-expanding buffer, plus the failure of all the other socialist revolutions (such as those in Bavaria and Hungary) that had followed the First World War—a failure that had arguably midwifed the rise of fascism. Since the revolution had only succeeded in Russia, the question arose whether socialism could be built within in a single country surrounded by antagonists, or was the existence of the single Soviet state an anomaly that could only be stabilized through world revolution and continued agitation therefor, precluding peaceful coexistence or normal trade relations with capitalist or monarchial states. This was the fateful question that created factions among Bolsheviks and formed the background to the Great Purge of the mid- to late 1930s.

The Third International, the so-called Comintern, had been formed in 1919 with the explicit aim of fomenting the world revolution that, according to Marxist and now Leninist theory, would inevitably follow the Russian one. The idea of socialism in one country obviously ran counter to that theory. But so did the success of the revolution in Russia in the face of defeat everywhere else; and so Stalin

was able to argue, beginning in 1924 with Lenin safely dead, that the revolutionary proletariat could and therefore must build socialism in the one country where that was possible, citing Lenin's handy dictum that "one cannot be a revolutionary Social-Democrat without developing [Marxism] and adapting it to changed conditions."[76] Stalin's position became official state policy in 1926, marking the point from which Stalin's unquestionable ascendency is usually acknowledged. It meant that the activity of the Comintern would henceforth be mainly directed not at provoking unrest abroad but at the defense of the Soviet state, classless in theory (as it therefore had to be described) but vertically organized in practice, the Communist Party now functioning as a ruling class.

The continued, expanding threat of fascism, made palpable by Hitler's rise to power alongside Mussolini, was responsible for the final step transforming the official ideology of the USSR from Marxist internationalism into what amounted to Russian hegemonism. The anti-Nazi turn was symbolized by the inspiring figure of Georgi Dimitrov, the Bulgarian Communist who, charged with having perpetrated the Reichstag fire in Berlin during the first month of Nazi rule, had astonished the world in 1934 by winning himself an acquittal at trial before a Nazi court in Leipzig, and was rewarded with a promotion to the helm of the Comintern. (Formerly he had directed its Central European operations.) On 2 August 1935, acting in his new capacity, it was Dimitrov who at the Seventh World Congress of the Comintern announced the radically changed policy that was known officially as "The People's Front against Fascism and War," more commonly as the Popular Front.

Reaching back to a stage in the evolution of Lenin's thought that preceded strictures against "great-power chauvinism," Dimitrov quoted from an article, "O natsional'noy gordosti velikorossov" (On the National Pride of the Great Russians),[77] which Lenin had published during the first months of World War I precisely to counter the allegation that Marxist internationalism precluded patriotism; and in reviving these ancient sophistries Dimitrov conclusively illustrated the retrospective tenor of the Great Retreat. "Is a sense of national pride alien to us, Great-Russian class-conscious proletarians?" Lenin had asked:

> Certainly not! We love our language and our country, and we are doing our very utmost to raise *her* toiling masses (i.e., nine-tenths of *her* population) to the level of a democratic and socialist consciousness.... We are full of national pride because the Great-Russian nation, *too,* has created a revolutionary class, because it, *too,* has proved capable of providing mankind with great models of the struggle for freedom and socialism, and not only with great pogroms, rows of gallows, dungeons, great famines and great servility to priests, tsars, landowners and capitalists.... And, full of a sense of national pride, we Great-Russian workers want, come what may, a free and independent, a democratic, republican and proud Great Russia, one that will base its relations with its neighbors on the human principle of equality, and not on the feudalist principle of privilege, which is so degrading to a great nation. Just

because we want that, we say: it is impossible, in the twentieth century and in Europe (even in the far east of Europe), to "defend the fatherland" otherwise than by using every revolutionary means to combat the monarchy, the landowners and the capitalists of one's own fatherland, i.e., the *worst* enemies of our country.[78]

Parties affiliated with the Comintern were now instructed to form defensive alliances with Social Democrats and other non-Communist antifascists (that is, bourgeois elements, hitherto regarded by orthodox Marxists as class enemies—in other words, as "fascists"), against the common foe.[79] These groups, which Dimitrov associated with the rural population and with "the petty-bourgeois masses of the towns" (elsewhere described as "small peasants, artisans, handicraftsmen, etc.") were no longer to be despised, but rather

> taken as they are, and not as we should like to have them. It is in the process of the struggle that they will overcome their doubts and waverings. It is only by a patient attitude towards their inevitable waverings, it is only by the political help of the proletariat, that they will be able to rise to a higher level of revolutionary consciousness and activity. To ensure that the workers find the road of unity of action, it is necessary to strive at the same time for *joint action with Social Democratic Parties, reformist trade unions and other organizations of the working people* against the class enemies of the proletariat. The chief stress in all this must be laid on developing *mass action*, locally, *to be carried out by the local organizations* through local agreements.[80]

The goal was to mobilize patriotic resistance to the threat of Nazi aggression, which (until the preemptive Hitler-Stalin Pact of 1939) was thought most likely to be directed first at the Soviet Union. While affirming, in hortatory italics, that "we Communists are *the irreconcilable opponents, in principle,* of bourgeois nationalism in all its forms," Dimitrov warned nevertheless that

> anyone who thinks that this permits him, or even compels him, to sneer at all the national sentiments of the broad masses of working people is far from being a genuine Bolshevik, and has understood nothing of the teaching of Lenin on the national question. [Here the passages excerpted above from Lenin's "O natsional'noy gordosti velikorossov" are adduced.] ... Proletarian internationalism must, so to speak, "acclimatize itself" in each country in order to strike deep roots in its native land. *National forms* of the proletarian class struggle and of the labor movement in the individual countries are in no contradiction to proletarian internationalism; on the contrary, it is precisely in these forms that *the international interests of the proletariat* can be successfully defended. ... We must at the same time prove by the very struggle of the working class and the actions of the Communist Parties that the proletariat, in rising against every manner of bondage and national oppression, is the *only* true fighter for national freedom and the independence of the people.[81]

The new policy could be regarded, more cynically, as the opportunistic mobilization in defense of the USSR of what Marxists continued to view as the false

consciousness of the proletariat under bourgeois manipulation, hence a double manipulation of the international working class. The Popular Front ushered in a period when, for example, the Communist Party of the United States, exploiting the country's revolutionary founding myth and Abraham Lincoln's aura as the Great Emancipator, could proclaim that "Communism is the Americanism of the 20th Century," and when composers in the Communist orbit pioneered the familiar, pastoral, "Americanist" idiom that still signifies America in movie soundtracks and commercials.[82] But the new policy reflected and affected Soviet domestic and cultural affairs as well. As a policy promulgated by the Comintern, the international alliance of Communist parties of which the Soviet party was one, the Popular Front was nominally a directive to which the Soviet party, like the others, was obedient. And so it became, in Russia as elsewhere, a pretext for nationalist revivals, in which, for example, the national heroes of prerevolutionary Russia were rehabilitated and co-opted by the Soviet regime, as anyone knows who has taken a walk on Tverskaya (formerly Gorky) Street in Moscow past the monument to the Great Prince Yury Dolgorukiy, or has seen the Sergey Eisenstein films glorifying (with a mighty assist from Prokofieff's powerful scores) the likes of Alexander Nevsky—and even Ivan the Terrible, a controversial figure in Tsarist Russia to say the least, whose blood-soaked contribution to the forcible unification and strengthening of the Russian state made him willy-nilly a Stalinist saint.

Dimitrov's report to the Seventh Congress of the Comintern was one of the earliest justifications of the new Soviet chauvinism, with its insistence that the cultivation of national culture, like the cultivation of socialism in one country, far from undermining Marx and Engels, actually brought their doctrine, uniquely, to its twentieth-century fulfillment. "Proletarian internationalism," he insisted, "not only is not in contradiction to this struggle of the working people of the individual countries for national, social, and cultural freedom, but, thanks to international proletarian solidarity and fighting unity, assures *the support* that is necessary for victory in this struggle." And beyond even that: "The revolutionary proletariat is fighting to save the culture of the people, to liberate it from the shackles of decaying monopoly capitalism, from barbarous fascism, which is laying violent hands on it. *Only* the proletarian revolution can avert the destruction of culture and raise it to its highest flowering as a truly national culture—*national in form and socialist in content*—which is being realized in the Union of Soviet Socialist Republics before our very eyes."[83]

7. *NATSIONAL'NAYA PO FORME, SOTSIALISTICHESKAYA PO SODERZHANIYU*

Dimitrov's peroration had culminated, as we would now say, in buzzwords. The mantra "national in form, socialist in content"—sometimes applied, as in Dimitrov's

speech, to culture *(kul'tura)*, which is a feminine noun in Russian so that the adjectives come out as in the heading above, and sometimes to art *(iskusstvo)*, which is neuter and so the slogan reads *natsional'noye po forme, sotsialisticheskoye po soderzhaniyu* (and with "socialist" sometimes replaced by *proletarskaya* or *-oye*, "proletarian")—was the Stalinist resolution to the quandary Marx's radical opposition of bourgeois-national and socialist-international cultures had posed. It followed on Lenin's previous provisional harmonization of the contradiction, adapted from that of Marx and Engels themselves, which (as roughed out in part 4, above) conceived of the nation-building project *(national'noye stroitel'stvo)* as a temporary matter of form, to be superseded by the universal class- and nation-transcending gospel of communism once the non-Russian nationalities had reached cultural parity with Russia. Dimitrov's version, adapted to the needs of an international forum, reversed the original order of the terms by putting the national before the socialist. Once the policy of the Popular Front had been promulgated, it became the standard form.

Stalin's original version, with *socialist in content* preceding *national in form*, achieved its canonical formulation in one of his most famous speeches, the mammoth report he delivered on behalf of the Central Committee, over the course of six days in June and July of 1930, to the Sixteenth Congress of the Soviet Communist Party.[84] The crucial, eminently Thermidorian difference between the new formulation and the old (for all that the new was cast as a faithful elucidation of the old) was that both terms, national and socialist alike, were now held to be essential, and therefore requisite. Rather than an oxymoron, the two terms now described a dialectic that properly synthesized the two formerly incompatible (because incomplete) discourses: Marxism applied to the one term, nationalism to the other.

"Deviationists," Stalin contended, think they are following Lenin when they make utopian predictions that

> with the victory of socialism nations must all flow into a single one and their languages all turn into a single common language, that the time has come to liquidate all national differences and no longer support the development of national cultures among formerly oppressed peoples.... Lenin said that under socialism all national interests will flow into a single whole;—does it not follow from this that it is time to be done with national republics and regions in the interests of ... internationalism? Lenin said in 1913, disputing the contentions of the Bundists, that the notion of national culture is a bourgeois notion;—does it not follow from that that it is time of be done with the national culture of the peoples of the Soviet Union in the interests of ... internationalism? Lenin said that the yoke of nationhood and the barriers of nationhood will be eradicated under socialism;—does it not follow from that that it is time to be done with the policy of taking account of national peculiarities among the peoples of the Soviet Union and switch to a policy of assimilation in the interests of ... internationalism?[85]

What deviationists failed to realize, Stalin told the assembled comrades, was that Lenin only meant that "the notion of national culture *under the reign of the bourgeoisie* was a reactionary notion." And now a typical Stalinist catechism:

> What is national culture under the reign of the national bourgeoisie? It is a culture that is bourgeois in content and national in form, and has as its purpose the poisoning of the masses with the venom of nationalism so as to strengthen the reign of the bourgeoisie. What is national culture under the dictatorship of the proletariat? It is a culture that is *socialist* in content and national in form, which has as its purpose the education of the masses in the spirit of internationalism and the strengthening of the dictatorship of the proletariat. How can one possibly confuse these two utterly different phenomena without utterly breaking with Marxism?[86]

How indeed? "In point of fact," Stalin went on:

> **the period of the dictatorship of the proletariat and the building of socialism in the USSR is a *golden age* for national cultures that are *socialist* in content and national in form**, for the nations themselves, within the Soviet order, are no longer ordinary "modern" nations but socialist nations, just as their national cultures are no longer ordinary bourgeois cultures in content but socialist cultures. They [i.e., deviationists] obviously do not understand that the development of national cultures must advance *with new force* with the introduction and establishment of compulsory primary education in one's native language. Nor do they understand that only under conditions of developing national cultures will it be possible to introduce truly backward nationalities to the enterprise of socialist construction. They do not understand that it is in this precisely that the Leninist principle of *assistance* and *support* of national cultures of the peoples of the USSR consists.[87]

This particular passage from the "Report of the Central Committee" became such a basic text in the Soviet national liturgy that the culminating scene from Grigory Aleksandrov's super-popular movie musical *Volga, Volga* (1938, music by Isaak Dunayevsky), which takes place at an all-Union "Olympiad" of amateur music-making *(muzïkal'naya samodeyatel'nost')*, strikingly reminiscent of the nation-building exercises Rousseau had prescribed for Poland a century and a half before (see part 1 above), unfolds on a stage peopled by a crowd of supernumeraries identifiable by their dress as representing a cross-section of Soviet nationalities, and dominated by two huge plaques bearing Stalinist scripture, the one on the viewers' right proclaiming the sacred words rendered in boldface in the foregoing extract and note.[88]

Returning to the subject in a somewhat later utterance, Stalin ventured a prediction that brought these notions about culture into line with more established aspects of Marxist utopianism, now putting the terms in the more familiar order soon to be made canonical by the Popular Front: "The development of cultures that are national in form and socialist in content is necessary for the purpose of their ultimate fusion into one General Culture, socialist both as to form and

content, and expressed in one general language."[89] But the report of the Central Committee to the Sixteenth Congress purported to describe the world that existed at the time, rather than the world to come, and that is the world in which Stalin's words did their performative work.

By 1930 Stalin's words were well on their way toward scriptural status; and like all scripture, they were ambiguous and tautological in the manner of the biblical God, who said, "I am that I am" (Exodus 3:14), and left it to Moses to figure out what he meant (hence the Bible). The effort to figure out what Stalin meant has given rise to a giant literature of exegesis. Here is one exegesis of the words we have been examining, published in 1950, which is to say within Stalin's lifetime, and by writers who are known to have ghostwritten for him, so that it is unquestionably in keeping with Stalin's own eventual view of the matter. It comes from an essay collectively authored by the philosophers Mark Borisovich Mitin (1901–87), Mark Davidovich Kammari (1898–1965), and Georgiy Fyodorovich Alexandrov (1908–61) as part of a yearbook published by the Soviet Academy of Sciences in somewhat tardy commemoration of Stalin's seventieth birthday.[90]

"Comrade Stalin," they begin, "points out that national culture was a bourgeois slogan as long as power remained in the hands of the bourgeoisie, and the consolidation of the nation took place under the leadership of the bourgeoisie," whereas "national culture . . . became a proletarian slogan when the proletariat achieved power, and the consolidation of the nation began to develop under Soviet power"; and this because [and here they actually quote rather than interpret the holy writ] "under the Soviet system, the nations themselves are not the ordinary 'modern' nations, but socialist nations, just as in content their national cultures are not the ordinary bourgeois cultures, but socialist cultures." Thus, Stalin's thesis implies, "in history there exist two types of nations—bourgeois and socialist; that bourgeois nations are linked to the fate of capitalism and that they should disappear with the collapse of capitalism, while the appearance of socialism leads to the creation on the basis of the old nations of new, socialist nations."[91]

"These statements," the philosophical troika concludes, "are a new, great contribution to the development of the Marxist-Leninist teachings on the national question, to the development of the teaching on socialism." To my ear, their ludicrous circularity recalls the words attributed to Comrade Yedinitsïn in the *Antiformalisticheskiy rayok*, Shostakovich's satirical rendering of the Zhdanovshchina: "Why is realist music written by people's composers while formalist music is written by anti-people composers? Because, comrades, people's composers, being by nature realists, cannot not write realist music, while anti-people composers, being by nature formalists, cannot not write formalist music."[92] Just so: under bourgeois rule nations are by nature bourgeois and under socialism they are by nature socialist.

Yet despite the magical essentialist thinking and the tautologies, something does get clarified after all: namely, the reason why the dichotomy of form and content was so necessary to the theory of national cultures under the dictatorship of the proletariat, and became even more so as the dictatorship of the proletariat became Stalin's personal dictatorship. Under both bourgeois rule and socialism, form is national. It is only content that differs under the two systems. So the same national form will "naturally" embody a bourgeois content under bourgeois rule and a socialist content under socialism. Thus, musical forms (or styles) that under bourgeois rule had been expressions of chauvinistic nationalism are purged of nationalism under socialism. Soviet culture, it thus transpires, may still look like a duck and quack like a duck, but it is no longer a duck—or rather, it is a socialist duck: anatine in form, proletarian in content. And that is why it was not only possible but desirable, and even inevitable, that the art of emancipated socialist society may, and even must, resemble the art of oppressive bourgeois society in style, and why it embodied no contradiction to regard as a progressive prerequisite the insistence that Soviet composers revert to a style often indistinguishable from that of nineteenth-century Russian music.

8. MNOGO PESEN POYOT NASH SOVETSKIY NAROD

Before hearing the duck quack, a short, somewhat achronological excursus may be in order on the now often forgotten Khrushchev, who saw it as his task—having succeeded Stalin to the pinnacle of power and having exposed his predecessor's crimes at the Twentieth Party Congress in 1956—to at last define Soviet nationhood, or at least define the term *sovetskiy narod* (the Soviet people), which his own 1939 article had helped popularize.[93] It was a difficult term to define, because it embodied a typically unacknowledged contradiction. Like "nation," which derives from the Latin *natio*, itself a derivative of *natus*, the past participle of *nasci* (to be born), the word "people" has a biological implication: the *-rod* in *narod* is the exact equivalent of *natio*, with a similar range of meaning ("birth, origin, stock," according to one dictionary)[94] and a similar connection with the cognate verb *rodit'* (to sire, beget) and its imperfective alternate *rozhat'* (to bear, give birth). Only ethnicity, not statehood, correlates with biology: a wholly secular, wholly political entity like the Soviet Union (or the United States for that matter, where the issue is also frequently beclouded) cannot, strictly speaking, be a nation or a *narod*, only a politically designated territory with a population or citizenry. This limitation would seem to apply even more decisively to a state that is defined, as the Soviet Union certainly was, as multinational.

Eppur si muove! Both the USA and the USSR, and every other modern state, did indeed describe or conceive of itself, at various times and for various reasons,

as a nation, and as a people ("the American people" being the entity that American politicians always claim to represent, and to which they appeal for support). Their different means of resolving the contradictions are often telling. The term *sovetskiy narod* had been in use in the Soviet Union as early as the 1920s.[95] By the time of the Friendship of Peoples campaign it was the common coin of Soviet propaganda, as in the very popular "Pesnya o Staline" (Song about Stalin: words by Sergey Alïmov, music by Alexander Alexandrov, 1937), whose first quatrain goes "Mnogo pesen poyot nash Sovetskiy Narod, / Nad polyami, lesami gustïmi. / V kazhdoy pesne zvuchit, v kazhdoy pesne zhivyot / Vsenarodonoye Stalina imya" (Our Soviet People sings many songs / over fields, over thick woods. / In every song resounds, in every song there lives / the omninational name of Stalin).[96] By the 1940s, it was well established in patriotic literature, as witness the texts submitted in competition for setting to Alexandrov's existing melody for the new state anthem in 1943,[97] not to mention slogans like the ubiquitous postwar "Slava sovetskomu narodu-pobeditlyu!" (Glory to the victorious Soviet people!).[98]

Perhaps most relevant, however, was the fact that even before it took power the Bolshevik Party had been calling its opponents *vrag naroda* ("enemy of the people"), a phrase derived, like so much Leninist rhetoric, from the vocabulary of the French revolution, *ennemi du peuple* being the term the Jacobins applied to those condemned during the Terror. In France the word *peuple* could be plausibly construed ethnically as well as politically, as it could not be in Soviet Russia, and yet it had been under that rubric that countless thousands had been condemned by Soviet courts. To be labeled *vrag naroda* was tantamount to excommunication; miscreants so labeled had to be shunned, lending the term something of a religious or doctrinal character as well as a legal one. The term was officially adopted in the *Stalinskaya konstitutsiya* of 1936, and rather blandly defined in its Article 131 as "persons infringing upon public socialist property" *(litsa, pokushayushchiyesya na obshchestvennuyu, sotsialisticheskuyu sobstvennost')*, but a positive definition of the *narod* against which its enemies transgressed was conspicuously lacking.

In his "secret speech" of 1956, Khrushchev claimed, falsely, that it was Stalin who had personally "introduced the concept of 'enemy of the people'" as one of his many abuses against the legal system in the exercise of his arbitrary rule and as a way of "justifying the physical destruction" of his opponents.[99] In order to continue justifying the legal use of the term, which was still embedded in the constitution and in statutes, an actual, concrete definition of *sovetskiy narod* was required. That, it seems, would be the main reason why, at the Twenty-Second Party Congress in 1961, Khrushchev proffered, for the first time, just such a definition. It was, he asserted, a community *(obshchnost')* of a type new to history, people of "differing nationalities" who nevertheless possess "common characteristics": "a common socialist motherland—the USSR; a common economic base—a socialist economy; a common social class structure; a common worldview—Marxism-Leninism; a

common goal—to build communism: thus many common characteristics in spiritual temperament and psychology."[100]

Note that the definition very carefully distinguishes *narod* from *natsional'nost'*. The Soviet *narod* comprises *raznïye natsional'nosti,* "various nationalities." But note, too, that the *sovetskiy narod* is united by virtue of a common creed (Marxism-Leninism) and a common goal (to build communism). And that is why Soviet nationalities theory could never be content to describe the population of the USSR simply as a population *(naseleniye),* but had to insist on *narod.* A *narod* is an entity of which one is not automatically a member by virtue of one's existence. It was a club one had to join. It demanded adherence. The motherland was not defined by territory but by its socialist politics and economy and its Marxist-Leninist worldview. Not to share the worldview is to define oneself as outside the community—that is to say, literally as an excommunicant, one to be shunned.

Ten years later, in 1971, with Khrushchev now a "personal pensioner" in forced retirement, the Twenty-Fourth Party Congress adopted the substance of the definition he had promulgated as an actual resolution, which now incorporated the time-honored, atavistically Stalinist bromide "a culture socialist in content" *(sotsialisticheskaya po soderzhaniyu kul'tura):* "The Soviet people: a new historical, social and international community of persons, having a single territory and economy, and a culture that is socialist in content, a federal state that is common to all of the people, and a common goal, the building of communism. [The new community] arose in the USSR as a result of the socialist transformation and drawing together of all laboring classes and social strata, all nations and nationalities."[101]

And this was the language later paraphrased, with inelegant redundancies, in the preamble to the last Constitution of the USSR (the so-called Brezhnev Constitution), instituted in 1977: "It is a society of mature socialist social relations, in which, on the basis of the drawing together of all classes and social strata and of the juridical and factual equality of all its nations and nationalities and their fraternal co-operation, a new historical community of people has been formed—the Soviet people."[102]

9. TEETH WILL BE PROVIDED

And now let the people's duck quack. The outstanding musical arena for *druzhba narodov* was opera, a genre in which there was by the 1930s a viable Russian canon with many conventions of national signification ripe for transfer to the Soviet present. The period extending from just before the proclamation of the Popular Front to the beginning of the Great Patriotic War was the period when operatic repertoires were inaugurated in (or for) the outlying republics of the Soviet Union, particularly the Central Asian "stans," representing territory acquired by the Russian Empire as recently as the latter part of the nineteenth century. This vast area of remote provinces or *gubernii* was carved up into republics according to rough

demographic (chiefly linguistic) criteria beginning in 1924 by the newly installed Soviet Commissar for Nationalities, a process that culminated on 5 December 1936, when the same Commissar of Nationalities, having attained supreme power, promulgated the new Soviet Constitution that from the beginning bore his name in common parlance. The *Stalinskaya konstitutsiya* added the Kazakh and Kirghiz republics (until then "autonomous" (*avtonomnïye*) entities within the Russian Federation) to the previously existing Tajik, Uzbek, and Turkmen Soviet Socialist Republics as full-fledged and nominally peer constituents of the indestructible union of free republics welded forever together by great Russia, their elder but equal brother.

Part of being a full-fledged constituent republic was having an indigenous artistic culture—which is to say, a professional and literate one in keeping with Soviet educational objectives and standards of *natsional'noye stroitel'stvo*—with an indigenous infrastructure to support it, and with products that could be displayed at *dekadï* in the capital. The process of achieving indigenous operatic repertoires national in form and socialist in content, expressive of the friendship of the peoples of the USSR, has been traced in some detail by Marina Frolova-Walker in the last chapter of her wonderfully titled book, *Russian Music and Nationalism from Glinka to Stalin*, and more comprehensively (if perforce less critically) by Abram Akimovich Gozenpud, the venerable Soviet historian of Russian opera, in the last chapter of the final volume in his monumental series chronicling the Russian and Soviet operatic stage as an institution.[103]

Especially emblematic of the *druzhba narodov* ideal were the creative teams or *kollektivï* that were occasionally assembled to produce these works, in keeping with Soviet industrial norms. In 1939, the Uzbek national opera house was inaugurated with an opera called *Buran* (The Storm), with music composed by the Moscow-born Sergey Nikiforovich Vasilenko (1872–1956)—a member of the most senior generation of Soviet composers, who had studied before the revolution with Sergey Taneyev and Mikhail Ippolitov-Ivanov—working in collaboration with his own former pupil Mukhtar Ashrafi (1912–75). In Frolova-Walker's apt metaphor, the native junior partner's job was to furnish raw materials—folk tunes or melodies of his own in a similar style—ready for the senior partner's Russian-conservatory refinery.[104]

The most prolific such collaboration was the Kirghiz troika Vlasov-Ferè-Maldïbayev. Its two Russian members, both trained at the Moscow Conservatory, were Vladimir Alexandrovich Vlasov (1902–86), a pupil of Georgiy Catoire, and Vladimir Georgiyevich Ferè (1902–71), a pupil of Nikolai Myaskovsky who had in his student days belonged to *Prokoll*, the short-lived *proizvodstvennïy kollektiv* or production team formed at the Moscow Conservatory in 1925, originally in order to enter a competition for a Lenin memorial cantata at short notice.[105] The native partner, Abdilas Maldïbayev (1906–78), a pupil of Ferè, was an operatic tenor by profession; among his roles were Lensky in Chaikovsky's *Yevgeniy Onegin* and leading parts in all six operas on which he collaborated with Vlasov and his former teacher. Besides operas,

the Vlasov-Ferè-Maldïbayev *kombinat* also provided the Kirghiz Soviet Republic with its state anthem, in use from 1946 to 1992 (compare the Mikhalkov-Registan showcase collaboration on the text of the All-Union anthem three years earlier). The theater in Bishkek (formerly Frunze), where Vlasov-Ferè-Maldïbayev operas are still performed, was renamed in memory of Maldïbayev at his death in 1978, and the one som banknote of the post-Soviet Kirghiz republic bears his image.[106]

The first of the stans to get an opera house and a national opera to inaugurate it, then bring to Moscow for a *dekada,* was Kazakhstan, the largest of them, with *Kyz-Zhibek* (The Silk Maiden), an opera—or more precisely a singspiel with spoken prose dialogue between the musical numbers—to a Kazakh-language libretto, composed in part on Kazakh folk melodies, by Yevgeniy Grigorievich Brusilovsky (1905–81), who had been trained at the Leningrad Conservatory by Maximilian Steinberg, Rimsky-Korsakov's son-in-law. In 1933, at the request of Akhmet Kuanovich Zhubanov (1906–68), a local musician charged with the task of being the Kazakh Anton Rubinstein, who was organizing the music profession for the autonomous republic and looking to staff its first conservatory, Brusilovsky was sent to Kazakhstan by the Leningrad branch of the Union of Soviet Composers on a *komandirovka*—in English we would say "on assignment"—to study the local folk music and from it create a score to clothe an already selected libretto by Gabit Makhmutovich Musrepov (1902–85), the eventual president of the Kazakh Writers' Union, after a Romeo-and-Juliet-like legend, set in the sixteenth century and first transcribed and published in 1894, of star-crossed lovers from opposing clans, with subsidiary plots portraying military valor, loyalty, and patriotism.

After conducting the gala premiere on 7 November 1934, as part of the festivities for the seventeenth anniversary of the October Revolution, Brusilovsky settled permanently in Alma-Ata (now Almaty), the Kazakh capital, as the republic's art-musician in chief, directing the opera theater that his work had inaugurated (now called the G. Musrepov Kazakh State Academic Theater after the *Kyz-Zhibek* librettist), adding to that post the directorship of the national philharmonic orchestra when it was founded in 1949, and teaching alongside Zhurbanov at the local conservatory from 1944 until his retirement. In 1945, following established practice, he collaborated with two indigenous musicians, Mukan Tulebayev and Latif Khamidi, in composing the melody to which the Kazakh state anthem was sung—and continues to be sung (to new words) in post-Soviet Kazakhstan. At the 1936 *dekada* of Kazakh art in Moscow, especially auspicious because it marked the promotion of Kazakhstan, according to the provisions of the Stalin Constitution, from autonomous republic to full status as an "SSR," the performance of the title character's "Swan Song" from *Kyz-Zhibek* by the singer Kulyash Zhasymovna Baiseyitova (1912–57) so brought down the house that it led almost immediately to her becoming, at twenty-four, the youngest person ever to be awarded the supreme title People's Artist of the USSR *(narodnaya artistka SSSR).*[107] Even after its

showcase function had been triumphantly discharged, *Kyz-Zhibek* remained popular, and remains so today in post-Soviet Kazakhstan, where Brusilovsky is still honored (e.g., with a postage stamp on his centenary) as a national composer.[108] No other big Russian brother was ever so fully accepted by the nation whose art music he was conscripted to develop.

A filmed version of the opera, issued in the year of its triumph at the *dekada*, described it in its introductory titles using the traditional tropes of romantic nationalism: "The Kazakh people themselves are the authors and composers of this drama. It was compiled from material gathered in obscure mountain villages by minstrels whose names have long since been forgotten."[109] Using the Asafiev-derived vocabulary of Soviet musicology, Gozenpud remarks of Brusilovsky's achievement that he "employed an abundance of well-studied Kazakh folklore and on its basis created a work with a well-developed musical dramaturgy. He fortunately managed to avoid both subordination of the folksong intonations to habitual operatic forms, on the one hand, and slavish obedience to folklore on the other."[110] Because it is chiefly negative, cast in terms of pitfalls successfully dodged, Gozenpud's description conveys little specific information as to the style of Brusilovsky's music vis-à-vis its indigenous prototypes. Gozenpud does emphasize, however, that the signal progressive achievement of the Soviet makeover of Central Asian musical cultures into professional and literate ones was the introduction of polyphony. "At first," he writes,

> composers striving to preserve fidelity to the national tradition did not overstep the limits of monophony, and for accompaniment relied on unison ensembles of folk instruments. From the midst of nationalistic "jealous guardians of indigenous antiquities," there emanated claims that polyphony and symphonic techniques were contrary to the nature of national art and that "Europeanization" would lead to leveling and to the obliteration of its peculiar characteristics. However, the forward-looking development of Soviet musical culture has shown that for the creation of a national opera it was necessary, while preserving everything valuable that the folk had created, to assimilate the traditions of realistic Russian and world art.[111]

Gozenpud's locution, with its fastidious value-laden distinction between *national* and *nationalistic*, shows that the old Marxist stigma still attached to nationalism (bourgeois by definition) even in post-Stalinist rhetoric. And while the description is still lacking in specifics, it does direct attention at what the adapter had to supply so as to assimilate the indigenous product to "realistic Russian and world" traditions. What it means to be realistic has always been a musicological enigma, but its meaning in this case was unexpectedly elucidated for me when I viewed a Russian-language Kazakh television feature on Brusilovsky, from a series called *Imena* (Famous Names), that happened to find its way, like so many unexpected treasures, onto YouTube. The introductory narration was accompanied by an underscoring track that contained something familiar (ex. 9.3).[112]

EXAMPLE 9.3. Ernest Gold, title theme from *Exodus* (1960).

The music was not by Brusilovsky, or by any Soviet composer. It was by a Vienna-born composer named Ernest Gold (1921–99, *né* Ernst Sigmund Goldner), who came with his family to America in 1938 after the Nazi *Anschluss* and made his fortune, beginning in 1945, writing music for Hollywood films. The film for which the music in ex. 9.3 was the title theme was—I dare say—not very popular in the USSR, although it was a colossal hit in America. *Exodus,* a movie from 1960, after a novel by Leon Uris and starring Paul Newman, depicted the founding of the state of Israel from a very chauvinistic Zionist perspective. Why was the title theme from such a film chosen to introduce a film about Yevgeniy Brusilovsky? I have no idea. But it was an apt choice, because it sounds a great deal like some of the music Brusilovsky wrote for *Kyz-Zhibek,* including another popular aria for the title character (ex. 9.4),[113] based on a folk melody called *Tolqyma* (Meditation),[114] which may be heard at the second of the YouTube sites referenced in note 107,[115] or, perhaps even more tellingly, at yet another site that testifies to its currency in active repertory at home, being a videotaped degree recital at the Almaty Conservatory posted in 2010.[116]

The two pieces, Gold's and Brusilovsky's, share a stylistic feature that identifies Russian or otherwise "nationalist" music of the nineteenth century as a prominent component of their common patrimony. The chord progression that supports Gold's melody, with upper case Roman numerals signifying major triads and lower case minor, is i–IV–VI–VII–i, or at more emphatic cadences i–IV–VI–v–I. The use of the major subdominant in relation to a minor tonic identifies the mode or scale on which the composer drew as what nowadays we casually call the Dorian, but which Balakirev, in his folksong collecting days, called the Russian minor.[117] The opening phrase of Gold's melody does not use the sixth degree, so it is only the harmonization that identifies the mode as "Russian" rather than ordinary minor. That was also true of many of Balakirev's harmonizations, showing that the signifier that stamps the music as "Russian" (or, in Gold's case, as exotic in some other way) is a feature supplied by the arranger rather than found in the original. Another feature of Balakirev's harmonization technique which Brusilovsky

EXAMPLE 9.4. Yevgeniy Brusilovsky, aria from *Kyz-Zhibek* (Almaty, 1981), 40–42.

EXAMPLE 9.4 *(continued)*

carried over from Russian territory into Kazakhstan and Gold into Hollywood, was the avoidance of the dominant in minor. Balakirev and Gold did it by keeping the seventh degree unaltered (the so-called flat seventh) and harmonizing it either with the minor v or the "modal" VII chord, thus avoiding borrowed leading tones and preserving a factitious modal purity.

Other chromatic touches, however, were welcome. Brusilovsky's aria also applies the major subdominant to a minor tonic (see mm. 3–5) but juxtaposes it with the ordinary minor-mode subdominant (mm. 10–12), thus producing an unstable or oscillating sixth degree. That feature is also found (as a cross-relation) in Gold's *Exodus* theme, when the major subdominant progresses to the ordinary minor-mode submediant. That unstable degree was a regular feature of Russian music of the kuchkist variety, whether or not it served simultaneously an orientalist marker. The line between the nationalist and the orientalist is a fine one, and not always possible or even necessary to draw.[118] When Brusilovsky, for his part, avoids the harmonic minor's leading tone by substituting a major supertonic chord for the cadential dominant (mm. 19–21, 26–28), he introduces another mutable degree alongside the sixth—namely (and predictably) the fourth degree, which when raised gives off a whiff of the Lydian mode as popularly conceived, and when applied directly to the tonic (especially over a tonic pedal that, as in Brusilovsky's harmonization, casts

the supertonic in 4/2 position) introduces into the harmony an implied augmented second between the thirds of the two chords—this, of course, being the most stereotypical all-purpose orientalist marker of them all, and for that reason the handiest.

Handy, because signifiers need to be read correctly or they are not signifiers. Authentic originals are by no means necessarily as legible as a composer like Ernest Gold or Yevgeniy Brusilovsky (or Balakirev) needed them to be. There is an old, no doubt apocryphal, story they tell in California about the evangelist Aimee Semple McPherson, who was preaching one day to a crowd of homeless men (as we call them now; in her day the word was bums), telling them that they needed to get right with the Lord or else they'd be going to hell, where there'd be "a weeping and a wailing and a gnashing of the teeth"; at which point one of the men shouted, "Hey sister, what if we ain't got no teeth?" "Teeth," she announced, "will be provided."[119] Brusilovsky could have given similar assurance to Akhmet Zhubanov. When the artifacts of the indigenous tradition were not easily read, signifiers would be provided. We have been sampling them.

The Russian—or, more precisely, "kuchkist"—style had already won its spurs as a necessary and versatile marker, indispensable precisely by virtue of its mutability. In the last chapter of her McGill dissertation, Adalyat Issiyeva ingeniously identifies the venue where its adaptability was most comprehensively exhibited: the so-called Ethnographic Concerts held under academic auspices in Moscow and St. Petersburg, which performed, in the waning days of the Russian Empire, the same display function as the Soviet *dekadï* would later do. The "Russian minor" is of course among her prime exhibits, and she illustrates its use by a wide variety of conservatory-trained composers—Nikolai Klenovsky, Dmitriy Arakchiyev (Arakishvili), Reinhold Glière, Yuriy Sakhnovsky, Alexander Gretchaninoff et al.—to harmonize an even wider variety of indigenous, chiefly Asian musics from the remote guberniyas.[120] It was capable of suggesting a virtually limitless variety of exotic identities—or rather, it signaled the generically exotic, from which the specific identity could be deduced and, as it were, "observed," according to context. As the example of Brusilovsky attests, its success could render it convincing even in indigenous eyes.[121]

10. *DOGADLIVÏY POYMYOT, CHEM OB"YASNYAYETSYA ETO*

What is necessary or indispensable, under conditions of an imperium, becomes ... well, imperative. Musicians caught by the imperial mandate to identify themselves with an assigned nationality are effectively confined to a ghetto. The most notorious case within the Soviet imperium was of course that of Aram Ilyich Khachaturyan (1903–78), the single Soviet composer from one of the *natsional'nosti* to achieve world fame. Even his latest Soviet biographer continued to insist on the old official narrative whereby the composer (born in Tiflis—now Tbilisi in

Georgia—to a family of transplanted Armenians) grew up in the "backwoods" listening to the music of *ashugs*, the wandering bards of the Caucasus, whose music inspired his ambition to compose and provided him with a stylistic model.[122] But Tiflis was not the backwoods. An important administrative center of the Russian Empire, it was a Russian-speaking, cosmopolitan city, comparable as a provincial center to German-speaking, cosmopolitan Prague within the neighboring Austrian Empire; and Khachaturyan's native language, most emphatically, was Russian. By the time of the composer's birth, moreover, Tiflis was one of eight cities to have a local branch of the Russian Musical Society, which meant it had an orchestra and a music school *(muzïkal'noye uchilishche)* that was reorganized into a full-fledged conservatory in 1917, when Khachaturyan was fourteen years old.[123]

Khachaturyan gave plenty of publicity interviews that supported the myth of his backwoods upbringing, but on occasion he allowed himself a franker self-assessment. An urban-born, conservatory-educated musician, a pupil of Mikhail Fabianovich Gnesin, and thus the grand-pupil of Rimsky-Korsakov, Khachaturyan cheerfully acknowledged that "the Oriental elements in Glinka's *Ruslan [and Lyudmila],* and in Balakirev's *Tamara* and *Islamey,* were striking models for me, and provided a strong impulse for a new creative quest in this direction."[124] Later he studied with Nikolai Myaskovsky. Acutely aware of his debt to the Soviet educational system, Khachaturyan was as loyal an artistic collaborator as the Soviet establishment could have desired, fully acknowledging the implications of the Soviet idea of *druzhba narodov,* which presupposed a relationship of cultural dependency on Russia, and the necessity for the nascent high cultures of the outlying republics to acknowledge the Russian high culture as their common prototype. Russian orientalist music, he allowed, "showed me not only the possibility, but also the necessity of a rapprochement between, and mutual enrichment of Eastern and Western cultures, of Transcaucasian music and Russian music."[125] Yet even Khachaturyan was occasionally heard to complain, as reported in the stenographic transcript of a meeting of the *Orgkomitet* (Organizational Committee) of the Union of Soviet Composers in 1944, that "they are trying to keep me within the boundaries of national music."[126]

Four years later the extent to which Khachaturyan had been ghettoized became apparent when, at the *soveshchaniya,* or preliminary hearings, convened by Andrey Zhdanov at the headquarters of the Central Committee of the Communist Party in January 1948, "they" accused him—alongside Prokofieff, Shostakovich, and his former teacher Myaskovsky, the other members of what then became known as the Big Four of Soviet Music—of formalism, a charge broadcast far and wide in the ubiquitously publicized Resolution on Music *(Postanovlyeniye o muzïke)* that followed in February. As regarded the others, the charge could be easily rationalized. Prokofieff, once an émigré who hobnobbed with Diaghilev and Stravinsky, was the cosmopolite supreme. Shostakovich, the composer of *The Lady Macbeth of the Mtsensk District,* had been chastised within everyone's memory for past misdeeds;

he was the usual suspect. Myaskovsky, with his (by then) twenty-six symphonies, epitomized the pitfalls of abstract instrumental genres—form without content by virtual definition. But how was the composer of "Sabre Dance" a formalist? What was he doing in such company? To many it had to seem implausible.

Khachaturyan was not among those taken by surprise. He knew what was in store for him. At the hearings, Zhdanov proposed a list of those to be formally censured. Here is the relevant passage from the official transcript:

> *Zhdanov:* We're talking about Shostakovich, Prokofieff, Myaskovsky, Khachaturyan, Popov, Kabalevsky, Shebalin. Who else would you like to join with these comrades?
>
> *Voice From The Hall:* Shaporin.
>
> *Zhdanov:* We will consider these particular comrades the leading figures of the formalist tendency in music.[127]

Yuriy Shaporin, probably named out of spite, was never indicted. A few days later, the chairman of the Committee on Artistic Affairs—the equivalent of what would later be called the Minister of Culture, and the man responsible for drawing up the Resolution—submitted a report that amounted to a first draft of the Resolution. He listed six out of the seven names Zhdanov had proposed: Shostakovich, Prokofieff, Myaskovsky, Khachaturyan, Shebalin, and Kabalevsky. The first four were the Big Four, and the remaining two, Vissarion Shebalin (the rector of the Moscow Conservatory) and Dmitry Kabalevsky (who had served as the wartime editor of *Sovetskaya muzïka*, the official organ of the Union of Soviet Composers, when censorship had been relaxed), were together with Khachaturyan members of the *Orgkomitet*. It was probably because he was not as prominent as the Big Four nor the occupant of an actual administrative post that Gavriyil Popov was dropped from the list. But Khachaturyan, both a big fish and a responsible officer, is listed right at the point of juncture between the two categories. The ordering of Soviet lists was always carefully considered, and carefully studied. Khachaturyan's inclusion was thus doubly inevitable, overdetermined by his prominence and his official status. But those were the de facto reasons for his inclusion, not the stated one. Calling him a formalist still had to be justified to the incredulous.[128]

The musicologist Tamara Nikolayevna Livanova (1909–86), a dependable enforcer of the party line, was given the task of vindicating the improbable charge. Her article, "Aram Khachaturyan and His Critics," appeared in the May 1948 issue of *Sovetskaya muzïka*, three months after the Resolution was promulgated. She took the bull straightaway by the horns:

> Lately many of us have been asking why Khachaturyan is a formalist, and in what, precisely, does Khachaturyan's formalism consist. Both musicians and music lovers have been asking such questions. If you understand formalism or the formalist tendency in a narrow, formal sense, that is, only as a fascination with tricks and stunts,

baffling hodgepodges of voices or musical designs without meaning, then such formalism would seem utterly out of character for Khachaturyan. Drily theoretical melodic configurations randomly combining the twelve tones (according to the antimusical atonal system of Schoenberg) are completely foreign to Khachaturyan, a natural, earthy artist and a lover of life. Khachaturyan never intellectualizes.[129]

"Yet nevertheless Khachaturyan has become a representative of the formalist tendency in Soviet music!" Livanova exclaims (literally, with an exclamation point).[130] To explain this, it is necessary that "we construe the word formalism broadly," according to the trusty Stalinist dichotomy: "Any predominance of form or the formal aspect of a work over its content or to the detriment of its content attests to the presence of formalism," she warns,[131] and cites Khachaturyan's own recantation at the Zhdanov hearings of his Third Symphony, subtitled *Simfoniya-Poema*, dedicated to the Thirtieth Anniversary of the October Revolution. The work had been ridiculed at the hearings for its outlandish sonic overkill: in addition to a bloated orchestra Khachaturyan had added an organ and fifteen extra trumpets. "I sincerely wanted," he told his assembled judges,

> to write for the anniversary something huge, triumphal, extraordinary. I sought the means to express my grand ideas (or so I thought). . . . But apparently I miscalculated in the choice of means. That's where all the trumpets came from, that's what made me pick the organ and try to transfer it from the sacred to the secular domain, since every other instrument had served our [Soviet] art except the organ. . . . I got carried away with the external form of things and did not manage in time to rein myself in.[132]

Having convicted Khachaturyan in his own words of formalism, as "broadly" defined, Livanova casts his career as a parable of a prodigal son, who allowed his concern with "means that are burdensome and unacceptable to the people" to lead him astray.[133] In his tutelary years he had been protected from the modernistic influence of his professors, Gnesin and Myaskovsky, and from the attraction of the high-prestige modernists of the 1920s such as Ravel, Prokofieff, and Stravinsky, by the fortunate accident of his birth into an atmosphere steeped in "the indigenous music of the Soviet East." "All that is best" in Khachaturyan's early works "is linked with the sunny and iridescent national soil, with Armenian, Georgian, Azerbaidjanian sources of melody, harmonic and rhythmic development, and above all the impulsive dance-suffused spirit of folk art."[134] His crowning works, the Piano Concerto of 1937 and the Violin Concerto that followed in 1940, were the proof of the "exceptional creative health" that this salubrious atmosphere had imparted to him. "What were the roots of Khachaturyan's artistic successes?" Livanova sums them up:

> They were rooted in a remarkable combination of particular conditions. In these works Khachaturyan speaks at the top of his voice in his national musical language, the language of the folk music of the Soviet East. Khachaturyan absorbs and to a degree successfully develops the classical tradition as well, first and foremost that of

the Russian School. Thus he speaks his national language in a new way, mastering the grand artistic scale that enjoys global authority. Khachaturyan aspired to speak for the whole world, but his voice had resonance only when the composer stood firmly on his native soil, that of the Soviet East and the Russian classics.[135]

But the greatest factor enabling Khachaturyan's creative success, according to Livanova, was the direct result of "the historical circumstances then taking shape in our country," namely, the miraculous transformation of art and culture from bourgeois-nationalist in both form and content to the dichotomized status defined by the Stalinist formula, national in form but socialist in content. At this point she invokes the "great leader of the nations" himself, quoting directly from the famous speech of 25 November 1936 to the Eighth Extraordinary Congress of Soviets in which Stalin presented to the nation the draft version of the *Stalinskaya konstitutsiya*, the very passage singled out in part 4 above as a classic instance of the "declaration of success" as implicit warning of impending upheaval.[136] "As a result," Stalin had said of the disappearance of mutual distrust and the growth of mutual friendship among the peoples of the USSR, "we now have a fully formed multinational socialist state, which has withstood all trials and whose solidity might well be envied by any national state in any part of the world."[137]

"In Khachaturyan's music of these years," Livanova now chimes in, "the image of the Soviet East shone forth anew, illuminated not only by the hot southern sun, but also by the sun of the *Stalinskaya konstitutsiya*." In consequence, Khachaturyan's Piano Concerto "can be rightly called the first oriental concerto of world significance," for in addition to the folk music of the Soviet East and the "classical 'Russian East' of Balakirev and Borodin," Khachaturyan leaned as well on "the symphonic traditions of Chaikovsky's and Rachmaninoff's piano concertos, on their lyric breadth, their resolute energy."[138] The Violin Concerto drew as well on the brilliance of Rimsky-Korsakov's *Scheherazade*. "Over and over again it reflects the sunny strength, the festivity and the uniquely vital grip of Khachaturyan's art."[139] Unlike the music of bourgeois composers, "it stands totally on terra firma, never philosophizing, never diluting, never cogitating, always feeling, breathing, pulsing, ... so that it captivates us and overwhelms all those abroad who had become used to tedious intellectualizing, to the cerebral ingenuity of a bourgeois art that had long since lost its vigor."[140] These concertos were Khachaturyan's peak.

And from a peak there can only be descent—into exaggeration, into disunity, away from the national into the cosmopolitan. In his Second Symphony, a severe if grandiose wartime work in which Khachaturyan clearly sought a greater seriousness and intensity than he had previously achieved, Livanova finds only a pretension that led him over the edge into an error it took the Zhdanovshchina to correct:

The composer's horizons have expanded here: he strives to convey the universally human *[obshchechelovecheskoye]*, the generally philosophical *[filosofski-obobshchyon-*

noye], the pathos of struggle, the calamities that have befallen the people, dreams of happiness, calls to victory. . . . But the Second Symphony has never received the popular recognition that its theme should have entitled it to. Why did this happen? Precisely because its "universally human" and "generally philosophical" content could have been conveyed only by means of a vivid, concrete, strongly national language, and Khachaturyan strove here to "transcend" his national origin! . . . The composer has lapsed here into cosmpolitanism.[141]

The Third Symphony, or *Simfoniya-Poema* for the Thirtieth Anniversary of October, the work with the fifteen trumpets on behalf of which Khachaturyan had offered the Zhdanovshchina the tribute of an autocritique, and the one work of his included in the secret order (Prikaz No. 17), issued four days after the Resolution on Music, that formally banned it from performance and broadcast, marked the end of the line.[142] Here Khachaturyan "turned away from his national soil—not only from the Soviet East, but also from the Russian classics. For the frightful 'trumpet voice' of the *Simfoniya-Poema* is as far from the popular conception of Armenia as it is from the Russian classical tradition."[143] And here he now stands, Livanova chillingly observes, taking her final thrust directly from the Resolution on Music. With hindsight, she warns, we now can see that the poor composer, and by implication all composers, were poised from the start on a slippery slope. Only franker criticism administered at the proper time might have saved him from "the dangers of formalism or aestheticism, the dangers of impressionistic infatuation with color and expressive discord; and now he has been named in a group of composers 'whose work most graphically presents the formalistic perversions, the antidemocratic tendencies in music that are so alien to the Soviet people and its artistic tastes.'"[144]

One does not quote a text like Livanova's for the sake of its critical insights, or for the sake of the aesthetic principles it expounds. As its title suggests, its chief purpose was to serve as a warning as much to critics as to composers, to look before leaping. (A large part of it is given over to sarcastic commentary on extracts from published reviews of the works it defames.) But what the article does very vividly show is the way composers, especially those who came from the Soviet East, were by 1948 confined to the ghetto of their nationality within the Soviet imperium. It grants us some insight into the way the Stalinist "friendship of peoples" maintained the colonialist or imperialist attitudes that Lenin himself correctly diagnosed and deplored when (following Alexander Herzen, who was following the marquis de Custine) he called the Russian Empire the *tyur'ma narodov*, "the prison house of peoples": the same concern with the authenticity of the other, the same unwillingness to allow true assimilation, the same strategy to keep subordinate nationalities in their place on the periphery.[145] And all of this under the regime of Lenin's "marvelous Georgian," whose toast to the *velikiy russkiy narod*— the great Russian people—at the end of the Great Patriotic War (after relentless campaigns against *velikoderzhavniy shovinizm* or "great-power chauvinism" in the

early decades of Soviet rule) at once gave the signal for the anticosmopolitan campaign and for the accelerated Russification of Soviet culture.[146]

11. ZA RODINU! ZA STALINA!

But of course the original ghetto was set aside in Venice in 1516 to confine the city's Jews. (The word may derive from *borghetto*, diminutive of *borgo*, meaning a borough or district.) Jews were not the only minority confined by law to special dwelling places within the Venetian republic, but the ghetto was their district, and the word has always had special relevance to the segregation of Jews and, by extension, to any sort of institutional antisemitism. That issue, too, looms large in the history of Russian nationalities policy long before the Soviet period. The largest implementation ever of the ghetto principle was the Russian *cherta osedlosti*, the "pale of settlement" that was set up in 1791 under Catherine the Great to keep the many Jews who had become subjects of the Russian crown in the course of territorial annexation to the west (my ancestors among them) from moving into the heart of Russia. The pale was abolished in 1917—not by the Soviets but as one of the first acts of the liberal provisional government that came to power with the tsar's abdication in February. The law abrogating the pale was called "On the Abolition of Religious and National Restrictions" *(Ob otmene veroispovednïkh i natsional'nïkh ogranicheniy)*; it was adopted on 20 March 1917 (2 April, New Style), and it was upheld by official Soviet policy, which guaranteed to Jews the liberty to reside and travel as full and free citizens.

But in fact the treatment of Jews within the Soviet Union was full of ambiguities and contradictions, reflecting the ambiguous status of Jews as a nation. The Jews, often to their misfortune, have confronted all modern theorists of nationality with a conundrum, and that emphatically included the marvelous Georgian in his tract of 1913, whose definition—chiefly derived (as Lenin implied to Gorky) from Austrian Marxist analyses of nationalism by Karl Kautsky and Otto Bauer—was this: "A nation is a historically evolved, stable community of people, formed on the basis of a common language, territory, economic life, and psychological make-up manifested in a common culture."[147]

The Jews, scattered all over the world, without a territory or a common vernacular language, economically and culturally diverse and united only atavistically by religion and liturgy—criteria that the Soviets were ideologically committed in any case to reject—furnished an exception to every aspect of Stalin's definition, as he himself repeatedly observed in the course of his discussion. The longest such passage was the following, intended as rebuttal to an earlier attempt by Bauer to define nationalities:

> Bauer speaks of the Jews as a nation, although they "have no common language"; but what "common destiny" and national cohesion is there, for instance, between the Georgian, Daghestanian, Russian and American Jews, who are completely separated from each other, inhabit different territories and speak different languages? The Jews

enumerated undoubtedly lead the same economic and political life as the Georgians, Daghestanians, Russians and Americans respectively and in the same cultural atmosphere; this cannot but leave a definite impress on their national character; if there is anything common to them left, it is their religion, their common origin and certain relics of a national character. All this is beyond question. But how can it be seriously maintained that petrified religious rites and fading psychological relics affect the "destiny" of these Jews more powerfully than the living social, economic and cultural environment that surrounds them? And it is only on this assumption that it is possible to speak of the Jews as a single nation at all.[148]

Soviet Jews, who as Yiddish-speaking Ashkenazim, for the most part, could be regarded as a distinct and uniform language group within the Russian Empire, were despite Stalin's prerevolutionary misgivings granted—or saddled with—the status of a Soviet nationality (their language being on the basis of proportionality among the official languages of the Belorussian republic until 1937). Their internal passports, beginning in 1932, identified them (at the notorious "item 5") as Jews, which made them increasingly vulnerable to persecution. They were assigned a national territory or "autonomous region" (Biro-Bidzhan, located arbitrarily—or maybe not so arbitrarily—in far eastern Siberia near the Chinese border) and were encouraged in the early Soviet years to organize official, state-supported national cultural institutions. They paid the price of their ambiguous status most heavily between 1948 and 1953. The musical side of that story makes an ironic and instructive counterpoint to the story of Khachaturyan's humiliation.

Its protagonist was the extremely prolific Polish-born composer Mieczysław Weinberg (1919–96), who entered the USSR as a refugee from the German invasion of Poland in 1939 and who as a Soviet composer was known by the first-name and patronymic Moisey Samuilovich. His renaming by a border guard with a stereotypical Jewish moniker (Russian for Moses) is already evidence of the Soviet nationalities policy.[149] But his career as a Soviet composer was comparable to the careers of other precariously successful Soviet Jews in other walks of musical life, such as David Oistrakh (1908–74) or Emil Gilels (1916–85), virtuosos of the violin and piano respectively, for both of whom Weinberg composed concertos and sonatas. As one who owed his life and career to the asylum he was granted in 1939, Weinberg never saw himself as a victim of Soviet power. On the contrary, he felt greatly indebted by virtue of his sheer survival to the country that had taken him in and supported his career. We are not speaking of a dissident, or of one who cast himself as a representative of an oppressed minority. But Soviet policy never let him forget that, still and all, it was a minority—or, in Soviet parlance, a particular *national'nost'*—that he represented. He too was ghettoized and suffered the chameleon vicissitudes of the nationalities policy with its complicated, volatile relationship to the Jews.

Not that this was at all times a disadvantage. In 1948, although he was as yet too small a fry to be mentioned at the hearings or in the Resolution, Weinberg did

endure a modicum of adverse criticism, both in the official report read by Tikhon Khrennikov, the newly appointed head of the Union of Soviet Composers, at the first post-Resolution Union Congress and reprinted in the pages of *Sovetskaya muzïka*,[150] and in a roundup of recent publications, where the musicologist Grigoriy Bernandt listed him prominently among the "'little Shostakoviches' . . . who blindly copy the most negative traits in Shostakovich's style."[151] Several compositions by Weinberg were on the list of works banned by order of Prikaz No. 17. The one work of Weinberg's explicitly exempted from Bernandt's critique was a collection of Jewish Songs *(Yevreyskiye pesni)*, op. 13 (named Children's Songs [*Detskiye pesni*] in the article), a work in which Weinberg had conspicuously employed "national" stylistic signifiers.[152] This was surely intended as a word to the wise, and Weinberg was alert to it. He immediately followed up with his *Sinfonietta*, op. 41, which, according to his wife, Nataliya Vovsi-Mikhoels, he began composing in March 1948, almost immediately after Bernandt's appraisal was published.[153]

In his recent study of the composer and his works, David Fanning rightly characterizes the *Sinfonietta* as Weinberg's "Creative Reply," adopting in translation the expression *(tvorcheskiy otvet)* associated with Shostakovich's Fifth Symphony on the basis of an article with that title that appeared, under the composer's byline, in 1938, relating his new symphony directly to the harsh criticism he had received two years earlier on account of his opera *The Lady Macbeth of the Mtsensk District*.[154] Weinberg's score is well larded with signs of compliance. Its ultra-safe heading reads *Posvyashchayetsya druzhbe narodov SSSR*, "Dedicated to the friendship of the peoples of the USSR," and the manuscript bore as well an epigraph quoting Weinberg's famous father-in-law, the Yiddish actor and theatrical director Solomon Mikhoels (dropped from the published score but noted in a report published in *Sovetskaya muzïka*), which read: "In the *kolkhoz* [collective farm] fields a Jewish song also began to sound; not a song from the past, full of sadness and misery, but a new, happy song of construction and labor."[155] The *Sinfonietta*'s first movement is headed *Bodro i reshitel'no* (high-spirited and resolute); the third is marked *Ozhivlyonno* (animated); and the last, *Ochen' bïstro i radostno* (very fast and joyous).

Bitter ironies abound. The year 1948 was a black one not only for Soviet composers but also for Soviet Jews. It began with the murder, in January, of Solomon Mikhoels, the very one whose cheerful words his son-in-law later placed at the top of his *Sinfonietta* score. The epigraph was dropped from the printed score because Mikhoels had been erased from Soviet public life along with the other leading figures of the wartime Jewish Anti-Fascist Committee, who had fallen under suspicion as possible Zionists and were later tried and executed. Mikhoels was assassinated rather than executed, it is now thought, because the charges would likely have been deemed implausible; at the time his death was attributed to a (now conceded as simulated) vehicular accident. The irony of Weinberg's celebration of Jewish emancipation at a time of Jewish mourning is inescapable to us in

retrospect. How salient it appeared in 1948 (and to whom) is a difficult question, especially given Weinberg's own gratitude to the nation (and, it follows, to the regime) that had saved him from the Nazis.

The irony is compounded by the *Sinfonietta*'s reception, which may strike us now as paradoxical in view of the conventional or easy view of 1948 as disastrous for Jews and musicians, and—it would appear to follow—especially for Jewish musicians. At the very moment when the Big Four of Soviet music were being castigated and much of their music banned from performance or broadcast, Weinberg, thanks to the *Sinfonietta*, was heavily promoted. In his second official report as the head of the Union of Soviet Composers, read at a meeting at the end of the year and published in *Sovetskaya muzïka* in January 1949 under the title "The Work of Composers and Musicologists since the Resolution of the Central Committee of the Communist Party on the Opera *The Great Friendship*," Tikhon Khrennikov checked the progress Soviet music had made under the guidance of the Party, singling out by name either continued reprobates (in the first instance Prokofieff, for his failed attempt at compliance in the form of an opera, *The Story of a Real Man*) or composers whose works had fulfilled the task to which the Resolution had called them—in Khrennikov's words, "steadfast" *(reshitel'nïy)* adherence to the "Stalinist definition of our culture as socialist in content and national in form. Our art must be substantial [*soderzhatel'noye*, literally 'full of content'] in the highest degree, which means embodying in musical images all the richness of our socialist life, the rich inner world of our Soviet people. Our art must be *partiynïy*—that is, it must be imbued with the ideas our people live by, under the guidance of the great Bolshevik Party."[156]

Khrennikov adduced works by seven young composers as evidence of progress toward this end, each given an encomium that was, according to the stenographic transcript in *Sovetskaya muzïka*, received with applause, lending the proceedings the air of an awards ceremony. In the order named they were Alexander Arutyunyan (1920–2012), an Armenian; then Weinberg; then Fikret Amirov (1922–84), from Azerbaidjan, followed by Vladimir Vasilyevich Bunin (1908–70), a Russian; Suleiman Aleskerov (1924–2000), another Azeri (cited, like Amirov, for a symphonic *mugham*); Gayaneh Moiseyevna Chebotaryan (1918–98), Armenian by nationality though born in Russia; and Alexey Alexeyevich Muravlyov (b. 1924), a Russian, born, like Khachaturyan, in Tiflis before it was Tbilisi, and in later life known primarily for music for films and for ensembles of folk instruments. Khrennikov, or his ghostwriters, had chosen what in American politics would be called a balanced ticket, the emphasis placed on "Eastern" republics, and including a token woman, who was at the same time a representative of an eastern nationality and who was congratulated for "organically feeling the musical language of her people."[157] But every work was praised for its national character, *including the Russian ones*. The title of Muravlyov's composition, *Russkoye skertso* (Russian Scherzo), advertises its nationalism outright, but Bunin's two symphonies are likewise

commended for their *nastoyashchaya russkaya pochvennost'* (genuine Russian earthiness), an archaic choice of words that conjures up the Russian romantic nationalism of the nineteenth century—a strain of Russian nationalism that was originally aligned with political reaction and bigotry and that carried a not-so-hidden "anticosmopolitan" message when used in the Stalinist context.

I have listed Khrennikov's young honorees in the order in which he named them because the descriptions of their works were couched in terms of progressively diminishing enthusiasm. The highest accolade went to Arutyunyan for his *Kantata o rodine* (Motherland Cantata), an explicitly patriotic work that Khrennikov pronounced "an attainment not only for Armenian musical culture, but for the rest of us as well."[158] Compositions further down the list are given mixed reviews, faulted for such forgivable youthful sins as unevenness, inexperience, naiveté. Weinberg placed second in this competition, and was one of the three young composers, along with Arutyunyan and Chebotaryan, to have his portrait printed as an illustration—not a photograph but an artist's rendering, which because it required more effort to produce conveys more emphatic approval. Alone among the encomia, moreover, Weinberg's was cast as a narrative of redemption, which made it especially apropos: "Striking evidence of the fruitfulness of the realist path is the *Sinfonietta* by Weinberg, a composer who had been heavily influenced by modernist art, which had monstrously warped his undoubted gift. Turning to the sources of Jewish folk music, Weinberg has created a brilliant, buoyant work, dedicated to the bright, free work life of the Jewish people in the Land of Socialism. In this work Weinberg has displayed outstanding mastery and richness of invention."[159]

As long as Khrennikov has made so strong a claim on its behalf, we ought to sample Weinberg's reliance on "the sources of Jewish folk music." The fast movements of the *Sinfonietta*, as listed above, obviously draw on the idiom of klezmer music, enhanced with all-purpose signifiers such as augmented seconds, oompah accompaniments, and heavy use of the clarinet as solo instrument. The slow movement is marked *Medlenno, pevuche*, which translates into something like *Andante cantabile*. It begins with a long unaccompanied melody for French horn; but as soon as chordal harmonies begin, the progression minor tonic to major subdominant is heard (ex. 9.5).[160] It is no more an Ashkenazic Jewish progression than it was a Kazakh progression when used by Brusilovsky or a Middle Eastern progression when used by Ernest Gold. Like the others, it is an adaptation of Balakirev's Russian minor and shows Weinberg to have absorbed well the lessons he had learned at the Minsk Conservatory from his professor Vasiliy Andreyevich Zolotaryov (1872–1964), a pupil of Rimsky-Korsakov—the same Rimsky-Korsakov who long ago had called upon the Jews to produce their Glinka.[161]

Like Khachaturyan at his Livanova-defined peak, Weinberg synthesized the imaginary Soviet East with memories of the Russian classics to produce art that was national in form and socialist in content. But whereas Khachaturyan in early

EXAMPLE 9.5. Moisey (Mieczysław) Weinberg, *Sinfonietta*, op. 41 (Moscow and Leningrad: Muzgiz, 1949), II, mm. 9–14.

1949 was still under a cloud along with the rest of the Big Four—Khrennikov berating him along with Shostakovich for taking refuge in utilitarian film music rather than facing up to the task of reforming their approach to serious composition[162]—Weinberg was promoted with such enthusiasm that one can hardly doubt Laurel Fay's suggestion that it may have been Weinberg's example that prompted Shostakovich's decision to emulate his younger friend and colleague's Jewish songs with a Jewish opus of his own, the now celebrated cycle *From Jewish Folk Poetry*, op. 79. Shostakovich composed it while Weinberg was composing the *Sinfonietta*, in the immediate aftermath of the Resolution. For both of them, reliance on folklore was a "creative reply," an earnest of good faith in fulfilling the tasks set by the Resolution. What worked for Weinberg, however, did not work for Shostakovich, who seems to have realized, in Fay's words, that "of all the available nationalities, great and small, he just happened to pick the wrong 'folk' as his inspiration," and so kept his songs in the drawer until 1955.[163] Putting it that way may sound off-puttingly offhand (and it has earned Fay considerable rebuke), but it fits the facts and implies a correct understanding of the applicable double standard. For Weinberg to write in a Jewish style meant staying put in his ghetto. For Shostakovich to do it meant making common cause with enemies of the people who would over the next several years face arrest and execution.

That fate eventually caught up with Weinberg as well. Having married into the Vovsi-Mikhoels family, he was caught up in the Doctors' Plot of 1953. Not only was

his wife the daughter of Mikhoels; she was also related to Miron Vovsi (by Russian reckoning, his niece), the chief defendant in that trumped-up case whereby the Kremlin doctors were accused of acting in collusion with Israeli and American Zionists to murder the Kremlin leadership. Weinberg was imprisoned in February 1953 and held until late April, seven weeks after Stalin's providential death. According to the recollections of his wife, along with his having conspired with Mikhoels to found an anti-Soviet Jewish state in the Crimea, Weinberg's *Sinfonietta* was cited as evidence of his bourgeois nationalism.[164]

Where Khachaturyan was censured for abandoning his national character, Weinberg could be censured and even condemned for embracing it—and so could Alexander Veprik, a pupil of Myaskovsky's who had been honored as the "founder" of the Kirghiz national school. Earlier in his career, in the 1920s and '30s, Veprik had written the same kind of Jewish national music that Weinberg had started writing in the 1940s. His Jewish music had been performed abroad by major artists like Arturo Toscanini, and on a *komandirovka* to Vienna in 1927 Veprik had hobnobbed with Arnold Schoenberg as well as Hindemith, Honegger, and Ravel, all of which made the composer a sitting duck in the aftermath of the Zhdanovshchina and the anticosmopolitan campaign. He was arrested as a Jewish nationalist in 1950 and "sat," to use the Soviet expression, until 1954, a year after Stalin's death. He wrote very little music after his release, concentrating instead on orchestration textbooks and also a study of the orchestral music of J. S. Bach, as safely universal as any music could conceivably be.

Thus, according to the fluctuating, unpredictable manner in which Soviet nationalities policy was defined and implemented, the same musical idiom could be evidence of compliance or defiance, just as it could be read as Jewish or Kazakh or Russian depending on who is doing the reading, where the reading is done, and to what end. Nationality is not a property of music, but of readings. It is not exhibited but attributed. It is neither virtue nor vice—or rather, it is both virtue and vice, depending. Any more definite claim is humbug.

But we know that now—don't we? And so did Marx, to bring things back to our starting point. As ever a great diagnostician and a dreadful prognosticator, Marx knew, as much as we now know, that false consciousness can move mountains. But he also thought false consciousness would give way to universalist reason, and we know by now that that was a utopian pipe dream. We know, better than he could have known, what happens when utopian dreamers gain control of a social structure and insist that its reality be made to conform to their dream, or at least that all pretend it did. Nationalism produces ghettos, empires, conflict, bloodshed, lies, and misery. But next to religion, for which it can be a surrogate, it is surely the greatest motivator of men and women ever conceived. Thousands died with the words *Za rodinu! Za Stalina!* (For the motherland! For Stalin!) on their lips. Did anyone ever die shouting *Za mezhdunarodnïy rabochiy klass!* (For the inter-

national working class!)? It is hard to disagree with Timothy Snyder's remark that "an apatriotic proletariat has never emerged, even in communist states," or to deny that class consciousness has often seemed to depend on national consciousness.[165] But if the international working class was an abstraction and an illusion, so is "motherland," and so was "Stalin" (who is said to have admonished his son Vasiliy that neither one of them could live up to the meaning of that name).[166] Some illusions produce social solidarity; others do not. Will we ever really know why?

Perhaps not, any more than we will ever fully achieve whatever really important goal we set ourselves. In the meantime we can try to learn more and understand more, a little at a time, proceeding along the endless asymptote toward insight.

NOTES

1. "The Count of Cavour" (anonymous review of three books by and about Cavour), *Westminster and Foreign Quarterly Review* 61 (1876): 443.

2. See Stephanie Malia Hom, "On the Origins of Making Italy: Massimo D'Azeglio and 'Fatta l'Italia, bisogna fare gli Italiani,'" *Italian Culture* 31 (2013): 1–16.

3. "Ma a fare il proprio dovere, ... il primo bisogno d'Italia è che si formino Italiani che sappiano adempiere al loro dovere; quindi che si formino alti e forti caratteri." Massimo d'Azeglio, *I miei ricordi*, MS (1866) at the Archivio dell'Istituto per la Storia del Risorgimento, Rome; quoted in Hom, "On the Origins," 3.

4. "Io pensavo (come ancora Io penso) che ... bisogno far gli Italiani se si vuol avere l'Italia; e che una volta fatti, davvero allora l'Italia *farà da sé*." D'Azeglio, *I miei ricordi*, ed. A. M. Ghisalberti (Turin: Einaudi, 1949), 480; quoted in Hom, "On the Origins," 4 (emphasis original).

5. Hom, "On the Origins," 4 and 14n6.

6. "Der italienische Befreiungskampf und die Ursache seines jetzigen Mißlingens," *Neue Rheinische Zeitung*, no. 73 (12 August 1848), available at www.phil.pku.edu.cn/resguide/marx/me05_366.htm (accessed 24 February 2015): "Der Hauptfeind der italienischen Freiheit unter den einheimischen Fürsten war und ist Karl Albert. ... Den Bourbonen Ferdinand brauchten sie nur wenig zu fürchten; er war längst demaskiert. Dagegen ließ sich Karl Albert als 'la spada d'Italia' (das Schwert Italiens) überall Loblieder singen und als den Helden preisen, dessen Degenspitze für Italiens Freiheit und Selbständigkeit die sicherste Garantie biete."

7. Hom traces the formation and exploitation of the famous slogan by degrees, beginning with the first printed edition of d'Azeglio's memoirs, in which the first of the "approximations" is altered by the editors to give it what we would now call a more nationalistic, if still pessimistic, twist: "Il primo bisogno d'Italia è che si formino Italiani dotata d'alti e forti caratteri. ... Pur troppo s'è fatta l'Italia, ma non si fanno gli Italiani" (Italy's first need is the formation of Italians endowed with lofty and strong characters. But unfortunately with each new day things are moving in the opposite direction: Italy is made, but Italians are not being made) (D'Azeglio, *I miei ricordi* [Florence: G. Barbèra, 1867], 7; quoted in Hom, "On the Origins," 5). The phrase seems to have reached its familiar, entirely positive form in 1896 in a newspaper column by Ferdinando Martini, a retired government minister, as part of an anecdote about d'Azeglio, whom Martini had known in his youth (Hom, 7–9). It achieved celebrity as a result of Fascist appropriations of the Risorgimento and its rhetoric, beginning with a book about d'Azeglio by Marco Rossi (alias Marcus de Rubris) called *Bisogna far gli Italiani: Aforismi di Massimo D'Azeglio* (Florence: Vallocchi, 1926) (Hom, 10), thence to Gabriele d'Annunzio and beyond, when the notion of *fare l'Italia* morphed into *fare*

la grande—and even *la più grande*—*Italia:* no longer the nation-state but the revived imperium (Hom, 11–13).

8. Benedict Anderson, *Imagined Communities: Reflections on the Origin and Spread of Nationalism* (London: Verso, 1991).

9. Jean-Jacques Rousseau, *The Government of Poland*, trans. Willmoore Kendall (Indianapolis: Bobbs-Merril, 1972), 10. (Further references to this source will be made in the main text.) Rousseau wrote the tract at the request of Count Michał Wielhorski (ca. 1730–94), who at the time of its commissioning was the envoy of the Polish Bar Confederation to France and the grandfather of the two St. Petersburg Counts Wielhorski (or Viyelgor'skiy) who figure as prominent Russian musical amateurs and patrons in the memoirs of Berlioz, Wagner, and many others. "Republic" here is synonymous with "state"; Rousseau's recommendations for Poland did not entail the abolition of its monarchy but rather its preservation.

10. The story about "black broth" (μέλας ζωμός, actually a pork stew) comes from one of Rousseau's favorite sources, Plutarch's biography of Lycurgus: "They say that a certain king of Pontus, having heard much of this black broth of theirs, sent for a Lacedaemonian cook on purpose to make him some, but had no sooner tasted it than he found it extremely bad, which the cook observing, told him, 'Sir, to make this broth relish, you should have bathed yourself first in the river Eurotas'" (trans. John Dryden, http://classics.mit.edu/Plutarch/lycurgus.html [accessed 28 February 2015]).

11. Eric Hobsbawm and Terence Ranger, ed., *The Invention of Tradition* (Cambridge: Cambridge University Press, 1983).

12. The inversion Rousseau proposes is of the Roman proverb "Ubi bene ibi patria" (Where I am at ease, there is my homeland), thought to be derived from a line from the tragic poet Marcus Pacuvius as quoted by Cicero: "Patria est ubicumque est bene" (roughly, One's homeland is wherever it feels good) (Marcus Tullius Cicero, *Tusculanarum disputationum ad M. Brutum libri quinque*, vol. 2, ed. Gustav Tischer [Berlin: Weidmann, 1887; reprint n.p.: Ulan Press, 2011], 158). "A certain czar," of course, was Peter the Great, of whose reign Voltaire had published a history, much detested by Rousseau, between 1759 and 1763. See Lina Steiner, *For Humanity's Sake: The Bildungsroman in Russian Culture* (Toronto: University of Toronto Press, 2011), 5–6.

13. *The Confessions of Jean-Jacques Rousseau* (New York: Random House [Modern Library], n.d.), 1.

14. "Look at Spain," he added, "where the bullfights have done much to keep a certain vigor alive in the people."

15. St. Basil, *Exegetic Homilies*, trans. S. Agnes Clare Way, The Fathers of the Church 46 (Washington, DC: Catholic University of America Press, 1963), 153.

16. For a comprehensive if somewhat dated treatment of this theme, see Conrad L. Donakowski, *A Muse for the Masses: Ritual and Music in an Age of Democratic Revolution, 1770–1870* (Chicago: University of Chicago Press, 1977); on the French revolutionary period specifically, see Laura Mason, *Singing the French Revolution: Popular Culture and Politics, 1787–1799* (Ithaca, NY: Cornell University Press, 1996).

17. Martin Gerbert, *De cantu et musica sacra . . .* , vol. 1 (St. Blasien, 1774), 74; trans. R. Taruskin in Piero Weiss and Richard Taruskin, *Music in the Western World: A History in Documents*, 2nd ed. (Belmont, CA: Thomson/Schirmer, 2008), 25. Augustine continues, "If you praise God and do not sing, you do not utter a hymn. If you sing and do not praise God, you do not utter a hymn. If you praise anything other than God, and if you sing these praises, still you do not utter a hymn."

18. Malcolm Boyd, "National Anthems," *New Grove Dictionary of Music and Musicians*, 2nd ed., vol. 17 (New York: Grove's Dictionaries, 2001), 659. The version Arne employed had been published the previous year in a miscellany called *Harmonia anglicana* (London: John Simpson, 1744), but the song is assumed to be much older.

THE GHETTO AND THE IMPERIUM 289

19. At the time of writing this song could be found on YouTube: www.youtube.com/watch?v=oLkokSxkoKo (unless otherwise noted, all URLs cited in these notes were accessed 2 March 2015).

20. The phrase in quotes comes from the London *Morning Post*, 5 May 1862, quoted in Roberta Montemorra Marvin, *The Politics of Verdi's "Cantica,"* RMA Monographs No. 24 (Farnham, Surrey; Burlington, VT: Ashgate, 2014), 56.

21. Quoted in Marvin, *Politics,* 21.

22. Piero Nardi, *Vita di Arrigo Boito* (Milan: Mondadori, 1942); quoted in Marvin, *The Politics,* 22.

23. Marvin, *Politics,* 36.

24. Translation from ibid., 11–12. At the first performance the line "Per una terra incatenata" was softened to "Per una terra che gemeva" (For a land that groaned).

25. This song, too, is in YouTube's repertoire: www.youtube.com/watch?v=T7pX4iMp7ZQ (accessed 3 March 2015).

26. *Times,* 24 April 1862, trans. Manfredo Maggioni; quoted in Marvin, *Politics,* 33.

27. *Athenaeum,* 31 May 1862; quoted in Marvin, *Politics,* 60.

28. The reporter for the *Revue et gazette musicale* offered this explanation explicitly; see Marvin, *Politics,* pp. 45–46

29. *Spectator,* 31 May 1862; quoted in Marvin, *Politics,* 46.

30. *Spectator,* 14 June 1862; quoted in Marvin, *Politics,* 46.

31. For the full program see Marvin, *Politics,* 70. The "Inno delle nazioni" was the last actual composition by Verdi in the *concerto verdiano,* but it was followed by three Risorgimento choruses, including the "Inno di Mameli," sung to Novaro's melody as quoted by Verdi.

32. Marvin, *Politics,* 87.

33. Michel Vovelle, "La Marseillaise: War or Peace," in *Realms of Memory: The Construction of the French Past,* ed. Pierra Nora, vol. 3: *Symbols,* trans. Arthur Goldhammer (New York: Columbia University Press, 1998), 61.

34. "La Marseillaise" and "L'Internationale" were from then on what might be called musical frenemies: often sung in conjunction, but just as often in rivalry for recognition as the true symbol of the French revolutionary spirit. See, in addition to the essay by Vovelle (see note 33), the famous article of Jean Jaurès, "Marseillaise et Internationale," *Petite république socialiste,* 30 August 1903, available at https://pandor.u-bourgogne.fr/img-viewer/CH/CH_1988_2T_n33_art10/iipviewer.html?base=mets&np=CH_1988_2T_n33_119.jpg&nd=CH_1988_2T_n33_125.jpg&monoid=FRMSH021_00008_de-1147&treq=&vcontext=mets; and also Eric Drott, *Music and the Elusive Revolution: Cultural Politics and Political Culture in France, 1968–1981* (Berkeley: University of California Press, 2011), chap. 1 ("Music and May '68").

35. Geoffrey Hosking, *Rulers and Victims: The Russians in the Soviet Union* (Cambridge, MA: Belknap Press of Harvard University Press, 2006), 71.

36. See note 6 above. "Die Italiener hätten stündlich den Spruch wiederholen und beachten sollen," Engels wrote: "'Der Himmel beschütze uns vor unsern Freunden, vor unsern Feinden werden wir uns schon selber schützen!'" (The Italians had constantly to remind themselves of the proverb: "Heaven protect us against our friends; against our enemies we will protect ourselves!").

37. Karl Marx and Friedrich Engels, *Manifesto of the Communist Party* (1848), trans. Samuel Moore in cooperation with Friedrich Engels (1888), *Marx and Engels: Selected Works,* vol. 1 (Moscow: Progress Publishers, 1969), 112.

38. See www.marxists.org/history/usa/parties/spusa/1920/1023-hapgood-debsinprison.pdf.

39. The very long lived Mikhalkov was the one who got to de-Stalinize the text of the anthem (in 1970), and even de-Sovietize it altogether thirty years later.

40. Walter Toscanini to Armando Borghi, 10 July 1966, trans. Roberta Montemorra Marvin, in Marvin, *Politics,* 107.

41. Ironically enough, "The Internationale" was snipped from the film during the McCarthyite red scare (while Toscanini was still alive) and restored in 1988 by the Library of Congress from a print loaned them by the Museum of Modern Art in New York; see Marvin, *Politics,* 108–9n88.

42. Leon Trotsky, "Socialism in One Country" (appendix to *The Revolution Betrayed*), trans. Max Eastman (Garden City, NY: Doubleday, Doran & Co., 1937), 220. Lenin's manifesto *(Deklaratskiya prav trudyashchegosya i èkspluatiruyemogo naroda)* was, of course, an adaptation of the French revolutionary *Déclaration des droits de l'homme et du citoyen* (Declaration of the Rights of Man and of the Citizen), passed by the Constituent Assembly on 26 August 1789.

43. Nicholas Timasheff, *The Great Retreat: The Growth and Decline of Communism in Russia* (New York: E. P. Dutton, 1946). The words attributed to Lunacharsky, the first Soviet People's Commissar of Enlightenment or Minister of Education, paraphrase what Serge Prokofieff recalled him saying when granting the composer leave to emigrate in 1918 (Sergey Prokofiev, *Autobiography, Articles, Reminiscences,* ed. Semyon Shlifstein, trans. Rose Prokofieva (Stockton, CA: University Press of the Pacific, 2000), 50. On the monumentality of socialist realism, see Boris Groys, *The Total Art of Stalinism: Avant-Garde, Aesthetic Dictatorship, and Beyond* (Princeton, NJ: Princeton University Press, 1992).

44. Trotsky, "The Soviet Union Today," *New International* 2, no. 4 (July 1935): 116–22; available at the Leon Trotsky Internet Archive, www.marxists.org/archive/trotsky/1935/02/ws-therm-bon.htm.

45. See David L. Hoffman, "Was There a 'Great Retreat' from Soviet Socialism? Stalinist Culture Reconsidered," *Kritika: Explorations in Russian and Eurasian History* 5 (2004): 651–74.

46. Trotsky, "Soviet Union Today" (see above, note 44).

47. The earliest formulation seems to have been the journalist Giovanni Amendola's, in the daily newspaper *Il Mondo* (28 June 1923), when he referred to fascism as a "sistema totalitario"; the actual "ism" seems to have been coined by an opponent of fascism, the socialist politician Lelio Basso, who wrote (in *La rivoluzione liberale,* 2 January 1925) that under fascism "all statutory organs, the crown, the parliament, the judiciary, which in traditional theory constitute the three powers of government, and also the armed forces which implement policy, become instruments of a single party that claims to mediate the undivided will of an undifferentiated totalitarianism" *(tutti gli organi statuali, la corona, il parlamento, la magistratura, che nella teoria tradizionale incarnano i tre poteri e la forza armata che ne attua la volontà, diventano strumenti di un solo partito che si fa interprete dell'unanime volere, del totalitarismo indistinto).* Two months later, Mussolini appropriated the term in a speech where he invoked the "feroce volontà totalitaria" of his regime. See Francesco Paolo Leonardo, "Il totalitarismo, storia di un concetto camaleontico" (available at http://win.storiain.net/arret/num155/artic1.asp).

48. For a comprehensive treatment, see Michael Geyer and Sheila Fitzpatrick, eds., *Beyond Totalitarianism: Stalinism and Nazism Compared* (Cambridge: Cambridge University Press, 2008).

49. "La nostra formula è questa: tutto nello Stato, niente al di fuori dello Stato, nulla contro lo Stato" (Mussolini, *Opera Omnia,* vol. 21 [Florence: La Fenice, 1967], 331).

50. See especially Yuri Slezkine, "The USSR as a Communal Apartment, or How a Socialist State Promoted Ethnic Particularism," *Slavic Review* 53 (1994): 414–52; and Terry Martin, *The Affirmative Action Empire: Nations and Nationalism in the Soviet Union, 1923–1939* (Ithaca, NY: Cornell University Press, 2001).

51. The phrase "prison house of nations" derives from a passage in the famous account of a journey to Russia by the French aristocrat Astolphe-Louis-Léonor, marquis de Custine (1790–1857): "Cette empire n'est qu'une prison, dont l'Empereur tient la clef" (This Empire is nothing but a prison, to which the Emperor holds the key) (*La Russie en 1839* [Paris: Librairie d'Amyot, 1843], 2:120). Lenin was among those who appropriated the idea and applied it to nationalities, in his essay "K voprosu o natsional'noy politike" (On the Question of Nationalities Policy), *Proletarskaya revolyutsiya,* no. 3 (1914). Referring to the prohibition on publishing the work of the poet Taras Shevchenko in the original Ukrainian, Lenin wrote, "After this measure millions and millions of 'inhabitants' were transformed into mindful citizens and convinced

of the correctness of the saying that Russia is 'a prisonhouse of nations'" (После этой меры миллионы и миллионы "обывателей" стали превращаться в сознательных граждан и убеждаться в правильности того изречения, что Россия есть "тюрьма народов"), available online at http://libelli.ru/works/25-5.htm (accessed 7 March 2015). Note that Lenin implicitly disavows having coined the saying, which has so often been attributed to him.

52. See above, note 50. The Russian term that corresponds to "affirmative action" in Soviet policy was *korenizatsiya* (derived from *koren'*, "root"), usually translated as "indigenization," the objective being to revoke the privileged status of Russians within the old "prison house" and counteract their likely dominance, by virtue of their numbers, their degree of urbanization, and their cultural and economic development, within the institutions of the Soviet state by discriminating against Russians in staffing them. Like any "reverse" discrimination, the policy produced a backlash among members of the displaced dominant group, in this case ethnic Russians who reacted the way many whites did to the American civil rights legislation of the 1960s. See Hosking, *Rulers and Victims,* chap. 2 ("Soviet Nationality Policy and the Russians").

53. "Obgleich nicht dem Inhalt, ist der Form nach der Kampf des Proletariats gegen die Bourgeoisie zunächst ein nationaler. Das Proletariat eines jeden Landes muß natürlich zuerst mit seiner eigenen Bourgeoisie fertig werden" (*The Communist Manifesto* [1848], chap. 1 ["Bourgeois und Proletarier"], full text at www.marxists.org/archive/marx/works/1848/communist-manifesto/ch01.htm) (English); www.communist-manifesto.org/bourgeois-und-proletarier.html (German).

54. Slezkine, "USSR as a Communal Apartment," 415.

55. S. Dimanshteyn, "Sovetskaya vlast' i melkiye natsional'nosti" (The Soviet Regime and Minor Nationalities), *Zhizn' natsional'nostey* 41, no. 49 (26 October 1919); quoted in Slezkine, "USSR as Communal Apartment," 420. Buryats are a Siberian people of Mongol extraction; Votyaks, or Udmurts, are a Finnic people living in the Urals region.

56. See Lenin, "Itogi diskussii o samoopredelenii" (Summary of the discussion on self-determination, 1916), as cited and glossed by Slezkine in "The USSR as Communal Apartment," 419–20. My translation somewhat adapted in light of the original: Перестроив капитализм в социализм, . . . при полном проведении демократии во всех областях, вплоть до определения границ государства сообразно "симпатиям" населения, вплоть до полной свободы отделения[,] . . . в свою очередь, расовьется практически абсолютное устранение малейших национальных трений, малейшего национального недоверия, создается ускоренное сближение и слияние наций (V. I. Lenin, *Polnoye sobraniye sochineniy,* vol. 30 [Moscow: Izdatel'stvo "Prospekt," 2013], 22).

57. The campaign was named for Alexey Grigor'yevich Stakhanov (1906–77), a miner who had exceeded the single-shift quota for mining coal by a factor of fourteen. His record became a benchmark for *sotsialisticheskoye sorevnovaniye* (socialist competition), one of the watchwords of the second five-year plan and after.

58. Martin, *Affirmative Action Empire,* 437.

59.

Но есть, товарищи, одна вещь, более ценная, чем хлопок,—это дружба народов нашей страны. Настоящее совещание, ваши речи, ваши дела говорят о том, что дружба между народами нашей великой страны укрепляется. Это очень важно и знаменательно, товарищи. В старое время, когда у власти в нашей стране стояли царь, капиталисты, помещики, политика правительства состояла в том, чтобы сделать один народ—русский народ—господствующим, а все народы—подчиненными, угнетенными. Это была зверская, волчья политика. В октябре 1917 года, когда у нас развернулась великая пролетарская революция, когда мы свергли царя, помещиков и капиталистов, великий Ленин, наш учитель, наш отец и воспитатель, сказал, что не должно быть отныне ни господствующих, ни подчиненных народов, что народы должны быть равными и

свободными. Этим он похоронил в гроб старую царскую, буржуазную политику и провозгласил новую, большевистскую политику- политику дружбы, политику братства между народами нашей страны.

С тех пор прошло 18 лет. И вот мы имеем уже благие результаты этой политики. Настоящее совещание является ярким доказательством того, что былому недоверию между народами СССР давно уже положен конец, что недоверие сменилось полным взаимным доверием, что дружба между народами СССР растет и крепнет. Это, товарищи, самое ценное из того, что дала нам большевистская национальная политика.

I. V. Stalin, "Rech' na soveshchanii peredovïkh kolkhoznikov i kolkhoznits Tadzhikistana i Turmenistana s rukovitelyami partii i pravitel'stva, 4 Dekabrya 1935 goda," in idem, *Sochineniya*, vol. 14 (Moscow: Pisatel', 1997), 100–101; full Russian text at http://grachev62.narod.ru/stalin/t14/t14_31.htm. See also Martin, *Affirmative Action Empire*, 438–39.

60. "Velikaya druzhba," *Pravda*, no. 334 (5 December 1935): 1; the next day the text of Stalin's speech was reprinted ("Rech' tov. Stalina," *Pravda*, no. 335 [6 December 1935]: 3), along with an article on the meeting that used a familiar variant of the slogan ("Velikoye bratstvo svobodnïkh narodov" [The Great Brotherhood of Free Peoples], *Pravda*, no. 335 (6 December 1935): 1. See Martin, *Affirmative Action Empire*, 438–40.

61. I. V. Stalin, "O proekte konstitutsii Soyuza SSR," in *Voprosï Leninzma* (Moscow: Ogiz, 1939), 513–14: Истекший период с несомненностью показал, что опыт образования многонационального государства, созданный на базе социализма, удался полностью. Это есть несомненная победа ленинской национальной политики.... изменился в корне облик народов СССР, исчезло в них чувство взаимного недоверия, развилось в них чувство взаимной дружбы и наладилось, таким образом, настоящее братское сотрудничество народов в системе единого союзного государства. В результате мы имеем теперь вполне сложившееся и выдержавшее все испытания многонациональное социалистическое государство, прочности которого могло бы позавидовать любое национальное государство в любой части света.

62. Martin, *Affirmative Action Empire*, 441.

63. Ibid., 440. Taking place when they did, as the so-called Cult of the Personality (*kul't lichnosti Stalina*, as Khrushchev christened it in 1956) was reaching flood tide, the *dekadï* were often looked back upon by art historians, especially during the Khrushchev period, with some embarrassment. In his history of Russian and Soviet opera, Abram Gozenpud wrote that "admittedly, under the conditions of the Cult of the Personality, some of the *dekadï* bore the earmarks of a showcase and did not give an accurate portrayal of the state of the operatic theater in a given republic; nevertheless, it would be wrong to minimize the significance of the national art festivals, thanks to which the operas of [the Georgian composer] Paliashvili, [the Azeri composer] Hajibeyov, [the nineteenth-century Ukrainian composer] Lysenko, and other composers became the common property of the whole Soviet Union" (*Russkiy sovetskiy opernïy teatr* [Leningrad: Muzgiz, 1963], 367). Our present interest is less in the aesthetic qualities of the artistic products of the Soviet nationalities policy, or the accuracy with which the showcase represented the actual cultural life of the republics, but precisely with the policies that drove the showcase.

64. "Official" birthday, because it has been fairly recently determined that Stalin's actual date of birth was 18 December (New Style) 1878 rather than 21 December 1879. On *Zdravitsa*, see Vladimir Orlov, "Prokofiev and the Myth of the Father of Nations: The Cantata *Zdravitsa*," *Journal of Musicology* 30 (2013): 577–620.

65. The full text of the article may be found at http://stalinism.ru/elektronnaya-biblioteka/stalin-k-60-letiyu-so-dnya-rozhdeniya.html?showall=&start=10. Khrushchev's "secret speech" to the XX Congress of the Communist Party of the Soviet Union in 1956, "Doklad na zakrïtom zasedanii XX s"yezda KPSS: O kul'te lichnosti i ego posledstviyakh" (On the Cult of Personality and Its Consequences), is available at https://archive.org/stream/DokladNaZakrytomZasedaniiXxSezdaKpssOKulteLichnostiIEgo

/SecretSpeech#page/n7/mode/2up (Russian) or www.theguardian.com/theguardian/2007/apr/26/greatspeeches1 (English).

66. Steven Kotkin, *Stalin*, vol. 1: *Paradoxes of Power 1878–1928* (New York: PenguinBooks, 2014), 77.

67. "How Does Social Democracy Understand the National Question?" ("Как понимает социал-демократия национальный вопрос?"), *Пролетариатис Брдзола* (*Борьба пролетариата*), no. 7 (1 September 1904). Full Russian text, translated from the Georgian in the official Soviet edition of Stalin's complete works, can be found at http://grachev62.narod.ru/stalin/t1/t1_06.htm.

68. У нас один чудесный грузин засел и пишет для "Просвещения" большую статью, собрав *все* австрийские и пр. материалы (Lenin to Gorky, February 1913; see http://leninism.su/works/87-tom-48/368-pisma-ynvar-fevral-1913.html).

69. Большевистская партия правильно подошла к разрешению национального вопроса в России. В разрешении этого вопроса огромная заслуга товарища Сталина. Под руководством товарища Сталина большевистская партия сплотила все национальности, все народы бывшей России и на основе взаимного доверия, на основе великой дружбы народов создала советское государство—Великий Союз Советских Социалистических Республик.

70. помочь трудовым массам невеликорусских народов догнать ушедшую вперед центральную Россию, помочь им (I. V. Stalin, "Ob ocherednïkh zadachakh partii v natsional'nom voprose: Tezisï k X s"yezdu RKP[b], utverzhdyonnïkh TsK partii" [On the Party's immediate tasks regarding the national question: Theses for the Tenth Congress of the Russian Kommunist Party (Bolshevik), ratified by the Central Committee], available at www.marxists.org/russkij/stalin/t5/immediatetasks.htm).

71. В Советском Союзе цветут и развиваются наши братские республики. Они крепят мощь Советского Союза и получают братскую помощь от своего старшего, но равного брата—великого русского народа.

72. Сталин является символом нерушимой дружбы великого советского народа. Все народы Советского Союза видят в Сталине своего друга, отца и вождя.

73. Украинский народ с большой любовью благодарит товарища Сталина за освобождение своих братьев украинцев, томившихся под гнетом польских панов и капиталистов. Украинский народ благодарит товарища Сталина за воссоединение великого украинского народа в едином украинском государстве.

74. Мы имеем возможность сейчас оказывать великую помощь финляндскому народу в освобождении его от ига империализма.

75. Чтобы отстоять независимое существование нашего государства, нужна сплоченность нашего народа. Эта сплоченность у нас есть. Все народы нашего Великого Советского Союза сплочены воедино. Эту сплоченность обеспечил нам товарищ Сталин своей гениальной теорией и практикой национальной политики.

76. Christopher Hill, *Lenin and the Russian Revolution* (London: Penguin Books, 1971), 35.

77. "O natsional'noy gordosti velikorossov," *Sotsial-Demokrat*, 12 (25, N.S.) December 1914.

78.

Чуждо ли нам, великорусским сознательным пролетариям, чувство национальной гордости? Конечно, нет! Мы любим свой язык и свою родину, мы больше всего работаем над тем, чтобы *ее* трудящиеся массы (т. е. 9/10 *ее* населения) поднять до сознательной жизни демократов и социалистов.... Мы полны чувства национальной гордости, ибо великорусская нация *тоже* создала революционный класс, *тоже* доказала, что она способна дать человечеству великие образцы борьбы за свободу и за социализм, а не только великие погромы, ряды виселиц, застенки, великие голодовки и великое раболепство

перед попами, царями, помещиками и капиталистами.... И мы, великорусские рабочие, полные чувства национальной гордости, хотим во что бы то ни стало свободной и независимой, самостоятельной, демократической, республиканской, гордой Великороссии, строящей свои отношения к соседям на человеческом принципе равенства, а не на унижающем великую нацию крепостническом принципе привилегий. Именно потому, что мы хотим ее, мы говорим: нельзя в XX веке, в Европе (хотя бы и дальневосточной Европе), "защищать отечество" иначе, как борясь всеми революционными средствами против монархии, помещиков и капиталистов *своего* отечества, т. е.*худших* врагов нашей родины.

Full text available at http://saint-juste.narod.ru/lenin.html (Russian) and www.marxists.org/archive/lenin/works/1914/dec/12a.htm (English).

79. For ruefully humorous reflections on this change, see Louis Francis Budenz, *This Is My Story* (New York: McGraw-Hill, 1947), 118–22. The author, a one-time editor of the *Daily Worker* who became an anti-Communist crusader and congressional witness in later life, recalled a meeting in 1934 at which "my quotation of this very article"—i.e., Lenin's "On the National Pride of the Great Russians"—"had caused pandemonium ... at this 'desecration' of Lenin's writings. They [i.e. the Communists present] wouldn't believe he had written any such thing as this praise of national pride" (119).

80. Georgi Dimitrov, "Nastupleniye fashizma i zadachi Kommunisticheskogo Internatsionala v bor'be za yedinstvo rabochego klassa protiv fashizma: Doklad na VII Vsemirnoy Kongress Kommunisticheskogo Internatsionala" (The Fascist Offensive and the Tasks of the Communist International in the Struggle for the Unity of the Working Class against Fascism: Report to the Seventh World Congress of the Communist International, 2 August 1935). Full text at www.marxists.org/reference/archive/dimitrov/works/1935/08_02.htm (in English). Italics here and everywhere in quotations from this speech are original.

81. Ibid.

82. See R. Taruskin, *The Oxford History of Western Music*, vol. 4: *Music in the Early Twentieth Century* (New York: Oxford University Press, 2009), 657–73.

83. Пролетарской классовой борьбы и рабочего движения отдельных стран не противоречат пролетарскому интернационализму, напротив, именно в этих формах можно с успехом *отстаивать* и международные интересы пролетариата.... Революционный пролетариат борется за спасение культуры народа, за ее освобождение от оков загнивающего монополистического капитала, от варварского фашизма, насилующего ее. *Только* пролетарская революция может предотвратить гибель культуры, поднять ее до высшего расцвета как подлинно народную культуру, *национальную по форме и социалистическую по содержанию*, что на наших глазах осуществляется в Союзе Советских Социалистических Республик (Институт Марксизма-Ленинзма при ТсК КPSS, *VII Kongress Kommunisticheskogo Internatsionala i bor'ba protiv fashizma i voyni*: Sbornik dokumentov [Moscow: Izdatel'stvo politicheskoy literatury, 1975], 181).

84. On the way to it there were earlier variants, of which the following, from a speech, "On the Political Tasks of the University of Eastern Peoples," which Stalin gave on 18 May 1925 to a group of students at the Communist University of Workers from the East (*Kommunisticheskiy Universitet Trudyashchikhsya Vostoka* or KUTV), may be the first. It uses "proletarian" rather than "socialist": "Proletarian culture, socialist by virtue of its content, takes different forms and employs differing means of expression among different peoples who are involved in socialist construction, depending on differences in language, customs, and so on. *Proletarian in content, national in form*—such is the universal culture toward which socialism progresses. Proletarian culture does not negate national culture, but gives it content. And contrariwise, national culture does not negate proletarian culture, but gives it form" (italics added). As published in *Pravda*, no. 115 (22 May 1925): Пролетарская культура,

социалистическая по своему содержанию, принимает различные формы и способы выражения у различных народов, втянутых в социалистическое строительство, в зависимости от различия языка, быта и т.д. Пролетарская по своему содержанию, национальная по форме,- такова та общечеловеческая культура, к которой идёт социализм. Пролетарская культура не отменяет национальной культуры, а даёт ей содержание. И наоборот, национальная культура не отменяет пролетарской культуры, а даёт ей форму ("O politicheskikh zadachakh universiteta narodov vostoka"; full text available at www.petrograd.biz/stalin/7-17.php).

85. "Politicheskiy otchyot Tsentral'nogo Komiteta XVI s'yezdu VKP(b)" (Political Account of the Central Committee to the Sixteenth Congress of the Soviet Communist Party), in I. V. Stalin, *Voprosï Leninizma*, 10th ed. (Moscow: Partizdat TsK VKP[b], 1937), 423. The original Russian text, uncut:

> Уклонисты этого типа исходят при этом из того, что так как при победе социализма нации должны слиться воедино, а их национальные языки должны превратиться в единый общий язык, то пришла пора для того, чтобы ликвидировать национальные различия и отказаться от политики поддержки развития национальной культуры ранее угнетенных народов. Они ссылаются при этом на Ленина, неправильно цитируя его, а иногда прямо искажая и клевеща на Ленина. Ленин сказал, что в социализме сольются интересы национальностей в одно целое,—не следует ли из этого, что пора покончить с национальными республиками и областями в интересах ... интернационализма? Ленин сказал в 1913 году в полемике с бундовцами, что лозунг национальной культуры есть буржуазный лозунг,—не следует ли из этого, что пора покончить с национальной культурой народов СССР в интересах ... интернационализма? Ленин сказал, что национальный гнет и национальные перегородки уничтожаются при социализме,—не следует ли из этого, что пора покончить с политикой учета национальных особенностей народов СССР и перейти на политику ассимиляции в интересах ... интернационализма?

86. *Voprosï Leninizma*, 425–26: Ленин, действительно, квалифицировал лозунг национальной культуры *при господстве буржуазии* как лозунг реакционный. Но разве могло быть иначе? Что такое национальная культура при господстве национальной буржуазии? *Буржуазная* по своему содержанию и национальная по своей форме культура, имеющая своей целью отравить массы ядом национализма и укрепить господство буржуазии. Что такое национальная культура при диктатуре пролетариата? *Социалистическая* по своему содержанию и национальная по форме культура, имеющая своей целью воспитать массы в духе социализма и нтернационализма. Как можно смешивать эти два принципиально различных явления, не разрывая с марксизмом?

87. Ibid.:

> На самом деле **период диктатуры пролетариата и строительства социализма в СССР есть период** *расцвета* **национальных культур,** *социалистических* **по содержанию и национальных по форме**, ибо сами-то нации при советском строе являются не обычными "современными" нациями, а нациями социалистическими, так же как их национальные культуры являются по содержанию не обычными, буржуазными культурами, а культурами социалистическими. Они, очевидно, не понимают, что развитие национальных культур должно развернуться с новой силой с введением и укоренением

общеобязательного первоначального образования на родном языке. Они не понимают, что только при условии развития национальных культур можно будет приобщить по-настоящему отсталые национальности к делу социалистического строительства. Они не понимают, что в этом именно и состоит основа ленинской политики помощи и поддержки развития национальных культур народов СССР.

88. A still photo in which some of these words are distinguishable in the background can be found at http://film.arjlover.net/ap/volga.volga.1938.avi/volga.volga.1938.avi.image2.jpg. For a general consideration of *Volga-Volga* and its paradigmatic significance for Soviet culture and music, see Peter Kupfer, "*Volga-Volga*: 'The Story of a Song,' Vernacular Modernism, and the Realization of Soviet Music," *Journal of Musicology* 30 (2013): 530–76. The first application of the slogan to music seems to have been made in the lead editorial in *Sovetskaya muzïka*, the organ of the recently organized All-Union Union of Soviet Composers (*Vsesoyuznïy Soyuz Sovetskiokh kompozitorov*; the redundancy is only apparent, the *soyuz* in *vsesoyuznïy* referring to the Soviet Union, not the Union of Composers), 1934, no. 1, 3. See Kupfer, "*Volga-Volga*," 571n95.

89. I. V. Stalin, *Marksizm i natsional'no-kolonial'nïy vopros* (Moscow: Partizdat, 1934), 195; translated in Marina Frolova-Walker, *Russian Music and Nationalism from Glinka to Stalin* (New Haven: Yale University Press, 2007), 301.

90. The translation is from an Indian Communist website, www.revolutionarydemocracy.org/rdv4n1/stalin70.htm.

91. Or as Stalin put it himself in 1925, in "O politicheskikh zadachakh universiteta narodov vostoka" (see above, note 84): "The notion of national culture was a bourgeois notion as long as the bourgeoisie was in power, and the consolidation of nations proceeded under the aegis of bourgeois regimes. The notion of national culture became a proletarian notion when the proletariat came to power, and the consolidation of nations began to proceed under the aegis of the Soviet regime. Anyone who does not understand this fundamental distinction between two discrete situations will neither ever understand Leninism nor ever grasp the essence of the national question" (Лозунг национальной культуры был лозунгом буржуазным, пока у власти стояла буржуазия, а консолидация наций происходила под эгидой буржуазных порядков. Лозунг национальной культуры стал лозунгом пролетарским, когда у власти стал пролетариат, а консолидация наций стала протекать под эгидой Советской власти. Кто не понял этого принципиального различия двух различных обстановок, тот никогда не поймёт ни ленинизма, ни существа национального вопроса).

92. Спрашивается, почему реалистическую музыку пишут народные композиторы, а формалистическую музыку пишут антинародные композиторы? Народные композиторы пишут реалистическую музыку потому, товарищи, что, являясь по природе реалистами, они не могут не писать музыку реалистическую. А антинародные композиторы, являясь по природе формалистами, не могут, не могут не писать музыку формалистическую. (Full Russian text available at http://lingvarium.org/maisak/data/shostakovich_rayok.htm.)

93. See note 65 above.

94. Kenneth Katzner, *English-Russian Russian-English Dictionary* (New York: John Wiley, 1984), s.v. *rod*, meaning 2.

95. Russian Wikipedia cites a line from a poem by Dem'yan Bednïy as an especially early use of the term: Советский народ загоранит—"Бра-а-а-во!"—"Бра-а-а-во!!" (The Soviet people will start bellowing, "Bra-a-a-vo! Bra-a-a-vo!!")

96. Много песен поет наш Советский Народ, / Над полями, лесами густыми. / В каждой песне звучит, в каждой песне живет / Всенародное Сталина имя (full text at http://sovmusic.ru/text.php?fname=stalin3).

97. See http://voenpesni.web.fc2.com/izdeliya/gimn.html. (E.g., *Slav'sya mogushchestvom, krepni derzhavoyu, / Zdravstvuy vo veki, sovetskiy narod!* [Be glorified in thy might, increase thy power, / thrive forever, O Soviet people!] as final couplet of the refrain. Compare the eventually selected text: *Znamya sovetskoye, znamya narodnoye, / Pust' ot pobedï k pobede vedyot!* [Soviet banner, national banner, / May it lead us from victory to victory!].)

98. Derived from Stalin's victory speech (9 May 1945), which had ended with the words, *Slava nashemu velikomu narodu, narodu-pobeditelyu!* (Glory to our great people, the victor-people!); full text at http://histrf.ru/ru/lichnosti/speeches/card/slava-nashiemu-vielikomu-narodu-narodu-pobieditieliu.

99. Сталин ввёл понятие "враг народа".... Для обоснования физического уничтожения таких людей и была введена формула "враг народа". For the full text in Russian and English, see the links provided in note 65 above.

100. "Otchyot tsentral'nogo komiteta kommunisticheskoy partii sovetskogo soyuza XXII s'yezdu KPSS: Doklad Pervogo sekretarya TsK KPSS tovarishcha N. S. Khrushcheva 17 oktyabrya 1961 goda," in *Materialï XXII s'yezda KPSS* (Moscow: Gospolitizdat, 1962), 1:153: Сложилась новая историческая общность людей различных национальностей, имеющих общие характерные черты,— советский народ. Они имеют общую социалистическую Родину—СССР, общую экономическую базу—социалистическое хозяйство, общую социально-классовую структуру, общее мировоззрение—марксизм-ленинизм, общую цель—построение коммунизма, много общих черт в духовном облике, в психологии.

101. *Materialï XXIV s"yezda KPSS* (Moscow: Gospolitizdat, 1971), 76; quoted in *Bol'shaya sovetskaya entsiklopediya*, s.v. *sovetski narod* (http://bse.sci-lib.com/article103879.html): Советский народ, новая историческая, социальная и интернациональная общность людей, имеющих единую территорию, экономику, социалистическую по содержанию культуру, союзное общенародное государство и общую цель—построение коммунизма; возникла в СССР в результате социалистических преобразований и сближения трудящихся классов и слоев, всех наций и народностей.

102. Translation by Novosti Press Agency Publishing House (Moscow, 1985): (www.departments.bucknell.edu/russian/const/1977toc.html): Это — общество зрелых социалистических общественных отношений, в котором на основе сближения всех классов и социальных слоев, юридического и фактического равенства всех наций и народностей, их братского сотрудничества сложилась новая историческая общность людей—советский народ. (www.hist.msu.ru/ER/Etext/cnst1977.htm)

103. Frolova-Walker, *Russian Music and Nationalism,* chap. 6 ("Musical Nationalism in Stalin's Soviet Union"); also idem, "'National in Form, Socialist in Content': Musical Nation-Building in the Soviet Republics," *Journal of the American Musicological Society* 52 (1998): 331–71; A. A. Gozenpud, *Russkiy sovetskiy opernïy teatr* (Leningrad: Muzgiz, 1963), chap. 12.

104. Frolova-Walker, *Russian Music and Nationalism,* 325.

105. See Neil Edmunds, "Aleksandr Davidenko and Prokoll," *Tempo,* no. 182 (1992): 2–5.

106. The banknote can be seen at https://ru.wikipedia.org/wiki/Малдыбаев,_Абдылас_Малдыбаевич#mediaviewer/File:KyrgyzstanP15–1Som-1999(2000)_a.jpg.

107. A film clip of her performance can be glimpsed at www.youtube.com/watch?v=BR-172AK2Xc&index=4&list=PLg2Uhk_kBy88Z80–1WVIQaj6_68NMZEwG, at 3:42. Her vocal production is decidedly exotic by the standards of traditional "trained" operatic singing as practiced by Russian artists, and presumably typical of indigenous singers. By contrast, the singer of the role in a complete performance of the opera at the Aksaray (White Palace) Theater in Almaty, posted on YouTube in 2014, uses a conventionally cultivated European operatic voice production, presumably reflective of what is now expected by Kazakh audiences: www.youtube.com/watch?v=K2b_aOdSC28, at 28:24 (to

29:40; the passage sung by Baiseyitova in the clip cited above occurs toward the end). One doubts that such a performance would have produced at the 1936 *dekada* the kind of furor that Baiseyitova's elicited there. As ever, exoticism was accepted, and rewarded, as showcase "authenticity."

108. Image available at http://en.wikipedia.org/wiki/Yevgeny_Brusilovsky#mediaviewer/File:Brusilovskiy.jpg. The opera was also commemorated with a stamp, in 2006: image at https://ru.wikipedia.org/wiki/%D0%9A%D1%8B%D0%B7_%D0%96%D0%B8%D0%B1%D0%B5%D0%BA#/media/File:Stamp_of_Kazakhstan_585.jpg.

109. *Shelkovaya devushka* (Alma-Ata: Alma-Atinskaya studiya kinokhroniki, 1936); quoted in Michael Rouland, "Unveiling Empire: The Multiple Lives of The Silk Maiden," *Canadian-American Slavic Studies* 47 (2014): 251–70, at 259.

110. Gozenpud, *Russkiy sovetskiy opernïy teatr,* 371: ... обильно использовал хорошо им изученный казахский фольклор и на его основе создал произведение с развитой музыкальной драматургией. Он счастливо избежал как подчинения народно-песенных интонаций привычным оперным формам, так и рабского следования фольклору.

111. Ibid., 369: первоначально композиторы, стремясь сохранить верность национальной традиции, не выходили за пределы одноголосия, а в качестве аккомпанимента использовали унисонный ансамбль народных музыкальных инструментов. Из среды националистических "ревнителей отечественной старины" исходили утверждения, что многоголосие и симфонизм якобы враждебны природе национального искусства и что "европеизация" приведет к нивелировке и уничтожению его характерных особенностей. Однако поступательное движение советской музыкальной культуры показало, что для создания национальной оперы необходимо было, сохранив все ценное, что создал народ, освоить традиции реалистического русского и мирового искусства.

This passage occurs during Gozenpud's discussion of Uzbek opera, but on p. 372 he states that "the development of Kazakh theater was similar to the Uzbek" (сходно с узбекским развивался и казахский театр).

112. It is the same YouTube page referenced in note 107 above(www.youtube.com/watch?v=BR-172AK2Xc&index=4&list=PLg2Uhk_kBy88Z80-1WVIQaj6_68NMZEwG), this time at 0:23.

113. Heartfelt thanks to David Fanning for securing the score for me during a research trip to Moscow, and to Alma Kunanbaeva for help with transliteration and translation of the Kazakh text.

114. Michael Rouland, "A Nation on Stage: Music and the 1936 Festival of Kazak Arts," in *Soviet Music and Society under Lenin and Stalin: The Baton and Sickle,* ed. Neil Edmunds (London: Routledge-Curzon, 2004), 195.

115. www.youtube.com/watch?v=K2b_aOdSC28, at 16:51.

116. www.youtube.com/watch?v=vPEmUW5wZt4.

117. Balakirev first used the term in a letter to Vladimir Stasov, 20 August 1860; in M. A. Balakirev and V. V. Stasov, *Perepiska,* ed. A. S. Lyapunova, vol. 1 (Moscow: Izdatel'stvo Muzïka, 1970), 114–15.

118. See Frolova-Walker, *Russian Music and Nationalism,* 141–60, which extends, and in part disputes, an interpretation of the kuchkist style as orientalist marker advanced in Taruskin, "Entoiling the Falconet: Russian Musical Orientalism in Context," *Cambridge Opera Journal* 4 (1992): 253–80, and "Russian Musical Orientalism: A Postscript," ibid., 6 (1994): 81–84; reprinted in Taruskin, *Defining Russia Musically* (Princeton: Princeton University Press, 1997), pp. 152–85.

119. I first encountered this story as an adolescent, in a joke book edited by Bennett Cerf: *Laughing Stock: Over Six-Hundred Jokes and Anecdotes of Uncertain Vintage* (New York: Grosset & Dunlap, 1945), 231 (I have freely paraphrased it); but Google now informs me that there are many older variants, going back as early as 1885, and the words have been attributed to many speakers, from Ian Paisley to Jesus Christ.

120. Adalyat Issiyeva, "Russian Orientalism: From Ethnography to Art Song in Nineteenth-Century Music" (diss., McGill University, 2013), chap. 6: "From Oriental Other to Stigmatized Brother: Ethnographic Concerts at the Service of Empire," 376–456, esp. 429ff. for "Russian minor."

121. And not only Brusilovsky, and not only within the Russian context. See Nalini Ghuman, *Resonances of the Raj: India in the English Musical Imagination, 1897–1947* (New York: Oxford University Press, 2014), chap. 5 ("Persian Composer-Pianist Baffles: Kaikhosru Sorabji"), for a stimulating discussion of how an English-born musician of Parsi ancestry formed his musical self-identification entirely on Western orientalist tropes.

122. Victor Yuzefovich, *Aram Khachaturyan,* trans. Nicholas Kournokoff and Vladimir Bobrov (New York: Sphinx Press, 1985), 2 ("backwoods"), 8 *(ashugs).*

123. Lynn M. Sargent, *Harmony and Discord: Music and the Transformation of Russian Cultural Life* (New York: Oxford University Press, 2010), 226, 269.

124. Quoted in Frolova-Walker, *Russian Music and Nationalism,* 338.

125. Ibid.

126. Quoted ibid., 378n54.

127. *Soveshchaniye deyateley sovetskoy muzïki v TsK VKP(b)* (Moscow: Izdatel'stvo "Pravda," 1948), 133.

128. Anyone who knows the actual text of the Resolution will know that Kabalevsky's name was eventually removed from the list and Popov's put back. In his very recently published posthumous memoirs, Levon Atovmyan, the Union's chief administrative functionary, recalled this substitution and added, cryptically, "those in the know will know how this is to be explained" *(dogadlivïy poymyot, chem ob"yasnyayetsya eto).* For the benefit of the less knowledgeable, Nelli Kravets, the volume's editor, relates that "a popular rumor *(narodnaya molva)* attributes this substitution to the extremely influential [second] wife of Dmitry Kabalevsky [Larisa Pavlovna Chegodayeva], who was closely allied with the security organs" (Kravets, ed., *Ryadom s velikimi: Atovmyan i ego vremya* [Moscow: Rossiyskiy universitet teatral'nogo iskusstva, 2012], 283, 435).

129. T. Livanova, "Aram Khachaturyan i ego kritiki," *Sovetskaya muzïka,* 1948, no. 5, 41: В последнее время многих из нас спрашивают: почему Хачатурян формалист, в чем именно заключается формализм Хачатуряна? Такие вопросы задают и музыканты и те, кто любит и слушает музыку. Если понимать *формализм* или *формалистическое направление узко-формально,* то есть лишь как увлечение музыкально-техническими "фокусами" и трюками", головоломными сочетаниями голосов или "музыкальными чертежами" вне художественного смысла, то подобный формализм , казалось бы, совсем не характерен для Хачатуряна. Сухие формально-теоретические построения мелодий из любых комбинаций 12 тонов (по антимузыкальной системе атоналиста Шенберга) вполне чужды Хачатуряну, художнику темпераментному, любящему жизнь и землю. Хачатурян вовсе не умствует.

130. И тем не менее, Хачатурян стал представителем формалистического направления в советской музыке! (ibid.).

131. Слово формализм мы понимаем широко. Любое преобладание формы или формальных сторон произведения над его содержанием или в ущерб ему свидетельствует о наличии формализма (ibid.).

132. *Soveshchaniye deyateley sovetskoy muzïki v TsK VKP(b),* 37; quoted in Livanova, "Aram Khachaturyan i ego kritiki," 41: Я искренно хотел написать к 30-й годовщине октября что-то большое, торжественное, необычайное. Я искал средств для выражения моих больших идей (я так думал). . . . Но, видимо, в выборе средств я ошибся. Отсюда появились мои трубы в большом количестве, это заставило меня взять орган, мне интересно было перевести орган из "духовного" состояния в светское. до сих пор все существующие инструменты служили нашему искусству, только орган еще не был использован в том плане. . . . Я увлекся внешней формой вещей и не сумел во-время соблюсти чувство меры.

133. ... средствами, тягостными и неприемлемыми для народа (Livanova, "Khachaturyan i ego kritiki," 41).

134. ... родная музыка советского Востока ... Все лучшее, что есть ... связано с яркой и колоритной радужной народной почве, с армянскими, грузинскими, азербайджанскими истоками мелодики, гармонического и ритмического развития, с жанровой, более всего импульсивно-танцевальной стихией народного творчества (ibid., 42).

135. ... исключительное творческое здоровье ... В чем же коренилась причина художественных побед Хачатуряна?—В замечательном сочетании нескольких условий. Хачатурян во весь голос говорит здесь, в этих сочинениях, на своем национальном музыкальном языке, на языке народной музыки Советского Востока. Хачатурян воспринимает и порою удачно развивает классическую традицию, прежде всего русской школы. Таким образом, он по-новому говорит на национальном языке, овладевая крупными масштабами искусства, которому принадлежит мировое господство. Хачатурян стремился говорить для всего мира, но его голос звучал лишь тогда, когда композитор твердо стоял на родной ему почве Советского Востока и русской классики (ibid., 43).

136. See note 61 above.

137. I. V. Stalin, "O proekte konstitutsii Soyuza SSR," *Voprosï Leninzma,* 514; quoted n Livanova, "Khachaturyan i ego kritiki," 43: В результате мы имеем теперь вполне сложившееся и выдержавшее все испытания многонациональное социалистическое государство, прочности которого могло бы позавидовать любое национальное государство в любой части света.

138. В творчестве Хачатуряна этих лет по-новому засверкали образы Советского Востока, освещенные не только горячим южным солнцем, но и солнцем Сталинской конституции (Livanova, "Khachaturyan i ego kritiki," 43–44). Фортепианный Концерт Хачатуряна может быть по праву назван первым восточным концертом мирового значения. ... при этом Хачатурян опирается не только на классический "русский Восток" Балакирева и Бородина, но и на симфонические традиции фортепианных концертов Чайковского и Рахманинова, на их лирическую широту, их волевую энергию (ibid., 44).

139. Вновь и вновь здесь выражаются светлая сила, праздничность и особая жизненная хватка хачатуряновского искусства (ibid.).

140. оно целиком стоит на земле, оно не мудрствует, не комбинирует, не размышляет; оно чувствует, дышит и пульсирует. ... этим оно особенно подкупает нас и поражает всех тех, кто привык за рубежом к скучным умствованиям, к головному изобретательству давно забывшего свою полнокровность буржуазного искусства (ibid.).

141. Горизонты композитора здесь словно раздвигаются; он стремится передать общечеловеческое, философски-обобщенное, пафос борьбы, народные бедствия, мечты о счастье, победные призывы. ... Но 2-я симфония не получила того народного признания, на которое она по своей теме непременно должна была бы опереться. Почему это произошло? Именно потому, что "общечеловеческое" и "философски-обобщенное" можно передать только ярким, конкретным, сильным национальным языком, а Хачатурян стремился здесь "преодолеть" свое национальное начало! ... Композитор погрешил здесь космополитизмом (ibid., 45).

142. For a facsimile of Prikaz No. 17, see Friedrich Geiger, *Musik in zwei Diktaturen: Verfolgung von Komponisten unter Hitler und Stalin* (Kassel: Bärenreiter, 2004), 130.

143. Он отвернулся даже от своей национальной почвы—не только от Советского Востока, но и от русской классики. Ибо страшный "трубный глас" Симфонии-поэмы равно далек и народному восприятию Армении, и русской классической традиции (Livanova, "Khachaturyan i ego kritiki," 47).

144. ... опасности формализма или эстетства, опасности импрессионистического увлечения краской и экспрессивной резкости; то теперь он назван в группе композиторов "в

творчестве которых особенно наглядно представлены формалистические извращения, антидемократические тенденции в музыке, чуждые советскому народу и его художественным вкусам" (ibid.; words within quotes from "Postanovleniye Politbyuro TsI VKP(b) Ob opera 'Velikaya druzhba' V. Muradeli, 10 fevralya 1948 g." [full Russian text at www.hist.msu.ru/ER/Etext/USSR/music.htm]).

145. V. I. Lenin, "On the National Pride of the Great Russians," *Sotsial-Democrat*, no. 35 (12 December 1914); available at www.marxists.org/archive/lenin/works/1914/dec/12a.htm#fwV21E050.

146. For the text of Stalin's toast, see Frolova-Walker, *Russian Music and Nationalism*, 306.

147. J. Stalin, *Marxism and the National Question* (Moscow: Foreign Languages Publishing House, 1950), 16.

148. Ibid., 19–20.

149. Weinberg told this story in various published interviews, quoted in David Fanning, *Mieczysław Weinberg: In Search of Freedom* (Hofheim: Wolke Verlag, 2010), 23.

150. T. Khrennikov, "Tridtsat' let sovetskoy muzïki i zadachi sovetskikh kompozitorov," *Sovetskaya muzïka*, 1948, no. 2, 38.

151. "Re-Mi" (Grigoriy Borisovich Bernandt), "Notograficheskiy zametki," *Sovetskaya muzïka*, 1948, no. 2, 157–58; quoted in Fanning, *Mieczysław Weinberg*, 65.

152. When the Jewish Songs were published in a mimeographed edition (Moscow: Muzgiz, 1944), the name of the author of the texts, the famous Yiddish "bourgeois" writer Isaac Loeb Peretz, was effaced by hand on each copy.

153. Quoted in Fanning, *Mieczysław Weinberg*, 63.

154. Fanning, *Mieczysław Weinberg*, 63. Cf. Dmitry Shostakovich, "Moy tvorcheskiy otvet," *Vechernyaya Moskva*, 25 January 1938, 3; "Sumbur vmesto muzïki," *Pravda*, 28 January 1936.

155. На колхозных полях зазвучала и еврейская песня: не песня прошлого, полная грусти и бездолья, а новые радостные песни творчества и труда. Quoted after the first (closed) performance in Marina Sabinina, "V soyuze sovetskikh kompozitorov," *Sovetskaya muzïka*, 1948, no. 4, 97; translation from Fanning, *Mieczysław Weinberg*, 63. David Fanning reports that a copyist's score now housed in the Glinka Museum of Musical Art in Moscow contains the Mikhoels motto, written in capitals on a preliminary page, but then crossed out (personal communication, 10 May 2015; I thank Prof. Fanning for sending me a copy of the music in ex. 9.5).

156. T. Khrennikov, "Tvorchestvo kompozitorov i muzïkovedov posle Postanovleniya Tsk VKP(b) ob opera 'Velikaya druzhba,'", 1949, no. 1, 23: . . . сталинское определение нашей культуры, как социалистическая по содержанию и национальная по форме. Наше искусство должно быть высоко содержательным, а это значит—воплощать в музыкальных образах все богатство нашей социалистической жизни, богатый внутренний мир наших советских людей. Наше искусство должно быть партийным, оно должно быть проникнуто идеями, которыми живет наш народ, руководимый великой большевистской партией.

157. . . . [композитор] органически чувствующего музыкальный язык своего народа (ibid., 28).

158. достижением не только армянской музыкальной культуры, но и нашим общим достижением (ibid., 27).

159. Ярким доказательством плодотворности реалистического пути является симфониетта Вайнберга, композитора, находившегося под сильным влиянием модернистского искусства, уродливо коверкавшего его несомненное дарование. Обратившись к истокам народной еврейской музыки, Вайнберг создал яркое, жизнерадостное сочинение, посвященное теме светлой, свободной трудовой жизни еврейского народа в стране социализма. В этом произведении Вайнберг проявил незаурядное мастерство и богатство творческой фантазии (ibid., 27–28).

160. The first two movements of the Sinfonietta are available for audition at www.youtube.com/watch?v=JsDjaKZW6O8 (slow movement at 4:50). Thanks again to David Fanning for access to the score.

161. See Albert Weisser, *The Modern Renaissance of Jewish Music: Events and Figures, Eastern Europe and America* (New York: Bloch Publishing Co., 1954), 44.

162. Khrennikov, "Tvorchestvo kompozitorov," 30.

163. See Laurel Fay, "The Composer Was Courageous but Not as Much as in Myth," *New York Times*, Arts and Leisure, 14 April 1996, 32.

164. Letter from Natalia Vovsi-Mikhoels to Per Skans, 18 May 2000; quoted in Fanning, *Mieczysław Weinberg*, 86.

165. Timothy Snyder, *Nationalism, Marxism, and Modern Central Europe* (Cambridge, MA: Harvard University Press, 1997), 250.

166. Memoir of Artyom Sergeyev, Stalin's adopted son, quoted in Simon Sebag Montefiore, *Stalin: The Court of the Red Tsar* (New York: Knopf, 2004), 6 ("You're not Stalin and I'm not Stalin. Stalin is Soviet power. Stalin is what he is in the newspapers and the portraits, not you, no not even me").

10

Two Serendipities
Keynoting a Conference, "Music and Power"

The subject of this conference is enticingly vague. There is no limit to the range of speculation and supposition it might prompt. Suppose, for example, we removed the conjunction. We might then expect to receive on registration a "Music Power!" T-shirt for wearing at sessions or, more menacingly, on the street. At such a fancied conference we might expect to hear papers about heavy metal and gangsta rap, maybe Scriabin—or, more seriously, about music and law enforcement or music and torture, two subjects to which important recent studies have actually been devoted.[1] But the propaedeutic that called forth the papers we have brought with us was not so neutral. It strongly implied that "music power" was not going to be our subject. "Those in positions of power," it read, "have traditionally sought to control music's communicative and transformative potential," and contrariwise, "music has also been employed as a means of resisting or undermining power relations of all kinds."

Either way, the relationship is cast as one between those with power and those with music, and it is cast as implicitly adversarial. I am sure that the announcement was not intended to limit the range of proposed topics and that nonconforming proposals would have been welcomed—papers, for example, that considered the way music has exercised as well as resisted power, or has worked to enhance as well as undermine existing power structures. But in the event, and as I would have expected, that is not the way participants viewed the matter. With only a

Delivered as the keynote address at the conference "Music and Power," Miami University (Oxford, Ohio), 28 February 2013, and published in the *Journal of Musicology* 33, no. 3 (Summer 2016), 401–31.

couple or three exceptions, as I count them, the papers elicited seem to adopt the usual adversarial view of music and power within the Russian and East European domain. Most of them address the time-honored questions: censorship, political interference, suppression—all variants of victimology.

And that is why I decided to play the nonconformist role, as my designated status as keynoter entitled—and, I thought, invited or even obliged—me. I do so partly in a sporting spirit, keynote addresses, after all, being as much an entertainment genre as a scholarly one. But my purpose is serious withal. Invitations to keynote usually start coming when your beard turns gray, identifying you as a person with a past. I thought I'd employ that potentially powerful resource, my personal past, to give the most meaningful spin I could to the traditional keynoter's task of considering and reconsidering agendas.

. . .

I am perhaps oversensitive to the bias toward dichotomizing music and power because of its affinity with the German Romantic view of art that has much too long dominated musicology. It is the view of art that sees its history, with Schopenhauer, as running parallel to the history of the world, the difference between the two being that the history of the arts and philosophy is *schuldlos und nicht blutbefleckt*: innocent and unstained by blood. That view still has many spokespersons: Charles Rosen, for one, with whom I fought a little battle over it a few years ago.[2] And it has had its share of Russian spokespersons as well, like Arthur Lourié, a figure in whom not only I but quite a few others have been taking a long overdue interest of late.[3] He was a great believer in the essential innocence of art, and especially music. In his all-but-posthumous retrospective collection of essays, *Le profanation et sanctification du temps*, published in 1966 only weeks before he died, Lourié wrote lovingly that "there can never be negative music; [music] always . . . asserts Life and Truth." And, "there is no need to 'understand' a flower in its bloom or a bird in its flight; to look at them is sufficient. Music does not need to 'be understood,' either; it needs to be listened to."[4]

Lovely thoughts, these, and comfortingly anti-intellectual, but they inevitably lead to places no scholar should wish to visit. I oppose them because it is in the end a very weak view of music—or a view of music as very weak—that denies its value as intellectual fodder; and to say that there cannot be negative music is to say that there cannot be performatively powerful music either. That is something that not only ideology contradicts, but also our experience of the world. And so I hunger for studies not just of music confronted by power, but of the power of music itself ("itself" here referring, of course, to power, not music). I have done a certain amount of work in that vein. The trouble, as I've learned, is that once you start investigating the power of music you are confronted with the Danger of

Music, and if you do not flinch from that you will find yourself lumped with the controllers and censors.[5] Let us pluck up and proceed with the job nevertheless.

I will tell a couple of old stories today concerning serendipities that have had a substantial bearing on my thinking. One of them goes back more than three decades, the other more than four. I'll begin with something I came across while casually perusing the *New York Review of Books*. It was the issue of 4 March 1982, and it contained an article by Simon Head, then the U.S. correspondent of the British magazine the *New Statesman,* called "Brezhnev and After." It was one of countless speculations that were appearing in the time of stagnation and *détente,* when Leonid Brezhnev, the *gensek,* or General Secretary of the Communist Party of the Soviet Union (Stalin's old title, deliberately revived by Brezhnev), stood as a symbol—not of threatening Soviet might but of enfeebled gerontocracy. The question that then burned was whether new blood in the seats of power would invigorate the Soviet state and, with it, the threat of renewed Cold War confrontation. The author's thesis was that "there has never been a Brezhnev regime at all, that the Soviet Union has for the last seventeen years been ruled by a collective leadership, and that the leadership which the West now faces is, in its essential structure, the one which it has faced since October 1964 and may continue to face after Brezhnev has gone."[6] Soviet power had, in the eyes of the smug West, achieved a dull equilibrium and stability that would likely endure for the foreseeable future no matter who succeeded Brezhnev. Quaint, no?

Head proved his point the old Kremlinological way, by analyzing the lines of patronage within the Politburo, an analysis that purported to show that Brezhnev had never managed, the way Khrushchev (let alone Stalin) had done, to pack that *de facto* source of political power with his own protégés. The "division of patronage in the Politburo," he wrote, "has held more or less unchanged since the Twenty-fourth Congress," that is, since 1971. "Apparatchiks have come and gone, but at no time during these eleven years has Brezhnev ever had more than four clients in the leadership. The stability of this arrangement suggests that Brezhnev and his colleagues may have struck a deal."[7] The cogency of Head's analysis may be measured by the predictions he based on it, which included the outright elimination as a possible successor of Yuri Andropov (the actual successor), owing to his identification with the KGB (the disqualifying precedent being Lavrentiy Beria). But events have long since made monkeys out of all the wizened Kremlinologists of yore.

Why recall this insignificant bit of futile speculation, then? Because of the photograph with which the editors of the *New York Review* chose to illustrate it after the jump. It was an inevitable choice: a photo of the assembled Politburo, which supplied faces to go with practically all the names the author was citing in his analysis of Soviet political patronage (fig. 10.1).

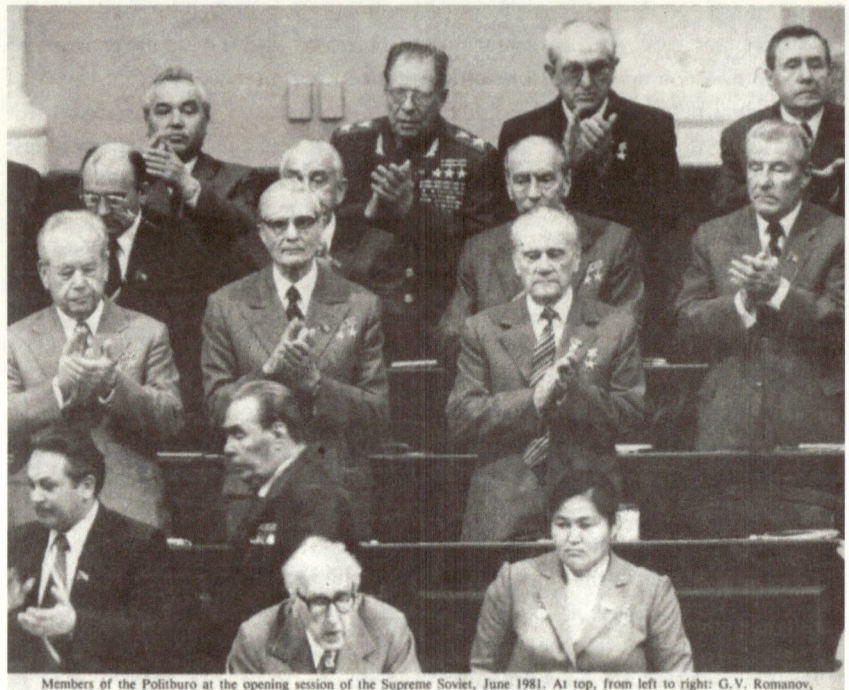

Members of the Politburo at the opening session of the Supreme Soviet, June 1981. At top, from left to right: G.V. Romanov, D.F. Ustinov, I.V. Andropov, A.A. Gromyko; Second row: M.S. Gorbachev, V.V. Grishin, A.I. Pelshe, M.S. Solomentsev; Third row: A.P. Kirilenko, M.A. Suslov, N.A. Tikhonov. At bottom: Leonid Brezhnev and three unidentified persons.

FIGURE 10.1. The Soviet Politburo at the convocation of the Supreme Soviet, photograph as printed in the *New York Review of Books*, 4 March 1982.

I emailed this picture to some friends in order to confirm what I intended to say about it, and one of them, Marina Frolova-Walker, reacted to it, as I did (or do now) with a weird sense of nostalgia. "These amazing dead faces," she wrote. "I forgot how it felt to look at them."[8] Marina, of course, is the author of the great article "Stalin and the Art of Boredom" and a connoisseur of Soviet ennui.[9] So come with me, dear friends, down memory lane as I reel off the forgotten names that go with the dead faces according to the caption, and in so doing echo that now-famous name-dropping letter from Shostakovich to his friend Isaak Glikman sent from Odessa in 1957:[10]

> Members of the Politburo at the opening session of the Supreme Soviet, June 1981. At top, from left to right: G[rigory] V[asilievich] Romanov [the Leningrad Party boss], D[mitry] F[yodorovich] Ustinov [the minister of defense], Y[ury] A[lexandrovich] Andropov [the KGB man and soon-to-be successor], A[ndrey] A[ndreyevich] Gromyko [the foreign minister, and surely at the time the best-known face in the picture after Brezhnev]; second row: M[ikhail] S[ergeyevich] Gorbachev [this was probably

the first glimpse we in the West ever got of that birthmark on his bald pate], V[iktor] V[asil'yevech] Grishin [partly hidden; he was the Moscow Party boss, soon to be replaced in that capacity by Boris Yeltsin], [the ancient] Arvid Yanovich Pel'she [then eighty-two years old, the Latvian-born chairman of the Party Control Committee, the only remaining member who had set eyes on Lenin—or "seen Ilyich," as they used to say], M[ikhail] S[ergeyevich] Solomentsev [chairman of the Council of Ministers of the Russian Federation and a candidate member of the Politburo]; third row [the old lions]: A[ndrey] P[avlovich] Kirilenko [head of cadres and economic planning and the only member of this list that was also in Shostakovich's list from 1957], M[ikhail] A[ndreyevich] Suslov [known in those years as the Party's "chief ideologist" and die-hard antireformer], N[ikolai] A[lexandrovich] Tikhonov [chairman of the Council of Ministers]. At bottom: Leonid Brezhnev [who has evidently just spoken and is now leaving the rostrum and receiving applause] and three unidentified persons.

And that is where I stopped reading, in great excitement, for I knew something the editors of the *New York Review* did not know. "I'd know that long face anywhere," I thought triumphantly, as I identified one of the unidentified persons at bottom: namely, the bespectacled gentleman in the middle. It was Dmitry Borisovich Kabalevsky, one of the Soviet Union's most venerable composers. Proud of my perspicacity and eager, in my baby pomposity (having just made tenure at Columbia), I sat down and wrote a letter to the editor, which the *New York Review* actually printed in the issue of 10 June 1982. I guess you could call it one of my early publications. These were certainly the first words I ever published in the *New York Review* (where my output has consisted solely of letters to the editor). "To the editor," the letter reads:

> It may be of interest to your readers that the middle unidentified figure in the picture of the opening session of the Supreme Soviet of the USSR, on page 36 of your issue of March 4, 1982, is the composer Dimitrii Kabalevsky, who has been a deputy to that ceremonial body since Stalin's day, and has become such an active musical ideologue and missionary that he has almost stopped composing. The pose in which he is shown, reading a speech at a public meeting, is in fact a far more typical one of him today than sitting at the piano or over staved paper.[11]

I might have done my homework a little better. Kabalevsky's membership in the Supreme Soviet did not go back to the Stalin years. He was put up for the second chamber, called the Soviet of Nationalities, in 1966, as one of the thirty-two deputies representing the RSFSR, his assigned district (that is, the district he was arbitrarily chosen to represent) being the *Permskaya oblast'*, the region surrounding Perm, a city in the foothills of the Ural Mountains in the eastern part of European Russia, about 700 miles from Moscow—a town Kabalevsky, who was born in St. Petersburg in 1904 and who had resided since adolescence in Moscow, had never lived anywhere near. But although the citizens of Perm were his nominal

constituency and he was required to serve their needs by receiving petitions, he was no more their representative than were most of his fellow deputies. The Supreme Soviet was more an honor society or a celebrity showcase than a legislative body, and their *sozïvï*, or ceremonial convocations, were always a field day for paparazzi.

A photo from the *sozïv* of 1966, the first one that Kabalevsky attended, shows him in the company of a couple of Soviet rock stars (fig. 10.2). It is safe to say that Kabalevsky's was the least famous face in this picture. On the right, as we face it, his neighbor was Yury Alexeyevich Gagarin, who five years earlier had become the first cosmonaut and who would die only two years later while test-piloting an experimental jet aircraft. And on the left, the neighbor was Shostakovich, who had been a deputy to the Supreme Soviet of the RSFSR since 1947, serving his home district in Leningrad, and who had been "elevated" to the Soviet of Nationalities in 1962.[12] As the most distinguished Soviet composer and the one with the highest international profile, Shostakovich was the one composer whose presence in the celebrity showcase was most probably a case of *génie oblige*, co-opted as an *obshchestvennïy deyatel'*, or public figure, in consequence of his name and prestige. Like Gagarin but unlike Kabalevsky, he lent more luster to the Supreme Soviet than it lent him. Two years before his election to the Soviet of Nationalities, as we all know by now, he was cajoled into joining the Communist Party as a trophy by the Khrushchev government, which wanted to be able to claim the active support of the arts intelligentsia in its campaign of de-Stalinization. Since the publication of Glikman's book of letters, that event, and the attendant shame that Shostakovich expressed in one of the letters published there, has been part of the story of his Eighth Quartet. I'll want to come back to this point, since the Party's exploitation of Shostakovich's prestige was not an unmixed co-option or abuse, in my view. Shostakovich's career has been read too easily and conveniently in terms of victimology, I have long believed, and as is already evident, my chief purpose here is to complicate what often looks to me like an oversimplified and overly dichotomized view of the relationship between music and power.

The case of Shostakovich is full of ambiguities, and we will likely never understand it in its full complexity. But Kabalevsky's relationship to Soviet power was, or at least certainly seems to have been, far less fraught. In the eyes of many contemporaries and compatriots, he actively sought the proximity to power that the photo from 1981, which put him together with the whole dead-faced Politburo, so dramatically illustrates. One of the friends to whom I sent the photo for verification was Izaly Zemtsovsky, a most distinguished Soviet-born ethnomusicologist who now divides his time between St. Petersburg and California. He is never without a relevant anecdote, and he wrote back to me about Kabalevsky's

> unique ability to appear in all official pictures without invitation. I well remember the 1962 Congress of the Union of Composers where he suddenly showed up behind

FIGURE 10.2. Shostakovich, Kabalevsky, and Gagarin at the 1966 convocation of the Supreme Soviet. Photograph from Alamy.

the group when a photographer took a picture of Khrushchev with Shostakovich, Khrennikov and other VIPs, and that picture ... came out the next day in all the important newspapers. That was quite a ... political trick. At that time it made a huge difference where and when you got depicted in central newspapers and magazines along with the politburo. I saw it with my own eyes: nobody invited Kabalevsky, but he virtuously [I think I. Z. meant virtuosically] took a right moment to appear thanks to his height. (He was a tall man.)[13]

And that is why I was able to elicit such an easy laugh, in October 2004, when beginning a talk at a daylong "Celebration of Scholarship" held at Indiana University, marking two seventy-fifth birthdays. In the morning there were four papers on German Baroque music in honor of George Buelow, at which Ellen Harris and Christoph Wolff were among the featured speakers. In the afternoon the celebrated figure was Malcolm H. Brown, the man I like to call the Good Brown of Russian music studies.[14] The invited speakers included Simon Morrison and Laurel Fay as well as me. During the morning session Prof. Wolff matter-of-factly referred to J. S. Bach as the greatest of all composers. Ellen Harris good-naturedly contested the claim, advancing Handel for the honor (and citing Beethoven in support). When it came my turn to speak I said I had finally realized what the

difference was between studying Russian music and studying "regular music," or whatever I called it. Regular musicologists will say, "Bach was the greatest!" "No, Handel was the greatest!" while Russian music scholars will say "Kabalevsky was the worst!" "No, Khrennikov was the worst!" What I meant, of course, was that we who study Russian music, exceptionally for musicology as it used to be practiced, have always been concerned, or obsessed, with the question of "Music and Power" that is now just beginning to impinge on the consciousness of our regular colleagues, and the closer a musician's proximity to power, the more harshly he was judged. I was implying this with a certain amount of ironic pride, of course, since I was already long since set upon nudging regular musicology into a higher social awareness. But the picture I was painting was a deliberate counter-caricature, and it is precisely that assumption, that good composers and powerful composers are antithetical groups (implying more generally that good people and powerful people were pure and opposing strains), that I now want to qualify and complicate.

So, obviously, Tikhon Nikolayevich Khrennikov is about to make an appearance in this paper, not only because he was the most powerful Soviet musician, but also because he was the protagonist, or rather the catalyst, of my other serendipity. But neither are we finished yet with Kabalevsky or with Shostakovich, the other members of the *ofitsioznaya troika*, the trio of Soviet officialdom, whom I am evoking today by considering Soviet musicians in relation to the Soviet of Nationalities. So we will now turn to Khrennikov, but then, as I have promised, we will return to the other two.

Khrennikov has always been the easiest Soviet composer to assess, and to dismiss. Like Kabalevsky, he joined the Communist Party much earlier than Shostakovich, in the 1940s; and like Shostakovich, he *was* a member of the Supreme Soviet from Stalin's time, having been put up for it in 1947 when he was thirty-four years old, and not because he would lend prestige to the body. He had earned his place there through exemplary *partiynïy* deportment, and the next year, as anyone knows who knows anything about him, he was handpicked to head the Union of Soviet Composers, a position he retained until the end of the Soviet regime—a total of forty-three years in power. Here now is what has become for this essay the obligatory *sozïv* or convocation photo for Khrennikov, taken at the opening session of the eighth *sozïv* in July 1970 (fig. 10.3).

It showcases Khrennikov alongside a scientific luminary, Nikolai Blokhin, director of the Research Institute of Experimental and Clinical Oncology of the USSR Academy of Medical Sciences. But the Supreme Soviet was the least of it. Khrennikov was the one Soviet musician who, all agree, was truly politically powerful, thanks to his official posts and the skill with which he deployed them—a skill that insured that, when in 1990 it became possible for the first time freely to elect the First Secretary of the Union of Soviet Composers, Khrennikov's colleagues freely elected—to the amazement of many, especially abroad—to return him to the post for which he had originally been handpicked by Stalin in 1948. But

FIGURE 10.3. Tikhon Khrennikov and Nikolai Blokhin at the 1970 convocation of the Supreme Soviet. Photograph from Alamy.

not even his executive post defines the nature and extent of the power that Khrennikov wielded. Even the Composers' Union was actually the least of it. Khrennikov was truly a *bol'shoy*, a big cheese.

In 1961 he was made a member of the TsRK (Tsentral'naya revizionnaya kommissiya KPSS) or Party Control Commission (the acronym sounds just like the Russian word for "circus"), a body of several dozen that watchdogged Party discipline, and in 1976 he was elevated to the rank of candidate member of the Tse-Ka itself, the Central Committee of the Communist Party of the USSR. The ruling elite of the Soviet Union were all his personal friends. He did not merely rub shoulders with the powerful, the way Kabalevsky did. Khrennikov was one of them.

How did Khrennikov regard his privileges and his membership in the USSR's ruling oligarchy? In an interview he gave during the last year of his long life (in 2006, when he was ninety-three) to the composer and music broadcaster Ivan Sergeyevich Vishnevsky, published in the reactionary (i.e. Communist) paper *Zavtra* ("Tomorrow," i.e. yesterday), Khrennikov formulated an answer to that question that wryly parodies the propaedeutic for our very conference. Do you

remember how our Call for Papers began? "From the time of Plato if not before," it read, "the fraught relationship between music and power has attracted commentary, discussion and debate." And here is what Khrennikov told his Soviet-nostalgic interlocutor in 2006:

> Generally speaking, in the USSR music was what it was in classical ancient Greece: a major state issue. The spiritual influence of the major composers and performers, in molding intelligent and strong-willed people, was enormous, in the first place through radio. Our Union of Composers possessed enormous material resources. We had twenty million rubles a year! In those days that was a colossal sum. We built houses, we gave away free apartments. We endowed rest homes for composers. And the festivals and concerts! Muzfond [the Union's commissioning and disbursing agency] had a special department for musical propaganda, whose task was the production and promotion of new works. We built our own printing plant and our own publishing house, "Sovetskiy kompozitor." We issued works, including those of young composers. Just try to publish something now! Only if you can pay for it out of your own pocket.[15]

His interlocutor also managed to wangle this really extraordinary outburst from the aging oligarch:

> In my opinion, Stalin knew music better than any one of us. He was always going to performances at the Bolshoy Theater and often brought the Politburo there—he was, you might say, educating his co-workers.... Stalin came to my opera *Into the Storm* [the opera that, according to all Soviet textbooks, was the first successful operatic treatment of revolutionary events, and the first opera in which Lenin appeared as a character]. Vladimir Ivanovich Nemirovich-Danchenko had produced it in 1939. So, there were Stalin, Molotov, Voroshilov, and they all liked it. Stalin invited Nemirovich-Danchenko and me to his box. They had warned me in advance that I should be ready for this. But that evening I was in Kiev for the première of the same opera, conducted by [Natan] Rakhlin, who had never studied the score. I couldn't not be there to at least show him the right tempos. But Stalin did not take offense and the next day in *Pravda* they printed an article in which it said that the leaders of the country had been at the première of *Into the Storm*, and Stalin was quoted as praising the production.[16]

Khrennikov goes on and on in this vein, recounting the four times he met Stalin personally, boasting that Stalin knew his music well and always liked it (referring the interviewer to the memoirs of Dmitry Trofimovich Shepilov, the one-time Soviet foreign minister, for proof), recalled how Stalin personally selected him to head the Composers' Union (although he quite plausibly admitted to being at first frightened of having all that power and responsibility and of having no time to compose) and how Stalin also chose him for membership in the committee that awarded the Stalin prizes. As a member of that committee, Khrennikov recalled, "I naturally had occasion to converse with Iosif Vissarionovich. But no one ever

gave me any special instructions on how to behave in Stalin's presence. I was often invited over by Zhdanov, who was an extremely cultivated man. By now he's been turned into a scarecrow: as if he were a total ignoramus, or as if he would sit at the piano and tell great composers how to compose".[17]

Asked by Vishnevsky what it was like to be with Stalin—"Was he malicious? fierce? indifferent? cold? Or the opposite—cordial, friendly?"—Khrennikov replied, "Stalin was a perfectly normal person. Fadeyev [the head of the prize committee] often argued with him. On one occasion I even argued with him." Then follow two anecdotes about standing up to Stalin. In one case Fadeyev stood up and was overruled; in the other Khrennikov was the courageous opponent and brought Stalin round. And don't forget, "Stalin never chaired the meetings of the Politburo." On the day Khrennikov came with Fadeyev and Simonov to report, "Malenkov was chairing; Stalin sat to the right and took part most actively in the discussion of all questions."[18]

Et cetera, et cetera. Although this interview was obviously meant to be read by readers of *Zavtra*, which is to say by other nostalgics for the Soviet *belle époque*, it fits only too well the scarecrow image of Khrennikov himself that we have all taken to some degree on board—which is why I called Khrennikov the easy one, the open-and-shut case that serves us as a paradigm of the malign alliance of music and the Soviet regime, which in Russian was called Soviet Power *(sovetskaya vlast')*, according to which paradigm any composer given power over his fellows becomes a monster, a tool of oppression.

But let me tell you about my second serendipity, or what I could have called "The Night I Met Khrennikov." During my ten months' *stazhorstvo*, my stint as an exchange student at the Moscow Conservatory in 1971–72, I had an aunt in Moscow whom I visited several times a week, and about whom I have written before.[19] She was actually the widow of my father's first cousin, which in English would make her my first cousin by marriage once removed, but in Russian she would be called my *dvoyurodnaya tyot'ya*, my aunt once removed, and this was quite suitable, because she was about forty years older than I.

She lived on a pension but not all that badly. She had a room in a *kommunalka*, a paradigmatically Soviet communal apartment, on Petrovka Street, in the very heart of Moscow, three blocks from the Bolshoy Theater. She had been an artist, and her one big room was decorated with many of her canvases. (Her paid work had always been in decorative or applied arts, *prikladnoye iskusstvo* in Russian.) She had some fine old furniture, including a four-poster brass bed that had been borrowed to be Anna Karenina's bed in a famous Soviet film (the one made in 1967 with Tatiana Samoilova in the title role). She had some social standing as a *generalsha* (even though the general whose widow she was, my father's cousin, had been Jewish). She had spent some years in Paris with her first husband, a mathematician named Bastamov, to whose name she reverted after my uncle, whose surname was

Lieb, had died. So she had a very colorful past, about which she talked endlessly, and almost always interestingly. And she had some amazing friends, or so she claimed. One day she told me that she had been out the night before with Aleksey Nikolayevich Kosygin, then the Soviet premier. "He adores me" *(On obozhayet menya)*, she said, quite casually. "How do you know him?" I asked, incredulous. "Through Tikhon Nikolayevich Khrennikov," she answered, "one of my closest friends." I told her what people thought of him where I came from. "But no," she protested, the way Khrennikov protested about Zhdanov. "He's the most charming, most cultured man" *(obayatel'neyshii, kul'turneyshii chelovek)*. I didn't know how to feel about that, or even whether I could believe it. I never had corroboration for her claims about Kosygin, but one day she told me, "Richin'ka, Tikhon Nikolayich has invited me to his *avtorskiy kontsert* [a retrospective concert of his works], and asked that I bring you with me. I've told him all about you."

And so we went. This was in the late winter or spring of 1972, and the concert was in the six-thousand-seat Dvorets S"yezdov, the Hall of Congresses on the Kremlin grounds. The enormous hall was fairly full. Before the concert I was introduced to Khrennikov's wife, the formidable Klara Arnol'dovna (née Vaks), who gave us our tickets, and his grotesquely made-up daughter Natasha, who was a few years older than I. Mrs. Khrennikov, knowing I was American, and perhaps also knowing that I was a student at Columbia University, told me that during his official visit to America in 1959 her husband had met the brother of Anna Akhmatova, who worked at Columbia as a fireman, she said. (I have never verified the information.)

The program spanned Khrennikov's output all the way from Opus 1, his first piano concerto, written when he was eighteen, which the composer played on stage while the orchestra, conducted by Maxim Shostakovich, accompanied from the pit. I had never seen any other pianist perform this way except Liberace. (The piece, in case you've never heard it, and I'm pretty sure you haven't, is fairly inane, blowing up some perky little tunes into colossal Rachmaninovian cadenzas; I was amazed that Khrennikov still wished to perform it, but perhaps that was the one showpiece that he still had in his fingers.) There were excerpts from operettas sung by the most famous Soviet singers. (The one I remember was Valentina Levko.) The most recent work was a one-act ballet called *Nash dvor,* or *Our Yard,* composed in 1970, that showed some upright Komsomoltsy (Communist Youth members) apprehending and reeducating a bunch of teenaged hooligans. The opener was the overture to Khrennikov's third opera, *The Mother,* after Gorky, for which the orchestra was brought up by the pit elevator to stage level and then sank down again for the rest.

That was the first half. The second half was an entirely different sort of concert. It consisted entirely of songs from movies, mostly composed many years before. There was a different conductor, Yurii Vasil'yevich Silant'yev (1919–83), whose

name may not be familiar to musicians or music lovers in the West, but who was a very big name in those days as the leader of the Variety-Symphony Orchestra of Central Television and All-Union Radio, to give it its official name as listed in the program *(Estradno-simfonicheskiy orkestr Tsentral'nogo televideniya i Vsesoyuznogo radio)*, or the Variety Orchestra of the Air, to give it a name that sounds intelligible in English—a group that performed ubiquitously on the radio and TV, usually accompanying popular singers. Its roster put it somewhere between Count Basie and Mantovani.

At Khrennikov's concert Silant'yevs's ensemble, on stage rather than in the pit, was accompanying the most popular singer of them all, Muslim Magomayev (1942–2008), a classically trained baritone, born in Baku to a famous Azeri musical and theatrical family, who was then about thirty years old and who was the main Soviet heartthrob for young girls, who were there in abundance and who reacted to him just the way teenage girls react now to Justin Bieber, with ecstatic squealing. After every number bouquets rained down on the stage, or were hurled over the now empty pit by his admirers (including Natasha Khrennikova), landing at Magomayev's feet or, more often, in the pit. I had never seen anything like it during my stay in Moscow, but then I was a little classical snob. But even if the concert only confirmed my opinion of Khrennikov as a *bezdarnost'*, an artistic nonentity, I was left agog at his power—power to command all the most high-powered resources of the Soviet musical and theatrical establishment. This man, whom I had often seen on stage at concerts making introductory remarks or presenting awards, was clearly the *khozyayin*, the boss of Soviet music. Incredible that my aunt Nina should be friends with him. (And I never really got to the bottom of that.)

But I have only described this concert as prelude to what followed it. My aunt and I went to the green room to greet the author. There was a surprisingly small assemblage of well-wishers: family members, a group of disgustingly sycophantic *aspiranti*, his graduate students from the Conservatory (I was not told their names, so I do not know how well they did in their careers), my aunt and I (to her he bowed low and kissed her hand; he bowed to me as well as he shook my hand: just as my aunt had said, Tikhon Nikolayevich had very courtly manners). And there was an elegant-looking elderly woman in a black astrakhan overcoat and a very chic white fur hat. My aunt said, "Poznakom'sya" (go meet her), and led me by the hand to where she was standing. She said, "Lina Ivanovna, this is my nephew; he is a great lover of your husband's music," and to me she whispered, as she pushed me toward Lina Ivanovna, "This is the wife of Prokofieff."

I was positively shocked to hear this. Not only would I never have suspected that I would meet the widow of the biggest loser in the history of Soviet music at the concert of the biggest winner, but I was not even aware of the fact that Prokofieff's first wife was still alive, long after the second, Mira Mendelson, had died and was buried alongside the composer in the Novodevichy Convent cemetery (I had

visited those graves more than once), let alone that she was still living in Moscow. Recovering my wits as fast as I could, I repeated what my aunt had already said, and (since I knew that Prokofieff's first wife had been of Spanish birth and had been raised in America) I said it in English. I'll never forget what she said to me, in perfect American English: she said, "I wouldn't show off my English like that if I were you." I told her, "No, no, I'm an American." She laughed to hear this and began asking me questions, starting off with the very question I wanted to ask her, namely, "What are you doing here?"

Some time later, I told the composer Nikolai Karetnikov, with whom I had become friendly, about my unexpectedly meeting Lina Prokofieva at Khrennikov's concert, and asked him how it was that they were friends. It was then that I heard for the first time about Lina Ivanovna's incarceration in 1948, and about Khrennikov's kindness to her after her release from the Gulag in 1956. It was the first time that I was made aware of Khrennikov's beneficence, for in the West he was viewed very one-sidedly in those Cold War years as an oppressor. That view of him still abounds in the popular and pseudoscholarly literature, as I can demonstrate by doing the unthinkable at a scholarly conference and quoting from Wikipedia. But of course I am only doing it to show you for the *n*th time why you should never, *ever*, quote from Wikipedia.

So, according to the stern judges of Wikipedia, "Khrennikov did not prevent Prokofiev's first wife, Lina Ivanovna, being charged as a 'spy' following her arrest by the NKVD on 20 February 1948. As head of the Composers' Union, Khrennikov made no attempt to have the sentence against Lina Prokofieva quashed, or even to mitigate her fate in the Gulag. The Composers' Union did not help Prokofiev's sons, who were compulsorily evicted from their apartment."[20]

This is sheer idiocy, not only because it relies on a simpleton's notion of *sovetskaya vlast'* as monolithic and omnipotent, or because it imagines the Composers' Union, set up to implement the policies of the *partiya* and *pravitel'stvo*, the Party and the government, as capable of opposing or overriding those policies, but chiefly because Lina Ivanovna was arrested on 20 February 1948, and Khrennikov was formally installed as the general secretary of the Composers' Union at the First Congress of the newly organized, redundantly named *Vsesoyuzniy soyuz*, the All-Union Union (meaning a single organization for the entire Soviet Union), which took place in late April, two months later. Even more idiotic is the contention that "after Lina Ivanovna Prokofieva returned from Gulag, the Composers' Union did nothing to improve the extremely bad living conditions of her family; it was the prominent singers Irina Arkhipova and Zurab Sotkilava who protected Prokofiev's first family." Lina Ivanovna's presence at Khrennikov's *avtorskiy kontsert* in 1972 is already enough to refute this. She was there not out of constraint but out of affection. I overheard Tikhon Nikolayevich say to her, after kissing her hand, "Oh, dear Lina Ivanovna, why have you come? It must have been so boring for you!" (I

could only agree.) But Lina Ivanovna answered, "Not at all, Tikhon Nikolayevich, I wanted to be with you at this lovely occasion."

By now we have documentary evidence concerning Khrennikov's efforts on her behalf. I will quote from Simon Morrison's biography, *Lina and Serge*, where, relying on documents furnished by Svyatoslav Prokofieff, Lina's elder son, he writes that Lina was given an apartment on Kutuzovsky Prospect, a fashionable street in 1959, "from the Moscow mayor's office thanks to the general secretary of the Union of Soviet Composers, Tikhon Khrennikov. Music historians tend, with good reason, to scorn Khrennikov for his role in the ideological denunciation of the leading Soviet composers—Prokofiev included—in 1948. But he supported Lina before and after her release from the gulag, even writing a letter urging a review of her arrest and conviction. His empathy with her plight counterbalances his antipathy toward Serge's second wife, Mira Mendelson, with whom he repeatedly clashed."[21]

This leaves room for cynicism, perhaps, insofar as Khrennikov's motives may not have been entirely altruistic but possibly spiteful toward Mira Mendelson, who was still alive at the time of Lina Ivanovna's release. Leonid Maximenkov has surmised that the good treatment accorded Lina Ivanovna had also to do with the decision posthumously to "immortalize" Sergey Prokofieff as a great classic of Russian music, in which case "his first wife could not be allowed to fend for herself on the streets."[22] And yet Lina Ivanovna's gratitude was evidently real, and rightly so: from the recipient's standpoint beneficence does not depend on motive. Maksimenkov is known as a zealous contrarian, as eager to portray Shostakovich as a beneficiary of the system that is now seen as his relentless oppressor as he is to portray Khrennikov as a benefactor of those he is now seen to have oppressed. And more power to him. The more gray to offset the black and white, the greater the verisimilitude of any depiction.

Khrennikov, as the one Soviet musician whose hands were on the real levers of power, needs to be studied carefully, especially for the positive impact he achieved when manipulating those levers. First and foremost there was the partial rescinding of the Resolution on Music of the Central Committee of the Communist Party, a document published in May 1958, a little past the tenth anniversary of the original decree, in which the composers named and censured in 1948 were formally rehabilitated. To achieve that result, Khrennikov had to spend real political capital, accrued by virtue of his cordial personal relations with Khrushchev. None of the other resolutions promulgated during the Zhdanovshchina was ever withdrawn, only the musical one. Whether Khrennikov deserves the credit he claimed for the fact that there were no repressions and few incarcerations of musicians during his tenure as Union secretary, or whether he was implicated in those that did occur, as in the case of Lev Mikhailovich Pulver or Alexander Moiseyevich Veprik, both convicted of "Jewish nationalism" during the anticosmopolitan campaign, in the aftermath of the dismantling of the Soviet Yiddish Theater (GOSET) in 1949, which

followed the assassination of its director, Solomon Mikhoels, the year before—these are precisely the questions that need to be investigated without prejudice.

What should be emphasized in such an assessment is the price that Khrennikov and the rest of the Soviet arts establishment paid for the rescinding of the 1948 resolution. The political capital expended in the effort was never recouped. Compare 1948 with 1979, the year in which Khrennikov delivered, *ex officio*, the last of his *otchyotnïye dokladï*, "summary reports" or keynote addresses, to which anyone paid real attention—that is, the one he delivered at the Sixth Congress of the Union of Soviet Composers. Its title, "Art Belongs to the People," was the most toothless cliché he could have chosen: a chestnut lifted from Klara Zetkin's *Erinnerungen an Lenin* of 1925, which every Soviet child learned by rote at school. Nor was the report, for the most part, in any way unusual. Like any other *otchyot*, it was a summary of achievements: concert halls built, new chapters of the Union incorporated, opera and concert attendance up, 150 new operas produced, 100 ballets, 130 operettas.[23]

The only part that anyone remembers now was a brief passage in which Khrennikov mocked a festival of contemporary Soviet music organized in Cologne in March of that year by Khrennikov's *bête noire*, the German musicologist Detlef Gojowy. Its programs juxtaposed the work of living Soviet composers with early Soviet modernist music—ASMovsky music, as it is now remembered, after the acronym of the Association of Contemporary Music *(Assosiatsiya sovremennoy muzïki)*, an internationally affiliated organization of the 1920s—by Arthur Lourié, Joseph Schillinger, Alexander Mosolov, and Nikolai Roslavets, as well as the work of the recent émigré Andrey Volkonsky. Affecting sympathy for the contemporary Soviet composers, "mainly young ones, [who] found themselves in the unenviable company" of these miscreants and defectors "by the will of the organizers," Khrennikov juxtaposed two lists of names: those excluded and those included in the festival programs. "Here one did not find music by Prokofieff, Myaskovsky, Khachaturyan, Karayev, Shchedrin, Eshpai, Boris Chaikovsky, or Kancheli. Rather, it so happened that in the festival program one found mainly the names of those whom the organizers considered worthy representatives of the Soviet avant-garde: Elena Firsova, Dmitry Smirnov, Alexander Knaifel, Victor Suslin, Vyacheslav Artyomov, Sofia Gubaidulina, and Edison Denisov. A somewhat one-sided picture, wouldn't you say?"[24]

The names singled out for censure gained immediate prominence as the *Khrennikovskaya semyorka*, the "Khrennikov Seven." The Union secretary's complaint only enhanced their prestige and public visibility at home in addition to the notoriety they had already won abroad. Although some of them exploited the situation by portraying themselves as victims, they unquestionably emerged from their encounter with Soviet power as winners. It's a striking contrast with 1948, especially in view of the really arresting fact that the first three names in the honor role that Khrennikov put up against the list of reprobates were three of the six names

singled out for abuse in the original Resolution on Music and in Khrennikov's maiden outing as Union secretary in 1948: Prokofieff, Myaskovsky, Khachaturyan. Certainly, the only reason why Khrennikov did not list Shostakovich alongside them was the inconvenient fact that a work by Shostakovich, his Second Violin Concerto of 1968, was included in the Cologne festival program. (And here one recalls that the year of the festival, 1979, was also the year in which Solomon Volkov's *Testimony* was first published, in English.)

The contrast is worth pondering and analyzing a bit. The difference between the Khrennikov Seven of 1979 and the Zhdanov/Khrennikov Six of 1948 is twofold, having to do not only with those listed but also with the relationship between them and the listers. The 1979 list—Firsova, Smirnov, Knaifel, Suslin, Artyomov, Gubaidulina, Denisov—could be plausibly regarded at the time as a group in opposition to the Union establishment represented by Khrennikov. That Khrennikov singled them out for censure was in fact a sign of recognition, an admission that he and his establishment could no longer control them or prevent the dissemination of their work. Four of the seven would eventually join Volkonsky in voluntary career-motivated emigration—something that was not an option in 1948, when all that those attacked could do was submit and try to conform. The 1948 list—Shostakovich, Prokofieff, Myaskovsky, Khachaturyan, Shebalin, Popov—was anything but a group in opposition to the Union establishment. Indeed, it *was* the Union establishment, under attack by a *force majeure*, the Central Committee. Their Union could offer them no protection. It was forced, like them, to submit, conform, and reorganize.

That, of course, is where Khrennikov came in. In 1948 Khrennikov was a thirty-five-year-old dragoon, appointed to do the bidding of the Central Committee, under orders to read a speech no one suspected him of having actually written. In 1979 the sixty-six-year-old Khrennikov was a member of the Central Committee, still reading a text he had not drafted himself, but one drafted at his behest and according to his specifications. Most pertinent of all: Khrennikov in 1948 was attacking his seniors in a sort of pincer action organized from above by those senior to his seniors. In 1979 he was attacking his juniors, and the whole affair now smacked of generational bullying, or "kicking down." No one took it as a serious ideological campaign. Rather, it was a minor aspect of the general Soviet picture of gerontocracy now remembered and dismissed as the *zastoy*, the Brezhnevite stagnation.

We are back to our starting point, if you recall my first serendipity, the photograph of Kabalevsky after Brezhnev had delivered his *otchotnïy doklad* to the Supreme Soviet in 1981. The next year, 1982, saw Brezhnev's long-anticipated expiration, which set in motion the events that over the next decade would produce the relaxation of the gerontocracy's grip on power and the eventual withering away of the Soviet state. The same year, 1982, saw a musical event that now looms in retrospect as a comparable symbol of impending irrevocable change: what Levon

Hakobian calls the "sensational Denisov-Gubaidulina-Schnittke program performed under [Gennady] Rozhdestvensky at the Great Hall of the Moscow Conservatoire on April 15, 1982 [which] put an end to the preposterous discrimination against this group."[25]

And note the new name that has joined Gubaidulina and Denisov at the head of the new *de facto* establishment. Where was Schnittke when Khrennikov drew up his list of seven? His music, too, figured in Gojowy's festival, along with that of Arvo Pärt, Sergey Slonimsky, and Valentin Silvestrov—much bigger names at the time than Firsova, Smirnov, Knaifel, or Suslin. One can only speculate about the reason. For what it's worth, it seems to me that the list was basically a snide sort of tribute to Denisov, for the younger names it contained all belonged to pupils of his. Including Schnittke, a bigger name than Denisov, would have diluted the venom.

But, as you may recall, even this has a curious parallel with 1948, for there was a famous name missing from the *postanovleniye*, the Central Committee's Resolution on Music. On 3 February 1948, In his report as chairman of the Committee on Artistic Affairs, preparatory to the issuing of the resolution, Mikhaíl Borisovich Khrapchenko listed Shostakovich, Prokofieff, Myaskovsky, Khachaturyan, Shebalin, and Kabalevsky as "holding the dominant position in the field of music, with the connivance of the Committee," and therefore to be personally indicted as formalists in the document the Committee was now charged with drafting.[26] And yet when the document was issued, one week later, on 10 February, Kabalevsky's name had been replaced by Gavriyil Popov's. It made sense for Kabalevsky's name to have been included, since, like Khachaturyan and Shebalin, he was part of the old leadership, the *orgkomitet*, of the Moscow Union, which was being scapegoated. In addition, he had been a party member longer than Khrennikov and had served as wartime editor of *Sovetskaya muzïka*, the Union organ, which is to say, he had served in this responsible post during a period when censorship had been relaxed. Popov had not been prominent in the leadership, and so the substitution raised eyebrows and has been the subject of speculation and gossip ever since. In his posthumous memoirs, Levon Atovmyan, the administrator of Muzfond, noted the substitution and added, cryptically, that those in the know would understand it.[27] The editor of the volume, Nelli Kravets, suggested that this was a reference to "the extremely influential wife of Dmitry Kabalevsky, who was closely allied with the security organs."[28]

So we are back to Kabalevsky. He, too, was demonstrably close to the sources of political power; and he is well remembered as perhaps the most unyieldingly *partiynïy* of all Soviet composers, the most orthodox in following the party line. His was the last voice opposing the revival of Shostakovich's *Lady Macbeth of the Mtsensk District* as *Katerina Izmailova* in 1962, his reason being simply that, unlike the 1948 Resolution on Music, the *Pravda* editorial "Muddle Instead of Music" that had led to the ban on performing the opera had never been retracted.[29] In the same

year Kabalevsky was the last holdout against inviting Stravinsky to make an official visit to the Soviet Union in celebration of his eightieth birthday.[30] Here he opposed even Khrennikov, whose motives were purely strategic: he wanted Stravinsky to return home so that he could be buried near the graves of his father and brother Gury Fyodorovich (not to mention Stasov, Chaikovsky, and the whole *moguchaya kuchka*) in the Alexander Nevsky monastery cemetery in Leningrad. Khrennikov, in other words, was looking forward to Stravinsky's inevitable canonization, along with Prokofieff, in the *zolotoy fond* of *russkaya klassika,* while Kabalevsky sought at all times the security of firm existing directives.

Which means that of the two of them, Khrennikov was the politician and Kabalevsky the ideologue, Khrennikov the Khrushchev and Kabalevsky the Suslov. Both, however, became fixtures, along with their political prototypes, in the sclerotic gerontocracy that eventually forfeited power. It was Kabalevsky's good fortune to die in 1987, precisely one year before the implementation of Gorbachev's *glasnost'* and *perestroika,* the preservative measures that proved ruinous to the Soviet system, and hence did not live to experience the disillusion that embittered Khrennikov's old age.

Again, pictures can help us catch the flavor of the geriatric stagnation. Consider a photograph of Kabalevsky in his old age, doing his job as deputy to the Soviet of Nationalities in his assigned district of Perm (fig. 10.4). He is shown in a characteristic pose, lecturing to a music class at a public elementary school. Those in the know will know the name of the book he is holding up to view. It is his own, by then quite ancient, primer on socialist realism for kiddies, *About the Three Whales and Many Other Things: A Book on Music (Pro tryokh kitov i pro mnogoye drugoye: Knizhka o muzïke),* the three whales being Song, Dance, and March, the categories that grounded all music, however complex, in the social realities that lend it social validity (fig. 10.5).

It's a book on socialist realism (more specifically, a translation of Asafyev's *intonatsiya* theory into childspeak), and yet the English-language edition shown in the picture, which comes from the Amazon.com website, is an Australian publication, from the Kabalevsky Center, a music education nonprofit comparable to the Orff-Zentrum in Munich, where another socially useful educational enterprise with dubious political associations tries to maintain a nonpolitical afterlife. A third such enterprise, the most distinguished and influential of all, is the Kodály method, worked out by a composer who is often contrasted invidiously with Bartók; for while the latter had made himself a voluntary exile in protest against the Hungarian fascist regime, and was then reviled after death by the Communist government, which banned much of his music, lending him a Cold War luster in the West, Kodály was able to work out an acceptable *modus vivendi* under both the fascists and the Communists, in part by avoiding the extremely individualistic modernist style that Bartók felt the need to cultivate beginning in the 1920s.

FIGURE 10.4. Dmitry Kabalevsky speaking to schoolchildren in Perm.

FIGURE 10.5. Title page of the English translation of Kabalevsky's *About the Three Whales* (North Melbourne: Australian Scholarly Publishing, 2009).

Indeed, it was the Communist government that facilitated the nationwide adoption of a Kodály-derived curriculum for music education in Hungarian schools.

That same government promoted the method globally through the International Society for Music Education, an organization founded as an arm of UNESCO in 1953. The ISME conference on the Kodály method was held in Vienna in 1958, a particularly fraught moment in East-West relations, particularly where Hungarian-Austrian relations were concerned, in the aftermath of the failed Hungarian revolt and the consequent reinforcement of the Iron Curtain that divided Europe. The field of music education provided a small but significant venue where common ground could be identified and the Iron Curtain ever so slightly breached, even at its apex. Kodály was made the honorary president of ISME in 1962 and served as the organization's figurehead until his death in 1967. Who succeeded him as honorary president? Kabalevsky, of course, who had been the Soviet delegate to the original UNESCO-sponsored founding conference in 1953, who had composed the official fanfare that was played at all subsequent meetings of the ISME, and who had served as the executive vice president of the organization beginning in 1964. He served as the figurehead until *his* death in 1987.

It is no wonder, of course, that totalitarian power should endorse and propagate utilitarian and socially ameliorative enterprises like childhood music education, which is not only a musical but also, and frankly, a socializing enterprise. But

its social benefits are available to, and appreciated in, nontotalitarian countries as well, even if their governments, like our American federal and state governments, which adopt a laissez-faire attitude toward the arts, are more apt to regard music education as an early expendable whenever budgets need to be trimmed. Nevertheless, Kabalevsky's and Kodály's social activism is among the reasons for their lesser prestige in the laissez-faire world, where a socially alienated stance still carries the greater cultural weight.

The best Stravinsky, for one, could do for Kodály was to call him a "sort of Hungarian composer"; but this was a cold-war response to a cold-war provocation. The passage containing the insult comes from an interview in the *New York Review of Books,* Robert Craft–ghosted on both sides, which the magazine's online archive has bowdlerized to remove the offensive phrase:

> *New York Review:* We hope you are enjoying your stay in New York, Mr. Stravinsky. Have you attended any interesting concerts or other performances?
>
> *I[gor] S[travinsky]:* No concerts, but I heard a good *Falstaff* at the Metropolitan. And, oh yes, there was a television program, the wisdom of Pablo Casals, I believe. *That* was an interesting performance. In one scene the cellist and a sort of Hungarian composer, Zoltan Kodaly, are shown together with their great-granddaughters—or so the viewer supposes until learning a blush later that they are the wives. And what are the two racy octogenarians talking about? Well, they are talking about the trouble with me which is that I must always be doing the latest thing—*they* say, who have been doing exactly the same old thing for the last hundred and eighty years.[31]

The latest thing vs. the same old thing. There we have one way of casting the essential twentieth-century debate or dialectic or zero-sum game: between modernism and traditionalism, between individualism and communitarianism, between adventure and safety, or—to state it in the terms most relevant to our conference theme—between liberty and security. It was the Cold War that brought this last binarism drastically to the fore, and we have already heard the argument for security from Khrennikov, when he extolled what the Union of Soviet Composers had been able to do for its members when it was backed up by the full force of Soviet power. The emphasis is on what state power could do for artists, more than what it could do for art, which was regarded not as an autonomous entity but as the product of what artists did. The argument for liberty is familiar to us in the Old West; it is usually made in terms of the benefit that creative freedom confers upon art rather than upon artists. And it is newer than you might think. One very clear early formulation of it can be found in the program essay that Nicolas Nabokov wrote for his festival "L'œuvre du XXème siècle," presented in 1952 by the anti-Communist Congress for Cultural Freedom, the organization exposed about a decade later as having been covertly funded by the CIA. "If the music of this century is what it is," Nabokov wrote,

—extraordinarily lively in sum, and singularly rich in success and promise—it is due, alongside the talent or genius of musicians, to the spirit of freedom that has in various ways presided over their destinies. Freedom to experiment, freedom to express oneself, freedom to choose one's own mentors and make one's own decisions, to choose irony or naïveté, to be esoteric or familiar. During this coming festival dedicated to the Works of the Twentieth Century and organized for the occasion by the Congress for Cultural Freedom, one will not hear any scores that do not owe their qualities, even their soul, to the fact that they are the music and the art of men who know the value of that freedom.

And those who live today know even better that value because they have seen, in their time, in various parts of the world, how powerful states have denied their citizens, among other material and spiritual freedoms, the freedom to be artists and musicians according to their own taste, their own conviction, their own sense of duty, and their own imagination.[32]

Khrennikov would have spoken here of the freedom to starve, as would Kabalevsky, no doubt imagining the extreme privation that befell musicians along with workers in all fields during the Great Depression, and the socialist innovations that had been forced upon even American society by the need for recovery—what we call the New Deal, which included, among other projects of the Works Progress Administration, programs that employed musicians in newly created government-sponsored orchestras and bands and commissioned celebratory works from composers to mark civic occasions. The American government, they would have said, stepped in to play precisely the role that the Union of Soviet Composers played in the lives of Russian artists, thus giving the lie to those who sang the praises of liberty to the exclusion of all other values.

What are the corresponding pitfalls on the other side? Have another look at figure 10.4, the photograph of Kabalevsky in Perm. What chiefly interests me in that picture is not Kabalevsky's person, or the children to whom he is talking, but the teacher looking on. She is wearing one of Marina Frolova-Walker's dead faces, a face that could easily join those of the Politburo in the photo in figure 10.1. That deadening ritualization—of always doing the same old thing—is the price of an extreme commitment to security. Or consider another Perm picture, this one showing Kabalevsky lecturing to honor students at the local conservatory (fig. 10.6). The woman at right is the rector, a Ms. Vorob'yova, who had no doubt introduced the speaker. She and Kabalevsky look like a stage hypnotist and his subject. She is virtually asleep.

In the contest of liberty and security, Soviet power drew the line, in music as everywhere else, so far over on the side of security as ultimately to weaken not only the vitality of cultural life, but the very foundations of their polity. And we in the West have tended to draw the line so far over on the side of liberty as to threaten social justice and, to confine matters to what interests us here, to undermine the

FIGURE 10.6. Kabalevsky lecturing to conservatory students in Perm, the district he nominally represented in the Supreme Soviet, while the rector looks on.

viability not only of contemporary academic and concert music, but of all institutions that support the performance of classical music.

Yet whatever the extremities of the social environment, those who are able to adapt to them can have successful careers. Once, as a sort of serious-minded joke, and also (I admit) to ruffle the complacency of Charles Rosen (whose last book, be it noted, was called *Freedom and the Arts*), I drew a series of parallels between Tikhon Khrennikov and Elliott Carter—or rather, between their careers, so as to show how successful musicians could be on either side of the Cold War divide without actually having an audience for their work, so long as they were adroitly aware of the sources of power and prestige within their respective milieux.[33] In a less flippant fashion, to conclude, I'd like to take one last look at Kabalevsky's career. When I wrote in to the *New York Review of Books* to identify him in the picture of the Politburo at the Supreme Soviet convocation, I called attention to the way Kabalevsky's career had turned him away from his original calling as a composer to the role of what in Russian is called an *obshchestvenniy deyatel'*, a hard-to-translate Soviet phrase meaning a public figure (as I put it above) or, more accurately perhaps, a civic activist. I was more or less consciously parroting something I'd read years before in Stanley Dale Krebs's *Soviet Composers and the Development of Soviet Music,* a pioneering book based on the author's University of Washington dissertation that is at times startlingly insightful, even prescient,

and ought not to be forgotten. Discussing the extent of Kabalevsky's *obshchestvennaya deyatel'nost'*, he wrote that "Kabalevsky perennially leads, hither and yon, delegations: another Soviet tradition. He addresses mass workers, he appears with Mongolian collective farm workers, he writes articles for the domestic and foreign newspapers and journals, he appears on television panels where he argues his view in articulate Russian, French, or English, he both receives and presents awards on festive and solemn occasions. He does not have time to compose."[34]

Any list of Kabalevsky's works will confirm this observation. He lived to the age of eighty-three, and his opuses number 103. Opus 93 dates from 1972, fifteen years before his death, which means that in his last fifteen years Kabalevsky completed only ten compositions. But Krebs had noted the drop-off in productivity even as of 1970. "The Western observer," he wrote, "is often quick to lay this to the ideological controls imposed about that time," meaning the late 1940s, when Kabalevsky's composing activity began to dwindle. "This, however, is clearly not the case with Kabalevsky," Krebs observed, stating that Kabalevsky seems never to have entertained a single unorthodox thought from the beginning of his career to the end. "Moreover," he wrote, and this seems to me to be one of those startling insights, "if, as has been suggested, popular acclaim is identified with creative success in Kabalevsky's thinking, then fresh creative effort may not seem necessary."[35]

Indeed, what happened to Kabalevsky is quite similar to what happens to some of our own colleagues when they "ascend" into administration. How do we regard that? Some of us may deplore it, but others seem to want it and think it a suitable reward. Are they necessarily the lesser scholars? Was Kabalevsky a bad composer? His Second Symphony was good enough for Toscanini, as was the Overture to the opera *Colas Breugnon*, of which Toscanini's fabulous recording was a best-seller. His Third Piano Sonata was good enough for Vladimir Horowitz. He was one of the most-published composers of the twentieth century, a distinction he earned by writing a wealth of pieces that have served generations of piano teachers. As Krebs noted more than forty years ago, over 90 percent of his publications were republications, and the ratio must obviously be much higher now. By any fair measure these are marks of great success, even without taking into account all the prizes, honors, and offices Kabalevsky commanded.

By fair measure of success I do not mean success measured in terms of any externally imposed standard of quality; rather, I mean a measure that compares ambition to achievement. Success, in this sense, means career success, and any successful career implies an agent's advantageous adaptation to the conditions that both furnish and limit opportunities. These are sociological criteria, and I think they are the ones most profitable for us to apply when considering the relationship between music, or musicians, and power. We want to understand how that relationship works. That, it seems to me, is a more difficult and a more important task

than to judge achievement by the ethical or esthetic values we have inherited. By assessing winners and losers rather than identifying good guys and bad guys (or geniuses and hacks) we run less risk of idealizing our objects of study or reinforcing our own prejudices.[36] Stanley Krebs ended his chapter on Kabalevsky with a characteristically acute pair of observations. "A superb technique, and an unusual insight into the nature of immediate popular success are his two creative weapons," he wrote. But then he added, "The essential third weapon, a personal depth which must, at times ignore the first and second, has always eluded him."

That last criterion is precisely the sort of sentimental, idealizing prejudice that impedes our understanding of the relationship we are here convened to investigate—not only sentimental, but quite literally Romantic: German-Romantic, to be precise. It names as essential a "weapon" that Kabalevsky surely never sought to wield, and one that could only have needlessly complicated his adaptation to the only social environment in which he was permitted to function. To put it another way, Krebs's first two points are observations; the third, not an observation but a judgment, merely registers the author's disapproval of a career that achieved remarkable success by adapting to conditions the author had learned to despise— or, to say it frankly, had been taught to despise. We are taught to be suspicious of successful adaptations. We call them "compromise" and "selling out"—more likely the first when the conditions adapted to are viewed as primarily political,[37] more likely the second when they are seen as economic or commercial.

And we are taught to admire, and to idealize, the maladapted, the losers. That is what happened so spectacularly in the wake of Volkov's *Testimony*, when it became possible to argue that Shostakovich, the most spectacularly successful Soviet composer in terms of international prestige, was actually a resentful and alienated outcast, sending out desperate messages in bottles. But actually Shostakovich's career, with all its vicissitudes, and precisely in the light of those vicissitudes (which by definition include ups as well as downs), is a spectacular illustration of the process of adaptation I am seeking to describe. Maximenkov, by publishing Shostakovich's thank-you notes to Stalin, has abetted a balanced view of Soviet power trying to control artists through rewards as well as punishment.[38] But don't forget that the same Shostakovich, exploiting his own international prestige and its value to the regime, provides the most dramatic instance in the history of Soviet music of speaking truth to power (in this case to Stalin on the telephone), and getting results.[39]

Neither let us forget that the esthetic doctrine that led Stanley Krebs into what I regard as a subjective error with respect to Kabalevsky, and that we echo when we accuse those with successful careers of selling out, was a doctrine born out of social abandonment. It arose alongside, and to some extent in consequence of, the collapse of the system of aristocratic or institutional patronage that had sustained

the high arts and the elite class of artists in the past. It arose, I should say, in compensation for that loss, and its purpose was to provide an alternative standard of artistic success, based not on public acclaim or the approbation of *Kenner und Liebhaber*, but on what Stanley Krebs called "personal depth," the consolation of losers. Our German Romantic esthetic heritage is in that sense an aesthetic of sour grapes.

The Soviet system in effect attempted a revival of the older patronage model. It did for successful composers what the opulent and ostentatious patronage of the *prachtliebende* Esterházys once did for Haydn. I hope I will not be understood as arguing that the Soviet system was benign. What I am arguing is that, like all socioeconomic systems, it confronted artists with a set of what ecologists call affordances—environmental possibilities for action. For those who seized their opportunities and realized their goals—for those who, so to speak, could come up with a baryton trio any time the patron asked for one—the environment was indeed benign. Kabalevsky and Khrennikov could regard it so, I am sure, with complete sincerity. For Prokofieff it turned out to be toxic; but don't forget that he, too, saw enticing career affordances in the Soviet environment and acted on that calculation, or rather that sad miscalculation, when he returned to Soviet Russia in high expectation of success—a success guaranteed as only Soviet power could guarantee it.

I seem to be building up to a ringing peroration, but I'll settle instead for a modest invitation: to supplement our study of artists and artworks with a greater focus on the grittier subject of careers—something all artists have to make, in addition to their art. It is there that we will stand to gain the most in our efforts to understand music, and power, and the ways they interact.

NOTES

1. Lily E. Hirsch, *Music in American Crime Prevention and Punishment* (Ann Arbor: University of Michigan Press, 2012); Suzanne Cusick, "'You Are in a Place That Is Out of the World': Music in the Detention Camps of the 'Global War on Terror,'" *Journal of the Society for American Music* 2, no. 1 (2008): 1–26.

2. R. Taruskin, "Afterword: *Nicht blutbefleckt?*" *Journal of Musicology* 26, no. 2 (2009): 274–84 (special issue: "Music and the Cold War"); Charles Rosen, "Music and the Cold War," *New York Review of Books*, 7 April 2011, 40–42.

3. See Klára Móricz and Simon Morrison, eds., *Funeral Games in Honor of Arthur Vincent Lourié* (New York: Oxford University Press, 2014), with contributions by Olesya Bobrik, Caryl Emerson, Richard Taruskin, and the editors.

4. Arthur Vincent Lourié, *Le profanation et sanctification du temps: Journal Musical 1910–1960, Saint-Petersbourg–Paris–New York* (Bruges: Desclée de Brouwer, 1966), 189, 191; from an anonymous translation published in advance of the book: Arthur Lourié, "The De-Humanization of Music," *Ramparts* 3, no. 5 (Jan.-Feb. 1965): 39–41; quoted in Móricz and Morrison (eds.), *Funeral Games in Honor of Arthur Vincent Lourié*, 229.

5. See R. Taruskin, *The Danger of Music and Other Anti-Utopian Essays* (Berkeley and Los Angeles: University of California Press 2009), a collection of mainly journalistic interventions equipped on republication with accounts of controversies that they have inspired over the years.

6. Simon Head, "Brezhnev and After," *New York Review of Books,* 4 March 1982, 34.

7. Ibid., 38.

8. Email to author, 25 January 2013.

9. Marina Frolova-Walker, "Stalin and the Art of Boredom," *Twentieth-Century Music* 1 (2004): 101–24.

10. Letter of 29 December 1957, in *Pis'ma k drugu: Pis'ma D. D. Shostakovicha k I. D. Glikmanu*, ed. Isaak Glikman (Moscow and St. Petersburg: DSCH and Kompozitor, 1993), 135–36; translated by Anthony Phillips as *Story of a Friendship: The Letters of Dmitry Shostakovich to Isaak Glikman with a Commentary by Isaak Glikman* (Ithaca, NY: Cornell University Press, 2001), 72–73.

11. *New York Review of Books,* 10 June 1982, 45.

12. Laurel Fay, *Shostakovich: A Life* (New York: Oxford University Press, 2000), 226.

13. Email to the author, 26 January 2013.

14. To distinguish him from David Brown, the author of a four-volume biography of Chaikovsky and the principal Anglophone spreader of the Chaikovsky suicide rumor.

15. Вообще в СССР музыка, как в классической Древней Греции, была крупнейшим государственным делом. Духовное влияние крупнейших композиторов и исполнителей, формирующее умных и волевых людей, было огромным, в первую очередь через радио. Наш Союз композиторов обладал огромной материальной мощью. Мы в год имели 20 миллионов рублей! По тем временам—это колоссальная сумма. Мы строили дома, давали бесплатно квартиры. Создавали Дома творчества. А фестивали и концерты! При Музфонде существовал специальный отдел музыкальной пропаганды, задачей которого была организация и пропаганда новых произведений. Мы построили свою типографию и свое издательство "Советский композитор". Издавали произведения, в том числе и молодых композиторов. Попробуйте сейчас что-нибудь издать! Только сами, за свои деньги. Ivan Vishnevsky, "Tikhon Khrennikov: 'Stalin znal muzïku luchshe nas . . . ' Beseda s Geroyem Sotsialisticheskogo Truda, narodnïy artist SSSR, laureatom Leninskoy, Stalinskikh i Gosudarstvennïkh premiy," *Zavtra*, no. 39 (671), 27 September 2006; available at http://zavtra.ru/content/view/2006-09-2781. Subsequent quotations are from this source.

16. Сталин, по-моему, музыку знал лучше, чем кто-либо из нас. Он постоянно ходил на спектакли Большого театра и часто водил туда Политбюро—воспитывал, так сказать, своих сотрудников. . . . Сталин был на моей опере "В бурю". Поставил ее Владимир Иванович Немирович-Данченко, премьера была в 1939 году. Итак, там присутствовали Сталин, Молотов, Ворошилов, и им понравилось. Сталин пригласил к себе Немировича-Данченко и меня. Еще раньше предупреждали, чтобы был наготове—но я в тот вечер был в Киеве. Там была премьера той же оперы, дирижировал Рахлин, он никогда не изучал заранее партитуру, и я не мог не быть в Киеве, чтобы хоть верные темпы показать. Но Сталин не обиделся. Во всяком случае, на следующий день в "Правде" напечатали статью, где говорилось, что руководители страны были на премьере оперы "В бурю", и Сталин высказал свою похвалу в отношении спектакля.

17. . . . Естественно, мне проходилось беседовать с Иосифом Виссарионовичем. Но какого-то специального разговора, когда бы меня учили, как нужно поступать, у меня со Сталиным не было. Меня приглашал Жданов, который был образованнейшим человеком. Это сейчас стали из него делать пугало: якобы он был незнайкой, якобы садился за рояль и показывал великим композиторам, как нужно сочинять.

18. *ЗАВТРА*: Сталин в общении был каким: злобным, ожесточенным, равнодушным, холодным, или наоборот—сердечным, приветливым?

Т.Х.: Сталин был совершенно нормальный человек. С ним часто спорил Фадеев, мне один раз пришлось поспорить.... Никогда Сталин не вел заседания Политбюро. И в тот день его вел Маленков. Сталин сидел справа и принимал самое активное участие в обсуждении вопросов.

19. See R. Taruskin, *On Russian Music* (Berkeley: University of California Press, 2009), 6, 190–93.

20. For this and other quotations from Wikipedia, see http://en.wikipedia.org/wiki/Tikhon_Khrennikov (accessed 2 March 2016).

21. Simon Morrison, *Lina and Serge: The Love and Wars of Lina Prokofiev* (Boston: Houghton Mifflin Harcourt, 2013), 282.

22. Ibid., 283, with reference to Leonid Maksimenkov, "Prokofiev's Immortalization," in *Prokofiev and His World*, ed. Simon Morrison (Princeton, NJ: Princeton University Press, 2008), 285–332.

23. See Boris Schwarz, *Music and Musical Life in Soviet Russia, 1917–1981*, enlarged ed. (Bloomington: Indiana University Press, 1983), 621.

24. Здесь не была показана музыка Прокофьева, Мясковского, Хачатуряна, Караева, Щедрина, Эшпая, Бориса Чайковского, Канчели.... Зато в программе фестиваля оказались друг в основном те, кого организаторы сочли достойными называться советским авангардом: Е. Фирсова, Д. Смирнов, А. Кнайфель, В. Суслин, В. Артемов, С. Губайдулина, Э. Денисов. Картина несколько однобокая, не правда ли? Tikhon Khrennikov, "Iskusstvo prinadlezhit narodu," *Sovetskaya kul'tura*, 23 November 1979.

25. Levon Hakobian, *Music of the Soviet Age, 1917–1987* (Stockholm: Melos Music Literature Kantat HB, 1998), 266.

26. Ekaterina Vlasova, *1948 god v sovetskoy muzïke* (Moscow: Klassika-XXI, 2010), 272.

27. Nelli Kravets, ed., *Ryadom s velikimi: Atovmyan i ego vremya* (Moscow: GITIS, 2012), 283.

28. Ibid., 435.

29. This story is recounted, with citations from relevant documents, in Glikman, *Pis'ma k drugu*, 119–21.

30. See Karen Khachaturyan, "Ya bïl rozhdyon dlya muzïki" (I Was Born for Music, interview with Svetlana Savenko on Stravinsky's visit to the USSR), *Muzykal'naya Akademiya*, no. 4 (1992): 220–22, at 221. Also Alexander Ivashkin, "Stravinsky and Khrennikov: An Unlikely Alliance," *Mitteilungen der Paul Sacher Stiftung*, no. 26 (April 1913): 12–16.

31. "An Interview with Igor Stravinsky," *New York Review of Books*, 3 June 1965; reprinted in Igor Stravinsky and Robert Craft, *Themes and Episodes* (New York: Alfred A. Knopf, 1966), 101–2.

32. Nicolas Nabokov, "Introduction à l'Oeuvre du XXe Siècle," *La revue musicale*, no. 212 (April 1952): 8.

33. Taruskin, "Afterword: *Nicht blutbefleckt?*" 280.

34. Stanley Dale Krebs, *Soviet Composers and the Development of Soviet Music* (New York: W. W. Norton, 1970), 255.

35. Ibid.

36. I hope I will be forgiven for pointing with pride to the work of one of my former doctoral students who has gone further, I think, than any other musicologist has yet gone toward applying professional sociological methods to musical data in answering these questions. See William Quillen, "Winning and Losing in Russian New Music Today," *Journal of the American Musicological Society* 67 (2014): 487–542.

37. The *locus classicus* is René Leibowitz, "Béla Bartók, or the Possibility of Compromise in Contemporary Music," *Transition* 48 (1948): 92–122; originally published in French as "Béla Bartók, ou la possibilité du compromis dans la musique contemporaine," *Les temps modernes* 3, no. 25 (October 1947): 705–34.

38. Leonid Maximenkov, "Stalin and Shostakovich: Letters to a 'Friend,'" in *Shostakovich and His World*, ed. Laurel E. Fay (Princeton, NJ: Princeton University Press, 2004), 43–58.

39. I refer, of course, to Shostakovich's agreement to go to New York to represent the Soviet Union at the Waldorf Peace Conference in 1949, in return for the cancellation of "Prikaz No. 17," the official ban on the performance of numerous works by the composers denounced as formalists in 1948. Shostakovich made this deal with Stalin without actually broaching a quid pro quo, which testifies to his excellent political skills. See Fay, *Shostakovich: A Life,* 172.

11

What's an Awful Song Like You Doing in a Nice Piece Like This?

The Finale in Prokofieff's Symphony-Concerto, *Op. 125*

In 1958, when I was thirteen years old, my family learned to its surprise that we had a whole other family living in Russia. It's a long story, and I've told it before.[1] It was so that I could correspond with my newfound relatives that I was originally motivated to learn Russian, and that is what eventually steered me into my vocation as a student of Russian music, the more so as our Russian cousins showered us all with gifts, which in my case included dozens of phonograph records and scores. I was studying cello at the time, so of course I was sent every cello composition on sale in the music stores of Moscow, even though very little of it was within my technical grasp.

One of these scores, and the one perhaps most beyond my ability to even think of playing, was the first edition of Prokofieff's *Simfoniya-Kontsert* or *Symphony-Concerto*, op. 125 (Moscow: Gosudarstvennoye muzïkal'noye izdatel'stvo, 1959; fig. 11.1), a *klavir*, or piano reduction for the use of students, edited and arranged by Rostropovich, to whom the work was dedicated, and with an introductory essay by Vladimir Mikhailovich Blok, the textual editor.[2]

Although I never put it on a music stand, I did enjoy following it as I listened to what was then the only recording of the work, by Rostropovich with the Royal Philharmonic Orchestra under Malcolm Sargent, made in 1957 during a concert tour.[3] The trouble was, I kept getting lost in the finale, and it took me a long time to figure out that for a long stretch in the middle of the movement (pp. 68–84, rehearsal figs. *15–22*), the score presented two versions concurrently (see fig. 11.2).

There was a footnote, visible in fig. 11.2, which announces (in the anonymous English translation) that "the musical text printed in brevier is a version of the middle episode of this movement." That didn't help, since I didn't know the English

FIGURE 11.1. First edition of Prokofieff's *Symphony-Concerto*, op. 125 (Moscow: Muzgiz, 1959).

FIGURE 11.2. The first edition opened to pages 68–69.

word "brevier" (and have never encountered it since).⁴ If I had been able to read the Russian version of the footnote in those days, I would have done better, since it was somewhat clearer and more specific: "The musical text in small print shows an alternative version for the middle episode of this movement."⁵ What made the score confusing was that the alternate text was not in fact distinguished in size from the main text. Left hand, evidently, had not consulted right in the Muzgiz office.

Once I had figured things out, I could follow as Rostropovich performed the odd-numbered systems on each score page. I doped out the even-numbered systems for myself at the piano, and found them to be a somewhat faceless waltz that reminded me a little of the ones in the first act of Prokofieff's *War and Peace* or the popular waltz in the suite from Khachaturyan's Prokofieff-derived music for Lermontov's *Masquerade*. I have never heard it performed either live or on record and wonder if it ever has been. The music in the odd-numbered systems, also a bit waltzlike but grotesque in a familiarly Prokofieffesque way, and with some especially amusing variations, was so obviously better that I had to wonder why Prokofieff had provided an alternative to it. Was it to make the music easier for poor cellists like me? If so, it didn't go far enough. (And elsewhere in the *Symphony-Concerto* there were alternative passages marked "facilitazione," which might have been done here as well had that been the reason.)⁶ What, then, was the point of it?

Scholarly interest replaced idle curiosity when I was asked, some three decades later, for a program note to accompany a performance of the *Symphony-Concerto* by Mischa Maisky and the San Francisco Symphony.⁷ By now, Vladimir Blok's monograph was available, and so I looked the piece up and was informed that the music for which Prokofieff had supplied an alternative had been based on a song called "Bïvaitse zdarovï" ("Be healthy"—obviously a toast). A footnote informed me further that "the song 'Bïvaitse zdarovï' (in Russian, 'Bud'te zdorovï'), often taken for a Belorussian folk song, is actually by the composer I[saak Isaakovich] Lyuban [1906–75] (and was not a folk arrangement but a personal reflection of the intonational and emotional makeup peculiar to Belorussian folk music)" (*VTP*, 66n). Blok noted that Prokofieff's theme was not a literal quotation of its model:

> In the theme of the central episode, the song "Bïvaitse zdarovï" has undergone substantial changes in melodic design and in its intonational and modal makeup (especially at the end), as well as in its general structure. At the same time, in its intonational patterning, its springy rhythm, and its general emotional coloration, Prokofieff's theme is undeniably close to western-Slavic folk dances. The humorous coloration of the whole central episode is obvious. It is as if the composer were parodying a performance by a little amateur ensemble, sometimes striking the "wrong" (but of course cunningly worked out) harmonies, sometimes fervently bringing out impossibly banal bass lines. . . . The tragicomically bumbling final cadence elicits a smile. (*VTP*, 129)

EXAMPLE 11.1

a. *Symphony-Concerto*, III, 5 after fig. 15, bassoon solo.

b. Isaak Isaakovich Lyuban, *Bïvaitse zdarovï* (transposed from F minor to facilitate comparison).

Bï - vai - tse zda - ro - vi. Zhi - vi - ti - tse ba - ga - ta. U - zho - zh mï pa - ye - dzem Da — sva - yey kha - ti

Parody reaches a peak in the second variation (fig. 18), where, as Blok notes, "the theme sounds deliberately dejected as played by a quintet of solo strings (typical of rural festivities in eastern European countries!)," adding that "Prokofieff wittily called this episode the 'poor relations,'"[8] and that "the picturesqueness of the music, its richness of genre portraiture and its humorous imagery are akin to certain characteristic sketches by Musorgsky" (*VTP*, 130).

All of this is certainly plausible enough, as a comparison of Lyuban's tune (Moscow-Leningrad: Muzgiz, 1941)[9] with Prokofieff's theme will confirm (ex. 11.1a–b). As Blok pointed out, the resemblance is closest at the beginnings of the tunes, with two parallel phrases that outline the degree progressions 1–3-1 and 3–5-3, respectively, and a melodic peak at the octave subsiding at the end to the first degree. Prokofieff's tune has two very characteristic, distinguishing features not found in Lyuban's: the start on the lower fifth rather than the tonic, and the chromatic middle phrase with its "wrong notes." But greater elaboration is something one would only expect from a high-echelon composer like Prokofieff.

And yet, learning that Prokofieff had borrowed the tune from the work of someone he, a notorious snob, could only have regarded as a hack composer only added another puzzle. I still had no idea why he should have resorted to quoting

a song by Lyuban, nor (especially) why he supplied an alternative to it so as to allow performers to avoid it. Most puzzling of all was the fact that both the Concertino for cello, op. 132 and the unfinished solo Sonata, op. 134, also made use of the tune putatively borrowed from Lyuban, in both cases, moreover, altering it further so that its resemblance to the original became less noticeable and even a bit farfetched. Blok of course took note of this anomaly: "Strictly speaking, what appears in the solo Sonata, as well as the Concertino, is not the actual melody of the song 'Bïvaitse zdarovï' but a further extension of the metamorphosis that is given first in the Symphony-Concerto ... in other words, an odd 'transformation of a transformation'" (*VTP*, 65–66). Later he calls the resurfacings of the tune "a very rare instance of a distinctive 'variation at a distance' of a single theme in three different, generically related works" (*VTP*, 69). In a footnote he recalls a similar instance in Beethoven: the melody that recurs in Beethoven's Variations and Fugue for piano, op. 35; the ballet *Creatures of Prometheus,* op. 43; and the finale to the *Eroica* Symphony, op. 55 (to which he could have added the Twelve German Contradances, WoO 14).

This was beginning to look like an obsession. But why this tune? Was Prokofieff trying to tell us something? Wondering about such things was an indoor sport or a cottage industry back in 1989, when everyone was looking for ciphers and portents in Soviet music (particularly the music of the immediate post-*Zhdanovshchina* period) in response not only to the "collapse of communism" that was going on around us, but also in the wake of Solomon Volkov's then ten-year-old bestseller *Testimony* and all the polemics it had stirred up. Fancying (I would then have said noticing), based on nothing more than my own experience and background, a Jewish tinge in Prokofieff's theme and its handling, I'm afraid I took the bait in my fortunately never much read and now forgotten program note. (I'll leave it to my enemies to dig it up.) But my conjectures then, which I hereby disown with gusto, were as nothing compared with the sort of speculation that followed upon another discovery. Prokofieff's theme, it seemed, bore an equal similarity to another song by Lyuban (who seems to have had a remarkably restricted "intonational" range, to put it the way Soviet critics used to do): see ex. 11.2.

This song was called "Nash tost" ("Our toast" [1942]; rev. 1948 [Moscow: Muzgiz, 1948]), and it had a text by Matvey Kosenko that made it politically sensitive, to say the least. Whereas the words of "Bïvaitse zdarovï" were innocuous ("Be healthy, live richly," etc.), "Nash tost" begins, "If we meet some old friends at a holiday celebration, we recall all that we hold dear and our song rings out all the more joyously," and it ends "Rise, comrades! Let us drink to the Guard! None can equal its bravery! Our toast is to Stalin! Our toast is to the Party! Your toast is to the banner of our victories!"

Not something to mess around with, this. And so the fact that Prokofieff appeared to be messing around with it elicited a lot of excited commentary, espe-

EXAMPLE 11.2. Lyuban, *Nash tost* (transposed from F minor).

cially in the blogosphere, of a sort without which no report of this kind would be complete. Here, for example, is the giddy reaction of one Boris Zindels, a record collector and dealer from Kiev, on the blog "The Prokofiev Page":

> Prokofiev had managed the last laugh on the "cockroach with whiskers" in the finale of his *Sinfonia Concertante* for Cello and Orchestra, op. 125.... I had been lucky enough to attend the final rehearsal and concert performance of Prokofiev's *Sinfonia Concertante* in Kiev on 24 March 1998, to honor the memory of Sviatoslav Richter who had died the previous August.... When the triple time central theme of the finale started I felt shivers down my spine—there was an old "official" drinking song to Stalin! Unfortunately I couldn't recall the exact name of the song nor its composer. Just one line of the toast screamed in my head: *Vypiem za Rodinu! Vypiem za Stalina!* [Let's drink to the Motherland! Let's drink to Stalin!] How brave Sergei Sergeyevich had been to treat such "sacred" material in such a scathingly satirical manner during such a bleak period in his life![10]

The reference to the "cockroach with whiskers" is an allusion to the poem about Stalin that cost Osip Mandelshtam his life. It is a typical hyperbole of the post-*Testimony* period. The line Mr. Zindels quotes from the text—"*Vypiem za Rodinu! Vypiem za Stalina!*"—is not in the published version of the song that I consulted, but it was very likely sung during the period of the song's currency, since *Za rodinu! Za Stalina!* (For the motherland! For Stalin!) was a catchphrase during the war, used not only in toasts but also as a battlecry. As patriotic allusion, a reference to this song in a symphonic work might have been plausible, but to allude to it (or even to a song resembling it) as post-Zhdanov mockery is (forgive me, Mr. Zindels) inconceivable, and to imagine Prokofieff doing such a thing is wishful and preposterous.

Problems were multiplying. Prokofieff's *Symphony-Concerto* was starting to resemble Russia itself as described by Churchill, "a riddle wrapped in a mystery inside an enigma."[11] But information continued to trickle. A major contribution came inconspicuously from Rostropovich, the man who inspired Prokofieff to revise his unsuccessful Cello Concerto of 1938 into the *Symphony-Concerto* in the

first place. In a memoir first published (as far as I know) in 1997 in the booklet accompanying a CD retrospective, Rostropovich recalled the matter of the quoted tune as follows: "Prokofiev incorporated a theme that was similar to 'Be of Good Health,' a popular song by Vladimir Zakharov, an apparatchik who mercilessly vilified all 'formalists.' After the work was played at the composer's Union, Zakharov stood up and said indignantly that he would write to the papers complaining that his own wonderful tune had been totally distorted. When I related this to Prokofiev he wrote a replacement tune (a waltz, which I never played), and said that once everything had settled down we could quietly revert to the original tune."[12]

Rostropovich's attribution of the tune to Zakharov is mistaken but understandable. Vladimir Grigorievich Zakharov (1901–56), an infamous denouncer but not at all a bad musician, was the director of the Pyatnitsky Choir, Russia's leading folk song-and-dance ensemble (founded by Mitrofan Yefimovich Pyatnitsky in 1910, before the revolution). He had arranged and recorded Lyuban's songs with the group, and had also written a song of his own called "Bud'te zdorovï" (Moscow-Leningrad: Muzgiz, 1939), which is the Russian equivalent of "Bïvaitse zdarovï" and also means "Be of Good Health." Zakharov's is an entirely different song, however, in 4/4 time rather than the triple meter of "Bïvaitse zdarovï" or "Nash tost," and bears no resemblance to Prokofieff's theme.[13] So Zakharov must have been complaining about the resemblance to Lyuban's song rather than his own, and Rostropovich misunderstood the story when he heard it. (He does not actually say he witnessed the scene, only that he reported it to Prokofieff.) In her biography of Rostropovich (largely based on interviews with him), his former pupil Elizabeth Wilson confirms the generally accepted attribution of the song and also adds some detail to the story, although the question of Rostropovich's status as an eyewitness is left unaddressed.

> The concerto found an unexpected antagonist among its listeners when it was auditioned. On hearing the theme in the Allegretto interlude of the finale (fig. 15), the director of the Piatnitsky Choir, Zakharov, jumped up and accused Prokofiev of plagiarism. The simple tune, a song with a Belorussian title, *Byvaitse zdorovy* (known in Russian as *Bud'te zdorovy* and in translation meaning "Be healthy"), had actually been composed by I. Lyuban, but Zakharov had arranged it for the Piatnitsky choir. Some confusion exists as to its true authorship, since the melody had become so popular that it was considered a folk song. Zakharov appeared to claim it as his own, and now charged Prokofiev with stealing it, demanding royalties and an apology. When Slava [Rostropovich] went to Prokofiev's home to tell him of the successful outcome of the audition, he also told him of the "scandal" that had erupted. Prokofiev laughed and said, "Well, next time I use it, I'll disguise the tune so well that Zakharov won't even recognize it." He was as good as his word.[14]

This version of the story seems to provide a rationale for the presence of (disguised?) variants of the tune in the Concertino and the solo Sonata. Relying on the facts as reported by Rostropovich and Wilson, Simon Morrison counters the sort

of implausible though regrettably rife readings that Zindels and Vishnevetsky have proposed by recalling the stringent political atmosphere within which Prokofieff was working, as well as a notice that had appeared earlier in 1952 in the magazine *Sovetskoye iskusstvo*, informing readers that "Sergey Prokofieff has been working with great intensity on his Concerto for Violoncello and Orchestra," and that "in his composition the author has made broad use of Russian folksong material."[15] Morrison writes:

> Both [Lyuban's and Zakharov's] songs became popular during the war, and both tended to be performed in concert in different variations, a practice good-humouredly reprised by Prokofiev in his score. Given that these songs ["Bud'te zdorovi" and "Nash tost"] were sung as toasts to Stalin Prokofiev would have been foolhardy to mock them in his concerto. It seems more likely that the paraphrase was intended as a sincere (not cynical) response to his official censure in 1948, when he was instructed to increase the popular content of his scores. The *Sovetskoye iskusstvo* columnist who mentions the "Russian folksong material" in the concerto was either engaging in specious politesse or referring to "Our Toast."[16]

It is refreshing that Morrison does not indulge in foolhardy speculations of his own, and it is quite true that Prokofieff's output during the miserable half-decade that remained to him after his official censure contains sincerely (not cynically) patriotic and "Party-minded" *(partiynïye)* compositions such as the oratorio *Na strazhe mira* (usually translated "On Guard for Peace," though "Guarding the Peace" or "In Defense of the Peace" would be closer to the meaning of the Russian title) or the "festive poem" for orchestra, *Vstrecha Volgi s Donom* (The Volga Meets the Don), composed in 1951 to celebrate the opening of the 101-kilometer Lenin Volga–Don Shipping Canal (largely constructed with slave labor from the Gulag) in 1952. There are also several works that incorporate folk melodies from Russian or other Soviet sources, like the ballet *Kamennïy tsvetok* (The Stone Flower) and, most notably, the opera *Povest' o nastoyashchem cheloveke* (The Story of a Real Man). There are, moreover, a couple of spots in the first and second movements of the *Symphony-Concerto* in which recognizably folklike "intonations" crop up in melodies that were not present in the original Cello Concerto of 1938 of which the *Symphony-Concerto* was an amplification (e.g., I:fig. 13, II:7 after 32). These would justify the words of the anonymous reporter for *Sovetskoye iskusstvo* without reference to the middle section of the finale, which, as Morrison implies, draws upon a wholly different set of "intonations." The introductory note by Blok in the 1959 *klavir* (printed in both Russian and English) repeats the claim of the anonymous reporter for *Sovetskoye iskusstvo*, and couches it in the unmistakable jargon of late-Stalinist or post-Zhdanov musicography—but without reference to Lyuban or Zakharov; I would wager that at the time he wrote the note Blok had no inkling of what he would later report in his monograph: "The brightly national nature of Prokofiev's musical language became even more pronounced in the works of the last years of his life, and their melodism acquired ever greater cantilena quality and

broadness. These features of the new stage in his creative work found their reflection also in the Symphony-Concerto for Cello and Orchestra (1952).... The finale, *Andante con moto,* bears the imprint of Slavonic song and dance tradition and is a convincing and life-asserting conclusion of the composition."[17]

The main problem nevertheless remains: there is no getting around the grotesquerie of that middle section, which (as Morrison obliquely admits) would have been terribly and dangerously inappropriate were Prokofieff actually quoting a toast to Stalin, or even a fakesong by Lyuban or Zakharov meant to come from the mouths of peasant-impersonators.

That is why I no longer believe that Prokofieff was actually quoting such a song. None of the accounts thus far quoted—whether Blok's, Rostropovich's, Wilson's, or Morrison's—actually attributes the information about the derivation of the theme in question to Prokofieff. Why assume that Zakharov's supposed recognition of the tune and his characteristically bullying threat was a response to something that Prokofieff had deliberately done? The mere fact that Zakharov "found" a song by Lyuban in the middle of Prokofieff's finale is not evidence that Prokofieff put it there. As it happens, there is another—to my mind, simpler and more convincing—way of accounting for the theme that has occasioned all of this reportage and interpretation. Example 11.3 shows the main theme of the finale, which was taken over directly from the earlier Cello Concerto, op. 58. Both in that work and in the *Symphony-Concerto* the theme is followed by a series of variations. Following the theme in ex. 11.3 is a demonstration, loosely modeled on the "Functional Analysis" or F/A method that readers with long memories may still associate with the late Hans Keller, of a series of putative stages through which the variations theme can be transformed, using only familiar elementary devices, into the theme of the middle section.

If we assume, as I am proposing, that the theme of the middle section of the finale is merely another variation of the opening theme, then we do not have to wonder which Lyuban song Prokofieff had adapted, or what he meant by doing so, or why he made the music sound so grotesquely humorous. Turning an abstract theme into a dance of recognizable genre is a standard technique when writing "character variations," such as Beethoven's Diabelli or Eroica sets exemplified. Viewed thus, Prokofieff was doing exactly what Stravinsky had done in the also grotesquely humorous second movement of his Octet for winds, in which the theme becomes by turns a recognizable march, a recognizable waltz, and (according to some) a recognizable can-can, before becoming a fugue. Or recall Charles Ives's "Variations on *America*" for organ, in which a tune that some will recognize as "God Save the Queen" is put through grotesquely humorous paces that include a waltz and a polonaise.

So here is a new scenario to consider: In transforming the finale of his older Cello Concerto, op. 58, into the finale of his *Symphony-Concerto,* op. 125, Prokofieff

EXAMPLE 11.3

a. Main theme of *Symphony-Concerto* finale (transposed from E major).

b.

c.

d.

e.

f.

g. "Belorussian" theme.

FIGURE 11.3. Official seal of the Belorussian Soviet Socialist Republic as it appeared from 1922 to 1937.

wrote a new variation of the main theme that had the character of a waltz as played by a village band. I still think it sounds Jewish—that is, "klezmerish"—and now there is no reason why it shouldn't.[18] There is no contradiction, in fact, between sounding Jewish and sounding Belorussian, in case you prefer the latter. "Belorussian" and "Jewish" were terms long associated with one another, quite unironically, in tsarist Russia and the early Soviet Union. From 1922 until sometime after 1937, the high proportion of Jews in the population of the rather small Belorussian Soviet Socialist Republic actually made Yiddish one of the republic's official languages, and the republic's official seal even had the illustrious slogan adapted

from Marx and Engels's *Communist Manifesto* in Yiddish alongside Russian and Belorussian (fig. 11.3).[19] As Marina Frolova-Walker informed us during question time at the Cambridge conference, "1948 and All That," after I had given the gist of this essay as a talk, "Belorussian" was a common Soviet euphemism for "Jewish" and could work also in the opposite direction, as an alibi (hence Blok's fastidious reference to the "Slavonic song and dance tradition").

But I digress. To return to my proposed scenario: On hearing Prokofieff's "Belorussian" variation, Zakharov was reminded of the tune by Isaak Isaakovich Lyuban (whose first name and patronymic identify him beyond doubt as Jewish) and registered an objection to it, whether on grounds of "plagiarism" or (as I suspect) on grounds of racial (er, "national") prejudice. When Rostropovich carried this news back to Prokofieff, the composer, not relishing the thought of a tussle with a notorious finger-pointer, decided to write a temporary replacement for the offending theme, which was duly published as an alternative in the first edition (where it was ineptly and confusingly presented).[20] And then, just as Rostropovich told Wilson Prokofieff had promised he would do, Prokofieff used the offending tune again in two subsequent works for cello, but with alterations that lessened its resemblance both to Lyuban's tunes and to his own variations theme.

My answer, therefore, to my titular question is "Nothing at all; you've mistaken me for somebody else."

NOTES

1. In the introduction to *On Russian Music* (Berkeley: University of California Press, 2009), 4–5.

2. Blok (1932–96) was a composer and scholar who made something of a specialty of Prokofieff's solo cello music. He completed the Sonata for Unaccompanied Cello, op. 134, from Prokofieff's sketches; revised Kabalevsky's completion of the Concertino, op. 132, and reorchestrated it for Stephen Isserlis; and published a monograph on the subject: *Violonchel'noye tvorchestvo Prokof'yeva* (Moscow: Muzïka, 1973) (hereafter cited as *VTP*, with further citations made in the main text).

3. It was reissued forty years later as part of an eleven-CD set commemorating the centenary of Electric and Musical Industries, Ltd. (EMI Centenary Edition 1897–1997: 100 Years of Great Music).

4. Google knows, of course: The *Merriam-Webster* online dictionary defines *brevier* as "a size of type between minion and bourgeois, approximately 8 point."

5. Нотный текст, напечатанный петитом, представляет собой вариант среднего эпизода этой части.

6. According to Rostropovich, Prokofieff insisted on marking the simplified passages *facilitazione* instead of the customary *ossia* to make sure that no self-respecting player would choose them; see Mstislav Rostropovich, "Prokofiev as I Knew Him" (1954), in Semyon Isaakovich Shlifshteyn, ed., *S. Prokofiev: Autobiography, Articles, Reminiscences*, trans. Rose Prokofieva (Moscow: Foreign Languages Publishing House, n.d.), 247 (hereafter cited as *PAAR*).

7. In the event, Mr. Maisky for some reason performed the Dvořák concerto instead, but my note was printed in the program anyway; the main piece on the program, conducted by Kurt Masur, was the *Alexander Nevsky* cantata. The Berlin Wall had fallen a month earlier. I was incredulous that Maestro Masur, one of the much-sung heroes of the events leading up to that great moment, was performing

such an orgy of Soviet tub-thumping (one of the few Prokofieff works exempted from the 1948 ban, so that hearing it actually came to irritate the composer—see Syatoslav Sergeyevich Prokofiev, "O moikh roditelyakh: Beseda sïna kompozitora s musïkovedom Nataliyey Savkinoy," in *Sergey Prokof'yev 1891– 1991: Dnevnik, pis'ma, besedï, vospominaniya,* ed. M. E. Tarakanov [Moscow: Sovetskiy kompozitor, 1991], 229). I wrote about my dismay somewhat later in the *New York Times,* thus producing the first of what have been taken—wrongly taken—as my anti-Prokofieff screeds: "Prokofiev, Hail . . . and Farewell?" *New York Times,* 21 April 1991, sec. 2.

8. This detail came from Rostropovich's memoir (*PAAR,* 247).

9. It was published three years earlier in Minsk in a collection called *Belaruskiya narodnïya revolyutsïynïya pesni;* there is also an edition (Voroshilovsk: Izdatel'stvo "Ordzhonikidzevskaya Pravda," 1940) that omits the attribution to Lyuban and calls it a Belorussian folk song (information kindly provided by Marina Frolova-Walker).

10. http://74.125.155.132/search?q=cache:VZN8lJc6X2oJ:www.prokofiev.org/articles/sinfonia.html +%22Isaak+Isaakovich+Lyuban%22&cd=1&hl=en&ct=clnk&ie=UTF-8 (link now defunct).

11. "The Russian Enigma," speech broadcast 1 October 1939; quoted in William Henry Chamberlin, *The Russian Enigma: An Interpretation* (New York: Charles Scribner's Sons, 1943), 1.

12. *Rostropovich: The Russian Years 1950–74* (13 CDs; EMI 72016), 28.

13. In his recent, very casually researched biography of Prokofieff, Igor Vishnevetsky somehow leapt from this story to yet another song by Zakharov popular during the war, "Na zakate khodit paren' vozle doma moego" (At Dusk a Fellow Strolls Past My House; better known by the words of its refrain, *I kto ego znayet*—"And who knows why"), and piles onto the clandestine-message-mongering bandwagon: "Prokofieff could not deny himself the pleasure of working into the theme-and-variations finale a quotation from one of those who had been held up by the organizers of the 1948 persecutions as a model composer—the refrain from the popular song 'At dusk a fellow strolls past my house' by Vladimir Zakharov to words by Mikhaíl Isakovsky. The refrain from this universally familiar song emerged in lampoonish, jocular fashion, making the rounds among the various groups of instruments and the solo cello. . . . Prokofieff was caustically ridiculing Zakharov himself, who had inveighed actively against 'useless' symphonies and been raised up by a turbid wave to the post of an undersecretary in the Composers' Union, and with undisguised sarcasm said right to his face what he thought of his unseemly role: 'And who knows why, / Why he's winking, / Why he's sighing, / What he's hinting . . .'" (Igor Vishnevetsky, *Sergey Prokofiev* [Moscow: Molodaya gvardiya, 2009], 656–57). As Vishnevetsky cites no sources, it is unclear how he arrived at this fairy tale, but it could not have been on the basis of listening to the song or to the *Symphony-Concerto.* The two have nothing at all in common. The refrain is, like Zakharov's "Bud'te zdorovï," in duple, not triple, meter, although the verses (as is common in Zakharov's rather sophisticated songs) are in the triple meter of Prokofieff's theme; but neither the refrain nor the verses show any resemblance to Prokofieff's melody (or to Lyuban's tunes). Vishnevetsky seems merely to be retailing a rumor he has heard.

14. Elizabeth Wilson, *Mstislav Rostropovich: Cellist, Teacher, Legend* (London: Faber & Faber, 2007), 74.

15. "Novosti iskusstv," *Sovetskoye iskusstvo,* 12 January 1952; cited in "Prokofiev and Atovmyan: Correspondence, 1933–1952," compiled and annotated by Nelly Kravetz, in Simon Morrison, ed., *Sergey Prokofiev and His World* (Princeton, NJ: Princeton University Press, 2008), 264.

16. Simon Morrison, "Review-Article: Rostropovich's Recollections," *Music and Letters* 91 (2010): 88.

17. Vladimir Blok, preface to the piano reduction of the *Symphony-Concerto* (Moscow: Muzgiz, 1959), anonymously translated.

18. Izrail' Vladimirovich Nest'yev (1911–93), Prokofieff's authorized Soviet biographer, agreed. In his biography, which was published in English translation in 1960 (just a little too late for me to consult

when, as a fourteen-year-old boy, I first wondered about the theme and its replacement), he wrote that what he calls the "second theme" in the finale "is in the style of a rhythmic folk dance and is thematically related to the familiar Belorussian song 'Good Health to You,' but in varying it, the composer gave its simple melody a slight trace of irony. This can be seen in both the 'moaning' harmonies and the stylized orchestration, which recall the music played by village wedding bands (the composer jestingly called this episode 'poor relations'). On the whole, the second theme and its variations convey an amusing picture of everyday life similar in quality to the one found in the *Overture on Hebrew Themes*, Op. 34" (Israel V. Nestyev, *Prokofiev*, trans. Florence Jonas [Stanford, CA: Stanford University Press, 1960], 428). For another example, cf. Mikhaíl Fabianovich Gnesin's *Yevreyskiy orkhestr na balu u gorodnichego* (The Jewish Orchestra at the Mayor's Ball), op. 41 (1926).

19. As it appeared in the original text of 1848: *"Proletarier aller Länder, vereinigt euch!"* or "Working men of all countries, unite!" (in Russian, *Proletarii vsekh stran, soyedinyaites'!*)

20. Simon Morrison, in his capacity as editor of the journal in which this text was first published, made the tantalizing suggestion that the replacement waltz might even have been composed by Rostropovich, who was trained in composition at the Moscow Conservatory and to whom Prokofieff farmed out a bit of the passagework in the *Symphony-Concerto*. This must remain conjecture for now, as the autograph score of the *Symphony-Concerto* became the personal property of Rostropovich, who always withheld his personal archive from scholars, "a prohibition," Morrison adds, "that his daughter Olga now happily upholds."

12

The Birth of Contemporary Russia out of the Spirit of Music (Not)

The title, you must realize, is a Wagnerian joke by way of Nietzsche. I not believe in music as prophecy, or even as cultural seismography, and I seem to be devoting my life of late to combating the kind of romantic overvaluation of art that leads to its decline. I have published a book recently, called *Defining Russia Musically*, that could be read, although I would not insist on it, as a sustained polemic against Russian exceptionalism. So it may be that I am starting out with two strikes against me in view of what you may be expecting from a musicologist.

In considering the best way to focus my remarks on what could seem an unmanageably broad and shapeless topic—the effect of recent Russian history on Russian music—I finally decided to cast the talk as a response to an unusually stimulating essay that appeared in the *Musical Quarterly*, the oldest academic music journal in the United States, in the late fall of 1992: that is, Year One of the post-Soviet era. A survey of recent Russian concert music against the background of contemporary Russian music life, it was called "The Paradox of Russian Non-Liberty" (probably someone's translation of *Zagadka russkoy nevoli*), and it was by Alexander Ivashkin, a remarkable musician and writer with whom I was slightly acquainted, having spent an afternoon chatting with him in a Berkeley café in 1989.[1]

Ivashkin (1948–2014) was a cellist who, before emigrating in the wake of the Soviet collapse, had been co-principal cellist in the orchestra of the Bolshoy

Delivered as a lecture at Stanford University on 5 November 1998 as part of a conference, "Russia at the End of the Twentieth Century." It was reprinted at the request of Katarina Tomašević, somewhat revised and lightly annotated, in the Serbian journal *Музикологија*, vol. 6 (2006), and I have revised it some more for its appearance here.

Theater in Moscow. From 1978 to 1991 he directed the Bolshoy Soloists Ensemble, which gave very well attended concerts of new music. He was also a gifted writer, who had published monographs on Alfred Schnittke, whom he knew intimately, as well as Krzysztof Penderecki and Charles Ives. Beginning in 1992, along with many prominent Russian or otherwise post-Soviet composers (Schnittke, Gubaidulina, Kancheli, Pärt, Dmitry Smirnov, Elena Firsova), he lived abroad, at first in Canterbury, New Zealand, where he worked as professor of cello and music history at the local university. In 1999, Ivashkin was appointed head of Performance Studies and director of the Centre for Russian Music at Goldsmiths College, University of London. He was a tall man, slim, trim, and blond, a natty dresser, very cosmopolitan and sophisticated. When the two of us stood side by side, I was the one who looked like the mad Russian.

So I was quite taken aback to find my elegant, globe-trotting friend trading so heavily in the old romantic rhetoric of difference and exceptionalism, and continuing to purvey so many traditional national stereotypes. It's a stale discourse but one we still have to deal with, it seems, because so many remain nostalgically attached to it, although reasons for attachment vary. In *Defining Russia Musically*, I put it this way: "Tardy growth and tardier professionalization, remote provenience, social marginalism, the means of its promotion, even the exotic language and alphabet of its practitioners have always tinged or tainted Russian art music with an air of alterity, sensed, exploited, bemoaned, asserted, abjured, exaggerated, minimized, glorified, denied, reveled in, traded on, and defended against both from within and from without."[2]

Now here is Ivashkin, writing from within: "I have discussed the morphological, rather than syntactic, character of Russian musical mentality. We borrow Western syntax and destroy it, moving deeper the roots, paying more attention to the expression of the particular moment than to its structure" (555). Or this: "A work of Russian art is a confession. There is nothing commonplace in it, nothing decorative, well balanced, or moderate. Everything is extreme, sometimes shocking, strange" (545). Or this: "An urge to interpret, to 'endure' is inherent in Russian culture. You will never find just a ready-made product in art or in music. This is true also of Russian icons: your positive relation to an icon when you view it is very mobile, multi-angled. To understand its symbolic meaning, you have to enter the space of the icon and move in different directions" (549).

So we still have the old picture of the Russian composer as some kind of cross between Oblomov, Raskolnikov and the *yurodivïy* or Holy Fool from *Boris Godunov*. And just as Oblomov must have his Stolz and Raskolnikov his Razumikhin, this totalized or essentialized specter has its counterpart in the totalized and essentialized West: rational, syntactic, structural, balanced, moderate, readymade. Ivashkin's juxtaposition of stereotypes has its prototype in a famous remark by Musorgsky: "When a German thinks, he reasons his way to a conclusion. Our

Russian brother, on the other hand, starts with the conclusion and might amuse himself with reasoning. That's all I have to say to you about symphonic development."[3] The traditional stereotype of Russian music is in fact a portrait of Musorgsky—Repin's red-nosed, bleary-eyed portrait, to be precise, with an added *soupçon* of Chaikovsky (say, the program of the Fourth Symphony and the subtitle of the Sixth) thrown in for the sake of confession.

But what of the many who don't fit in? Where does Rachmaninoff enter the scheme? Where is Prokofieff, the least confessional composer that ever lived? Where is Stravinsky, long widely accepted as the avatar of all the "Western" values Ivashkin has implicitly constructed against his Russian icon? Ivashkin, a performer by training, even coins a stereotype all his own to cast Russian music in opposition to Western. He calls it "performance ephemera," and like a true Eurasian goes on to say that it is "probably an Oriental feature, like the Japanese art of flower arrangement, which is also ephemeral." From this he generalizes: "all ephemeral things, and only ephemeral things, are beautiful for Russians: music, performance art, and ultimately life itself" (555). So add Scriabin to the ranks of the excluded, and all his Silver-Age contemporaries, obsessed like him with the transcendent, the supernal, the enduring, the One. But of course that, too, is often touted (though not by Ivashkin) as an essentially if not exclusively Russian trait.

And where is Anton Rubinstein, the most famous (and, many used to think, the greatest) Russian musician of the nineteenth century? Not a Russian? Not "really" a Russian? You know what I mean. There in an ethnic nutshell is the reason why we'd better think twice about defining the Russian musical essence. As soon as you've defined authentic Russian music, you have also identified, through music, authentic Russians. What an abuse of music! And that is not even the worst of it. As feminists and queer theorists could have told our proud Russian, trading in essences plays into the hands of misogynists and homophobes, who often define the relevant essences no differently from misguided advocates for human rights. Ivashkin's national essences are just as likely to turn around and bite their protagonists. Compare David Brown, Chaikovsky's most copious British biographer: "His was a Russian mind forced to find its expression through techniques and forms that had been evolved by generations of alien Western creators, and, this being so, it would be unreasonable to expect stylistic consistence or uniform quality."[4] And yet, despite Chaikovsky's having inherited what Brown is pleased to call a "wholly different set of racial characteristics and attitudes," Brown concludes that "a composer who could show so much resourcefulness in modifying sonata structure so as to make it more compatible with the type of music nature had decreed he would write was no helpless bungler."[5]

Is there any way to stop thinking thoughts like these? Is it so hard to regard compositional style as an aspect of behavior rather than biological endowment, as

something to be discussed and evaluated alongside other forms of musical behavior such as performance and reception, rather than as an emanation of preternatural essence? Ivashkin's biases lead him to interpret only those musical responses to recent Russian history that confirm his stereotypes as being "correct" or "authentic" responses. In particular, he is at pains to devalue responses that see the waning of Soviet power, the crumbling of walls, and so forth, as an opportunity to erase the mythology of essential difference. He sees this attitude as threatening loss of the "inner tension" that sustained Russian music and made it great. A young post-Soviet composer, Vladimir Tarnopolsky, put it to Ivashkin this way: "Maybe I've lost programmatic, extramusical ideas, but I've got a new quality, and a new understanding of pure sound instead" (544).

I'd like to quarrel with Tarnopolsky's dichotomy of "extramusical ideas" vs. "pure sound," but Ivashkin picks a different fight. He sees Tarnopolsky's attitude as being akin to privatization of the economy, implying objectivity and commercialism, both un-Russian traits. "Now we can export our music and art," he complains. "Russian music and Russian composers are known everywhere. Sometimes it seems to be not far away from our century's very common stream." The "typical attitude" of such a moment, Ivashkin asserts, is "Everything must be sold" (555). Clearly, his idea of Russianness has been colored by his Soviet education. But there is another, more attractive—or at least less objectionable—way of looking at the attitude Tarnopolsky expressed. In 1991, the year of the August putsch and the dissolution of the Union, another Moscow composer, Alexander Raskatov, composed a lovely piece for cello and piano called *Dolce far niente* (A Sweet Nothing). What appeals to me in Raskatov's response is its resonance with Robert Benchley's wonderful old essay "Johnny-on-the-Spot," which begins:

> If you want to get a good perspective on history in the making, just skim through a collection of news photographs, which have been snapped at those very moments when cataclysmic events were taking place throughout the world. In almost every picture you can discover one guy in a derby hat who is looking in exactly the opposite direction from the excitement, totally oblivious to the fact that the world is shaking beneath his feet. That would be me, or at any rate, my agent in that particular part of the world in which the event is taking place.[6]

And that would be music, some would say—or more to the point, that *should* be music. Music is for *Dolce far niente*s, or for "a new understanding of pure sound," not for social cataclysms. It can be an especially attractive idea when one has been brought up with the opposite idea—that *your* music must register *my* engagement with history.

This kind of retreat has happened once before in the fairly recent history of Russian music. The most widely publicized musical reaction to the post-Stalinist "thaw" of the mid-1950s to mid-60s was the emergence of the so-called

underground avant-garde in Moscow, Leningrad, and Kiev. At a time when artists and writers were pushing the envelope of the permissible by treating social problems unrecognized within the canons of socialist realism, a group of young composers began aping the styles of the then-current Western European avant-garde—mainly composers associated with the summer classes at Darmstadt such as Pierre Boulez, Karlheinz Stockhausen, and Luciano Berio. The figure widely regarded then as their ringleader was Andrey Volkonsky, a scion of one of the great noble families of Russia, who was born in Geneva in 1933, studied piano with Dinu Lipatti and composition (he claimed) with Nadia Boulanger, and moved back to Russia with his family in 1948, a rather inauspicious year for Soviet musicians. His embrace of serialism was as much a rejection of the Boulangerie as it was of the Moscow Conservatory, and it may seem a paradox—shall we call it the "Paradox of Russian Non-Liberty"?—that his first celebration (or assertion) of post-Stalinist creative freedom should have been a composition called *Musica Stricta* for piano (1956). His most famous piece, *Zhalobï Shchazï* (or *Les plaintes de Chtchaza*, as its published title page puts it), was so slavish an imitation of Boulez's *Le marteau sans maître* that it was quickly nicknamed "The Hammer without a Sickle" in the West, where of course it was chiefly performed. It makes tame, faintly embarrassing listening now, as do the first works of Edison Denisov and Alfred Schnittke to have achieved performance in the West. *Solntse Inkov* (The Sun of the Incas, 1964) by the former and *Pianissimo* for orchestra (1968) by the latter, although they would have marked their composers as camp followers and conformists in the West, and though their musical content was doggedly abstract and noncommittal, were received both at home and abroad as harbingers of "dissidence" on a par with the writings of Vladimir Dudintsev or Andrey Sinyavsky or even Solzhenitsyn.

But there is really no paradox at all. Nothing is received out of context, and the context in this case was obviously the Cold War, which invested this rigorously academic, socially alienated music with an aura of civil disobedience, because its methods were opposed by the culture politicians in the one sphere and touted by the culture politicians in the other. The composers of the early underground Soviet avant-garde did not help their careers in the narrow sense by affiliating with it, but they gained an otherwise unavailable prestige, not only in the West (where at the time Soviet music, even Shostakovich's, otherwise attracted very little interest) but also at home, where their names, as I can testify, were spoken in reverent whispers by conservatory students. And at least one Western academic—Joel Spiegelman, then a professor of music at Sarah Lawrence College—made his career almost exclusively on the basis of his Soviet avant-garde importing and brokerage business.

The abstract and academic serial model did not keep its prestige very long within the Soviet Union, even among the dissident set, which by the 1960s was as irrevocable a presence on the musical scene as it was in the political arena, and there is no discernible movement toward its revival in the post–Cold War

environment, now that it has lost its allure even in the Western academy. For even late-Soviet dissidents and post-Soviet free traders are after all Soviet composers at heart, who now regard the old Western avant-garde and the work of its more recent epigones, in Ivashkin's well-chosen words, as being "too dietetic, too vegetarian" (545). I will never forget a conversation I had in 1972 with Nikolai Karetnikov (1930–94), then one of the best-known Soviet composers "for the drawer," whose works were nevertheless a frequent presence in Warsaw and (until 1968) in Prague, and were even recorded in Leningrad (under Igor Blazhkov) expressly for foreign broadcast ("to show we have ugliness too," he chuckled). He earned his living the usual way, by writing soundtrack music for animated cartoons. He, too, wrote serial music, but one would never take it for Darmstadt music. When I told him this he made a wry face and said, "If I thought that music was just a *zvukovaya igra*—a play of sounds—I could write a symphony every week. *No k sozhaleniyu, i yest' dramaturgiya*: But unfortunately, there is also dramaturgy." *Dramaturgy* was a word only Soviet musicians used when talking about instrumental music. Despite his disaffection, Kolya Karetnikov was showing his Soviet colors. Like any other Soviet musician, he did not think of symphonic dramaturgy as something "extramusical," either. God bless his soul.

And speaking of God, Kolya Karetnikov was also drawn to composing church music in a modernistic style. What an instinct for success, I thought, when he showed it to me. But yes, there was "inner tension" in his music aplenty, and great vitality. One hears it too, albeit more naively, in the early work of Arvo Pärt, in which Darmstadt avant-gardism rubs up against neomedievalism. That equation of the archaic and the up-to-the-minute was characteristic of the Western avant-garde, too. Anything that deviated from the nominal mainstream was fair game, whether the mainstream was defined Westernly as the commercial mainstream, or Russianly as the political or civic mainstream. Nowadays, having divested himself of his Cold War (i.e., twelve-tone) baggage, Pärt has attached his archaism to a more viable contemporary discourse, joining the ranks of the New Age (or, as they like to call it in the music biz, "newage"). He has become, in the witty words of the *New York Times,* "the gentlest and least angry of our Luddites,"[7] and right now by far the most popular of the post-Soviets.

One spots the same pattern in Volkonsky's career: unable to gain a hearing as a composer, in the sixties he fell back on his keyboard training, became the Soviet Union's best-known (or only) professional harpsichordist, and founded an early music group known as Madrigal, modeled on the New York Pro Musica, which played to sold-out houses both at home and abroad. Even the music of Josquin des Prez or William Byrd, in what was by then the Brezhnevite stagnation, could give audiences a frisson of dissidence. Now, in the laissez-faire state that Russia has become artistically, not even Heavy Metal can achieve that. The prevailing musical mood is one of futility, and not only because economic prospects are so poor.

But the mainstream or official modern style that the dissident faction played off against in late-Soviet Russia was one that contradicted Ivashkin's romanticized image of Russian music in every way. The combination of excellent training and well-rewarded conformism had produced a music of repellent glibness: ready-made and commonplace in every way, completely devoid of "confession," utterly "syntactic," utterly lacking in anything "extreme, shocking, or strange." Sometime in the mid-1980s, around the time of Gorbachev's accession but (as I recall) just a bit earlier, a delegation of young talents handpicked by the Union of Soviet Composers visited several American campuses including Columbia University, where I then taught. They were led by Alexander Chaikovsky (no relation, I was told, to P. I., but a nephew of Boris), a pupil of Tikhon Khrennikov who at the time was touted as his teacher's eventual successor as Union head,[8] and it included several composers from the outlying "republics"—Baltic, Caucasian, Central Asian. No matter where it came from, though, the music was in a very alarming way the same: it seemed to revive the old Baroque *Fortspinnung* technique, the manner of writing that makes Baroque music such a dependable source of sonic wallpaper to be dispensed on FM radio. The music was anodyne, remarkably polished, and as unstoppable as a Fidel Castro speech. There didn't seem to be such a thing as a short piece anymore in the USSR. Or maybe they just seemed long.

But worst of all was the nearly universal reliance on hothouse folklore—an old Russian vice, to be sure, as was its exportation to the republics. But there was a difference. Rather than treating folklore, in the older Russian fashion, as thematic material for academic elaboration, this newer Soviet music belonged to what had by then been known for a decade or so as the *novaya fol'klornaya volna*, the "new folkloric wave." As in the older movement retrospectively christened "neonationalism" by art historians, which touched music but little, the new Soviet folklorism sought not merely thematic material but also stylistic traits in folklore. To quote Yakov Tugendhold's 1910 review of the *Firebird* ballet, now famous as an encapsulation of neonationalism, "the folk, formerly the object of the artist's pity, is now increasingly the source of artistic style."[9] Neonationalism promised an "authentic" modernism: that is, a modernistic style based not on the abstract universalism of numbers (as in serialism and its antecedents), but on the particular reality of national traditions. As the reference to *Firebird* already suggests, the one Russian composer to embrace neonationalism wholeheartedly in its time was Stravinsky. But Stravinsky's neonationalist works, such as *Le sacre du printemps* and especially *Svadebka* (a.k.a. *Les noces*), were particularly reviled during the Stalinist period, when modernism was anathematized and a modernistic style based on folklore could only be interpreted as mockery of the folk. The official embrace of neonationalism a half century later under the rubric *novaya fol'klornaya volna* looked benign enough—but only until one recalled the connections between the older neonationalism and *Yevraziystvo*, "Eurasianism," the extreme protofas-

cist Russian nationalism hatched in the emigration between the wars, in which Stravinsky, alas, also participated. This was the worst and most intolerant manifestation ever of Russian exceptionalism, and its resurrection as an official Soviet modernism in opposition to a modernism tainted by association with Schoenberg, a "rootless cosmopolitan" (to say it *po-sovetskomu*) could only strike another rootless cosmopolitan like me as sinister.

There are unwelcome echoes of *Yevraziystvo* as well as *Oblomovshchina* in Ivashkin's diagnosis of the current situation in Russia. "The fateful role of Russia is to join West and East in both a social and cultural sense," he writes. "In the past, there was no real contact between the culture of the West and Russia.... Russia never had freedom. And life in Russia was never so scheduled, so well organized, as in the West, so the perception of Western traditions and cultural pattern could not be direct: there was always some Russian amendment, some modification" (550). But this is a variant of the same glibness I was protesting a moment ago in its musical manifestation.

And yet, although Ivashkin's essay does not register them, there have been signs of change. I encountered them in May 1991 at a conference in Chicago organized in connection with the American première, by the Chicago Symphony under Daniel Barenboim, of Edison Denisov's *Symphonie pour grand orchestre*, a piece that continued, as its title suggests (and as Denisov had always done), to appropriate Western traditions and cultural patterns without any Russian amendment whatsoever. But a few hours earlier, at a chamber concert at the Chicago Art Institute devoted to recent works by late-Soviet composers, I had been powerfully struck by the renunciation, not only of folklore, but of all easy rhetorical effect and of the smooth spinning-out of bland ideas that had so appalled me a few years before. The younger composers (especially Elena Firsova, who now lives with her husband, Dmitry Smirnov, in England, and Sofia Gubaidulina, now living in Germany) seemed to have lost their voices, so determinedly did they seek to avoid the specious volubility of the recent past.

The models here were two: the late quartets of Shostakovich, particularly the Thirteenth (which made a point of voicelessness with its unsettling substitutions of bow-tapping on music stands for conventionally played notes), and, most proximately, the recent work of Shostakovich's former pupil, the mysterious, reclusive Galina Ustvolskaya, whose music also figured in the Chicago concert. Behind it all lay the example of Beethoven, especially the passage in the "Cavatina" from the B-flat Major Quartet (prefigured at the end of the *Eroica* Symphony's "Funeral March"), where Beethoven breaks his song with sobs and gasps, made explicit with the marking *beklemmt* ("choked up"). At the tail end of the Soviet era, it seemed, composers were doing costive penance for past loquacity, and I found it intensely moving.

Now the mantle of *Beklemmtheit*, "tongue-tiedness," has fallen on the St. Petersburg composer Alexander Knaifel, another hermetic figure. His *Agnus Dei* is a

2½ hour chamber quartet. Filling such a span of time with music might seem the opposite of tongue-tied, but imagine a conference report like the one I am now giving delivered by a morbidly bashful speaker with a severe stammer. That is the effect for which Knaifel, who I sometimes think of as the Russian Morton Feldman, is celebrated, and for which he is beginning to be revered the way Schnittke and Denisov were once revered. But Denisov, in whose honor the Chicago chamber concert was given, remained loquacious: his clarinet quintet, played on the same program as Ustvolskaya and Firsova, seemed very Soviet indeed in its smooth garrulity. And although my saying so may win me few friends, that is how I have always felt about the teemingly prolific work of Alfred Schnittke, too, whose very public and oratorical stance and too-easily-decoded dichotomies and antitheses have always struck me as socialist realism minus socialism.

The difference, and it could be a saving difference, lay in the stylistic eclecticism (or "polystylistics") that Schnittke's international prestige helped make newly acceptable—indeed expectable, and not just in Russia. Ivashkin, who was Schnittke's close friend and confidant, is especially eloquent on this score. In Schnittke's late- or post-Soviet idiom he sees "the development of a new type of culture, a meta-culture." Reminding us that "meta" is the Greek for "post," which is Latin for "after," he explains: "Meta-culture takes different traditions, different idioms, and puts them into a new context, or at a different level. These idioms, traditions, ready-made products, of particular cultures are amalgamated in a meta-culture, where they begin to function as primary elements of a new parasitic culture, and they are productive at the same time" (551).

For example, Ivashkin continues, "the heroes of works by James Joyce, Charles Ives, Luciano Berio are styles and historical traditions, mixed and melted together." The three names are well chosen. They show that Schnittke's polystylistic idiom was not so revolutionary after all, that it was not preternaturally Russian, and that in view of hardcore modernist antecedents like Joyce, there is no point in slapping the fashionable "postmodern" label on it. Rather than postmodernism, it is simply post-ism, after-everythingism, an evocation of Dostoevsky's terrifying world without God where anything was possible, and so nothing mattered. In the context of the Leninist world in which Schnittke lived, where nothing was possible and everything mattered—or in that of the equally administered, equally deterministic Western world of academic modernism—such a vision promised not nihilism but liberation, or at least a change.

Now we've had the change and nihilism is setting back in. Nostalgia for the bad old days is returning in the music world, as it is doing everywhere. Remember Ivashkin's comment on the "inner tension" that sustained Russian difference. Here is the sentence that preceded it: "Of course, the cultural context changed completely after the Second Russian Revolution of August 1991: there is no longer any pressure, control, or censorship. Russia has become a new country, but in spite of

its new freedom, something is definitely missing" (543). I would suggest that what is missing for Ivashkin and many other nostalgic Russians, and what he is calling "inner tension," is in fact the heroism, the greatness that, as we like to imagine, tyranny calls forth in response. Without a Stalin there cannot be a Shostakovich, this theory goes, and it is fed by the torrent of strained sentimental revisionism now being visited on poor Dmitry Dmitriyevich, who is being shamelessly promoted, both in Russia and (even more) in the excuseless West, not merely as an anti-Stalinist but as the veritable anti-Stalin.

These ideas, too, are anything but new. They are the stalest romanticism. Consider Stendhal's *Life of Rossini,* a book first published in 1825. Throughout its length, the author argues that art, and music in particular, can flourish only under tyranny, never in a democracy, and this for two reasons: first, because democracy demands so much participation from its citizens that they will be left with no leisure for art; and second, because under tyranny the arts give silenced people a precious avenue of expression. The day that the people rise up against the papal government, Stendhal wrote, will "mark the end and death of art in Italy; instead, we shall be greeted by the cold blast of earnest political discussion, as though Venice were no longer Venice, but rather London, or Washington!"[10] When followed to the point of folly, as in certain writings of George Steiner,[11] the implicit overvaluation of art breeds contempt for democracy, indeed for politics *tout court.*

God knows there's a lot of that about in Russia today. But, let me hasten to remind you, Stendhal himself did not follow his reasoning to the point of idiocy. Artist and art-lover though he was, he kept things in perspective, finally acknowledging that "the arts are only a luxury in life: the essentials are honesty, reason, and justice."[12] And that is why at first I resisted the invitation to participate in these commemorative and predictive exercises. I feel no nostalgia for the totalitarian past, however great the concomitant musical yield; still less do I regret the loss of new music's dissident cachet in post-Soviet Russia, nor have I any presumptuous predictions to offer.

I do have some modest advice, perhaps. As Nietzsche wrote, "Music reaches its high-water mark only among men who have not the ability or the right to argue."[13] Let them now get used to honest argument in Russia, let us lose the habit of heartless fatalism, and maybe one day we'll have great art and honesty, reason, and justice, too.

NOTES

1. Alexander Ivashkin, "The Paradox of Russian Non-Liberty," *Musical Quarterly* 76 (1992): 543–46. Page references in the text are to this source. Sasha Ivashkin and I renewed our acquaintanceship in 2002 at a Shostakovich conference he had organized at the University of Glasgow. We remained in sporadic contact for the next decade.

2. Richard Taruskin, *Defining Russia Musically* (Princeton, NJ: Princeton University Press, 1997), xiv.

3. Musorgsky to Nikolai Rimsky-Korsakov, 15 August 1868, in *Modest Petrovich Musorgsky: Literaturnoye naslediye*, vol. 1, ed. A. A. Orlova and M. S. Pekelis (Moscow: Muzïka, 1971), 107.

4. David Brown, *Tchaikovsky*, vol. 4: *The Final Years: 1885–1893* (New York: W. W. Norton, 1991), 10.

5. David Brown, *Tchaikovsky*, vol. 1: *The Early Years: 1840–1874* (New York: W. W. Norton, 1978), 108–9.

6. Robert Benchley, *The Benchley Roundup: A Selection by Nathaniel Benchley of His Favorites* (Chicago: University of Chicago Press, 1982), 241.

7. Bernard Holland, "In the Midst of Today's Chaos, the Middle Ages Echo," *New York Times*, 26 October 1998.

8. That he did not become, but he did fetch up briefly (2004–6) as rector of the St. Petersburg Conservatory.

9. Yakov Tugenhold [sic], "Russkiy sezon v Parizhe," *Apollon*, no. 10 (1910): 21

10. Stendhal, *Life of Rossini*, trans. Richard N. Coe (Seattle: University of Washington Press, 1972), 44. Thanks to Benjamin Walton for the reference.

11. E.g., *In Bluebeard's Castle: Some Notes towards the Re-Definition of Culture* (New Haven, CT: Yale University Press, 1971), 65ff.

12. Stendhal, *Life of Rossini*, 131.

13. Friedrich Nietzsche, "The Wanderer and His Shadow" (1880), in *The Philosophy of Nietzsche*, ed. Geoffrey Clive (New York: New American Library, 1965), 303.

PART TWO

Revisiting Stravinsky

13

Just How Russian Was Stravinsky?

Are we postracial yet? Not as long as the whole country looks over President Obama's shoulder to see what race he checks off on his census form. Are we postnational? Not while we still fight tooth and nail over how Russian a composer Igor Stravinsky was. We often assume, or piously pretend, that categories are there to be transcended, and perhaps some ought to be. Race and nation, both bloodsoaked, might be nice candidates for elimination. But without categories there would be nothing to help us sort out what William James called nature's "blooming buzzing confusion." Are they arbitrary, sociocultural constructions or inbuilt evolutionary predispositions? Need we choose? Can we? In any case, we're stuck with them.

So where do we slot Stravinsky, who spent the first twenty-eight years of his life in Russia, the next twenty-nine in Switzerland and France, and the last thirty-two in America? The New York Philharmonic has no doubts. Their three-week festival, beginning Wednesday, is called "The Russian Stravinsky," even though it will include works composed in every country Stravinsky inhabited. And their promos promise to "reveal how, even as he became the world's most famous composer—emigrating to Paris, Hollywood, and, finally, New York City's Upper East Side—the colorful, passionate pulse of Stravinsky's Russian heart never waned."

Not everyone agreed with this while Stravinsky lived; and among the most vociferous disagreers was Stravinsky. Is the orchestra's claim just hype, prompted by the presence of the ubiquitous Russian maestro Valery Gergiev on the podium?

Originally published in the *New York Times*, 18 April 2010, Arts and Leisure, 21, and reprinted (as "Стравинский—тайный русский" ["Stravinsky—The Secret Russian"]) in *Novaya gazeta,* 23 April 2010.

(But wait—Gergiev's not Russian, he's Ossetian! Ossetian, I tell you!) Or is there some Russian essence that binds Stravinsky's career *malgré lui*?

Not even Stravinsky could deny the Russianness of his first period—not while his music so obviously traded on it. The only great composer to establish his fame on the basis of ballets, the young Stravinsky rode the crest of a craze for Russian music and scenic art as the protagonist of Sergei Diaghilev's Ballets Russes. The concentration on ballet was not the only anomaly in Stravinsky's early career: there was also the fact that the Ballets Russes was a Russian company that never performed in Russia. His great trio of early ballets—*Firebird, Petrushka, The Rite of Spring*—were composed for Parisian—which is to say cosmopolitan—consumption, and were calculated to appeal to an audience that prized Russianness as exoticism.

This put Stravinsky decidedly out of step with his creative contemporaries at home. Russian critics around 1910 were congratulating themselves that Russian music no longer had to assert its right to exist by sounding Russian. And here was Stravinsky quoting folk songs galore: not only in *Firebird*, which used songs already popularized by his teacher Rimsky-Korsakov, or *Petrushka*, which used Russian equivalents of "Jimmy Crack Corn" or "Darling Clementine," but even in *The Rite*, in which they were hidden behind a screen of dissonant harmony and crashing orchestration (which gave Stravinsky the opportunity, later, to deny that they were there). Compared with Scriabin or the young Prokofieff, this was a very old-fashioned way of being musically Russian, but the conditions of Stravinsky's contracted labor demanded it.

Later, during World War I, which Stravinsky waited out in neutral Switzerland, homesickness brought on his most intense and heartfelt bout of musical nationalism—the bout that produced *Les noces*, the choral ballet that apotheosized a Russian peasant wedding. This period culminated in the *Symphonies of Wind Instruments*, an instrumental work composed in 1920 in memory of Debussy, which mimicked the liturgy of the *panikhida*, the Russian Orthodox funeral rite.

But before the end of the war came the Russian Revolution and the Bolshevik coup, and Stravinsky decided he would never go home. That decision, plus the first big flop of his career with the one-act opera *Mavra* in 1922, convinced Stravinsky that he had to stop representing himself as a Russian composer. He never set another word of Russian to music after *Mavra*, and declared himself a composer of "pure music," pledging "to exhaust and scuttle the limited tradition of my birthright," as he put it, much later, to his musical assistant Robert Craft. Taking his cue from a review of the *Symphonies of Wind Instruments* that stressed the work's architectural precision, Stravinsky proclaimed that it represented nothing at all—that it was merely an arrangement of "tonal masses sculptured in marble, to be regarded objectively by the ear." That was the beginning of his so-called neoclassical phase, the longest of his creative periods, which lasted until the première of his single full-length opera, *The Rake's Progress*, in 1951.

In renouncing not only Russian but all "extramusical" content, Stravinsky was hardly alone. "They who hate the revolution hate romanticism," wrote the English critic T. E. Hulme, and in the aftermath of World War I, romantic nationalism was in bad odor—an odor that only worsened with the rise of aggressively nationalistic totalitarians to power in Italy and Germany, the two countries, as it happened, with the most distinguished nineteenth-century musical traditions. After World War II, music became even purer with the emergence of the serial avant-garde—the "international grey on grey," in the skeptical words of Olivier Messiaen. Stravinsky was no skeptic. He leapt at the serial method—the most abstract and abstruse method of composition available at the time—and embraced it during the last fifteen years of his composing career. You couldn't get less Russian than that, it seemed. And until fairly recently, that was the general verdict on the later Stravinsky. Especially in the academy, musicians were happy to accept Stravinsky's assurances that Russia, for him, was only a phase. Hearts, even colorful, passionate, pulsing hearts, were (like anything biological) a matter of geographical and cultural indifference. Being Russian was a matter of behavior, and we can change that. Can't we?

We'd like to think so, but are we always conscious enough of the sources of our behavior, or sufficiently in control of it, to change at will? The recent history of Stravinsky studies has thrown some new and fascinating light on Stravinsky's behavior—and on ours.

Current conceptions of Stravinsky's music, or at least the way in which questions about it are framed, date from the year 1963, when the American composer Arthur Berger published an epoch-making article called "Problems of Pitch Organization in Stravinsky." Taking as his starting point a theme from *Les noces* that could not be analyzed according to traditional notions of musical structure (it is the one to which the bride's and groom's mothers sing their lament at the end of the third tableau), Berger had the inspired idea of laying out all of its constituent notes as a scale. When he did this, a striking pattern emerged: the notes in the scale were spaced alternately a whole step and a half step apart. Because there were eight notes in the scale, Berger christened it "octatonic"—a term that you will now find in any English-language music textbook, whether of music history, music theory, or even music appreciation (and a peek at Google has turned up *la gamme octatonique* and *die oktatonische Tonleiter* as well). To Arthur Berger, then, goes the credit of having contributed a universally accepted term to the international technical vocabulary of music.

Berger played around with the scale and showed various ways in which harmonies and harmonic progressions could be derived from it: and lo and behold, the same harmonies and progressions turned up wherever he looked in the early works of Stravinsky—and not only the early works. One of Berger's most exciting discoveries was that the theme in the variations movement of Stravinsky's Octet

for Wind Instruments of 1923—one of the emblematic neoclassical pieces—was also drawn from his newly identified octatonic scale. This was really big news, because it provided tangible evidence of the continuity that underlay Stravinsky's many stylistic metamorphoses—something previously sensed and declared, but only as enthusiastic propaganda, not as the fruit of technical analysis. Berger's latest example came from *The Rake's Progress*, a work only twelve years old when the article was written—and later analysts, particularly Pieter van den Toorn in a brilliant series of articles that culminated in a book published in 1983, even discovered octatonic traces in the serial music.

Not everyone accepted this new holistic view of Stravinsky's music at first. There are at least as many ways of dissecting a musical surface as there are to skin a cat, and if one was really determined, one could turn up octatonic scales wherever one wished. Here I thought I could help, because in the late 1970s I had begun researching Stravinsky's music from a historical rather than an inferential perspective and I knew something that Berger and Van den Toorn didn't know—namely, that the octatonic scale actually had a considerable history in Russia, where it was known . . . (drumroll, please) . . . as the Rimsky-Korsakov scale. Yes, it was named after Stravinsky's teacher, and it could be found not only in Rimsky's own music but in that of almost all of his pupils. (Earlier, I found, it had been used by Liszt, from whom Rimsky knowingly appropriated it, and even by Schubert, from whom Liszt took it.) Rimsky had used the scale in all of the ways Berger had seen Stravinsky using it, so he must have been the source not only of Stravinsky's knowledge of the scale, but also of Stravinsky's techniques for manipulating it, at least as far as *Petrushka*. So Berger's analytical approach turned out to be anything but arbitrary. It gave Stravinsky, willy-nilly, a distinguished genealogy. He was the last and most extensive participant in a hitherto unnoticed line that went back to early-nineteenth-century Vienna.

The trouble was, that line passed through Russia on the way to Stravinsky, and in the years since the Diaghilev craze Russia's musical stock had disastrously declined in the West, thanks in no small part to Stravinsky himself. Potentially embarrassing, in fact, was the debt I had uncovered to Rimsky-Korsakov (though why it should have surprised anyone that a pupil had learned from his teacher is beyond me), for Stravinsky had gone far out of his way to disavow the legacy of his old mentor. In his autobiography of 1936 Stravinsky still professed filial piety toward the man he called his *cher maître;* but by the time he had turned to memoir-dictating on an industrial scale, even the value of Rimsky-Korsakov's teaching had to be denied. Rimsky, Stravinsky told Mr. Craft, was "shockingly shallow in his artistic aims." His knowledge of composition "was not all it should have been." His "modernism" was "based on a few flimsy enharmonic devices," so that "the most important tools of my art I had to discover for myself."

So, far from validating the findings of Messrs. Berger and Van den Toorn, I had created a new problem for them. As Kofi Agawu, a music theorist now at Princeton

University, wrote in exasperation, my "claim that the extensive use of the octatonic scale indexes a Russian compositional sensibility" has "the effect of depriving Stravinsky of what might be called his hard-won cosmopolitanism." Pieter van den Toorn began to retreat from his own findings. "What do we really gain by Russianizing Stravinsky to the bone?" he now affected to wonder. As for Berger, when Mr. Craft, who had his own reasons for resisting a challenge to the memoirs on which he had collaborated, remarked to him that he found the vogue of octatonic analysis "tiresome," Berger (according to Mr. Craft's own memoirs) "chimed in with 'So do I. I wish I had never mentioned it.'"

These reactions, while of course depressing, are fascinating. When conducted on such categorical terms, the debate between music analysts and music historians can become something very like a debate between creationists and evolutionists. What evolutionists like me hope to achieve by means of analysis is not merely a description of musical configurations, as one might dissect a fern or a coelacanth, but insight into practice and behavior. In the case of Stravinsky, Rimsky-Korsakov offers an indispensable source of technical information to evolutionists, and the impulse to ignore him, which often takes the form of fastidious attacks on crowd-pleasers like Rimsky's *Scheherazade* (which—sorry—had a huge influence on *Petrushka*), seems to me to be of a piece with the resistance of creationists to the prospect that mankind may have descended from lower primates, or that the species *Homo sapiens* may have originated in Africa. It is comforting to those who rank him supreme to assume that God said, "Let there be Stravinsky," and lo! there was Stravinsky, and he was good.

So was the good Stravinsky a Russian Stravinsky? It all depends. What, after all, makes a Russian a Russian? By citizenship, Stravinsky was not Russian after 1918, when as a stateless person he accepted a Nansen passport from the League of Nations. By professed cultural orientation, it could be argued, he stopped being Russian in 1922, after *Mavra*. But musically he thought the way he was trained to think; and his training took place in Russia. He went in directions nobody dreamed he'd go while he was living at home, but as he himself told a reporter for *Komsomolskaya pravda* in Moscow in 1962, during his very emotional eightieth-birthday visit to his homeland, "I have spoken Russian all my life. I think in Russian, my way of expressing myself is Russian. Perhaps this is not immediately apparent in my music, but it is latent there, a part of its hidden nature." Thanks to Arthur Berger and Pieter van den Toorn, whether they like it or not, it is no longer hidden.

14

How *The Rite* Became Possible

"*Igor Fyodorovich, why did you write* Le sacre du printemps? *It's such a horror!*"
"*Well you see, Volodichka, there was such a fashion.*"[1]

"You know, my dear, I've often wondered, if I'd opened that door, whether I would have written *Le Sacre du Printemps*." The door was the door out of Diaghilev's house in St. Petersburg into the street. Diaghilev had invited Stravinsky over after hearing a performance of the *Scherzo fantastique*, op. 3. He wanted to enlist Stravinsky's help in reorchestrating Fokine's ballet *Les sylphides*, after Chopin, for performance in Paris during the first of his *saisons russes* in 1909. He had kept Stravinsky waiting for twenty minutes. "I was young, but already impatient. I grew restless," Stravinsky recalled five and one half decades later. "I got up and moved to the street door. As I grasped the handle, a voice behind me said, 'Stravinsky, pridite, pridite,' come in. I went in."[2]

Who knows whether this story is true? In its factual details it is as inaccurate as Stravinsky's recollections were always apt to be.[3] But there can be only one answer to the tantalizing counterfactual question: No, never. There was no way that, but for Diaghilev, Stravinsky would ever have written *Le sacre du printemps*, and this for two reasons: first, it was a ballet; and second, it had a Russian "national" subject.

The son of an opera star and a pupil of Rimsky-Korsakov, Stravinsky had been brought up to despise ballet. Indeed, if Rimsky-Korsakov had not died in time, tactless though it be to put it so, Stravinsky could never have accepted Diaghilev's proposal to collaborate. He would have been in the position of Mikhail Fabianovich Gnesin and Maximilian Oseyevich Shteynberg, his contemporaries and (while

Written for, and first published in, Hermann Danuser and Heidy Zimmermann, eds., *Avatar of Modernity: "The Rite of Spring" Reconsidered* (London: Boosey & Hawkes for the Paul Sacher Stiftung, 2013), 380–400.

Rimsky lived) friends, all bound by loyalty to a circle hostile to Diaghilev and to the whole *Mir iskusstva* clique. There is a very telling story in Gnesin's memoirs of his first meeting with a member of Diaghilev's circle, Walter (Valechka) Nouvel. At the time, Gnesin was thought of as the most advanced member of the *korsakovskaya molodyozh'*, the "Korsakovian youth," meaning the youngest generation of the great teacher's pupils. He had been demonstrating some new romances he'd written to words by the scandalous symbolist poet Balmont at a gathering at the home of another scandalous symbolist, Vyacheslav Ivanov, when he was accosted by Nouvel and Vyacheslav Karatïgin, then St. Petersburg's most militant critic.

> "Nice pieces, but they don't open any new paths," Karatïgin announced. Nouvel's opinion was the same. "You take a negative view of the contemporary French composers, but Scriabin also fails to enrapture you (me neither, by the way)—but what *do* you like in music?"—As I recall, I answered rather demonstratively, "I love Rimsky-Korsakov, I love Musorgsky and Borodin."—"That's very nice," answered Nouvel, "I also love *Saltan* and *Kashchey*—excellent things. But then you have no future ... all this is in the past, the beautiful past! *I* think that the sooner Rimsky-Korsakov dies, the better it will be for Russian music. His tremendous stature crushes our youth and prevents them from traveling new paths."
>
> In view of my reverence for my teacher, who at the time had just written *Kitezh* and was working on *Le Coq d'or*, and who had helped form so many composers and such different ones, including the then beginning Stravinsky, it was simply nauseating for me to listen to Nouvel. The conversation was quickly terminated.[4]

Stravinsky would certainly have felt the same in Gnesin's place, as long as Rimsky lived. In fact, in a memoir of Diaghilev (ghostwritten, as it happens, by none other than Nouvel, many years later), Stravinsky made a point of emphasizing that, "living in the same city" as Diaghilev, "I naturally had more than one occasion to meet him, but I never sought these occasions" during his years of study.[5] Rimsky-Korsakov would have seen it as a betrayal. Ever since Diaghilev showed up at Rimsky-Korsakov's door in 1894 with a portfolio of his own compositions under his arm, with a request to take private theory lessons, and had been told straight out that his compositions were "worse than nonsensical," and left shaking his fist and telling Rimsky-Korsakov that "he would never forget this day, and that someday Rimsky-Korsakov's opinion would occupy a place of shame in his future biography and would make him more than once regret his rashly uttered words of long ago, but that then it would be too late"[6]—ever since then, as he began to make a name for himself in St. Petersburg cultural affairs (though not, of course, as a composer), Diaghilev would remain a figure of fun for the Rimsky-Korsakov circle. The account just quoted of their first meeting comes from the memoirs of Vasily Vasil'yevich Yastrebtsev, Rimsky-Korsakov's devoted Boswell, and it served in its original context as the springboard for a merry discussion of the psychiatrist Cesare Lombroso's theories, then widely accepted, which sought to explain "decadence" of

all kinds, including cultural and artistic, in terms of actual genetic decay. Diaghilev, to general hilarity, was dubbed a "mattoid," Lombroso's term (derived from *matto*, Italian for insane) for what other turn-of-the-century psychologists called "borderline dwellers" or semi-insane types, especially graphomaniacs. As long as he remained a member of the circle around Rimsky-Korsakov, who was more than a teacher to him, but something approaching a substitute father, Stravinsky could never have taken a step in the direction of decadence.

Nor would he likely have felt able to accept a commission for a ballet. Rimsky-Korsakov communicated his derision of ballet to all of his associates and pupils, none of whom, with only two exceptions, ever wrote ballets while their teacher was alive. The exceptions were Alexander Glazunov, who had become close to Chaikovsky and in so doing aroused great jealousy in his former teacher, and Nikolai Cherepnin, who was related by marriage to Alexandre Benois, with whom he collaborated on *Le pavillon d'Armide* (1901), eventually Diaghilev's maiden balletic offering in Paris. These older men outranked Stravinsky; Glazunov, indeed, had achieved the status of near-equal to the master by the time he had dared write a ballet, and that was a status Stravinsky had no hope of ever attaining in his teacher's eyes. As far as Rimsky-Korsakov was concerned, ballet was a throwback to an outmoded aristocratic taste, and its products, for him, were still what Apollon Grigor'yev, writing in 1864 in a journal edited by Dostoyevsky, called "the fruits of M. Petipa's and St. Léon's nonsensical imaginations," naming the two Frenchmen who guided the fortunes of the Russian ballet from the 1840s to the end of the century.[7]

True, Rimsky had written plenty of dances for his operas, and even a hybrid opera-ballet called *Mlada*, but he repented of it. In 1900, the critic Semyon Kruglikov had written to ask him whether, now that his prize pupil, Glazunov, had written three ballets, theatrical dance had matured to the point where other composers of the front rank, perhaps even Nikolai Andreyevich himself, might apply themselves to it. Rimsky remained obdurate:

> I'm inclined to think not, probably. And therefore I myself will *never* write such music. *In the first place,* because it is a degenerate art. *In the second place,* because miming is not a full-fledged art form but only an accompaniment to speech. *In the third place,* balletic miming is extremely elementary and leads to a naïve kind of symbolism. *In the fourth place,* the best thing ballet has to offer—dances—are boring, since the language of dance and the whole vocabulary of movement is extremely skimpy. With the exception of character and national dance (which can also become tiring), there is only the classical, which makes up the greater part. These (that is, classical dances) are beautiful in themselves; but they are all the same, and to stare for a whole evening at one classical dance after another is impossible. *In the fifth place,* there is no need for good music in ballet; the necessary rhythm and melodiousness can be found in the work of any number of able hacks today. *In the sixth place,* in

view of its paltry significance in the spectacle, ballet music is usually performed in a sloppy, slapdash way which would tell sorely on the work of a highly talented composer.[8]

The idea that a pupil of Rimsky-Korsakov's would make his name as a composer of ballets was inconceivable at the time. No major composer had ever made his name that way. Neither Glazunov nor Chaikovsky (nor Leo Delibes nor Adolphe Adam nor Gluck nor Beethoven, to name all the greatest names associated with the genre as of 1900) had become famous as a result of their ballets. Stravinsky would be the first. And in doing so, he lost the friendship and support of Rimsky-Korsakov's survivors, even the two sons who had been among his closest friends. (Indeed, before he betrayed Stravinsky with a caustic review of *Petrushka,* Andrey Nikolayevich Rimsky-Korsakov had been the dedicatee of *Firebird.*) When the time came, Stravinsky could afford to trade them all for the new cohort of peers and mentors that Diaghilev's enterprise provided. He might even have been glad to escape by the time Diaghilev called upon him, because the surviving Rimsky-Korsakov pupils, who thought of him as an unschooled upstart owing to his training outside the conservatory, were giving him a cold shoulder. He never had the freedom of access to the Belyayev publishing house that Rimsky's favorite, Maximilian Shteynberg, enjoyed, nor could he count on performances under Belyayev auspices.

One of his most stressful experiences involved the *Pogrebal'naya pesn'* (*Chant funèbre*), his memorial tribute to his teacher, which he composed immediately on getting news of Rimsky's death in June 1908. He had a terrible fright at first that he would not be able to get the piece performed, because the St. Petersburg orchestras had commissioned memorial pieces from Glazunov and Shteynberg, rather than from him. Because Rimsky's widow intervened, Stravinsky's piece was performed at a Belyayev concert alongside Glazunov's. But it was not published alongside Glazunov's, for which reason it is now the single major work of Stravinsky's to have been lost.[9] The resentment Stravinsky felt after this humiliation lasted for the rest of his life, and is well known to all readers of his voluminous late dictated memoirs. It gave him the push he needed to respond to Diaghilev's pull the next year. But if Rimsky Korsakov had not died just then, leaving Stravinsky exposed to the indifference, verging on hostility, of the Belyayev establishment, there would have been no overt humiliation, no conscious resentment, and no push. Later, when Stravinsky sided with Diaghilev against the Rimsky-Korsakov family in the matter of balletifying first *Scheherazade* and then *Le coq d'or*, and compounded the offense by cooperating in writing a final chorus for Musorgsky's *Khovanshchina* to supersede his teacher's, he earned the enmity of the whole clan, including the two sons of Rimsky-Korsakov to whom had been so close. But by then the loss of their friendship was the price, willingly paid, of revenge.

So, were it not for Rimsky-Korsakov's fatal asthma attack in 1908, there would have been no *Firebird*—at least, no *Firebird* by Stravinsky. And had there been no *Firebird*, would Stravinsky have made his name in Paris? Never; he would have remained one of a number of former pupils of Rimsky-Korsakov competing for recognition in St. Petersburg—and, as we have observed, competing at a disadvantage. He would no doubt have finished *The Nightingale* in due course, with all of its acts being in the same exquisitely refined pastel-colored idiom of the first act; and he would no doubt have submitted it to the Maryinsky Theater for staging. Whether Vladimir Telyakovsky, the intendant, would have accepted it is anyone's guess, and so is the matter of what Stravinsky might have written next. It is certain, though, that it would not have been *Petrushka* or *Le sacre du printemps*.

And just to take this thread to its logical conclusion: Had he not cast his lot with Diaghilev, Stravinsky would have been at home in St. Petersburg when the Great War began, and there would have been no "Swiss" period. At the end of the war, or rather, a year before the end of the war, Stravinsky would have been at home in St. Petersburg when revolution came, followed nine months later by the Bolshevik coup. Would he have emigrated then, like Rachmaninoff or Prokofieff? Anyone's guess again, except that, as we know, the rest of his family stayed where they were, and took the revolution's consequences. His older brother Yury, although he was in Switzerland as the Russian consul general in Geneva in 1915,[10] returned home and lived out his life as an architect in Leningrad. He died in 1941, shortly before the outbreak of the Great Patriotic War. His childless granddaughter, Yelena Alekseyevna, whose family name (after her father, Yury's son-in-law) was Yakovleva, and whose married name was Stepanova (but who reverted to Stravinskaya in her old age), lived in St. Petersburg until her death, in 2015, extinguished the line in Russia. If Igor had stayed home with his mother and brother, he might very well have ended up, like Gnesin and Shteynberg, the other outstanding members of his cohort, as a Soviet composer—something altogether impossible to imagine.

The other reason Stravinsky would not have composed *Le sacre du Printemps* without Diaghilev's prompting is more interesting from the cultural point of view. He was a member of a generation of Russian composers who had forsworn what music historians commonly call nationalism. In this, too, they were encouraged and influenced by their teacher, for all that Rimsky-Korsakov is generally slotted in with the maverick, autodidact nationalists of the *moguchaya kuchka* in the history books. But that group had by Stravinsky's time ceased to exist—or rather, continued to exist only in the mind of Vladimir Vasil'yevich Stasov, their aging propagandist, whose viewpoint has been canonized (at first by Western disciples such as Rosa Newmarch, later by the Stalinist arts policies of the so-called Zhdanovshchina).[11] Rimsky-Korsakov was the leader of an altogether different cohort by the time Stravinsky met him: the so-called Belyayev school, named for a patron who (although patriotically committed to promoting the work of Russian composers)

favored the classics of the "unmarked" standard repertoire and hoped to see the work of highly professionalized, conservatory-trained Russians rival them.

Rimsky-Korsakov's "Belyayevets" attitudes are already evident in an interview he gave before the turn of the century, which however remained unpublished until shortly after his death, when it must have surprised and even shocked many readers. His interlocutor, Pavel Alekseyevich Karasyov (1879–1958), was a member of the Music-Ethnographic Commission of the University of Moscow, which is to say a folklorist of rigorous academic principles. He asked Rimsky-Korsakov whether the work of the new wave of "scientific" folk song collecting that had been stimulated by Tsar Alexander III's Imperial Geographical Society might have a beneficial impact on Russian art music. Rimsky's unforeseen reply was a grave disappointment to him:

> In my opinion, a special "Russian music" does not exist. Both harmony and melody are one, pan-European. Russian songs introduce into counterpoint a few new technical devices, but create a new, individual type of music they cannot. And the very quantity of such devices, apparently, is limited. Russian traits—and national traits in general—are achieved not by writing according to specific rules, but rather by removing from the common language of music those devices which are *inappropriate* to a Russian style. This method is rather of a negative character, a method of avoiding certain devices. Thus, for example, this turn of phrase:
>
>
>
> I would not use if I were writing in a Russian style, as it would be inappropriate; but in other contexts I might use it freely. Otherwise it would not be a creative process, but simply some kind of mechanistic process of writing by certain rules. To achieve a Russian style I would avoid some devices, for a Spanish style I would avoid others, and for a German style, still others.¹²

A few years later, writing up the interview for the Music-Ethnographic Commission's official organ, Karasyov quoted an even more pessimistic forecast. Asked whether Russian music would long "continue to take its nourishment from the juices of folk art," Rimsky glumly replied, "It seems to me that this period is near its end. Look what a crowd there is now writing folk choruses and *khorovod* songs. It's getting harder and harder to come up with something truly original in a folk style." To which Karasyov was constrained sadly to assent, adding a corroborating observation of his own: "Apparently the interests of contemporary composers have been diverted from folk music. The names Rachmaninoff, Scriabin, et al.—so characteristic of the newest current in our music—testify that the quests of contemporary art are in the direction of the deepest and most intimate sufferings of the human soul."¹³

Whether or not one agrees with Karasyov's assessment of the direction in which "the quests of contemporary art" had turned as of 1911 (and Scriabin, for

one, would certainly have disagreed), there can be little doubt that the younger Russian composers, evidently following Rimsky's behest, had turned away by then from ostentatious displays of national character. Such displays were regarded as passé, a sort of adolescence that Russian music had happily outgrown. When Miliy Balakirev, the old leader of the Mighty Kuchka (known officially as the New Russian School) died at last in 1910, Karatïgin came to bury him in an obituary that cast him, unkindly, as a walking anachronism, meanwhile proclaiming:

> Before our eyes there has occurred, or rather there is occurring, a new revolution in Russian music. A certain denationalization of it is taking place, alongside a noticeable invasion of it by elements of Western European "impressionism." Debussy and Ravel, Reger and Strauss, have taken the place of Schumann and Berlioz in our musical history. . . . But in order for a new fertilization of Russian musical thought with the aid of Western European creative achievements to take place painlessly and without the eventual loss of our musical physiognomy, it was necessary that in preparation that physiognomy be shown fully. And this was the task accomplished by the members of the "New Russian School."[14]

Even earlier, in 1904, Alfred Nurok, the music critic for Diaghilev's own *Mir iskusstva* (World of Art), called for eclecticism and cosmopolitanism as marks of maturity in Russian music. "Isn't it high time," he demanded, "that the best representatives of contemporary Russian music came to their senses and acknowledged that the so-called 'national' tendency has long since become a fiction, that for Russian composers like Rimsky-Korsakov and Glazunov and the whole talented group of deceased warriors for once-new truths in music there is no longer any reason at the present time to stand apart" from the European mainstream?[15] All the earliest reviewers of Stravinsky's music, beginning in 1907 with its initial public performances, associated him with the fashionably deracinated faction.[16] And indeed, although a connoisseur of Russian art music would easily recognize Stravinsky's early output as Russian, its Russian quality was due to its stylistic debts to the personal styles of the leading Russian composers of the immediately preceding generations: Lyadov, Glazunov, Scriabin, Rimsky-Korsakov, and Chaikovsky. Of his pre-*Firebird* compositions, only the Symphony in E-flat, op. 1 (written with Rimsky-Korsakov looking over his shoulder), incorporated any folklike material, but only in two stereotypically conventional places, where precedents could be found in Brahms and even in Haydn: the Trio of the Scherzo and the Finale. Even in his songs to poems by Sergey Gorodetsky, op. 6, in which the texts were actual imitation folk poems, Stravinsky's music had kept a fastidious distance from the soil, getting no closer than Musorgskian tintinnabulations out of the coronation scene from *Boris Godunov*—a Russian art-music cliché if ever there was one. (Gorodetsky himself objected to their banality.)[17] Where Stravinsky aimed at a folklike lyricism in these songs, the music came out sounding Griegish. The young

Stravinsky was a composer who knew little native folklore and may have wished to know even less. His attitudes mirrored precisely those of his aristocratic social class, his professional peer group, and the historical moment in Russian music.

When the peer group changed, so did the attitudes, and so did the music. But Diaghilev, too, had to traverse a substantial trajectory before he would demand of Stravinsky the folklore-saturated pieces that made them both famous. His portrait exhibition at the Tauride Palace in St. Petersburg in 1905 was just as programmatically antinationalist as Karatïgin's or Nurok's strictures on music; and his 1906 art exhibition in Paris, his first Western European venture, which purported to give a thorough conspectus of Russian painting, conspicuously snubbed the *peredvizhniki* or "wanderers," the realists and nationalists who were the precise visual-arts counterparts to the New Russian School. Diaghilev, like Stravinsky a petty, untitled aristocrat, grew up wholly devoted to the aristocratic taste embodied in the Russian silver age. His greatest wish was to bring Chaikovsky's *Sleeping Beauty*—the most perfect embodiment of the Europeanized Russian imperial style—to Paris.

But Paris wasn't interested. The French wanted to see the Russia of their own imagination represented on their stages, not the Russia of the Russian epicureans of the upper crust. Their imagined Russia was a semi-Asiatic land of "moujiks," onion domes, scimitars, and fairy tales. Chaikovsky was (and is) box-office poison in France, as Diaghilev found out to his nearly ruinous cost in 1921, when he tried despite everything to mount *The Sleeping Beauty* in London and Paris and failed miserably. "Devoid of the Russian character that pleases and attracts us in the music of the New Slavic School," wrote the composer and critic Alfred Bruneau in 1903, "excessively developed in a hollow and empty way, and in a bloated and faceless style, [Chaikovsky's] works astonish without overly interesting us."[18] Without an exotic mask, Russians were "faceless" to the French, and they knew it. "The whole of our vast country to the average occidental mind still remained a land of barbarians," wrote Tamara Karsavina, Diaghilev's prima ballerina.[19] Diaghilev, sacrificing his own tastes and convictions on the altar of conquest, presented the Russia of the French to the French, much to the chagrin of Russian artists and connoisseurs at home.[20]

Consider the repertory of the first two *saisons russes*. The *succès fou* of the 1909 season was not *Le pavillon d'Armide* but the second ("Polovetsian") act of Borodin's *Prince Igor*, with the dances choreographed by Fokine and with a sensational set by Nikolai Roerich, the eventual designer of *Le sacre du printemps*. Alongside it the company presented the "Apparition of Cleopatra" from Rimsky-Korsakov's opera-ballet *Mlada*; the Dances of the Persian Slave Girls from Musorgsky's *Khovanshchina* (presented, like the *Mlada* music, in an omnium-gatherum choreographed by Fokine under the title "Cléopâtre"); the Arabian Dance from Glinka's *Ruslan and Lyudmila*, presented as part of another Fokine *salade russe* entitled "Le festin"; and Rimsky-Korsakov's *Scheherazade*, choreographed by Fokine to a murder-

in-the-harem scenario by Benois. Stravinsky's *Firebird*—or rather, the ballet Stravinsky ended up composing after Tcherepnin and Lyadov (and probably Glazunov and the now-forgotten Nikolai Sokolov) had turned Diaghilev down[21]—fits right into this pattern of oriental exotica-cum-erotica, the near-pornographic sex lure that underpinned Diaghilev's incredible success.

Firebird emblematized the paradox of a Russian art that was forced to become "national" again in order to pander to a foreign audience with an utterly spurious idea of *le vrai russe*. Nationalism for export only, it is better described as autoexoticism. But then any markedly national artwork is also (and by the same token) exotic, depending on who is observing it and from where; and even the works of the Mighty Kuchka, when presented to urban audiences in Russia who had no firsthand knowledge of peasant lore, made (and were designed to make) an exotic appeal. All of these ironies and ambiguities were multiplied when the subject matter was "oriental," because what to Russians marked the "other" marked the Russians themselves in the eyes of the French. Even Russians were of two minds about such works, because Russia was a contiguous empire in which Russian and Asian populations intermixed and interbreeded (and even intermarried). Was Central Asia "self" or "other"? Borodin gave a typical answer in his "musical picture" (*muzïkal'naya kartina*) of Central Asia when he put the Russian and the oriental themes in counterpoint. *Firebird* did the same when, in the finale tableau, the title character's snaking chromatic motif is montaged against a diatonic folk song from Rimsky-Korsakov's published collection that accompanies the wedding procession of Ivan-Tsarevich and his bride.

The fact that the first full-length work Diaghilev ever commissioned should have been a ballet was a purely commercial decision. The impresario decided that, starting in 1910, he could no longer afford the financial risk of presenting operas, and the French critics had complained that the 1909 ballets had been musically undistinguished and of dubious nationality. He was effectively on notice that if he was to continue with his seasons he would have to justify his enterprise with a ballet on the level of the exotic Russian operas that had thrilled the public in 1908 and 1909. It was an unheard-of demand that Diaghilev now sought to meet. But for a single indigenous exception (the 1864 Saint-Léon/Pugni *Konyok-gorbunok* or *Little Humpbacked Horse*, which served as the Maryinsky Theater's children's Christmas treat before there was a *Nutcracker*), *Firebird* was the first Russian ballet ever to have a Russian national subject. Forgetting there was a precedent, Diaghilev emphasized the anomalous nature of the envisioned product when he wrote to entice Lyadov to compose the score: "I need a *ballet*, and a *Russian* one—the *first* Russian ballet, for there is no such thing as yet. There is Russian opera, Russian symphony, Russian song, Russian dance, Russian rhythm—but no Russian ballet. And it is precisely such a thing that I need, to perform it in May of the coming year at the Paris Grand Opéra and in the enormous London Royal Drury Lane."[22]

As Diaghilev all but spells out, it was the export campaign that made it necessary to mix oil and water, to produce a ballet such as had never existed in Russia, because it had no call to exist in a country where ballet was regarded, and prized, as a fancy French import. Exporting the import back to France was what made it necessary to give it an exotic Russian coloration. It is only *Firebird*'s century-long status as a world classic that prevents us from seeing it now for what it was: the freak product of an improbable juncture. Russians knew that the scenario was only a hackneyed boy-meets-girl plot concocted out of a hodgepodge of stock folktale ingredients. And yet many were convinced that a masterpiece had somehow emerged out of this opportunistic and specious initiative, and time has endorsed that judgment. What, then, was the saving spark of authenticity that lurked within, if not its concept, then at least the ballet's execution?

To identify that spark will mean identifying the spark that ignited Stravinsky's spectacular career. Our strongest hint comes from the most significant review his first ballet received. It was published in the very same issue of the arts journal *Apollon* that contained Karatïgin's obituary for Balakirev, with its call for denationalization. It was the work of Yakov Aleksandrovich Tugendhold (1882–1928), an art critic then at the beginning of his career—he was even younger than Stravinsky—who was then residing in Paris and serving as a correspondent writing letters home to the leading Russian journals on the latest developments in French painting. Viewing the ballet with a confirmed modernist's eye, Tugendhold saw novelty precisely where many saw regression. "Despite all the cosmopolitanism of our art," he wrote,

> one can already discern the beginnings of a new and long-desired style in Russian archaism. The folk, formerly the object of the artist's pity, is becoming increasingly the source of artistic style. To its inexhaustible living mine music has returned, and now art is returning along with choreography. *Firebird*, this ballet based on Slavonic myth, these ballet numbers *[tantsï]* transformed into folk dance *[plyas]*, this music, suffused with folk melodies, this painting by Golovin, brocaded with antique patterns (even to the point of being too patterned and honey-caked)—is this not the very latest attainment of our art? ... This is no patriotic display of our "national countenance," but a serious aspiration toward the unfettered milieu of folk mythology.[23]

Tugendhold's marvelous sentence about the artist's pity versus artistic style sums up with stunning succinctness the tendency that art historians have long called "neonationalism," which is not just a new nationalism but a fundamental change in attitude toward folklore and its creative potentials. Composers of Rimsky-Korsakov's generation took themes from folklore anthologies the way an academic painter might choose a peasant as a subject. In both cases, the subject was treated according to established esthetic and technical canons that did not differ from those applied to any other sort of subject or theme. When realist writers or painters like the

peredvizhniki chose peasant subjects, moreover, it was often for the purpose of exposing social ills in hopes that exposure would abet amelioration. Neonationalist painters found creative inspiration in the sorts of stylization that often caused professional artists to despise folk art, and they used them to point the way out of academicism or realism toward something "unfettered," to use Tugendhold's word. One such painter, Ivan Yakovlevich Bilibin (1876–1942), wrote in the pages of *Mir iskusstva* how "recently, like an America, we discovered the ancient Rus' of art" and from it sought to create "a new, completely individual Russian style with nothing of tawdriness about it."[24] And Diaghilev himself, during his one visit to America, when asked by the music critic Olin Downes where the esthetic innovations of the Ballets Russes had originated, replied, "We went where you in America will have to go before you can produce art of your own—to the people." Exaggerating the extent to which it had been a conscious program, but nevertheless accurately pinpointing the sources about which Downes had inquired, he continued:

> I found in the most unexpected places the real art of Russia, cropping out where it could, flourishing, vigorous and true, wherever it had been able to escape the attention of the educated classes, and developed in a sincere and normal way.... But do you think these precious tokens came from the courts, or from the artists imported with such ceremony and expense? They came from the people. They were found by myself and my colleagues in the shapes of domestic implements in the country districts, in the painting of sleds, in the designs and the colors of dresses, in the carving about a window, and so forth.
>
> It was on this foundation that we built.[25]

Neonationalism was thus the fully considered and impassioned program of the circle of artists that provided the creative brainpower behind the Ballets Russes. As soon as Stravinsky joined this circle he was exposed to his new peer group's creative creed and became the single important neonationalist composer. And if his particular contribution to *Firebird* was less deserving of Tugendhold's specific accolades than the visual aspects of the work (although the ostinato treatment of the folk tune in the final apotheosis did furnish a good example of incipient musical neonationalism), he quickly made up for any shortfall. Beginning with *Petrushka,* and culminating in *Svadebka* (*Les noces*), Stravinsky went further than any musician—and, arguably, further than any other Russian artist—in founding his personal modernistic idiom on the stylistic legacy of folklore.

The best illustration of neonationalist technique to cite in this, *Le sacre du printemps*'s centennial year, would be the *Russkaya,* or "Danse russe," from the first tableau of *Petrushka.* The reason is that this familiar music, irrevocably associated as it has become with the dancing of puppets in St. Petersburg's Admiralty Square in Stravinsky's second great ballet, was originally composed (and was the first music to be composed) for the third one, where it would have been the "Ritual of Abduction."

EXAMPLE 14.1. "Oy da ya bezhu, bezhu po pozhenke," in Fyodor M. Istomin and Sergey M. Lyapunov, *Pesni russkogo naroda, sobrani v guberniyakh Vologdskoy, Vyatskoy i Kostromskoy v 1893 godu* (St. Petersburg: Imperial Geographical Society, 1899), 167.

How is it possible to know this? We know from Stravinsky's first authorized biography, his ghostwritten autobiography, and many later testimonies that the original idea for *Le sacre* occurred to him when he saw in his mind's eye a scene, reputedly corresponding to what became the *Danse sacrale,* while composing the finale to *Firebird* in the spring of 1910.[26] Corroborating documents exist in the form of letters to Nikolai Roerich, whom Stravinsky had immediately sought out for the scenario. These letters date from July 1910, and in one of them Stravinsky informs his collaborator that he had already composed "a little something" *(koye-chto)* for the new ballet.[27] The "Danse russe" from *Petrushka* is based on two folk songs: the outer sections on "Ai, vo polye lipin'ka" (A Linden Tree Is in the Field), a song from Rimsky-Korsakov's published anthology, which Rimsky himself had borrowed long before for *Snegurochka* (The Snow Maiden) of 1881; and the middle section quotes "Oy da ya bezhu, bezhu po pozhenke" (Oh Yes, I Am Running after a Bride), from a collection by Fyodor Istomin and Sergey Lyapunov, published by the Imperial Geographical Society in 1899 and identified by the collectors as an *Ivanovskaya,* a Song for St. John's (or Midsummer) Eve (ex. 14.1).[28]

These songs have no special relevance to the action at the point where they appear in *Petrushka:* any suitably lively and rhythmic tunes would have served the purpose of accompanying the three puppets as they dance. But the song about a linden tree is actually a song about matchmaking: a girl is sitting beneath the tree weaving a wreath and singing, "No old man shall carry off this wreath; ... My sweetheart will wear this wreath."[29] And the *Ivanovskaya* has a text quite similar in implied action, but from the masculine perspective: "Oh yes, I am running after a bride; I'll run right up to the chapel." Both songs, in other words, together with the rituals of bride-chasing and wreath-snatching, are vestiges of the ancient "ritual of abduction" *(igra umïkaniya)* that figures so prominently in the first tableau of *Le sacre,* the scenario of which had been adapted by Roerich from the rites of Kupala, the Slavonic midsummer festival that in Christian times had been

assimilated to St. John's Eve. Roerich must have told Stravinsky that parallel, and very likely also told him to get hold of an *Ivanovskaya* on which to base the music for this dance. And Stravinsky's eye may well have been drawn to Rimsky's linden tree song because in the poem "Stavyat Yarilu," from Gorodetsky's collection *Yar'*, from which Stravinsky had made two settings in 1908, an idol is hacked out of a linden tree in the process of sacrificing a chosen maiden, and the name of the tree, likened to the maiden, comes in for a great deal of incantatory repetition *(Lipa, nezhnoye derevo, lipa—/Lipovïy stvol . . .).*

Surely, then, this was the "little something" sketched in the early summer of 1910 for "The Great Sacrifice," as Stravinsky and Roerich were calling their project in its infancy (and before the scenario had anything to do with spring). It was ripe for cannibalization when, having written what is now the second tableau of *Petrushka* as a *Konzertstück* for piano and orchestra, Stravinsky needed a companion movement. When Diaghilev heard the two movements in the late summer of 1910 he saw the makings of a topper for his 1911 season that would repeat or exceed the success of *Firebird,* and the rest is history. Stravinsky would have to start *Le sacre* over again from scratch.

It is hard to associate the merry music of the "Danse russe" with the grim action of the eventual *Sacre,* but it actually accords better with the tenor of the original scenario, which Roerich had based on an essay of his own, called "Joy in Art" ("Radost' iskusstvu"), which he had published in March of 1909. It celebrated the primordial wholeness of experience that the art of prehistory offered to rekindle in contemporary man. Here is the culmination:

> A holiday. Let it be the one with which the victory of the springtime sun was always celebrated. When all went out into the woods for long stretches of time to admire the fragrance of the trees: when they made fragrant wreaths out of the early greenery, and adorned themselves with them. When swift dances were danced, when all wished to please. When horns and pipes of bone and wood were played. Clothes, whole trimmed furs, floral garlands all mingle in the crowd. Beautifully decorated footwear of reeds and of skins shuffle along side by side. Amber pendants, stripes, stone beads, and white enamel talismans gleam and flash in the *khorovod.*[30]

When swift dances were danced. When all wished to please. That is the spirit of the "Danse russe," not of *Le sacre* as we know it, except where Roerich's brightly colored costumes are concerned—costumes that seemed to jar against the grim and brutal action when the Joffrey Ballet mounted its speculative reconstruction of the original *Sacre* in 1987. Clearly Stravinsky changed his attitude toward the subject of the ballet, and toward his own contribution to the whole, after Roerich's contribution had been set. But the "Danse russe" already bears traces of an essentially neonationalist outlook on the relationship between folk and professional art, and that is precisely why the Rimsky-Korsakov circle (with Andrey Nikolayevich

at their head) received *Petrushka* so coldly, finding in it *"a deliberate and sophisticated pseudo-nationalism,"* an uncouth and incongruous mixture of "Russian moonshine" *(sivukha)* and "French perfume."[31] Though ill-intentioned, these complaints are informative and useful; they take the exact measure of neonationalism, for they call attention to the hitherto inadmissible intermingling of folklore and modernism.

To be specific: the quality of the rhythmic periods in the "Danse russe," prefigured in the music Stravinsky actually wrote later to precede the dance in the first tableau, when imitating the asymmetrical rhythms of the carnival barker's pitch (known as *rayoshnïy stikh* or "peepshow verse"),[32] takes the form of static, additive, nondeveloping ostinati of variable length that continually break off and start up again. The approach to the final cadence in the "Danse russe" is foreshadowed by violent lurches brought about by unprepared suppressions of the strong beat that depend for their effect on the absolutely inelastic prior adherence to a rhythmic-melodic pattern of extreme uniformity and monotony. It was an effect occasionally hinted at in previous Russian orchestral music based on instrumental dance tunes *(naígrïshi)*, beginning with Glinka's *Kamarinskaya*—the very acorn, as Chaikovsky had once exclaimed, out of which the oak of Russian music grew.[33] But no one, in the sixty-three years between *Kamarinskaya* and the "Danse russe," had ever come up with anything as rhythmically radical as Stravinsky's coda. It is instantly recognizable as "Stravinskian"; it was a permanent acquisition and become one of his trademarks, continuing to characterize his music throughout his career, whether we are speaking of his "Russian," his "neoclassical," or his "serial" phases. Its origins, however, lay in an attempt to render faithfully—more faithfully, indeed, than the conventions of art music had previously permitted—an aspect of folk reality. "The folk," Tugendhold had said of *Firebird*, "are becoming a source of artistic style." Tugendhold had said it mainly of the sets and costumes. As of this moment, in a part of *Petrushka* that had been at first intended for *Le sacre*, Stravinsky's music caught up with the other neonationalist arts.

And then surpassed them. In *Le sacre*, elements that had played gaudily on the surface of *Firebird* and even *Petrushka* were now submerged to work their influence at the deepest strata of structure and style, and in the process gave rise to the unprecedented harmonic and rhythmic constructs that made Stravinsky's third ballet the modernist benchmark that it became. The deeper they went—the more they thus, as it were, receded from view—the more pervasive and determinant their influence became. For an idea of how deep they could go, consider one of the most recent—and most ingenious—attempts at rationalizing Stravinsky's creative methods in *Le sacre*. Drawing extensively on the facsimile sketchbook,[34] Matthew McDonald has proposed that the irregular rhythmic-metric patterns in the ballet were derived by a simple *ad hoc* algorithm from the intervallic content of harmonic and melodic ideas, many of which were derived from folklore, the idea

being that rhythmic successions educed by a mechanical process from a found object, precisely because they were not chosen but generated impersonally, would not be predictable or memorable, hence perpetually surprising.[35] The whole idea depends on the all-determinant source of the patterns being hidden from view. Even if one stops short of crediting Stravinsky with anticipating Harrison Birtwistle's methods by forty years, one can appreciate the epochal difference between the older nationalism and the "neo": where it had been easy to separate the "folk-derived" from the "original" elements in F*irebird* and even *Petrushka*, this was no longer possible in *Le sacre* or *Les noces*.

And that, paradoxically enough, is what enabled Stravinsky for so long and so successfully to dissemble, to deny the presence of folk artifacts in these his greatest works when, having renounced Russia, he wanted to recast himself as a universal master and a classicist. We now know that the score of *Le sacre* is host to at least nine authentic folk melodies: five from the anthology of Lithuanian wedding songs from which Stravinsky made his one acknowledged borrowing; two (one of them from the same Rimsky-Korsakov anthology that furnished the two folk songs in *Firebird*) that could be identified on the basis of Stravinsky's sketchbook; and two more that can be identified by genre, if not with any specific published tune.[36] Stravinsky admitted to only a single borrowing, namely the opening unaccompanied bassoon melody. As to the rest of *Le sacre*, and the rest of his output, he blandly remarked that "if any of these pieces *sounds* like aboriginal folk music, it may be because my powers of fabrication were able to tap some unconscious 'folk' memory."[37] The fabrication here was not of music but of tall tales; and Stravinsky went even further, claiming that *Le sacre du printemps* was conceived as abstract instrumental music without a subject or scenario: "un oeuvre architectonique et non anecdotique," as he put it to a French reporter at the time of the ballet's postwar revival.[38] He even claimed, when speaking of Bartók, that "I never could share his lifelong gusto for his native folklore," and what is more, "I couldn't help regretting it in the great musician."[39]

We seem to be back to the composer who knew little folklore and wished to know less. But the newly antinationalist Stravinsky was not the same composer as the prenationalist Stravinsky. Where the fledgling composer was motivated to renounce nationalism precisely out of patriotism (the ambitious wish to promote the Russian school to major status among the musics of the world), the expatriated master was in the grip of what his fellow-émigré Prince Nikolai Sergeyevich Trubetskoy, the founder of Eurasianism, called panromanogermanic chauvinism, the aggressive supranationalism of the West, founded on a profound sense of Russian inferiority.[40] For the rest of his life Stravinsky would try to overcome what he could not help regarding as the handicap of his Russian origins, "born to a minor musical tradition and twice transplanted to other minor ones," from which he could relate "only from an angle to the German stem."[41] But his own work belied

these assumptions. The reception of *Le sacre du printemps* had transcended exoticism and, likened by the faithful Robert Craft to a "prize bull" that "inseminated the whole modern movement," turned the world of music Russian for a while.[42] Yes, "there was such a fashion," to return to our epigraph, and Stravinsky's creative appropriations from folklore were what made it so.

NOTES

1. "Игорь Федорович, зачем ты написал 'Весну священную'? Такая гадость!" "Ну, видишь, Володичка, была такая мода." Exchange between Igor Stravinsky and Vladimir Nikolayevich Rimsky-Korsakov in Leningrad, October 1962, as related by Aleksandr Andreyevich Rimsky-Korsakov, Vladimir Nikolayevich's grandson, at the conference "N. A. Rimsky-Korsakov and His Heritage in Historical Perspective," St. Petersburg, Rimsky-Korsakov Home-Museum, 20 March 2010.

2. Stravinsky, interviewed by John Drummond in 1966, in Drummond, *Speaking of Diaghilev* (London: Faber & Faber, 1997), 21.

3. In the interview, Stravinsky says it was *Fireworks*, op. 4, that Diaghilev had heard right before they met, but that detail has long since been corrected by research; see, inter alia, R. Taruskin, *Stravinsky and the Russian Traditions* (Berkeley: University of California Press, 1996), 418.

4. Raisa Vladimirovna Glezer, ed., *M. F. Gnesin: Stat'i, vospominaniya, materialï* (Moscow: Sovetskiy kompozitor, 1961), 140–41.

5. Igor Stravinsky, "The Diaghilev I Knew," trans. Mercedes de Acosta, *Atlantic Monthly* 192, no. 5 (November 1953): 33.

6. Vasiliy Vasil'yevich Yastrebtsev, *Nikolai Andreyevich Rimskiy-Korsakov: Vospominaniya, 1886–1908*, ed. A. V. Ossovsky, vol. 1 (Leningrad: Muzgiz, 1959), 207.

7. Apollon Grigor'yev, "Russkiy teatr v Peterburge," *Epokha* 3 (1864): 232.

8. Letter of 2 February (Old Style) 1900, in N. A. Rimsky-Korsakov, *Polnoye sobraniye socheniniy: Literaturnïye proizvedenii i perepiska*, vol. 8b (Moscow: Muzgiz, 1982), 105.

9. Until it was found again, in 2015, owing to the renovation of the building that houses the St. Petersburg Conservatory, which had to be evacuated. The *Pograbal'naya pesn'* was discovered in a floor-to-ceiling stack of scores and parts that was hidden behind another floor-to-ceiling stack. See Natalia Braginskaya, "New Light on the Fate of Some Early Works of Stravinsky: The *Funeral Song* Rediscovery," trans. Stephen Walsh, *Acta Musicologica* 87 (2015): 133–51. As of this writing (March 2016) it has not yet been published or revived in performance. On the first performance, see Taruskin, *Stravinsky and the Russian Traditions*, 395–401.

10. See Patrick M. R. Gibson, *An Intrepid Woman: The Odyssey of Dorothy McLorn* (Leicester: Matador, 2009), 38–39.

11. See "Non-Nationalists, and Other Nationalists," in the present collection.

12. P. A. Karasyov, "Besedï s Nikolayem Andreyevichem Rimskim-Korsakovom," *Russkaya muzïkal'naya gazeta* 15, no. 49 (7 December 1908): cols. 1119–20. Anyone who knows Shostakovich's famous "Romance" from his soundtrack score for the film *Ovod* (The Gadfly) will experience a shock of recognition when reading Rimsky's example of a "non-Russian" musical phrase; the allusion is so exact that one has to suspect it was a deliberate in-joke.

13. P. A. Karasyov, "Narodnoye tvorchestvo, russkaya muzïka i N. A. Rimskiy-Korsakov," *Trudï muzïkal'no-ètnograficheskoy komissii, sostoyashchey pri ètnograficheskom otdele Imperatorskogo obshchestva lyubiteley yestestvoznaniya, antropologii i ètnografii*, vol. 2 (Izvestiya Imperatorskogo obshchestva lyubiteley yestestvoznaniya, antropologii i ètnografii, sostoyhashchego pri Imperatorskom

Moskovskom universitete, vol. 113) (Moscow: Tovarishchestvo skoropechatii A. A. Levenson, 1911), 376–77.

14. V. A. Karatïgin, "M. A. Balakirev," *Apollon*, 1910, no. 10, 54.

15. A. N. Nurok, "Po kontsertam," *Mir iskusstva*, 1904, no. 11, 70.

16. See in particular Karatïgin's "Molodïye russkiye kompozitorï" (Young Russian Composers), *Apollon*, 1910, no. 11, 33–41; and Gregoire Timoféev (Grigoriy Nikolayevich Timofeyev), "Les nouveautés de la musique russe," *Revue musicale S. I. M.* 5 (1909): 692–98 (Stravinsky's first notice abroad). Cf. Taruskin, *Stravinsky and the Russian Traditions*, 500–501.

17. "I describe a time-to-time ringing of long, slow bells, and your music is a kind of jingle bells" (Igor Stravinsky and Robert Craft, *Memories and Commentaries* [Garden City, NY: Doubleday, 1960], 78). Stephen Walsh complains of their "gauche extension of the stock Musorgsky bell-tolling style" in *Stravinsky: A Creative Spring—Russia and France, 1882–1934* (New York: Alfred A. Knopf, 1999), 109.

18. Alfred Bruneau, *Musiques de Russie et musiciens de France* (Paris: Bibliothèque Charpentier, 1903), 27–28.

19. Tamara Platonovna Karsavina, *Theatre Street* (London: W. Heinemann, 1930), 147.

20. See Alexandre Benois, "The Origins of the Ballets Russes" (1944), in Boris Kochno, *Diaghilev and the Ballets Russes* (New York: Harper & Row, 1970), 1–2.

21. See Taruskin, *Stravinsky and the Russian Traditions*, 574–79.

22. Diaghilev to Lyadov, 4 September 1909, given complete in Russian in Ilya Zilbershteyn and Vladimir Samkov, eds., *Sergey Diagilev i russkoye isskustvo* (Moscow: Izobratitel'noye iskusstvo, 1982), 2:109–10; in English in Taruskin, *Stravinsky and the Russian Traditions*, 576–77.

23. Ya. A. Tugenhold [sic], "Russkiy sezon v Parizhe," *Apollon*, 1910, no. 10, 21.

24. I. Ya. Bilibin, "Narodnoye tvorchestvo russkogo severa," *Mir iskusstva*, 1904, no. 11, 317.

25. Olin Downes, "The Revolutionary Mr. Diaghileff," *New York Times*, 23 January 1916.

26. See André Schaeffner, *Strawinsky* (Paris: Éditions Rieder, 1931), 35; Igor Stravinsky, *An Autobiography* (New York: Simon & Schuster, 1936), 47; the earliest testimony was a letter, dated 2 December 1912 (Old Style), to Nikolai Findeyzen, the editor of the *Russkaya muzïkal'naya gazeta*, who published it in the issue of 20 January 1913: "The first thought of my new choreodrama . . . came to me when I was still finishing *The Firebird* in the spring of 1910" (quoted from L. S. Dyachkova and B. M. Yarustovsky, eds., *I. F. Stravinskiy: Stat'i i materialï* [Moscow: Sovetskiy kompozitor, 1973], 470). Note that this first report does not specify a visualization of the sacrificial dance.

27. Stravinsky to Roerich, 27 July 1910, in Irina Yakovlevna Vershinina, ed., "Pis'ma Stravinskogo Rerikhu," *Sovetskaya muzïka*, 1966, no. 8, 59.

28. The first to identify this song was Frederick W. Sternfeld, in "Some Russian Folk Songs in Stravinsky's *Petrouchka*," *Music Library Association Notes* 2 (1945): 98–104 (with a credit to Nicolas Nabokov); curiously enough, Stravinsky had given a clue to its provenance in an interview with Émile Vuillermoz in 1912, where "Liapunow" is listed along with Rimsky and "Tschaïkowsky" among those whose publications furnished Stravinsky with his source tunes (*Revue musicale S.I.M.* 8, no. 5 [May 1912]: 20).

29. N. A. Rimsky-Korsakov, *Sbornik russkikh narodnïkh pesen* (Paris: Bessel, n.d.), no. 54.

30. Nikolai Konstantinovich Roerich, "Radost' iskusstvu," *Vestnik Yevropï*, 1909, no. 2, 532.

31. A. N. Rimsky-Korsakov, "7-y simfonicheskiy kontsert S. Kusevitskogo," *Russkaya molva*, no. 45 (25 January–7 February 1913); it was this review that ended Stravinsky's good relations with the Rimsky-Korsakov family.

32. See Simon Karlinsky, "Stravinsky and Russian Pre-literate Theater," *19th-Century Music* 6 (1982–83): 237.

33. Diary entry of 27 June 1888, in Wladimir Lakond, ed. and trans., *The Diaries of Tchaikovsky* (New York: W. W. Norton, 1945), 251.

34. *The Rite of Spring: Sketches 1911–13* (London: Boosey & Hawkes, 1969).

35. Matthew McDonald, "*Jeux de Nombres:* Automated Rhythm in *The Rite of Spring*," *Journal of the American Musicological Society* 63 (2010): 299–352.

36. See Taruskin, *Stravinsky and the Russian Traditions*, 891–921, or, for a more detailed discussion, idem, "Russian Folk Melodies in *The Rite of Spring*," *Journal of the American Musicological Society* 33 (1980): 501–43. The additional borrowings from the Lithuanian source (Anton Juszkiewicz, *Melodie ludowe litweskie* [Cracow: Wydawnictwo Akademii Umiejętności, 1900]) were first identified in Lawrence Morton, "Footnotes to Stravinsky Studies: 'Le Sacre du printemps,'" *Tempo*, no. 128 (1979): 9–16; Stravinsky's acknowledgment of the one borrowing from this source is reported in André Schaeffner, *Strawinsky,* 43n1; the actual tune is given and the exact source identified in the "Table des planches" after p. 217 (plate 21).

37. Stravinsky and Craft, *Memories and Commentaries*, 92.

38. Michel Georges-Michel, "Les deux Sacres du printemps," *Comoedia*, 11 December 1920; cited in Truman C. Bullard, "The First Performance of Stravinsky's *Sacre du printemps*" (PhD diss, University of Rochester, 1971), 1:2–3.

39. Igor Stravinsky and Robert Craft, *Conversations with Igor Stravinsky* (Garden City, NY: Doubleday, 1959), 82.

40. See N. S. Trubetskoy, *Yevropa i chelovechestvo* (Sofia: Rossiysko-Bolgarskoye Knigoizdatel'stvo, 1920).

41. Igor Stravinsky and Robert Craft, *Dialogues and a Diary* (Garden City, NY: Doubleday, 1963), 10, 10n.

42. Robert Craft, "'The Rite of Spring': Genesis of a Masterpiece," introduction to *The Rite of Spring: Sketches 1911–13*, xv.

15

Diaghilev without Stravinsky? Stravinsky without Diaghilev?

Success begets envy, and envy seeks to belittle. Diaghilev was the greatest impresario of his time, perhaps the greatest the world has ever seen. Stravinsky was, in the eyes of many, the greatest composer of his time. Sheer luck, their detractors said: it was luck that brought Diaghilev and Stravinsky together, and without each other they would have been nothing. And it was not only their detractors who said this. Their friends agreed, if less ungraciously. "Were it not for Diaghilev," wondered Nikolai Myaskovsky in a rapturously positive review of *Petrushka*, "would Igor Stravinsky's incomparable talent have bloomed with such might and brilliance?"[1] "Without you," Manuel de Falla wrote to Stravinsky when he heard about Diaghilev's death, "the Ballets [Russes] would not have been able to exist."[2]

Both were undoubtedly right. When I was writing my book about Stravinsky, some thirty years ago, I kept marveling at the miracle of symbiosis that made both Diaghilev and Stravinsky, as we know them, possible; and I was constantly beset by counterfactual fantasies, like Grandpa's in *Peter and the Wolf: Nu, a yeslib Petya ne poymal volka, chto togda?* "Well, and if Peter had not caught the wolf, what then?"

What then, indeed? Today I want to indulge the fantasies I had to suppress when recounting and interpreting what actually happened. It could have been so different. And, when you think about it, it should have been.

What, to begin with, if Rimsky-Korsakov had not died in time? What a question! And especially what a question to be asking here, in his very house. Nevertheless, although Stravinsky felt the sincerest grief at the loss of his beloved teacher,

Delivered as keynote lecture at an international conference, "In Diaghilev's Circle: An Impresario in Dialogue with Composers," at the Rimsky-Korsakov home-museum, St. Petersburg, 25 October 2011.

it came at just the right time for him. Had Rimsky lived longer, Stravinsky would have been in the position of Gnesin and Shteynberg, bound by loyalty to a circle hostile to Diaghilev, indeed to the whole *Mir iskusstva* crowd. Nor, in all likelihood, would he have accepted a commission to write a ballet, a genre his teacher had despised. If Rimsky-Korsakov had been alive in 1909, there would have been no *Firebird* in 1910, Stravinsky would not have gone to Paris, would have been home in Russia at the time of the revolution, and might very well have ended up as a Soviet composer. That is something altogether impossible, and moreover highly unpleasant, to imagine, and so I will call a halt to these speculations insofar as they pertain to Stravinsky.[3]

But what of Diaghilev, if Stravinsky, constrained by loyalty to Rimsky-Korsakov, had politely declined the impresario's invitation to collaborate? *Chto togda?*

The easy part of the answer is a list of all the works that Diaghilev would not have been able to present to Paris and the world. Leaving aside minor efforts and arrangements, the list would include a round ten: *Firebird, Petrushka, Le sacre du printemps, The Nightingale, Renard, Svadebka, Pulcinella, Mavra, Apollon musagète,* and *Oedipus Rex.* Would the remainder of Diaghilev's repertoire have sufficed to offset the loss of these? That is of course another imponderable—but would there even have been a Diaghilev repertoire, at least as we now think of it? That is a harder, more interesting, and more important question. And the answer seems to be that, had there not been a *Firebird,* there probably would never have been such a thing as the Ballets Russes.

Unlike Alexander Benois, whose role as both participant and historian has both illuminated and distorted our view of the Diaghilev enterprise, Diaghilev himself was not a balletomane. Although as an official of the Imperial Theaters he had a hand in a few ballet productions (including the production of Delibes's *Sylvia* that caused his dismissal "with prejudice" from the Russian civil service), there was nothing in his early entrepreneurial activity to suggest that he would ever specialize in ballet, or wish to. We now associate the name of Diaghilev with a tremendous amount of promotional propaganda for ballet, which often took the form of antioperatic propaganda—a genre to which Stravinsky was also a conspicuous contributor. But that propaganda, which followed an antiliterary line that originated with Benois, was all an *ex post facto* justification for a business decision that was forced on Diaghilev at the end of the first so-called *saison russe* in 1909 (to which Stravinsky had contributed only a pair of orchestrations for *Les sylphides*).

That season was the first in which ballet had figured at all. Diaghilev's first Paris event, in 1906, was an art exhibition, as anyone who knew Diaghilev in Russia might have expected. It was a seemingly natural extension of his activities connected with *Mir iskusstva* or *The World of Art,* both the journal of that name and the attendant annual art shows. The next year Diaghilev was back in Paris with the musical equivalent of his 1906 exhibition: a series of "historical" concerts that

acquainted Parisian audiences quite systematically with the full range of Russian operatic and instrumental composition as of 1907. In 1908, realizing a long-standing ambition, Diaghilev presented Musorgsky's *Boris Godunov* at the Paris Opera, introducing not only the work, in a specially souped up, flamboyantly augmented version of Rimsky-Korsakov's forceful arrangement, but also the vocal and histrionic artistry of Chaliapin, to the world at large.

The 1909 *saison russe* was to have doubled or tripled up on the *Boris* extravaganza with a comprehensive series of Russian operas, all chosen as vehicles for Chaliapin. Besides a revival of *Boris* they were to include Rimsky-Korsakov's first opera, *Pskovityanka* (rechristened *Ivan le Terrible* for the occasion so as to feature Chaliapin once again in a title role), Borodin's *Prince Igor*, Glinka's *Ruslan and Lyudmila*, and finally *Judith*, an opera by Alexander Serov, the father of Diaghilev's favorite contemporary painter, Valentin Serov, who of course would design the production. (The role of Holofernes, the Assyrian commander, in that opera was one of Chaliapin's greatest vehicles, as it had previously been for Igor Stravinsky's father, Fyodor Ignat'yevich Stravinsky, who preceded Chaliapin as the preeminent Russian operatic basso.)

To give Chaliapin some nights off, and at Benois's insistence, a single evening of dance was planned as a showcase for Mikhail Fokine's choreography. It was to consist of one original ballet, *Le pavillon d'Armide* (after Théophile Gautier, with a scenario by Benois and music by his brother-in-law, Nikolai Cherepnin), along with two more recent compositions by Fokine to existing music: *Chopiniania*, which was retitled *Les sylphides* for Paris, and *Cléopâtre*, which had been performed in Russia under the title *Egyptian Nights (Yegipetskiye nochi)*, after Pushkin's erotic poem, to music by Arensky. For Paris, Diaghilev scrapped Arensky's original score and substituted a *salade russe,* as his crony Walter Nouvel sneeringly called it, consisting of fragments of Arensky preceded by the overture to Sergey Taneyev's opera *The Oresteia* (which begins with a theme resembling the fate leitmotif from Bizet's *Carmen*) and interspersed with music by Rimsky-Korsakov (the apparition of Cleopatra from *Mlada*), Glazunov (the "Autumn Bacchanale" from *The Seasons*), and, to finish, the Persian dances from Musorgsky's *Khovanshchina*.

And then fate intervened. On 9 February 1909, without warning, the Grand Duke Vladimir Alexandrovich, the tsar's uncle and Diaghilev's principal backer, dropped dead. This catastrophic event led, through a series of court intrigues and mysterious cancellations of contracts, to the sudden withdrawal of a crown subsidy that Diaghilev had secured through the grand duke to finance the Paris season.[4] A huge cutback became necessary. The solution was to present only one opera, *Pskovityanka (Ivan le Terrible)*, in full. Two others, *Ruslan and Lyudmila* and *Prince Igor*, would be represented by single acts, each of which would play on a triple bill with two ballets. For this reason a fourth ballet had to be hastily concocted. The result was *Le festin*, another *salade russe* excerpted from various existing operas

and ballets as choreographed by Marius Petipa and Alexander Alexeyevich Gorsky *(Mlada, Ruslan, Raymonda, Sleeping Beauty)* plus a few extras choreographed by Fokine: the *hopak* from Musorgky's *Fair at Sorochintsy,* the *trepak* from Chaikovsky's *Nutcracker,* and an ensemble finale set to the last movement of Chaikovsky's "Little Russian" Symphony (No. 2), perhaps his most stereotypically "Russian"-sounding composition.

The two ballet/opera bills now consisted of *Le pavillon d'Armide / Prince Igor* (act 2) / *Le festin,* and *Ruslan and Lyudmila* (act 1) / *Les sylphides / Cléopâtre.* Toward the end of the run, the fourth and fifth acts of *Judith* were performed as a vehicle for Chaliapin with the dramatic soprano Felia Litvinne in the title role. Unexpectedly successful thanks to its star performers, it replaced *Ruslan and Lyudmila* in the second triple bill. (This was the only fully professional staging that Alexander Serov—my beloved Serov, on whom I wrote my doctoral dissertation—has ever been accorded in the West.)

Thus, contrary to the original plan—and, it should be emphasized, utterly contrary to Diaghilev's predilections—ballet was now more conspicuous than opera in the programs of the first *saison russe.* The first triple bill in particular was essentially a ballet evening with only a little singing, since the second act of *Prince Igor* is dominated by the Polovetsian Dances, which Folkine choreographed brilliantly for the occasion. Danced thrillingly by the male corps de ballet headed by Adolphe Bolm, it made the greatest sensation of the season, Chaliapin notwithstanding.

No one expected this. Nor did Diaghilev expect that, when the season had ended and all the reviews were written, the critical consensus would be that music had made a poor showing within the otherwise brilliant Russian spectacles. What had been the dominant element in the Wagnerian synthesis had unaccountably become recessive in Diaghilev's. The venerable Camille Bellaigue, whose credentials as a propagandist for Russian music in France went back many decades, asserted flat out that the music had contributed nothing to the success of *Cléopâtre* or *Les sylphides.*[5] Even Michel Calvocoressi, Diaghilev's paid publicist and French liaison, and as staunch a partisan as the Russian impresario would ever have, came away from the 1909 season with misgivings about the fate of Russian music. "The young Russian composers had better get to work seriously," he wrote, "and furnish some works of a more personal character, worthy of being shown here; otherwise the displays of Russian music abroad will be forced to maintain a retrospective character that will no longer interest anyone except historians."[6]

Diaghilev, in effect, was put on notice by the French critics that in any future productions music would have to be brought up to the level that dance and design had reached by 1909. They wanted a musical *frisson* from him to match those administered by Benois, Bakst, Roerich, Fokine, Nijinsky, Pavlova, and the rest. And this could only mean an original score that, unlike *Le pavillon d'Armide,* would provide a novel and worthy counterpart to the neonationalist decorative

and choreographic delights of the Polovetsian Dances and *Cléopâtre*, for these represented for the French the quintessence of Slavic (that is, quasi-Asiatic) exotica, the *raison d'être* for Diaghilev's activity in their midst.

And another factor spoke even louder than the critics. When the receipts were tallied, it was evident that only *Cléopâtre* had been a money-maker. This was clear even before the end of the season, and Diaghilev began tacking extra performances of the Bakst/Fokine sensation onto performances of *Ivan le Terrible* as a lure to fill the hall for Rimsky's serious historical opera, which, despite Chaliapin's presence in the title role, had suffered by comparison with the previous season's dazzling *Boris* and had been playing to smaller and smaller houses. The other operatic presentations (not counting *Prince Igor*, which was really another ballet) had not done even that well. Taking stock, it was obvious that the relatively cheap ballets had succeeded where the insanely expensive operas had failed. Chaliapin alone had cost Diaghilev more than all the ballet soloists combined, and the other principal singers plus the chorus cost the equivalent of two and one-half corps de ballet. Diaghilev finished the season with a deficit of thirty-eight thousand francs, and he was now without a crown subsidy to absorb it.[7] When word came from Chaliapin that, having just been named "imperial soloist" and required to make an all-Russia tour as such, he would not be available for Paris appearances in 1910, Diaghilev made the inevitable decision. In the perhaps not quite ingenuous words of Benois, "Looking to the future, Diaghilev saw himself, quite contrary to his own taste, forced to limit his Parisian repertoire to ballets."[8]

The 1910 season, then, would have to have as centerpiece a major new work in an unprecedented genre: a Russian neonationalist ballet that could take the place of the operas that were no longer economically feasible to produce but that had represented for the French an authentically and seductively exotic Russian art. If the Russian ballet was to continue to attract the attention of the Paris public, it would have to stop looking like a transplanted French genre and develop a deliberately, in fact self-consciously "Russian" repertory, one with no indigenous antecedent but rather created expressly for a non-Russian audience. It would be a repertory manufactured specially for export, for without Diaghilev's "export campaign" (as Benois liked to call it, somewhat sardonically) there would never have been any call for such a thing to exist, least of all in Russia.

And that, of course, is where Stravinsky came in—or rather, where he came in after Cherepnin and Lyadov had withdrawn or refused, and perhaps Glazunov and Nikolai Sokolov as well if, as I suspect, Diaghilev went down the list of composers who had contributed orchestrations to *Les sylphides*, among whom Stravinsky was by far the greenest. And this prompts two more Grandpa-questions.

First, if Grand Duke Vladimir Alexandrovich had not suddenly met his maker, *chto togda?* In that case, the season of operas that had been planned for 1909 would have gone ahead as scheduled. The ballet evening would have seemed entirely sec-

ondary and *Cléopâtre* would have competed for attention with the revived *Boris,* the entire *Prince Igor,* and the equally exotic *Ruslan and Lyudmila.* Would there have been a call from the critics for a neonationalist ballet? I have to doubt it. The 1910 season, assuming that Diaghilev retained his subsidy from his trusty patron, would in all likelihood have been another operatic season with some danced divertissements, and ballet would not have achieved the enhanced status that *Firebird* won for it, not only within the Diaghilev repertoire, but in the eyes of the world. The improbable twentieth-century revival of ballet as a major spectator attraction in western Europe and America was entirely due to Diaghilev's fortuitous example. At the end of the nineteenth century, ballet was moribund or already dead everywhere but Russia. All the companies that sprang into existence in the wake of Diaghilev's epochal success were originally led by post-Diaghilev refugees—Fokine, Massine, Lifar, Ninette de Valois, George Balanchine. None of this would have happened without the hard commercial decisions that were made in response to the existential crisis that the grand duke's sudden death inflicted.

And don't forget the most daring of Diaghilev's decisions—namely, to commission a "Greek" ballet from Ravel at the same time that he commissioned *Firebird,* even before Stravinsky was on board. That was the true visionary stroke, because it made the revived and enhanced ballet an international, not just an insularly Russian, phenomenon. But it, too, was the result of a turn that had been forced on Diaghilev by a bolt from the blue. As with Rimsky-Korsakov's death, we are dealing once again, in the case of the grand duke, with a death that might be described—tastelessly, perhaps, but accurately—as providential, although it seemed an unmitigated disaster at the time. A less determined figure than Diaghilev might not have turned it so decisively into an opportunity, and that, perhaps, is the best measure of his entrepreneurial genius. But at the same time, what better example could one find of the contingent nature of all great events and historical turning points?

And again we must ask, but now from Diaghilev's perspective, "And if Stravinsky had not written *Firebird, chto togda?*" Is there any other composer who might have come to the rescue? Stravinsky once said he could not think of one, and neither can I. Can you? Cherepnin's *Zacharovannoye tsarstvo,* a.k.a. *Le royaume enchanté,* the tone poem that contains the music he sketched for the first scene of the ballet before pulling out, is a lovely, evocative piece, but could he have sustained the level of intensity required for a forty-minute act? And in particular, could he have come up with the required contrasts? I know nothing by Cherepnin that conveys the dynamism of Stravinsky's *poganïy plyas* ("Danse infernale"), although I know a piece by him that tries: the *Dramaticheskaya fantaziya* (or *Fantaisie dramatique*), op. 17 (1903), after Tyutchev, which I came across while investigating pre-Stravinskian uses of the *gamma ton–poluton* or whole step–half step (octatonic) scale. It is a suitably turbulent piece and comes to a loud climax to justify its title, but I am confident that, performed in Paris, it would have met the same reception as *Le pavillon*

d'Armide, about which Louis Laloy, the dean of the Parisian critics, wrote: "The only extenuating circumstance one could invoke in favor of such insignificant music is that after five minutes one no longer hears it."[9] I would not have rated Cherepnin's work so low, but I am not a Paris critic in 1909. As Cherepnin himself remarked in his memoirs, "Who can look at my 'Fantaisie Dramatique,' op. 17 and not see a marked influence of Brahms' orchestral style on the composition?"[10] I can forgive him that transgression, but Laloy could hardly be expected to.

Thus, without Stravinsky, whose ambition was fueled by a resentment that Cherepnin never had reason to feel, Diaghilev's attempt to reform his repertoire would surely have failed. He might have kept things going for another season or two, but the fickle Paris public would have turned to newer sensations, and the enterprise would not have lasted as it did. It would likely have folded before the war, which means before the revolution, and Diaghilev himself might have ended up afterward not as one of the magnetic poles of the Russian emigration, one of the central figures of what we now call "Russia abroad," but on the home side of the border. He might not have stayed long—one can easily imagine him on the *filosofskiy parokhod* in 1922, the "philosophers' steamship" that carried out of Russia a host of intellectuals whom Lenin's government had designated *persona non grata*—but he might also have shared the fates of his half brothers, Yury and Valentin, as revealed by Sjeng Schiejen in his recent biography: imprisoned and, in the case of Valentin, executed by the Bolsheviks.[11]

By now I have cast both Diaghilev and Stravinsky as the other's rescuer from a dire Soviet fate. These speculations have grown too lurid, and it is time to dial them back. I don't expect that anyone actually disagrees with my premise that Stravinsky and Diaghilev were both sustained by a miraculous symbiosis; and as a wise person has observed, "Things would be so different if they were not as they are."[12] But as I am fond of pointing out to my own pupils, any historical event looks like a miracle if we assume it to be a culmination or an outcome. Imagine what the odds were against our all being in this room at this very moment—we, that is, and no one else. Practically every decision we have ever made in the course of our lives would have had to be exactly what it was in order for that miraculous confluence to occur, and that goes for all the people who are not here as well. And not only our decisions, but also external circumstances over which we exercised no control would have had to be just as they were to enable us to achieve the miracle of our presence here today. But of course today's gathering is not an outcome, just an event in a stream—or rather an event in as many streams as there are people in this room.

Just so: his participation in Diaghilev's Ballets Russes was, similarly, an event in a stream for Stravinsky, and the commissioning of *Firebird* from him was an event in a stream for Diaghilev. These events, or rather the collaboration that marked the confluence of the two streams (and now it sounds like I am describing *Les noces*) made other events possible, in a chain that lasted until the end of both their

lives, by which time their interactions with others had set in motion an infinity of other streams. And if theirs were singularly lucky lives, that was a result both of the fortunate conditions and opportunities that I have been describing, and of the ability of my two protagonists to exploit their opportunities and take advantage of conditions. I'm talking about their superior abilities and talents—all right, their genius—in which I definitely do believe.

Firebird offers an ideal illustration of this point. In later years Stravinsky tended to disparage his first ballet. In his so-called conversations with Robert Craft he quoted Debussy as saying, when asked what he really thought of it, *"Que voulez-vous, il fallait bien commencer par quelque chose"* (Well, you had to start with something). His own verdict, expressed a little further on in the same memoir, had a somewhat forced irony: "*The Firebird* belongs to the styles of its time. It is more vigorous than most of the composed folk music of the period, but it is also not very original. These are all good conditions for a success." But he also quoted a more flattering opinion that he attributed to Ravel, who explained the ballet's success by saying that "the Parisian audience wanted a taste of *avant-garde,* and *The Firebird* was just that."[13] Like all verbal utterances published under Stravinsky's name, these are wily, well-calculated words— calculated mainly to remind us how much further he would go, and how fast. In fact, most of the music in *Firebird,* namely the music that pertains to the magical characters, has nothing to do with folklore, and while it does belong to the styles of its time (as all music does, since the existence of any style can only be in and therefore of its time), it consists of some very ingenious *Kunststücke* (a word with which Stravinsky's friends liked to tease him at the time) that rang some new changes on the patented *Gebrauchs*-formulas of the Rimsky-Korsakov school.[14] They may not be avant-garde, exactly, but they were fresh, and they were not fully rationalized by analysts until the 1980s. (As for Ravel's comment, if he really said it, he probably meant to tease Stravinsky for swiping some flashy effects, like the orchestral glissando at the end of the *poganïy plyas,* from Ravel, in this case the *Rapsodie espagnole*).

What really made *Firebird* perfect for Diaghilev at the moment of its presentation was not just its neonationalist coloration (the main requirement as stipulated by the commission), nor the mild taste it gave the audience of avant-garde, but rather the fact (to put it as ironically as possible) that it was the work of a composer who at the time of its creation looked down upon ballet from the lofty height of opera, just as Diaghilev did (and as the Paris critics did as well). The most eccentric aspect of the work is its constant aspiration to the condition of opera, the genre it perforce replaced in the 1910 *saison russe*. One feature of that aspiration was Stravinsky's meticulous observance of a convention inherited from *Ruslan and Lyudmila* (one of the operas he was replacing) and passed down through such works of his teacher as *Sadko* and *Kashchey the Deathless,* whereby the human world is distinguished from the magical world by way of a contrast between what was diatonic and folkloristic, on the one hand, and what was chromatic and based

on synthetic scales, on the other. (This was a variant, of course, of the older and commoner orientalist trope.)

But that was the least of it. There is a heavier dose of pantomime in *Firebird* than in any other *ballet d'action*, and the way mime alternates with dance is a more obvious analogy to the alternation of operatic recitative and aria than one finds in any other ballet. Not only that, but *Firebird* conspicuously emulates Wagnerian music drama, the genre Stravinsky would devote so many pages of *Poétique musicale* to excoriating. No other ballet is so heavy with leitmotives, *leit-harmonie*, *leit-musique* of all kinds, to use a couple of terms that Stravinsky himself coined in the notes accompanying his piano-roll performance of the ballet, by which time he was already somewhat embarrassed by his reliance on representational devices.[15] He was even more embarrassed in 1962, when he complained that some of the *Firebird* music was "as literal as an opera."[16] In 1910, however, this was seen as the work's greatest strength—an earnest of the new seriousness with which Diaghilev's company addressed ballet, a new seriousness that was perhaps Diaghilev's greatest single bequest to the esthetics of the twentieth century. And yet, to any musician contemplating the score today, the mime episodes—the part Stravinsky later disavowed not only in words but also in musical deed, when he pruned most of them out of the score in 1945—contain the most interesting music, and the only music that gives any premonition of the later Stravinsky, the one who (I suppose he meant implicitly to claim) so transcended the styles of his time.

The literal, or operatic, qualities that distinguish *Firebird* from other ballets were to a degree implicit in the scenario that Stravinsky was given, and no doubt reinforced by Fokine when they worked closely together in a manner that Fokine has vividly described (his descriptions being limited, by the way, to the mimed episodes, the parts that, as far as he was concerned, contained whatever "taste of *avant-garde*" the ballet afforded its public).[17] It must also have been impressed upon Stravinsky that *Firebird* was to be no childish divertissement but a serious work of art with solid cultural and dramatic values—a "*skazka* for grownups," in the words of Benois, who, reaching even further toward the Symbolists and Scriabin and all that was loftiest, also called it "a Russian mysterium."[18]

Nevertheless, Stravinsky brought his own deep knowledge of the Russian operatic repertoire, derived both from his family experience as the son of an opera singer and from his training at the hands of Russia's greatest composer for the operatic stage, to bear on the project, along with his own antiballetic prejudices. The fact that within a couple of years he was competing with Diaghilev in enthusiastic antioperatic rhetoric (in both public interviews and private letters) shows to what extent, and how quickly, he had been socialized into his new cohort, and how utterly he had cast in his lot with them.

Here is an example: "I dislike opera. Music can be married to gesture or to words—not to both without bigamy." That is what Stravinsky told a reporter from

the London *Daily Mail*, who published it in the issue of 13 February 1913.[19] It is pure Benois boilerplate, but I'm sure Stravinsky sincerely believed what he was saying. He was conscious of owing everything to the Diaghilev enterprise, and its continuing success was his continuing success. But he owed more to Diaghilev than his success; he also owed to Diaghilev the preconditions for success: a ready, indeed voracious, outlet for his work; a powerful machine for its dissemination; and, perhaps most important of all, especially to a modernist, utter confidence in his abilities, which bred self-confidence.

That allegiance, and the gratitude that went with it, lasted his whole life, even though he and Diaghilev went through periods of estrangement and mutual disaffection (often brought about by financial concerns) and although the management of his career demanded that Stravinsky advertise his independence after 1929. By the time of his late dictated memoirs, Stravinsky was apt to patronize Diaghilev. My favorite bit of this kind involved the ending of *Petrushka*. "Diaghilev wished to have me change the last four pizzicato notes in favor of 'a tonal ending,' as he so quaintly put it," Stravinsky recalled in 1962.[20] A few years later, Craft's diary contains an entry in which Pierre Souvtchinsky, in California to help catalogue Stravinsky's manuscripts, "repeats I.S's story about Diaghilev's reaction to the ending of Petrushka: 'But you finish with a question?' 'Well,' I.S. used to add, 'at least he understood that much.'"[21]

Diaghilev could not have expressed himself in 1911 the way Stravinsky has him doing in the story. The use of the adjective "tonal" to denote music governed by major-minor tonality was a retronym; it actually followed the coinage of the term "atonal," as in "Tonal oder atonal?," the question with which Schoenberg mocked the new terminology in 1925.[22] The catty comment on the limits of Diaghilev's comprehension arose in conjunction with Souvtchinsky's ungenerous contention that "so far from [Diaghilev's] having discovered Stravinsky, Stravinsky happened to him, and Diaghilev never really understood how big Stravinsky's genius was"— a remark that chiefly testifies to Souvtchinsky's envy of Diaghilev's relationship to Stravinsky.[23] Craft had his own reasons to envy Diaghilev. We all have our reasons for envying Diaghilev. And with that, we're back to the beginning: envy, the great motivator of all such attempts at minimizing or annulling debts. But Stravinsky put paid to all quibbles when he had himself buried in Venice, a few paces from his friend and savior, for whom he had been friend and savior in turn.

NOTES

1. "Peterburgskiye pis'ma," *Muzïka*, no. 53 (3 December 1911); reprinted in S. I. Shlifshteyn, ed., *N. Ya. Myaskovskiy: Stat'i, pis'ma, vospominaniya* (Moscow: Sovetskiy kompozitor, 1960), 2:31.

2. Letter of 22 August 1929, in *Stravinsky: Selected Correspondence*, ed. Robert Craft, vol. 2 (New York: Alfred A. Knopf, 1984), 171.

3. They are pursued at greater length in essay 14 in this collection, "How *The Rite* Became Possible."

4. See S. L. Grigoriev, *The Diaghilev Ballet, 1909–1929* (London: Constable, 1953), 11–13.
5. "La saison russe du Châtelet," *Revue des deux mondes*, 15 July 1909, 450; quoted in Vera Mikhailovna Krasovskaya, *Russkiy baletnïy teatr*, vol. 1 (Moscow: Isskustvo, 1971), 337.
6. *Mercure de France*, quoted in Louis Laloy, "Le mois," *Revue musicale S.I.M.*, no. 5 (June 1909): 589.
7. For all the figures, see Richard Buckle, *Diaghilev* (New York: Atheneum, 1979), 153.
8. Alexandre Benois, "The Origins of the Ballets Russes" (1944), in Boris Kochno, *Diaghilev and the Ballets Russes* (New York: Harper & Row, 1970), 16.
9. Laloy, "Le mois," 583.
10. Nikolai Tcherepnin, *Under the Canopy of My Life (Pod sen'yu moyey zhizni)*, trans. John Ranck, available online at www.tcherepnin.com/pdf/NNT_UnderTheCanopyOfMyLife.pdf, 24.
11. Sjeng Scheijen, *Diaghilev: A Life*, trans. Jane Hedley-Prôle and S. J. Leinbach (London: Profile Books, 2009), 417–19, 444.
12. Anna Russell, "How to Write Your Own Gilbert and Sullivan Opera," Columbia Masterworks LP ML4594 (1953).
13. Igor Stravinsky and Robert Craft, *Expositions and Developments* (Garden City, NY: Doubleday & Co., 1962), 149.
14. For *Kunststücke*, see the autograph of eleven measures from the *Ronde des princesses* from *Firebird*, inscribed to Maximilian Shteynberg on 5 December 1909 with the note: "Max! Take this as a souvenir of the ballet which you still look upon (or so it seems to me) as a series of curiosities and 'Kunststück's,'" reproduced and described in Arkadiy Klimovitsky, "Ob odnom neizvestnom avtografe I. Stravinskogo (k problem tvorcheskogo formirovaniya kompozitora)," *Pamyatniki kul'turï: Novïye otkrïtiya 1986* (Leningrad: Nauka, 1987), 227–36. On the harmonic novelties in *Firebird*, see R. Taruskin, *Stravinsky and the Russian Traditions* (Berkeley: University of California Press, 1996) 586–614.
15. Typescript in Stravinsky archive, dated 1927; quoted in Taruskin, *Stravinsky and the Russian Traditions*, 587, 589. When the rolls were issued by Aeolian in London in 1929, Stravinsky notes were printed (in Edwin Evans's translation), directly on the rolls.
16. Stravinsky and Craft, *Expositions and Developments*, 146.
17. Mikhail Fokine, *Memories of a Ballet Master*, trans. Vitale Fokine, ed. Anatole Chujoy (Boston: Liitle, Brown, 1961), 161.
18. Alexandre Benois, "Khudozhestvennïye pis'ma: Russkiye spektakli v Parizhe: 'Zhar-ptitsa,'" *Rech'*, 18 July 1910.
19. Reprinted in Eric Walter White, *Stravinsky: The Composer and His Works* (Berkeley: University of California Press, 1969), 187.
20. Stravinsky and Craft, *Expositions and Developments*, 156.
21. Igor Stravinsky and Robert Craft, *Retrospectives and Conclusions* (New York: Alfred A. Knopf, 1969), 265.
22. The opening words of "Am Scheideweg" (At the Crossroads), the first of Schoenberg's *Drei Satiren*, op. 28 (1925).
23. Stravinsky and Craft, *Retrospectives and Conclusions*, 265.

16

Resisting *The Rite*

I

Sworn Stravinskians saw this coming from afar. We knew that we would spend a year dancing with *The Rite of Spring*. It was one of those inescapable tributes to round numbers on which the classical music business depends. Carolina Performing Arts stole a march on the actual centennial by starting its celebrations, where this essay had its beginnings, in the fall of 2012, thus steering clear of the twin steamrollers, Wagner and Verdi, heading our way in 2013. But practically every year there's something. In 2011 it was Liszt, while 2010 brought us Chopin and Schumann. There was Haydn in 2009, and Rimsky-Korsakov in 2008 (inescapable in Russia, anyway, even though they didn't get around to the official celebrations until 2010). The Shostakovich centennial in 2006 was one that I personally resisted. I spent the whole year declining invitations, and waited till 2007 to start airing a talk that I subtitled "Post-centennial Reflections," in which I reviewed and deplored the polluted pool that Shostakovich studies had become, so full of political invective and fraudulent claims. But I found the prospect of commemorating *The Rite of Spring* irresistible.

Why the inconsistency? Is there an inconsistency? I would contend that there isn't, because the *Rite* centennial differs from the others in that it celebrates not a person but a piece, and how many pieces of music have that kind of stature? I can

Written to arm me with a warhorse for the *Sacre du printemps* centennial year and delivered, in various parts, in many venues between the fall of 2012 and the spring of 2015: Paris, Moscow, Budapest, Toruń (Poland), Amsterdam, and Carnegie Hall, in addition to other locations in the USA.

think of only one other, and I will name it in due course. But not even that one possible rival has actually been celebrated, as far as I know, with galas and conferences and exhibits all over the world. *The Rite* is unique, and uniqueness invites inquiry.

So: Why *The Rite*?

To begin with—and this is something musicologists are apt to forget—*The Rite* is not just a piece of music. It originated, very self-consciously, as a *Gesamtkunstwerk*, a mixed-media synthesis, and belongs to the histories of dance and stage design as well as music. One of the marks of *The Rite*'s unique status is the number of books that have been devoted to it—certainly a greater number than have been devoted to any other ballet, possibly to any other individual musical composition (that same likely rival perhaps aside). They include general introductions by Peter Hill, in English, and Volker Scherliess, in German (the latter published during Stravinsky's centennial year).[1] There are heavy-duty academic analytical studies by Allen Forte and Pieter van den Toorn.[2] There is a deluxe facsimile edition of Stravinsky's sketches, with detailed annotations by his assistant, Robert Craft, and an even more deluxe facsimile of the full autograph score, plus the piano four-hands arrangement, published for the current centennial along with a large collection of essays.[3] An even more lavish commemorative collection was issued by the Moscow Bolshoy Theater.[4] There is a copious compilation of facsimile reviews in several languages, from Russian to Catalan, which seems to have become a bibliographical rarity: the single copy offered for sale at Amazon.com the day I looked was priced at $2,500.[5] (Hang on to your copies!) There is even a book about *The Rite of Spring*'s tympani part—just a pamphlet, really, at thirty-five pages, and self-published, but a bound volume nonetheless.[6] And there is a little book called *Le sacre du printemps: Le tradizioni russe, la sintesi di Stravinsky*, which turns out to be a translation of the twelfth chapter of my monograph of 1996, *Stravinsky and the Russian Traditions*.[7] Its Italian publication was an act of pure piracy, suggested, according to the preface, by Luciano Berio, who I'm sure intended me no harm. I mention it not (or not only) out of immodesty, but also so that, if these words should ever come to the attention of the publishers, they might be shamed into coughing up some royalties.

But there are almost an equal number of books devoted to *The Rite* as dance, beginning with surveys by Shelley Berg and Ada D'Adamo (the latter a veritable coffee-table book).[8] Three volumes have been devoted to individual choreographies, two of which address the original one by Nijinsky: one a booklet by the prolific theater historian Étienne Souriau and the other being Millicent Hodson's magnificently illustrated account of her painstaking reconstructive work for the Joffrey Ballet, laid out measure by measure against Stravinsky's piano score.[9]

Last, and far from least, there is Truman C. Bullard's imposing dissertation on *The Rite*'s first night, which reminds us that *The Rite* was not just a score, and not just a ballet. *The Rite* was an event—perhaps the most notorious event in the

history of twentieth-century art, and one that links up momentously, or at least suggestively, with other notorious events in other histories.[10] Bullard set it as his task to get to the bottom of the event and determine who or what was responsible for it, and, like any other writer in his wake, I will be mining his wonderful documentary compendium in this essay. But there was never any doubt who its protagonist was. The leading role in *The-Rite*-as-event was played neither by Stravinsky nor by Nijinsky, nor by Nikolai Roerich, the scenarist and designer. Nor was it played by the orchestra or by its conductor, Pierre Monteux. Nor was it even played by Sergey Diaghilev, the Man behind the Curtain, the puppetmaster who set it all in motion. Nor by Gabriel Astruc, the manager of the brand-new Théâtre des Champs-Élysées, who (as Bullard revealed for the first time) also had a major hand in the run-up to the event.[11] It was none of these.

As those who know the story will recall, the protagonist of *The-Rite*-as-event was the audience, whose outraged and outrageous resistance to the work took everyone else by surprise, even if (as always) various parties claimed later to have foreseen or even engineered it (Jean Cocteau supposedly writing that the audience had played the part written for it; or Diaghilev saying, according to Stravinsky, that it was "exactly what I wanted").[12] There are any number of reports and memoirs by eyewitnesses, including eyewitness who were not there.[13] The first night of *The Rite*, when, as Stravinsky laconically reported in a letter home, *"delo dokhodilo do draki"* (things got as far as fighting),[14] lives in history as a supreme *succès de scandale,* but it was in fact a fiasco, a rejection that would not be redeemed for many years. It left everyone, whatever their later contentions, with a sense of failure and letdown and loss. If the first night had indeed been a *succès de scandale,* it would have generated the kind of publicity that guaranteed full houses and revivals. But that is not what happened.

The Ballets Russes presented *The Rite* three more times in Paris in June of 1913, as scheduled, then took it to London for another three showings in July. These performances went off without incident, but neither did they generate any special enthusiasm or interest. London critics expressed a bit of self-satisfaction at the placidity with which their countrymen received what had so antagonized the Parisians a month before. "We are either surprisingly quick or surprisingly careless in accommodating ourselves to new forms of art," said the *Times.*"[15] Nijinsky gave an interview to the *Daily Mail* in which he "cordially sa[id] thanks and 'Bravo!' to the English public for their serious interest and attention in *The Festival of Spring.* There was no ridicule ... and there was great applause."[16]

And yet after this London run Diaghilev decided not to revive *The Rite,* whereas *Firebird* and *Petrushka* had become, and would remain, Ballet Russes perennials. The usual explanation for this is the break between Diaghilev and Nijinsky over Nijinsky's decision to marry. But that was more a pretext than a reason. *The Rite* was expensive. It required nineteen more musicians than any other score in

the Ballets Russes repertory, and many extra rehearsals. Canceling it seemed an inevitable commercial decision. Diaghilev knew enough to accompany *The Rite* on every showing (including the stormy première) with his most dependable crowd-pleasers: *Les sylphides, Le spectre de la rose,* and the *Danses polovtsiennes du "Prince Igor."* That kept the houses full enough. But Stravinsky's third ballet had proved a bad investment, and Diaghilev seems to have told Stravinsky as much. In an all but uniquely self-revealing letter he sent four months later to Alexandre Benois, his collaborator on *Petrushka,* Stravinsky gave vent to the anxieties he was feeling in the wake of *The Rite. "Akh, dorogoy!"* Stravinsky wrote, "Ah, my dear"—

> even now this last offspring of mine won't give me a moment's peace. What an incredible storm of teeth-gnashing rages about it! Seryozha [Diaghilev] gives me horrible news about how people who were full of enthusiasm and unwavering sympathy for my earlier works have turned against this one. So what, say I, or rather think I—that's how it ought to be. But what has made Seryozha himself seem to waver toward *Le Sacre,* a work he never listened to in rehearsals without exclaiming, "Divine!"? He has even said (something that by rights ought to be taken as a compliment) that this piece ought to ripen a while after completion, since the public is not yet ready for it—but why then did he *never before* bring up such a course of action? ... To put it as simply as possible, I'm afraid that he has fallen under bad influences—strong not so much from the moral as from the material point of view (and *very* strong). To tell the truth, reviewing my impressions of his attitude toward *Le Sacre,* I am coming to the conclusion that he will not encourage me in this direction. This means that I am deprived of my single and truest support when it comes to propagating my artistic ideas. You will agree that this knocks me completely off my feet, for I cannot, I simply *can not* write what they want from me—that is, repeat myself—repeat anyone else you like, only not yourself!—for that is how people write themselves out. But enough about *Le Sacre.* It makes me miserable.[17]

What rescued *The Rite* was the first Parisian concert performance of the score, led by Pierre Monteux, who had conducted the all-but-drowned-out première, and who in later life confirmed his first impression of *The Rite:* "I decided then and there that the symphonies of Beethoven and Brahms were the only music for me, not the music of this crazy Russian!"[18] But he gave the crazy Russian the night of his life, leading an "ideal" performance, as the composer gratefully recalled it half a century later, and allowed him to experience what he called (thinking perhaps of Nijinsky's curtain calls) "a triumph such as few *composers* can have known the like of."[19] *The Rite* now began to make its way, until it achieved the colossal iconic status that it has today. It is an unequaled status (but for the single possible exception with which I continue to tantalize you, dear reader); but what possesses that status is just the score, the artifact—or the experience—that was vindicated by Pierre Monteux on 5 April 1914, not the *Gesamtkunstwerk* that went down in flames on 29 May 1913. That night in May is the date that shimmers in history,[20] but the per-

manence of *The Rite* was assured on that later night in April. It is from then that the unbroken tradition of the piece—that is, of the score—in performance dates.

That artifact, the *Sacre* score, has a rare distinction among twentieth-century "concert" or "classical" compositions as a central constituent of both the academic canon and the performing repertory. The gulf that opened up in the twentieth century between the canon (that is, the works praised, or at least parsed, in the classroom) and the repertory (that is, the works presented to, and applauded by, paying customers in the concert hall) may embarrass us now, but it was an accepted fact of life when I was a student half a century ago. You would almost never hear tell of Rachmaninoff or Shostakovich or Respighi or Vaughan Williams in the classroom or in textbooks, and you would almost never hear Schoenberg or Webern, and only rarely Bartók or Berg, in the concert hall. Some twentieth-century composers inhabited both the canon and the repertory, but only by dint of compartmentalization. Richard Strauss crossed over from canon to repertory between *Elektra* and *Rosenkavalier*. Aaron Copland deliberately wrote some of his pieces for the one and others for the other. But by the 1950s, *The Rite of Spring* had become indispensable to both. Both as a work and as an event it is reported in every textbook on music history, and heard in every music history course. Countless graduate seminars have worried to death its every jot and tittle. But it is also universally heard and studied in music appreciation courses and books, which aim to popularize the repertory rather than maintain the canon; and it is in the active repertoire of every professional orchestra (but very few ballet companies; Balanchine, for one, never went near it). So, while the canonical status of *The Rite* could not be higher or more secure, as witness the list of serious scholarly monographs reeled off above, you will also find *The Rite* in any list of the favorite fifty pieces and in any consumer guide to recordings, and there are many dozens of recordings to choose from.

The whole story of its absorption into the repertory is encapsulated in a comment that Louis Speyer, the veteran Boston Symphony oboist and English horn player, who had played in the orchestra at the première under Monteux (who had brought him to Boston), made to Truman Bullard, who was interviewing him for his dissertation. Describing the first sectional rehearsal of the winds and brass, Speyer recalled that "already the introduction was a surprise, a bassoon in that register, we all looked and even some composers present asked if it was a saxophone." (Later, as you may recall, this story morphed apocryphally into an anecdote about the aged Saint-Saëns at the première.)[21] Speyer then continued, referring to the bassoonist Abdon Laus (1888–1945), who also went on to play under Monteux in Boston, that he "was the first to attack this difficult solo; he had to find fingerings which was a terrible experience. Today any good player knows this solo."[22] And not only good players; all conservatory students study their parts for *The Rite* because they know they will be asked to play them at auditions. Programming the piece is no longer a special event; audiences expect it alongside their Beethoven

symphonies and Chaikovsky concertos. Since the 1980s, when musicology developed a conscience—or, at least, became self-conscious—the canon and its formation have been the object of skeptical sociological study. But while consciousness of the social pressures and practices that have informed the construction of canon and repertory alike has softened their borders somewhat, it has not effaced the distinction, or the invidious judgments that follow from it.

The invidiousness works in both directions. Stravinsky lived to see his early works achieve standard repertory status, and it made him nervous. In the late 1950s, finally succumbing to Robert Craft's importuning and dictating some memoirs about his three prewar ballets—something he had refused to do for their first collaboration, *Conversations with Igor Stravinsky* (1959)—for use in various publicity releases before they were consolidated and revised for *Expositions and Developments* (1962), he remarked that "*Petroushka [sic]*, like *The Firebird* and *Le Sacre du Printemps,* has already survived a half-century of destructive popularity, and if it does not sound as fresh today as, for example, Schoenberg's *Five Pieces for Orchestra* and Webern's six, the reason is partly that the Viennese pieces have been protected by fifty years of neglect."[23] His nervousness was understandable given the puritanical strictures, as common in those days as they were authoritative, against modern music that audiences liked: a verdict pronounced not only by Adorno, whose *Philosophie der neuen Musik* Stravinsky seems (by Robert Craft's avowal) never to have read, but also, and even more ominously, by those, like René Leibowitz, who accused composers of audience-pleasing music—most notably Bartók, whose late works crossed over, like Strauss's operas, from canon to repertory—of "compromise," a baleful term with ruinous implications in the aftermath of World War II, especially for someone like Stravinsky, who had an interwar flirtation with fascism to live down.[24]

But of course Carolina Performing Arts would not have hosted the yearlong bacchanalia of tribute that provided this essay with its pretext in honor of Schoenberg's *Five Pieces for Orchestra* or Webern's six. Nor did we have one in 2010 in honor of *The Firebird*, or in 2011 in honor of *Petrushka*. Severine Neff, the Schoenberg specialist to whose initiative we owed said bacchanalia, and to whom we participants have all expressed heartfelt gratitude for giving us our forum, knows this better than anyone. Inasmuch as she let it be known in Carolina Performing Arts's publicity materials, I feel it permissible to mention here that she had originally proposed honoring the centennial not of *The Rite* but of Schoenberg's *Pierrot lunaire,* and was overruled. From all these stories and testimonies we can conclude that neither a piece belonging only to the canon, like *Pierrot,* nor a piece belonging only to the repertory, like *Firebird,* could have given rise to such an orgy of commemoration. You have to have the dual status that seems to be *The Rite*'s alone, among twentieth-century masterpieces. And the relevant question is not how did it happen that a piece of modernist music managed, unlike Schoenberg's

or Webern's, to join the standard repertory, but rather how did it happen that in its crossing over to the repertory *The Rite* did not lose its commanding place in the academic canon?

The answer (rather obviously, I think) lies in the relationship between *The Rite* as an artifact and *The Rite* as an event. It was the furious resistance the work encountered on its first exposure that prevented its later popularity from becoming "destructive" of its reputation. Its equal fame as artifact and as event combined to give it an even higher status—the status of myth. And now it is time to name the work I have been adumbrating as *The Rite*'s only possible rival in iconic or mythic stature—and that work, as you have probably already guessed (especially if you are familiar with books by Thomas Kelly), is Beethoven's Ninth Symphony, another work that lives as an epoch-making feat of composition but that also had a legendary first night.[25] The legend of the Ninth also entails audience incomprehension, if not violent resistance. Beethoven was the first composer, in fact, whose legend was fed by the myth of resistance.

Audience resistance to artistic greatness was part of the myth of romanticism, according to which creative genius is socially alienating and isolating. The artist, no longer an especially skilled craftsman but an especially endowed spirit—that is, a genius—is by that gift or curse estranged from the rest of mankind, cast into a vanguard that inspires both awe and resentment from the mass of ordinary men, who are made to feel and acknowledge their ordinariness in his presence.[26] Beethoven's socially alienating deafness certainly played into this myth, and sure enough, the most famous story involving Beethoven's deafness pertains to the Ninth's première, when Caroline Unger, the alto soloist, had to turn Beethoven around after the Scherzo to acknowledge applause that he could not hear.[27]

So the story of the Ninth is a story of *Kampf und Sieg*, struggle against and victory over adversity, with the deaf genius Beethoven the hero. Its content symbolized freedom and brotherhood, the humanistic values of the Enlightenment, brought to a transcendent level by Romantic genius, despite the social alienation that genius entails. Its vibes were all good, and the import of its myth was entirely positive. *The Rite* stood for something else—something that challenged those good enlightened vibes, something that its original audiences, whether or not they actively resisted, recognized as frightful. Even the most favorable reviewers saw it that way. The one writing for the London *Evening Standard* expressed the opinion that "everyone should go and see *Le Sacre du Printemps*, if only on account of its bizarrerie and astonishing ugliness—ugliness on the stage and in the orchestra. The thoroughness with which it is pursued in every department is extraordinary, scenic artist, composer, and dancer combining together with marvelous success in accomplishing the general purpose."[28] That reviewer was reacting to *The Rite*'s esthetic ugliness. But its moral ugliness was also recognized, and even praised, especially by the awestruck critic who now looms in retrospect as the most

prescient reviewer of the première: Jacques Rivière, the editor of the *Nouvelle revue française*, who exclaimed, *"C'est un ballet sociologique"*:

> This is a sociological ballet.... We witness the movements of man at a time when he did not yet exist as an individual.... At no time during her dance does the Chosen Maiden betray the personal terror that ought to fill her soul. She accomplishes a rite; she is absorbed by a social function and, without giving any sign of comprehension or interpretation, she acts according to the will and the convulsions of a being more vast than she, a monster full of ignorance and appetites, cruelty and gloom.

And even more frightening, *"Ce ballet est un ballet biologique"*: "This ballet is a biological ballet. Not only is it the dance of the most primitive man, it is the dance before there was such a thing as man."[29]

These perceptions of Rivière's jibe clairvoyantly with Nijinsky's own view of his choreographic creation. Nijinsky told a London reporter that *The Rite* "is really the soul of nature expressed by movement to music. It is the life of the stones and the trees. There are no human beings in it."[30] This chilling dehumanized vision and its angry rejection at first sight contributed mightily to the romantic myth of *The Rite*; and inasmuch as modernism, in Leonard Meyer's wonderful phrase, was "late, late Romanticism," so *The Rite* was the *ne plus ultra* of the Romantic myth of the alienated artist, adapted to the bleak vision of early modernism.[31] That is what gained *The Rite* its spectacular place, unrivaled by any other musical work, in the cultural history of the early twentieth century, epitomized by Modris Eksteins's now celebrated book *Rites of Spring: The Great War and the Birth of the Modern Age*, whose title, and whose very thesis, is a tribute to the myth. The first chapter of the book, which is otherwise devoted to real war and mayhem, is a description of *The Rite*'s tempestuous première, cast as if it were a rehearsal for the devastating war unleashed the next year. That is mythmaking on a grand scale, mythmaking with a vengeance. A sample: "*The Rite of Spring*, which was first performed in Paris in May 1913, a year before the outbreak of war, is, with its rebellious energy and its celebration of life through sacrificial death, perhaps the emblematic oeuvre of a twentieth-century world that, in its pursuit of life, has killed off millions of its best human beings. Stravinsky intended initially to entitle his score *The Victim*." And a little later: "Most history of warfare has been written with a narrow focus on strategy, weaponry and organization, on generals, tanks, and politicians. Relatively little attention has been paid to the morale and motivation of common soldiers in an attempt to assess, in broad and comparative terms, the relationship of war and culture. The unknown soldier stands front and center in our story. He is Stravinsky's victim."[32]

Thus, when contemplating the "Danse sacrale" at the end of *The Rite*, Eksteins would have us think of the furious Abram in Wilfred Owen's harrowing, posthumously published poem "The Parable of the Old Man and the Young" (1920; familiar to musicians from its setting in Britten's *War Requiem*), who refused to stay his

hand when the Angel bade him spare Isaac, "but slew his son, / And half the seed of Europe, one by one." It is a gripping thought; and anything that adds intensity to the experience of *The Rite* is welcome. But although Stravinsky and Nicholas Roerich, the artist and archeologist to whom he turned for a scenario, did initially call their project *Velikaya zhertva*, and while *zhertva*, in Russian, can mean "victim," Eksteins's parallel is somewhat strained. *Velikaya*, the other word in the working title, means "great"; and with that word in front of it, *zhertva* has to revert to its other meaning, *sacrifice* or *offering*. Thus the ballet was originally conceived, in accordance with Stravinsky's originating vision, as *The Great Sacrifice* (now the subtitle to part II), the title evoking the action rather than the victim—whence the title finally adopted, coined (originally in the plural, as "Les sacres du printemps") by the painter Lev Bakst. Eksteins's conceit was fertile. The book it brought forth, on the carnage of World War I and its lasting cultural aftermath, is justly fêted. But while recommending it heartily, I nevertheless resist the romantic urge to elevate our artists into prophets.

Like any myth, the myth of *The Rite* coexists uneasily with the facts. For some, the appropriate rejoinder will be "What price facts, then?" But while sharing the aversion to what I fear I may have started to resemble—namely, the academic pest who is forever toting a pail of cold water with which to douse all fertile conceits—I do think that the myth of *The Rite* could use, and will survive, a fresh, cold look.

II

As *The Rite* made its way with the assistance of its myth, a contradiction very swiftly developed and grew. As we have seen, the progress of *The Rite* was, at least at first, the progress of the score, not the whole ballet. That score has never suffered the resistance that was shown the ballet on its legendary first night. Indeed, the music of *The Rite* as such has never attracted that sort of protest. That first night a lot of it went unheard beneath the whistling and hooting. One of the reviewers, Louis Vuillemin, writing in the theatrical journal *Comoedia*, stated outright that "at the end of the prelude [that is, when the curtain went up on what Stravinsky in later life (inaccurately) called Nijinsky's 'group of knock-kneed and long-braided Lolitas jumping up and down']"[33] the crowd simply stopped listening to the music so that they might better amuse themselves with the choreography,"[34] and his remark is, as it were, negatively corroborated by the many reviews that neglect Stravinsky's contribution altogether beyond merely naming him as composer.[35]

But blaming the fiasco on Nijinsky and his "crime against grace" also appears to be an inadequate explanation, for the same review by Vuillemin has a passage that suggests the audience had been antagonized in advance and was ready to protest no matter what it saw or heard (thus partially substantiating the famous surmises of Cocteau that have become so familiar a part of *The Rite*'s lore).

Some people, invited to a few final rehearsals, went back out into [the streets of] Paris wild-eyed and convinced they had reason to be. They were of two kinds; both wild and both convinced. "Marvelous, magnificent, splendid, definitive!" cried some to everyone who would listen for a moment. "Abominable, hateful, ridiculous, pretentious!" screamed the others even to those who did not have time to listen. I leave it to you to surmise the kind of damage brought about by such passion. It spread through the entire public like wild-fire thirty-six hours before the curtain rose. "Just you wait," those convinced said, "we are about to witness the great musical revolution. This evening is the appointed time for the symphony of the future!" "Watch out," warned the skeptics, "They are out to make fun of us. They take us for fools. We must defend ourselves!" Result: the curtain goes up—I should say even before the curtain went up—you could hear "OH!" and then they all began to sing, to hiss, to whistle. Some clapped, some cried "Bravo!" some shrieked, some cheered. Some hooted, some extolled. And there you have the première of *Le Sacre du Printemps*. You can well imagine how that half-dozen people who were not fanatics were prevented from getting a clear idea of the work or forming a logical and rational opinion.[36]

We can supplement Vuillemin's semi-satirical description of a house divided in advance and armed to the teeth (quite literally so, many having come with whistles in their pockets)[37] with a couple more documents from Bullard's incomparable dossier plus one that I discovered serendipitously while preparing this essay. Bullard's very first exhibit is a press release from the management of the Théâtre des Champs-Élysées, published the morning of the première in all the main Paris newspapers. *"Le Sacre du Printemps,"* it averred,

> which the Russian Ballet will perform for the first time this evening at the Théâtre des Champs-Elysées, is the most amazing creation ever attempted by M. Serge de Diaghilev's admirable company. It evokes the primitive gestures of pagan Russia as conceived by the triple vision of Stravinsky, poet and composer, of Nicholas Roerich, poet and painter, and of Nijinsky, poet and choreographer.
>
> Here we see powerfully portrayed the characteristic attitudes of the Slavic race in its response to beauty in the prehistoric era.
>
> Only the wonderful Russian dancers could portray these first stammered gestures of a half-savage humanity; only they could represent these frenzied mobs of people who stamp out untiringly the most startling polyrhythms ever produced by the brain of a musician. Here is truly a new sensation which will undoubtedly provoke heated discussions, but will leave every spectator with an unforgettable memory of the artists.[38]

That is heavy hype. It is a bizarre pitch, actually: the oxymoronic image of half-savage humanity reproducing the most startling polyrhythms ever produced by the brain of a musician recalls Debussy's immortal sally—made the very same day, hence possibly in response—that *The Rite* was "primitive music with all modern conveniences."[39] The prediction of heated discussions helped produce them.

The extent to which the publicity surrounding the ballet was held responsible for the hostilities in the theater can be judged from a front-page editorial that appeared four days later in *Le Figaro*, signed by Alfred Capus (1858–1922), not a critic of the arts but the paper's senior foreign-affairs correspondent, who the next year would become the paper's very jingoistic wartime editor. You may be sure that this article in the leading boulevard daily (whose author gives no sign of having actually attended the première) did not escape the notice of Modris Eksteins, who discovered it, as I did, in Bullard's dissertation. Seizing upon the coincidence that the Treaty of London, ending the war between the Balkan League and the Ottoman Empire, had been signed the day after the *Rite* première, Capus started embroidering: "Although peace has been signed in the Balkans there remain nevertheless a number of international issues that still have to be settled. Among these I have no hesitation in placing in the front rank the question of the relationship of Paris with the Russian dancers, which has reached a point of tension where anything can happen. It has already produced the other night a border incident whose gravity the government should not underestimate."[40]

Under the command of Nijinsky, "a sort of Attila of the dance," Capus reported, the Russian dancers had "seized the small section of the eighth arrondissement [that is, the block on which the Théâtre des Champs-Élysées was located] after a fierce battle with the city of Paris, and today they form a little independent state there."[41] At the end of the article Capus proposes a treaty with the Russians: "Nijinsky would have to agree not to stage any more ballets that aspire to a level of beauty inaccessible to our feeble minds, and not to produce any more three-hundred-year-old 'modern' women, or little boys feeding at breasts, or, for that matter, even breasts. In return for these concessions we would continue to assure him that he is the greatest dancer in the world, the most handsome of men, and we would convince him that we mean it. We should then be at peace."[42]

Between these opening and closing sallies Capus lodged a more serious and pointed complaint, thanks to which the *Rite* première was covered by the *New York Times*. This was the discovery that surprised me as I was trawling the *Times* online archive for news of *The Rite*. I had not heard that the *Times* had a correspondent in attendance at the *Rite* première—and in fact they did not have one. But their Paris correspondent noticed the Capus piece owing to its prominent front-page placement in the French capital's premier political newspaper, and on 7 June 1913 filed a report on *it*, which the *Times* ran the next day under the headline "PARISIANS HISS NEW BALLET," followed by a trio of banners:

"Russian Dancer's Latest Offering, 'The Consecration of Spring,' a Failure"

"Has to Turn Up Lights"

"Manager of Theatre Takes This Means to Stop Hostile Demonstrations as Dance Goes On"

Here is how the *Times* reported Capus's complaint, and the event that inspired it:[43]

"Bluffing the idle rich of Paris through appeals to their snobbery is a delightfully simple matter," says Alfred Capus in *Le Figaro* this week. "The only condition precedent thereto is that they be gorged with publicity."

"Having entertained the public with brilliant dances," he adds, "the Russian ballet and Nijinsky now think that the time is ripe to sacrifice fashionable snobs on art's altar. The process works out as follows:

"Take the best society possible, composed of rich, simple-minded, idle people. Then submit them to an intense régime of publicity. By booklets, newspaper articles, lectures, personal visits and all other appeals to their snobbery, persuade them that hitherto they have seen only vulgar spectacles, and are at last to know what is art and beauty.

"Impress them with cabalistic formulae. They have not the slightest notion of music, literature, painting, and dancing: still, they have heretofore seen under these names only a rude imitation of the real thing. Finally, assure them that they are about to see real dancing and hear real music.

"It will then be necessary to double the prices at the theatre, so great will be the rush of shallow worshippers at this false shrine.

"This," observes M. Capus, "is what the Russian dancers have been doing to Paris. The other night, however, the plan miscarried. The piece was 'The Consecration of Spring,' and the stage represented humanity. On the right are strong young persons picking flowers, while a woman, 300 years old, dances frenziedly. On the left an old man studies the stars, while here and there sacrifices are made to the God of Light.

"The public could not swallow this. They promptly hissed the piece. A few days ago they might have applauded it. The Russians, who are not entirely acquainted with the manners and customs of the countries they visit, did not know that the French people protested readily enough when the last degree of stupidity was reached."

At this point the *Times* correspondent turned from Capus's article to an interview with Gabriel Astruc, the theater manager: "'The Consecration of Spring' was received with a storm of hissing. The manager, M. Astruc, however, has devised a novel method for silencing a demonstration. When hisses are mingled with counter-cheers, as they were the other night, M. Astruc orders the lights turned up. Instantly the booing and hissing stop. Well-known people who are hostile to the ballet do not desire to appear in an undignified rôle." (So according to the *Times* reporter who interviewed him, it was Astruc rather than Diaghilev, who often gets the credit, who resorted to this method of crowd control.) And only now is the composer named, as the *Times* correspondent moves on to report an interview with the composer that had appeared on the front page of *Gil Blas* on 4 June.[44]

Igor Stravinsky, who wrote the music of "The Consecration of Spring," says that the demonstrations are a bitter blow to the *amour propre* of the Russian ballet dancers,

who are sensitive to such displays of feeling and fear they may be unable to continue the performances of the piece.

"And that is all we get," added M. Stravinsky, "after a hundred rehearsals and one year's hard work."

The composer, however, is not altogether pessimistic, for, he adds: "No doubt it will be understood one day that I sprang a surprise on Paris, and Paris was disconcerted. But it will soon forget its bad temper."

The cause of the bad temper, it would appear, was neither the music nor the dancing, but rather the hype, which outsnobbed the snobs, and the insult it thus administered to French taste. When in 1909 the Russian dancers first exported back to the French an imitation of the ballet they had previously imported from France, and at a level of accomplishment the French themselves could no longer equal, the French had been flattered and captivated. But when four years later the Russians presumed to go beyond their hosts in esthetic discrimination, they committed an unforgivable *faux pas* that required punishment.

The Rite's reception in London the next month was, as we know, far more reserved. But the same sort of social resentment can be detected in the measured but skeptical reviews. The terms of British resistance are effectively summarized in a notice that appeared in the magazine *The Lady* about a week after the London première. The anonymous writer was clearly speaking up not on behalf of Philistines, but rather in defense of the local connoisseurs:

> Report said before the curtain rose ... that all previous efforts of Diaghilev ballets were going to be eclipsed. With such stupendous seriousness was the novelty taken up by its creators that Mr. Edwin Evans[45] was sent before the curtain to explain beforehand what it really meant.... All this did not inspire confidence, for a beautiful work of art ought to be able to reveal itself. If we are allowed to take *Sacre* on its merits, we may accept it and even enjoy it, but all attempts to represent it as inspired truth about the movements of the youth of mankind are likely to alienate us.... I found [the ballet] very interesting. There were some charming patterns made by the permutations and combinations of different groups of dancers. There were ideas in profusion. But as a whole I am afraid that it appeals to all that is pretentious in human nature, and so I condemn it as the evocation of a principle. It may be quaint and delightful to see people crawling on all fours, but it is irritating to be told that in that posture they are more "original" than when walking on foot. It is quite possible to be original in erect motion.[46]

The same reviewer had taken similarly stern positions on the other novelties the Ballets Russes had brought to London that season. Before *The Rite*, Londoners had been shown Debussy's *Jeux* and Florent Schmitt's *La tragédie de Salomé*. Reviewing the latter, *The Lady*'s man expressed by now familiar suspicions of charlatanism, and adapted the resistance previously shown by the French audience to the traditional British leeriness of the French. "There are some people,"

he wrote, "who appear to swallow the Russian Ballet and all its works with open-mouthed and closed-eyed enthusiasm. I have often been enthusiastic ... but one must discriminate. *Salomé*, the novelty of last week, is worse than *Jeux*, the novelty of the week before. It strikes me, not for the first time, that Paris is not exerting an altogether wholesome influence on the Russian Ballet."[47]

The man had a point. Paris was more than a performance venue for *The Rite*. Paris had helped shape both the ballet's conception and the discourse that surrounded it; and it was to the discourse that the London reviewer, like the French reviewers quoted earlier, was reacting—and showing resistance. The neoprimitivist impulse, of which *The Rite* now looms in retrospect as the supreme embodiment (or at least the supreme remnant in active repertory), had a legitimate Russian pedigree. Under the name *skifstvo*, or Scythianism, it had become something of a craze in the Russia of the late Silver Age. "Poets wore themselves out trying to roar like wild animals," Korney Chukovsky recalled in 1922. "The craze for the savage, the primitive, and the beast of the forest," he wrote, "became the outstanding feature of the epoch."[48] A book by one such poet, Sergey Gorodetsky, called *Yar'*, from which Stravinsky had set two poems in 1906, contained another, "Yarila," which described a virgin sacrifice to the God Yarilo: exactly the culminating "vision" or "dream" of the future *Rite* that, according to the familiar story, Stravinsky imagined in 1910 as he was finishing *Firebird*. These neat correspondences prompted me to remark—a bit too archly, perhaps—in my book about Stravinsky that his "was by no means an unusual sort of dream for a creative artist to have in St. Petersburg in 1910. In that environment, one could even call it conventional."[49]

But behind all modern primitivist movements lurked an old-fashioned colonialist exoticism, much of it of French inspiration.[50] Everyone recognized the shadow of Paul Gauguin behind the work of Nicholas Roerich. Behind Stravinsky's primitivism there lay a cognate Russian orientalism that, when presented to the French, cast the ostensibly native in garishly auto-exoticized terms.[51] That parallel between the French and Russian orientalist strains vouchsafed Diaghilev's Parisian triumphs, for he knew that the Russia the French wanted to see was a Frenchified, exoticized, orientalized, racialized—one almost wants to say Negrified—Russia. *Firebird* had followed directly on, and brought to a new plane, the exotic fare of the first Russian seasons—*Shéhérazade, Cléopâtre, Danses polovtsiennes, Danses persanes*—even as *The Rite* followed directly upon *Firebird* and brought *it* to a new plateau in every way from radicalized (and racialized) style to pretentious publicity.

In any case, everyone sat at the feet of the French to learn the art of *faire réclame*, and to exploit the *prestige*-making *cachet* of the *avant-garde*. In lumping together and resisting *tout d'un coup* all the novelties of the 1913 season—Debussy's *Jeux*, Schmitt's *Salomé*, and Stravinsky's *Sacre*—the London critic was resisting France, not Russia, and by his lights he was indeed perceptive. The Russian dancers were

bringing the news to London not directly from their barbaric, chthonous homeland, but from effete and decadent, overcivilized Paris.

III

These, then, are among the reasons why as a score *The Rite* inspired so much less resistance than it had as a ballet. Audiences received the music without protest and often with enthusiasm, and it inexorably eclipsed the ballet in fame. The earliest concert performances took place in Russia under Koussevitzky (one each in Moscow and St. Petersburg early in 1914), and they were well enough received to disgust seventy-nine-year-old César Cui, the lone survivor from the Mighty Kuchka, who, after describing it as "a treasure chest in which Stravinsky has lovingly collected all sorts of musical filth and refuse," went on to observe that "this *Rite* has been booed everywhere abroad, but among us it has found some applauders—proof that we are ahead of Europe on the path of musical progress."[52]

And then came the triumph under Monteux, which set the score on its inexorable path of conquest. And why not? While it was at first a sore test for orchestra and conductor, and while it took fully half a century before music analysts caught up with it,[53] *The Rite* has never been a difficult piece for concert audiences. Stravinsky, who had already experienced two huge audience successes, had every reason to expect a third. Looking forward to the première with confidence, he wrote to Roerich that "from all indications I can see that this piece is bound to 'emerge' in a way that rarely happens."[54] It is not, after all, a complex score. Its textures are simple, though very artfully and colorfully elaborated. What there is in it of counterpoint (beyond the prelude preceding the action) is uncomplicated. Its ostinato-driven forms are downright rudimentary, as is only right given the subject and setting. Its dissonances are indeed harsh and grating, but never mystifying (except to analysts), and neither are the irregular percussive rhythms. They all have obvious topical correlatives in the argument and action, and that argument and action are sufficiently conveyed by the title. Nobody ever wonders why Stravinsky wrote the piece the way he did—that is (as he once put it to Vladimir Ussachevsky), "with an axe."[55] The sounds of the music make a direct and compelling appeal to the listener's imagination, and the listener's body. Thanks to Stravinsky's peerless handling of the immense orchestra they have a visceral, cathartic impact. They leave—and to judge from the history of the score's reception, have always left—most listeners feeling exhilarated. It is only the mythology of *The Rite* that would suggest anything else.

The path of conquest was sure, but it was not rapid, and not only because few orchestras were capable of tackling the piece at first. The progress of *The Rite* as an orchestral score was retarded in the first place by the war that broke out almost immediately after its first concert performances, which put an end to all performances in

the immediate future and delayed publication until 1921.[56] During the decade of the twenties, performances were rare, but their very rarity made them big events, always enhanced by repetitions of the legend of the original event. The fact that it was always preceded by its reputation—a reputation founded on the opening-night scandal, with which the score as such had little to do—actually smoothed the path of conquest; for in light of the legend, the music always came as a pleasant surprise. And the myth took hold, according to which the scandal itself was evidence of the music's greatness and originality—an originality the music theory establishment to this day works very hard to defend against historical contextualizers like me.[57] And so the myth lives on. The review of the New York concert première in January 1924 by Olin Downes, then fresh from Boston and just starting his long tenure at the *New York Times*, can serve to illustrate its early stages:

> To Pierre Monteux and the Boston Symphony Orchestra fell the task, superbly executed, of introducing to the public of this city Igor Strawinsky's "Le Sacre du Printemps," as the work is most commonly known, last night in Carnegie Hall. This work, which created a riot when it was first performed, by Mr. Monteux and the Russian Ballet in Paris in 1913, has been more discussed than any other composition of Strawinsky.
>
> The audience, knowing this and fearing more through the many articles of a descriptive kind which had appeared in the daily press, came prepared for the worst, to listen to the new music. After the first part of the score had come to an end there were a few hisses—whether in indignation or to suppress premature applause was not easy to tell. After the second part it was apparent that a majority had enjoyed themselves. The applause of this majority was long and loud, and to all appearances most sincere. Two false impressions had been spread abroad, concerning this music, first, that it was unequaled in ugliness and fearfulness generally, and secondly, that it was completely unprecedented among Strawinsky's compositions. Both these reports, as Mark Twain would have said, seem greatly exaggerated. The music, filled as it is with a primitive and at times vertiginous energy, has pages of a rare and highly individual beauty. The score is obviously a logical evolution of the style of Strawinsky, following naturally from indications contained in "The Fire-Bird" and "Petrouchka." There are a number of passages in "Sacre du Printemps" which could come straight from both these earlier works. . . . The expression, however, is greatly intensified. It is done principally by the force and individuality of the counterpoint, and also by rhythms that have an at times all but hysterical shock and fury. There is the effect of the complete abandon of mood and manner in this music. We believe that it is written with the most exact precision, with enormous power and with an uncanny knowledge—prescience—of the capacities of a greatly extended orchestra.[58]

What's the problem, Downes seemed to be asking. So safe was the reputation of the score after the triumph under Monteux that when Diaghilev revived the ballet in 1920, freshly choreographed by Leonid Massine and warmly received in Paris as if in atonement for the 1913 fiasco, he took out a sort of insurance policy

on its success before having it danced in London, sponsoring a concert performance under Eugène Goossens in June 1921, so that London audiences, too, could be won over by the music in conjunction with—or in contrast to—the legend. As Nesta Macdonald, the chronicler of Diaghilev's London exploits, averred, this was a "master-stroke" and a "resounding success," and won for the ballet, now for the first time titled in English the way we know it today, a lasting *succès d'estime* that finally disarmed critical resistance.[59] Percy Scholes, writing in the London *Observer*, elicited a quote from Bernard Shaw, so as "to give," he said, "*Observer* readers the view of our oldest music critic, and he replied: 'Mind, I'm not to be understood as condemning it, but—if it had been by Rossini people would have said there was too much rum-tum-tum in it!'"[60]

By 1929 the impresario could exult, in a letter from London to Igor Markevitch, posted about a month before Diaghilev's untimely and unexpected death, that *The Rite*, in what turned out to be its last performance by the Ballets Russes, "had a real triumph last night. The idiots have caught on to it. *The Times* says that *Sacre* is for the twentieth century the same as Beethoven's Ninth Symphony was for the nineteenth! At last!"[61]

It would seem that resistance was at an end. In fact, it was only entering a new phase, one that has lasted up to our own time. And of course Diaghilev knew that perfectly well. The master of spin was still spinning, even in a letter to one of his intimates, egregiously misrepresenting the snide way in which the anonymous commentator for the London *Times* had reacted to what was evidently a bit of overheard (and no doubt oversold) partisan scuttlebutt, quite likely planted by Diaghilev himself. "'Le Sacre,'" he wrote, "is 'absolute' ballet, and we are assured that it will come to be regarded as having a significance for the 20th century equal to that of Beethoven's choral symphony in the 19th. Well, perhaps; meanwhile there was a rather thin attendance in stalls and boxes last night, but the lovers of true art in the gallery applauded to the echo."[62] Clearly the good grey *Times* found the comparison absurd.

But it has been resilient, for it does point up that unique status that *The Rite* shares with the Ninth. Their affinity was recognized in actual concert programming. The once very prominent conductor Oskar Fried, for example, conducted the two works back to back with the Paris Conservatory Orchestra at the Palais Garnier at a monster concert ("300 éxécutants," the adverts promised) on 26 May 1927.[63] The idea of pairing them is not hard to fathom. Both are emblematic bulwarks of canon and repertory alike; both possess that magical combination of a cherished and prestigious score with an unshakable reputation for innovation, plus a hardy first-night legend that makes them "historic." They are executed on what seems an equally monumental scale—which is an extra tribute to *The Rite*, because it is only half the length of the Ninth. But what it lacks in length it makes up in weight of sound—and then some. Both have accordingly cast enormous

shadows and wielded enormous influence. As my old colleague Joseph Kerman once observed, "We live in the valley of the Ninth Symphony—that we cannot help."[64] Robert Craft was a bit more sanguine about *The Rite,* calling it "the prize bull that inseminated the whole modern movement"—a lovely metaphor for a work that is all about fertility.[65] Many composers have testified to the justice of Craft's metaphor—most famously, perhaps, Elliott Carter, who often said that he decided he wanted to be a composer when he heard the New York première of *The Rite* (as a concert piece, of course) with the Boston Symphony under Monteux in 1924, the very performance of which we have already sampled the *New York Times* review.[66]

In other ways, though, *The Rite* and the Ninth can look like opposites. Pablo Casals, the great cellist, was asked by his Boswell, José Maria Corredor, to comment on the comparison, attributed on this occasion to Francis Poulenc, whom Corredor quoted as saying that "what the Ninth Symphony did to stir up the people of the XIXth century, the *Sacre du Printemps* does already for those of the XXth century." Casals retorted, "This time I completely disagree with my friend Poulenc.... Although I acknowledge the talent of Stravinsky and the interest of the *Sacre du Printemps,* I think that to compare these two works is nothing short of blasphemy."[67]

Blasphemy—a violation of holiness. The Ninth has that aura. It gives compelling voice to the highest humanitarian ideals—the very ideals for which Pablo Casals, as famous in the mid-twentieth century for his antifascist stance as for his cello playing, had become a spokesman and an emblem in his turn. He too had an aura of sanctity, and that could only make him allergic to *The Rite*—hardly a herald of universal fellowship, and certainly no Ode to Joy. One could hardly imagine devout or ceremonial performances of *The Rite* at occasions like the breaching of the Berlin Wall, such as the one Leonard Bernstein so memorably led of the Ninth in 1989. But neither could one imagine *The Rite* being ritually performed before an assemblage of the Nazi elite on Hitler's fifty-third birthday, as Wilhelm Furtwängler did the Ninth in 1942, and as we can still see him doing (marvelously!) online.[68]

That 1942 performance is a painful thing to witness now, especially the handshake between Dr. Furtwängler and Dr. Goebbels at the end. Such a reminder of the transitivity or relativity of noble aspirations (for make no mistake, the Nazis certainly thought of their cause as holy) can cast a countershadow over the Ninth, as it has compromised the pretensions of high art to the moral high ground generally—and that probably accounts in part for Joseph Kerman's gloom at having to dwell in its valley. From many, by now, the Ninth attracts derision the way a cartoon millionaire's top hat attracts snowballs. Ned Rorem, the American composer, has made spreading contempt for the Ninth one of his life's missions, insulting it repeatedly in print ("the first piece of junk in the grand style")[69] and in public

speech, as I heard once at Columbia University some thirty years ago, where he called it "utter trash" in a lecture to student composers.

Stravinsky, or his ghostwriter, took some whacks of his own at the Ninth—at Casals, too—in "his" very late interviews that were published in the *New York Review of Books* long after he could have actually given them. So with all appropriate Craft-related caveats in place: here, dated September 1970, is the ultimate aestheticist critique of Beethoven's magnum opus. If Oscar Wilde had known more about music, he could have written it:

> Concerning the great-untouchable finale, however, one hardly dares tell the truth, [which] is that some of the music is very banal—the last Prestissimo, for one passage, and, for another, the first full-orchestra version of the theme, which is German-band music about in the class of Wagner's *Kaisermarsch*. . . . Still more of the truth is that the voices and orchestra do not mix. The imbalances are a symptom. I have not heard a live performance since 1958, when I conducted a piece of my own on a programme with it; but I have *never* heard a balanced one. The "wrong" notes stick out wrongly in the "apocalyptic" opening chord, despite recording engineers, nor can all of their periphonic [?] faking pick up the string figuration in the *"Seid umschlangen* [sic], *Millionen!"* the failure being not electronic but musical. Yet the greatest failure is in the "message," hence, if you will pardon the expression, in the "medium." For the message of the voices is a finitude greatly diminishing the message of the wordless music. And the first entrance of the voice is a shocking intrusion. The singer is as out of place as if he had strayed in from the prologue to *Pagliacci*.[70]

So that is another thing the Ninth shares with *The Rite:* both have "extramusical" baggage that has caused embarrassment and aroused resistance. Leonard Bernstein changed the words of the Ninth at that Berlin-wall performance, substituting *Freiheit* for *Freude* in the finale, and justified the change the way one always justifies such interventions, by claiming that it was Schiller's true intention. And while nobody has ever proposed that the text of the Ninth be ditched altogether, turning the symphony back into an instrumental piece—nobody except Brahms, anyway, who came up with a pointedly instrumental, or devocalized, Ode to Joy when he wrote "Beethoven's Tenth"—there has been a strong move to divest *The Rite* of its troubling subject matter ever since 1920, and the original divestors—which is to say the leaders of the new resistance—were Diaghilev and Stravinsky themselves.

The vindication *The Rite* enjoyed as a score at the hands of Monteux induced Diaghilev to take another chance on the ballet when that became possible after the war, thanks in the first instance to an anonymous gift of money from Coco Chanel. The company he led, however, though still called Les Ballets Russes, was no longer in the same sense the Russian Ballet—that is, a troupe of Russian dancers performing abroad. By 1920 it had become a troupe of postrevolutionary Russian émigrés, now augmented by non-Russian dancers with Russian stage names, like

Lydia Sokolova (*née* Hilda Tansley Munnings in Wanstead, England), who danced the role of the Chosen One in the revival to the new choreography Diaghilev had commissioned from Leonid Massine. Roerich's costumes and one of his backdrops were kept, as an economizing measure, but the scenario was effectively scrapped. The program no longer included a synopsis about the great sacrifice to "Iarilo, le magnifique, le flamboyant."[71] Instead, there was a paragraph that described *The Rite* as "a spectacle of pagan Russia," adding only that "the work is in two parts and involves no subject. It is choreography freely constructed on the music."[72] That rhetoric is what the London *Times* critic had in mind when he wrote with ironic scare-quotes that *The Rite* was being touted as "'absolute' ballet." Critics who had seen Nijinsky's version almost unanimously deplored the elimination from the new choreography of all historical and ethnological references. "I am not quarreling with this," wrote André Levinson, who was obviously quarreling: "The theater is not a museum. But the void is filled with a succession of movements without logic, with a collection of exercises devoid of expression. Nijinsky's dancers were tormented by the rhythm. Here, they must simply keep time."[73]

When Leopold Stokowski collaborated with Massine on a performance of *The Rite* for the League of Composers in 1930 with Martha Graham cast as the Chosen One—the American première of the ballet as such—he announced that "we are not aiming to make this production of the work essentially Russian because we felt that the ideas and feelings it expresses are universal."[74] And he got Nicholas Roerich, the author of the original scenario, now living in the United States and already at the center of what we would today call a New Age cult, to in effect revoke the scenario in a talk he gave at the Wanamaker Auditorium in Philadelphia, in which he, as it were, bequeathed *The Rite* to America. "So many beautiful things," he wrote,

> are possible if we can keep our positive attitude and open-mindedness. We can feel how the primal energy is electrified in this country; and through this energy in the easiest way you can reach the inner constructive feeling of the nation. This constructive striving of spirit, this joy before the beautiful laws of nature and heroic sacrifice, certainly are the essential feelings of "Sacre du Printemps." We cannot consider "Sacre" as Russian, nor even Slavic—it is more ancient and pan-human.
>
> This is the natural festival of the soul. This is the joy of love and self-sacrifice, not under the knife of crude conventionality, but in exuberance of spirit, in connecting our earthly existence with a Supreme.[75]

For Roerich, then, *The Rite* had become the American dream, or rather, his dream of America. For the rest, surrounded by epithets like "absolute" and "universal" and even "devoid of expression," *The Rite* had been pressed into the service of the postwar "dehumanized" esthetic, later to be dubbed "neoclassical"; and Stravinsky's voice was the loudest and most insistent of all in repositioning it—

indeed, in rewriting its history and revising its meaning, all the while refusing to acknowledge that he was doing anything of the sort. Four decades later, dictating a memoir to Robert Craft, he was more candid, explaining simply that by the time Diaghilev revived *The Rite*, he (Stravinsky) "realized that I prefer *Le Sacre* as a concert piece."[76] Of course he did. When performed that way it was unencumbered by those aspects of the work that (he must have thought) had been the greatest obstacles to its success in 1913, and besides, he could take all the credit for it as a concert piece.

But that is not what he told a Paris reporter in 1920. Asked which choreography he preferred, he did as Diaghilev would certainly have wished him to do, perhaps as Diaghilev had told him to do, and chose Massine over Nijinsky as more faithful to what he now touted as his original conception. "I composed this work after *Petrouchka*," he told the reporter, Michel Georges-Michel, who was interviewing him for *Comoedia*, as always the Paris organ friendliest to the Diaghilev ballet:

> The germinal idea of it is a theme which came to me when I had finished *Firebird*. Because this theme and those which grew out of it were conceived in a rough and brutal manner, I chose as a pretext for developing their implications the prehistoric epoch of Russia, since I am a Russian. But note well that this idea came from the music and not the music from the idea. I have written an architectonic work, not an anecdotal one. And it was a mistake to treat it anecdotally, which goes against the whole thrust of the piece.[77]

This is completely at variance with all other accounts Stravinsky gave of *The Rite*'s moment of conception, which took place in his mind's eye, not his mind's ear. The music did indeed come from a visual "idea," and not, moreover, until the idea had been elaborated into a detailed and (but for the originating sacrificial vision) ethnographically quite accurate scenario with Roerich's help. Stravinsky here assumed the role he would play to the end of his days: one could say with little exaggeration that he spent the second half of his long life telling lies about the first half. And until the 1980s his lies possessed unchallengeable authority.

Stravinsky's resistance to the scenario, and his propaganda on behalf of the score as an abstract concert piece, succeeded in changing the "whole thrust of the piece" for generations of listeners and critics. Pieter van den Toorn was unquestionably correct in announcing, at the very outset of his book-length treatise on the work, that "for the greater part of this century [i.e., the twentieth], our knowledge and appreciation of *The Rite of Spring* have come from the concert hall and from recordings."[78] Whether he was as obviously right in further asserting that the scenario and the choreography and what he calls "the close 'interdisciplinary' conditions under which the music is now known to have been composed" were "matters which, after the 1913 première, quickly passed from consciousness" is less clear, at least to me. "Like pieces of a scaffolding," he wrote, "they were

abandoned in favor of the edifice itself and relegated to the 'extra-musical.'" And hence, "they became history, as opposed to living art."[79] As he often does in writing about Stravinsky's music, van den Toorn relies on the passive voice to create the impression that the processes he describes were inevitable and impersonal. But they had their agents—powerful ones, like the impresario, the scenarist, the new choreographer, and above all the composer, who used the press quite actively to repress consciousness of those old "interdisciplinary" conditions and just as actively to assert a new line.

Among the first to swallow the new line—and not just the line, but the hook and sinker as well—was Olin Downes, in his *New York Times* review of the 1924 New York première. Defending *The Rite* against its reputation as a shocker mainly notable for its grisly action, Downes wrote of the score that "it is music, not mere sound to accentuate or accompany something done in the theatre. This should be emphasized, as Strawinsky has emphasized in various statements. 'Sacre du Printemps' is not an accompaniment for a ballet. It is the other way round. The ballet was the accompaniment for the representation, after the conception, of the music."[80]

Lest there be any doubt as to the source of these assertions, Mr. Downes went on to paraphrase the *Comoedia* interview: "Long before the scenario of the ballet existed, as Strawinsky told Michel Georges-Michel, he had conceived the 'embryo-theme' of the score." And then a direct quotation, in Downes's translation, ending with the famous insistence that "my work is architectonic, not anecdotical; objective, not descriptive construction."

"That is the story," Downes concluded, "and, we believe, the sincere story of the musical evolution of this extremely interesting and exciting creation." Stravinsky was exploiting the media to control the reception of his work, as he had learned to do from Diaghilev, the press manipulator of all press manipulators, and as he would continue to do throughout his career. In this case the press was cooperating in Stravinsky's own resistance to *The Rite*, which demanded the rejection of the scenario as an "extramusical" appendage. That resistance is still going strong—most obviously in much of the academic writing on the piece, which still insists on decontextualizing it, decontextualization being the indispensable price of understanding it within the terms set by the conventions of the academic disciplines, which still tend adamantly to confine the purview of scholarly interest and discussion to the making of the object.[81] "It may indeed be the case," Arnold Whittall wrote, in what amounted to the keynote article in the maiden issue of the British journal *Music Analysis*, "that the 'rules' of the game can only be discovered if the discords are 'translated' into some other medium [he was speaking of Allen Forte's 'pitch-class sets'], in which they can be examined without the psychological burden of their true character and quality. For *Le Sacre* remains an explosive work, and analysis may be impossible unless the score is first defused."[82]

That is a fine description of active resistance and repression. And that resistance has drastically affected performance as well. Even without jettisoning the subject *in toto*, the message of *The Rite* has been relentlessly muted over the years by its performers. Beginning with Massine's, staged versions of the ballet have recoiled from or toned down the "sociological" or "biological" action that so impressed Jacques Rivière with its remorselessness. In keeping with the new view of the work as "absolute" and "objective construction," Massine favored geometrical designs and what he called dance counterpoint over the folkloric or ceremonial dances that could still be detected in Nijinsky's version. Stravinsky assisted him in soft-pedaling the folkloric basis of the work by flatly denying the presence of nearly a dozen folk melodies in his score, admitting only that the opening bassoon solo in the prelude had come from an anthology of Lithuanian wedding songs.[83] He even gave his first biographer, André Schaeffner, the exact page reference, evidently in the hope that his show of candor would forestall investigation of the claim.[84] The ruse worked for nearly fifty years, until Stravinsky's Los Angeles friend Lawrence Morton decided one day, seven years after Stravinsky's death, to reopen the Lithuanian anthology and browse for other tunes.[85] Morton once told me, as I was starting my own investigations of Stravinsky and his works, that I was lucky I had not known the man. He was thinking of the inhibitions, born of personal loyalty, that had prevented him from making the most elementary tests of Stravinsky's many spurious assertions and denials until the Old Man had left the scene.

Many of the more recent choreographies of *The Rite*, perhaps most famously Maurice Béjart's, have replaced the grim sacrifice with another sort of fertility rite, turning the work into a joyously orgiastic celebration of human sexuality—"very positive, very youthful and very strong," in Béjart's own description, which unwittingly echoed Roerich's introduction of the piece to American audiences.[86] Most recently, Mark Morris has continued this Americanizing line, giving, in the words of Alastair Macaulay, the *New York Times* dance critic, who reviewed the Berkeley première, "a latter-day American answer to the score's original Russian primitivist scenario. Barefoot, his dancers are dressed . . . to look like Californian devotees of alternative cultures. The women, wearing flower garlands in their hair and two-toned (white and saffron) calf-length smocks, might be followers of Isadora Duncan (who came from the Bay Area) and 1960s flower power. The men, bare-chested in brightly colored jeans with vine leaves in their hair, might be Berkeley student rebels of the 1960s." And while "the original 'Rite' scenario is of a ritual that builds to a chosen maiden dancing herself to death," and while "most other versions have featured aspects of violence, whether self-harming, social, biological or sexual," in Mark Morris's rendering, retitled *Spring, Spring, Spring*, "nobody dies or suffers. Nobody loses control or seems even remotely agitated."[87]

The clumsiest attempt at resistance in performance that I've seen was the first Soviet production of the ballet, choreographed for the Bolshoy Theater in Moscow

by Natalia Kasatkina and Vladimir Vasilyov in 1965. I caught it in 1972 and will never forget how it startled me. Although the composer had become *persona grata* by then in the homeland on which he had turned his back so long ago, and was touted, especially since his death, as *russkaya klassika*, "a Russian classic," the ballet scenario was still a problem, which the Soviet choreographers solved by having a young man, identified in the program as "the shepherd," leap out of the corps de ballet during the little flute scale that comes right before the final fatal crashing chord, sweep the Chosen One off her feet and into safety, and (coinciding with that final chord) plunge a dagger into the idol of Yarilo, the sun god before whom she was doing her fatal dance (rechristened Dazh'-bog for the occasion, in accordance with the eleventh-century Russian *Primary Chronicle*).

Even Millicent Hodson's now much-traveled version for the Joffrey Ballet, which purported faithfully (and, for many, convincingly) to reconstruct Nijinsky's harsh original to the extent that it could be reassembled from the available evidence, may have flinched a bit, allowing a hint of humanitarian sentiment to creep into the pitiless "Danse sacrale," when the Chosen One, a look of terror on her face, tries repeatedly to break out of the circle of tribal elders that surrounds and confines her as she performs her lethal leaps. The evidence on which Hodson based this episode consists of two items.[88] The first is a notation, evidently in the hand of Marie Rambert, the eurythmics coach, on the piano four-hands score that guided Nijinsky in fashioning the choreography. The second is a passage in the memoirs of Bronislava Nijinska, the choreographer's sister, whose testimony carried authority because until she became inopportunely pregnant, Nijinska had been the intended performer of the role of Chosen One, and it was on her body that Nijinsky had created the original steps. (Her recollections had been incorporated by Vera Krasovskaya, the great Soviet dance historian, in her monograph on Nijinsky.)

Rambert's actual words as inscribed in the four-hands rehearsal score indicate that the Chosen One "runs across clutching her head" *(perebegayet khvataya s' za golovu)*; it is Hodson, not Rambert, who interprets the gesture as a "foiled escape attempt."[89] Nor does Krasovskaya's text corroborate this interpretation directly. She quotes Nijinska, in language also quoted by Hodson, likening the Chosen One to "the image of a prehistoric bird ... conjured up by the force of the music and by the mad scramble of jumps." But then Nijinska adds (only now not in direct discourse but in Krasovskaya's paraphrase), "it was a bird" whose "wings were attempting to raise its clumsy body not yet ready for flight."[90] Given this ambiguous evidence, I believe it is fair to describe thoughts of escape as an interpolation by Hodson.

It was later strongly endorsed by Tamara Levitz in an article proposing that, whatever the implications of Stravinsky's music or the explicit assertion of Roerich's scenario, Nijinsky's "Chosen One may not have been a passive victim who succumbed to her community without conflict, ... but rather a subject who experienced deep animosity toward her peers." In that case, Levitz argues, "the 'Danse

sacrale' becomes less an essay in inhumane musical form than a physical expression of a critical spirit of opposition."[91] I do not find any support for this thesis in the work, in the documents pertaining to its genesis, or in the discourse surrounding it at the time of its unveiling. Like Béjart's, Morris's, and such other revisionary choreographies as Mary Wigman's or Pina Bausch's, Prof. Levitz's interpretation seems to me a projection that attempts to salvage something "positive" from *The Rite* according to our contemporary ethical and moral standards. This is what we are always tempted to do with works we want to keep current, and it is a reasonable and justifiable endeavor. The only part I object to is the attempt to usurp Nijinsky's authority by attributing the revisionary reading to him.

Nijinsky's contribution to *The Rite*, unhappily, has perished. It is no longer available for inspection. It was never filmed, and Millicent Hodson, by her own admirably frank admission, had to do a great deal of speculative supplementing in order to turn the evidence she had—chiefly verbal descriptions and still drawings and photos—into actual *plastique animée*, the realization of movement in space and time. It is from Hodson's supplements, further supplemented, I would venture to say, by her own strong moral convictions, that Prof. Levitz derived her argument that Nijinsky's Chosen One "expressed her opposition to the people who had chosen her to die."[92] "From all accounts," she further claims, "the dominant emotion [of the 'Danse sacrale'] seems to have been . . . fear and a deep antagonism between the Chosen One and her surroundings."[93] I know of no such accounts. None of the witnesses Levitz cites—to "fear and grief," to "tragedy," or to the Chosen One's "subjective will," her "defiant expression," her "attempts to flee"[94]—had actually seen Nijinsky's version of the 'Danse sacrale'; and those who did see it, especially those few who described it sympathetically and in detail, contradict her contentions.

Andrey Levinson, for one, in what seems to me a masterpiece of pithy accuracy of observation, wrote of the Chosen One in her moment of glorious agony: "To the sound of ferocious rhythmic pounding, deafened by the piercing tonalities of the orchestra, she crumples and writhes in an ecstatic angular dance. And once again the icy comedy of this primeval hysteria excites the spectator with its unprecedented impression of tortured grotesquery."[95]

Levinson's use of the word "comedy" was exact: the *dénouement* of *The Rite of Spring*, foreseen and desired, is the opposite of tragic. And as we have seen, Jacques Rivière, whose account Levitz praises as "remarkably insightful,"[96] wrote that the Chosen One "accomplishes a rite, absorbed by a social function, and without giving the slightest sign of comprehension or of interpretation, she acts according to the will and the convulsions of a being more vast than she." Her fate is shown not as horrible but as inevitable and, by the lights of the tribe for whom she dies, beneficent. In the ballet's final gesture, when the elders bear her aloft, her death is celebrated, not deplored—and that, of course, is what to us is horrible.

An icy comedy of primeval hysteria. Convulsions of a will more vast. We don't get, because we don't want, such messages from *The Rite* anymore. In the ballet theater it has become a humane indictment of oppression or else a pastoral revelry or one of procreative sex. There were intimations of all of these, it seemed to me, in the latest new choreography, by Sasha Waltz, which was given its première performance in a double bill with Hodson's reconstructed Nijinsky at the Théâtre des Champs-Élysées on the actual anniversary date, 29 May 2013. In the concert hall (as opposed to the theater), amnesia has been complete, and *The Rite* has become Olympic fun and games, a showpiece for instrumental virtuosity. These are all resistances to *The Rite*—both to the shocking object unveiled on 29 May 1913 and to the disorderly reaction that it incited.

But do not think that I am deploring these transformations. Change is a concomitant of all artistic reception, and all traditions. It can be celebrated or opposed, but never stopped. It is what keeps beloved works alive, or (in Pieter van den Toorn's language) maintains their status as "living art." It is precisely because *The Rite* has changed enormously, both in sound and in significance, over the century of its existence that we can celebrate it today with such enthusiasm and such a sense of engagement. To assess and account for these changes is perhaps the most fascinating task of the art or music or ballet historian confronting *The Rite*, and certainly the most pressing one. So in conclusion, I offer a few vignettes to illustrate the way in which *The Rite* has been resisted in concert performance.[97] As before, the chief resister turns out to be the composer himself, which is what has made resistance so irresistible.

The earliest recordings, by Monteux and by Stravinsky, date from 1929, the year of the last Ballets Russes performances.[98] They show the work to have been an almost unplayable ordeal at the time—and literally unplayable when it came to maintaining the marked tempos. The performances are arduous and sloppy, and in the "Danse sacrale," the hardest part of all, they convey something of the crushing force and tension that drive the Chosen One to her doom. You can still hear a little of that arduousness and tension in Stravinsky's much faster 1940 recording with the New York Philharmonic.[99] The "Danse sacrale" is still a mess, and, like the doomed dancer, it totters more and more inelegantly as it nears the end—this despite the presence of Saul Goodman, perhaps the greatest kettledrummer of all time, in what is surely the most spectacular timpani part in the whole literature. It wasn't Goodman's fault, or the orchestra's. Nobody knew the piece very well in those days. It was still a relative rarity on concert programs in 1940, and the unpredictable accents and irregular phrase lengths were a constant surprise and challenge to all concerned, including Stravinsky, who was not a trained conductor. The combination of his uncertain beat and the orchestra's need for guidance through the rhythmic thickets conspired to prevent a good performance—if by a good performance one means a fluent and rhythmically secure performance.

But is a fluent and rhythmically secure performance the sort of performance Stravinsky originally intended? A recent study of *The Rite* by the music theorist Matthew McDonald showed, to me convincingly, that in order to evoke a genuine sense of primeval hysteria the composer used *ad hoc* algorithms, formulas derived arbitrarily from the harmonies and melodies, to assemble rhythmic patterns that would defeat anyone's expectations, even his own, and prevent the music from ever losing its shock value by becoming familiar or predictable.[100] But now everybody knows *The Rite*. It is a classic, and an audition piece that every music student practices, so that now any conservatory orchestra can give a spiffy performance of what used to stump their elders, and professional orchestras can play it in their sleep, and often do.

Stravinsky came to want it that way. After the Great War came the great neoclassical reaction, in which Stravinsky played the leading role among musicians. That is when he started resisting *The Rite* by touting it as "architectonic, not anecdotal," an "objective construction," and "absolute ballet." One of the strange fruits of his neoclassicism—but not so strange when you put it in the context of that objectivist esthetic—was Stravinsky's infatuation with the pianola, a mechanical instrument that never misses a note or a cue and never grows tired. It can maintain a regularity of tempo and rhythm far beyond the capacity of any mortal performer, and Stravinsky eagerly arranged all his music for the machine that so epitomized his new impersonal (or, to speak the language of the period, "dehumanized") ideals. His piano roll of the "Danse sacrale" gave the piece a new meaning: no longer a dance of lethal fatigue and exhaustion but a paean to imperturbable stability and speed. For make no mistake: "dehumanized" meant superhuman, not subhuman; and for *The Rite* this was a diametrical reversal of meaning.[101]

Ever since the 1920s, that lithe stability and speed have been the performance ideal for *The Rite*, which Stravinsky officially sanctioned by renotating and slightly rescoring the "Danse sacrale" (in 1943, after his frustrating experience with the New York Philharmonic three years earlier) to make the conductor's part easier to beat and the orchestral parts easier to read. From then on it became the John-Henryish ideal of performers to match or even exceed the piano roll's rendition, and when the first recordings to do so (Benjamin Zander's with the Boston Philharmonic and Robert Craft's with the Orchestra of St. Luke's) were issued in 1991, they were greeted as a breakthrough.[102]

Now the best orchestras and conductors can proudly equal or exceed that feat in live performance, as one may see the San Francisco Symphony doing, under Michael Tilson Thomas, in a DVD the orchestra issued on its own label in 2006.[103] As is usual in performance videos, it is full of close-ups, both of individual members of the orchestra and of the conductor, whose face live audiences never get to see during performances. At the very end of the "Danse sacrale," when the applause begins, Maestro Thomas's beaming face fills the screen, and it is a perfect

picture of what *The Rite of Spring* conveys now: elation and euphoria, the emotion of an athlete who has just completed the decathlon or an engineer who has designed and demonstrated a perpetual motion machine. Precision tooling is the message the camerawork is obviously deployed to emphasize throughout the performance, hopping from player to imperturbable player through all the rhythmic intricacies. The dark biological ballet of 1913, the icy comedy of primeval hysteria, has been decisively resisted, rejected, repressed, and tamed in favor of "positive" good vibrations.

But not necessarily for all time. The tradition continues. Who can say where it is headed? What I have just described is merely the rendering of *The Rite* that best accords with current views and thus follows what is now the line of least resistance. If the work endures a second century, it will surely assume new and, at present, unimaginable guises.

NOTES

1. Peter Hill, *Stravinsky: The Rite of Spring*, Cambridge Music Handbooks (Cambridge: Cambridge University Press, 2000); Volker Scherliess, *Igor Strawinsky, Le sacre du printemps*, Meisterwerke der Musik (Munich: Wilhelm Fink Verlag, 1982).

2. Allen Forte, *The Harmonic Organization of "The Rite of Spring"* (New Haven, CT: Yale University Press, 1978); Peter C. van den Toorn, *Stravinsky and "The Rite of Spring": The Beginnings of a Musical Language* (Berkeley: University of California Press, 1987).

3. Igor Stravinsky, *The Rite of Spring (Le Sacre du Printemps): Sketches 1911–1913* (London: Boosey & Hawkes, 1969); idem, *The Rite of Spring: Facsimile of the Autograph Full Score*, ed. Ulrich Mosch (Basel: Paul Sacher Stiftung; London: Boosey & Hawkes, 2013); idem, *The Rite of Spring: Facsimile of the Version for Piano Four-Hands*, ed. Felix Meyer (Basel: Paul Sacher Stiftung; London: Boosey & Hawkes, 2013); Hermann Danuser and Heidy Zimmermann, eds., *Avatar of Modernity: "The Rite of Spring" Reconsidered (Essays)* (Basel: Paul Sacher Stiftung; London: Boosey & Hawkes, 2013).

4. Pavel Gershenzon and Olga Manulkina, eds., *1913/2013: Vek "Vesnï svyashchennoy"—vek modernizma* (Moscow: Bolshoi Theater, 2013).

5. François Lesure, ed., *Le Sacre du Printemps: Dossier de presse* (Geneva: Minkoff, 1980).

6. Charles Lafeyette White, *Tympani Instructions for Playing Igor Stravinsky's "Sacre du printemps"* (Los Angeles: C. L. White, 1965).

7. R. Taruskin, *Le sacre du printemps: Le tradizioni russe, la sintesi di Stravinsky*, trans. D. Torelli (Milan: Ricordi, 2002; 2nd ed., Universal MGB, 2011); cf. R. Taruskin, *Stravinsky and the Russian Traditions* (Berkeley: University of California Press 1996), 849–966.

8. Shelley Berg, *Le Sacre du Printemps: Seven Productions from Nijinsky to Martha Graham* (Ann Arbor, MI: UMI Research Press, 1988); Ada D'Adamo, *Danzare il rito: "Le sacre du printemps" attraverso il Novecento*, Biblioteca teatrale (Rome: Bulzano, 1999).

9. Étienne Souriau, *"Le sacre du printemps" de Nijinsky* (Paris: Théâtre des Champs-Élysées, 1990); Millicent Hodson, *Nijinsky's Crime against Grace: Reconstruction Score of the Original Choreography for "Le Sacre du Printemps"* (Stuyvesant, NY: Pendragon Press, 1996).

10. Truman C. Bullard, "The First Performance of Igor Stravinsky's *Sacre du Printemps*," 3 vols., Ph.D. diss., Eastman School of Music, 1971.

11. On Astruc and his role, see most recently Nathalie Sergent et al., eds., *Théâtre, comédie et studio des Champs-Élysées: Trois scènes et une formidable aventure* (Paris: Verlhac Éditions, 2013).

12. Cocteau, *A Call to Order*, paraphrased in Richard Buckle, *Diaghilev* (New York: Athaneum, 1979), 253; Igor Stravinsky and Robert Craft, *Conversations with Igor Stravinsky* (Garden City, NY: Doubleday, 1959), 48.

13. The best-known fake memoir is the one by Carl van Vechten in his *Music after the Great War* (New York: G. Schirmer, 1915), 87–88. Its fakery is exposed in Edward White, *The Tastemaker: Carl van Vechten and the Birth of Modern America* (New York: Farrar, Straus & Giroux, 2014), 103–5. (Van Vechten, together with Gertrude Stein, attended the second night, which was relatively quiet.) As Edward White puts it, "For both Stein and Van Vechten, the event of *Le Sacre du Printemps* was too perfect a moment to be sullied by the straightforward truth" (105). Among those beguiled by Van Vechten's colorful (but, as White, alas, justly observes, absurd) account were Piero Weiss and I, in our anthology *Music in the Western World: A History in Documents* (New York: Schirmer Books, 1984; 2nd ed., Belmont, CA: Thomson/Schirmer, 2009); its juiciest paragraph can be found there in reading no. 129 in the original, no. 132 in the second edition, and will be regretfully deleted if there is a third.

14. Letter to Maximilian Steinberg, 20 June/3 July 1913, in "Pis'ma I. F. Stravinskogo," ed. Igor Blazhkov, in *I. F. Stravinskiy: Stat'i i materialï*, ed. Lyudmila Sergeyevna Dyachkova and Boris Mikhailovich Yarustovsky (Moscow: Sovetskiy kompozitor, 1973), 474; also in I. F. Stravinsky, *Perepiska s russkimi korrespondentami*, ed. Viktor Varunts, vol. 2 (Moscow: Kompozitor, 2000), 99.

15. *Times* (London), 26 July 1913, quoted in Nesta MacDonald, *Diaghilev Observed* (New York: Dance Horizons, 1975), 104.

16. *Daily Mail*, 12 July 1913, quoted ibid., 99.

17. Letter of 20 September/3 October 1913, in Dyachkova and Yarustovsky (eds.), *I. F. Stravinskiy: Stat'i i materialï*, 477–78.

18. Doris G. Monteux, *It's All in the Music: The Life and Work of Pierre Monteux* (New York: Farrar, Straus & Giroux, 1965), 91.

19. Igor Stravinsky, "Apropos 'Le Sacre du Printemps,'" *Saturday Review*, 26 December 1959, 30; the wording was improved ("... such as few *composers* have enjoyed") when the text was reprinted in Igor Stravinsky and Robert Craft, *Expositions and Developments* (Garden City, NY: Doubleday, 1962), 164 (italics original both times).

20. And not just for musicians. Pauline Kael began her legendarily hyperbolic review of Bernardo Bertolucci's *Last Tango in Paris* (now usually cited as her greatest blunder) by declaring that its opening night "should become a landmark in movie history comparable to May 29, 1913—the night *Le Sacre du Printemps* was first performed—in music history" ("Tango," *New Yorker*, 28 October 1972; reprinted in Pauline Kael, *Reeling* [Boston: Atlantic Monthly Press/Little, Brown, 1976], 171).

21. It surfaces most dependably in promotional hype, especially in France, as in the following passage from a French ad for a San Francisco Symphony DVD: "Premier basson de l'orchestre de San Francisco, Stephen Poulson, à qui échoit le rude honneur d'entonner à découvert les six premières mesures de l'oeuvre, rapporte que le vénérable Saint-Saëns, 78 printemps à la création du Sacre, se récriait: 'Si ça, c'est de la musique, moi je suis un babouin!'" (The principal bassoonist of the San Francisco Symphony, Stephen Poulson, to whom falls the tough honor of intoning the first six measures of the work, reports that the venerable Saint-Saëns, a man of 78 springs at the time of the *Rite* première, protested, "If that's music, I'm a baboon!") (www.telerama.fr/musiques/16663-le_sacre_du_printemps_san_francisco_symphony_orchestra_dir_michael_tilson_thomas.php). Stravinsky claimed in a late memoir that Saint-Saëns ("a sharp little man—I had a good view of him") came not to the première but to the triumphant 1914 concert performance ("A propos 'Le Sacre du Printemps,'" 30; rpt. *Expositions and Developments*, 164).

22. Bullard, "First Performance," 1:99.

23. Igor Stravinsky and Robert Craft, *Expositions and Developments* (1962; rpt. Berkeley: University of California Press, 1981), 137.

24. René Leibowitz, "Béla Bartók, ou la possibilité du compromis dans la musique contemporaine," *Les temps modernes* 3, no. 25 (October 1947): 705–34; in English as "Béla Bartok, or the Possibility of Compromise in Contemporary Music," *Transition Forty-Eight*, no. 3 (1948): 92–123.

25. See Thomas Forrest Kelly, *First Nights: Five Musical Premières* (New Haven: Yale University Press, 2000), in which the Ninth and *The Rite* are each accorded chapters, along with Monteverdi's *Orfeo*, Handel's *Messiah*, and Berlioz's *Symphonie fantastique*.

26. For the even more extreme version of this myth associated with modernism, see José Ortega y Gasset, *La Deshumanización del arte* (1925), trans. Helene Weyl in Ortega, *The Dehumanization of Art and Other Essays* (Princeton, NJ: Princeton University Press, 1968), esp. 6–8.

27. For various versions of this story, see Alexander Wheelock Thayer, *The Life of Beethoven*, ed. Elliot Forbes (Princeton, NJ: Princeton University Press, 1967), 909.

28. *The Standard*, 12 or 13 July 1913, quoted in Macdonald, *Diaghilev Observed*, 98.

29. Jacques Rivière, "Le Sacre du Printemps," *La nouvelle revue française*, 1 November 1913; reprinted in Rivière, *Novelles études* (Paris: Gallimard, 1947), 95.

30. Quoted in Macdonald, *Diaghilev Observed*, 97.

31. Leonard B. Meyer, "A Pride of Prejudices; or, Delight in Diversity," *Music Theory Spectrum*, 13, no. 2 (Autumn 1991): 241.

32. Modris Eksteins, *Rites of Spring: The Great War and the Birth of the Modern Age* (Boston: Houghton Mifflin, 1989), xiv–xv.

33. Stravinsky and Craft, *Expositions and Developments* (1981 reprint), 143. In Nijinsky's choreography the curtain actually goes up on the male corps de ballet, plus one soloist portraying a three-hundred-year-old crone; the knock-kneed Lolitas enter later.

34. Quoted from Bullard, "First Performance," 2:49.

35. There are still those who find this a difficult point to concede. Alastair Macaulay maintained quite recently in the *New York Times* (responding, perhaps, to a piece of mine that gave a preview of this very essay) that "though some have claimed that the famous audience first-night furor of the 1913 'Sacre' was a reaction to Nijinsky's choreography rather than to Stravinsky's music, this cannot have been so, since there are two extended passages with curtains lowered and no dancing" ("A Spirited Journey Backward, from Modernism to Classical," *New York Times*, 2 February 2015; see also R. Taruskin, "Shocker Cools into a 'Rite' of Passage," *New York Times*, 16 September 2014). But all accounts, including Stravinsky's own, concur that the "heavy noises" began precisely with the raising of the curtain on the "Augures printanières"; see Igor Stravinsky and Robert Craft, *Conversations with Igor Stravinsky* (New York: Doubleday, 1959), 46–47.

36. Bullard, "First Performance," 2:48. And this further resolves the issue raised by Macaulay (see previous note): the "early responders" that evening were reacting against neither the music nor the choreography, but against the hype.

37. As reported by Victor Debay in his review, "Les Ballets russes au Théâtre des Champs-Elysées," *Le courier musicale*, 15 June 1913; quoted in Bullard, "First Performance," 1:146.

38. Quoted from *Le Figaro*, 29 May 1913, 6, in Bullard, "First Performance," 2:1–2 (translation adapted).

39. Letter to André Caplet, 29 May 1913, in *Debussy Letters*, ed. François Lesure and Roger Nichols (Cambridge, MA: Harvard University Press, 1987), 270.

40. Alfred Capus, "Courrier de Paris," *Le Figaro*, 2 June 1913, 1; translation adapted (via comparison with the original in Bullard's dissertation) from Eksteins, *Rites of Spring*, 53.

41. Bullard, "First Performance," 2:77–78.

42. Adapted from Eksteins, *Rites of Spring*, 53.

43. "Parisians Hiss New Ballet," *New York Times*, 8 June 1913.

44. Henri Postel du Mas, "Un entretien avec M. Stravinsky," *Gil Blas*, 4 June 1913, 1; cited in Bullard, "First Performance," 3:87–89.

45. Evans (1874–1945) was then the music critic of the *Pall Mall Gazette;* co-opted by Diaghilev as a publicist, he was the author of some early handbooks about Stravinsky's ballets.
46. *The Lady*, 17 July 1913; quoted in Macdonald, *Diaghilev Observed*, 100.
47. *The Lady*, 10 July 1913; quoted ibid., 96.
48. Korney Chukovsky, *Futuristï* (1922), quoted in Israel V. Nestyev, *Prokofiev* (Stanford: Stanford University Press, 1960), 91.
49. Taruskin, *Stravinsky and the Russian Traditions*, 860.
50. See Ralph P. Locke, "Cutthroats and Casbah Dancers, Muezzins and Timeless Sands: Musical Images of the Middle East," *19th-Century Music* 22 (1998–99): 20–53.
51. See R. Taruskin, "Entoiling the Falconet: Russian Musical Orientalism in Context," in *Defining Russia Musically* (Princeton, NJ: Princeton University Press, 1997), 152–85.
52. Letter to M. S. Kerzina, 16 February/1 March 1914, in Cesar Antonovich Cui, *Izbrannïye pis'ma* (Leningrad: Muzgiz, 1955), 446.
53. The breakthrough came in 1963 with Arthur Berger's seminal article "Problems of Pitch Organization in Stravinsky," *Perspectives of New Music* 2, no. 1 (Autumn–Winter 1963): 11–42.
54. Letter of 1/14 December 1912, in Irina Yakovlevna Vershinina, ed., "Pis'ma Stravinskogo Rerikhu," *Sovetskaya muzïka*, 1966, no. 8, 62.
55. Vladimir Ussachevsky, "My Saint Stravinsky," *Perspectives of New Music*, 9, no. 2–10, no. 1 (1971): 37.
56. Of the full score, that is; the piano four-hand reduction was published by Éditions russes de musique at the time of the première.
57. See R. Taruskin, "Catching up with Rimsky-Korsakov," *Music Theory Spectrum* 33, no. 2 (Fall 2011): 169–85 (reprinted in this volume), followed by seven rebuttals (186–228) and a response (229), which are condensed and paraphrased in the postscript.
58. Olin Downes, "Music: 'Sacre du Printemps' Played," *New York Times*, 1 February 1924. The Mark Twain reference is to a familiar misquotation of a letter he wrote in May 1897 in which he stated that "James Ross Clemens, a cousin of mine[,] was seriously ill two or three weeks ago, in London, but is well now. The report of my illness grew out of his illness, the report of my death was an exaggeration" (facsimile at www.twainquotes.com/Death.html; accessed 16 May 2015).
59. Macdonald, *Diaghilev Observed*, 264.
60. Ibid.
61. Letter of 23 July 1929, in Ilya Samoylovich Zil'bershteyn and Vladimir Alekseyevich Samkov, *Sergey Dyagilev i russkoye iskusstvo* (Moscow: Izobratitel'noye iskusstvo, 1982), 2:148.
62. *The Times*, 23 July 1929, quoted in Macdonald, *Diaghilev Observed*, 379.
63. Full-page advertisement on the inside back cover of *La revue musicale*, 1927, no. 4. The soloists in the Beethoven included Nina Koshetz and Georges Thill.
64. Joseph Kerman, *The Beethoven Quartets* (New York: W. W. Norton, 1979), 194.
65. Robert Craft, "'The Rite of Spring': Genesis of a Masterpiece," introduction to Stravinsky, *The Rite of Spring: Sketches 1911–1913*, xv.
66. See, for example, Daniel Wakin, "Turning 100 at Carnegie Hall, with New Notes," *New York Times*, 11 December 2008.
67. J. Ma. Corredor, *Conversations with Casals*, trans. André Mangeot (New York: E. P. Dutton, 1956), 174.
68. www.youtube.com/watch?v=GHlPC3CAZ2o.
69. *The Nantucket Diary of Ned Rorem, 1973–1985* (San Francisco: North Point Press, 1987), 8.
70. Igor Stravinsky, *Themes and Conclusions* (Berkeley: University of California Press, 1982), 168–69. For his animadversions at Casals, see "An Interview with Igor Stravinsky," *New York Review of Books*, 3 June 1965; or (somewhat reined in), Igor Stravinsky and Robert Craft, *Themes and Episodes* (New York: Alfred A. Knopf, 1966), 101–2.

71. Facsimile in Bullard, "First Performance," 1:241.
72. Théâtre des Champs-Elysées program, quoted in Berg, *Seven Productions*, 67.
73. André Levinson, "Les Deux *Sacres*," *La revue musicale* 4 (1 June 1922); trans. Shelly Berg in *Seven Productions*, 71–72.
74. Oliver Daniel, *Stokowski: A Counterpoint of View* (New York: Dodd, Mead, 1982), 225; quoted in Berg, *Seven Productions*, p. 77.
75. Nicholas Roerich, "Sacre" (Address at the Wanamaker Auditorium, under the auspices of the League of Composers, 1930), reprinted in idem, *Realm of Light* (New York: Roerich Museum Press, 1931), 185–86.
76. Stravinsky and Craft, *Expositions and Developments* (1981 reprint), 144.
77. Michel Georges-Michel, "Les deux *Sacre du Printemps*," *Comoedia*, 11 December 1920; adapted from the translation in Bullard, "First Performance," 1:2.
78. Van den Toorn, *Stravinsky and "The Rite of Spring*," 1.
79. Ibid., 2.
80. Olin Downes, "Music: 'Sacre du Printemps' Played," *New York Times*, 1 February 1924. Subsequent quotations are from this source as well.
81. See R. Taruskin, "The Poietic Fallacy," *Musical Times* 145, no. 1886 (Spring 2004): 7–34; reprinted in idem, *The Danger of Music and Other Anti-Utopian Essays* (Berkeley: University of California Press, 2009), 301–29.
82. Arnold Whittall, "Music Analysis as Human Science? *Le Sacre du Printemps* in Theory and Practice," *Music Analysis* 1, no. 1 (March 1982): 50. For pitch-class sets, see Allen Forte, *The Structure of Atonal Music* (New Haven, CT: Yale University Press, 1973); and idem, *Harmonic Organization of "The Rite of Spring*."
83. Anton Juszkiewicz, *Melodje ludowe litewskie* (Cracow: Wydawnictwo Akademji Umiejętności, 1900).
84. See André Schaeffner, *Strawinsky* (Paris: Éditions Rieder, 1931), 43n1; also "Table des planches," pl. 21 (217).
85. See Lawrence Morton, "Footnotes to Stravinsky Studies: *Le Sacre du Printemps*," *Tempo*, no. 128 (March 1979): 9–16.
86. Interview with Shelly C. Berg, quoted in Berg, *Seven Productions*, 93.
87. Alastair Macaulay, "A Latter-Day American Answer to Stravinsky's 'Rite of Spring,'" *New York Times*, 16 June 2013.
88. So identified by her in an oral exchange with me following my keynote address at the conference "*The Rite of Spring* at One Hundred," organized by Carolina Performing Arts at the Chapel Hill campus of the University of North Carolina on 25 October 2012.
89. Hodson, *Nijinsky's Crime*, 172, 174.
90. Vera Krasovskaya, *Nijinsky*, trans. John A. Bowlt (New York: Schirmer Books, 1979), 267 (Bowlt has "still not ready" for "not yet ready"; this is a common error in translations into English from Russian, in which the word *yeshcho* can be translated as both "still" and "yet"). Cf. Hodson, *Nijinsky's Crime*, 174 (which purports to represent Nijinska's text in faithful translation rather than paraphrase): "Leaning to the ground, the Chosen One sits (in *plié*) such that the hand that is down hangs to the earth, and just then her legs begin to stamp and her hands beat against her bent knees—like a large bird choosing and setting up a nest."
91. Tamara Levitz, "The Chosen One's Choice," in *Beyond Structural Listening? Postmodern Modes of Hearing*, ed. Andrew Dell'Antonio (Berkeley: University of California Press, 2004), 72.
92. Ibid., 85.
93. Ibid., 85–86.
94. Ibid., 86, 96–97.

95. Andrey Yakovlevich Levinson, "Russkiy balet v Parizhe," *Rech'*, 3 June 1913.

96. Levitz, "Chosen One's Choice," 96.

97. For a comprehensive discussion of *The Rite*'s evolving performance practice, see Robert Fink, "'Rigoroso (♪= 126)': *The Rite of Spring* and the Forging of a Modernist Performing Style," *Journal of the American Musicological Society* 52 (1999): 299–362. The conclusions Fink draws—viz., that "the composer struggled mightily to get his own music played 'as if composed by Stravinsky,'" and that "early interpretations of the *Rite* were slower and more elastic—more 'romantic'—than the composer wanted" (to quote his abstract)—are somewhat different from the ones offered here, although they draw upon the same evidence, interpreted similarly. The difference lies in the construal of what it was that "the composer wanted."

98. Both have been reissued on Pearl CDs: GEMM 9334 (Stravinsky) and GEMM 9329 (Monteux).

99. Most recently reissued, together with nine other historical "reference recordings" (including Stokowski's with the Philadelphia Orchestra, first published somewhat later in 1929), on Sony Music/RCA Red Seal B00BXQ3KXY (2013).

100. Matthew McDonald, "*Jeux de Nombres:* Automated Rhythm in *The Rite of Spring*," *Journal of the American Musicological Society* 63 (2010): 499–551.

101. The piano roll has been recorded by Rex Lawson on IMP Masters CD 25 (1991).

102. Zander's performance is preserved on the same CD as the piano roll (see note 101); Craft's is on Musicmasters B000000FQS ("Stravinsky the Composer, vol. 1").

103. *Keeping Score: Revolutions in Music—Stravinsky's "Rite of Spring"* (San Francisco Symphony Productions 821936001493).

17

Stravinsky's *Poetics* and Russian Music

I

"If Stravinsky had not gone to America in 1939, he might have compromised himself politically," Pierre Souvtchinsky told Robert Craft over dinner in Paris (with Pierre Boulez looking on) on 7 November 1956, by coincidence the thirty-ninth anniversary of the Bolshevik coup d'état—the so-called "October Revolution"—that made a permanent exile, and an enthusiast of the political right, out of the great Russian composer.[1] Souvtchinsky's opinion carries weight, for although, until recently, he had not figured all that prominently in the Stravinsky literature, and is a name unlikely to be known by most musicians, Pierre Souvtchinsky (or, in Russian, Pyotr Petrovich Suvchinsky) was by Stravinsky's open avowal in 1966 "my oldest living friend" and the one who "knew me more closely than anyone else in my later Paris years," that is, precisely up to 1939.[2] There will be much more to say about Souvtchinsky, who is rather better known among Slavists than he is among music scholars. For now, let it suffice to say that if Souvtchinsky was right, then Stravinsky owed Harvard University a lot. For it was Harvard that spirited him out of wartime Europe with its invitation, tendered (with Nadia Boulanger's connivance) on 27 March 1939, to spend the academic year 1939–40 on campus as the twelfth occupant (following Gilbert Murray, T. S. Eliot, and Robert Frost, among others) of the Charles Eliot Norton Chair of Poetry, thus enabling him to evade the pitfall of which Souvtchinsky warned, into which Soulima Stravinsky, the

Prepared at the invitation of the Harvard University Department of Slavic Languages and Literature, and first delivered there, in part, on 13 March 2009.

composer's pianist son, who had joined the French army in 1939 and spent the war years in occupied Paris, had indeed, and sadly, fallen.[3]

The chair to which Stravinsky was appointed had been endowed in 1925 by a gift of $200,000 from Charles Chauncey Stillman (class of 1898), scion of a long line of Harvard-educated financiers, to provide for the annual appointment, at full professorial rank, of eminent practitioners of the arts, to be chosen, according to the terms of the gift, "without limits of nationality, from men of high distinction and preferably of international reputation."[4] As Professor Edward Forbes, the art historian who headed the selection committee (and whose son, Elliott Forbes, would be a mainstay of the Harvard music department), remarked when introducing Stravinsky to the audience at the first of the public lectures the composer gave under the terms of his appointment (later published as *La poétique musicale, sous forme de six leçons* [Poetics of Music in the Form of Six Lessons], probably the most famous, influential, and widely quoted book by any twentieth-century composer, in its sixteenth printing as of 2003), the Norton chair was named for the professor who had a comparable influence in the last quarter of the nineteenth century, the one whose "famous lectures on Fine Arts and ... admirable course on Dante," in Prof. Forbes's words, "filled his students with enthusiasm, implanting in them new conceptions of culture."[5] Although his most recent biographer has been at pains to attempt a rebuttal, Charles Eliot Norton had earned a reputation, especially posthumously, as America's most resolute and unregenerate aesthete, a status that could only be enhanced by presenting in his name a musician who had recently become notorious by asserting that "music is, by its very nature, essentially powerless to *express* anything at all."[6]

Stravinsky was the first musician to occupy the chair. That was not the only way in which his appointment, and the lectures themselves, were unusual. He was also the first Norton Professor to have earned his eminence entirely outside the academy—a glittering international eminence that quite outstripped that of his predecessors in the post, so that, as marvelously described by Frederick Jacobi Jr., then a Harvard freshman and the son of a prominent composer then on the faculty of the Juilliard School of Music, Stravinsky's lectures were "a series of brilliant social events." Jacobi painted a vivid picture of the scene as Harvard's New Lecture Hall (now called the Lowell Lecture Hall) began filling up with "early intellectuals," eager for a seat, followed by

> a rush of ... Harvard and Radcliffe esthetes. Next came the big names of the Harvard music department, with their wives. This kind of an audience was what we had expected—musicians and music lovers from in and around the University. But then, to our amazement, black, sleek limousines began to drive up to the New Lecture Hall, Beacon Hill dowagers, radiating white hair, evening dresses, diamonds, and dignity entered and added a *ton* of glamour to the affair. No sooner had we settled down to Beacon Hill than the New Lecture Hall rustled again. This time it was for

Koussevitzky. The Doctor was beaming, surrounded by friends and admirers in the aisle; the friends and admirers sat down; Koussevitzky was still standing. He was looking for a friend.

And then, Stravinsky:

> At a moment of psychological tenseness he made a sweeping entrance, in tails. He was followed by Professor Edward Forbes, director of the Fogg Art Museum, in tails. Stravinsky made a low, courtly, athletic bow to the warm, dignified applause. Dr. Forbes introduced Mr. Stravinsky. More applause. Stravinsky grasped Forbes by the hand, bowed to him and again to the audience, and began his *Prise de Contacte*. Reading a manuscript of beautifully written academic French, he spoke slowly, distinctly, in a quiet Russian accent. He looked up from his paper infrequently, and then only jerkily.... "My course will only be an explanation of music," he said apologetically. Is that all, we thought.

After the briefest of discussions of its content, young Mr. Jacobi went back to what really interested him about Stravinsky's *leçon:* namely, the audience and its reaction to what it heard:

> To Stravinsky's witticisms the audience reacted like a grove of aspens; a few trees quivered at first, and eventually the foliage of the whole grove was alive. The assembly looked distinguished and cultured, however, and we may be wrong about its collective linguistic attainments. Wild, but dignified, applause greeted Stravinsky as he concluded his first lecture. Harvard and Radcliffe intelligentsia, beaconesses of Beacon Hill, Koussevitzky—all were wildly, but dignifiedly, enthusiastic. Stravinsky bowed low, almost to the ground, and shook Dr. Forbes warmly by the hand. He breezed out, his tails flying behind.[7]

The reality behind Stravinsky's lectures quite belied the merry, scintillating façade our eyewitness describes. Harvard's invitation came at one of the lowest points in the composer's life. He was ill with tuberculosis, the family disease; indeed, he received Forbes's invitation on the twelfth day of a three-month stay at a sanatorium in Sancellemoz, Switzerland, where his wife and two daughters had preceded him. And he was deeply in guilt-ridden mourning: first for his daughter Mika, who died of tuberculosis on 30 November 1938 while Stravinsky was off with his mistress on a concert tour in Italy; next for his wife Katya, who died, also of tuberculosis, on 2 March 1939, only weeks before the Harvard invitation arrived, and whom he had been more or less openly betraying for fifteen years with Vera Sudeykina, *née* de Bosset, who would become his wife very shortly after the Harvard gig was up. Right in the midst of drafting the lectures he was bereaved yet again, this time by the death of his aged mother, Anna Kirillovna, on 7 June. "For the third time in half a year," he much later recalled, only somewhat hyperbolically, "I endured the long Russian requiem service for one of my own

family, walked through a field to the cemetery of Sainte Geneviève des Bois, . . . and dropped a handful of dirt in an open grave."⁸ His sole refuge was composing: "I think it is no exaggeration," he wrote, "to say that in the following weeks I myself survived only through my work on the *Symphony in C*." Surely the last thing in the world he wanted to compose right then was the eight academic lectures Harvard was requesting. As his biographer Stephen Walsh puts it, "the thought of a lecture series in the northern states in winter must have depressed him almost beyond measure."⁹

But Harvard was offering ten thousand dollars, and Stravinsky could not afford to refuse, though he did manage to talk Harvard up to twelve thousand dollars and down to six lectures. At least he didn't have to write them himself. Stravinsky's public words were always the work of ghosts, and the reason for the extra two thousand dollars (though of course Stravinsky did not tell Harvard) was to pay them. It has long been known that the beautifully written academic French in which Stravinsky delivered his lectures was actually the work of Roland Alexis Manuel Lévy (1891–1966), known as Roland-Manuel, a minor composer and an experienced writer on music, who had by then written five books (two of them on his mentor, Maurice Ravel). Letters of acknowledgment now preserved in the Paul Sacher Stiftung in Basel, Switzerland, record two payments to Roland-Manuel, the first, dated 28 April 1939, for one thousand francs, and the other, dated 22 June on the completion of the task, for five thousand, to be split with a second collaborator. (Those 6,000 francs were worth about $400 US in 1939, so Stravinsky made out handsomely on the deal.)¹⁰

Stravinsky had known Roland-Manuel since 1911 when Ravel introduced his then twenty-year-old protégé to the then composer of *Petrushka*. The younger man had by 1939 written rapturous reviews of Stravinsky's recent compositions, and also a review of *Chroniques de ma vie*, Stravinsky's ghostwritten autobiography, that managed in very short space to extract from that book a bunch of theses and judgments that will give anyone who knows it a strong foretaste of *La poétique musicale*:

> The creator of the *Symphony of Psalms* describes for us the period during which his aesthetic has become more and more akin to *askesis* [Gr. "exercise," i.e., asceticism]. No matter whether he is creating or discussing his art, our author's most distinct tendency is the one that draws him constantly toward the cleansing of his music of all that is not inherently musical. . . . Stravinsky is a true realist; his devotion to the concrete is absolute. He feels and knows that man is a creator of only the lowest rank, who must wrestle with his material. He openly avows that any *a priori* idea, any will toward expression admits something external, some ferment of disorder and impurity. . . . *Durus hic sermo*. We cannot fail, however, to return to the intransigent Aristotelian thesis that a musical work is inevitably expressive. Whether he wishes it or not, music expresses its author. It bears traces of the hand that made it. To this

Stravinsky will answer that a creator cannot and must not interfere in the working of the object he hands us. Precisely when Pygmalion masters his tools, Galatea comes to life and escapes to meet her unpredictable fate.... According to Stravinsky, a particular appetite arises in direct proportion to the resistance of the intractable material. Now the problem is solved for him by establishing a new order among elements indifferent in themselves. We enthusiastically applaud the success of such works as the *Symphony of Psalms*, the *Duo concertant*, or the recent Concerto for Two Solo Pianos, in which the persistent rigor of the craftsman uncovers for us, however limited by rigidity and calculation, the joys of spiritual delight.[11]

And these words will remind anyone who knows it, as well, of *Art et scholastique*, the celebrated treatise of 1920 by the neo-Thomist philosopher Jacques Maritain, from which a great deal of the substance and terminology in the early lessons of the *Poétique musicale* derived, as conclusively demonstrated with parallel citations by Louis Andriessen and Elmer Schönberger in their marvelous book of Stravinskian commentaries, *The Apollonian Clockwork*.[12] This was no wonder: Maritain had assumed the role of godfather when Roland-Manuel, a convert from Judaism to Catholicism, had himself baptized in 1926, and Maritain was also a close friend of Stravinsky's secretary and publicist at the time (one is tempted to say his then Robert Craft), the Russian émigré composer Arthur Vincent Lourié, who was very likely the one who fingered Roland-Manuel for the job of ghostwriting Stravinsky's lectures. Roland-Manuel was also Stravinsky's likely conduit to Paul Valéry's series of university lectures on aesthetics, titled *De l'enseignement de la poétique au Collège de France*—"sous forme de deux leçons," according to its subtitle—published two years previously, in 1937. We can be fairly sure that Stravinsky did not know this book at first hand, for in Valéry's diary for 7 September 1939, about two weeks before Stravinsky set sail for America, we find this peculiar entry, following an evening with Stravinsky at Nadia Boulanger's: "Conversation in the twilight about rhythm. [Stravinsky] goes to fetch the texts of the lectures that he has just written and will give at Harvard. He calls them *Poétique* (he too!), and his first ideas are more than analogous to those of my courses in the college—something very curious here."[13]

But although the language of *La poétique musicale*, as elaborated by Roland-Manuel, is obviously cribbed from that of the French academic writers whose style Stravinsky so noticeably aped when performing before his American academic audience, the sentiments expressed or implied were familiar enough to those who, like Roland-Manuel, had been following Stravinsky's career. As early as 1924, writing of the *Octuor*, one of his earliest so-called neoclassical pieces, Stravinsky—or whoever was ghosting for him at the time—had insisted that it was "not an 'emotive' work but a musical composition based on objective elements which are sufficient in themselves."[14] There, *in nuce*, were Roland-Manuel's *askesis* and realism. Stravinsky maintained this pose to the very end. In the same touching memoir

from 1966 in which, with Robert Craft's help, Stravinsky told of his reliance on his work on the Symphony in C to see him through his multiple bereavements, he nevertheless "hasten[ed] to add that I did not seek to overcome my personal grief by 'expressing' or 'portraying' it 'in' music, and the listener in search of that kind of exploitation will search in vain, not only here but everywhere in my art."[15]

Poetics of Music represents the pinnacle of this line of thought. At the very outset, in that prefatory lesson titled "Prise de contacte," Stravinsky characterized his frosty approach to art (and to lessons), in a now celebrated locution, as "dogmatic confidences."[16] Expanding on the term, partly in an effort to forestall the reflexive objections to it he expected from American listeners ("richer in sincerity than they are strong in certitudes," as he taunted them preemptively), he warned his audience that

> we cannot observe the creative phenomenon independently of the form in which it is made manifest. Every formal process proceeds from a principle, and the study of this principle requires precisely what we call dogma. In other words, the need that we feel to bring order out of chaos, to extricate the straight line of our operation from the tangle of possibilities and from the indecision of vague thoughts, presupposes the necessity of some sort of dogmatism. I use the words dogma and dogmatic, then, only insofar as they designate an element essential to safeguarding the integrity of art and mind and I maintain that in this context they do not usurp their function.... Throughout my course and on every hand I shall call upon your feeling and your taste for order and discipline. For they—fed, informed and sustained by positive concepts—form the basis of what is called dogma.[17]

But while Stravinsky's proud formalism served for many decades as a bedrock to academic certitudes about music and its aesthetics in Western Europe and its American academic colonies, and continues to serve in that capacity for many arts practitioners of a certain age, a newer style of critical theorizing—not necessarily American, but characteristically so—prefers contextualization to isolation, seeks to restore factitious order to its native or natural chaos, rejects certitudes and proceeds from a principle that precisely requires opposition to dogma. To theorists of this sort, and it is my sort, Stravinsky's obsessive reiterations of these mightily fraught terms—"dogma" or "dogmatic" ten times in two pages, "order" or "discipline" five times on one page—resonate as well with Pierre Souvtchinsky's disquieting dogmatic confidence to Robert Craft, the one quoted at the beginning of this chapter. What fascinates me in Stravinsky's *Poetics of Music*, and has fascinated me now for a quarter of a century, is its pervasive subtext of authoritarian politics.

My interest is not entirely "academic," to use the word now in its ironic sense, meaning "moot" or "without practical application." My earlier investigations of the *Poetics* mainly concerned the sixth and last lesson, the one on musical performance, with its radical opposition of "execution" (good) and "interpretation" (bad), the former implying "the strict putting into effect of an explicit will that contains nothing beyond what it specifically commands," and the latter lying "at the root

of all the errors, all the sins, all the misunderstandings that interpose themselves between the musical work and the listener and prevent a faithful transmission of its message."[18] Countering this argument, with its assumption of a social hierarchy and a correspondingly stratified distribution of power among musical agents, served what I took to be an eminently social purpose, one could even say a practical one: namely, that of making classical musical performances less boring and—were it only possible—stemming the mass defections from classical music to genres less subject in their performance practice to stultifying authoritarian dogmas.

Today I am happy to take the opportunity provided by an invitation to address an audience of Slavists to examine the fifth lesson, the one somewhat cryptically titled (in the original French) "Les avatars de la musique russe." Arthur Knodel and Ingolf Dahl, the translators of the *Poétique musicale* into English, took the easy way out and opted for a cognate, "The Avatars of Russian Music." But the word "avatar" is neither French nor English; it is Sanskrit, and its meaning is elusive. The commonest English translation is "incarnation," as when a Hindu God was said to take human form. (And an avatar, strictly speaking, always implied a descent from a higher to a lower estate, which added what may turn out to seem an appropriate nuance to Stravinsky's use of the term.) The first time the title was translated into Russian, which (for reasons that will be obvious) did not happen for many years, a near synonym to incarnations, *voploshcheniya* ("embodiments," literally "enfleshings"), was chosen;[19] but when the entire book was finally issued in Russian, as recently as 2004, another and better term—*prevrashcheniya*, literally "transformations"—was used.[20] It is indeed the transformations of Russian art music over a rough century from the time of Glinka to the time of Stravinsky that furnish the chapter with its subject.

One of the most remarkable features of Roland-Manuel's review of the *Chroniques*, and one that must have made him especially attractive to Stravinsky as a collaborator, was his insistence that Stravinsky's so-called neoclassical turn, much deplored by lovers of his Russian ballets, was in fact the logical and necessary outgrowth of his earlier style:

> In contrast to the opinion of the majority, who are distressed at the prospect of the tight and ever-narrowing path on which [Stravinsky] has embarked over the past fifteen years, we do not find here any new principles. A pupil of Rimsky-Korsakov, Stravinsky came of age in the wake of the Russian Five, who had nourished their musical nationalism with the findings of ethnographers. The young author of *Firebird* drew from folk sources the elements that made possible the pungent flavor of his earliest works. But Stravinsky has gradually liberated himself from the "doctrinaire esthetic" of his preceptors. Having renewed his ties with the traditions of Russian Europeanism (Pushkin, Glinka, Chaikovsky), he has renounced the easy charm of material that is in itself beautiful and precious. For art is not made with the help of ready-made artifacts.[21]

Here, of course, we already find a strong whiff of that strange fifth chapter, which has always seemed within the scheme of the *Poetics* an odd man out (and as we shall see, was sometimes literally out). Unlike the rest of the book, it treats of specifics rather than generalities, or what Stravinsky asserted (dogmatically) as universals. Unlike the rest of the book, it is narrative rather than meditative in form. Above all, unlike the rest of the book, it renders explicit rather than implicit or occult political judgments. For this reason it is often written off as a lapse, to be explained by what in Russian are called *kon"yunkturnïye dela,* considerations of the moment. And indeed, it did fit in with, and just as surely arose out of, its moment in history. But so did the rest of the book, and I prefer to take at face value Stravinsky's justification for its inclusion within his scheme. "If I have seen fit to devote one session of my course to Russian music," he told his audience, "it is not because I am particularly fond of it by reason of my origins; it is chiefly because the music of Russia, particularly in its latest developments, illustrates in a characteristic and very significant way the principal theses that I desire to present to you."[22] I take this to mean not only that general points made elsewhere are here clarified by (chiefly negative) example, but also that the very obvious and overt political content of this chapter—consisting as it does of a sustained invective against the Soviet regime and its musical products—is a necessary subtext to all the chapters of the book.

II

Stravinsky's hatred of the Bolsheviks was personal. He was born into a petty aristocratic family. His Russian passport identified him as a *dvoryanin,* a nobleman (literally a courtier)—not a member of the titled aristocracy but rather of the gentry, the hereditary landowning class. His mother's sisters had all married men who still had country estates (Anna Kirillovna had to content herself with a famous artist, the leading basso of the Russian operatic stage). Ustilug, the estate in Volhynia, the westernmost Russian province (now in Ukraine), where Stravinsky spent his youthful summers, belonged to one of these uncles, and after marrying his cousin Katya, the owner's daughter, Stravinsky built himself a luxurious mansion there and stood to inherit the rent income from the local industry, a distillery.

Like many members of his class, Stravinsky was brought up with what we would now call "limousine liberal" views. He welcomed the February Revolution of 1917, which toppled the tsar and replaced the Romanov dynasty with a government of liberal aristocrats like himself, headed by Prince Georgiy Yevgeniyevich L'vov, the leader of the Constitutional Democrat or "Kadet" Party (to which Vladimir Nabokov's father, another prominent liberal aristocratic politician, also belonged). "Toutes nos pensées avec toi dans ces inoubliables jours de bonheur que traverse notre chère Russie liberée (All our thoughts are with you in these unforgettable

days of joy our dear liberated Russia is now going through), Stravinsky cabled to his mother from Morges, in French Switzerland, where he was hard at work on *Svadebka*, his culminating "Russian-period" composition.[23] He had as yet no idea that he would not go back home to Russia, just as he had no idea, when he left Paris on 23 September 1939 to take up his chair at Harvard, that he would never go back home to Europe. But the Bolshevik coup seven months later insulted his patriotism. Like many, then and since, he regarded Lenin (who had come back to Russia from Switzerland after the revolution in a sealed train through German-held territory) as an enemy agent. And then, after insulting him, they injured him by confiscating his family's property.

Impoverished, Stravinsky had to give up prospects of independent wealth and autonomous creativity and start making a living by performing his own music (at first at the keyboard, which meant spending time practicing and writing a raft of not-too-difficult piano music during the 1920s), by accepting commissions from anyone who'd pay his asking price (which eventually meant writing ballets for circus elephants and Broadway revues and negotiating, fruitlessly and humiliatingly, with Hollywood studios), and by accepting uncongenial assignments like tutoring rich amateurs like Earnest Andersson (with whom Stravinsky co-authored a "Futurama" Symphony)[24]—or devising a course of lectures for Harvard. Like many other dispossessed aristocrats, Stravinsky fell in with the "white émigré" crowd, wintering at Biarritz, their favorite watering hole, and making a great show of anti-Bolshevik solidarity with the exiled Russian Orthodox Church. It must have been with keen thoughts of renewed resentment against those whose economic injustice had reduced him to a peripatetic chaser of dollars that Stravinsky delivered that fifth, specifically anti-Bolshevik, lesson.

Stravinsky left Europe about a month into the so-called *drôle de guerre* or "phony war" that followed the German invasion of Poland, when armies were glaring at one another along the western front, but without serious engagements, and everyone was still hoping that it would all blow over quickly. He had a return boat ticket for May of 1940 in his pocket. By the time he delivered the fifth lesson, on 20 March 1940, the Soviet Union, then (lest we forget) Germany's ally, had emerged as the main aggressor nation, having invaded the same Poland from the east and having been expelled from the League of Nations over its opportunistic Winter War with Finland. That surely gave added point and conviction to the lecture. By 10 April, when Stravinsky read the sixth lesson and concluded his course, Germany had embarked on its triumphant series of easy early conquests with the invasion of Denmark and Norway.

It was at this point that Stravinsky made his momentous decision to remain in neutral America, as he had decided twenty-three years earlier to stay in neutral Switzerland, and for the same reason: sitting out the war on neutral territory would enable him to work without the disturbances that wartime conditions

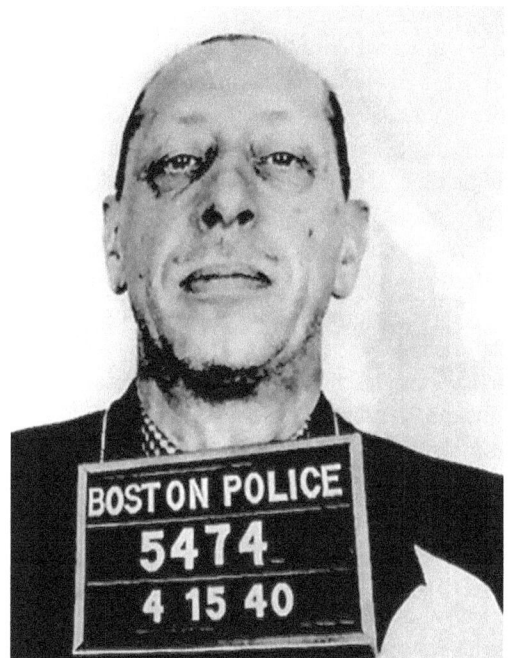

FIGURE 17.1. Not a mug shot: Stravinsky, photographed by the Boston police in connection with his application for a reentry visa to the United States in 1940.

would entail. Five days later Stravinsky applied for a renewal of his temporary visa, with the eventual intention of applying for citizenship. The photo taken at Boston police headquarters in connection with that application (fig. 17.1) has lived in infamy in another, irrelevant connection: Stravinsky's contretemps with the Boston police over his arrangement of "The Star-Spangled Banner," which took place much later, in January 1944; and it has given rise to what is surely the silliest of all the persistent Stravinsky myths, according to which (as Stephen Walsh summarizes it) "Stravinsky was supposedly arrested, held in police custody for several nights, and even photographed full-face and in profile for police records."[25] Sorry, figure 17.1 is not a mug shot.

But there is another way in which the fifth chapter has long been assumed to differ from the rest, namely, in its authorship. It was largely the work of the same Souvtchinsky whose striking political allegation furnished the starting point of this inquiry. In circling back to him now, we can pull all of the loose threads in our account thus far of the motley genesis of Stravinsky's lectures into a single skein, for a flurry of recent scholarship has at last begun to show how extensive Souvtchinsky's input was into the conception and elaboration of the *Poétique musicale*.

Souvtchinsky had always been a presence in the book, because unlike Maritain, Valéry, or even Roland-Manuel, he is named within it. In the second lesson, called "De phénomène musical" (The Phenomenon of Music), Roland-Manuel had made a précis of an article by Souvtchinsky that had just appeared in a special Stravinsky issue of the Paris journal *La revue musicale*. It was titled "La notion du temps et la musique: Reflexion sur la typologie de la création musicale," and it dealt, in a manner obviously derived from the theories of Henri Bergson, with two modes of musical temporality: ontological or objective "clock time," and psychological or subjectively experienced time. These, in turn, were associated with two types of music, classic (good) and romantic (bad). In a tactful letter to Souvtchinsky, Roland-Manuel admitted that paraphrasing this very elusive piece of writing was the hardest part of his job.[26] The article's subtitle, "Typologie de la création musicale," prefigures two more of Stravinsky's eventual lessons: the fourth ("Typologie musicale") and the third ("De la composition musicale").

Among the materials related to the *Poétique* in Stravinsky's archive at the Paul Sacher Stiftung, besides the main preparatory document, a nineteen-page outline in Stravinsky's hand from which Roland-Manuel worked, there is also a seventeen-page typescript in old-orthography Russian that corresponds, as exactly as a translation can correspond, to the text of the fifth lesson as eventually published, excepting the first fifteen paragraphs, amounting to about a fifth of the whole, which were left to Roland-Manuel to elaborate, and a page of closing remarks that Souvtchinsky later supplied at Stravinsky's request.[27] When Robert Craft translated and published Stravinsky's autograph outline, he mistook this Russian typescript, which he could not read, for a sheaf of research notes rather than the completed original of the fifth lesson. It remained for a Russian researcher, Svetlana Il'yinichna Savenko of the Moscow Conservatory, working at the Sacher Stiftung, to recognize Souvtchinsky's text for what it was. She edited it for publication in 1999, and existing published translations should now be checked against it and modified accordingly, in ways that will emerge over the course of this discussion.[28]

But Souvtchinsky's hand reached even further than that into the poetics of the *Poétique*. The most recent document to be discovered is the earliest and most fundamental one of all: a three-page outline in French, in Souvtchinsky's hand, now in the possession of Eric Humbertclaude, Souvtchinsky's literary executor, which was published and annotated by Valérie Dufour of the University of Brussels in an article that appeared in a French journal in 2003.[29] It clearly predates all other sketches and outlines, because its contents are distributed into the eight portions originally requested by Harvard, rather than the eventual six. Dufour discovered Souvtchinsky's outline in the course of her research for her doctoral thesis, which she published in 2006 under the title *Stravinski et ses exégètes*, a book I was thrilled to discover as I worked on my own Harvard lecture.[30]

The Souvtchinsky documents recently discovered and annotated by Dufour and Savenko can be collated with the somewhat longer outline in Stravinsky's hand, in a mixture of Russian and French, comprising about 1,500 words (fig. 17.2). This was first described by Robert Craft in 1983 and published in an execrable English translation, later supplemented by more accurate translations (in Russian of the French parts and in French of the Russian parts), and finally by a diplomatic transcription by Dufour.[31] It was evidently sketched out during a week stolen from the Symphony in C, from 29 April to 5 May, in consultation with Roland-Manuel, who had been summoned for the purpose to Sancellemoz (fig. 17.3).

In addition to all these, the Sacher Stiftung has more recently acquired Roland-Manuel's own notes and drafts, which have been described and annotated by Myriam Soumagnac in her new French edition of the *Poétique*, published in 2000.[32] From this paper trail one can assemble a hypothesized genesis of *La poétique musicale* as follows: on getting the commission, Stravinsky asked Souvtchinsky to outline a course of eight lectures, which Stravinsky then revised into a series of six in consultation with Roland-Manuel, who then undertook to compose five of them, leaving the remaining one, on Russian music, to Souvtchinsky, who wrote out a text for it in Russian, which was then translated by Soulima Stravinsky and polished by Roland-Manuel, all of this work being done over a period of five months, from late March to mid-August 1939.[33]

But like most sketch (or "genetic") studies, this hypothesis leaves open several vital questions. Just as Stravinsky's musical sketches usually fail to record the most basic phase of his creative process, which took place trial-and-error fashion at the keyboard (as we know from many testimonies and descriptions, including that given in the *Poétique* itself), so the preliminary documents for the lectures, while by now impressive in their numbers, and thought-provoking in their revelations as to the extent and the nature of collateral input, cannot offer any answers to questions of priority. Questions as to who had which ideas when can only be answered by those who participated in the unrecorded face-to-face (or telephonic or epistolary) consultations that produced the documents we have. The participants are long gone, but even were they alive and available, they would be most unreliable witnesses. The crucial question, the extent of Stravinsky's own role in the collaboration, must remain unanswered for now, and probably forever, his track record for veracity being proverbially poor—so poor, in fact, as to prompt a warning, under the rubric "Authenticity in the Writings of Stravinsky," in a recent music history textbook:

> The composer's deceptions in claiming authorship for other people's words continued [throughout] his life. His *Poetics of Music*—lectures for the 1939 Charles Eliot Norton Lectures at Harvard University—were written by the French critic Roland-Manuel and the Russian émigré Pierre Souvtchinsky. They contain an interesting statement *about* Stravinsky's aesthetic of the 1930s, but they are not what they purport to be—a

FIGURE 17.2. A page from Stravinsky's handwritten outline for *La poétique musicale*, showing the bilingual draft for the beginning of the lecture on Russian music. Courtesy of Paul Sacher Stiftung.

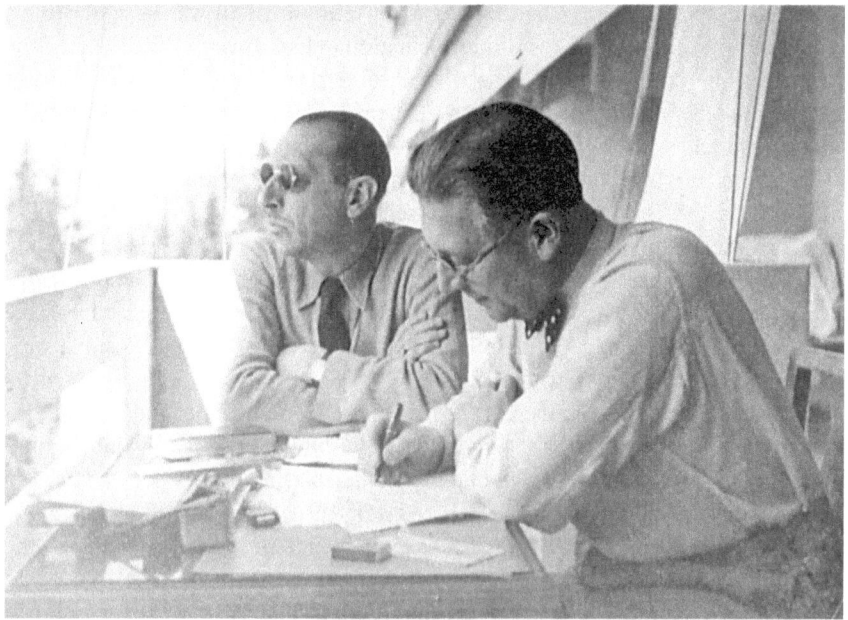

FIGURE 17.3. Stravinsky and Roland-Manuel seated on a balcony in Sancellemoz, Switzerland, at work on *La poétique musicale*. The photograph captures well the nature of their collaboration: Roland-Manuel is bent intent over the page before him; Stravinsky is looking abstractedly over the balcony at the landscape, perhaps wondering what he'll have for dinner.

far more important declaration *by* Stravinsky himself. Stravinsky's unwillingness to speak his own mind has cast doubt upon and created misinformation about his life and musical oeuvre. Stravinsky was often clumsy in his deceptions, sometimes stumbling into ludicrous situations [then follows a description of Stravinsky's *faux pas* in the presence of Paul Valéry, recounted above].[34]

As one of the early whistle-blowers on Stravinsky's mendacity, I should be pleased at this, perhaps; but in fact I think it shows that even scholarly skepticism, carried to an excess born paradoxically of credulity, can turn counterproductive. There is no reason to believe that a "declaration by Stravinsky himself" would be any more reliable or revelatory—hence any more "important"—than the ones he made in collaboration with others. Moreover, when it comes to statements of principles, as opposed to purported statements of fact, Stravinsky's willingness to stand behind an idea and take responsibility for it carries sufficient weight, if not for its acceptance as an oracular pronouncement, then at least for admittance into a critical discussion like this one. We are each answerable for our own sins, and the only sinner standing before the audience at Harvard over the course of the 1939–40 academic year was Stravinsky, not Roland-Manuel or Souvtchinsky.

So I believe that we may, and should, accept the words Stravinsky spoke to his audience in 1939 and 1940 as a fair representation of the principles and beliefs—the dogmas, as he put it—by which he wished to be represented as of then. And of course it is only because *Stravinsky* spoke them that they have become so famous and influential, hence worthy of investigation and critique. Souvtchinsky was well aware of this. In a letter of thanks after Stravinsky had signaled his acceptance of the fifth lesson as drafted, Souvtchinsky confessed how glad he was that his words would have the benefit of Stravinsky's authority.[35] That is precisely what makes pressing the task of discovering and evaluating the sources of Stravinsky's influential words, the influence of which has extended to the present day. And thus it becomes all the more vital and interesting to trace the relationship between Stravinsky's public professions and declarations and the ideas of his various *éminences grises*, for thanks to the Stravinskian megaphone they have become influential too, and we ought to know where our influences are coming from. It will not surprise anyone familiar with my previous writings that among these *éminences* I consider Souvtchinsky to be the most significant, or that from here on my attention will shift to him alone and focus on his contribution to the *Poétiques* in light of the new documents, on the subtexts this new awareness allows us to discern in Stravinsky's public oratory, and on the significance of these subtexts to our understanding and our interpretation of Stravinsky's achievement in its full musical and cultural ambit.

III

So who, at long last, was Pierre Souvtchinsky (fig. 17.4)?

Born in Kiev in 1892, thus ten years Stravinsky's junior, Pyotr Petrovich Suvchinsky was a very wealthy man—the heir to a sugar fortune in a country where everyone drank tea, and a Maecenas to numbers of artists and scholars. Having nurtured musical ambitions, both as a pianist and as an operatic tenor, Souvtchinsky had been the patron and copublisher of *Muzïkal'nïy sovremennik* (The Musical Contemporary), an important music journal of the immediate prerevolutionary period, of which Andrey Rimsky-Korsakov, the son of Stravinsky's teacher, was the editor, and to which Boris Vladimirovich Asaf'yev, later the most eminent of Soviet musicologists, was a frequent contributor. In 1917, Souvtchinsky and Asaf'yev bolted from the *Muzïkal'nïy sovremennik* in dissatisfaction over the editor's hostile treatment of contemporary composers (mainly Stravinsky, with whom the younger Rimsky-Korsakov had had a personal falling out) and founded a new, frankly avant-garde journal called *Melos*, which lasted in the midst of revolution for only two issues. It was this bolt, catalyzed by Asaf'yev, that brought Souvtchinsky decisively into the modernist—and specifically Stravinskian—camp.

Stravinsky and Souvtchinsky may have been slightly acquainted in prerevolutionary Russia, but they became friends, and Souvtchinsky became a source of

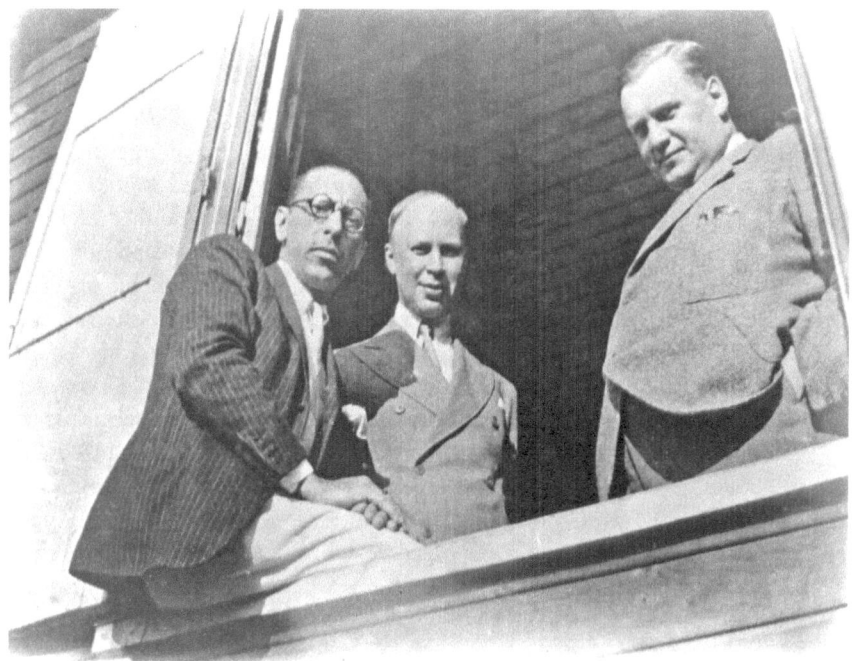

FIGURE 17.4. Photograph taken by Théodore Strawinsky (son of Igor) in September 1929 at Pierre Souvtchinsky's house in Paris. Left to right: Stravinsky, Prokofieff, and Souvtchinsky.

ideas to Stravinsky, only in emigration. Their close association began in the fall of 1922 in Berlin, where Souvtchinsky was then living and Stravinsky was fretfully awaiting the arrival of his mother on a steamer from Soviet Petrograd. Like many who found themselves in the Ukraine during the Civil War, Souvtchinsky had left Russia via the Black Sea, traveling through Turkey and into the Balkans. In 1920, while living in Sofia, Bulgaria, he founded and bankrolled the Russian-Bulgarian Publishing House *(Russko-bolgarskoye knigoizadel'stvo)*, whose first publication, *Yevropa i chelovechestvo* (Europe and Humanity) by Prince Nikolai Sergeyevich Trubetskoy, was one of the founding documents of the movement known as *Yevraziystvo* or Eurasianism. When, shortly after meeting Stravinsky, Souvtchinsky wrote to him that "knowing you are alive on this earth helps me go on,"[36] it was to his Eurasianist activities that he was referring.

Eurasianism was an explosive rejection of Europe on the part of intellectuals forced by the Russian revolution to live there—intellectuals whose outlook was conditioned by a intermingling of nineteenth-century Slavophilism and early-twentieth-century Scythianism. The former was the belief that Russia's salvation—and, through Russia, the salvation of the world—depended on a return from the

legalistic mores of what Prince Trubetskoy called "pangermanoromanic" modernity, founded first on Roman and then on Napoleonic law, to a primordial, organically harmonious social organization—what Eurasianists, after the theologian and philosopher Lev Platonovich Karsavin, a later convert to their cause, called a "symphonic society"—such as was imagined to have existed among the Slavic tribes in prehistory, a natural harmony that still subsisted in the organic connection with the soil that existed among peasants under serfdom, and that might yet be salvaged from the unspoiled Russian village culture of the nineteenth- or early-twentieth-century present. It was not salvageable, however, from the legalistic world of modern capitalism or from the monstrous Russia of the Bolsheviks, who had brought the country through Marxism into a bacchanalia of pangermanoromanic discord from which only a counterrevolution could rescue it—a counterrevolution the Eurasianists saw it as their mission to abet and eventually lead.

Eurasianists were nostalgic in a manner reminiscent of the American "Southern Agrarians," whose yearning for an organic society led them to a romanticized rationalization of the gentle, paternal world of slavery as preferable to the impersonally exploitative despotism of contemporary capitalism.[37] But Eurasianists were not gentle. From Scythianism, the clamorous avant-garde of prerevolutionary Russia, when in the words of Korney Chukovsky "poets wore themselves out trying to roar like wild animals,"[38] they adapted their irascible rhetorical style, their aestheticized attraction to violence, and their nostalgic attraction to the imagined cleansing barbarism of Asia, epitomized in Trubetskoy's assertion of the "Turanian" affinities of the Russians—that is, their affinity not for their brother Slavs to the west and south, but to their Central Asian neighbors to the east (the Turkic peoples, to the study of whose languages Trubetskoy, a famous linguist, devoted his professional career). The combination of Slavophilism and Scythianism struck many as oxymoronic, as reflected in the spiteful epithet often applied to the Eurasianists by rival émigré factions, who liked to deride them as "National Bolsheviks." There came a moment in the 1930s when this epithet, alas, began to ring true.[39]

The extent of Stravinsky's personal involvement with Eurasianism, and its influence on his outlook and output, have been matters of debate. I have argued for it; many have resisted.[40] Stravinsky was well acquainted in Russia with at least one important proto-Eurasianist, Karsavin, who lived in the same apartment house on the Kryukov Canal as the Stravinsky family, whose sister became Diaghilev's first prima ballerina (and *créatrice* of two leading roles in Stravinsky's early ballets: the Firebird and the puppet ballerina in *Petrushka*), and whose daughter Marianne later became the wife of Souvtchinsky. But such an acquaintance, whatever the intellectual yield, had to predate the movement as such, which was entirely a figment of the Russian diaspora and postdated Stravinsky's own prerevolutionary emigration. Whatever Stravinsky's relationship to the movement, however, there is no doubt at all that (as Souvtchinsky's letter to Stravinsky already indicates)

the Eurasianists saw in Stravinsky's work all their cherished ideals epitomized in works of artistic genius. *The Rite of Spring* was for them the very *ne plus ultra* of Scythianism, even as *Svadebka* portrayed a latterday Slavophile vision of totally harmonious social cohesion brought about through the complete and willing sacrifice of individual liberty: Karsavin's "symphonic society" made (virtual) flesh.

Souvtchinsky propagandized for a Eurasian view of Stravinsky in the pages of *Vyorstï* (Versts, or Mileposts), the latest and most distinguished of the Eurasianist periodicals, which he edited (along with Prince Dmitry Svyatopolk-Mirsky, the great historian of Russian literature) in Paris between 1926 and 1928, having moved there from Berlin in 1925. He was no longer bankrolling the publication, however, having been, like Stravinsky, impoverished by the Bolsheviks. The chief Maecenas now was an English philanthropist named Henry Spalding, who kept Souvtchinsky's *Yevraziyskoye knigoizdatel'stvo* (Eurasianist Publishing House) afloat with a spectacular £10,000 endowment.[41] The very first issue of *Vyorstï* carried a lengthy article called "The Music of Igor Stravinsky" by the newly emigrated Arthur Lourié. The last issue contained an article by Lourié called "Two Operas by Stravinsky," namely *Mavra* and the brand new *Oedipus Rex*. These were the most extensive critical pieces ever published by the Eurasianist press on music or a musician.[42]

Souvtchinsky spent the war years in occupied Paris, supporting himself through freelance writing and editing. After the war, he became active as a concert organizer and resumed his journalistic activities in connection with two short-lived periodicals. *Contrepoints*, which Souvtchinsky edited together with the Dutch-born journalist Frederick Goldbeck, appeared from 1946 to 1949 before being absorbed by *La revue musicale*. The other journal, *Musique russe*, lasted, like the old *Melos*, for only two issues in 1953. Both are best remembered today for serving as sites for early, now notorious squibs by the young Pierre Boulez ("Trajectoires," in *Contrepoints* in 1949, and "Strawinsky demeure," the once widely quoted analysis of *The Rite of Spring*, in *Musique russe*). Souvtchinsky was one of Boulez's earliest supporters, and he liked to claim credit for having discovered him. In 1954 he helped Boulez set up the Domaine musical concerts; two years later, he engineered the meeting between Robert Craft and Boulez alluded to at the beginning of this chapter, while Stravinsky lay in a Munich hospital recuperating from a stroke—a meeting that led to Boulez's being invited to Los Angeles in 1957 to conduct at the Evenings on the Roof concerts just as Craft and Stravinsky were getting under way with the first of their literary collaborations and Stravinsky was finishing *Agon*, one of the earliest of his (then intermittently) twelve-tone compositions.

Souvtchinsky was thus chiefly responsible for the brief close relationship between Stravinsky and Boulez that flowered in 1956 and withered in 1958 after Boulez's disastrously underprepared performance of *Threni* at the Domaine musical, a performance Souvtchinsky had helped arrange. In between came the

publication of *Avec Stravinsky,* a miscellany of articles and memorabilia edited by Souvtchinsky, which contained a sixty-page preview of the initial "conversations book," in the form of interviews with Robert Craft, that gave the first sign of Stravinsky's new, Boulezian attitudes toward the music of his century.[43] As Craft has averred, Souvtchinsky was the only one of Stravinsky's European friends who welcomed Craft's transforming participation in Stravinsky's life without any reservations. Thus the voice that speaks to us from the Stravinsky/Craft books—and especially from the first of them, *Conversations with Igor Stravinsky* (1959)—is in an indirect but important sense as much the creation of Pierre Souvtchinsky as the voice that had spoken two decades earlier out of the *Poétique musicale.*

IV

Before proceeding to a close look at the fifth chapter—Souvtchinsky's chapter—in *La poétique musicale,* there is one last point—rather a sore point—that needs to be disposed of. The one place where the Eurasianists and the émigré Stravinsky definitely came together was in their enthusiasm for Mussolini, whose *fascisti* represented for Eurasianists a synthesis of ancient organicism and modern ferocity similar to their own.[44] In particular, fascism offered the clearest and cleanest response to Bolshevism, the ultimate pangermanoromanic heresy, further tainted by the Jewishness of its proponents beginning with Karl Marx. In one of Souvtchinsky's Eurasianist publications, an annual called *Yvraziyskiy vremennik* (Eurasian Almanac), a young economist named Yakov Dmitriyevich Sadovsky sounded off as follows:

> By now it is clear to every right-thinking person that one cannot simply and categorically pit "revolution" against "counterrevolution" on the prior assumption that the one is a healthy manifestation and the other a morbid one. Nowadays one often hears that revolution means "swimming with the tide," or "riding the wheels of history." ... But meanwhile, can one apply this "axiom" to the communist revolution in Russia, or to the fascist counterrevolution in Italy? Obviously not. Fascism is certainly a reaction to Bolshevism, but [it is] full of energy. There are reactions and reactions. There are pernicious reactions and creative ones. In a creative reaction life throws off the wrongs and falsehoods of revolution and shows other ways to well-being and prosperity.[45]

This passage has many noteworthy Stravinskian resonances, starting with interviews the composer gave the press during his first American tour in January 1925, the year in which Souvtchinsky published Sadovsky's rant. In these interviews, Stravinsky equated "modernism" with Bolshevism and startled reporters with pronouncements like "Modernists have ruined modern music," which became a headline.[46] The *Poétique* also contains a rant against modernism, cast therein first as "a form of theological liberalism which is a fallacy condemned by the Church of

Rome" and then more generally as "a sign of decadence in morality and taste."[47] In the meantime, he had told a Rome newspaperman, right before an audience with the Duce: "I don't believe that anyone venerates Mussolini more than I. For me, he is the one man who counts nowadays in the whole world. I have traveled a great deal: I know many exalted personages, and my artist's mind does not shrink from political and social issues. Well, after having seen so many events and so many more or less representative men, I have an overpowering urge to render homage to your Duce. He is the savior of Italy and—let us hope—the world."[48]

A year later still, Stravinsky allowed himself to be described in print by Arthur Lourié as "the dictator of the reaction against the anarchy into which modernism degenerated."[49] Stravinsky had by then consciously cast himself as the Mussolini of music, who wanted to do for modern music what the Duce promised to do for modern Europe. The same enthusiasm for Mussolini peeps through the lines in the second volume of Stravinsky's autobiography, issued in 1936, when, speaking of his "traditional" Russian attachment to Italy, he gave it a contemporary political twist by lauding "the marvelous regenerative effort which has manifested itself there for the last ten years, and is still manifesting itself in every direction."[50]

Most recent writers who have had to confront this side of Stravinsky have made strenuous efforts to write it off. Harvey Sachs, the author of a book called *Music in Fascist Italy*, in which he reported both the Rome interview and also one in which Stravinsky had gone so far as to tell reporters that he had personally confessed his political loyalty to the Duce in a private audience, predictably tried to excuse Stravinsky's attraction to Mussolini on the basis of the composer's having been "bamboozled," as he put it, by the attention paid him in Italy.[51] But of course attention was paid him everywhere. The same explanation—political (or "apolitical") naïveté—is dependably adduced to rationalize Prokofieff's return to the Soviet Union, Furtwängler's cooperation with the Nazis, Schoenberg's unreconstructed monarchism, and the list goes on. But these are not explanations, merely tautologies. Backing losers, or figures held retrospectively in opprobrium, is just the working definition of "naïveté" in these contexts. If the Axis had won the war, so that the world we lived in now looked more like the world Stravinsky dreamed of in the 1930s, he would look shrewd enough. His biographers would now be touting his political acumen and foresight, just as revisionist biographers of Shostakovich have been doing since the proclamation of "glasnost'" and the later collapse of the Soviet Union.

The fascist subtext is indispensable to understanding the motivation for Stravinsky's "neoclassicism," and it reverberated loud and clear, for those not covering their ears, in the *Poetics*—spectacularly so in a three-page tirade that suddenly interrupts the placid course of the first lesson, the "Prise de contacte." Here is a sample from it, as translated by Knodel and Dahl from Roland-Manuel's French. As one may confirm by comparing Roland-Manuel's French text with Dufour's

diplomatic transcription of the first three pages of Stravinsky's autograph notes for the *Poétique*, this passage is one of the very few spots in the finished text that is based directly on Stravinsky's own somewhat fractured French. "So I am obliged to be polemical," it begins:

> By some chance, which it pleases me to regard as a happy one, my person and my work have in spite of myself been stamped with a distinctive mark from the outset of my career and have played the part of a "reagent" *[réactif]*. The contact of this reagent with the musical reality around me, with human environments and the world of ideas, has provoked various reactions whose violence has been equaled only by arbitrariness.... I am well aware that there is a point of view that regards the period in which the *Rite of Spring* appeared as one that witnessed a revolution. A revolution whose conquests are said to be in the process of assimilation today. I deny the validity of that opinion. I hold that it was wrong to have considered me a revolutionary.[52]

While it is understandable enough that a white émigré would reject the revolutionary brand, it is hard to say what Stravinsky meant when he called himself and his work a "reagent" *(réactif)*. The term (interchangeable in English with "reactant") comes from chemistry and denotes, according to the International Union of Pure and Applied Chemistry, "a test substance that is added to a system in order to bring about a reaction or to see whether a reaction occurs."[53] How that definition might apply to a composer or a body of musical works is not immediately apparent, but look now at the first page of Souvtchinsky's preliminary outline titled "Thèses pour une explication de musique en forme de 8 leçons," the document recently uncovered and published by Dufour (fig. 17.5).

This first lesson, as originally drafted, bears the title—"Le fénomène musical"—that now heads the second chapter of *La poétique musicale,* and its contents correspond with that chapter. Its main themes—music as speculation in sound and time, the dialectics of the creative process, the principles of contrast and similarity—all pass in review, along with the title of Souvtchinsky's "La notion du temps et la musique," leaving no doubt that we are dealing with the conceptual kernel of Stravinsky's poetics and that they were expressly preformulated for him by Souvtchinsky. And now notice that above the *précis* of the second lesson we find two words scrawled in pencil, indicating, as Dufour plausibly suggests, that they were entered during the first face-to-face discussion between Stravinsky and Souvtchinsky at Sancellemoz, and reflect revisions to be incorporated into Stravinsky's autograph outline. These two words are *réactif* and *rapport*, and between them they give the first whiff of what would be the first chapter of the eventual finished text, the *prise de contacte,* for which (according to my trusty *Petit Larousse*) *rapport* is a synonym.[54] As for the other word, the mysterious *réactif*: knowing that Souvtchinsky was involved in its choice, one may be justified in seeking its meaning not in the realm of chemistry but in that of politics, in the dialectical

Sauguet I

<u>Thèses pour une Explication de Musique</u>
en forme de 8 leçons.

réactif

<u>I^{re} Leçon</u>. <u>Le Phénomène musical</u> rapport

Ce que n'est pas, à mon sens, la musique.*) La vraie expérience musicale. La notion du Temps et la musique. "Le <u>Khronos</u>."
L'instant sonore. La durée musicale ; l'écoulement du Temps musical. Le problème du "Lento" et du "Scherzo." (Coda)
"Les hautes mathématiques" de la Musique. La Spéculation musicale. La dialectique du processus créateur en musique
« Coincidentia oppositorum ». Le principe de contraste et de similitude dans la création musicale. La méditation.
L'émotion musicale. Les limites de l'art musical.
La crise d'unité de conscience et de concepts.

<u>2^{me} Leçon</u>. <u>L'œuvre musicale</u>. (Eléments et morphologie)
 structure
Le Melos, le thème l'harmonie, l'intervalle. Les modes
 mélodie (la tonalité) l'accord
 (la modulation)
La polyphonie, le mouvement, le mètre, le rythme, le temps,
la sonorité ; les registres et les timbres ; la phrase, le mot,
la parole, la syllabe l'intonation. Les développements
 la cantate, l'opera ;
La Forme. (le choral, la fugue, la sonate, la symphonie, le poème, le prélude, la danse)
 La vraie et la fausse durée

 Cinéma — profane — Scène
(profane)
 sacré
*) Magie, l'irrationnel, musique ésotérique I

relation of "revolution" and "reaction" we have by now noted in several Eurasianist writings.

If this interpretation is admitted, it provides a link between Stravinsky and Eurasianist thought that reaches beyond the circumstantial level into the conceptual. The suspect is at last at the scene, and it is the fifth lesson, on Russian music appropriately enough, that will clinch the matter. Having proceeded from Roland-Manuel's finished text through Stravinsky's autograph outline to their source in Souvtchinsky's preliminary plan, let us turn around now and approach the Russian chapter from the opposite direction. Figure 17.6 shows Souvtchinsky's outline for the fifth lesson—at this early stage called the sixth, but identifiable by its heading, "Musique russe." This outline too shows a notation penciled in above the main text, likely entered in direct consultation with Stravinsky. It reads "Citoïen du monde" (citizen of the world). Here is a translation of the rest:

> Folklore and cultivated music. Plainchant/Kastalsky. Russia-Eurasia. The "Italianisms," "Germanisms," and "Orientalisms" of Russian music. The basic elements of Russian historiography. The two Russias. The Russian Revolution and Reaction. The two "disorders."
>
> Glinka, Tchaikovsky, Mussorgsky, R. Korsakoff. Scriabin. The new Soviet "folklorism" (Ukrainian, Georgian, Azerbaidjanian, Armenian, etc.) and the subversion [written above: degradation] of values.

Souvtchinsky's jottings contain two smoking guns—"Eurasia" and "reaction"—each of which takes on a special meaning in relation to the other. The first did not survive into Stravinsky's outline or into Roland-Manuel's French text, which is why the document unearthed by Dufour is such an important find: the suppressed word names explicitly the subtext that pervades the finished chapter, which, as I intend to show, cannot be fully understood without it.

V

In modifying Souvtchinsky's outline of the fifth chapter to guide Roland-Manuel, Stravinsky elaborated in full, and in his own hand, the part corresponding to Souvtchinsky's penciled additions, as shown above in fig. 17.2. Knowing that Souvtchinsky would be sitting at Roland-Manuel's elbow, he drafted the beginning in Russian, then switched to French, replacing the word *réactif* with the phrase *conservatisme russe* (Russian conservatism). Since this is one of the few spots where the input seems to have come straight from Stravinsky, we may regard the substitution as a self-characterization.

> [In Russian] Why have I suddenly begun to speak about Russian music in particular? Not because I am Russian or because I especially value it in comparison with other

<u>III</u>

6^{ème} Leçons <u>Musique russe</u> Citoyen du monde

Le Folklore et la culture musicale. Le plainchant Kastalsky
"Russie-Eurasie". "Italianismes", "germanismes" et "orientalismes"
de la musique Russe. Les Eléments fondamentaux de l'historiosophie
russe. Les deux Russies. La Révolution et la Réaction russe.
Les deux "désordres".

Glinka, Tchaikowsky, Moussorgsky, R.-Korsakoff.
Scriabine. Le nouveau "Folklorisme" soviétique (ukrainien,
géorgien, Azerbadjien, Arménien etc.) et le déclassement des
valeurs.

8^e Leçons <u>De l'Exécution</u>

Le néant et la vie musicale. La musique, les
exécutants, les auditeurs. Le public. L'interprétation
et l'exécution. La critique musicale; ses aberrations et
ses égarements "classiques". La musique "accessible" et Énigmatique
. Le vrai sens de la Musique. Le "moi" le non-moi
– est l'être. Monisme créateur.

Académisme

FIGURE 17.6. Souvtchinsky, "Théses," folio 2r. Courtesy of Eric Humbertclaude.

musics. Neither should you think that I am hostile toward the manifestation of national character provided it is an unconscious manifestation.⁵⁵

[In French] I do not claim to be a citizen of the world as the Russian revolutionaries of the nineteenth century loved to say. Folklore and cultivated music. Plainchant, sacred and secular music. The Italianisms, Germanisms and Orientalisms of nineteenth-century Russian music. The complexity of Russian culture. The two Russias (the revolution and [in place of "reaction"] Russian conservatism—the two disorders). <u>Glinka</u>, <u>Tchaikovsky</u>, order, <u>Scriabin</u>, disorder (religious, political, ideological, psychological and musical). Mussorgsky—between the two. The new Soviet folklorism, Ukrainian, Georgian, Armenian, Azerbaidjanian, etc. and the degradation of values.⁵⁶

Those familiar with the finished text of the fifth "lesson" will have noticed the strangely lopsided quality of this outline. Once past the Russian preamble, there is a fairly detailed, point-by-point summary of the contents of its first fifteen paragraphs, about one-fifth of the whole. This part purports to sum up the whole history of Russian music up to the time of the revolutionary catastrophe, slanted in orthodox Eurasianist fashion to imply the catastrophe's inevitability as the outcome of pangermanoromanic infiltration. This much was meant as a guide for Roland-Manuel, who fleshed it out at the end of June after a long consultation with Souvtchinsky, and sent it to Stravinsky on 17 July.⁵⁷ The last sentence of the outline stands in for the remaining four-fifths of the lesson, which Stravinsky left entirely to Souvtchinsky, and which comprises the sustained invective against Soviet "modernism," taking the word now in the sense assigned to it in the fourth lesson, i.e. "decadence in morality and taste."

The Russian-language preamble from Stravinsky's draft became the second paragraph of the fifth lesson. The bend-over-backward assurance that Stravinsky had no special love for his country's music bears an obviously ironic relationship to Stravinsky's actual musical achievement, because up to the time of *Svadebka* and *Mavra* no composer's exhibition of national character had ever been more conscious and deliberate than Stravinsky's. Indeed, Stravinsky's insatiable utilization of folklore in the works that made him famous smacked of what Russians call *pokaznoye potrebleniye*, conspicuous consumption, in defiance of the historical trajectory of Russian art music as a whole, which, from the 1880s to the time of the revolution—the time of the Silver Age and, in music, of the so-called Belyayev Circle—had been increasingly remote and even antagonistic toward the folkloric nationalism associated with the period that preceded it, running from the time of Glinka to that of the Mighty Kuchka. It put Stravinsky at odds with almost every other major Russian composer of the time. Theirs was the unconscious Russianness Stravinsky purported to tout in the *Poétique*, his the demonstrative Russianness that he ostentatiously rejected. After the death of Lyadov in 1914 Stravinsky became the only Russian composer of note who still relied on folklore for

inspiration. And this seemingly regressive stance would only increase over the next half dozen years toward the pinnacle represented by *Svadebka*.

This seeming paradox was of course conditioned by another seeming paradox: Stravinsky became more and more Russian as his career became more and more international. At first it was a matter of expediency and (Diaghilev's) commercial strategy: seducing the Paris public with exotic fare. With the onset of the war, however, it became an impassioned response to exile, linking up quite poignantly with a famous saying of Gogol's that Souvtchinsky misremembered in the first paragraph of the part of the fifth lesson that came directly from him. Living by choice in Rome, Gogol wrote, "I needed this distance from Russia so as the more vividly to inhabit Russia in my thoughts."[58] Gogol's words read like a paraphrase of the passage in Stravinsky's autobiography that immediately preceded the notorious claim that music "cannot *express* anything at all": "My profound emotion on reading the news of war, which roused patriotic feelings and a sense of sadness at being so distant from my country, found some alleviation in the delight with which I steeped myself in Russian folk poems."[59]

This was the phase of Stravinsky's career—the moment of renunciation—that allied him willy-nilly with the Eurasian movement, wholly a product of emigration and exile, and precluded identification with the world-citizenship to which Russian composers were now aspiring at home, including Stravinsky in the period of his apprenticeship. The overstressed hostility toward folklore in the *Poétique musicale* was a reaction to two complementary pressures: the need to reinvent himself esthetically and stylistically after renouncing red Russia, and the regressive turn red Russia itself had taken under Stalin toward the old folklorism, flimsily camouflaged by socialist realism, which demanded an art "national in form and socialist in content."[60] The political roots of Stravinsky's esthetic and stylistic turns could hardly have been more conspicuous, and in the fifth lesson he (or rather, Souvtchinsky) made no effort at all to hide them.

Thus Glinka, whose decision to adopt a Russian style (by the testimony of his own memoirs) was as deliberate as, a century later, Stravinsky's would be to renounce it, became, for the Stravinsky of the *Poétique,* the supreme example of "unconscious" Russianism. In the opera *A Life for the Tsar,*

> the *melos* of the people is quite naturally incorporated into art music. Glinka . . . does not think of laying the groundwork of a vast enterprise for export purposes [the task that awaited Diaghilev and Stravinsky]: he takes the popular motif as raw material and treats it quite instinctively according to the usages of the Italian music then in vogue. Glinka does not hobnob with the common people, as certain of his successors did, to reinforce his vigor through contact with the plain truth. He is merely looking for elements of musical enjoyment (*un plaisir musical*) . . . , and it is without any desire to establish a system that he introduced into his works melodies of popular origin or feeling.[61]

But of course no opera had ever mongered a more overtly political message than *A Life for the Tsar*, which glorified, through the legend of Ivan Susanin, a peasant who sacrificed his life to save the founder of the still-reigning Romanov dynasty, the theme of submission to divinely sanctioned authority—what in the time of Tsar Nikolai I was called Official Nationality. And no Russian composer was ever more demonstratively and consciously motivated to adopt Russian folklore as thematic material, for Glinka deliberately cast his opera as a calculated contrast of Polish and Russian national idioms, to reflect the political turmoil out of which the modern Russian dynastic state emerged. For him Russian folklore was not merely an element of musical enjoyment. It was a political symbol.[62] When he "merely" went looking for elements of musical enjoyment, whether in his second opera, *Ruslan and Lyudmila,* or in his orchestral pieces, he was more apt to find them in Spain or Finland or the capacious "Orient" than at home.

The fifth lesson now turns to the next generation of Russian composers, and the political animus becomes irrepressible. Stravinsky characterizes the composers of the so-called Five, the group around Balakirev that had once included his teacher, in insulting terms: in Roland-Manuel's French as "slavophiles de l'espèce populiste"; or in Knodel and Dahl's English as "Slavophiles of the populist variety" (122–23). Slavists will recognize these epithets as weird anachronistic oxymorons arising out of the impossible conflation of—or confusion between—the terms *slavyanofil* and *narodnik.* If Stravinsky intended it, it could only have been one of his many efforts to belittle the memory of his teacher, whose aristocratic political liberalism (very similar to, and perhaps the model for, the attitudes of his own youth) he had come to regard the way Eurasianists regarded it, as the inexorable prelude to Bolshevism. The *narodniki,* radical petty-aristocratic reformers like Pyotr Lavrov and Nikolai Mikhailovsky, who emerged about half a century after slavophilism, properly so-called, had had its day, were anything but nostalgic for the imagined symphonic society of peasant culture. They had sought to elevate the peasants not by idealizing them but by enlightening them, with the aid of modern science and philosophy, to the point where they could recognize their true social and economic interests and take political action on their own behalf. From the Eurasian-influenced vantage point of the fifth lesson, that was enough to start Russia down the slippery Europeanizing slope toward liberal-democratic perdition. Elaborating on the political and esthetic sins of Rimsky-Korsakov and his associates, Souvtchinsky's Stravinsky, in Roland-Manuel's words, characterized "their ideas and their tastes" as "inclin[ing] toward a kind of devotion to the people's cause," for which reason they were compelled to "set up [Glinka's] unconscious utilization of folklore as a system . . . a tendency which, of course, had not yet taken on the vast proportions that it has in our day in conformity with the instructions of the Third International" (123). I have to wonder what Balakirev, as rabid a right-winger as any pogrom-loving *chernosotnik,* would have made of that.[63]

By now the strategy is clear. Stravinsky/Souvtchinsky is adumbrating the quintessential Eurasianist theme: that of the two Russias, as prefigured in the outline, the one contaminated by rationalism and legalism—the systems that led the country into the vortex of Bolshevism; and the other, the true Russia, natural and organic, that had been exiled and now had the task, from its perch abroad, of saving the *rodina,* the motherland, from pangermanoromanic doom. The dichotomy is pursued through a series of oppositions: Belyayev-circle academicism, forsaking Italianism in favor of "an ever-increasing enthusiasm for German technique" (125), countered by the brilliance of Chaikovsky, who managed, despite an education "conducted along the lines of the German academies," to forge a musical language "as completely apart from the prejudices that characterized The Five as Glinka's had been" (125). Like Glinka, Chaikovsky represented the natural and organic, unconscious nationalism of the true Russia: "however attentive and sensitive he was to the world outside of Russia," Chaikovsky nevertheless "showed himself to be ... profoundly national in the character of his themes, the cut of his phrases and the rhythmic physiognomy of his work" (127).

And now another Eurasianist theme is broached, that of the twin disorders:

> Academicism, the first signs of which were visible in the activity of the Belyaev [*sic*] circle [and in the first instance, in the work of Stravinsky's now-discarded teacher], was not long in gathering epigones [he means Glazunov, who never took Stravinsky seriously as a composer because he never went through the conservatory mill and never even mastered elementary *solfège*], while the imitators of Tchaikovsky degenerated into a mawkish lyricism [he means Rachmaninoff, who was heavily touted in America as the last of the great composers]. But just when one might have thought we were on the eve of a dictatorship of conservatism, a new disorder had wormed its way into Russian thought, a disorder whose beginnings were marked by the success of theosophy; an ideological, psychological, and sociological disorder that took possession of music with impudent unconcern. For, frankly, is it possible to connect a musician like Scriabin with any tradition whatsoever? Where does he come from? And who are his forebears? (127)

Well, as long as you ask, his forebears were Chopin and Wagner, admittedly an unusual parentage—an unwed parentage, Stravinsky would be quick to insist, to which (on returning to Russia from a long sojourn in Western Europe) Scriabin added many of the same Rimsky-Korsakov-school innovations as formed Stravinsky's own stylistic patrimony. But Stravinsky/Souvtchinsky was not concerned with stylistic or cultural genealogies. What he wished to establish was Scriabin's illegitimacy. Here Stravinsky was motivated by a personal animus, Scriabin having been the object of an intense unrequited youthful crush. Souvtchinsky's animus was more political: Scriabin was the eccentric by-product of orthodoxy, having been a prize-winning trainee (in Russian, *vospitannik*) of the ultra-traditionalist Moscow conservatory establishment and the most cherished protégé of

Mitrofan Belyayev, the timber merchant who supported the whole world of academic music from which Stravinsky had been excluded and against which he harbored an animus that his later, greater fame could never assuage. Even Professor Rimsky-Korsakov had to admire Scriabin's craftsmanship, his impeccable part-writing (or voice-leading, as music professors say), his utter mastery of all the conventional classroom skills Stravinsky was said to lack.[64] So Scriabin had to be portrayed as an upstart and a rebel so that he could supply a necessary ingredient in support of a Eurasianist reading of Russian musical history.

There you have it, the historical survey concludes: "We are brought to consider two Russias, a Russia of the right and a Russia of the left, which embody two kinds of disorder: conservative disorder and revolutionary disorder" (127). The opposition of the two evils, Glazunov vs. Scriabin, stood in for illegitimate tsarist legitimacy on the one hand—asserted top-down rather than of spontaneous growth, contaminated under Peter the Great with an influx of "German" science, and utterly spoiled in the late nineteenth century by hasty admixtures of legalistic administrative liberalism—vs. Bolshevism on the other, the ultimate pangermanoromanic administered perversion, imported even more directly and recently from the West. Between the two of them, the twin disorders had squeezed out the authentic Russia, the Russia Stravinsky presciently described to Romain Rolland in a conversation that took place in the garden of the Hotel Mooser in Vevey, Switzerland, on the north shore of Lake Geneva, on 26 September 1914, about six weeks into the First World War. But for Eurasianism's specifically religious component, to which he would come in time, Stravinsky's description foreshadows the whole Eurasianist prescription:

> Stravinsky declares that Germany is not a barbarian state, but a decrepit and degenerate one. He claims for Russia the role of a splendid, healthy barbarism, heavy with germs that will inseminate the thinking of the world *[le rôle de belle et saine barbarie, grosse de germes nouveaux qui féconderont la pensée du monde]*. He is counting on a revolution to follow the war, which will topple the dynasty and found a Slavic United States *[les États-Unis slaves]*. Moreover, he attributes the cruelties of the tsarist system in part to German elements that have been incorporated into Russia and run the main wheels of the government or the administration. The attitude of German intellectuals inspires him with boundless contempt. Hauptmann and Strauss, he says, have the souls of lackeys. He touts the Old Russian civilization, unknown in the West, the artistic and literary monuments of northern and eastern cities. He also defends the Cossacks against their reputation for brutality . . .[65]

What could this be but a description of what Lev Karsavin would call symphonic society, as one easily imagines Stravinsky hearing it from Karsavin himself? For corroboration one need look no further than Stravinsky's *Symphonies d'instruments à vent*, his memorial to Debussy, composed in 1920. The title of this work evokes not the usual, Italianate meaning of *Sinfonia*, so familiar in Western classical music

as to seem timeless and self-evident. Stravinsky's use of the plural, and his use of the preposition *de* instead of *pour*,⁶⁶ show that Stravinsky was relying on Karsavin's idea of *simfonichestvo*, in such phrases as *simfonicheskoye obshchestvo* (symphonic society), *simfonicheskaya lichnost'* (symphonic personality), and *simfonicheskiy sub'yekt* (symphonic subject), to define the consciousness of those who live in the perfect harmony of an organic society in which they have a subjective sentiment of freedom but who function within it unreflectively, without ever having to make a conscious decision or exercise choice. In a foundational manifesto of 1926, "Yevraziystvo: Opït sistematicheskogo izlozheniya" (Eurasianism: An Attempt at a Systematic Exposition), communally authored by the editorial staff of Souvtchinsky's journal *Yevraziyskiy vremennik*, Karsavin (for it could only have been he, the "principal religious thinker" of the movement)⁶⁷ attempted to define the proper relationship of church and state, in vehement opposition to the "enlightened" separation of the two in pangermanoromanic thinking, by invoking "a term used by the *kanonistï* (hymn-writers) of Byzantium: *simfoniya*, that is concinnity [*soglasovaniye*] or coordinated activity [*soglasovannaya deyatel'nost'*]. When there is a clear understanding of what the Church is and what the state is, and of their true relationship, the theory of 'symphony' should present no problems."⁶⁸

Stravinsky's *Symphonies*, in which the music constantly shifts among three precisely calibrated proportional tempos as if to expound the idea of *soglasovannaya deyatel'nost'*, is modeled on the liturgy of the Orthodox funeral service, or *panikhida*, the longest individual component of which is the nine-fold strophic hymn known as the *kanon*, to which Karsavin made specific reference in the philological fantasy out of which he constructed his vision of Eurasian "symphonic" social order.⁶⁹

VI

My hypotheses about Stravinsky and Eurasianism have often been disputed, and of course they are fair game for dispute, but their most convincing confirmation—one that I did not have the wit to cite when laying out my arguments in favor of Stravinsky's "symphonic" thinking in *Defining Russia Musically*⁷⁰—comes in the *Poetics of Music* the moment Souvtchinsky takes over directly as the author of the fifth lesson and launches his diatribe at Soviet Russia.

"Music is what I am going to speak about," he writes for Stravinsky to read, "but before I do that, it is absolutely essential in order that this particular problem may be the better delimited and placed, that I say a few words to you about the Russian Revolution" (129). What follows is pure Eurasianist boilerplate, which I will quote from the English text published by Harvard, but which I will interpret with the help of the Russian original that was finally published by Savenko in 1999. "What strikes us above all," Souvtchinsky asserts:

is that the Revolution came at a time when Russia seemed to have freed itself once and for all (at least in principle) both from the psychosis of materialism and from the revolutionary ideas that had enslaved it since the middle of the nineteenth century up until the first revolution of 1905. In truth, the nihilism, the revolutionary cult of the common people, the rudimentary materialism, as well as the shady plots hatched in the underworld of terrorism, had little by little disappeared. By that time Russia had already become enriched with new philosophic ideas. She had undertaken researches into her own historical and religious life, researches attributable chiefly to [Konstantin Nikolayevich] Leont'yev, [Vladimir Sergeyevich] Solovyov, [Vasiliy Vasil'yevich] Rozanov, [Nikolai Alexandrovich] Berdyayev, [Nikolai Fyodorovich] Fyodorov, and [Victor Ivanovich] Nesmelov. On the other hand, the literary "Symbolism" that we connect with the names of [Alexander] Blok, Zinaída Gippius, and [Andrey] Belïy, as well as the artistic movement "Mir Iskoustva" [*Mir Iskusstva*, "The World of Art"] of Diaghilev, had contributed much to this enrichment. Not to mention what was then called "legalistic Marxism," which had supplanted the revolutionary Marxism of Lenin and the exiles grouped around him. (129, 131)

I'll begin my gloss by pointing out a couple of translation mistakes in the last sentence. What Knodel and Dahl, Harvard's translators, rendered as "legalistic Marxism" (and what Roland-Manuel had more correctly, because literally, translated as "le marxisme légal") was in Souvtchinsky's original *legal'nïy marksizm*. The Russian word *legal'nïy* is not a full cognate of the English "legal." It does not mean "pertaining to law" but only "permitted by law." A better English translation would be "lawful." "Lawful Marxism" was a Marxism sufficiently tame and nonrevolutionary—one writer calls it "decaffeinated" Marxism[71]—that it could be promulgated in print even under conditions of tsarist censorship. It was an academic form of Marxism in which Marx's theories were used only for the purpose of historical explanation (mainly of the evolution of capitalism) rather than as a program of political action. It had nothing in common with the revolutionary Marxism of the Bolsheviks, and when confronted with Bolshevism, all the legal Marxists—including such figures as Souvtchinsky's personal friends Semyon Lyúdvigovich Frank and Pyotr Berngardovich Struve (and note how their patronymics indict them in Eurasianist eyes!) as well as Nikolai Berdyayev (who is named by Souvtchinsky in another context and to whom we will return)—fled from Marxism, taking refuge either in constitutional liberalism (i.e., the Kadet Party) or in utopian religious thought. Struve became a patron of the Eurasianists.

To suppose that legal Marxism ever supplanted the revolutionary Marxism of Lenin is nonsensical, but Souvtchinsky's purpose in saying so can be clarified by adjusting the translation of the phrase by which he characterizes Lenin's faction. Where Knodel and Dahl have "the exiles grouped around him," and Roland-Manuel, again more literally, had "des émigrés groupés autour de lui," Souvtchinsky had written *ego èmigrantsk[aya] grupp[a]*, "his émigré group" or "émigré

faction"—i.e., the émigré group *to which he belonged*. The idea was to cast Lenin as the bearer of a foreign ideology, infecting Russia from without (and succeeding only by dint of a treasonous deal with Russia's wartime enemies), in contrast with the native Russian tradition exemplified by the long list of names, many unfamiliar by now to nonspecialists in Russian history or philosophy, and surely mysterious to the Harvard audience of 1940.

It is a litany of Eurasianist saints, either forerunners of the movement or martyrs to the cause. All of them were theorists of what might be called civic spirituality. All were united in the conviction that the West, exemplified above all by German philosophical and social thought, was "decrepit and degenerate," as Stravinsky put it to Rolland. Konstantin Leont'yev (1831–91) was among the first to pit the still healthy, still tough traditions of Byzantium against the soft and flabby putrefaction wrought by the liberal Latinate secularism of the West. After a career in diplomacy and journalism, Leont'yev took holy orders and ended his days as a monk at the Troitse-Sergiyevsky Monastery at Zagorsk near Moscow. Vladimir Solovyov (1853–1900) was a major antipositivist philosopher and mystical poet, still much studied in the West, and now again in Russia too, whose descriptions of holy emanations in daily life had a great influence on Russian Symbolism, another trend that Souvtchinsky names as representative of the real Russia displaced by Communist disorder. Solovyov's social thinking was an important influence on Eurasianist visions of Sophia—the sage eternal harmony embodied in the feminine principle of reconciliation and brotherly (or sisterly) love. Vasiliy Rozanov (1856–1919) was a writer Stravinsky might have named had he written the fifth lesson himself. Nicolas Nabokov reported seeing one of Rozanov's books of aphorisms—*Opavshiye list'ya* (Fallen Leaves, 1915)—on the shelf in Stravinsky's Hollywood guestroom in 1947.[72] Rozanov's magnum opus was a book, *Apokalipsis nashego vremeni* (The Apocalypse of Our Time), that cast the Russian Revolution as a cosmic tragedy. Nikolai Fyodorov (1829–1903), a nearly exact contemporary of Lev Tolstoy, was a religious ascetic who believed in the total rejection of modernity in favor of a utopian communal society. His *Filosofiya obshchego dela* (Philosophy of the Common Task) is of a piece with Tolstoy's late Christian pacifism. Victor Ivanovich Nesmelov (1863–1920), a follower of Solovyov, was an academic theologian and a Gnostic philosopher.

I have saved for last the eminent religious philosopher Nikolai Berdyayev (1874–1948), for he was the only figure in Souvtchinsky's list who was still alive in 1939, when the fifth lesson was composed—in fact living, along with Souvtchinsky and Stravinsky, in Paris, where he had founded an academy. A contributor to *Vyorstï*, the most richly appointed of the Eurasianist journals, he was the link between the older members of Souvtchinsky's sainted list and the current political and cultural scene. Most significantly for Souvtchinsky's purposes, Berdyaev, along with Semyon Frank and Lev Karsavin among names that have already

figured in this discussion, was a passenger on the celebrated "philosophy steamer" *(filosofskiy parokhod)*, the boat that carried 160 intellectuals who had been declared *persona non grata* by Lenin's government into exile in 1922.[73] The meaning of the paragraph I have been glossing, then, is that there had been an exchange of Russias. The true Russia, the bearers of authentic Russian culture, who included not only the philosophers and writers in Souvtchinsky's list but also the *Mir iskusstva* circle around Diaghilev, which had furnished the brainpower and some of the manpower behind the Ballets Russes, as well as the Symbolist poets who carried Russian religious thought into the realm of art, had all been lost to Russia through death and exile, even as the impudent band of émigrés under Lenin had invaded and taken possession of the land in the name of a foreign and godless ideology. This was an idea that, for fairly obvious reasons, had great currency among Russian exiles.[74]

Souvtchinsky names the true villains of Russian intellectual history in the next paragraph, where he indicts "the dark period of the years 1860 to 1880, the period of the Chernyshevskys, the Dobrolyubovs, the Pissarevs [and let us savor the extra "s" the translators have given Pisarev, as if to identify his contribution to Russian civilization], when a perfidious wave that defiled the true foundations of culture and the state welled up from the milieu of false intellectuals, morally disinherited and socially uprooted, and from the centers of atheistic seminarists and flunked-out students" (131). Souvtchinsky's juicy invective—*deklassifirovann[aya] intelligentsi[ya], snorovivshi[ye]sya seminarist[i] i nedouchivshi[ye]sya student[i]*—deserves a better translation. How about "intellectual derelicts, wise-ass seminarians, and dropouts"? This wretched refuse was all that remained after the postrevoutionary brain drain, the crooked timber from which Soviet civilization had been hewn.

Souvtchinsky affects wonder that the revolutionary catastrophe could have overtaken Russia at a cultural high point, the so-called Silver Age when, thanks to its religious renaissance, Russia was on the point of realizing the old dream of the Third Rome. It is "truly inexplicable" *(poístine neob"yasnim)*, Souvtchinsky exclaims, topping it off with a choice aphorism from Rozanov's *Apokalipsis:* "Russia faded away in two days, three at most" *(Rus' slinyala v dva dnya—samoye bol'sheye, v tri)*.[75]

But a seasoned Eurasianist can find an explanation for all this. Far from the stereotype of Russian irrationality, Russia was seized with "a peculiar dogged and often simpleminded rationalism," which comes to Russia from abroad, but which "shades into a specifically Russian pointless carping and empty preaching" *(bespredmetn[aya] kritichesk[aya] refleksiy[a] i pustoye rezonyorstvo)*.[76] Thus the casuistry, the utilitarianism, the polemics that ask, on the one hand, *chto takoye iskusstvo* (What Is Art?, Tolstoy's titular question), and on the other, what Souvtchinsky calls "the famous sixties debate" *(znamenitoye rassuzhdeniye shestidesyatnikov)*, namely "What's more important—Shakespeare or a pair of boots?"[77] This celebrated question, which served as a slogan for the radical utilitarians of the

1860s. was the brainchild of Pisarev, in his *Razrusheniye iskusstva* (The Abolition of Aesthetics) of 1865.[78] Like many resentful aesthetes, Souvtchinsky blamed the radical utilitarians (the Soviets called them the "radical democrats") for the perversions of the Soviet era. The inevitable outcome of such thinking, in Souvtchinsky's view—and surely one outcome, in the view of any observer—was socialist realism, an eminently utilitarian dogma, which Souvtchinsky derives from a simplistic paraphrase of Marx to the effect that "art is a superstructure erected on a base of productive relations." What Marx actually wrote, in *Capital,* was that "the reciprocity of productive relations constitutes the economic structure of society, the real basis, on which a legal and political superstructure is erected and to which the effective forms of social consciousness correspond."[79] However tortured the explanation, however, the diagnosis is correct: few would disagree that (in Souvtchinsky's words) by the late 1930s "art in Russia [was] nothing more than instrument of political propaganda at the service of the Communist Party and the government" (135).

So we arrive at the status quo as of 1939: the true Russia languishing abroad and the false Russia triumphant at home, the latter embodied in the Soviet state and the former scattered in a diaspora whose most eminent representative, Stravinsky, now stood before an audience at Harvard. Five out of six lessons in the *Poetics of Music* having been devoted to an exposition of true Russian thinking, the remaining one, namely the fifth, could be devoted to an exposé of the false Russia, and that is why Souvtchinsky's direct contribution to the book consisted of what was surely the most detailed critical survey by an outsider of Soviet musical production as of its date.

Souvtchinsky had done his homework. The lesson made specific references to names and dates, including proletarianist operas by the likes of Vladimir Mikhailovich Deshevov (1889–1955) and Arseniy Pavlovich Gladkovsky (1894–1945), which were never performed abroad, and which neither he nor Stravinsky could have known at first hand. Thanks to Souvtchinsky's diligence, Stravinsky was able to quote from *Pravda* and *Izvestiya,* and also from the official publications of the Union of Soviet Composers. Not all the references were entirely correct, and Souvtchinsky was not above settling scores. Deriding the Soviet fetishizing of Beethoven as the voice of revolution with a garland of quotations, he arrives at an unnamed critic, "even more prominent and famous" than the ones previously quoted, who "affirms in one of his articles that 'Beethoven fought for the civic significance *[grazhdanstvennost']* of music,' and that in his works there was 'no room for aristocratic compositional preoccupations' *[dlya aristokraticheskikh kompozitorskikh oshchushcheniy].*" This came out even more damagingly, in terms of the likely reaction from the Harvard audience, in Roland-Manuel's version and that of the English translators. Possibly because Soulima Stravinsky, in making the rough translation into French, mistook the word *grazhdanstvennost'* for

grazhdanstvo, Roland-Manuel had the critic saying that "Beethoven luttait pour défendre les droits civiques de la musique," or, in English, "Beethoven battled to defend the civil rights of music as art."[80]

This no doubt got a great laugh at the unnamed critic's expense. And who was he? None other than Boris Asaf'yev, Souvtchinsky's old comrade on the staff of *Muzïkal'nïy sovremennik* and *Melos,* and the author of what was then the one Soviet book about Stravinsky. (It is called, simply, *Kniga o Stravinskom,* or "A Book about Stravinsky.")[81] Asaf'yev had become the outstanding Soviet musicologist, and was by then—no doubt out of a typical combination of careerism and trepidation—a dependable apologist for the regime's musical policies. Souvtchinsky deeply resented him, and so could not resist the impulse to quote him, especially as the article from which he was quoting, called "Beethoven's Legacy," had been published in *Izvestiya,* the official government newspaper of the USSR. Stravinsky, too, resented Asaf'yev, though for a different reason, caught well by Robert Craft, who wrote, in a perceptive preface to the first English edition of *A Book about Stravinsky,* that Stravinsky "would tolerate no interpreter he could not control [and] surely ... was annoyed that an infidel Marxist, living so far from the center and with only the rarest opportunities to hear the music, had penetrated it so profoundly—and it is inconceivable that Stravinsky did not realize that Asaf'yev understood him as no one else did, least of all the authors of the French and Italian monographs published at about the same time and written quite literally under the subject's nose."[82] I enthusiastically endorse Craft's judgment, and recommend Asaf'yev's book as a corrective to the fifth lesson of the *Poétique.*

Asaf'yev came in for another bout of anonymous ridicule in the discussion that lay at the heart of the fifth lesson, on the mandated use of folklore, especially the folklore of the non-Russian peoples of the USSR, as the basis for professional composition. This was the subject of the single sentence in the original draft outline for the *Poetics* that directly corresponded to the fifth lesson as Souvtchinsky eventually wrote it, and we may surmise that Stravinsky had insisted on its prominence, folklore being an especially sore point for Stravinsky as well as Souvtchinsky, because, as we have seen, Stravinsky had a past he needed to live down. The raising of folklore to a creative mandate in the red Russia that Stravinsky abhorred—epitomized by that Stalinist slogan "an art national in form and socialist in content"—was the most powerful incentive he could have had for renouncing and condemning it and attempting to deny his former reliance on it.

Accordingly, the discussion of folk operas, the quintessential Soviet genre, is introduced by a quotation from another article by Asaf'yev that had been published in *Izvestiya,* on the music of Kazakhstan. I quote from the original text as furnished by Savenko: "It is time to forget the feudal and highfalutin *[visokomernïy]* bourgeois division of music into folk and art categories, as if artistic quality were inherent only in individual invention and the work of particular composers."[83] In

Souvtchinsky's text Asaf'yev's declaration precedes a list of outlandish exotic titles, unattached to composers' names as Stravinsky read them aloud, again most likely angling for, and eliciting, laughs: *Shakhsenem, Gyul'sara, Daísi, Abesalom and Eteri, Aichurek, Altïn Kïz, Adzhal Orduna, Taras Bulba*, etc. "All of these," he sneered, "are operas of the conventional sort, which, of course, solve no creative problems but are examples of a cartoonish *[lyubochnïy]* pseudofolkloric genre." In the margin of his typescript Souvtchinsky, possibly at Stravinsky's urging, wrote the word *pompier* as a cue to Roland-Manuel.[84] The word—French for fireman—was code, standing for *l'art pompier,* firemen's art, a term of abuse for the official art of the academy at the time of the *salons des refusés* (nineteenth-century firemen's helmets resembling the helmets worn by soldiers in neoclassical paintings). It is a word that Stravinsky had picked up from the French journalism of his Ballets Russes days and used to the point of obsession in his correspondence. And it is a word that crops up time and again in the *Poétique,* whenever the subject turns to matters academic, conventional, or philistine. Roland-Manuel picked up the cue and translated Souvtchinsky's "cartoonish and pseudofolkloric genre" as "genre pompier et affectant le genre pseudo-populaire," and Knodel and Dahl followed suit with "the category of 'official' art [affecting] a pseudo-popular idiom."

But at this point Souvtchinsky and Stravinsky have crossed the line between satire and lies. Three of the operas in their list were not Soviet operas at all, let alone examples of Stalinist official art. Mykola Vitaliyevich Lysenko's *Taras Bulba,* after Gogol's novella of the same name, was composed between 1880 and 1891 by a Ukrainian subject of the Russian tsar, though it was not performed in an opera house until 1924 because the composer had not orchestrated it. *Abesalom and Eteri* was composed by Zakharia Paliashvili in the briefly independent state of Georgia in 1918, and *Daísi* (Twilight), by the same composer, was in progress when Georgia was annexed to the Soviet Union in 1922; it was performed in Tbilisi in 1923, before there was any such thing as socialist realism or a Soviet arts policy. Slipping the names of these operas into the list of Soviet cartoons (for all that *Daísi* was known to be a favorite of Stalin, the composer's fellow Georgian) is an example, I am bound to say, of pangermanoromanic bigotry.

The lies continue. Recounting the unhappy story of Shostakovich's opera *The Lady Macbeth of the Mtsensk District* and his ballet *The Limpid Stream,* suppressed after the appearance of two strident, unsigned editorials in *Pravda* within six days, Souvtchinsky offered a heartless commentary: "Shostakovich's music and the subjects of his works were roughly and cruelly criticized (and this time, perhaps, not without reason). They were declared 'bogus' *[fal'shyu]* 'formalistic and anti-Soviet stunts' *[formalisticheskim i antisovetskim tryukachestvom],* and 'decadent formalism' *[upadochnïm formalizmom]*."[85]

The word *fal'sh* occurs in the very title of the editorial condemning the ballet, but the other phrases Souvtchinsky purports to quote do not appear in the *Pravda*

editorials at all. What the anonymous author (identified by recent research as David Zaslavsky [1880–1965], a *Pravda* staff writer) did write is bad enough.[86] Shostakovich was accused of "left deviation," his music was described as "petty-bourgeois formalistic spasms" *(melkoburzhuaznïye formalisticheskiye potugi)*, and, in a phrase that must have scared the poor man half to death, the official organ of Soviet power declared that "this trifling with serious matters could end very badly." But of decadence he was not accused, and especially not of committing anti-Soviet stunts; for, as the post-Soviet editor of Souvtchinsky's original text for publication put it, with proper reserve but evident indignation, "after such a public accusation only arrest could follow, which was apparently not Stalin's intention."[87] Roland-Manuel evidently knew that much, because he omitted the phrase about anti-Soviet stunts in his translation, as did the English translation based on the published French text.

Shostakovich's Fifth Symphony, the work with which he managed to rehabilitate himself in the eyes of the Soviet authorities, is the subject of an even bigger lie, and a famous one. As his final exhibit exposing what Roland-Manuel translated as *l'état d'esprit russe actuel* ("the present Russian mentality" in the English version, 152–53), Souvtchinsky postulated two levels in the Soviet relationship to music, one low, the other high. I will let his original text speak for itself without adducing the published French or English translations:[88] "For the low style, collective farmers may serve as a model, merrily and cleverly dancing to the strains of an amateur *[samodeyatel'nïy]* orchestra, surrounded by tractors and automachines. Describing the high style is a more complicated task. Here music is called upon to assist in the 'formation of a human personality, steeped in the milieu of its great epoch'; music imparts 'a consummate formulation of psychological tribulations,' it 'amasses energy' (A. Tolstoy)."[89]

And indeed, the phrases set off by quotation marks are quotations from the review of the Fifth Symphony by the famous Soviet novelist Alexei Nikolayevich Tolstoy, alias "The Red Count," which had appeared in *Izvestiya* on 28 December 1937. But then the quotations continue: "Here we have the 'Symphony of Socialism, beginning with the "largo" of the masses, working underground,' an *accelerando* corresponding to the subway; an 'allegro' symbolizing 'the gigantic apparatus of a factory, prevailing over nature'; and an 'adagio' representing 'a complex of Soviet culture, science and art'; and a scherzo, reflecting the athletic life of the happy inhabitants of the Soviet Union—and at the end, a finale, reflecting the 'gratitude and enthusiasm of the masses.'"[90]

"What I have just read to you is not a parody I myself have thought up," Stravinsky said to his Harvard audience. And this was true, but only because the parody was Souvtchinsky's, not Stravinsky's. The paragraph about the "Symphony of Socialism" does not actually mention the Fifth Symphony or name Tolstoy, perhaps to give Stravinsky/Souvtchinsky an alibi in case someone checked, but following directly on the quotation from Tolstoy it certainly seems to continue the reference to him, and to the Fifth, and Roland-Manuel took the bait. His

version did explicitly connect the paragraph mocking the "symphony of socialism" with the description of the Shostakovich Fifth, and of course what Stravinsky read aloud at Harvard was Roland-Manuel's version, not Souvtchinsky's. And so a legend was born, testifying, as Souvtchinsky and Stravinsky evidently intended, to the "bad taste, mental infirmity, and complete disorientation in the recognition of the fundamental values of life" that now reigned in Stalin's Russia (155).

As fabrications go, this one was very crude, with the movements misnamed and in the wrong order. One might note what looks like an implicit admission that the second batch of quotes did not come from Alexei Tolstoy, when in Roland-Manuel's version Stravinsky attributes the quoted words to "a musicologist of repute," which is not a description of Tolstoy; but no, Souvtchinsky's Russian text refers them only to "a prominent author," which does fit the Red Count. On the strength of Stravinsky's authority, Souvtchinsky's jape has been believed for the last seventy years and more, even by such reputable experts as James Billington, our Librarian of Congress, who in his magisterial survey of Russian culture called *The Icon and the Axe*—now half a century old but still widely assigned—accepted Souvtchinsky's fabrication at face value as "Alexis Tolstoy's paean to Shostakovich's Fifth Symphony as the 'Symphony of Socialism'" and advanced it as a paradigm to illustrate "the role of music in the Stalin era."[91]

Why has it been believed? Because we have wanted to believe it. But rather than launch into a supplementary lecture on lingering Cold War prejudices, I will note a final irony. After surveying the irate account of Soviet music that is the fifth lesson of Stravinsky's *Poétique,* which however exaggerated or at times mendacious contains many important points to ponder—prominently including the fate of the arts in a milieu that countenances suppression—it may come as a surprise to learn that *Poetics of Music* has twice been published without the fifth lesson. Or maybe only half a surprise, since one of these truncated redactions was a Soviet publication of excerpts, in which the suppression of an anti-Soviet manifesto was inevitable.

But that was the second of the two suppressions. The first took place in France, when a reprint of the French text, first published by Harvard University Press in 1942, was undertaken by Éditions Janin so as to make the work available to readers who, as a result of the German occupation, had not been able to obtain the original book. In February 1945, after the liberation of France but before the German surrender, Roland Bourdariat, the acquisitions editor at Janin, wrote to Stravinsky:

> I have just had a long conversation with Roland-Manuel and Souvtchinsky. It seems to us perhaps inopportune to publish the fifth lesson at this time, since the military censor will very likely prohibit it. I think that it might be all right to let the work appear devoid of a chapter without which the whole will not suffer. . . . Of course if you demand that the text be given complete, we will present it in that form to the censor; you are after all the only judge. I permit myself nevertheless to insist on the fact that our opinion is unanimous.[92]

In May, not having heard from Stravinsky, the publisher wrote again with the same request. The war was now over in Europe, but the wartime "Big Three" alliance still held, and it was now the Big Four, since a separate treaty allying liberated France with Stalinist Russia had been signed in December 1944. The publisher now further requested that Stravinsky authorize a rewrite by Roland-Manuel that would eliminate references to the occasion at which the lectures were given, "so that the book would have a more general and universal appeal." Stravinsky cabled his refusal to the latter suggestion, but accepted the suppression of the fifth lecture. Thus the second edition of the *Poétique musicale* appeared in censored form, a fact to which none of the reviewers—and they included Roland-Manuel *lui-même!*—saw fit to call attention.

Despite the publisher's assurances to Stravinsky, and despite his acceptance of their terms, I believe it is obvious that the book does suffer from the elimination of the fifth lesson—that is, if one is reading it with an eye toward understanding it not dogmatically but historically. Souvtchinsky himself underscored the reasons for that in the sentence that ended the lesson before Stravinsky asked that he write an eleven-paragraph coda, for which no Russian text survives, but only the translation by Roland-Manuel.[93] The original ending, as drafted in Russian, read as follows: "Music is neither a 'dancing kolkhoz' nor a 'symphony of socialism,' and what it actually is you have already heard and learned from me in the preceding lectures."[94]

That may be true, but I would add the proviso that the other lectures, with their obsessive insistence on order, voluntary discipline, dogma, and rule, present the Eurasian obverse to the negative example communicated by the fifth lesson. A thoroughgoing Eurasianist interpretation of the whole *Poétique,* while beyond this chapter's remit, has I think been sufficiently adumbrated, and the point is worth insisting upon; for just as Stravinsky saw it as his necessary task to repudiate nineteenth-century thinking in order to clear space for a truly twentieth-century musical discourse, so it behooves us now to get beyond the limits of musical discourse that were set in the twentieth century, a century full of violence and reaction to violence that left an enormous imprint on the art of Europe and its cultural colonies. Wagner, the very Wagner he had worshiped in his youth, was the stone in the path that, in the *Poétique,* Stravinsky had to kick away. Stravinsky is the stone in our path. As one who has devoted years of his life to making Stravinsky's legacy known and intelligible, I have exercised today what I regard as my right to kick.

NOTES

1. "From the Diaries of Robert Craft, 1948–1968," in Igor Stravinsky and Robert Craft, *Retrospectives and Conclusions* (New York: Alfred A. Knopf, 1969), 195.

2. Igor Stravinsky and Robert Craft, *Themes and Episodes* (New York: Alfred A. Knopf, 1966), 42.

3. On Soulima Stravinsky's rumored collaborationist activities, which left him under a cloud, see Robert Craft, *Small Craft Advisories: Critical Articles 1984-1988* (New York: Thames & Hudson, 1989), 154-55; and idem, *Stravinsky: Chronicle of a Friendship*, rev. ed. (Nashville, TN: Vanderbilt University Press, 1994), 153.

4. www.fas.harvard.edu/~english/events/nortonlectureshist.html (accessed 3 March 2009).

5. Alexis Kall, "Stravinsky in the Chair of Poetry," *Musical Quarterly* 26 (1940): 283.

6. For the rebuttal, see Linda Dowling, *Charles Eliot Norton: The Art of Reform in Nineteenth-Century America* (Concord: University of New Hampshire Press, 2007). The famous quote comes from Stravinsky's autiobiography, *Chroniques die ma vie* (1935-36), translated by Norman Collins as *Stravinsky: An Autobiography* (New York: Simon & Schuster, 1936), 83.

7. Frederick Jacobi, Jr., "Harvard Soirée," *Modern Music* 16, no. 1 (Oct.-Nov. 1939): 47-48.

8. Stravinsky and Craft, *Themes and Episodes*, 41.

9. Stephen Walsh, *Stravinsky: The Second Exile—France and America, 1934-1971* (New York: Alfred A. Knopf, 2006), 92.

10. Myriam Soumagnac, "Préface," in Igor Strawinsky, *Poétique musicale sous forme de six leçons* (Paris: Flammarion, 2000), 20.

11. Roland-Manuel, "A propos des mémoires de Strawinsky," *Courrier royal*, 4 January 1936. The Latin phrase is from the Vulgate translation of the Gospel according to St. John, 6:60: *Multi ergo audientes ex discipulis ejus, dixerunt: Durus est hic sermo, et quis potest eum audire?* (King James version: "Many therefore of his disciples, when they heard this, said, This is an hard saying, who can hear it?")

12. See L. Andriessen and E. Schönberger, *The Apollonian Clockwork: On Stravinsky*, trans. Jeff Hamburg (Oxford: Oxford University Press, 1989), 86-96.

13. Quoted by Robert Craft in Stravinsky, *Selected Correspondence*, vol. 2 (New York: Alfred A. Knopf, 1984), 511.

14. Igor Stravinsky, "Some Ideas about my *Octuor*," reprinted in Eric Walter White, *Stravinsky: The Composer and His Works* (Berkeley: University of California Press, 1966), 528.

15. Stravinsky and Craft, *Themes and Episodes*, 41.

16. Igor Stravinsky, *Poetics of Music in the Form of Six Lessons*, bilingual ed., trans. Arthur Knodel and Ingolf Dahl (Cambridge, MA: Harvard University Press, 1970), 5.

17. Ibid., 7.

18. Ibid., 163.

19. See Svetlana Savenko, *Mir Stravinskogo* (Moscow: Kompozitor, 2001), 275.

20. Igor' Stravinskiy, *Khronika, Poètika*, trans. L. V. Yakovleva-Shaporina, E. A. Ashpis, and E. D. Krivitskaya, ed. Svetlana Il'yinichna Savenko (Moscow: Rosspèn, 2004), 214.

21. Roland-Manuel, "A propos des mémoires de Strawinsky." Pushkin, Glinka, and Chaikovsky were the troika to whom Stravinsky dedicated *Mavra*, the work in which he sought to reorient his music away from the "nationalist" school (and, arguably, the first of his "neoclassical" compositions; see R. Taruskin, *Stravinsky and the Russian Traditions: A Biography of the Works through "Mavra"* [Berkeley: University of California Press, 1996], chap. 19).

22. Stravinsky, *Poetics of Music*, 121.

23. Telegram dated 20 March (7 March O.S.) 1917. Text from L. S. Dyachkova, ed., *I. F. Stravinskiy: Stat'i i materialï* (Moscow: Sovetskiy kompozitor, 1973), 489; date corrected according to Victor Varunts, ed., I. F. Stravinskiy, *Perepiska s russkimi korrespondentami*, vol. 2 (Moscow: Kompozitor, 2000), 398.

24. H. Colin Slim, "Lessons with Stravinsky: The Notebook of Earnest Andersson (1878-1943)," *Journal of the American Musicological Society* 62 (2009): 323-412.

25. Walsh, *Stravinsky: Second Exile*, 152.

26. Roland-Manuel to Souvtchinsky, 29 June 1939, at the Bibliothèque nationale, Paris, quoted in Soumagnac, "Préface," 26.

27. Correspondence establishing these facts is quoted in Svetlana Savenko, "P. P. Suvchinsky i 'Muzïkal'naya poètika' I. F. Stravinskogo," in *Pyotr Suvchinskiy i ego vremya*, ed. Alla Bretanitskaya (Moscow: Kompozitor, 1999), 274–75; also see Stravinsky, *Khronika, Poètika*, 253–54. Thus it is not quite correct to state, as Walsh does, that "the final French texts were entirely written by Roland-Manuel" (*Stravinsky: Second Exile*, 95); Souvtchinsky's Russian text was translated, in the first place, by Soulima Stravinsky (ibid.) and merely polished, if that, by Roland-Manuel.

28. Bretanitskaya (ed.), *Pyotr Suvchinskiy i ego vremya*, 276–82; the Russian typescript is also the basis for the relevant portion of the text in Stravinsky, *Khronika, Poètika*.

29. Valérie Dufour, "La *Poétique musicale* de Stravinsky: Un manuscript inédit de Souvtchinsky," *Revue de musicologie* 89 (2003): 373–392; also idem, "Strawinsky vers Souvtchinsky: Thème et variations sur la *Poétique musicale*," *Mitteilungen der Paul Sacher Stiftung* 17 (March 2004): 17–23.

30. Valérie Dufour, *Stravinski et ses exégètes* (Brussels: Éditions de l'Université de Burxelles, 2006). An abridged version of the chapter on the *Poétique* has been published in English: Valerie Dufour, "The *Poétique musicale*: A Counterpoint in Three Voices," trans. Bridget Behrmann and Tamara Levitz, in Tamara Levitz, ed., *Stravinsky and His World* (Princeton, NJ: Princeton University Press, 2013), 225–54.

31. Robert Craft, "Roland-Manuel and the 'Poetics of Music,'" *Perspectives of New Music* 21 (1982–83): 487–505; idem, "Roland-Manuel and *La Poétique musicale*," in *Stravinsky: Selected Correspondence*, ed. R. Craft, vol. 2 (New York: Alfred A. Knopf, 1984), 503–17; Svetlana Savenko, "Zametki Stravinskogo dlya 'Muzïkal'noy poètiki,'" in Stravinsky, *Khronika, Poètika*, 255–62; Dufour, *Stravinski et ses exégètes*, 222–27.

32. Igor Strawinsky, *Poétique musicale, sous forme de six leçons*, éd. établie, présentée et annotée par Myriam Soumagnac (Paris: Harmonique Flammarion, 2000).

33. Cf. Dufour, "La *Poétique musicale* de Stravinsky," 375.

34. Sidebar in Craig Wright and Bryan Simms, *Music in Western Civilization*, media update (Boston: Schirmer Cengage Learning, 2010), 635. For the incident with Valéry, see text associated with note 13 above.

35. Letter of 25 May 1939, quoted in Savenko, "Suvchinskiy i 'Muzïkal'naya poètika' Stravinskogo," 275: "How glad I am that my text has pleased you. . . . I am glad that at last things will be said that no one has dared say openly. And what joy, and what a coup, that all this will be said by you, specifically by you."

36. Letter of 21 November 1922, in Vera Stravinsky and Robert Craft, *Stravinsky in Pictures and Documents* (New York: Simon & Schuster, 1978), 658.

37. See Louis D. Rubin Jr., ed., *I'll Take My Stand: The South and the Agrarian Tradition* (Baton Rouge: Louisiana State University Press, 1978).

38. Korney Chukovsky, *Futuristy* (1921), quoted in Izraíl Nestyev, *Prokofiev*, trans. Florence Jonas (Palo Alto, CA: Stanford University Press, 1960), 91.

39. For more on Eurasianism, see "Turania Revisited, with Lourié My Guide" in the present collection.

40. See, inter alia, Orlando Figes, *Natasha's Dance: A Cultural History of Russia* (New York: Metropolitan Books, 2002), 681.

41. Catherine Andreyev and Ivan Savicky, *Russia Abroad: Prague and the Russian Diaspora, 1918–1938* (New Haven, CT: Yale University Press, 2004), 139.

42. See Taruskin, *Stravinsky and the Russian Traditions*, 1133.

43. "Entretiens d'Igor Stravinsky avec Robert Craft," in *Avec Stravinsky*, ed. Pierre Souvtchinsky (Monaco: Éditions du Rocher, 1958), 11–70.

44. For examples of Mussolini worship in the Eurasianist press, see R. Taruskin, *Defining Russia Musically: Historical and Hermeneutical Essays* (Princeton, NJ: Princeton University Press, 1997), 448–51.

45. Yakov Sadovsky, "Iz devnika 'Yevraziysta,'" *Yevraziyskiy vremennik* 4 (1925): 400.

46. Henrietta Malkiel, "Modernists Have Ruined Modern Music, Says Stravinsky," *Musical America* 41 (10 January 1925): 9.

47. Stravinsky, *Poetics of Music*, 107.

48. Alberto Gasco, *Da Cimarosa a Stravinsky* (Rome: De Santis, 1939), 452; quoted in Harvey Sachs, *Music in Fascist Italy* (New York: Norton, 1988), 168.

49. Arthur Lourié, *Sergei Koussevitzky and His Epoch* (New York: Alfred A. Knopf, 1931), 196.

50. *Stravinsky: An Autobiography*, 270.

51. Sachs, *Music in Fascist Italy*, 167.

52. Stravinsky, *Poetics of Music*, 11, 13.

53. http://goldbook.iupac.org/R05163.html (accessed 11 March 2009).

54. *Le petit Larousse: Dictionnaire encylopédique pour tous* (Paris: Librairie Larousse, 1962), s.v. *rapport* ("Pl. Relations que les hommes ont entre eux"), *contact* ("Fig. Fréquentation, relation"). The same dictionary defines *réactif* as "substance employée en chimie à reconnaître la nature des corps, par suite des reactions qu'elle produit."

55. Почему я вдруг заговорил именно о русск. муз. Не потому что я русский или что я ее особ. ценю по сравнению с другими музыками. Так же не думайте, что я враждебен к проявлению наций. Начала разумеется поскольку проявление бессознательно. (Prerevolutionary orthography modernized.)

56. "Je ne pretends pas d'être citoyen du monde comme aimaient le dire les revolutionnaires russes du 19ème siècle. Le folklore et la culture musicale. Le plain chant, la musique sacré et profane. Les italienismes, les germanismes, et les orientalismes de la musique russe du 19 siècle. La comlexité [sic] de la culture russe. Les 2 Russies (la revolution et le conservatisme russe—les deux desordres). Glinka, Tchaikovsky" (etc.). Cf. Dufour, *Stravinsky et ses exégètes*, 227.

57. Letter of Roland-Manuel to Stravinsky of 29 June 1939, quoted in Soumagnac, "Préface," 38–39.

58. N. V. Gogol, "Author's Confession," quoted in Bretanitskaya (ed.), *Suvchinskiy i yego vremya*, 283n2. Souvtchinsky's version, as mediated by Roland-Manuel, Arthur Knodel, and Ingolf Dahl: "But did not Gogol say that from a distant land (in his case, Italy, his adopted country) 'it was easier for him to embrace Russia in all its vastness'"? (*Poetics of Music*, 129).

59. *Stravinsky: An Autobiography*, 83. The contentious claim about expression was a by-product of Stravinsky's analysis of the delight to which he refers, a delight produced (he said) by the purely esthetic contemplation of verbal patterns and play, or what in the next extract from the *Poétique* he calls "un plaisir musical," as distinct from emotional expression.

60. I. V. Stalin, *Marksizm i natsional'no-kolonial'niy vopros* (1934); see Marina Frolova-Walker, "'National in Form, Socialist in Content': Musical Nation-Building in the Soviet Republics," *Journal of the American Musicological Society* 51 (1998): 131–71. For the history of the phrase, see "The Ghetto and the Imperium" in the present collection.

61. Stravinsky, *Poetics of Music*, 121, 123. Subsequent references to this work are cited directly in the text.

62. See R. Taruskin, "M. I. Glinka and the State," in *Defining Russia Musically*, 25–47.

63. *Chernosotniki* were members of the Black Hundred (*chernaya sotnya*), a militant nationalistic and antisemitic organization of the very late Tsarist period.

64. For Rimsky-Korsakov's comments on Scriabin's impeccable technique ("not a trifler like Reger or Strauss," etc.), see Vasiliy Vasil'yevich Yastrebtsev, *N. A. Rimskii-Korsakov: Vospominaniya*, ed. A. V. Ossovsky, vol. 2 (Leningrad: Muzgiz, 1960), 309, 365, 392.

65. Romain Rolland, *Journal des années de la guerre, 1914–1918* (Paris: Éditions Albin Michel, 1952), 59.

66. This is something that Henry Prunières, editor of *La revue musicale*, failed to understand when he published the final "chorale" section from this work in piano score in the "Tombeau de Claude Debussy," a supplement to the second issue of the journal (November 1920), containing compositions commissioned from a dozen composers. Evidently considering Stravinsky's unusual usage the result of the composer's nonnative grasp of French, he "corrected" the title of the work to the more conventional form *Symphonies **pour** instruments à vent*, "Symphonies *for* wind instruments."

67. Nicholas Riasanovsky, "The Emergence of Eurasianism," *California Slavic Studies* 4 (1967): 47.

68. *Yevraziystvo: Opït sistematichesgo izlozheniya* (Paris: Yevraziyskoye knigoizdatel'stvo, 1926), 43.

69. See Taruskin, *Stravinsky and the Russian Traditions*, 1486–93.

70. See Taruskin, *Defining Russia Musically*, 400–405.

71. Alan Woods, *Bolshevism: The Road to Revolution* (London: Wellred Books, 1999), 86.

72. Nicolas Nabokoff, "Christmas with Stravinsky," in *Stravinsky: A Merle Armitage Book*, ed. Edwin Corle (New York: Duell, Sloan & Pearce, 1949), 160.

73. See Lesley Chamberlain, *Lenin's Private War: The Voyage of the Philosophy Steamer and the Exile of the Intelligentsia* (New York: St. Martin's Press, 2007).

74. Another, more insularly musical variant of it, put forth by Arthur Lourié, is discussed in essay 7 in this collection, "Is There a 'Russia Abroad' in Music?"

75. V. V. Rozanov, *Apokalipsis nashego vremeni*, in idem, *Uyedinyonnoye* (Moscow: Izdatel'stvo politicheskoy literature, 1990), 393. Knodel and Dahl translate the line thus: "Russia lost its colors in three days, if not in two" (*Poetics of Music*, 133).

76. Knodel and Dahl: ". . . a rudimentary and almost childlike rationalism that frequently degenerates into fault-finding and sterile disputation" (*Poetics of Music*, 133).

77. *Poetics of Music*, 135 (paraphrased on the basis of the original text, Savenko, "Suvchinskiy i 'Muzïkal'naya poètika' Stravinskogo," 277).

78. See Stravinsky, *Khronika, Poètika*, 246n72.

79. Karl Marx, *Capital: A Critique of Political Economy*, vol. 1 (New York: International Publishers, 1967), 170.

80. Stravinsky, *Poetics of Music*, 140–41.

81. Igor' Glebov (pseudonym), *Kniga o Stravinskom* (Leningrad: Triton, 1929; reprint Leningrad: Muzïka, 1977).

82. Robert Craft, "Foreword: Asaf'yev and Stravinsky," in Boris Asaf'yev, *A Book about Stravinsky*, trans. Richard F. French (Ann Arbor, MI: UMI Research Press, 1982), viii. The identification of Asaf'yev as the author of the passage about Beethoven (in an article, "Naslediye Betkhovena" [Beethoven's Legacy], published in *Izvestiya* on 26 March 1937 under the author's literary pseudonym Igor' Glebov) was made by Svetlana Savenko in *Suvchinsky i yego vremya*, 283n12.

83. Igor' Glebov (Boris Asaf'yev), "Muzïka Kazakhstana," *Izvestiya*, 26 May 1936; see Stravinsky, *Khronika, Poètika*, 283n16.

84. See Stravinsky, *Khronika, Poètika*, 225, 249n94.

85. Knodel and Dahl: "Shostakovich's music and the subject matter of his compositions were severely censured, perhaps not altogether wrongly this time. They were additionally attacked as being decrepit formalism" (*Poetics of Music*, 145).

86. On Zaslavsky's authorship, see Laurel Fay, *Shostakovich: A Life* (New York: Oxford University Press, 1999), 304n67.

87. Stravinsky, *Khronika, Poètika*, 248n88.

88. They can be found in *Poetics of Music*, 152–55.

89. Savenko, *Suvchinskiy e yego vremya*, 282.

90. Ibid.

91. James Billington, *The Icon and the Axe: An Interpretive History of Russian Culture* (New York: Vintage Books, 1970), 478.

92. Soumagnac, "Préface," 22.

93. Stravinsky's letter, dated 25 June 1939, requesting this addition is quoted by Savenko in *Suvchinskiy i yego vremya,* 275.

94. Savenko, *Suvchinskiy i yego vremya,* 282; cf. *Poetics of Music,* 154–55. Roland-Manuel mitigated the dogmatism slightly when he converted Souvtchinsky's last clause into a complete sentence: "Ce qu'elle est en réalité, j'ai essayé de vous dire au cours de mes leçons précédents" (as translated by Knodel and Dahl: "What it really is I have tried to tell you in the course of my preceding lessons").

18

Did He Mean It?

Dialogues and a Diary, the fourth of the six books jointly authored by Stravinsky and Robert Craft, was the last in which some of the contents were still cast in the format that the first book called "conversations," now given (as "dialogues") a more Platonic—and a more honest—designation, since the books—all of them—were wholly and stylishly literary rather than colloquial. Some of the dialogues in this fourth volume, issued in 1963, were really program notes for use in Stravinsky's concert tours and recordings, in which a "question" from Craft served merely as a sort of preface to a little essay cast in Stravinsky's first-person voice. In the two remaining books in the series, these essays would be called, frankly, "program notes" and the dialogue conceit would be dropped. I say all this, perhaps unnecessarily, as a reminder of the questions surrounding the authorship of any and all published words attributed to Stravinsky.

The program note I want to gloss concerns the Symphony in Three Movements, which was composed over the years 1942 to 1945 and first performed, on 24 January 1946, by the New York Philharmonic–Symphony Orchestra under the composer's baton.[1] Craft's prefatory "question" was this:

> You have at times referred to your Symphony in Three Movements as a "war symphony." In what way is the music marked by the impression of world events?

Adapted from two keynote talks, given respectively at the international conference "Stravinsky: Between Emotion and Objectivity," Freie Universität, Berlin, 26 January 2012 ("Did He Mean It?"), and at the international festival and seminar "Bartók—Predecessors, Peers, Followers," Szombathely, Hungary, 17 July 2011 ("Bartók Meets Stravinsky on the Field of Mozart"); published in *Studia Musicologica* 56/1 (2015), 89–124.

Stravinsky's "answer" is laid out in seven well-organized paragraphs, of which this is the first:

> I can say little more than that it was written under the sign of them. It both does and does not "express my feelings" about them, but I prefer to say only that, without participation of what I think of as my will, they excited my musical imagination. And the events that thus activated me were not general, or ideological, but specific: each episode in the Symphony is linked in my imagination with a concrete impression, very often cinematographic in origin, of the war.

This paragraph both is and is not a mystification. The useful part is the acknowledgment that the correspondence between the music of the Symphony and what is usually called the extramusical is to be found in concrete imagery. That sounds very Russian, in fact. *Konkretnost'* and *obraznost'* (imagery) were among the official desiderata of socialist realism, and Stravinsky's Symphony has often struck me as a counterpart or companion piece to Shostakovich's Seventh, the mother of all war symphonies, which Stravinsky, along with millions of his newfound fellow Americans, heard on 19 July 1942 when the American première, by the NBC Symphony under Arturo Toscanini, was broadcast nationwide.[2] Stravinsky never had a good word to say about that piece, or about Shostakovich, but I think it likely that it was one of the impressions that may have excited Stravinsky's musical imagination without the participation of what he thought of as his will.

The strained locution that I just parodied is one indication of the squeamishness with which Stravinsky always approached the question of musical representation or expression. And of course saying that the Symphony "both does and does not 'express my feelings'" is pure haze and alibi—doubletalk in the most literal sense. What interests me is why Stravinsky painted himself into this corner. Earlier he had always simply denied the representational aspect of his music (or any music, come to that) when queried, to the point of outright lies about, for example, the *Scherzo fantastique* and the ballet *Les abeilles*, which was based on it.[3] We know now from posthumously published letters that the piece was inspired by, and very concretely referred to, Maurice Maeterlinck's *La vie des abeilles*, but Stravinsky would not admit that in the 1950s.[4]

About the Symphony in Three Movements he issued similar denials at first, as in a letter to the man who commissioned it—Bruno Zirato, the managing director of the New York Philharmonic—who wanted to give the Symphony the subtitle "La Victoire." "It is well known that no program is to be sought in my musical output," Stravinsky insisted. "Sorry if this is desapointing [sic] but no story to be told, no narration and what I would say would only make yawn the majority of your public which undoubtedly expects exciting descriptions. This, indeed would be so much easier but alas. . . ."[5] Pressed, he contributed a grudging "Word" to the

Philharmonic program book for the 1946 première, allowing that the symphony had been in some sense prompted "by this our arduous time of sharp and shifting events, of despair and hope, of continual torments, of tension, and, at last, cessation and relief."[6]

Stravinsky recommended the composer Ingolf Dahl, a Los Angeles neighbor (and cotranslator of the *Poétique musicale*) who had played the work over with him many times, as one who could furnish acceptable program notes, and for the most part Dahl confined himself to properly yawn-making technical observations. But Dahl warmed a little to the Victory theme at the end by proclaiming that "one day it will be universally recognized that the white house in the Hollywood Hills in which this Symphony was written and which was regarded by some as an ivory tower, was just as close to the core of a world at war as the place where Picasso painted *Guernica*."[7] Possibly because Picasso had joined the French Communist Party and was offering his services as painter of doves to the Soviet-dominated postwar peace movement, this comparison provoked a reproachful response from Stravinsky. There may have been other reasons as well. The film composer David Raksin seized on Dahl's program note in a little war of words he was waging with Stravinsky, who, after many unsuccessful attempts to sell his music to the Hollywood studios, had hypocritically derided "film people" as having "a primitive and childish concept of music."[8] Raksin retorted that by endorsing Dahl's program note, at which "many of us were greatly surprised," Stravinsky had shown that "he is not unaware of the significance of his music" as war propaganda.[9] Stravinsky now complained to Dahl that "if passages from the program notes are used to imply extramusical connotations in my work, I have to disclaim any responsibility for such interpretations."[10]

But in 1963 Stravinsky seemed to have had a change of heart that rendered him willing to admit what he had formerly denied, even if he still needed to cloak the admission in paradox. Beginning with the second paragraph, the program note in *Dialogues and a Diary* gives an astonishingly frank and detailed account of the Symphony's hitherto forsworn "connotations": "The third movement actually contains the genesis of a war plot, though I recognized it as such only after completing the composition. The beginning of that movement is partly, and in some—to me wholly inexplicable—way, a musical reaction to the newsreels and documentaries that I had seen of goose-stepping soldiers. The square march-beat, the brass-band instrumentation, the grotesque crescendo in the tuba—these are all related to those repellent pictures."

What is inexplicable to me is Stravinsky's resort to the word "inexplicable." In fact, the music could well have come from the soundtrack to a newsreel depicting marching soldiers. The next paragraph is one that I really wish Stravinsky had not published; or—should I say—the one that I both do and do not wish Stravinsky had not published:

Though my visual impressions of world events were derived largely from films, they also were rooted in personal experience. One day in Munich, in 1932, I saw a squad of Brown Shirts enter the street below the balcony of my room in the Bayerische Hof and assault a group of civilians. The civilians tried to protect themselves behind sidewalk benches, but soon were crushed beneath these clumsy shields. The police arrived, eventually, but by then the attackers had dispersed. That same night I dined with Vera de Bosset [who in 1940 became the second Mrs. Stravinsky] and the photographer Eric Schall [*recte*: Schaal] in a small Allee restaurant. Three men wearing swastika armbands entered the room, and one of them began to talk insultingly about Jews and to aim his remarks in our direction. With the afternoon street fight still in our eyes, we hurried to leave, but the now shouting Nazi and his myrmidons [I looked it up—it means a loyal follower of Achilles] followed, cursing and threatening us the while. Schall protested, and at that they began to kick and hit him. Miss de Bosset ran to a corner, found a policeman, and told him that a man was being killed, but this piece of intelligence did not rouse him to any action. We were then rescued by a timely taxi, and though Schall was battered and bloody, we went directly to a police court where, however, the magistrate was as little perturbed with our story as the policeman had been. "In Germany today, such things happen every minute," was all he said.

Eric Schaal (1905–94) eventually fled Germany for America, where he became famous as a photographer for *Life* magazine. One of his best-known pictures was a publicity photo of Sergey Rachmaninoff's hands that appeared first in the magazine and later on the cover of a 78-RPM record album containing a reissue of Rachmaninoff's own recording of his famous Second Piano Concerto.[11] I find Stravinsky's wholly unwarranted digression here embarrassing, in view of his private but intense antisemitism, which is now well known and for which the evidence continues to accumulate. If you will permit me an unwarranted digression of my own, I very recently received a letter from a friend, a Russian musicologist who now lives in Basel and of course regularly visits the Paul Sacher Stiftung, where she recently made a study of Stravinsky's personal collection of Russian books. One of the books she found there was a copy of Modest Chaikovsky's biography of his brother, the famous composer, which includes copious extracts from Chaikovsky's letters. All the passages that insult Jews—and there are quite a few in the original Russian text—were underscored.[12] Well, that is neither here nor there, but in 1932 Stravinsky was very much a sympathizer with the fascist cause.[13] The story about Eric Schaal was gratuitously interpolated, it seems to me, as a preemptive alibi to assuage Stravinsky's unease, when discussing his "war symphony," about his prewar European past.

For America had changed him. As Stravinsky's house guest in 1947, Nicolas Nabokov heard him say, "As far as I am concerned, they can have their Marshals and Fuehrers. Leave me Mr. Truman and I'm quite satisfied."[14] Could this change be linked, somehow, with the change in Stravinsky's attitude toward musical

representations? Both changes could be described as lessened intransigence. It is something to ponder, and to return to.

But first let us finish with Stravinsky's program note. These are the next three paragraphs:

> In spite of contrasting episodes, such as the canon for bassoons, the march music [in the finale] is predominant until the fugue, which is the stasis and the turning point. The immobility at the beginning of the fugue is comic, I think—and so, to me, was the overturned arrogance of the Germans when their machine failed. The exposition of the fugue and the end of the Symphony are associated in my plot with the rise of the Allies, and perhaps the final, albeit rather too commercial, D-flat sixth chord—instead of the expected C—tokens my extra exuberance in the Allied triumph. The figure
>
> ♪ 𝄾 𝄾 ♪ 𝄾 ♪♪ 𝄾
>
> was developed from the rumba in the timpani part in the introduction to the first movement. It was somehow associated in my imagination with the movements of war machines.
>
> The first movement was likewise inspired by a war film, this time a documentary of scorched-earth tactics in China. The middle part of the movement—the music for clarinet, piano, and strings, which mounts in intensity and volume until the explosion of the three chords at No. 69—was conceived as a series of instrumental conversations to accompany a cinematographic scene showing the Chinese people scratching and digging in their fields.
>
> The formal substance of the Symphony—perhaps Three Symphonic Movements would be a more exact title—exploits the idea of counterplay among several types of contrasting elements. One such contrast, the most obvious, is that of harp and piano, the principal instrumental protagonists. Each has a large obbligato role and a whole movement to itself and only at the turning-point fugue, the *queue de poisson* [abrupt end] of the Nazi machine, are the two heard together and alone.

The juxtaposition of piano and harp came about in a peculiar way that Stravinsky does not report. Although he had been forthcoming enough about the outer movements of the symphony to cause himself discomfiture, his program note contains nothing about the slow middle movement. It was originally written on spec to accompany a movie, one that became very famous when its star, Jennifer Jones, won the Academy Award for best actress. The movie was *The Song of Bernadette* (1943), based on a novel by Stravinsky's Hollywood neighbor Franz Werfel. The music that became the second movement of the Symphony in Three Movements was meant to accompany the scene in which the title character sees an apparition of the Virgin Mary that led to the founding of the shrine at Lourdes. Like all the music Stravinsky wrote for the Hollywood studios, it was rejected; Alfred Newman wrote the eventual soundtrack score. It was the addition of this harp-heavy

Hollywood reject to the symphony's first movement, with its piano obbligato, that gave Stravinsky the idea of combining piano and harp in the finale. To those who know Russian music, the combination has a very famous precedent in Glinka's opera *Ruslan and Lyudmila,* where it is used to evoke the sound of gusli, the ancient Russian bardic psaltery that had fascinated Stravinsky during his "Swiss" period, and that he had already imitated with the Hungarian cimbalom in several works, notably *Renard* and some preliminary versions of *Les noces.*

I suppose it was the fact that the imagery in the second movement was unrelated to the war, and therefore irrelevant to Craft's ersatz prefatory "question," that that kept the information I have just related out of Stravinsky's program note. But I thought it worth imparting, for it shows that the second movement, too, was full of concrete imagery. One can, I think, tell when listening to it just where the Virgin Mary appears: at the music for the four solo violins and two solo violas, accompanied by the harp, at one measure before [124].

But we are even now not quite finished with Stravinsky's program note. There is a coda. After spilling the beans about the War Symphony's surprisingly concrete imagery and its sources, Stravinsky suddenly tries to take it all back. "But enough of this," he blurts. "In spite of what I have said, the Symphony is not programmatic. Composers combine notes. That is all. How and in what form the things of this world are impressed upon their music is not for them to say."

Sorry, too late—you've already said it. This bizarre retraction, as if Stravinsky all at once remembered that he was Stravinsky, with a long inventory of pronouncements behind him that he had just contradicted, will fool only those who wish to be fooled. It is all too obvious from what Stravinsky here divulged that he believed what most of us believe: that yes, composers combine notes, but no, that is not all. The antiexpressive pose had always been just that—a pose. Even the original gauntlet, thrown down by the composer (or his ghostwriter, Walter Nouvel) in *Chroniques de ma vie,* Stravinsky's (originally) two-volume autobiography of 1935–36, a sentence that paid-up Stravinskians can recite by heart, was carefully hedged: "Music is, by its very nature, essentially powerless to *express* anything at all."[15]

Did you remember that in the original text the word "express" is italicized (as is the word "expression" in the next sentence, where we read, "*Expression* has never been an inherent property of music")? The italics imply that these words were chosen from among alternatives. It must have been as obvious to Stravinsky as it is to me that if he had written "represent" instead of "express," the assertion would have been too absurd to persuade anyone. And the insertion of the word "inherent" in the second sentence is also a hedge, because one can make the same claim about words, which (onomatopoeia apart, as in music) also represent not inherently but only in the way that music does, which Stravinsky calls "an illusion, . . . simply an additional attribute which, by tacit and inveterate agreement, we have lent it,

thrust upon it, as a label, a convention—in short, an aspect that, unconsciously or by force of habit, we have come to confuse with its essential being."[16]

So what else is new? The sounds you will make if you read these words aloud will convey more than mere sounds to you only because, long before you and I ever came into contact, we made a tacit and inveterate agreement to thrust upon them, as a convention, connotations that are quite separable from their essential being as sounds. If I were speaking or writing Russian, it would make a difference only if you and I had not made the tacit and inveterate agreement we would have made if you had learned that language. If I were making arbitrary noises or combining written letters at random, there would be no tacit and inveterate agreement between us, hence no meaning, no matter how full my heart. There used to be a newspaper feature in the United States called "Ripley's Believe It or Not!," consisting of facts the editor asserted as incredible but true. It was of course a favorite object of parody. One parody I'll never forget was by the comedian Ernie Kovacs in *MAD* magazine; it went: "Gottfried Günther, famous Bavarian linguist, spoke two hundred and twelve languages. None of them could be identified."[17] Now *there's* a would-be Stravinskian.

But no, not really. Gottfried Günther's "speech" lacked not only meaning but also syntax, which Stravinsky's music never lacks. Meaning and syntax are related as complementary sign systems, with meaning pointing outside the sounds to their agreed-upon referents, and syntax pointing from sound to sound. The argument about music is not, and has never been, between expression and pure, neutral, nonsignifying sound, but among the many alternative ways of characterizing the relationship between music and the world of objects, emotions and ideas: "express," as opposed to "evoke," or "suggest," or "connote," or "symbolize," or "transmit," or "stimulate," or some other verb, in addition to "represent." Among these alternatives, "represent" probably makes the most modest claim, and I doubt whether anyone today would seriously propose, as Stravinsky stops well short of doing, that music is inherently incapable of representation. The legitimate arguments concern what and how music represents, not whether.

Except where Stravinsky refers to his own feelings, the only feelings he or anyone can properly *express*, the description of the Symphony in Three Movements as a war symphony entails representation, not expression. Even feelings can be represented without being expressed, as any opera composer knows, and if we allow that the extra exuberance at the Allied triumph in 1945 was not Stravinsky's alone, then the commercial chord at the end could be classed as a representation, whether or not it is also an expression. The continued squeamish pretense of denial at the end of Stravinsky's *explication de texte* is all the more striking when you consider that in the book of "conversations" that immediately preceded *Dialogues and a Diary*, Stravinsky had already gone out of his way to disavow "that overpublicized bit about expression (or non-expression)," although he still rather wanly claimed to "stand by the remark."[18] It was only the reduction of music to a

verbal paraphrase that he now purported to reject, which puts him, actually, in the company of Schumann, who, while praising Berlioz's *Symphonie fantastique,* nevertheless deplored the limiting specificity of the program ("all of Germany gladly returns it to Berlioz: such signposts always smack of something unworthy and pretentious").[19] Stravinsky's program note for the Symphony in Three Movements actually demonstrates the pitfall that Schumann deplored: after reading it, a listener's imagination is no longer free. The explicitness of programs is a constraint that Romantics of Schumann's stripe resisted.

Schumann would have been pleased, however, to hear Stravinsky (in the same passage from *Expositions and Developments*) say that "music is suprapersonal and superreal and as such beyond verbal meanings and verbal descriptions." This put him in the company of the German theorists of what eventually came to be known as absolute music.[20] Just what you might have expected, this, from a Stravinsky who was suddenly eager to forge retrospective links with the post-Expressionists of Vienna. But then—again—he spoils it all by reducing it to a lame tautology: "Music expresses itself"—to which, in a filmed interview, he once quaintly added, "eloquently."[21] By now the obstinate clarity of the interwar Stravinsky's pronouncements has been hopelessly muddled by ambivalence.

After years of dealing with Stravinsky's prevarications and distortions, and his many striking but shallow and careless aphorisms, I had become so fed up with Stravinsky as a publicist in his own behalf that it was only the promise of a free trip to a conference in Berlin, for which I thank Albrecht Riethmüller, that got me to agree to reopen the question of Stravinsky and expression.[22] Nor was I alone in my exasperation. A recent excellent study of Stravinsky's formal processes by Gretchen Horlacher contains a little passage of a kind that has become *de rigueur* in writing about a composer who issued so many contradictory words to so many interlocutors for so many undisclosed purposes. Having made various claims, and proposed various hypotheses about Stravinsky's techniques of superimposition and intercutting, Horlacher did as many writers do and looked to the composer's own writings for corroboration. "Stravinsky's writings are sprinkled with references to counterpoint and polyphony (both in his music and that of others), suggesting that he was comfortable with such descriptions [as I have been making]," she wrote. But then, as if in reflex, she added: "It is not always easy to evaluate the significance of the composer's remarks for a variety of reasons; Stravinsky's statements are often contradictory or self-serving, and it would be simplistic to assume he held a single opinion over the years. Moreover, the authorship of much of 'his' writing has been questioned."[23]

Surely, however, you can guess the next word in Horlacher's text. It was "Nonetheless," of course, signaling that despite all caveats, quoting from Stravinsky's voluminous writings—where you can find support for virtually any assertion—is inescapable and irresistible. And so it is, and here I am, doing it too.

Why?

Neither in Horlacher's case nor in mine is it a matter of simple opportunism, the way it is for the many writers who still utter *pro forma* caveats before passing along their favorite nuggets from Solomon Volkov's *Testimony,* the faked oral memoirs of Shostakovich.[24] Both she and I, and of course many others, are now more likely to critique the words we quote from Stravinsky than echo them. But still we quote. And again I ask, why?

The best answer comes from Pierre Souvtchinsky, the *éminence grise* behind Stravinsky's *Poétique musicale,* a text from which I will soon be quoting *in extenso.* Thanks to the recent spadework of Myriam Soumagnac, Svetlana Savenko, and especially Valerie Dufour, we now know a great deal about the authorship of these lectures, and how little input Stravinsky actually had into their conception and elaboration, to say nothing of the elegantly written text in a language Stravinsky spoke quite imperfectly.[25] The chief revelation was that the lectures were sketched out in their entirety by Pierre Souvtchinsky before Stravinsky made the outline from which his ghostwriter, Alexis Roland-Manuel, worked, and that Souvtchinsky wrote the fifth chapter, or "lesson," the one on Russian music, virtually in its entirety in Russian, and the published text was translated by Stravinsky's son Sviatoslav (Soulima) and only edited (if that) by Roland-Manuel. In a letter of thanks after Stravinsky had signaled his acceptance of the fifth lesson as drafted, Souvtchinsky wrote how glad he was "that at last things will be said that no one has yet dared say aloud. And what good fortune, and what a *coup,* that you, yes you, are the one who will say them."[26] The irony is delicious, no? Edgar Bergen here congratulates Charlie McCarthy. But he was right to do so.

Knowledge that the words Stravinsky uttered in Harvard's New Lecture Hall on six evenings spaced throughout the 1939–40 academic year did not come from Stravinsky gives scholars a new mandate to determine where they did come from, and of course we are working on that.[27] But the fact that the words came out of Stravinsky, that is, out of his mouth, gave them an energy and lent them an authority no other mouth could have furnished. They have been echoing around the world now for three-quarters of a century, reinforced by endless exegesis and paraphrase. They are still the most uncritically accepted twentieth-century words about music (with Adorno's a distant second), and so they can never be ignored or evaded; they must be dealt with. But (as Stravinsky loved saying) *marquez bien:* Because Stravinsky uttered them Stravinsky is responsible for their energy and influence, and so it hardly matters now whether Stravinsky was the one who actually strung them together. He is responsible for the work they have done. And in a sense, therefore, the question I have posed in my title is a trivial one. It does not matter whether Stravinsky meant them inasmuch as he did intentionally propel them into the world where they have done their enormous cultural and social work—work that continues right up to the present moment.

If we think that that work has been harmful to some degree, if we would like to see it to some extent undone, our best recourse is contextualization. To situate Stravinsky's attitudes and utterances in history, or rather in histories—intellectual, esthetic, political, social, and cultural, including the history of Stravinsky's career—is to relativize them, which is already a gain. And one of the questions such situating helps us answer is the question of motive. What did Stravinsky hope to gain from espousing the fairly untenable postulates with which he was so irrevocably associated that he could not shake them even when he may have wished to do so, and which, thanks to that irrevocable association, have been upheld regardless and continue to affect our musical and intellectual environment? To all of which I now would add the question that at present interests me most of all: What made him change his mind—if indeed he did, or needed to?

. . .

Can we ever know whether anyone means (or intends) anything? That is not exactly the question that the famous "intentional fallacy" addresses,[28] but to presume that we can know these things would be to propound another sort of intentional fallacy. Nevertheless, as with nearly every other epistemological project, the impossibility of its final achievement has not deterred and should never deter attempts to get a little nearer to the unreachable goal. On what sort of evidence would an answer to my titular question depend? How might we assess its reliability?

Stravinsky's investment in objectivity and his deprecation of emotional expression are usually associated with the widespread esthetic reaction to the First World War, in which the *loci classici* are writings by such authors as Ortega y Gasset ("The Dehumanization of Art"), T. S. Eliot ("Tradition and the Individual Talent"), and, perhaps most intensely and pertinently, the somewhat earlier writings of T. E. Hulme that were collected and published after the author's death (on the battlefield) under the title *Speculations*.[29] Parallels between these writings and the famous written and oral statements attributed to Stravinsky are very easily drawn and generally conceded, even if actual smoking guns have not been found. One of the early letters from Stravinsky to Robert Craft, for example, has, as a postscript, this: "What is *Speculations* by T. E. Hulme, have no idea?"[30] It is easy enough to guess what elicited that sentence: Craft had spotted the obvious parallels and asked Stravinsky whether he knew the book. Apparently not. It is not even possible to establish Stravinsky's acquaintanceship with the sources on which his ghostwriters drew, such as Jacques Maritain, Paul Valéry, or the many so-called Eurasianist and proto-Eurasianist writers on whom Souvtchinsky drew both in the fifth lesson of the *Poétique*, which he actually wrote, and in the outline he drafted for the whole. And while it is very easy to establish Alexis Roland-Manuel's reliance on Paul Valéry's series of university lectures on esthetics when it came to ghostwriting

the *Poétique musicale,* we can be fairly sure that Stravinsky did not know this book at first hand, or he would not have committed the faux pas, at a soirée *chez* Nadia Boulanger shortly before sailing to America, of reading the first lecture aloud to a small audience that included Valéry, who was not particularly amused to recognize his words and thoughts.[31]

But if we cannot account for Stravinsky's general ideas in terms of specific borrowings, we can easily find reasons to attribute to Stravinsky the motives usually invoked to account for the post–Great War objectivist turn. One of these was the aristocratic or (to give it its more recent and more contentious name) the elitist impulse—the desire to preserve high art as a socially exclusive realm (or, as Ortega put it in "The Dehumanization of Art," an art "for 'quality' and not for hoi polloi").[32] Stravinsky's writings have always striven to scare off or embarrass the masses. His most forbidding esthetic manifesto of all was the one accompanying one of his friendliest, most diverting compositions, the *Octuor* of 1924. Surely, to pick one typical passage, no one who read this—

> Form, in my music, derives from counterpoint. I consider counterpoint as the only means through which the attention of the composer is concentrated on purely musical questions. Its elements also lend themselves perfectly to an architectural construction.
>
> This sort of music has no other aim than to be sufficient in itself. In general, I consider that music is only able to solve musical problems; and nothing else, neither the literary nor the picturesque, can be in music of any real interest. The play of the musical elements is the thing.[33]

—would ever have guessed that the composition under discussion included a funny set of character variations sporting a waltz and a circus march, let alone that it ended with some kind of Charleston or shimmy. Forty years or so later, in an interview filmed at the University of Texas, Stravinsky blurted, "Emotion in music is for geeerls!"[34] Everybody laughed, girls included; but the meaning was clear enough—Stravinsky's "geeerls" was an even snootier version of Ortega's "hoi polloi."

In one of the latest ersatz conversations ghosted by Craft, devoted to the *Requiem Canticles* (1966), the last of Stravinsky's major works, the composer is quoted defending himself against the charge of "aestheticism," which he paraphrases as "the self-sufficiency, or as it may be, the selfishness, of an artist who refuses to come out and play. . . . Whether or not the description fits me," the text continues, "I suspect that its use against me derives from very different terms: for instance . . . my lack of sympathy with the use of music as an advertisement for extra-musical causes, even the greatest symphony, as I see it, being able to do very little about Hiroshima."[35] On one level that is a remarkably trite defense of moral indifference, the degraded estate to which esthetic autonomy, too zealously defended, will inevitably descend. On another, it is a more justifiable defense against the

subversion or distortion of artworks in the interests of propaganda, a process that may be imposed by political authorities through coercion or co-option, or else at times self-imposed to avoid trouble or, more rarely, to game the system.

The reference to Hiroshima may well have been a tacit rebuke to Penderecki, whom many suspected (as it turned out, not wrongly) of exploiting the memory of a horrific event to advance his career; the example of Alfred Schnittke's early oratorio *Nagasaki* is also relevant here, although Stravinsky could not have had knowledge of it.[36] His notorious dismissal of Britten's *War Requiem* was probably motivated in part by a similar indignation.[37] One also thinks of the fate of Shostakovich, or of Stravinsky's old comrade Prokofieff, not to mention his own probable fate had he remained in the land of his birth, where (as he commented one day, no doubt with Zhdanov in mind) "every *tchinovnik* can tell you what to do."[38] What happened to poor Shostakovich after the reign of the *tchinovniki* had ended and his works became fodder for furious political contests over their "message" may have been even worse. To disavow all expressive content would at least discourage co-option and political exploitation. Stravinsky may well have felt that in his Symphony in Three Movements he had veered too close for comfort toward an accommodation with propaganda, especially after Ingolf Dahl compared it with Picasso's *Guernica*, and that may help account for the special squeamishness we have observed in his attitude toward that exceptional work. A self-protective instinct, as well as an exigent sense of propriety, surely lurked behind his objectivist hyperboles.

But no matter how much we may speculate about reasons and motives, they cannot in and of themselves provide an answer to the titular question, which I continue to regard as an important one in the case of a figure with such colossal authority. Public words are meant for public consumption and are calculated for public effect, and we can no more judge an artist's sincerity from public words alone than we can judge a politician's sincerity by his campaign slogans. We learn what politicians really believe only after they are in office and no longer seeking reelection; and it is from their deeds rather than their words that we learn (by which time it is often too late). So from here on I will look to Stravinsky's musical deeds as the test of his words.

The Great War and its consequences affected Stravinsky in very personal ways. The Bolsheviks expropriated his family's property, impoverishing him. That gave him a White émigré outlook, in contrast to the aristocratic liberalism with which Stravinsky greeted the so-called February revolution of 1917, which had forced the tsar to abdicate in favor of an aristocratic liberal regime (known historically as the Provisional Government *[vremennoye pravitel'stvo]* because it lasted only a few months). Resentment of the Bolsheviks impelled Stravinsky's politics far to the right, where (as we have seen) he nurtured the class prejudices that fed the zesty elitism of his neoclassicist years. But more immediately, his economic insecurity turned him into a working musician in a way he had never foreseen. He now had

to earn money by performing, and also by recording his works. These activities are the deeds we need to examine first. They led to documentation galore, of course, but bear in mind that Stravinsky's professional career as a performer, mainly of his own works, coincided with the onset of his neoclassicism and with the beginnings of his career as a writer of esthetic manifestos. His performances and his pronouncements were mutually illustrative. Stravinsky the performer was the "dehumanizing" Stravinsky, whatever the music he was performing.

To understand what Ortega called dehumanization we need to remember that it was a transcendental ideal. Dehumanization implied the superhuman, not the subhuman. What is shed when art is dehumanized is not the *menschlich* but the *allzumenschlich*, as Nietzsche would have said. Emotions, being transient and often uncontrollable, are reminders of our transience and helplessness as humans. Art can aspire to a permanence that is denied to life. It offers a space where (having first, as if paradoxically, submitted to limits) man can be master. The evidence of that masterly control, Hulme wrote, was the "dry hardness which you get in the classics."[39] Its musical symbol was uniformity—of rhythm and tempo above all. To achieve the kind of streamlined, relentless rhythm that Stravinsky wished to implement as a performer, and that he demanded of others, was literally a superhuman task. And that must be the reason why of all the major composers of the twentieth century Stravinsky was the most enchanted by mechanical reproduction, beginning with the pianola, a mechanism that almost all other composers actively despised. Even Robert Craft has expressed bafflement at "Stravinsky's infatuation with the instrument," it being (in Craft's eyes) "one of the inexplicable eccentricities of his career—not the delight in the novelty of the machine reflected in the *Etude* [for pianola of 1917], . . . nor even his profligate expenditures of time and labor in transcribing his music for this dodo (since he earned substantial sums of money thereby), but in his musical enthusiasm for it."[40]

It is a measure, perhaps, of the change that had taken place in Stravinsky that he should have become enamored of the pianola as a recording device (or, even more than a recording device, a means, as he once put it, of "reconstituting" his music)[41] after writing an opera, *The Nightingale,* on the subject of a tale by Hans Christian Andersen that explicitly glorified natural music over artificial.[42] That change in outlook is precisely what makes his *pleyelisation* of *The Rite of Spring* such a precious document—though not a document of that work's proper performance practice, even if that is the way it has been used in recent decades.[43] When you compare the piano roll of the "Danse sacrale" with recordings of the piece up to the 1940s (definitely including Stravinsky's own recordings), you realize that the primary beauty of the pianola for Stravinsky lay not, or not only, in what he emphasized to interviewers, namely its possession of eighty-eight fingers with textural and contrapuntal potential to match,[44] but rather its boundless stamina. The "Danse sacrale," as Stravinsky wrote it, was surely meant to be borderline

unplayable. The lurchy, insecure early orchestral performances, which constantly lose speed and then regain it, communicate the deadly dance's exhausting violence, and particularly the lethal strain that it is meant to convey, in a way that the postwar piano roll altogether transcends. The strain on the orchestral musicians parallels, or even recreates, the strain on the Chosen One; listening, you feel that buffeting force. The piano roll is enormously exciting and bracing, but in a wholly other way. Nothing is difficult for the pianola; like an inhumanly capable athlete, it shows itself impervious to strain. The fact that conductors like Benjamin Zander and Robert Craft himself have taken the piano roll as the ideal for the piece and, John Henry–like, have tried to beat the machine at its own game only shows to what extent we have lost touch with the original, protest-inciting meaning of *The Rite*—just as Stravinsky would have wanted us to, I have to think, beginning in 1920, when he let it be known that *The Rite* was "un oeuvre architectonique, et non anecdotique." For an idea of dehumanized neoclassicism in music, nothing can beat the mechanized "Danse sacrale."[45]

Though never achieving such élan in his own performances of *The Rite*, Stravinsky obviously took the pianola as the ideal to which he aspired in his own piano playing. The works he wrote to serve as his own performing vehicles, the Concerto for Piano and Winds of 1924, the *Sonate* of 1925, and the *Sérénade en la* of 1926, already show the influence of the pianola in the uniformity of their rhythm, with seemingly endless strings of isochronous subtactile note values (what Stravinsky liked to call monometric rhythm). You could say, as many did, that they were reminiscent of Bach's keyboard works (at least the looks of them), but their principal import (like Bach's in those days, come to think of it) was as the conveyor of mechanized transcendence. This comes through in Stravinsky's impressively relentless playing of the "Rondoletto" from the *Sérénade en la* on the original 10-inch 78-RPM French Columbia disc for the sake of which the piece had been commissioned;[46] but it emerges with greatest, indeed crushing, force in Stravinsky's *pleyelisations,* especially that of the Concerto, which spectacularly conveys the pianola's superhuman steadiness, even when played back on a faulty instrument.[47]

Stravinsky could never equal as a real-time pianist that utter uniformity—no human pianist could—but his attempt to do so could still produce an overbowling effect; and that is how Stravinsky, never a virtuoso, was able to impress real virtuosos with his playing, including Prokofieff—who grudgingly admitted that "Stravinsky has delivered himself of a horrifying piano sonata, which he himself performs not without a certain chic"[48]—and Bartók, who fell reluctantly and ambivalently under its spell for a while. Stravinsky elicited their astonishment by turning himself, as far as was humanly possible, into a walking pianola. Both the powerful impression and the ambivalent reaction to it emerge from a description Bartók's second wife, herself a pianist and a frequent duo-partner with her

husband, sent in a letter to her mother-in-law after hearing Stravinsky play the Concerto in Budapest in March 1926:

> Monday was Stravinsky's concert. Now I know quite exactly what the new direction is. Imagine, Mama, for yourself such a music, in which there is absolutely no room for feelings, in which you can find no part that causes tears to come to your eyes. You know bare rhythm, bare hammering, bare some-kind-of-timbre. I can say that the whole thing, as it is, really carries one away. Stravinsky is a magnificent genius, and we very, very much enjoyed the evening: truly one gets caught up in his miraculously beautiful-timbred machine music, music of pulsating rhythm—but if Béla would make such music, then for Béla I would not be able to be the artist that I am and always will be. Because this music is not my homeland. Mine is Béla's music, where there is also the profound pulsating rhythm, the timbre, but where the feelings live and are, and which has soul.[49]

We can pursue the Bartók-Stravinsky dialectic for a while, since Bartók's playing can also be sampled in recordings. What kind of pianist was he? Here is how today's foremost Bartók scholar, László Somfai, answers the question: "It is a unique situation that one of the greatest composers of our century was also an extraordinary concert pianist who was intimately familiar with the Vienna-Budapest tradition of interpreting common-practice music around the turn of the century and who furnished detailed performing instructions for the whole *Well-Tempered Clavier* by Bach, nineteen sonatas by Haydn, twenty sonatas by Mozart, twenty-seven sonatas and five other piano works by Beethoven, as well as pieces by Couperin, Scarlatti, Schumann, and Chopin."[50]

Intimately familiar with the Vienna-Budapest tradition of interpreting common-practice music: in other words, a pianist of exactly the kind Stravinsky's playing implicitly opposed and purported to supersede. That is what produced the uneasiness Mrs. Bartók expressed in her letter. That uneasiness bore magnificent musical fruit in the guise of Bartók's First and Second Concertos, the First composed later in the same year, 1926, as the concert where he heard Stravinsky, and the Second five years later. Both are haunted by Stravinsky, and the First is haunted, quite specifically, by Stravinsky's Concerto for Piano and Winds. It is the closest Bartók ever came to Stravinsky's mechanized style, but he did not and could not go all the way. Bartók always used tempo variation for expressive purposes, and even his First Concerto has what Somfai calls "Hungarian culmination points," where the tempo is slowed for emphasis and the music takes on a patently national coloration ("my homeland . . . ") of a kind that Stravinsky's universalistic neoclassicism unequivocally abjured.

Stravinsky uses sectional contrasts of tempo in his Concerto. Its first movement, for example, has a slow introduction that is reprised at the end, and also a cadenza marked *più mosso* right before the reprise. These contrasting tempos are juxtaposed without trasnsitions, however, and sound like mechanical gear shifts.

Bartók's Concerto, in keeping with "the Vienna-Budapest tradition of interpreting common-practice music," is full of accelerandos and ritardandos, explicitly rejected, along with crescendos and descrescendos, in Stravinsky's manifesto on the *Octuor:*

> I have excluded from this work all sorts of nuances, which I have replaced by the play of . . . volumes.
>
> I have excluded all nuances between the *forte* and the *piano;* I have left only the *forte* and the *piano.*

And later:

> The play of these volumes is one of the two active elements on which I have based the action of my musical text, the other element being the movements [i.e., tempi] in their reciprocal connection.[51]

The article by Somfai containing his characterization of Bartók the pianist consists mainly of a description of Bartók's editing practice. That practice, for Bartók as for any other musical editor in what Somfai called the Vienna-Budapest tradition, was largely a matter of indicating in specific notation the conventional nuances that went without saying in any idiomatic rendition. But even after the editor had finished making explicit what composers and seasoned performers held (presumably) to be implicit, it remained Bartók's assumption, the usual assumption of pianists in the tradition, that (to quote from Somfai again) "musical notation was by nature inadequately precise," or more strongly, that even the most detailed notation can only be a "shorthand."[52] That was Bartók's reason for wishing to document his own performance practice in recordings—but never pianola rolls, which could not (he thought) transmit the unnotatable nuances.

Stravinsky's attitude toward notation, of course, differed completely. In the Octet manifesto of 1924 he wrote that once the composer had fixed the two crucial performance constraints for the composition, the performer had nothing more to add:

> These two elements, which are the object for the musical execution, can only have a meaning if the executant follows strictly the musical text.
>
> This play of movements [i.e., tempi] and volumes that puts into action the musical text constitutes the impelling force of the composition and determines its form.
>
> A musical composition constructed on that basis could not, indeed, admit the introduction of the element of "interpretation" in its execution without risking the complete loss of its meaning.

And hence:

> A work created with a spirit in which the emotive basis is the nuance is soon deformed in all directions; it soon becomes amorphous, its future is anarchic and its

executants become its interpreters. The nuance is a very uncertain basis for a musical composition because its limitations cannot be, even in particular cases, established in a fixed manner.[53]

These pithy sentences from 1924 already foreshadow *in nuce* the sixth and final *leçon* of the *Poétique musical*, "De l'éxécution," that notably snooty and dogmatic sermon on performance, which, precisely because its terms had been set fifteen years earlier in the Octet manifesto, is the one chapter from Stravinsky's Harvard lectures in which I believe the ideas enunciated by Stravinsky and sent into the world with the massive force of his authority were in fact Stravinsky's own ideas. He meant it (at the time).

The *leçon* starts by affirming the primacy and the adequacy of notation, not even making allowance for the distinction, still recognized in his manifesto of 1924, between music conceived on the basis of nuance and music based on invariable tempi and volumes: "Having been fixed on paper or retained in the memory, music exists already prior to its actual performance, differing in this respect from all the other arts, just as it differs from them, as we have seen, in the categories that determine its perception."[54]

From this follows the crucial distinction between execution and interpretation, culminating in what is probably the most oft-quoted sentence from the Harvard lectures (italicized below):

> The language of music is strictly limited by its notation. The dramatic actor thus finds he has much more latitude in regard to *chronos* and intonation than does the singer who is tightly bound to *tempo* and *melos*.
>
> This subjection, that is often so trying to the exhibitionism of certain soloists, is at the very heart of the question that we propose to take up now: the question of the executant and the interpreter.
>
> The idea of interpretation implies the limitations imposed upon the performer or those which the performer imposes upon himself in his proper function, which is to transmit music to the listener.
>
> *The idea of execution implies the strict putting into effect of an explicit will that contains nothing beyond what it specifically commands.*
>
> It is the conflict of these two principles—execution and interpretation—that is at the root of all the errors, all the sins, all the misunderstandings that interpose themselves between the musical work and the listener and prevent a faithful transmission of its message.[55]

Stravinsky defends the fundamentalist doctrine of textual literalism with moralistic and even pseudobiblical locutions. "The sin against the spirit of the work always begins with a sin against its letter and leads to the endless follies which an ever-flourishing literature in the worst taste does its best to sanction."[56]

And:

> Between the executant pure and simple and the interpreter in the strict sense of the word, there exists a difference in make-up that is of an ethical rather than of an aesthetic order, a difference that presents a point of conscience: theoretically, one can only require of the executant the translation into sound of his musical part, which he may do willingly or grudgingly, whereas one has the right to seek from the interpreter, in addition to the perfection of this translation into sound, a loving care—which does not mean, be it surreptitious or openly affirmed, a recomposition.[57]

And finally:

> Here we are back at the great principle of submission that we have so often invoked in the course of our lessons. This submission demands a flexibility that itself requires, along with technical mastery, a sense of tradition and, commanding the whole, an aristocratic culture that is not merely a question of acquired learning.
>
> This submission and culture that we require of the creator, we should quite justly and naturally require of the interpreter as well. Both will find therein freedom in extreme rigor and, in the final analysis, if not in the first instance, success—true success, the legitimate reward of the interpreters who in the expression of their most brilliant virtuosity preserve that modesty of movement and that sobriety of expression that is the mark of thoroughbred artists.[58]

These remarks link Stravinsky's ideas on performance to the social, political, and ethical principles that underwrote them, which are treated in other chapters of this book.[59] Occasionally, however, Stravinsky descends from this lofty philosophical perch and deigns to make more specific and even practical recommendations. These are particularly interesting and useful, because they are the ones that can be actually tested against practice:

> Thus it follows that a *crescendo*, as we all know, is always accompanied by a speeding up of movement, while a slowing down never fails to accompany a *diminuendo*. The superfluous is refined upon; a *piano, piano pianissimo* is delicately sought after; great pride is taken in perfecting useless nuances—a concern that usually goes hand in hand with inaccurate rhythm. . . .
>
> These are just so many practices dear to superficial minds forever avid for, and satisfied with, an immediate and facile success that flatters the vanity of the person who obtains it and perverts the taste of those who applaud it.[60]

Here, of course, Stravinsky directly indicts not only the Heifetzes and the Horowitzes, and not only the Medtners and the Rachmaninoffs, but even Bartók—which may shock those who think of Bartók as Stravinsky's fellow modernist, but is consistent with both Bartók's reaction to Stravinsky's Concerto and Somfai's description of Bartók's relationship to performing tradition. The correlation of loudness and tempo of which Stravinsky complains was indeed a central tenet of the Vienna-Budapest tradition of interpreting common-practice music.[61] Along with a wealth of *nuances inutiles*, the disparaged correlation is not only to

be observed in Bartók's recorded performances; it can also be found prescribed in Bartók's didactic editions of classical repertoire.[62]

Stravinsky's opposition to the practice was unusual in a European. The nonaccelerating crescendo was something that many musicians associated with America, and with *Amerikanismus*—the crass industrialized modernism from which "old Europe" recoiled. A bit later, in 1948, in an article called "On Being American" which attempted to arbitrate among various nationalistic and antinationalistic factions in the United States, Virgil Thomson wrote, in his capacity as the chief music critic for the *New York Herald Tribune,* that "two devices typical of American practice are the nonaccelerating crescendo and a steady ground rhythm of equalized eighth notes (expressed or not). Neither of these devices is known to Europeans, though practically all Americans take them for granted."[63]

But as Thomson ought to have known (and surely did know when not engaged in polemics), these were both salient characteristics of Stravinsky's music, which was coordinated in its shifting meters by what nowadays one calls a subtactile pulse, nothing other than Thomson's more clumsily defined "steady ground rhythm of equalized eighth notes (expressed or not)." Adorno certainly knew this, and it became an important stipulation in his bill of indictment against Stravinsky in *Philosophie der neuen Musik*. Someone else who definitely disapproved of it was Schoenberg, living in 1948 only a couple of miles from Stravinsky in another suburb of Los Angeles. Schoenberg may very well have read Thomson's column, and therefore may have been reacting to it directly when he wrote the little squib that follows, which was discovered among his papers after his death. He wrote it in English—his English—but the text as published and quoted here was edited by Dika Newlin:

> Today's manner of performing classical music of the so-called "romantic" type, suppressing all emotional qualities and all unnotated change of tempo and expression, derives from the style of playing primitive dance music. This style came to Europe by way of America, where no old culture regulated presentation, but where a certain frigidity of feeling reduced all musical expression. Thus almost everywhere in Europe music is played in a stiff, inflexible meter—not in a tempo, i.e. according to a yardstick of freely measured quantities. Astonishingly enough, almost all European conductors and instrumentalists bowed to this dictate without resistance. All were suddenly afraid to be called romantic, ashamed of being called sentimental. No one recognized the origin of this tendency; all tried rapidly to satisfy the market—which had become American. One cannot expect a dancer who is inspired by his body and narcotized by his partner to change tempo, to express musical feelings, to make a ritardando or *Luftpause*....
>
> Music should be measured—there is no doubt. As an expression of man it is at least subject to such changes of speed as are dictated by our blood. Our pulse beats faster or slower, often without our recognizing it—certainly, however, in accommodation to our emotions. Let the most frigid person be asked a price much higher than

she expected and feel her pulse thereafter! And what would become of the lie-detecting machine if we were not afflicted by such emotions? Who is able to say convincingly "I love you," or "I hate you," without his pulse registering? ... Why is music written at all? Is it not a romantic feeling which makes you listen to it? Why do you play the piano when you could show the same skill on a typewriter? ... Change of speed in pulse-beats corresponds exactly with changes of tempo.[64]

Stravinsky would have accused Schoenberg of lacking respect for typewriters as well as pianolas, and behind that, perhaps, proper respect for skill. But unlike Schoenberg, Bartók was a supremely skilled performer well protected from snobs by his reputation as a composer and a scholar, and we are fortunate in being able directly to compare Stravinsky and Bartók as performers not only in theory but also in practice, because both of them applied their theories of performance practice not only to their own compositions, where we might be deterred by the prospect of comparing apples and oranges, but also to the standard repertoire. Both of them recorded works by Mozart, where neither made any pretense of "historical" performance because both were convinced that their ideas on performing were transhistorically valid—or, to put it as many might prefer today, both are equally to be reprimanded for anachronistically universalizing a performance style originating in a century other than Mozart's (Bartók's in the nineteenth, Stravinsky's in the twentieth) and inappositely applying it. And that, of course, is what makes their recordings such precious documents.

Nor need it preclude enjoying or admiring the results. In the case of Bartók, the details we are most likely to admire, it seems to me, are precisely the ones that could never have been notated, and are thus beyond the Stravinskian pale. Bartók was a master of agogics. In a snatch, happily preserved in a broadcast recording, from Mozart's Concert Rondo in A Major, K. 386—in which Bartók was accompanied by the Budapest Philharmonic Orchestra under Ernő von Dohnányi at a concert that took place on 26 October 1936—the discrepancy between Bartók's rhythm and that of the orchestra is very noticeable.[65] While soloists today might restrain themselves so as to maintain uniformity, there being little chance of an ensemble tutti achieving "ensemble" in nuances such as those Bartók applied to the solo part, Bartók evidently thought of such concerns the way Emerson, or any other Romantic, would have thought of them: as the sort of "foolish consistency" derided in Emerson's famous essay "Self-Reliance" (1841) as "the hobgoblin of little minds, adored by little statesmen and philosophers and divines." Self-reliance, submission's very antipode, was not among the Stravinskian virtues.

Or consider the rondo finale of Mozart's Sonata for Two Pianos, K. 448, broadcast by Béla and Ditta Bartók on 23 April 1939 (the famous composer at the second piano). The tempo is a real performer's tempo, very impressive for its speediness; but that does not preclude *des nuances inutiles*. The one I would focus attention on, in one of the episodes, is a response to a simple *sforzando* as marked in the score.

We know what Stravinsky would have said about the slight but telling broadening of tempo with which Bartók made the *sforzando* an emotional as well as a temporal nuance. As he put it at Harvard only a few months later, such a thing was *un péché contre l'esprit de l'oeuvre*. Refusing to distinguish such a sin from *un péché contre la lettre*, he would have consigned it to a place among *ces éternels errements qu'une littérature du pire goût et toujours florissante s'ingénie*—a literature to which I guess this essay counts as a contribution.

Did he mean it? We know by now that we can never know that for sure; but we *can* ask whether Stravinsky practiced what he preached. And to answer that question we can listen to another Mozart work for two pianos, in which instead of two Bartóks the performers were a pair of Stravinskys. In November 1935, Stravinsky and his son Sviatoslav, who went professionally by the name Soulima, unveiled Igor's just-completed *Concerto per due fortepiani soli* at a series of concerts, followed by a concert tour, in which the new work was preceded by a curtain-raiser in the form of Mozart's Fugue in C Minor, K. 426. They recorded the Concerto, with the Mozart Fugue as an album filler (to occupy an otherwise empty sixth 78-RPM side), in 1938. (Again, the famous member of the team plays the second piano part.) The recording is no longer the great rarity it once was, having now been more once than reissued on CD and even posted (intermittently) on YouTube.[66] Nevertheless, if you have not heard it, you cannot imagine it.

Stravinsky the pianist can be accused of many things, but not hypocrisy. The man did indeed practice what he preached, striving toward an absolutely unyielding tempo and maintaining what the *pianoleur* Rex Lawson, mocking common misconceptions about the pianola, called "terrace dynamics with only one terrace."[67] The subject is articulated only one (somewhat ghastly) way, with a dry, undifferentiated staccato one recognizes immediately as "Stravinskian," and the changing textures are not reflected by any unnotated changes in touch, even right before the end when, as often happens in Mozart fugues, the fugue forgets that it is a fugue and the subject is heard as a melody, homophonically accompanied and extended. Nothing in the rendition changes to match even so radical a change in *facture*. The very end is the most remarkable stroke of all: the players don't quite manage to maintain tempo with the same inhuman rigidity as before, but it is evident that they intended to do so, and come appallingly close.

Such a performance is hardly enjoyable in the same conventional way that Bartók's Mozart is enjoyable. Having played it for audiences many times, I have seen listeners gape at it in open-mouthed amazement bordering on horror. Carl Schachter, the eminent theorist, told me after a talk I'd given at Queens College in New York that even though he had taught the piece numberless times and knew it by heart, when he heard the Stravinskys play it he got lost and could not follow its shape. But even he, recoiling from it and objecting vociferously, endured it not with boredom but with revolted fascination, and confessed after-

ward to a certain awe in its presence. As the letter from Ditta Bartók has already testified, this kind of performing, if one has the stomach for it, makes a formidable impression.

What makes the impression so strong? Stravinsky read a little speech before playing the Concerto with Soulima, and continued to give the speech even later, in America, for example in concerts he gave in March 1940 when his playing partner was Adele Marcus (1906–95), later a famous Juilliard pedagogue and a pupil of Alexis Kall, a friend of Stravinsky's youth who preceded him in Los Angeles. The speech (always given in French, no matter where) tied Stravinsky's performance practice not only to the quasi-ethical strictures familiar from the *Poétique musicale,* but beyond that, to a time-honored aestheticist discourse going all the way back to its founder, Immanuel Kant. Here is the peroration:

> The limited time I have at my disposal prevents me from giving you a technical analysis of my concerto. As for extramusical commentaries, I hope you will not expect them from me. I would be truly embarrassed at furnishing such a thing.
>
> There are different ways of loving and appreciating music. There is, for example, the way that I would call self-interested love, the kind that demands from music emotions of a general sort—joy, sorrow, sadness, something to dream about, escape from ordinary life. That would be to deprecate music by assigning it a comparably utilitarian purpose. Why not love it for itself alone? Why not love it the way one loves a picture, for the beautiful quality of the painting, the beautiful design, the beautiful arrangement of its parts? Why not admit that music has an intrinsic value, independent of the feelings or images that, by analogy, it might evoke, and could only distort the listener's judgment? Music needs no assistance. It is self-sufficient. Don't look for anything in it beyond what it contains.
>
> Nothing is more difficult than talking about music. One can only do that usefully by keeping to the technical and professional plane. As soon as one abandons this terrain, one leaps into boundless space and starts to babble. A great Romantic, Robert Schumann, who wrote a great deal and thought deeply about music, and whom one could never accuse of aridity or pedantry, came to the conclusion that in music one can prove nothing.
>
> "Science," he said, "relies on mathematics and logic, poetry on words, and the plastic arts on nature, but music is an orphan who has neither mother nor father. And in the mysteriousness of its origin," he added, "may reside the secret of its allure."
>
> After that, it would be best for me to stop speaking and sit down at the piano.[68]

What, then, makes the Stravinskys' performance of Mozart's Fugue so appallingly, intimidatingly impressive? One factor, surely, is its commanding negation of everything that is usually meant by the colloquial term "musicality," or even "musical" as conventionally or casually applied to a person or a performance. The meaning of that term is famously elusive, but it certainly has to do with what, just as loosely, we call "natural" in music making. To perform "naturally" or "musically," I

would suggest, means to adhere to what are considered good standards in a manner that appears effortless and intuitive. What that really means, I would further suggest, is an easy and ingratiating adherence—at best an exceptional and inspiring adherence—to conventional (read: traditional) norms. In that sense musicality is inherently unreflective and conservative. So if one of the cardinal or even tautological traits of "modernism," as an attitude, is opposition to conservatism, the challenge to unreflective habits or the intransigent rejection of conventional norms, we might expect self-avowed modernists to oppose "musicality." And sure enough, enough modernists have gone on record mocking the notion ("that blissful state of cretinism," in Paul Zukofsky's memorable phrase) to confirm our expectations.[69] Aaron Copland, thought a modernist in his youth but roundly outstripped in his maturity, corroborated the point in a slightly different way when he remarked wistfully to an interviewer: "It worries me a little bit that one doesn't meet up now with the kind of composer we used to think of as being 'musical.' If you said of someone, 'He is terribly musical,' that was the highest compliment you could pay. Nowadays, to stress the 'musicality' of a composer would seem to be somehow pinning a bad name on him or making him seem lesser or limited or not so interesting."[70]

Bartók's Mozart performances exude musicality in the highest degree. Stravinsky's Mozart performance excludes and implicitly derides it. It is not at all an effortless performance—not at all intuitive, not at all natural. It is very much "on purpose," self-conscious in the highest degree, and obviously fights every "normal" or "natural" inclination. In the spirit of our titular question, it is definitely "meant." Stravinsky has obviously chosen his path deliberately, whereas Bartók beautifully and skillfully applies default assumptions that are by definition unconsidered reflexes, or at least should sound as if they were. That sense of high determination and resolve, of going resolutely against the grain, lends an aura of extraordinary authenticity to Stravinsky's performance, even when it inspires revulsion (as it certainly does in me).

Here, of course, we enter a realm of paradox, because the concept of authenticity has been so much abused in connection with musical performances. The subject can easily turn into a morass,[71] so let us content ourselves merely to note and briefly reflect on the way in which the commercial releases of the Mozart recordings we have been considering have been described by annotators. The annotations to the complete edition of Bartók's piano recordings, both published and private, that formed part of the Centenary Edition of Bartók's recorded legacy were the work of Professor Somfai, who noted of the duo Sonata that "many critics today would describe the Mozart sonata performance as unacceptably aggressive and fast, as romantic in some of its parts. It is true the Allegro con spirito is passionate, in parts rich in choleric outbursts; and the Molto Allegro finale even has a biting character. Then there are the problems due to the performing style of the

times. Thus Bartók undertakes the slower tempo of the secondary subject with complete conviction. Whatever a purist might think, or someone who favors historic authenticity, this is a great performance."[72]

Meanwhile, the annotator of the Stravinsky performance, issued on CD by the Andante firm in 2003, also makes apologies: "Only an authenticist pedant would complain at the thoroughly Stravinskian staccato with which Mozart's fugue subject is announced. This is an uncommonly rare and precious example of Stravinsky creatively interpreting the music of another composer. What might his Beethoven have been like?"[73]

Do we really want to know? The irony, or paradox, appears when one reflects on the changing consensus that has emerged over the last three decades in the course of debate about historical performance practice. It is now pretty widely conceded that the style advocated by what the Andante annotator disparagingly called "authenticists" was based precisely on the objective approach to which Stravinsky lent the authority of his name in the 1920s and 1930s. This is the style against which Bartók was presumed by the Hungaroton annotator to have transgressed; and yet the consensus among historians now is that Mozart's playing, and eighteenth-century playing in general, very likely exhibited much more of the tempo fluidity and nuance that we find in Bartók's playing than it did the uniformity of Stravinsky's approach. Over the last three decades it seems to have emerged, to the satisfaction of most investigators, that the assumption under which many or most early-music performers used to labor—to wit, that the post-nineteenth-century style of performance exemplified or advocated by Stravinsky had a pre-nineteenth-century counterpart, with the nineteenth-century "romantic" style as a deviation—was a misapprehension for which there is no confirming evidence. On the contrary, such evidence of actual eighteenth-century practice as exists favors tempo variation rather than what Paul Henry Lang once called the "steady, relentless tempo" of the imagined eighteenth century.[74] In other words, the antiromantic backlash was not a restoration of preromantic style. Bartók's playing may have some historically Mozartean precedent; Stravinsky's surely has none.

But it nevertheless possesses conviction, which is the philosopher's rather than the musicologist's definition of authenticity, implying the sovereign assertion of one's identity. That conviction is what gave Stravinsky's playing the enormous authority that it once enjoyed, and enabled Stravinsky and his advocates to sell it as a transhistorically valid approach to performance of all music, with huge repercussions on the performing style of the twentieth century.

But just as Stravinsky's ideas about composing and its relationship to expression and representation changed over the years, away from the intransigent positions expressed in the *Autobiography* and the *Poétique* toward the more conciliatory and conventionally "musical" attitudes of Stravinsky's American years, so did his ideas about performance (and so, of course—and analogously?—did his

ideas about politics). For this we have lots of evidence, not only in what Stravinsky said ("Leave me Mr. Truman and I'm quite satisfied"), but also in what he did. A particularly valuable testimony is a memoir by Soulima Stravinsky, co-perpetrator of the duo-piano Concerto and Mozart Fugue performances. In an interview that was published shortly after Igor Stravinsky's death, Soulima recalled of his father:

> I know that he himself evolved not only in his music but in his concept of interpretation.... He was then [i.e., at the time of the Concerto and Fugue recording] much more strict in his statements about interpretation. He had a great mistrust of most conductors and performers; it is the more surprising that his printed piano music has so few indications of how to play it. He was afraid to put in anything. He said, "If I put in a crescendo, they will give me too much, so I'd better put nothing." [...]
>
> When we were separated during the war I had no contact with him, and I had several years in which to mature. I was no longer a young student. I had played a lot and had developed my own opinions; I still played his music of course, but I revised it completely. I knew I was doing something that people liked more. I applied not the techniques of, say Chopin to Stravinsky but what I knew about sensitive playing. And I must tell you about one instance when I had a reward. After many years of life in different countries, we got together again, and in a Town hall concert [in New York] I played his music, in a quite different way. It was much more human, more elaborate, more evaluated. I didn't tell him I had reworked it. He was delighted. He said, "You never played my music better! Don't change anything." So I knew I was going in the right direction.[75]

In answer to the question "You feel then, that [your father's] interpretations of his own music are the authoritative versions?" Soulima said: "I would say so. In orchestral performances, it is beyond question. As for piano, I would say he gave an excellent idea of what he wanted, but perhaps you could add something more which he didn't because he did some recordings at a time when he still held very strict opinions as to rhythm."[76]

There are many ways to interpret Soulima's answer (and many ways to interpret his acceptance of the word "interpretation" rather than "execution" in his interlocutor's question), but among them, surely, is the construal that assigns primary importance to the word "still" in Soulima's last sentence, implying an end—from which emerges the point that I think needs much more purposeful consideration from scholars. The influential ideas we associate with Stravinsky, like anyone's ideas, were temporary ideas—the *mot juste* would be the Russian *kon"yunkturnïy*, meaning "pertaining to a certain moment"—that have to be interpreted in the light of the various temporal and geographical environments to which Stravinsky reacted; hence, like anyone's thoughts, they have to be situated in the proper context and, consequently, no longer held to be timelessly valid, even with respect to the man who formulated them. Does that sound so obvious as not to be worth the saying? I might have thought so too, but several years ago, in 2009, when I was invited to Harvard (by the Slavists, I should point out) to give an *explication*

de texte of the fifth *leçon* in the *Poétique musicale* (the one on Russian music),[77] I learned that at Harvard, where of course the lectures originated, they were still being preached by some members of the music faculty as a gospel.

By 1971, Soulima could even say that he regretted that "there was not enough 'romanticism' in the way I played his music." And by 1982, the year of Stravinsky's centennial, John McClure, Stravinsky's producer for Columbia Records, and the man who probably worked more closely with Stravinsky the conductor than anyone else, did not hesitate to call Stravinsky's pronouncements about tempo "baloney."[78] In Stravinsky's own late performances, the romanticism seeps back. There is a filmed rehearsal of the ballet *Apollo* (or *Apollon musagète*) with the Norddeutscher Rundfunk Orchestra in Hamburg, in which Stravinsky very carefully strives to make all kinds of nuances—the very sort of thing he chastised as unethical in the *Poétique musicale*. And he not only makes them, he reacts to them with his face in a way that seems to convey delight that he was able to elicit such expressive playing.[79]

We are back to our starting point, the elderly Stravinsky's lessened intransigence. Was it just regression toward the mean, the inevitable eventual triumph of default modes (in this case, "musicality") the moment one lowers one's guard? Is it evidence that (to recall a book of outdated centennial essays) Stravinsky the musician never really meant what Stravinsky the modernist averred?[80] We'll never know. Meanwhile, we'll go on performing and interpreting Stravinsky's music the way not he but we need to hear it. As long as we do that, his work will live.

NOTES

1. Igor Stravinsky and Robert Craft, *Dialogues and a Diary* (Garden City, NY: Doubleday, 1963), 83–85.

2. As recorded in Vera Stravinsky's diary, *Dearest Bubushkin: The Correspondence of Vera and Igor Stravinsky, 1921–1954, with Excerpts from Vera Straavinsjy's Diaries, 1922–1971*, ed. Robert Craft (New York: Thames & Hudson, 1986), 125.

3. See Igor Stravinsky and Robert Craft, *Conversations with Igor Stravinsky* (Garden City, NY: Doubleday, 1959), 40: "I wrote the Scherzo as a piece of 'pure' symphonic music. The bees were a choreographer's idea."

4. See his letter to Rimsky-Korsakov, dated 18 June (Old Style) 1907: "I am . . . composing a fantastic Scherzo, 'The Bees,' about which I'll tell you . . ." (in L. S. Dyachkova and B. M. Yarustovsky, eds., *I. F. Stravinskiy: Stat'i i materialï* [Moscow: Sovetskiy kompozitor, 1973], 441).

5. Quoted by Joseph Horowitz from the original in the New York Philharmonic archives: "Stravinsky, the New York Philharmonic, and Program Music," *Unanswered Question: Joe Horowitz on Music* (blog), 29 March 2010, available at www.artsjournal.com/uq/2010/03/stravinsky_the_new_york_philha.html.

6. As edited for printing and quoted in Eric Walter White, *Stravinsky: The Composer and His Works* (Berkeley: University of California Press, 1966), 391. Stravinsky's original wording, in another letter to Zirato, is also posted by Horowitz in his blog; "During the process of creation in this our arduous time of sharp shifting events, time of despear *[sic]* and hope, time of continual torments, of tention *[sic]* and

at last cessation, relief, my [sic] be all those repercussions have left traces, stamped the character of this Symphony."

7. Quoted in Anthony Linick, *The Lives of Ingolf Dahl* (Bloomington, IN: AuthorHouse, 2008), 175.

8. "Igor Stravinsky on Film Music: As Told to Ingolf Dahl," *Musical Digest* 28, no. 1 (September 1946): 4–5, 35–36, at 35.

9. David Raksin, "Hollywood Strikes Back: Film Composer Attacks Stravinsky's 'Cult of Inexpressiveness,'" *Musical Digest* 30, no. 1 (1948): 5–7; available online at www.filmmusicsociety.org/news_events/features/2003/102403.html.

10. Letter of 9 February 1948, quoted in Charles M. Joseph, *Stravinsky Inside Out* (New Haven, CT: Yale University Press, 2001), 129.

11. Victor DM-58, with Leopold Stokowski and the Philadelphia Orchestra (originally recorded in 1929).

12. They were omitted from the abridged translation by Rosa Newmarch (*The Life and Letters of Tchaikovsky*, originally published in 1908) and have never been available in English.

13. To mention just one item from a rapidly growing literature, see Joan Evans, "Stravinsky's Music in Hitler's Germany," *JAMS* 56 (2003): 525–94.

14. Nicolas Nabokoff, "Christmas with Stravinsky," in *Stravinsky*, ed. Edwin Corle (New York: Duell, Sloan & Pearce, 1949), 143.

15. Igor Stravinsky, *An Autobiography* (1936; New York: W. W. Norton, 1962), 53. The original French: "la musique, par son essence, est impuissante à *exprimer* quoi que ce soit."

16. Ibid., 53–54.

17. *MAD*, no. 33 (June 1957); see http://thatmansscope.blogspot.com/2011/11/none-of-which-could-be-identified.html.

18. Igor Stravinsky and Robert Craft, *Expositions and Developments* (Garden City, NY: Doubleday, 1962), 114–15.

19. Robert Schumann, *Neue Zeitschrift für Musik*, July–August 1835, quoted in Jonathan Kregor, *Liszt as Transcriber* (Cambridge: Cambridge University Press, 2010), 72.

20. See Sanna Pederson, "Defining the Term 'Absolute Music' Historically," *Music and Letters* 90 (2009): 240–62.

21. *Once at a Border*, film by Tony Palmer (1982).

22. This chapter began life as the keynote address at a conference, "Stravinsky: Between Emotion and Objectivity," sponsored by the Freie Universität, Berlin, in January 2012.

23. Gretchen Horlacher, *Building Blocks: Repetition and Continuity in the Music of Stravinsky* (New York: Oxford University Press, 2011), 137.

24. *Testimony: The Memoirs of Dmitri Shostakovich as Related to and Edited by Solomon Volkov* (New York: Harper & Row, 1979). To sample the controversies that have surrounded this book, one may consult Malcolm Hamrick Brown, ed., *A Shostakovich Casebook* (Bloomington: Indiana University Press, 2004).

25. Valérie Dufour, "La *Poétique musicale* de Stravinsky: Un manuscrit inédit de Souvtchinsky," *Revue de musicologie* 89 (2003): 373–92; idem, "Strawinsky vers Souvtchinsky: Thème et variations sur la *Poétique musicale*," *Mitteilungen der Paul Sacher Stiftung* 17 (March 2004): 17–23; Svetlana Savenko, "P. P. Suvchinskiy i 'Muzïkal'naya poètika' I. F. Stravinskogo," in *Pyotr Suvchinskiy e yego vremya*, ed. Alla Bretanitskaya (Moscow: Kompozitor, 1999), 276–82; Myriam Soumagnac, "Préface," in Igor Strawinsky, *Poétique musicale sous forme de six leçons* (Paris: Flammarion, 2000), 11–55.

26. Letter of 25 May 1939, quoted in Savenko, "P. P. Suvchinskiy i 'Muzïkal'naya poètika' I. F. Stravinskogo," 275.

27. See "Stravinsky's *Poetics* and Russian Music" in this collection.

28. W. K. Wimsatt Jr. and Monroe C. Beardsley, "The Intentional Fallacy," *Sewanee Review* 54, no. 3 (July–Sept. 1946): 468–88; reprinted in Wimsatt, *The Verbal Icon: Studies in the Meaning of Poetry*

(Lexington: University of Kentucky Press, 1954), 3–20, and endlessly anthologized thereafter. The interpretive fallacy the essay does address is that of invoking intentions not evident in or inferable from a given text but only in other authorial documents (sketches and drafts, letters, interviews, direct interrogation, whatever) or otherwise obtained information as a key to interpreting the text.

29. José Ortega y Gasset, "The Dehumanization of Art" (1925), in *The Dehumanization of Art and Other Essays on Art, Culture, and Literature*, trans. H. Weil (Princeton, NJ: Princeton University Press, 1968), 3–56; T. S. Eliot, "Tradition and the Individual Talent" (1919), in *Selected Prose of T. S. Eliot*, ed. Frank Kermode (New York: Harcourt Brace Jovanovich/Farrar, Straus & Giroux, 1975), 36–44; T. E. Hulme, *Speculations*, ed. Herbert Read (London: Kegan Paul, Trench, Trübner, 1924).

30. Igor Stravinsky, *Selected Correspondence*, ed. Robert Craft, vol. 1 (New York: Alfred A. Knopf, 1982), 330.

31. See Igor Stravinsky, *Selected Correspondence*, ed. Robert Craft, vol. 2 (New York: Alfred A. Knopf, 1984), 511.

32. Ortega y Gasset, *Dehumanization of Art*, 12.

33. Igor Stravinsky, "Some Ideas about My Octuor" (*The Chesterian*, 1924); reprinted in Piero Weiss and Richard Taruskin, eds., *Music in the Western World: A History in Documents*, 2nd ed. (Belmont, CA: Thomson/Schirmer, 2008), 390.

34. David Oppenheim, producer, "CBS News Special: Stravinsky," narrated by Charles Kuralt, first aired 3 May 1966.

35. *Bravo Stravinsky*, with photographs by Arnold Newman, text by Robert Craft, foreword by Francis Steegmuller (Cleveland: World Publishing Co., 1967), 112; reprinted with minor changes in Igor Stravinsky, *Themes and Conclusions* (London: Faber & Faber, 1972), 98.

36. On Penderecki, see Ludwik Erhardt, *Spotkania z Krzysztofem Pendereckim* (Warsaw: Polskie Wydawnictwo Muzyczne, 1975), where it was first revealed that Penderecki's *Tren ofiarom Hiroszimy* (*Threnody for the Victims of Hiroshima*, 1961) was originally titled *8'37"* à la Cage and only given the politically fraught title that made it (and him) famous at the suggestion of the director of the Polish Radio, after it had been rejected by the state publishing house. On Schnittke, see Peter J. Schmelz, "Alfred Schnittke's *Nagasaki*: Soviet Nuclear Culture, Radio Moscow, and the Global Cold War," *Journal of the American Musicological Society* 62 (2009): 413–74.

37. See Stravinsky, *Themes and Conclusions*, 26–7.

38. Nabokov, "Christmas with Stravinsky," 142. *Tchinovnik*, in prerevolutionary Russian, meant a civil servant (who was always referred to by his rank, or *tchin*) or, more commonly, a bureaucrat.

39. T. E. Hulme, "Romanticism and Classicism" (1911), in *Speculations*, 126–27.

40. Vera Stravinsky and Robert Craft, *Stravinsky in Pictures and Documents* (New York: Simon and Schuster, 1979), 164.

41. *Les nouvelles littéraires*, 8 December 1928, quoted ibid.

42. Daniel Albright argues emphatically that Stravinsky never shared Andersen's outlook on the content of his tale, in a book that borrows its title from a remark of Baudelaire's ("J'aime mieux une boîte à musique qu'un rossignol") that Stravinsky happened to quote—à propos Messiaen, whose music he (or Craft) wished that day to despise—in one of his very late "interviews" (first published in *Commentary* magazine); see D. Albright, *Stravinsky: The Music Box and the Nightingale* (New York: Gordon & Breach, 1989), 23. This seems to me a prime example of reading the neoclassical Stravinsky's esthetics back onto his earlier work.

43. See Benjamin Zander, "Righting *The Rite*," at http://benjaminzander.com/recordings/boston-philharmonic/rite-of-spring/review/128.

44. In the *New York Times Magazine*, 18 January 1925, Stravinsky praised the pianola's "unplumbed possibilities" for "polyphonic truth"; quoted in *Stravinsky in Pictures and Documents*, 164.

45. For fuller discussion of these points, see "Resisting *The Rite*" in this collection.

46. Reissued on vinyl LP as Angel Seraphim 60183 and on CD in the set *Stravinsky: The Recorded Legacy* (Sony Classical BMG 88697 103112 [1991]).

47. As it is in a recording that may be sampled at www.youtube.com/watch?v=Ssi4HE64Deo&feature=results_video&playnext=1&list=PLBF93ACED1338FF5F.

48. Letter to Nikolai Myaskovsky, in *S. S. Prokof'yev i N. Ya. Myaskovskiy: Perepiska*, ed. M. G. Kozlova and N. R. Yatsenko (Moscow: Sovetskiy kompozitor, 1977), 195.

49. Ditta Pasztory Bartók, letter to Paula Voit Bartók, 18 March 1926, trans. David E. Schneider, in D. Schneider, "Bartók and Stravinsky: Respect, Competition, Influence, and the Hungarian Reaction to Modernism in the 1920s," in *Bartók and His World*, ed. Peter Laki (Princeton, NJ: Princeton University Press, 1995), 184.

50. László Somfai, "Nineteenth-Century Ideas Developed in Bartók's Piano Notation in the Years 1907–14," *19th-Century Music* 11 (1987–88): 75.

51. Stravinsky, "Some Ideas about My Octuor," 389.

52. Somfai, "Nineteenth-Century Ideas," 90. The characterization as shorthand is from Somfai's paper "Critical Edition with or without Notes for the Performer," delivered orally at the conference "Scholarly Research and Performance Practice in Bartók Studies: The Importance of the Dialogue," Szombathely, Hungary, 16 July 2011.

53. Stravinsky, "Some Ideas about My Octuor," 389–90.

54. Igor Stravinsky, *Poétique musicale, sous forme de six leçons*, bilingual ed. (Cambridge, MA: Harvard University Press, 1970), 161, as translated by Arthur Knodel and Ingolf Dahl; the original French (facing on 160): "Fixée sur le papier ou retenue par la mémoire, [la musique] préexiste à son execution, différente en ceci de tous les autres arts, de même qu'elle s'en distingue, comme nous l'avons vu, par les modalités qui président à sa perception."

55. Ibid., 160–63:

Le langage musical est strictement limité par sa notation. L'acteur dramatique se trouve ainsi beaucoup plus libre à l'égard du *Chronos* et de l'intonation que le chanteur, lequel est étroitement soumis au *tempo* et au *mélos*.

Cette sujétion, dont s'impatiente si souvent le cabotinage de certains solistes est au coeur de la question que nous nous proposons de traiter maintenant: celle de l'exécutant et de l'interprète.

La notion d'interpétation sous-entend les limites qui sont imposées à l'exécutant ou que celui-ci s'impose à lui-même dans son exercice propre, qui revient à transmettre la musique à l'auditeur.

La notion d'exécution implique la stricte réalisation d'une volonté explicite et qui s'épuise dans ce qu'elle ordonne.

Le conflit de ces deux principes—exécution et interpretation—est à la racine de toutes les erreurs, de tous les péchés, de tous les malentendus qui s'interposent entre l'oeuvre et l'auditeur, et qui altèrent la bonne transmission du message.

56. Ibid., 164–65: "Le péché contre l'esprit de l'oeuvre, commence toujours par un péché contre la lettre et conduit à ces éternels errements qu'une littérature du pire goût et toujours florissante s'ingénie."

57. Ibid.: "Entre l'exécutant purement et simplement pris comme tel et l'interprète proprement dit, il existe une différence de nature qui est d'ordre éthique plutôt que d'ordre esthétique et qui pose un cas de conscience: théoriquement, on ne peut exiger de l'exécutant que la traduction matérielle de sa partie qu'il assurera de bon gré ou de mauvaise humeur, alors qu'on est en droit d'obtenir de l'interprète, outre la perfection de cette traduction matérielle, une complaisance amoureuse—ce qui ne veut pas dire une collaboration subreptice ou délibérément affirmée."

58. Ibid., 168–71:

Et nous voici revenus au grand thème de la soumission que nous avons si souvent évoqué au cours de nos leçons. Cette soumission exige une souplesse qui requiert elle-même, avec la maîtrise technique, un sens de la tradition et, brochant sur le tout, une culture aristocratique qui n'est pas entièrement susceptible d'acquisition.

Cette soumission et cette culture que nous exigeons du createur, il est bien juste et natural de l'exiger aussi de l'interprète, [qui] en trouver[ait] d'ailleurs la liberté à l'extrème de la rigueur et, en dernière analyse, sinon en première instance, le succès—la vrai succès, recompense légitime des interprètes qui, dans l'expression de la plus brillante virtuosité, conservent cette modestie du geste et cette sobriété de l'expression qui est la marquee des artistes de race.

59. See, in particular, "Turania Revisted, with Lourié My Guide" (essay 8 in this volume), where the principle of submission is identified with a specific strain of "Eurasianist" thought endemic to the Russian interwar diaspora.

60. Stravinsky, *Poétique musicale*, bilingual ed., 164–65:

Moyennant quoi le *crescendo* commande toujours, comme on sait, l'accélération du mouvement, tandis qu'un ralentissement ne manqué jamais d'accompagner le *diminuendo*. On raffine sur le superflu; on recherché délicatement le *piano, piano pianissimo*; on se fait gloire d'obtenir la perfection des nuances inutiles—souci qui va généralement de pair avec un mouvement inexact....

Autant de pratiques chères aux esprits superficiels, toujours avides et toujours satisfaits d'un succès immédiat et facile qui flatte la vanité de celui qui l'obtient et pervertit le goût de ceux qui l'applaudissent.

61. For persuasive confirmation of its reality based on evidence from sound recordings, and a feisty defense of its integrity, see Will Crutchfield, "Brahms, by Those Who Knew Him," *Opus* 2, no. 5 (August 1986): 12–21, 60.

62. Cf. exx. 1 and 3 and pls. 1–4 in Somfai, "Nineteenth-Century Ideas Developed in Bartók's Piano Notation."

63. Virgil Thomson, "On Being American," *New York Herald Tribune*, 25 January 1948.

64. Arnold Schoenberg, "Today's Manner of Performing Classical Music" (1948), in idem, *Style and Idea*, ed. Leonard Stein (Berkeley: University of California Press, 1984), 320–21.

65. Like the rest of the Bartók performances discussed here, this recording was included in the enormous centenary collection issued by Hungaroton in 1981: LPX 12334–38.

66. It has been reissued at least twice on CD: in Sony Classical's omnibus 22-disc Stravinsky box set (see note 46 above) and in Andante set RE-A-1100 (*Igor Stravinsky: Composer and Performer*, vol. 2 [2003]). Also available (as of July 2014) at www.youtube.com/watch?v=lPoLj41Kjno.

67. Rex Lawson, "Stravinsky and the Pianola," in *Confronting Stravinsky: Man, Musician, and Modernist*, ed. Jann Pasler (Berkeley: University of California Press, 1986), 286.

68. Igor Stravinsky, "Quelques confidences sur la musique," Conférence de M. Igor Strawinsky faite le 21 novembre 1935 à 2 h. 45, répété le même jour a 5 h. et le 22 novembre, *Conferencia*, Journal de l'Université des Annales, 15 December 1935; reprinted in White, *Stravinsky*, 539:

Le temps limité dont je dispose m'empèche de vous donner une analyse technique de mon concerto. Quant à des commentaires extramusicaux, de moi, vous n'en attendez pas, j'espère. Je serais vraiment bien embarrassé de vous en fournir.

Il y a différentes manières d'aimer *et d'apprécier* la musique. Il y a, par exemple, la manière que j'appellerai l'amour intéressé, celle où l'on demande à musique des émotions d'ordre général, la joie, la douleur, la tristesse, un sujet de rêve, l'oubli de la vie prosaïque. Ce serait déprécier la

musique que de lui assigner un pareil but utilitaire. Pourquoi ne pas l'aimer pour elle-même? Pourquoi ne pas l'aimer comme on aime un tableau, pour la belle peinture, le beau dessein, la belle composition? Pourquoi ne pas admettre la musique comme une valeur en soi, indépendante des sentiments et des images que, par analogie, elle pourrait évoquer, et qui ne sauraient que fausser le jugement de l'auditeur? La musique n'a pas besoin d'adjuvant. Elle se suffit à elle-même. N'y cherchons donc pas autre chose que ce qu'elle comporte.

Rien n'est plus difficile que de parler musique. On ne peut le faire utilement qu'en se plaçant sur le terrain technique et professionel. Dès qu'on abandonne ce terrain, on plonge dans le vague et . . . l'on divague.

Un grand romantique, Robert Schumann, qui a beaucoup écrit et profondément réfléchi sur la musique et qu'on ne saurait en aucune façon accuser d'aridité ou de doctrinarisme, finit par déclarer qu'en musique rien ne peut être prouvé.

"La science," dit-il, "s'appuie sur les mathématiques et la logique, la poésie sur la parole, les arts plastiques sur la nature, mais la musique est une orpheline dont personne ne saurait nommer ni le père ni la mère. Et c'est peut-être dans ce mystère de son origine," ajoute-t-il, "que réside l'attrait de sa Beauté."

Après cela, il vaut mieux me taire et me mettre au piano.

69. Paul Zukofsky: "The Performer: Revitalization or Stagnation?" *Perspectives of New Music* 3, no. 2 (Spring–Summer 1965): 172–73.

70. Aaron Copland, quoted in Edward T. Cone, "Conversation with Aaron Copland," *Perspectives of New Music* 6, no. 2 (Spring–Summer 1968): 70. Note that Copland's remark appeared in the same journal as did Zukofsky's, a few issues later, perhaps even in response.

71. For an attempt to navigate it, see R. Taruskin, *Text and Act* (New York: Oxford University Press, 1995), in which these questions, including an evaluation of the same performances of Mozart by teams of Bartóks and Stravinskys, is placed in a large context of performance practice and its theories.

72. László Somfai, "Marginal Notes to the Piano Recordings in the Bartók Archives," trans. Rudolf Fischer, booklet accompanying Hungaroton LPX 12334–38 (1981), 29.

73. Michael Oliver, "Neo-Classical Stravinsky," booklet essay for Andante RE-A-1100 (*Igor Stravinsky: Composer and Performer*, vol. 2 [2003]).

74. See Taruskin, *Text and Act*, 253.

75. Ben Johnston, "An Interview with Soulima Stravinsky," in "Stravinsky: A Composers' Memorial," *Perspectives of New Music* 9, no. 2–10, no. 1 (1971): 15–16. That Town Hall concert included a performance of the Concerto for Piano and Winds that was recorded by RCA Victor and issued in 1949 as LM 7010.

76. Ibid., 18.

77. It is essay 17 in this volume ("Stravinsky's *Poetics* and Russian Music").

78. *Once at a Border* (Palmer film).

79. Richard Leacock and Rolf Liebermann, A Stravinsky Portrait (New York: Pennebaker Hegedus Films, 1965; restored and remastered 2011); snatches are available at www.youtube.com/watch?v=f5TEg8 bFC3A&list=PL3DC6D7CC42C1AC68&index=11 and at www.youtube.com/watch?v=JTAvIORDCnU.

80. Cf. the title of the book referenced in note 67 above.

19

In Stravinsky's Songs, the True Man, No Ghostwriters

No composer of classical music was ever more attuned to the power of publicity, or courted it more ardently, than Igor Fyodorovich Stravinsky. A celebrity by the age of thirty, he learned the art of *réclame* from his early mentor Sergei Diaghilev, the master press manipulator of his day. The earliest "typical" Stravinsky interviews—charming, crafty, hyperarticulate, unerringly self-serving—appeared in the St. Petersburg newspapers in 1912, and the stream, or torrent, continued unabated for nearly six decades, in dozens of languages and on every continent save Antarctica. By the end of his life, the composer quipped that he was living in a perpetual state of interview. The last of them appeared—in the *New York Review of Books* on July 1, 1971—almost three months after his death.

By then it was an open secret that Stravinsky's public words had long been ghosted by his close associate (and, as he likes to say, "famulus"), the conductor Robert Craft, who kept the words coming long after Stravinsky's physical infirmities precluded his actually participating in their collaboration. Mr. Craft actually admitted it, sort of—though, as always, over Stravinsky's signature—in the Author's Foreword to *Themes and Conclusions,* a miscellany of writings attributed to Stravinsky that appeared in England in 1972. "The balance between my income and my needs," wrote the ghost, "has, for a decade or more, rested on the 'deductibility' of the latter; and my deductibility 'status' has depended, in turn, on the production, if not of music, then, *faute de mieux,* of words. For to write, in America, is to 'write-off.'" But Robert Craft was only the caboose in a long train of Stravinskian

Written as a concert promo and published in the *New York Times,* 13 April 2008, Arts and Leisure, 29, 34; reprinted as "Stravinsky's Songs" in *St. Petersburg Times* (Russia), 18 April 2008.

ghostwriters. Others included Walter Nouvel, an associate of Diaghilev, who wrote Stravinsky's *Autobiography*; Alexis Roland-Manuel, a French composer, and Pierre Souvtchinsky, a Russian émigré intellectual, who together wrote Stravinsky's Harvard lectures, *Poetics of Music*; and Mercedes de Acosta, Alexis Kall, and Arthur Lourié, who at various times played the roles Robert Craft later permanently took on.

Surely it is obvious that the deluge of verbiage was meant to hide the man from the world rather than to expose him. Stravinsky, whose music waged unending war on the assumption that art was a medium of self-revelation, hugely enjoyed the game of misleading the curious. One of his favorite ploys was to plant a "fact" or manufacture a recollection that would send program annotators afield. Asked by Mr. Craft in a mock-interview published in 1960, "What do you love most in Russia?" Stravinsky answered, "The violent Russian spring that seemed to begin in an hour and was like the whole earth cracking." It's a sentence that has been recycled, as planned, in at least a gazillion essays on the composer's violent balletic masterpiece, *The Rite of Spring*. (Google just yielded up fifty-seven.) The very first memory recorded in the ghosted autobiography of 1936 was of "an enormous peasant seated on the stump of a tree" who sang a song "composed of two syllables" that were "devoid of any meaning, but he made them alternate with incredible dexterity in a very rapid tempo," accompanying them with his right hand, which, placed under his left armpit, produced "a succession of sounds which were somewhat dubious but very rhythmic, and which might be euphemistically described as resounding kisses." Anyone care to guess how many learned disquisitions on Stravinsky's devotion to "pure music" or his "liberation of rhythm" this morsel has unleashed? One is reminded of the zoo: the keeper digs into his pail and flings a bit of pseudo-biographical fishmeat at the crowd of barking, flipper-flapping (that is, pen-pushing) seals.

And yet an unprejudiced listener can circumvent the plants, the ghosts, and the recyclers, and learn a great deal about Stravinsky from his music, especially in programs, like the one coming Thursday at the Morgan Library's Gilder Lehrman Hall, in which five singers, accompanied by Steven Osgood and the International Contemporary Ensemble, will lay out Stravinsky's complete output of songs. For in that lifetime of work there lurks, inevitably, a true—if partial and implicit—autobiography.

Solo song was not a major genre for Stravinsky, and that is precisely what makes it possible to present a full, fascinating retrospective in a single evening. That paucity is a telling fact in itself: when we think of art song, we think of lieder, preeminently the genre of intimate disclosure, and intimate disclosure (as we've been noticing) was anything but Stravinsky's bag. Besides, his father, Fyodor Ignatievich Stravinsky—a stern, unbending figure toward whom the future composer harbored feelings far more complicated than the Freudian minimum—was a famous

singer. Any wonder, then, that Stravinsky became the greatest of all composers of ballet: the one music-theatrical genre that excludes singers? Or that, when he finally did write a great opera, it would be about King Oedipus?

Skimpy though it is, the list of Stravinsky's songs is unusually comprehensive. It covers all phases of his career and includes both his earliest extant work and his last finished composition. The early item, "Storm Cloud," was composed in 1902 on assignment for Fyodor Akimenko, a pupil of Stravinsky's eventual teacher, Nikolai Rimsky-Korsakov, to whom Stravinsky was at first farmed out for preliminary (actually remedial) instruction. It is a thoroughly conventional setting of a short poem by Pushkin, the sort of piece every fourteen- or fifteen-year-old composer-in-training turns out. Only Stravinsky wrote it at nineteen. A wunderkind he was not.

The last piece, a past-masterly setting of Edward Lear's "The Owl and the Pussycat," was composed nearly sixty-five years later, in the fall of 1966, and is lovingly dedicated to the composer's second wife, Vera, who had learned the poem when studying English. Like all the music Stravinsky composed in the last two decades of his life, it employs the twelve-tone technique. Perhaps unexpectedly, the piece is anything but forbidding. It is not even dissonant, its tone row having been calculated to yield up pretty harmonies. The piano part, easy enough for a nonpianist to play, was actually played by Robert Craft in its first recording, making the piece doubly an intimate family portrait.

That intimate portrait has many earlier counterparts among Stravinsky's songs. The second in order of composition, "How the Mushrooms Prepared for War," is a setting of a nursery rhyme every Russian child of Stravinsky's generation knew by heart, cast with hilarious incongruity as a huge concert aria for bass voice. It turns out to be a salad of allusions to Fyodor Stravinsky's favorite opera roles, composed in memoriam in 1904 and dedicated to the composer's then best friend, Andrey Rimsky-Korsakov, a son of Stravinsky's surrogate father. One gathers its sentimental significance from the fact that Stravinsky kept the manuscript with him throughout his life but never published it—indeed, never quite finished it. It was reassembled from two incomplete drafts by the composer's son Soulima, who had it published by Boosey and Hawkes in memoriam in 1979, thus repeating the gesture of homage an ambivalent Stravinsky son paid to an illustrious, loved, but also resented Stravinsky father.

Complex family relations inform the next Stravinsky vocal opus as well: a little cycle called "The Faun and the Shepherdess," based on a set of erotic poems by Pushkin. It was conceived during the composer's honeymoon with his first wife (and first cousin), Catherine, whom he betrayed (but never forsook) for Vera eighteen years before death did them part. Though listed as opus 2, it was Stravinsky's first published composition. The first edition (1908) carried a dedication to Catherine that was removed on reprinting (by the same publisher, which means

Stravinsky must have requested the omission). There are also songs dedicated to each of the composer's children. Most poignant is a lullaby composed in 1917 for his daughter Ludmila (or Mikushka, as the endearing text calls her), who died of tuberculosis, aged twenty-nine, in 1938. It was published (as "Berceuse," with a French text replacing the original Russian) only in 1962, in the appendix to one of Stravinsky's books of memoirs as dictated to Robert Craft.

Besides these family glimpses, Stravinsky's solo songs include elegiac settings of verses by Dylan Thomas in memory of the poet, who at the time of his death in 1953 was planning to collaborate with Stravinsky on an opera, and by W. H. Auden in memory of John F. Kennedy. There are settings of Russian symbolist poetry of a kind that every Russian composer was setting in the period before the First World War. There are imitations of Debussy in the form of a pair of Verlaine settings made in 1910, right after meeting the great French composer following the première of *Firebird*, Stravinsky's first ballet, and settings of Japanese poetry in Russian translation that show the dual influence of Stravinsky's new French friends with their passion for *japonaiserie* and of Schoenberg, whose "Pierrot lunaire" provided the immediate model. A more significant influence from Schoenberg, of course, can be seen in Stravinsky's late conversion to serial techniques, of which "Three Songs from William Shakespeare," composed in 1953, was a harbinger.

These are all minor works. But there is one spate of songs that, taken collectively, mark a major watershed in Stravinsky's musical development. These are the four sets—*Pribaoutki* (Jingles), *Berceuses du chat* (Cat's Lullabies), *Trois histoires pour enfants* (Three Children's Tales), and *Quatre chants russes* (Four Russian Songs)—that he composed in Switzerland during and immediately after World War I. They have French or French-transliterated titles because they were published by a Geneva printer with French texts by the novelist Charles-Ferdinand Ramuz, and they were the work of a stateless person, but they are the most intensely Russian pieces Stravinsky (or, arguably, anyone) ever composed.

Intensely homesick and imbued with a nationalist fervor he had never felt at home, Stravinsky became obsessed with Russian folk verses of a kind that had been published in quantity by nineteenth-century ethnographers but had never been of much interest to composers of art songs because they were, well, artless. But Stravinsky, inspired by the work of the painters associated with Diaghilev, who found not only subject matter but also stylistic models in folk art, saw in Russian folk verses the foundations of a far more authentically Russian art music than his teacher's generation had achieved.

The consummation of this quest was *Svadebka* (or *Les noces*), Stravinsky's choral ballet recreating a Russian peasant wedding, thought by some (well, by me) to represent the composer's absolute summit of achievement. The songs, written on the way to that towering work, were successful enough as imagined folklore to convince Béla Bartók that they were based on genuine Russian folk melodies.

Actually, only one tune in all the songs (the first in the *Pribaoutki*) was "genuine," that is, found in a book. That Stravinsky managed to take in a connoisseur like Bartók shows he had learned to make up rather than look up genuine folk melodies. One of the ways he did this was to notice that the verbal accent in Russian folk singing was movable. It could fall on any syllable of any word, leading to all kinds of "wrong" accentuations that produced delightful rhythmic and metrical effects. Stravinsky's account of these effects in his autobiography, as told to Nouvel, immediately preceded, and inspired, the famous declaration there that the true value of music was not to be sought in its expressive dimension but in the sound patterns. No public words of Stravinsky's were ever more potent, more overstated, or more thoroughly misconstrued. To realize what he meant, one need only compare the enchanting songs of the "Swiss" years, based on distorted folk texts (some of them unintelligible even to their collectors), with the composer's conventionally expressive and (say it softly) rather pallid earlier songs. All of a sudden, as audiences on Thursday will hear, Stravinsky's music springs from watery pastels into blazing Technicolor.

Stravinsky continued to set words this way for the rest of his life. In languages other than Russian, his willful misaccentuations are often taken as errors. (Rarely does any reviewer of *The Rake's Progress* refrain from setting the poor old Russian straight about English pronunciation.) But in Stravinsky's manhandling of words he asserted the sovereign power of music, and he did it first in his songs.

20

"Un Cadeau Très Macabre"

"Un cadeau très macabre"—a very morbid gift—is what Sergey Diaghilev, the Ballets Russes impresario, called Stravinsky's *Oedipus Rex*, on being presented with it in 1927 on the twentieth anniversary of his earliest musical season in Paris.[1] Stravinsky had ample reason for celebrating along with Diaghilev, because the Ballets Russes had been the launching pad from which his own spectacular career had taken off. But in its austerity, its asperity, its severity, *Oedipus Rex* clashed stridently with the gaudy, luxurious ballets that had made Stravinsky's and Diaghilev's reputations before the Great War. And a friezelike opera-oratorio, in which the characters in a tragedy stand paralyzed like statues on stage by the composer's express command, is the very last thing one would expect a ballet company to mount. In *Oedipus Rex*, nobody moves.

And yet the Diaghilev company did perform the work—frankly as an oratorio, with no staging at all—on 30 May 1927. It was Stravinsky's last Ballets Russes première. *Apollon musagète*, the next season, was not a world première, only a European première, the work having been previously performed in Washington, DC, at the Library of Congress, according to the terms of its commissioning by Elizabeth Sprague Coolidge. And the season after that, in which there were no Stravinsky premières, was Diaghilev's last. He died, in Venice, on 19 August 1929, at the age of fifty-seven, the victim of undiagnosed diabetes. Macabre indeed.

Delivered at a conference organized around the Canadian Opera Company's production "Oedipus Rex with the Symphony of Psalms" in October 2002; published in the *University of Toronto Quarterly* 72 (2003): 801–16.

But the work itself, not merely its circumstances, was inherently morbid, for it was one of the most prominent early "thematizations," as we would now say (at least in the classroom, where nobody is listening), of what W. H. Auden, a later Stravinsky collaborator, called "the modern problem"—the problem of being "no longer supported by tradition without being aware of it."[2]

Not being able to take tradition and its validating support for granted, modern artists (including those who now prefer to call themselves postmodern) are self-conscious to an unprecedented degree. The failure of unconscious tradition leads to conscious obsession with history—an obsession just as strong in those who flout traditions as it is in those who uphold them, for rejection and advocacy alike are by definition conscious acts, acts of conscience.

The roots of "the modern problem" go back to the dawn of Romanticism, when people (and peoples) first became conscious of their unique identities—as something desirable, anyway—and artists came to see the expression of their individuality as their mission. (Remember Rousseau's *Confessions?* "If I am not better, at least I am different"[3]—and so worth writing and reading about.)

Those are the roots. But the "problem" became a problem after the First World War—simply "the Great War" until there was a second one—the great revolutionary conflagration that doomed the ancient dynasties of Europe. It sheared the past, with all its traditions, off from the present irrevocably, and left the European world in chaos—palpable political and economic chaos that destroyed societies. That, it seemed to many, was the legacy—no, the curse—of Romantic individualism. As Don Alhambra put it in *The Gondoliers,* when it was still possible to joke about such things: "When everyone is somebodee, / Then no one's anybody!"

We are familiar enough with the political and economic reaction to this great loss of order. Whatever else the totalitarian ideologies of the new Europe may have been, however the proponents of the swastika and hammer and sickle may have clashed in their rhetoric, they were united in backlash against the arrogant individual, whose hubris had brought disaster. It is less common now to note the parallel with postwar esthetics, but at the time it was drawn explicitly enough. "It was romanticism that made the revolution," wrote the English critic T. E. Hulme, who barely lived to see the Russian one (he died on the Flanders battlefield in 1917); "they who hate the revolution hate romanticism."[4]

Igor Stravinsky, scion of a noble Russian family, saw the Russian one, all right, and the Bolshevik coup that followed. It was the latter that uprooted him, impoverished him, and made him hate Romanticism. In the decade of the 1920s he became arbiter supreme of that authoritarian and reactionary stance we now call neoclassicism. Stravinsky did not call it that at first. Paradoxically, he called it "antimodernism." During his first American tour, in 1925, the composer of the proverbially revolutionary *Rite of Spring* loved to shock reporters by saying, "Modernists Have Ruined Modern Music," to quote the banner of a typical interview (in *Musical*

America). He went on, pointedly: "The modernists set out to shock the bourgeoisie, sometimes they succeed only in pleasing the Bolshevists. I am not interested in either the bourgeoisie or the Bolshevists."[5] Spoken like a true aristocrat—an aristocrat not only of taste but of actual blood, colored blue.

The chief target of Stravinsky's down-with-modernism interviews was the unnamed but unmistakable Arnold Schoenberg, who had brought the German Romantic phase to its final shriek in his expressionist monodrama *Erwartung*, which Stravinsky knew only by reputation if at all, and in that ironic but disquieting study of morbid subjectivity known as *Pierrot lunaire*, which Stravinsky heard in Berlin in 1912 as the composer's guest, and which he compared in his autobiography to the decadent drawings of Aubrey Beardsley.[6] To Stravinsky, Schoenbergian atonality now looked like the exact analogue to the mess the world was in.

In the words of his disciple and assistant Arthur Lourié, an early Soviet defector who played a role in Stravinsky's life between the wars comparable to that played later by Robert Craft, Stravinsky now became a sort of musical Mussolini: "the dictator of the reaction against the anarchy into which modernism degenerated."[7] Stravinsky's high regard for, and friendly relations with, the actual Mussolini of politics is no longer such a secret. Right before an audience with Il Duce in 1930, Stravinsky told a Rome newspaperman: "I don't believe that anyone venerates Mussolini more than I. To me, he is *the one man who counts* nowadays in the whole world. I have traveled a great deal: I know many exalted personages, and my artist's mind does not shrink from political and social issues. Well, after having seen so many events and so many more or less representative men, I have an overpowering urge to render homage to your Duce. He is the savior of Italy and—let us hope—the world."[8]

Don't be too shocked if this is the first you've heard of Stravinsky's political sympathies between the wars. Enthusiasm for Mussolini or a profession of fascist sympathies in the 1920s should not be confused with what a similar enthusiasm for Hitler, or a similar profession, would have implied a decade later, let alone two. In the decade and a half between his rise to power and the establishment of the Rome-Berlin Axis, Mussolini had many enthusiasts, among them Wallace Stevens, Bernard Shaw, even Winston Churchill. The version of the Cole Porter song "You're the Top" that Londoners heard in 1935 included the lines, "You're Mussolini, you're Mrs. Sweeney, you're camembert!" (The original American lines were "You're an O'Neill drama, you're Whistler's Mama, you're camembert!") It wasn't until he invaded Ethopia later that same year, 1935, that Mussolini began looking like a bad boy.

But there is no point in minimizing Stravinsky's politics, either, because it provides a necessary subtext to his art of the period. It is tempting to write it off as typical artistic irresponsibility, but it had a serious side. Let us concede that the neoclassical Stravinsky wanted to do for modern music what Il Duce promised to do for modern Europe: bring back order, bring back stability, bring back "traditional values" that

transcended individuals. And for music that meant bringing back Bach—Bach, that is, as he was then understood: not the great religious dramatist or the poet of the affections one encounters in the Passions and the cantatas, but rather the Bach one encountered at the keyboard, the fount of elite discipline and impersonal craft. (The joke, of course, was that, unbeknownst to Stravinsky, his *bête noire* Schoenberg had joined the same postwar reaction. The early twelve-tone pieces, through which Schoenberg was attempting to reintroduce rigorous order into atonality, were cast in the form of baroque dances—minuets, gavottes, and gigues.)

Thus, both the style of Stravinsky's music of the first unsteady postwar decades ("Bach with smallpox," in the words of the unconvinced Prokofieff, who would soon make his peace with the Bolsheviks)[9] and Stravinsky's famous anti-Romantic polemics ("Music is, by its very nature, essentially powerless to *express* anything at all")[10] were part of the same reaction, the same vicarious Restoration. It was inevitable that, in his effort to restore order and class, this refugee from the turbulent East would eventually push back to the classics themselves, to the serene foundations of "Western civilization"—and declare himself the bearer of their tradition. As Mussolini sought to resurrect the grandeur that was Rome, Stravinsky sought the glory that was Greece.

Between January 1926 and January 1928, Stravinsky created his two emblematic neoclassical scores: the gentle, nostalgic ballet *Apollon musagète* ("Apollo, Leader of the Muses," now known, thanks to its second choreographer—Georgiy Melitonovich Balanchivadze, far better known as George Balanchine—simply as *Apollo*) and the forbidding, magisterial opera-oratorio *Oedipus Rex*. Like most of Stravinsky's output in those days, both works were at once artistic offerings and political manifestos.

Half a century after Nietzsche's *Birth of Tragedy*, no one could think of Apollo, the sun god, except as the antonym of Dionysus, the wine god. The one stood for the light of reason, the other for dark passion. Apollo versus Dionysus was first of all Music versus Drama, thence stasis vs. flux, beauty vs. frenzy, purity vs. mixture, repose vs. desire, containment vs. expression. Decoded, it was Classicism vs. Romanticism: as Stravinsky's old mentor and collaborator, the painter and art historian Alexandre Benois, once wrote, the art of the nineteenth century had been "one great slap in the face of Apollo."[11] Or rather, that *was* the code for an antiegalitarian message more safely insinuated by the example of artistic excellence than proclaimed.

And what an example Stravinsky set with his miraculously poised composition for strings, symbolizing Apollo's lyre. It epitomized "exquisite care in craftsmanship, elegant spareness, historic obligation and humane responsibility," in the words of Lincoln Kirstein, the co-founder with Balanchine of the American Ballet School and the New York City Ballet, who did not mind proclaiming the elitist message.[12] And Balanchine, who did *Apollon musagète* for Diaghilev at the very

outset of his career, learned from it, by his own later confession, the most important lesson he ever received: "In its discipline and restraint, in its sustained oneness of tone and feeling the score was a revelation. It seemed to tell me that I could dare not to use everything, that I, too, could eliminate."[13]

As for *Oedipus Rex*, it was the first opera in which Stravinsky, having renounced his Russian nationality, renounced the Russian language as a medium for his music. Instead, as a metaphor of the "universality" of the traditions he now wished to embrace and (if he could) dominate, he composed the opera on a "universal" myth, and in Latin, a "universal" and "classical" language, "not dead," as Stravinsky put it, "but turned to stone."[14] Nothing better symbolizes the thirst for monumentality that seized so many artists in the confusing decade that followed the Great War than that lapidary metaphor.

He probably chose Latin over the original Greek of Sophocles, whose tragedy was the libretto's chief source text, because, unlike Greek, it signified religious ritual to contemporary Europeans, especially the Roman Catholics among them, and this further emphasized notions of universality and authority. Stravinsky turned to Jean Cocteau, who had been clamoring to collaborate with him since 1914, for a radically scaled down condensation of the Sophocles text. Poor Cocteau had to rewrite the thing three times before Stravinsky was satisfied that it was sufficiently ceremonious and rigid to merit the designation "opera-oratorio."[15] (Material from the rejected drafts later went into Cocteau's play *La machine infernale* [The Infernal Machine].) Next it was translated into Latin by a Jesuit priest (later a cardinal) named Jean Daniélou, who was then studying for a doctorate in theology at the Sorbonne.

The fact that the language was unintelligible to modern audiences anywhere in the world did not worry Stravinsky. He solved the problem, at least to his own satisfaction, by having Cocteau furnish a hideous little précis of the action—haughty, coyly simplified summaries of each scene for the edification of "the vulgar"— that could be announced to the audience by a narrator-interpreter (identified in the score as "Le Speaker") in the language of the country where the opera was performed.

There could hardly be any greater "distancing" of a drama than that. In its dire renunciation of the transparent conventions of realistic (or rather "illusionist") theater, and its installation in their place of such a set of conspicuously artificial conventions, *Oedipus Rex* has often been compared with the contemporaneous didactic "epic theater" of Bertolt Brecht. But a far better comparison would be the so-called liturgical dramas of the Middle Ages. Stravinsky's strange methods made the same assumptions as did the methods of medieval ritual drama. Their subjects, biblical stories and myths, were well-known stories; nobody, Stravinsky could reasonably suppose, would go to see an *Oedipus* opera for the plot. In that sense attending a mythological opera really was, or could be, like attending a reli-

gious service. It provided an occasion for an audience to come together in worship: not of God, precisely, in this case, but of an artifact of "universal" culture that bore a "universal" message.

But what *was* that message? By the time Stravinsky wrote his opera, the myth of Oedipus, the tale of a ruler who unwittingly kills his father and marries his mother, was well on its way to being appropriated and transformed by Sigmund Freud and his followers in psychoanalysis into an allegory of family relationships and the guilt anxieties they produce in modern men. For the Greeks, especially as embodied in the tragic text of Sophocles, it was an allegory of fate, or nemesis, which took revenge on the great and powerful king by revealing to him the horrible and unacceptable circumstances of his ascent to the throne: a "classic" case of skeletons in the closet and a chilling reminder that good fortune is precarious and provisional. Because he must acknowledge crimes he has unwittingly committed, the lofty Oedipus is cast down. Sophocles's chillingly memorable last line, spoken by the moralizing Greek chorus, exhorts the audience to "count no mortal happy till he has passed the final limit of his life secure from pain."[16]

For Stravinsky, the play was less a "family romance" or a parable of fate than a timely allegory of insubordination and submission. It is not fate but rather Oedipus's pride—standing for all human pride in a world that was not made by man, or for him—that brings him down, for it causes him to tempt fate and pursue dangerous knowledge. To symbolize and ratify the offended universal order, Stravinsky resurrected in glory every stiff traditional convention of the eighteenth-century musical stage (da capo arias, monolithic choruses, accompanied recitatives) and every seemingly outmoded harmonic cliché (arpeggiated triads, diminished seventh chords, formulaic cadences). It was (to put it Greekly) as if Apollo himself were now beating back the "Wagnerian revolution" (here standing in for revolution in general) with its vaunting individualistic hubris and its frenzied, Dionysiac overthrow of conventions for the sake of untrammeled emotional arousal and expression.

Of course it is possible to hear *Oedipus Rex,* for these very reasons, as a salad of clichés. Let's sample them for effect. First, because most spectacularly hackneyed: Creon's aria, conveying the oracle's treacherous behest that Oedipus seek and expose the criminal that will turn out to be himself. While it does not literally involve an unwritten da capo repeat, the aria is cast tonally and thematically in the three-part form inherited from the Italian *opera seria*. The opening theme and key return at the end: and what a key—C major!—and what a theme—a tonic arpeggio! (ex. 20.1).

It didn't require the author of *The Rite of Spring* to think that up, one has to think. Possibly even more hackneyed is Jocasta's accompanied recitative when she intervenes in the dispute between Oedipus and Tiresias to discredit the oracle and call off the manhunt. She is heralded by an inevitable pair of instruments, flute and

EXAMPLE 20.1. *Oedipus Rex*, Creon's aria, da capo.

EXAMPLE 20.2. *Oedipus Rex,* Jocasta's recitative.

harp: inevitable, because they are the equivalents of the Greek aulos and kithara. Again Stravinsky seems to follow the line of least resistance—the line available to every Hollywood soundtrack seeking to provide period flavor to a trite costume drama or biblical epic. When Jocasta makes reference to their "clamor and howling," the harp (reinforced by a piano) howls out an arpeggiated diminished-seventh chord, the moustache-twirling villain chord abused in every second-rate melodrama, not to mention the silent-movie accompaniments that were part of the daily experience of the opera's original audience (ex. 20.2).

As for a monolithic chorus, the very opening of the opera will do. The lamenting Thebans, singing in stylized lockstep, appeal to Oedipus to save them from the plague. Sure enough, the harmony again relies on the diminished-seventh chord to

convey their terror as quickly and cheaply as possible. When they turn to their king, the accompaniment becomes an ostinato, all too obviously set to the rhythm of his name; but when they actually sing the name, they continually distort it (OE-di-pus, Oed-I-pus, Oe-di-PUS) in a fashion that Stravinsky's detractors (all the way up to *The Rake's Progress*, and even now, occasionally) have always loved to seize upon as evidence of his nonchalance, if not his incompetence, as an opera composer (ex. 20.3).

But while the opera's every component, taken singly, may be described as a cliché, sometimes of amazingly clumsy banality, taken in the aggregate the work has uncanny power. Never was a whole so much greater than the sum of its parts. And that is chiefly due to the single-mindedness of Stravinsky's musical dramatization, bent in every aspect—tonality, symbolism, thematic recapitulations, and all—on plotting the terrible humbling of the title character.

Oedipus begins in a vocal ambience of arrogant coloratura: his musical utterances are placed high, they are richly and ostentatiously ornate, and they are accompanied by the cliché of all Bachy clichés—"regal" dotted rhythms, actually inherited (by Bach as well as Stravinsky) from the French seventeenth-century court opera (ex. 20.4). At the end, Oedipus sinks into stony syllabic simplicity as the light of Apollo (symbolized by the blinding concord of D major) dawns on him, laying low his vaunting, all-too-human self-importance (ex. 20.5).

Oedipus makes one last, mute appearance in the opera—showing himself, blinded, to the populace before embarking on his exile. The opening chorus comes back, its orchestration reinforced, its diminished sevenths now expressing not their terror at the plague, but their horror at their former ruler's fallen estate. We begin to see how a salad of clichés, perhaps precisely because they are clichés and therefore everybody's common property, can be manipulated to produce a shattering catharsis (ex. 20.6).

In the lectures he gave at Harvard in 1939 while occupying the Norton Chair of Poetry—lectures later published under the title *Poetics of Music*—Stravinsky connected the theme of his *Oedipus* specifically with the objectives of his musical neoclassicism. He invited his audience to receive his words as "dogmatic" and "objective" confidences, delivered "under the stern auspices of order and discipline,"[17] virtues that are finally associated, in the fourth lecture, with their "best example" in music, a Bach fugue: "A pure form in which the music means nothing outside of itself. Doesn't the fugue imply the composer's submission to the rules? And is it not within those strictures that he finds the full flowering of his freedom as a creator?"[18] The artist must "submit to the law," to ordained values that transcended individuals, because, Stravinsky finally said explicitly, "Apollo demands it."[19]

While at Harvard, Stravinsky also attended and advised Walter Piston's composition seminar, and at one meeting the discussion turned to *Oedipus Rex*. "An observation that he made," Piston later recalled, "threw a bright light on a most important aspect of his artistic ideals."

EXAMPLE 20.3. *Oedipus Rex,* opening chorus.

EXAMPLE 20.4. Oedipus's first line.

EXAMPLE 20.5. Oedipus's last line.

EXAMPLE 20.6. *Oedipus Rex*, beginning of the final chorus.

He said, "How happy I was when I discovered that chord!" Some of us were puzzled, because the chord, known in common harmonic terms as a D-major triad, appeared neither new nor complex. But it became evident that Stravinsky regarded every chord as an individual sonority, having many attributes above and beyond the tones selected from a scale or altered this way and that. The particular and marvelous combination of tones in question owed its unique character to the exact distribution of the tones in relation to the spaces between them, to the exact placing of the instrumental voices in reference to the special sound of a given note on a given instrument, to the dynamic level indicated, and to the precise moment of sounding of the chord.

"When we realize," Piston concluded, "that such precision marks Stravinsky's approach to every technical and esthetic problem connected with musical compo-

sition, we begin to see why his influence has been inescapable, why his music has been so great a stimulation to other composers."[20] Everything that Piston says is true, and very suggestive of why Stravinsky's music is the music from its period that has survived best into our own. And yet, being a "symphonist" rather than a musical dramatist, Piston neglected to mention what must have been the main thing on Stravinsky's mind at the moment when he joyously "discovered" the chord in question.

That "ordinary" D major chord is in fact the most crucial harmonic resolution in the drama: the one that accompanies Oedipus's final line, "Lux facta est," already shown in ex. 20.5. Its extreme simplicity at "the precise moment of its sounding" is a rhetorical simplicity that is meant to persuade and influence a much greater cross-section of humanity than the merely professional one with which Piston was exclusively concerned. Avoiding that which is in itself new or complex, exotic or *recherché*; striving rather to achieve eloquence within strictly delimited, inherited stylistic constraints amounting to commonplaces, in the original and literal meaning of that word (a place available to one and all)—these are the most basic tenets of neoclassicism. Their target, in a context like *Oedipus Rex*, was no longer just Romanticism, but secular humanism, Romanticism's first parent, and the first threat to tradition. Like many in those frightening years of toppled thrones and rampant proletariats, Stravinsky wanted to undo the Renaissance.

"The change which Copernicus is supposed to have brought about is the exact contrary of the fact," T. E. Hulme had written. "Before Copernicus, man was not the centre of the world; after Copernicus he was. You get a change from a certain profundity and intensity to that flat and insipid optimism which, passing through its first stage of decay in Rousseau, has finally culminated in the state of slush in which we have the misfortune to live."[21] Stravinsky's icy neoclassical muse, summoning up (especially in *Oedipus Rex*) exactly that grim profundity and intensity that Hulme so longed to see again, did what it could to freeze things back.

Needless to say, Stravinsky's opera made Schoenberg ill. He went to see it on the evening of 23 February 1928 on the occasion of its fully staged première, at the Kroll Opera in Berlin, and vented his rage at it, and at Stravinsky, in his diary the next day. "I do not know what I am supposed to like in *Oedipus*," he railed. "It is all negative: non-standard theater, non-standard setting, non-standard resolution of the action, non-standard vocal writing, non-standard acting, non-standard melody, non-standard harmony, non-standard counterpoint, non-standard instrumentation—all this 'non,' without being anything in particular...."

"This work is nothing," he concluded in exasperation; and yet he also noted, with impressive candor, that he feared it, for "the works which in every way arouse one's dislike are precisely those the next generation will in every way like."[22] The *Oedipus* première came at the end of a period that Schoenberg later remembered as the worst in his life as an artist, "the first time in my career," as he put it, "that

I lost, for a short time, my influence on youth."[23] The reason? A French journalist summed it up: "Schoenberg is a romantic; our young composers are classic."[24] That sense of vulnerability conditioned Schoenberg's furious rejection of neoclassicism. And yet in retrospect, as we have already observed, he was himself one of the most influential neoclassicists, and his twelve-tone technique one of the most potent neoclassicizing forces of its day. He could not resist the thing he thought he hated, and channeled its force in spite of himself. Stravinsky had no reason to resist it. He channeled it consciously and willingly; and that is what made him briefly the stronger force. His was the principal musical voice of the interwar years, and *Oedipus Rex* was that voice's most characteristic utterance.

For neoclassicism was more than Back to Bach, more than a musical movement, more than a matter of style. It was a cultural force in alliance with the most powerful political currents of its time. The political currents finally led to disaster. They have turned radioactive; they've become a taint. One's immediate impulse is to ignore them. But sanitizing powerful works of art reduces their power. If we want to understand the uncanny power that *Oedipus Rex* wielded with its deliberately simplified and conventionalized means, we have to make ourselves imaginatively vulnerable not just to its theatrical, but also to its political allure. Then we will truly know—perhaps better than Diaghilev, who never lived to see the consequences—what it meant to be "un cadeau très macabre."

NOTES

1. Igor Stravinsky and Robert Craft, *Dialogues and a Diary* (Garden City, NY: Doubleday, 1963), 7.
2. W. H. Auden, "Yeats as an Example" (1948), in *The Kenyon Critics*, ed. John Crowe Ransom (Cleveland: World Publishing Co., 1951), 111.
3. Jean-Jacques Rousseau, *The Confessions of Jean-Jacques Rousseau* (New York: Random House, 1945), 3.
4. T. E. Hulme, "Romanticism and Classicism," in idem, *Speculations: Essays on Humanism and the Philosophy of Art*, ed. Herbert Read (London: Routledge, 1924), 115.
5. Quoted in Scott Messing, *Neoclassicism in Music from the Genesis of the Concept through the Schoenberg/Stravinsky Polemic* (Ann Arbor: UMI Research Press, 1988), 141.
6. Igor Stravinsky, *An Autobiography* [originally published as *Chroniques de ma vie*, 1936] (New York: Norton, 1962), 43.
7. Arthur Lourié, *Sergei Koussevitzky and His Epoch* (New York: Knopf, 1931), 196.
8. Alberto Gallo (1939), quoted in Harvey Sachs, *Music in Fascist Italy* (New York: Norton, 1988), 168.
9. M. G. Kozlova and N. R. Yatsenko, eds., *S. S. Prokof'yev i N. Ya. Myaskovskiy: Perepiska* (Moscow: Muzïka, 1977), 211.
10. Stravinsky, *An Autobiography*, 53.
11. Alexandre Benois, "Vrubel'," in *Mir iskusstva*, 1903, no. 10, 40.
12. Lincoln Kirstein, "The Curse of Isadora," *New York Times*, 23 November 1986, Arts and Leisure, 1.
13. George Balanchine, "The Dance Element in the Music," in *Stravinsky in the Theatre*, ed. Mina Lederman (1949; rpt. New York: Da Capo, 1975), 81.

14. Stravinsky, *An Autobiography*, 125.

15. Stravinsky and Craft, *Dialogues and a Diary*, 5.

16. Sophocles, *Oedipus the King*, trans. David Grene, in *Three Tragedies*, ed. David Grene and Richmond Lattimore (Chicago: University of Chicago Press, 1954), 76.

17. Igor Stravinsky, *Poetics of Music in the Form of Six Lessons*, bilingual ed., trans. Arthur Knodel and Ingolf Dahl (Cambridge, MA: Harvard University Press, 1970), 21–23.

18. Ibid., 99.

19. Ibid., 105.

20. Walter Piston, "Stravinsky's Rediscoveries," in Lederman (ed.), *Stravinsky in the Theatre*, 130–31.

21. Hulme, "Modern Art and Its Philosophy," in Read (ed.), *Speculations*, 80.

22. Arnold Schoenberg, "Stravinsky's Odipus, 24 February 1928," in *Style and Idea: Selected Writings of Arnold Schoenberg*, ed. Leonard Stein, trans. Leo Black (Berkeley: University of California Press, 1985), 483.

23. Schoenberg, "How One Becomes Lonely," in Stein (ed.), *Style and Idea*, 52.

24. Paul Landormy (1928), quoted in Messing, *Neoclassicism in Music*, 126.

INDEX

Abraham, Gerald, 46, 48, 80, 89
absolute music, 415, 479
Acocella, Joan, 12
Acosta, Mercedes de, 504
Adam, Adolphe, 369
Adams, John, 19; *The Death of Klinghoffer*, 18–19, 21
Ader, Lidia, 159n11
Adorno, Theodor W., 129, 219, 480; *Philosophie der neuen Musik*, 111, 163, 400
Aesopian discourse, 54–55
affirmative action, 251–53
Agawu, V. Kofi, 95–96, 105, 107, 113–14, 364–65
Akhmatova, Anna Andreyevna, 158, 181, 314
Akimenko, Fyodor Stepanovich, 505
Aksakov, Sergey Timofeyevich, 193
Albright, Daniel, 499
Aldanov, Mark Alexandrovich, 191
Aleskerov, Suleiman Eyubovich, 283
Alexander, Tamsin, 35
Alexander II (Tsar), 60, 72
Alexandrov, Alexander Vasilyevich, General, 247–48;
Alexandrov, Anatoly Nikolayevich, 145
Alexandrov, Grigoriy Vasilyevich: *Volga, Volga*, 263
Alimov, Sergey, "Pesnya o Staline," 266
Alyokhina, Mariya Vladimirovna, 4
Amendola, Giovanni, 290n47
Amerikanismus, 490

Amirov, Fikret Mashadiyevich, 283
analysis, 101–4
Anderson, Benedict, 151, 234
Andersson, Earnest, 436
Andriessen, Louis, and Elmer Schönberger, *The Apollonian Clockwork*, 432
Andropov, Yuriy Alexandrovich, 305–6
Anrep, Boris Vasilyevich (von), 181
Ansermet, Ernest, 114
Antipov, Konstantin Afanasyevich, 43
Antokoletz, Elliott, 106
Appel, Alfred, 158
Arabov, Yury Nikolayevich, 5
Arakchiyev (Arakishvili), Dmitry Ignatiyevich, 274
Archimedes, 199
Arensky, Antoni Stepanovich, 43, 80, 114, 386
Arkhangelsky, Alexander Andreyevich, 202
Arkhipova, Irina Konstantinovna, 316
Arne, Thomas, 237
art and power, 303–31
Artsïbushev, Nikolai Vasilyevich, 43
Artyomov, Vyacheslav Petrovich, 318
Arutyunyan, Alexander Grigoryevich, 283–84; Motherland Cantata, 284
Asafyev, Boris Vladimirovich, 71, 230n141, 442, 462–63; "intonatsiya" theory, 194, 321. WORKS: *A Book about Stravinsky*, 57, 462
Ashrafi, Mukhtar Ashrafovich, 168
Association for Contemporary Music (*ASM*), 318

INDEX

Astruc, Gabriel, 397; and *Sacre du printemps* première, 406
Atovmyan, Levon Tadevosovich, 128, 320
Auber, Daniel François Esprit, 238
Auden, Wystan Hugh, 506, 509
Augustine, Saint, 237
Aumont, Jean-Pierre, 80
authenticity, 236, 298n107, 494–95
avatar, defined, 434
Avec Stravinsky, 446

Bach, Johann Sebastian, 124, 309–10, 485, 511; compared with Karl Marx, 142, 192; with smallpox, 511; Stravinsky on, 516. WORKS: Prelude in E major for solo violin (arr. Rachmaninoff), 130
"Back to Bach," 220n14
Badoglio, Pietro, 244
Baiseyitova, Kulyash Zhasymovna, 269
Bakst, Lev (Léon) Samoilovich, 387, 403
Balakirev, Miliy Alexeyevich, 34, 39, 40, 45, 79, 87, 271, 278, 372, 454; *Islamey*, 275; *Tamara*, 275
Balanchine, George (Balanchivadze, Georgiy Melitonovich), 216, 389, 511–12
ballet: cultural status of, 368–69; national status of, 374
Ballets Russes, 35, 138, 156; founded, 388–89; and *Gesamtkunstwerk* ideal, 387; *Une Nuit sur la Mont Chauve* (after Musorgsky), 59
Balmont, Konstantin Dmitriyevich, 367
baloney, 497
Barenboim, Daniel, 355
Bartók, Béla, 321, 506; on musical notation, 487; as pianist, 486–92, 494; Stravinsky on, 380; on Stravinsky's piano playing, 485–86; as "Turanian," 229n126. WORKS: Piano Concerto No. 1, 486; Piano Concerto No. 2, 486
Basil, Saint, 237
Basso, Lelio, 290n47
Bastamova, Nina Andreyevna, 313–15
Baudelaire, Charles, 499n42
Bauer, Marion, 141
Bauer, Otto, 280
Baur, Steven, 94
Bausch, Pina, 419
Beach, Amy Marcy Cheney (Mrs. H. H. A.), 34
Beardsley, Aubrey, 510
Beardsley, Monroe, 498n28
Beauharnais, Hortense de, 240
Bednïy, Demyan, 296n95

Beerbohm, Max, 22
Beethoven, Ludwig van, 240, 309, 369; Soviet view of, 461–62. WORKS: *Creatures of Prometheus*, 338; Diabelli Variations, 342; German contradances, WoO 14, 338; Symphony No. 3, 338; Symphony No. 9, 219; —, compared with *Le Sacre du printemps*, 401, 411–13; Quartet no. 13 in B-flat, op. 130: Cavatina, 355; Variations and Fugue for piano ("Eroica"), op. 35, 338, 342; *Wellington's Victory*, 237
Béjart, Maurice, 417
Belicheva, Svetlana Afanasyevna, 7–9
Belïy, Andrey (Boris Nikolayevich Bugayev), 458
Bellaigue, Camille, 387
Belyayev, Mitrofan Petrovich, 43, 456
"Belyayev circle," 82, 369
Belyayev school, 370–71
Benchley, Robert, 351
Bennett, William Sterndale, 238
Benois, Alexandre (Alexander Nikolayevich), 368, 374, 385, 387–88, 398, 511; on opera, 393
Berberova, Nina Nikolayevna, 8, 154
Berdyayev, Nikolai Alexandrovich, 222n37, 458–60
Berezovsky, Maxim Sozontovich, 201
Berezowsky, Nikolai Tikhonovich, 145
Berg, Shelley, 396
Berger, Arthur, 83–87, 89–90, 101, 104; "Problems of Pitch Organization in Stravinsky," 83–86, 363–65
Bergson, Henri, 164
Beria, Lavrentiy Pavlovich, 305–7
Berio, Luciano, 352, 356, 396
Berlin, Isaiah, 159n5, 224n67
Berlioz, Hector, 128; *Requiem*, 204
Bernandt, Grigoriy Borisovich, 282
Bernstein, Leonard, 412–13
Bilibin, Ivan Yakovlevich, 376
Billington, James: *The Icon and the Axe*, 465
Bilson, Malcolm, 130
Biro-Bidzhan, 281
Bizet, Georges, 45, 124; *Carmen*, 56
Blazhkov, Igor Ivanovich, 353
Blok, Alexander Alexandrovich, 458
Blok, Vladimir Mikhailovich, 332, 336–37, 341, 345, 345n1
Blokhin, Nikolai Nikolayevich, 310–11
Blumenfeld, Felix Mikhailovich, 43
Boito, Arrigo, 239, 241
Bolm, Adolphe, 387
Bonds, Mark Evan, quoted, 37

INDEX 527

Boretz, Benjamin: *Meta-Variations,* 109
Borodin, Alexander Porfiryevich, 34, 39, 278; *In Central Asia,* 212, 374; *Prince Igor,* 194; —, Polovetsian Dances from, 373, 408; second act of, staged by Diaghilev in Paris, 386
Bortnyansky, Dmitry Stepanovich, 201
Bosset, Vera de. *See* Stravinsky, Vera
Boston Symphony Orchestra, 18, 21, 28n45, 134, 202, 399
Boulanger, Nadia, 90, 352, 482
Boulez, Pierre, 9–12, 172, 428, 445; *Le Marteau sans maître,* 351
Bourdariat, Roland, 465
"Bozhe, tsarya khrani," 237
Braginskaya, Nataliya Alexandrovna, 381n9
Brahms, Johannes, 167; Symphony No. 1, 219, 413
Brezhnev, Leonid Ilyich, 305–7
Brezhnev Constitution, 267
Brezhnevite stagnation (*zastoy*), 319, 353
Britten, Benjamin, 10; *War Requiem,* 402, 483
Brodsky, Joseph (Iosif Alexandrovich), 157
Brown, David, 46, 49, 350
Brown, Malcolm Hamrick, 15, 309
Bruckner, Anton, 34
Bruneau, Alfred, 47, 373
Brusilovsky, Yevgeniy Grigoryevich, 269–74; *Kyz-Zhibek,* 269–73
Budenz, Louis Francis, 294n79
Buelow, George, 309
Bullard, Truman C., 396
Bullock, Philip Ross, 44–45
Bunin, Ivan Alexeyevich, 154
Bunin, Vladimir Vasilyevich, 283–84
Burkholder, J. Peter, 47
Busoni, Ferruccio: Concerto for piano and orchestra, with men's chorus, op. 39, 231n168
Buyanov, Mikhaíl Ivanovich, 5–7, 9
Byron, George Gordon, Lord, 92
Byzantine church, 172

Calvocoressi, Michel-Dmitri, 46, 387
Camajani, Giovanni, 211
Cannobio, Carlo, 53
canon *vs.* repertory, 399–400
"Canto degli Italiani," 240, 242
Capus, Alfred. 405–6
cards: identity, 58–59; victim, 96, 113
Carlo Alberto, King of Piedmont-Sardinia, 234, 238, 246
Carter, Elliott, 15; compared with Khrennikov, 325; and *Le Sacre du printemps,* 412

Casals, Pablo, 323, 411
Catherine (Yekaterina) II (The Great), Tsarina, 52–54, 56–57, 280; *The Early Reign of Oleg,* 53; *Fevey,* 53
Catoire (Katuar), Georgiy Lvovich, 268
Cavour, Camillo Benso, Count of, 233
censorship, 18–22; of *Poetics of Music,* 465–66
Central Intelligence Agency, 323
Chaikovsky, Alexander Vladimirovich, 354
Chaikovsky, Boris Alexandrovich, 318
Chaikovsky, Modest Ilyich, 6; *The Life and Letters of Peter Ilich Tchaikovsky* (trans. Newmarch), 44; *Zhizn' Petra Ilyicha Chaikovskogo,* 475
Chaikovsky, Pyotr Ilyich, 34, 37–42, 45, 126, 278, 321, 434; controversies about, 1–2, 16, 350; homosexuality of, 4–9, 37, 80; liturgical compositions, 202; Lourié on, 142; performances of at Olympics, 4. WORKS: *Cherevichki,* 56; *Eugene Onegin,* 2, 34, 42; *Marche slave,* 237; *The Nutcracker,* 387; *The Oprichnik,* 47, 61; Piano Concerto No. 1, 134, 136; *The Queen of Spades,* 54, 57; *Sleeping Beauty,* 48; —, produced by Diaghilev, 373, 387; Symphony No. 2, "Little Russian," 387; *Vakula the Smith,* 47; *The Year 1812, Festive Overture,* 237
Chaliapin, Fyodor Ivanovich, 386–87
Chanel, Gabrielle "Coco," 125, 413
change, as necessary part of reception, 420
chant, Orthodox, 137
character variations, 342
chastushki, 230n150
Chauve-souris de Moscou, Théâtre de la, 155
Chebotaryan, Gayanè Moiseyevna, 283–84
Chegodayeva, Larisa Pavlovna, 299n128
Chekhov, Anton Pavlovich, 6
Cherepnin, Nikolai Nikolayevich, 43, 91, 366, 374; *Fantaisie dramatique,* 389; *Le Pavillon d'Armide,* 368, 373, 387, 389–90; *Le Royaume enchanté,* 389
Chernïshevsky, Nikolai Gavrilovich, 460
Chesnokov, Pavel Grigoryevich, 202
Chisla (journal), 153
Chopin, Fryderyk, 34; Sonata No. 2, Funeral March, 131
Chopiniana. See Les Sylphides
Chorley, Henry, 241
Chukovsky, Korney Ivanovich, 444
Churchill, Winston, 510
Cicero, Marcus Tullius, 288n12
Clementi, Muzio, 220n14

Cocteau, Jean, 397; as librettist for *Oedipus Rex* (Stravinsky), 512; *La Machine infernale*, 512; *Le rappel à l'ordre*, 223n55; on *Le Sacre du printemps*, 403
Code of the Russian Federation on Administrative Offenses, 4
Cold War, 2, 14, 38, 49, 323
Comintern (Third International), 258–61, 454
Communist Manifesto, 246–47, 251, 345
Communist Party of the United States (CPUSA), 261
Congress for Cultural Freedom, 323
Contrepoints (journal), 445
Copland, Aaron, 15–16, 156; on musicality, 494; on Stravinsky, 160n18
Craft, Robert, 9–12, 104, 185, 227n99, 362, 364, 391, 393, 415, 428, 438, 445, 481, 506; annotations to *Poetics of Music*, 439; on Asafyev, 462; ghostwrites for Stravinsky, 323, 432–33, 482, 503–4; on Lourié, 183; on *Le Sacre du printemps*, 381, 396, 411; records *Le Sacre du printemps*, 421, 485
creationism, 100, 107–11, 365
Crociata, Francis, 133n27
Crutchfield, Will, 501n61
Cui, César Antonovich, 39, 45, 47, 65, 79; on *Le Sacre du printemps*, 409. LITERARY WORKS: *La musique en Russie*, 46–47; MUSICAL WORKS: *Angelo*, 47; *The Mandarin's Son*, 47; *William Ratcliff*, 47
Cusick, Suzanne, 328n1
Custine, Astolphe-Louis-Léonor, marquis de, 290n51
cyclic form, 137
Czerny, Karl, 220n14

D'Adamo, Ada, 396
Dahl, Ingolf, 434, 458, 474, 483
Dahlhaus, Carl, 15–16; *Analyse und Werturteil*, 101, 119n86
Damrosch, Walter, 135
Daniélou, Jean, 512
Danilevsky, Nikolai Yakovlevich, 167–68
D'Annunzio, Gabriele, 287n7
Dargomïzhsky, Alexander Sergeyevich, 40, 63; *Rusalka*, 54; *The Stone Guest*, 63
Davies, Norman, 168
Davydov, Vladimir Lvovich (Bob), 7
D'Azeglio, Massimo, 233–34, 237–38, 287n7
Deathridge, John, 15–16
Debs, Eugene Victor, 247

Debussy, Claude-Achille, 79, 97, 172; on *Firebird*, 391; Lourié on, 142; on *Le Sacre du printemps*, 404; and Stravinsky, 95, 361. WORKS: *Jeux*, 407–8
de Carlo, Yvonne, 80
De Geyter, Pierre, 245
dehumanization, 110, 481–82, 484
Delage, Maurice, 10–12
Delibes, Léo, 45, 369
Demarquez, Suzanne, 140
Denisov, Edison Vasilyevich, 318; Clarinet Quintet, 356; *Sun of the Incas*, 352; *Symphonie pour grand orchestra*, 355
Deshevov, Vladimir Mikhailovich, 145, 461
Diaghilev, Sergey Pavlovich, 11–12, 35, 48, 58–59, 83, 138, 156, 168, 460; attitudes toward ballet, 385; early activities in Paris, 385; on neonationalism, 376; portrait exhibition in Tauride Palace, 373; and *Oedipus Rex* (Stravinsky), 508; on *Le Sacre du printemps*, 397, 411; and Stravinsky, 366–67, 384–94
Diaghilev, Valentin Pavlovich, 390
Diaghilev, Yury Pavlovich, 390
Diletsky, Nikolai Pavlovich, 201
Dimanshteyn, Shimon Mordkevich, 252
Dimitrov, Georgi, 259–62
Dmitriyevsky, Sergey V., 222n48
Dobrolyubov, Nikolai Alexandrovich, 460
Dobuzhinsky, Mstislav Valerianovich, 196
Doctors' Plot, 285
dogma, 433–34, 516
Dohnányi, Ernő, 491
Dolgorukiy, Yury, Great Prince, 261
Domaine musical, Le, 172, 445
Donakowski, Conrad L., 288n16
Donauweibchen (singspiels), 56
Dorsey, Tommy, 78
Dostoyevsky, Fyodor Mikhailovich, 193, 356, 368
Downes, Olin: on *Concerto spirituale* (Lourié), 209, 231n171; interviews Diaghilev, 376; on *Le sacre du printemps*, 410, 416
Dubinets, Elena, 157–58
Duchiński, Franciszek, Rev., 168–69
Dudintsev, Vladimir Dmitriyevich, 352
Dufour, Valérie, 148, 220n37, 438–39, 448–50, 480
Dukas, Paul, 145
Dukelsky, Vladimir Alexandrovich (Vernon Duke), 114, 145, 181; on *Concerto spirituale* (Lourié), 231n171; and Eurasianism, 149. WORKS: *Zéphyr et Flore*, 146

dukhovnïy kontsert, 201–2
Dunayevaky, Isaak Osipovich: music for *Volga, Volga*, 263
Dushkin, Samuel, 125
Dvořák, Antonin, 34, 55, 167; Symphony No. 9 in E minor ("From the New World"), 137
Dwight, John Sullivan, 129

Early Music movement, 130
Efron, Sergey Yakovlevich, 153, 179
Einstein, Alfred, 50n8
Eisenstein, Sergey Mikhailovich, 261
Eksteins, Modris: *Rites of Spring*, 402–3, 405
Elgar, Edward, 34
Eliot, Thomas Stearns, 164, 428; *The Hollow Men*, 20; "Tradition and the Individual Talent," 481
El-Registan (Gabriel Arkadyevich Ureklyan), 247, 257
Elson, Arthur, 35, 115n9
Emerson, Ralph Waldo, 491
"enemy of the people" (*vrag naroda*), 266
Enesco, Georges, 141
Engels, Friedrich, 234, 246–47
Erkel, Ferenc, 75n1; *Bank Ban*, 75n1
Eshpai, Andrey Yakovlevich, 318
Esterházy family, 328
esthetic autonomy, 482
Étude (magazine), 124
Eurasianism, 143, 147–49, 165–72, 174–99 *passim*, 354–55, 443–45; and fascism, 225n80, 446; and submission, 501n59
Evans, Edwin, 407
Evenings on the Roof, 445
Ewen, David, 124
execution vs. interpretation, according to Stravinsky, 433–34
Exodus (film), 271
exoticism: as "authenticity," 298n107; and nationalism, 374

Facchi, Agostino, 230n162
Fadeyev, Alexander Alexandrovich, 313
Fairclough, Pauline, 132n5
Falla, Manuel de, 96, 140, 384
falsification, 107
Fay, Laurel E., 13, 15, 285, 309
Feinberg, Samuil Yevgenyevich, 145
Feldman, Martha, 53
Feldman, Morton, 356
Feofanov, Dmitry, 27n45
Ferè, Vladimir Georgiyevich, 268

Ficino, Marsilio: commentary on *Philebus*, 3
Figes, Orlando, 127
Findeyzen, Nikolai Fyodorovich, 382n26
Fink, Robert W., 111, 427n97
Finko, David Rafailovich, 157
Firsova, Elena Olegovna, 157, 318–20, 349, 355–56
Fisk, Charles, 126–28
Fitzpatrick, Sheila, 250
Flothuis, Marius, 130
Fokine, Mikhaíl Mikhailovich, 366, 373, 387, 389; *Chopiniana (Les Sylphides)*, 386; *Cléopâtre* (medley), 373, 386, 388, 408; *Le festin* (medley), 373, 386; *Shéhérazade* (after Rimsky-Korsakov), 408
Forbes, Edward, 429–30
Forbes, Elliott, 429
Forte, Allen, 87, 97–101, 106–7, 416; *The Harmonic Organization of* The Rite of Spring, 90, 396; *The Structure of Atonal Music*, 98
Franck, César, 34; Symphony in D minor, 137
Frank, Semyon Lyudvigovich, 458
Frederick the Great, 17, 167
Freud, Sigmund, 118n62; on psychoanalysis, 122
Fried, Oskar, 411
"friendship of peoples" (*druzhba narodov*), 251–54, 257, 268, 282
Frolova-Walker, Marina, 157, 306, 345; *Russian Music and Nationalism from Glinka to Stalin*, 268; "Stalin and the Art of Boredom," 306
Frost, Robert, 428
Furtwängler, Wilhelm, 412, 447
futurism, 185–86
Fyodorov, Nikolai Fyodorovich, 220n37, 458–59

Gabetti, Giuseppe, 238
Gabrieli, Giovanni, 201
Gagarin, Yury Alexeyevich, 308–9
Galuppi, Baldessare, 201
Garden, Edward, 79
Gatti, Guido M., 141
Gauguin, Paul, 408
Gebrauchs-formulas, 89, 91, 102, 391
Gebrauchsmusik, 140
Georges-Michel, Michel, 415–16
Gergiyev, Valeriy Abisalovich, 9, 48, 73, 361
Geyer, Martin H., 95
Ghedini, Giorgio Federico, 231n162
ghetto, defined, 280

Gilbert and Sullivan: *The Gondoliers*, 509
Gilels, Emil Grigoryevich, 281
Gippius, Zinaída Nikolayevna, 458
Gjerdingen, Robert, 101–2, 105–6, 114
Gladkovsky, Arseniy Pavlovich, 461
glasnost', 447
Glazunov, Alexander Konstantinovich, 43, 73, 91, 114, 142, 368–69, 372, 374; completes *Prince Igor*, 194. WORKS: *Raymonda*, 387; *The Seasons*, 386
Glebov, Sergey, 177
Glebova-Sudeykina, Olga Afansyevna, 183
Glière, Reinhold Moritzevich, 126, 274
Glinka, Mikhaíl Ivanovich, 34, 37, 40, 41, 45, 52, 125–26, 175, 434; Stravinsky on, 453–54; whole-tone scale in, 91. WORKS: *Kamarinskaya*, 379; *A Life for the Tsar*, 454; —, "Slav'sya" from, 49, 248; *Ruslan and Lyudmila*, 54, 275, 391; —, combination of piano and harp in, 477; staged (in part) by Diaghilev in Paris, 386–87
Glinski, Mateusz, 141
Gluck, Christoph Willibald, 369
Gnesin, Mikhaíl Fabianovich, 275, 277, 366–67, 385; *The Jewish Orchestra at the Mayor's Ball*, 347n18
Godet, Robert, 79
"God Save the King/Queen," 237, 239, 241, 244, 342
Goebbels, Joseph, 412
Gogol, Nikolai Vasilyevich, 52, 56, 193, 453, 463; *Marriage*, 63
Gojowy, Detlef, 318, 310
Gold, Ernest (Ernst Goldner), 271, 273–74
Goldbeck, Frederik, 206, 445
Golenishchev-Kutuzov, Arseniy Arkadyevich, 71
Golovin, Alexander Yakovlevich, 375
Goodman, Saul, 420
Goossens, Eugène, 411
Gorbachev, Mikhaíl Sergeyevich, 306, 353
Gorky, Maxim (Alexey Maximovich Peshkov), 180, 254–55, 280
Gorodetsky, Sergey Mitrofanovich, 372; *Yar'*, 378; —, "Yarila" from, 408
Gorsky, Alexander Alexeyevich, 387
GOSET (Soviet State Yiddish Theater), 317
gosudarstvenníy gimn, defined, 241
"Gosudarstvennïy gimn SSSR," 247–48, 250, 257–58
Gould, Glenn, 130
Gounod, Charles, 45
Gourko, Henriette de, 140

Gozenpud, Abram Akimovich, 268, 270, 292n63
Graham, Martha, 414
"great-power chauvinism" (*velikoderzhavnïy shovinizm*), 251, 279
"Great Retreat," 249, 253
Grechaninov, Alexander Tikhonovich, 43, 155, 274; liturgical compositions, 202
Greco, El, 206
Greiner, Alexander, 133n29
Grigoryev, Apollon Alexandrovich, 61, 368
Grishin, Viktor Vasilyevich, 306–7
Gromyko, Andrey Andreyevich, 306
Grout, Donald Jay, 47
Gubaidulina, Sofia Asgatovna, 36, 157, 318, 349, 355
Gurevich, Yakov Grigoryevich, 26n32
Gushee, Lawrence, 106

Haas, Georg Friedrich, 5
Haggin, Bernard H., on Shostakovich, 230n145
Hajibeyov, Uzeyir, 292n63
Hakobian (Akopyan), Levon Oganesovich, 319–20
Handel, George Frideric, 309–10
Handschin, Jacques, 228n106
Hanslick, Eduard, 194
Hanson, Howard, 156
Haraszti, Emile, 140
Harris, Ellen T., 309
Harris, Roy, 156
Harvard University, Charles Eliot Norton Chair of Poetry, 428–29, 431
Hauptmann, Gerhard, 456
Haydn, Franz Joseph, 328
Head, Simon, 305
Hegel, Georg Wilhelm Friedrich, 210
Helfgott, David, 135
Hétu, Jacques, 130
Hill, Peter, 396
Hindemith, Paul, 286
Hippocrates, 224n70
Hirsch, Lily E., 328n1
historiography, 59–63
Hitler, Adolf, 18, 222n48, 412
Ho, Allan B., 27n45
Hobsbawm, Eric, 235
Hodson, Millicent, 9, 396, 418–20
Hofmann, Josef, 135
Holden, Anthony, 8–9
Hom, Stephanie Malia, 287n7
Honegger, Arthur, 286

Horlacher, Gretchen, 479
Horowitz, Joseph, 131; *Classical Music in America: A History of Its Rise and Fall,* 129
Horowitz, Vladimir, 131, 134, 326
Horst Wessel Lied, 18
Hubbs, Nadine, 12
Hughes, Howard, 16
Hulme, Thomas Ernest, 164, 363; antiromanticism of, 509, 521; on classics, 484. WORKS: *Speculations* (ed. H. Read), 481
Humbertclaude, Eric, 438

identity card, 58–59
ideocracy, 179
Ignatius of Loyola, Saint, 163
indigenization (*korenizatsiya*), 291n52
"Inno di Mameli." *See* "Canto degli Italiani"
intentional fallacy, 481, 498–99n28
"Internationale, L," 244–48, 250, 289n34
International Society for Music Education (UNESCO), 322
intonatsiya, 194
Ippolitov-Ivanov, Mikhaíl Mikhailovich, 43, 73, 268; liturgical compositions, 202; "Procession of the Sardar," 215
Irving, Clifford, 16
Isakovsky, Mikhaíl Vasilyevich, 346n13
Issiyeva, Adalyat, 274
Istomin, Fyodor Mikhailovich: *Pesni russkogo naroda* (folksong anthology, with Lyapunov), 377
Ivan (Ioann) IV (The Terrible), Tsar, 61–62, 68
Ivanov, Georgii Vladimirovich, 154
Ivanov, Vyacheslav Ivanovich, 214, 367
Ivashkin, Alexander Vasilyevich, 157; "The Paradox of Russian Non-Liberty," 348–51, 353–57
Ives, Charles E., 349, 356; "Variations on America," 342
Ivry, Benjamin, 12
Izvestiya, 461

Jacobi, Frederick, Jr., 429–30
James, William, 361
Jaurès, Jean, 289n34
Jews: and Russia Abroad, 150; as rootless cosmopolitans, 355; as a Soviet nationality, 280, 344; Stalin on, 280–81
Joffrey Ballet, 378, 396, 418
John of the Cross, Saint, 203
Johnson, Douglas, 106
Jones, Jennifer, 476

Josephson, David, 50n8
Joyce, James, 356

Kabalevsky, Dmitry Borisovich, 14, 126, 307–10, 319–28; and *Zhdanovshchina,* 276, 199n128. LITERARY WORKS: *About the Three Whales and Many Other Things,* 321; MUSICAL WORKS: *Colas Breugnon,* Overture, 326; Piano Sonata No. 3, 326; Symphony No. 2, 326
Kabalevsky Center (Australia), 321
Kadet Party, 153, 458
Kael, Pauline, 423n20
Kahan, Sylvia, 96
Kall, Alexis (Alexey Fyodorovich), 493, 504
Kammari, Mark Davidovich, 264
Kancheli, Giya Alexandrovich, 318, 349
Kant, Immanuel, 17
Karamzin, Nikolai Mikhailovich, 60–65
Karasyov, Pavel Alexeyevich, 371
Karatïgin, Vyacheslav Gavrilovich, 367; on musical nationalism, 372
Karayev, Kara, 318
Karetnikov, Nikolai Nikolayevich, 316, 353
Karlinsky, Simon, 13–14, 158
Karsavin, Lev Platonovich, 148, 153, 170–72, 175, 444, 456–58; on Eurasianism, 165–66
Karsavina, Tamara Platonovna, 153, 373, 444
Kasatkina, Natalya Dmitriyevna, 418
Kastalsky, Alexander Dmitriyevich, 202
Kautsky, Karl, 280
Keller, Hans: "Functional Analysis," 341
Kelly, Thomas Forrest, 401
Kennedy, John F., 506
Kerensky, Alexander Fyodorovich, 223n66
Kerman, Joseph, 59; on Beethoven's Ninth, 412
Khachaturyan, Aram Ilyich, 126, 274–80, 318–19; compared with Weinberg, 284–85; and *Zhdanovshchina,* 276–79. WORKS: Piano Concerto, 277–78; Symphony No. 2, 278–79; Symphony No. 3 (*Simfoniya-Poèma*), 277, 279; "Sabre Dance" (from *Gayanè*), 276; Violin Concerto, 277–78; Waltz (from *Masquerade* after Lermontov), 336
Khamidi, Latif, 269
Khlebnikov, Velimir (Viktor Vladimirovich), 162, 182, 216
Khodasevich, Vladislav Felitsianovich, 154–55, 181
Khomitsky, Vsevolod Vyacheslavovich, 160n17
Khomyakov, Alexey Stepanovich, 193

Khrennikov, Tikhon Nikolayevich, 14, 126, 282–83, 285, 309–21, 323–25, 354; compared with Elliott Carter, 325; on Stalin, 312–13. WORKS: *Into the Storm,* 312; *The Mother,* 314; *Nash dvor,* 314; Piano Concerto No. 1, op. 1, 314
Khrennikova (née Vaks), Klara Arnoldovna, 314
Khrennikova, Nataliya Tikhonovna, 314
"Khrennikov Seven, The," 318
Khrushchev, Nikita Sergeyevich, 305, 309, 317; defines "Soviet people," 265–67; de-Stalinization campaign, 308; "Stalin i velikaya druzhba narodov," 254–57
Kielian-Gilbert, Marianne, 105
Kirchner, Leon, 104
Kirilenko, Andrey Pavlovich, 306–7
Kirstein, Lincoln, 511
Klenovsky, Nikolai Semyonovich, 274
Klimovitsky, Arkadiy Iosifovich, 394n14
Knaifel, Alexander Aronovich, 318–20, 355–56
Knodel, Arthur, 434, 458
Kodály, Zoltan, 321–23
Koechlin, Charles: "Le Retour à Bach," 221n16
Komsomolskaya pravda, 365
Konchalovsky, Andrey Sergeyevich, 73
Konradi, Kolya, 7
Korndorf, Nikolai Sergeyevich, 157
Kornilov, Lavr Georgiyevich, General, 223n66
Kosenko, Matvey Yevgenyevich, 338
Kostomarov, Nikolai Ivanovich, 60–61, 68–72, 76n26
Kosygin, Alexey Nikolayevich, 314
Kots, Arkadiy Yakovlevich, 247
Koussevitzky, Serge (Sergey Alexandrovich), 145, 155–56, 174, 208, 409, 430
Kovacs, Ernie, 478
Kozlovsky, Ivan Semyonovich, 73
Krasovskaya, Vera Mikhailovna, 418
Kravetz, Nelly, 299n128, 320
Krebs, Stanley Dale, 325–28; *Soviet Composers and the Development of Soviet Music,* 325–27
Krein, Alexander Abramovich, 145
Krein, Yulian Grigoryevich, 145
Kreisler, Fritz, 124
Kruglikov, Semyon Nikolayevich, 368
Krumhansl, Carol, 113
Kupala (midsummer festival), 377
Kyl, John, Senator, 159n10

Laborde, Alexandre de, Count, 240
Laloy, Louis, 390
Lamansky, Vladimir Ivanovich, 168
Lamm, Pavel Alexandrovich, 72

Lang, Paul Henry, 36, 81–82, 495; *Music in Western Civilization,* 81
Langovoy, Alexander Alexeyevich, 224n67
Lanza, Mario, 79
Lardner, Ring, 146
Laroche (Larosh), Herman (Gherman) Avgustovich, 51n37
Laus, Abdon, 399
"lawful Marxism," 458
Lawson, Rex, 492
Lazhechnikov, Ivan Ivanovich, 61
Lefébure, Yvonne, 231n171
Leibowitz, René: "Béla Bartók, or the Possibility of Compromise in Contemporary Music," 330n37, 400
Lenin (Ulyanov), Vladimir Ilyich, 245, 248, 250, 253, 255, 280, 307, 436, 458–59; on nations, 262. WORKS: "Declaration of the Rights of the Toiling and Exploited People," 249; "On the National Pride of the Great Russians," 259–60, 294n79; "On the Question of Nationalities Policy," 290n51
Leontyev, Konstantin Nikolayevich, 169, 193, 458–59
Lerdahl, Fred (Alfred), 97
Lessing, Gotthold Ephraim, 112
Levidou, Ekaterini, 211, 231n172
Levinson, Andrey Yakovlevich, on *Le Sacre du Printemps,* 419
Levitz, Tamara, on *Le Sacre du printemps,* 418–19
Levko, Valentina Nikolayevna, 314
Liberace, 314
Lifar, Serge (Sergey Mikhailovich), 389
Likhachyov, Dmitry Sergeyevich, 1, 3
Lipatti, Dinu, 352
Lisle, Rouget de, 244
List, Guido von: *Das Geheimnis der Runen,* 226n80
Liszt, Franz, 34, 93, 128, 364; Forte on, 106; mediant cycles in, 91. WORKS: *Ce qu'on entend sur la montagne* (Symphonic Poem No. 1), 87; *Faust-Symphonie,* 107
Livanova, Tamara Nikolayevna: on Khachaturyan, 276–79
Livshits, Benedikt Konstantinovich, 186
Lloyd-Jones, David, 73
Locke, Ralph P., 33
Lombroso, Cesare, 367–68
Lopatnikov, Nikolai Lvovich, 145, 157
Losev, Alexey Fyodorovich, 231n172
Lourié, Arthur Vincent (Artur Sergeyevich), 14, 36, 140–53, 156, 158n, 162–232 *passim,*

318, 447; antimodernism of, 190; not a Communist, 226n86; correspondence with Stravinsky, 183–85; and dialectics, 232n175; Jewishness of, 227n96; and Maritain, 432; on Musorgsky, 192–94; nationalism, changing views on, 191–96; on neoclassicism, 220n16; on quarter-tones, 200; on Rachmaninoff, 189–90; on relationship with Stravinsky, 228n104; on Shostakovich, 196–99; as Soviet commissar, 181–84; as Stravinsky's factotum, 227n99, 504, 510; as Stravinsky's famulus, 228n106. LITERARY WORKS: "Approach to the Masses," 198; "The Evolutionary Lines of Russian Music," 191, 195; "Krizis iskusstva," 187–89, 196; "Neogothic and Neoclassic," 153, 163–65, 170–71, 173–74, 184, 188, 205, 22n13; "Muzïka Stravinskogo," 172, 445; *Le Profanation et sanctification du temps*, 304; "The Russian School," 140–48, 175, 191–93; "Scriabin and Russian Music," 200; "Toward a Music of Higher Chromaticism," 200; "Two Operas by Stravinsky," 445; "We and the West," 185–86; MUSICAL WORKS: *Pir vo vremya chumï*, 184; *Concerto spirituale*, 162, 184, 187, 201–10, 212–13; *Sinfonia dialectica*, 162–63, 184, 210–14, 216; Symphony No. 2, "Kormtchaïa," 212, 214–19

Lunacharsky, Anatoly Vasilyevich, 144, 181–82, 249

Lvov, Alexey Fyodorovich, 237

Lyadov, Anatoly Konstantinovich, 43, 87, 91, 372, 452; commissioned to write *Firebird*, 374

Lyapunov, Sergey Mikhailovich: *Pesni russkogo naroda* (folksong anthology, with Istomin), 377

Lysenko, Mykola Vitaliyovych, 292n63; *Taras Bulba*, 463

Lyuban, Issak Isaakovich, 336–42, 345; "Bïvaitse zdarovï," 336–38, "Nash tost," 338–39

Macaulay, Alastair, 417, 424n35
Macdonald, Ian, 27n45
Macdonald, Nesta, 411
Machabey, Armand, 140
MAD magazine, 478
Maes, Francis, 127
Maeterlinck, Maurice: *La Vie des abeilles*, 473
Magomayev, Muslim Magometovich, 315
Mahler, Gustav, 20, 135. WORKS: Symphony No. 2, 29n61
"mainstreaming," 34–35
Maisky, Mischa, 336, 345n7

Maksimenkov, Leonid Valentinovich, 317, 327
Maldïbayev, Abdilas, 268
Malenkov, Georgiy Maximilianovich, 313
Mameli, Goffredo, 240
Mandelshtam, Osip Emilyevich, 339
Manziarly, Irma Vladimirovna de, 229n128
Mao Zedong, 214
"Marcia reale d'ordinanza," 238, 241
Marcus, Adele, 493
Maria Theresa, Empress, 167
Marinetti, Filippo Tommaso, 185–86
Marini, Francesco Maria, 230n162
Maritain, Jacques, 114, 163, 179, 211, 481; *Art et scholastique*, 432
Mariyinsky Theater, 370; orchestra of, 9
Markevitch, Igor Borisovich, 145, 411; and Eurasianism, 149
Mark Twain, 425n58
Marnold, Jean, 115n9
Marschalk, Max, 29n61
"Marseillaise, La," 239–42, 244–45, 289n34
Martin, Terry, 251
Martini, Ferdinando, 287n7
Marx, Karl, 143, 246–47; *Capital*, 461
Marxism, contra nationalism, 246–47, 262, 270; reconciled with nationalism, 248–50
Massine (Myasin), Leonid Fyodorovich, 389, 410, 414, 417
Masur, Kurt, 345n7
Matyushin, Mikhail Vasilyevich, 200
Mayakovsky, Vladimir Vladimirovich, 200
Mazo, Margarita, 157
Mazzini, Giuseppe, 240
McClary, Susan, 59, 74–75n1
McClure, John, 497
McDonald, Matthew, 379, 421
McPherson, Aimee Semple, 274
Meck, Nadezhda Filaretovna von, 6, 39, 41
mediant cycles, 91
Medinsky, Vladimir Rostislavovich, 5–6
Medtner, Nikolai Karlovich, 125, 128–29, 142, 146; Lourié on, 200. WORKS: *Muza i moda*, 125
Melos (journal), 230n141, 442
Mendelson (Prokofieva), Mira Alexandrovna, 315, 317
Mendelssohn, Felix, 41, 124
Menezes, Juliete Telles de, 141
Mercer, Johnny, 79
Messiaen, Olivier, 86, 89, 208, 363, 499n42; *Technique de mon langage musical*, 84
Mey, Lev Alexandrovich, 75n11
Meyer, Leonard B., 103, 128, 402

Meyerbeer, Giacomo, 238
Michelangelo (Buonarotti), 214
Mielczewski, Marcin, 201
Mikhalkov, Sergey Vladimirovich, 247, 257, 289n39
Mikhoels, Solomon, 282, 286, 318
Mintcheva, Svetlana, 18
Mir iskusstva, 367, 372, 376, 458, 460
Mirsky, D. S. *See* Svyatopolk-Mirsky
Mitin, Mark Borisovich, 264
Mlada (collectively authored opera-ballet), 194
modernism, 110, 121–22, 128, 131, 174, 509
Moevs, Robert, 90
moguchaya kuchka (Mighty Kuchka, Mighty Five), 37, 65, 79, 174, 321, 370, 434, 454
Moiseiwitsch, Benno, 131
Molotov (Skryabin), Vyacheslav Mikhailovich, 312
Monteux, Pierre, 398–99, 410–11, 413, 420
Morgan, Robert P., 37
Morris, Mark, 417
Morrison, Simon, 8–9, 309; on Prokoffief's *Symphony-Concerto*, 340–42, 347n20; *Lina and Serge*, 317
Morton, Lawrence: "Footnotes to Stravinsky Studies: *Le Sacre du printemps*," 383n36, 417
Moscow Conservatory, 313
Mosolov, Alexander Vasilyevich, 145, 318
Mozart, Wolfgang Amadé; performed by Bartók, 491–92, 494–95; performed by Rachmaninoff, 130; performed by Stravinsky, 112, 492–93, 495. WORKS: Concert Rondo, K. 356, 491; Fugue in C Minor for Two Pianos, K. 426, 112; Sonata in A major, K. 331, 130; Sonata in D major for two pianos, K. 448, 491–92
Muck, Karl, 135
"Muddle Instead of Music" (*Sumbur vmesto muzïki*), 320, 463–64
Mueser, Barbara, 78
Munch, Charles, 231n171
Muradeli, Vano Ilyich, 126; *The Great Friendship*, 254
Muravlyov, Alexey Alexeyevich: *Russkoye skertso*, 283
Murray, Gilbert, 428
musicality, 493–95, 497
Musical Quarterly, 348
Music Theory Spectrum, 105
Musique russe (journal), 445
Musorgsky, Modest Petrovich, 5, 39, 79–80, 124, 337, 349–50; alcoholism of, 80; Lourié on, 142. WORKS: *Boris Godunov*, 34, 58–77, 79–80, 193; —, Coronation Scene, 206; —, imitated by Stravinsky, 372; Kromy Forest Scene, 66–68; St. Basil's Scene, 63–65, 71–72; staged by Diaghilev in Paris, 386; *The Fair at Sorochintsy*, 387; *Khovanshchina*, 27n39, 61, 193; —, Persian dances from, 373, 386, 408; *A Night on Bald Mountain*, 59
Musrepov, Gabit Makhmutovich, 269
Mussolini, Benito, 176, 244, 250, 446, 510; and totalitarianism, 290n47
Muzïkal'nïy sovremennik (journal), 230n141, 442
Myaskovsky, Nikolai Yakovlevich, 126, 145, 147, 155, 268, 275, 277, 286, 318–19; on Stravinsky, 384; and Zhdanovshchina, 276

Nabokov, Nicolas (Nikolai Dmitriyevich), 145, 157, 382n28, 459, 475; on Lourié, 183, 227n98, 323–24; "L'oeuvre du XXème Siècle" (festival), 323. WORKS: *Ode*, 146
Nabokov, Vladimir Vladimirovich ("V. Sirin"), 149, 154, 156, 196
Nápravník, Eduard Frantsevich, 71
Naroditskaya, Inna, 52–57
narodniki, 454
national anthems, 237–38
"national in form, socialist in content," 261–65, 294n84, 296n88, 453, 462
nationalism, 33–51, 58–59, 151, 191–96; and essentialism, 348–58; compared with patriotism, 246; eclipsed after World War I, 363; as motivator, 286–87; thought outdated by Stravinsky's generation, 370–71
national vs. nationalist art, 270
"nation-building" (*natsional'noye stroitel'stvo*), 251, 262, 268
nations, defined, 242–43; compared with states, 242
Nattiez, Jean-Jacques, 103
Nazi-Soviet Pact, 256, 260
NBC Symphony, 244–45
Neff, Severine, 105–6, 400
Nelson, Amy, 182, 184
Nelsons, Andris, 28n45
Nemirovich-Danchenko, Vladimir Ivanovich, 312
neoclassicism, 164, 177, 220n16, 362, 447, 522; and irony, 85
neonationalism, 354, 375–76
Nesmelov, Viktor Ivanovich, 220n37, 458–59
Nestyev, Izraíl Vladimirovich, 346n18
New Deal, 324
new folkloric wave (*novaya fol'klornaya volna*), 354

New German School, 34, 128
Newlin, Dika, 490
Newman, Alfred, 476
Newmarch, Rosa, 44–46, 370; *The Russian Opera*, 45–46
New Russian School, 65, 372
New York Philharmonic-Symphony Orchestra, 420, 473
New York Review of Books, 305–7, 323, 325
New York Times, report of *Sacre du printemps* première, 405–7
New York Youth Symphony, 18–20
Nietzsche, Friedrich, 348, 357, 484; *The Birth of Tragedy*, 511
Nijinska, Bronislava Fominichna, 418
Nijinsky, Vaslav Fomich, 9, 387; breaks with Diaghilev, 397; on *Le Sacre du printemps*, 402
Nikolai I, Tsar, 60
Nikolsky, Vladimir Vasilyevich, 72
Norton, Charles Eliot, 429
Nouvel ('Nuvel'), Walter Fyodorovich, 367; ghostwrites *Chroniques de ma vie*, 477, 504
Novaro, Michele, 240
Noviy zhurnal, 191
Nurok, Alfred Pavlovich, 372

Obama, Barack Hussein, 361
Oborin, Lev Nikolayevich, 145
Obukhov (Obouhov), Nikolai Borisovich, 145, 147, 156, 209; *Kniga zhizni* (*Book of Life*), 155
octatonicism, 83–94, 96–97, 104, 113, 389
Offenbach, Jacques, 240
Oistrakh, David Fyodorovich, 281
Oja, Carol J., 220n13
Oldani, Robert W., 73
O'Malley, Lurana, 53
"On the Abolition of Religious and National Restrictions," 280
Orff-Zentrum (Munich), 321
orientalism, 81
orientalist stereotypes, 273–74, 392, 408
Ortega y Gasset, José, 424n26; *The Dehumanization of Art*, 481–82, 484
Osborne, Conrad L., 55
Ostrovsky, Alexander Nikolayevich, 25n22
Otsup, Nikolai Avdeyevich, 153, 229n128
Owen, Wilfred, 402

Paganini, Niccolò: Caprice No. 24, 122
Pale of Settlement, 280
Paliashvili, Zakharia Petrovich, 292n63; *Abesalom and Eteri*, 463; *Daisi*, 463

Palisca, Claude, 47
Paoli, Domenico de, 163
Pärt, Arvo Avgustovich, 320, 349, 353
"Partant pour la Syrie," 240–41
partimento, 102, 114
Pascal, Blaise, 163, 211
Pashkevich, Vasiliy Alexeyevich, 53
Paul Sacher Stiftung, 438, 475
Pavlova, Anna Pavlovna, 387
Pazovsky, Ariy Moiseyevich, 72
Peerce, Jan, 244
Pel'she, Arvid Yanovich, 306–7
Penderecki, Krzysztof, 349, 483; *Tren ofiarom Hiroszimy*, 499n36
Peretz, Isaac Loeb, 301n152
Perlis, Vivian, 15–16
Perspectives of New Music, 83, 109
Peter I (The Great), Tsar, 167, 169–70, 456
Petipa, Marius, 368, 387
Petrushka-chord, 84, 89, 92, 97, 113
"philosophers' steamship" (*filosofskiy parokhod*), 390, 460
Picasso, Pablo, 188–89; *Guernica*, 474, 483
Piencikowski, Robert, 9–11
Pijper, Willem, 115n15
Pisarev, Dmitry Ivanovich, 460–61
Piston, Walter, 90, 516, 520–21
pitch-class set theory, 106, 416
Plato: *Philebus*, 3
Plutarch, 288n10
poietic fallacy, 14
Polignac, Edmond, Prince de, 96
Politburo, 305–6
Polovinkin, Leonid Alexeyevich, 145
polystylistics, 356
polytonality, 140
Ponchielli, Amilcare: *La Gioconda*, 47
Poplavsky, Boris Yulianovich, 154
Popov, Gavriyil Nikolayevich, 145; and *Zhdanovshchina*, 176, 319–20
Popper, Karl, 107
Popular Front, 259–60, 263
Porter, Cole, "You're the Top," 510
Poslednïye novosti (newspaper), 153
Pottier, Eugène, 244–45, 247
Poulenc, Francis, 59
power in relation to art, 303–31
Poznansky, Alexander, 7–8
Pravda, 320, 461, 463
"Prikaz No. 17" (*Zhdanovshchina* ban), 279–80, 331n39
Pring, Samuel William, 153, 175, 220n13

Prokofieff, Sergey Sergeyevich, 48, 114, 126, 145, 147, 318–19, 350, 362; controversies about, 1–2, 14, 36; emigration and return, 52, 154–56, 180, 370, 447; and Eurasianism, 149; fidelity to Russian language, 154–55; and Lunacharsky, 182; on Stravinsky's piano playing, 485, 511; and *Zhdanovshchina*, 275–7, 317. WORKS: *Alexander Nevsky*, 261, 345n7; *Cantata for the Twentieth Anniversary of the October Revolution*, 177; Concertino for cello, op. 132, 338; Concerto for cello and orchestra, op. 58, 339, 342; *The Fiery Angel*, 154–55; *Guarding the Peace*, 341; *Ivan the Terrible*, 261; *The Love for Three Oranges*, 56, 155; *Overture on Hebrew Themes*, 347n18; *Le Pas d'acier*, 186; *Peter and the Wolf*, 384; Sonata for cello solo, op. 134, 338; *The Stone Flower*, 341; *The Story of a Real Man*, 283, 341; Symphony No. 3, 155; *Symphony-Concerto for cello and orchestra*, op. 125, 332–47; *The Volga Meets the Don*, 341; *War and Peace*, 154, 336; *Zdravitsa*, 17–19
Prokofiev, Svyatoslav Sergeyevich, 346n7
Prokofieva, Lina Ivanovna, 315–17
Prokoll, 268
propaganda, 483
Protopopov, Sergey Vladimirovich, 145
Prunières, Henry, 140, 470n66
Puccini, Giacomo: *Turandot*, 59
Pugni, Cesare: *Little Humpbacked Horse (Konyok-gorbunok)*, 374
Pulver, Lev Mikhailovich, 317
Punin, Nikolai Nikolayevich, 181–82
Purgold, Alexandra Nikolayevna, 5–6, 70
Purgold, Nadezhda Nikolayevna, 6
Pushkin, Alexander Sergeyevich, 63–64, 434; *Boris Godunov*, 60–62, 66–67; *Faun and Shepherdess*, 505; *The Stone Guest*, 63
Pussy Riot, 4
Putin, Vladimir Vladimirovich, 3, 6–7
Pyatnitsky Choir, 340

Quillen, William N., 330n36

Rabinovich, Alexander Semyonovich, 53–54
Rachmaninoff, Sergey Vasilyevich, 36, 42, 43, 114, 120–39 *passim*; 278, 350; as antimodernist, 121; as anti-Soviet, 124; arrangements by, 124, 130; Bach performed by, 133n27; Chopin performed by, 131; compared with Scriabin, 123; and coughing, 129; as émigré, 370; hands, photographed, 475; liturgical compositions, 202; Lourié forgets about, 142–43; Lourié on, 189–90; Mozart performed by, 130; and nationalism, 371. WORKS: *The Bells*, 206; *Francesca da Rimini*, 134; *The Isle of the Dead*, 135; *The Miserly Knight*, 134; Piano Concerto No. 2, 122; Piano Concerto No. 3, 122, 134–39; Piano Concerto No. 4, 132n5; Prelude in C-sharp minor, 229n120; *Rhapsody on a Theme of Paganini*, 122, 128; *Variations on a Theme of Corelli*, 129; Vespers (*Vsenoshchnoye bdeniye*), 132n5
radical utilitarians, 460–61
Radio Armenia, 6–7
Raeff, Marc, 156; *Russia Abroad*, 149–52
Rahn, John, 87
Rakhlin, Natan Grigoryevich, 312
Raksin, David, 474
Rambert, Marie, 418
Ramuz, Charles-Ferdinand, 506
Randel, Don, 106
Ranger, Terence, 235
Raskatov, Alexander Mikhailovich: *Dolce far niente*, 351
Ratner, Leonard, 194
Ravel, Maurice, 10–11, 89, 105, 123, 277, 286; on *Firebird*, 391; and Stravinsky, 95. WORKS: *Boléro*, 198; *Daphnis et Chloé*, 389; *Jeux d'eau*, 92; *Rapsodie espagnole*, 391
referability, argument from, 97, 117n51
Reilly, Sidney, 224n67
Remizov, Alexey Mikhailovich, 154–55, 181
Renard, Jules, 129–30
"Resolution on Music" (*Postanovleniye o muzïke*), 275, 279, 319–20; rescinded, 317
Revue musicale, La, 140, 438, 445
Richter, Svyatoslav Teofilovich, 339
Riesemann, Oskar von, 72
Riethmüller, Albrecht, 479
Rimsky-Korsakov, Alexander Andreyevich, 381n1
Rimsky-Korsakov, Andrey Nikolayevich, 10–12, 72, 223n59, 442, 505; dedicatee of *Firebird*, 369; on *Petrushka*, 378–79
Rimsky-Korsakov, Nikolai Andreyevich, 45, 48, 57, 78–83, 87–98, 101–5, 115n9, 117n40, 124, 275, 284, 372, 434; atheism of, 80; on ballet, 368–69; biopic about, 80; completes *Prince Igor*, 194; Lourié on, 142–43, 193, 195; as non-nationalist, 370–71; and the

INDEX 537

octatonic (a.k.a. Rimsky-Korsakov) scale, 364; positivism of, 91; and St. Petersburg Conservatory, 39; sketchbooks of, 88; timely death of, 384–85. LITERARY WORKS: *Chronicle of My Musical Life,* 87, 89–90; *Principles of Orchestration,* 90; MUSICAL WORKS: *Capriccio espagnol,* 79; *Christmas Eve,* 56; *Le Coq d'or,* 81–82, 102, 367; *Heaven and Earth* (sketches), 92; *Kashchey the Deathless,* 367, 391; *The Legend of the Invisible City of Kitezh,* 80, 367; *The Maid of Pskov,* 61–62, 65–66, 72, 74, 80, 82; —, staged by Diaghilev in Paris, 386; *May Night,* 61, 82; *Mlada,* 54, 89, 368, 387; —, Apparition of Cleopatra from, 373, 386; Procession of the Nobles from, 215; *Russian Easter* Overture, 79, 206, 212; *Sadko* (opera), 54, 79, 90, 391; —, "Song of India" from, 78–79; *Sadko* (symphonic picture), 87; *Sheherazade,* 79, 278, 365; —, staged by Diaghilev, 373; *The Snow Maiden,* 377; *Tale of Tsar Saltan,* 78, 88, 367; —, "Flight of the Bumblebee" from, 78
Rimsky-Korsakov, Vladimir Nikolayevich, 381n1
Ritzarev (Ritsareva), Marina Grigoryevna, 54
Rivière, Jacques, 402, 417, 419
Robinson, Harlow, 28n45
Rockwell, John, 17
Roerich, Nikolai Konstantinovich, 373, 377–78, 387, 403, 414; and Gauguin, 408; "Joy in Art," 378; on *Le Sacre du printemps,* 414
Rogers, Lynn, 105, 119n86
Roland-Manuel, Alexis, 163; reviews *Chroniques de ma vie,* 431, 434; ghostwrites *Poetics of Music,* 165, 431–32, 434, 481, 504; reviews *Poetics of Music* (!), 466
Rolland, Romain, 456
Romanov, Grigoriy Vasilyevich, 306
Romanticism, 509
Rorem, Ned, on Beethoven's Ninth, 412
Rosand, Ellen, 53
Rosen, Charles, 83, 304; *Freedom and the Arts,* 325
Roslavets, Nikolai Andreyevich, 145, 200, 318
Ross, Alex, 28n51
Ross, Hugh, 209
Rossi, Marco (Marcus de Rubris), 287n7
Rossini, Gioachino, 238, 240
Rostropovich, Mstislav Leopoldovich, and Prokofieff's *Symphony-Concerto,* 332, 336, 339–40, 345, 345n6, 347n20

Rostropovich, Olga Mstislavovna, 347n20
Rousseau, Jean-Jacques, 234–37, 521; *Confessions,* 236, 509; *Considérations sur le gouvernement de Pologne,* 234–36, 263
Rozanov, Vasiliy Vasilyevich, 193, 458–59; *Fallen Leaves,* 459; *The Apocalypse of Our Time,* 459–60
Rubinstein, Anton Grigoryevich, 34, 35, 37, 45, 167, 194; Chopin performed by, 131; dubious ethnicity of, 350; Lourié on, 142; and St. Petersburg Conservatory, 38–39. WORKS: *Demon,* 41; "Persian Songs," 41
Russia, as "prison house of nations," 251, 279, 290n51
"Russia Abroad" (*russkoye zarubezh'ye*), 36, 140–61, 165
Russian Association of Proletarian Musicians (RAPM), 132n5, 144
"Russian minor," 271, 274, 284
"Russomania," 35
Ryazanov, Pyotr Borisovich, 145

Sabaneyev, Leonid Leonidovich, 155
Sachs, Harvey, 447
Sadovsky, Yakov Dmitriyevich, 446
Said, Edward W.: *Orientalism,* 165
Saint-Exupéry, Antoine de, 141
Saint-Léon, Arthur, 368; *Little Humpbacked Horse (Konyok-gorbunok),* 374
Saint-Saëns, Charles-Camille, 34, 45; and *Le Sacre du printemps,* 423n21
Sakhnovsky, Yuriy Sergeyevich, 274
Saminsky, Lazare, 89, 102, 105
Samoilova, Tatyana Yevgenyevna, 313
Sargent, Malcolm, 332
Sarti, Giuseppe, 53, 201
Satie, Erik, 96, 123
Saussine, Renée de, 141
Savenko, Svetlana Ilyinichna, 220n37, 438–39, 470n82, 480
Savitsky, Pyotr Nikolayevich, 147–48, 165, 180
Savva, Archbishop, 214
Scarlatti, Alessandro, 230n162
Schaal, Eric, 475
Schachter, Carl, 492–93
Schaeffner, André, 417
Scherliess, Volker, 396
Schiejen, Sjeng, 390
Schiff, David, 15–16, 28n51
Schiller, Friedrich, 75n16
Schillinger (Shillinger), Joseph (Iosif Moiseyevich), 318

538　INDEX

Schirmer, G. (music publishers), 120
Schmitt, Florent: *La Tragédie de Salomé*, 407–8
Schnittke (Shnitke), Alfred Garriyevich, 36, 157, 320, 349; and polystylistics, 356. WORKS: *Nagasaki*, 483; *Pianissimo* for orchestra, 352
Schoenberg, Arnold, 83, 170, 286; Lourié on, 184–85; monarchism of, 447; and neoclassicism, 511; on *Oedipus Rex* (Stravinsky), 521; on performance practice, 490–91. WORKS: *Erwartung*, 510; *Five Pieces for Orchestra*, 400; *Gurrelieder*, 184; *Pelléas et Mélisande*, 184; *Pierrot lunaire*, 184, 506, 510; "Tonal oder atonal?" 393
Schoenberg/Stravinsky dialectic, 163–65, 172
Scholes, Percy, 411
Schopenhauer, Artur, 304
Schubert, Franz, 90, 124, 364; sexuality of, 24n14
Schumann, Robert, 240; on *Symphonie fantastique* (Berlioz), 479
Schütz, Heinrich, 201, 231n162
Scipio, Publius Cornelius, 240
Scriabin, Alexander Nikolayevich, 38, 42, 43, 89, 105, 146, 303, 350, 362, 372; Lourié on, 142, 200; and nationalism, 371; compared with Rachmaninoff, 123
Scythianism, 142–44, 148, 408, 443–44
self-censorship, 21, 23n9
Sellars, Peter, 18
Serebrennikov, Kirill Semyonovich, 5
Sergeyev, Artyom, 302n166
Serov, Alexander Nikolayevich, 34, 40; *Judith*, 76n26; —, presented by Diaghilev in Paris, 386–87; *Rogneda*, 61
Serov, Valentin Alexandrovich, 386
Shapero, Harold, 104
Shaporin, Yury Alexandrovich, 126; and *Zhdanovshchina*, 276
Shaw, George Bernard, 510; on *Le Sacre du printemps*, 411
Shchedrin, Rodion Konstantinovich, 230n150, 318
Shcherbachyov, Vladimir Vladimirovich, 145
Shebalin, Vissarion Yakovlevich, 126, 145; and *Zhdanovshchina*, 276, 319–20
Shepilov, Dmitry Trofimovich, 312
Shestov, Lev Isaakovich, 181, 193
Shevchenko, Taras Hryhorovych, 290n51
Shostakovich, Dmitry Dmitriyevich: controversies about, 1–2, 13–16, 36, 126, 145, 310, 357, 447, 480, 483; letters to Isaak Glikman, 306; Lourié on "Shestakovich," 147; as member of the Supreme Soviet, 308–9; quartets, 48; thank-you notes to Stalin, 327; and *Zhdanovshchina*, 275–76. WORKS: *Antiformalist Peepshow*, 264; *From Jewish Folk Poetry*, op. 79, 285; *The Lady Macbeth of the Mtsensk District*, 147, 275, 282, 320, 463; Quartet No. 8, 308; Quartet No. 13, 355; "Romance," from incidental music to *The Gadfly*, 381n12; Symphony No. 5, 197; —, as "creative reply," 282; derided in *Poetics of Music*, 464–65; Symphony No. 6, 197; Symphony No. 7 ("Leningrad"), 124, 244, 473; —, Lourié on, 196–99; Symphony No. 10, 28n45; Violin Concerto No. 2, 319
Shostakovich, Maxim Dmitriyevich, 314
"Shostakovich Wars," 15, 55, 483
Shteynberg (Steinberg), Maximilian Oseyevich, 87–88, 91, 366, 369, 385, 394n14; *Prélude symphonique*, op. 7, 92–93
Sibelius, Jean, 34
Silantyev, Yuriy Vasilyevich, 314
Silvestrov, Valentin Vasilyevich, 320
Simonov, Konstantin Mikhailovich, 313
Simpson, Mark, 160n17
sincerity, 483
Singer, Winnaretta (Princesse de Polignac), 96
Sinyavsky, Andrey Donatovich, 157, 352
Six, Les, 96
Slavophilism, 443–44, 454
Slezkine, Yuri Lvovich, 251
Slobin, Greta N., 153–54, 160n19
Slonimsky, Nicolas (Nikolai Leonidovich), 208–9
Slonimsky, Sergey Mikhailovich, 320
Smart, Mary Ann, 77n43
Smetana, Bedřich, 34
Smetona, Antanas, 176
Smirnov, Dmitry Nikolayevich, 157, 318–20, 349, 355
Snyder, Timothy, 287
"socialism in a single country," 258–59
socialist realism, 453, 473
Sokolov, Nikolai Alexandrovich, 43, 374
Sokolova, Lydia (Hilda Tansley Munnings), 414
Solomentsev, Mikhaíl Sergeyevich, 306–7
Solomon, Maynard, 24n14
Solovyov, Sergey Mikhailovich, 60, 62
Solovyov, Vladimir Sergeyevich, 193, 222n37, 458–59
Solzhenitsyn, Alexander Isayevich, 352
Somfai, László, 486–87, 494
Somov, Yevgeniy Ivanovich, 125

Song of Scheherazade, The (film), 80
Sorabji, Khaikosru Shapurji (Leon Dudley), 299n121
Sotkilava, Zurab Lavrentyevich, 316
Soudeikine, Serge (Sergey Yuryevich), 183
Soumagnac, Myriam, 439, 480
Souriau, Étienne, 396
Southern Agrarians, 444
Souvtchinsky, Marianne (Marianna Lvovna), 444
Souvtchinsky (Suvchinsky), Pierre (Pyotr Petrovich), 82, 147–48, 162, 172, 393; career, 442–43, 445; and Eurasianism, 149, 164–65, 176–80; ghostwrites for Stravinsky, 180, 437–38, 481, 504; outlines Stravinsky's Norton lectures, 438–39, 480; relationship to Stravinsky, 428; Soviet connection, 224n67; on Soviet music, 461. WORKS: "La Notion du temps et la musique: Reflexion sur la typologie de la creation musicale," 438, 448; "The New 'West,'" 178–79, 187, 196; "Pax Eurasiana," 225n79
Sovetskaya muzïka (journal), 282, 296n88, 320
Sovetskoye iskusstvo (journal), 341
Soviet music: Lourié on, 144–45
Sovremennïye zapiski (journal), 153, 181
Spalding, Henry, 445
Speaight, Robert, 179
Speyer, Louis, 399
Spiegelman, Joel, 351
Spies, Claudio, 94; "Conundrums, Conjectures, Construals; or, 5 vs. 3," 117n40
Stakhanov, Alexey Grigoryevich, 291n57
Stalin (Jhugashvili), Iosif Vissarionovich, 17–18, 214, 222n48, 245, 247–48, 250, 287, 305; as Commissar of Nationalities, 256, 268; cult of personality around, 256, 292n63; and friendship of peoples, 252–57; as music lover, 312–13, 463–64; toast to the Russian people, 279. WORKS: "The National Question and Social Democracy," 255; "Report of the Central Committee to the Sixteenth Party Congress," 262–64
Stalin Constitution, 253, 266, 278
Stalinism, 249
"Star-Spangled Banner, The," 244; arranged by Rachmaninoff, 124; arranged by Stravinsky, 437
Stasov, Vladimir Vasilyevich, 34, 38–47, 49, 61, 75n8, 76n26, 321, 370; *The Art of the Nineteenth Century,* 38–44; "Twenty-Five Years of Russian Art," 40–41
Stasyulevich, Mikhaíl Matveyevich, 61

"State Anthem of the USSR." *See* "Gosudarstvennïy gimn SSSR"
states, compared with nations, 242
Statuto Albertino, 234
Steblin, Rita, 24n14
Stein, Gertrude, 423n13
Steiner, George, 357
Stendhal (Marie-Henri Beyle): *Life of Rossini,* 357
Sternfeld, Frederick W., 382n28
Stevens, Wallace, 510
Stillman, Charles Chauncey, 429
St. Luke's, Orchestra of, 421
Stockhausen, Karlheinz, 352
Stokowski, Leopold, 414
St. Petersburg Conservatory, 38–43, 89
Straus, Joseph N., 87, 116n18
Strauss, Richard, 456; *Elektra,* 92
Stravinskaya, Anna Kirillovna, 183, 430, 436, 443
Stravinskaya, Catherine (Yekaterina Gavrilovna), 430, 505
Stravinskaya, Lyudmila Fyodorovna (Mika, Mikushka), 430, 506
Stravinskaya, Yelena. *See* Yakovleva
Stravinsky, Fyodor Ignatyevich, 321, 386, 504–5
Stravinsky, Guriy Fyodorovich, 321
Stravinsky, Igor Fyodorovich, 57, 145, 156, 277, 350; abandonment of Russian language, 154–55, 362; on academicism, 455; becomes American, 436–37, 475; antimodernism of, 446–47, 510; antiromanticism of, 80, 433; antisemitism of, 475; on Bartók, 229n126; on Beethoven's Ninth, 413; and Bolsheviks, 483; and "call to order," 174; on Belyayev circle, 455; on Casals and Kodály (via Robert Craft), 323; on Chaikovsky, 455; claim of kinship with Glinka and Chaikovsky, 125–26; and Debussy, 95; delivers Norton lectures, 429–30, 480; and Diaghilev, 367, 384–94; and dogma, 433; early influences on, 372; and Eurasianism, 148–49, 450, 456–60; on expression, 433, 469n59, 473–74, 476–79; fascism, flirtation with, 400, 428, 510–11; and fashion, 125; on film music, 474; folklore, use of, 452, 506–7; and formalism, objectivity, 481–83; and his ghostwriters, 479–80, 504; on Glazunov, 455–56; on Glinka, 453; "instrumental dialectic" (Lourié), 211; and interviewers, 503–4; and Lourié, 162, 181, 183–85; Lourié on, 143–44; Medtner on, 125; memoirs of, 95; on musical notation, 487; and Mussolini, 447; and neonationalism,

Stravinsky, Igor Fyodorovich (*continued*)
354; octatonicism of, 83–94, 363–65; and opera, 392–93; on performance, 488–90; as performer, 436, 484–88, 495–97; performing style of, 110–12; and pianola, 484–85, 499n44; Picasso, compared with, 188–89; and Rachmaninoff, 124, 455; and Ravel, 95; and reaction, 174, 448–50; recordings of *Le Sacre du printemps*, 420; and Rimsky-Korsakov, 82–83; as a Russian composer, 3, 36, 95, 361–65; and "Russian Europeanism," 434; on the Russian spring, 504; and "rythme monométrique," 231n173, 485; on *Le Sacre du printemps*, 397–98, 400, 406–7, 415–20; on Scriabin, 455–56; serial compositions of, 94, 363, 506; sexuality of, 9–13, 16; social class affinities, 435–36; on technique, 183; text-setting habits, 507, 516; and "Turania," 170; veracity of, 439, 441–42; visits USSR, 321; as "white" émigré, 182

—LITERARY WORKS: *Chroniques de ma vie*, 82, 220n16, 431, 434, 477, 495, 504; *Conversations with Igor Stravinsky* (with Robert Craft), 400, 446; *Dialogues and a Diary* (with Robert Craft), 472–77; *Expositions and Developments* (with Robert Craft), 400, 478–79; *Poetics of Music*, 14, 82, 130, 163, 165, 170, 173, 188, 392, 428–42, 446–71, 495; —, second chapter ("De phénomène musical"), 438; third chapter ("De la composition musicale"), 438; fourth chapter ("Typologie de la création musicale"), 438; fifth chapter ("Les avatars de la musique russe"), 177, 180, 227n95, 229n134, 437–38, 450–66; —, French and Russian censorship of, 465–66; sixth chapter ("De l'exécution"), 191, 433–34, 488–90, 492; and authoritarianism, 433–34, 516; and Eurasianism, 148; at Harvard, 496–97; cribbed from Maritain and Valéry, 432; reviewed by Roland-Manuel (!), 466; Souvtchinsky's outline for, 438–39; Stravinsky's outline for, 440; "Quelques confidences sur la musique," 493; "Some Ideas about My Octet," 482, 487–88

—MUSICAL WORKS: *Apollon musagète*, 216, 227n99, 385, 497, 508, 511; "Berceuse" ("Mikushka, Mikushka"), 506; *Berceuses du chat*, 506; *Chant funèbre*, 369, 381n9; *Concertino* for string quartet, 227n92; Concerto in E-flat ("Dumbarton Oaks"), 216–17; *Concerto per due pianoforti soli*, 86, 432, 492; Concerto for Piano and Winds, 485–87, 502n75; *Duo concertant*, 432; *The Faun and the Shepherdess*, 91, 505; final chorus for Musorgsky's *Khovanshchina*, 369; *Firebird*, 3, 125, 362, 375, 385, 434; —, as first "Russian" ballet, 388; as hybrid opera/ballet, 391–92; as nationalist, 74; as orientalist, 374, 392; pantomime in, 392; performed at Sochi Olympics, 4; *Petrushka*-chord in, 92; sketch for, 394n14; *Fireworks*, 381n3; *Four Norwegian Moods*, 10; *Histoire du soldat*, 86, 94, 226n92; "How the Mushrooms Prepared for War," 505; *Mavra*, 155, 362, 385; *The Nightingale*, 174, 370, 385; Octet, 84–85, 182, 342, 363–64, 432; *Oedipus Rex*, 163, 385, 508–9, 511–23; "The Owl and the Pussycat," 505; *Perséphone*, 86; *Petrushka*, 59, 84–85, 92, 364, 385; —, folk tunes in, 223n61, 362; influence of *Sheherazade* on, 365; as *Konzertstück*, 378; and neonationalism, 376; "peepshow verse" (*rayoshniy stikh*) in, 379; "Danse russe" from, intended for *Le Sacre du printemps*, 376–79; *Pribaoutki*, 506–7; *Pulcinella*, 385; *Quatre chants russes*, 506; *The Rake's Progress*, 86, 362, 364, 507; *Renard*, 110–11, 385; *Requiem Canticles*, 202; *Le Sacre du printemps*, 84–86, 89, 93–94, 100–1, 111, 125, 143, 354, 366–83, 385; —, "Action rituelle des ancêtres" from, 219; advance hype for, 404; and "Asiatic spirit of Russia," 187; audience appeal of, 409–10; axe, written with, 134; centennial of, 2–3, 9–10, 395–96; compared with Beethoven's Ninth Symphony, 401, 411–13; as concert piece, 398; "Danse sacrale" from, revised, 421; early recordings of, 420; as enacted ritual, 203; piano roll of, 484; "Évocation des ancêtres" from, 219; as fiasco, 397–98; folk melodies in, 380; "Jeu de rapt" from, 377–78; literature on, 396–97; myth of, 402–3; New York première, 410; and orientalism, 408; originally titled "Great Sacrifice," 403; performance practice of, 420–22, 427n97; and pianola, 421; première, as event, 397–98, 403–7; "Procession du sage" from, 216; reception in London, 397, 407–9; reception in Russia, 409; revived after Great War, 410–11, 413–14; rhythmic-metric innovations in, 379–80; and *skifstvo*, 408, 445; Soviet stating of, 417–18; status in

INDEX 541

canon and repertory, 399–400; substitute scenarios for, 417–19; ugliness of, 401–2; *Scherzo fantastique*, 88, 366, 473; *Sérénade en la*, 485; *Sonate* for piano, 163, 210, 220n16, 485; solo songs, 504–7; songs to texts by Gorodetsky, op. 6, 372; "Storm Cloud," 505; Suites for chamber orchestra, 226n92; *Svadebka* (*Les Noces*), 83–84, 86, 89, 94, 208, 226n92, 354, 362–63, 385, 436; —, as enacted ritual, 203; and neonationalism, 376; and Slavophilism, 445; *Symphonies of Wind Instruments*, 86, 172, 182, 202–3, 216, 362, 456–57; Symphony in C, 216, 431, 433; Symphony in E-flat Major, op. 1, 91, 372; *Symphony in Three Movements*, 86, 98, 472–77, 483; *Symphony of Psalms*, 86, 162, 202, 204, 432; *Three Songs from William Shakespeare*, 506; *Threni*, 445; *Trois histoires pour enfants*, 506; *Zvezdolikii*, 93
Stravinsky, Soulima (Svyatoslav Fyodorovich), 428–29, 461, 505; collaborationist activities, 467n3; on his father's performances, 496–97; performs Mozart with his father, 492
Stravinsky, Vera Arturovna (de Bosset, Sudeykina), 183, 228n104, 430, 475, 505
Stravinsky, Yuriy Fyodorovich, 370
Struve, Pyotr Berngardovich, 159n12, 458
Stutschewsky, Joachim, 78
Sudeykina, Vera. *See* Stravinsky, Vera
Supreme Soviet: Soviet of Nationalities, 307–11
Suslin, Victor Yevseyevich, 318
Suslov, Mikhaíl Andreyevich, 306–7
Svyatopolk-Mirsky, Dmitry Petrovich, Prince (D. S. Mirsky), 153, 171, 177–80, 445; "The Eurasian Movement," 225n80
Swingle Singers, 78
Sylphides, Les, 366, 386, 388
"symphonic society," 171–72, 178, 226n80, 444, 456–57

Tamberlik, Enrico, 239
Taneyev, Sergey Ivanovich, 38, 42–43, 114, 268. LITERARY WORKS: *Invertible Counterpoint in the Strict Style*, 38; MUSICAL WORKS: *Oresteia*, 36, 386
Tarm, Jonas, 18–22
Tarnopolsky, Vladimir Grigoryevich, 351
Taruskin, Richard: "Chernomor to Kashchei," 106; "*Chez Pétrouchka*: Harmony and Tonality chez Stravinsky," 117n51; *Defining Russia Musically*, 33, 225n80, 348–49, 457; *New Grove Dictionary of Music and Musicians*, s.v. "nationalism," 243; *New Grove Dictionary of Opera*, s.v. "Russia," 154; *On Russian Music*, 1; *Oxford History of Western Music*, 34, 36, 120–23, 127; "Russian Folk Melodies in *The Rite of Spring*," 383n36; *Stravinsky and the Russian Traditions*, 98, 148; "Stravinsky and Us," 110
Tchaikovsky. *See* Chaikovsky
Tcherepnin, Alexander Nikolayevich, 145, 155
Tcherepnin, Nikolai. *See* Cherepnin
Telyakovsky, Vladimir Arkadyevich, 370
Tertullian, 100
Testimony: The Memoirs of Dimitri Shostakovich as Related to and Edited by Solomon Volkov, 1, 13–16, 319, 327, 338, 480
thaw, post-Stalinist, 351–52
Théâtre des Champs-Élysées, 9
Theostirikt, Abbot, 214
Thomas, Dylan, 506
Thomas, Michael Tilson, conducts *Le Sacre du printemps*, 421–22
Thomson, Virgil: on performance practice, 490; on Rachmaninoff, 122, 127; on Shostakovich, 230n145
Tikhonov, Nikolai Anlexandrovich, 306–7
Timasheff, Nicholas, 249
Times Literary Supplement, 11
Titov, Vasiliy Polikarpovich, 201
Tolokonnikova, Nadezhda Andreyevna, 4
Tolstoy, Alexey Nikolayevich, 465–66
Tolstoy, Lev Nikolayevich, 15; *What Is Art?* 460
topics, theory of, 194
Toscanini, Arturo, 243–45, 248, 286, 326, 473
Toscanini, Walter, 244, 248
totalitarianism, 250, 290n47
transcendental triad (The Good, the True, the Beautiful), 3, 22
Trest, 224n67
tripartition sémiologique, 103
Trotsky (Bronshteyn), Leon (Lev Davidovich), 249–50; *The Revolution Betrayed*, 249
Trubetskoy, Nikolai Sergeyevich, Prince, 147–48, 165, 169–72, 176, 180, 444; *Europe and Humanity*, 165, 168; and Karsavin, 443; on "panromanogermanic chauvinism," 380
Truman, Harry S., 475
Tsetlin, Mikhaíl Osipovich, 191
Tsvetayeva, Marina Ivanovna, 153, 181
Tugendhold, Yakov Alexandrovich, 354, 379; on *Firebird*, 375
Tulebayev, Mukan, 269
"Turania," 169–70, 175

Turanian language group, 169
Tymoczko, Dmitri, 97–98, 101, 103, 105–6, 113–14, 117n50
Tyutchev, Fyodor Ivanovich, 31, 193, 229n134, 389

Umberto II, King of Italy, 240
Unger, Caroline, 401
Union of Soviet Composers, 126, 282, 310–12, 316, 320, 323, 461
Updike, John, 48
Ussachevsky, Vladimir Alexeyevich, 134, 409
Ustinov, Dmitry Fyodorovich, 306
Ustvolskaya, Galina Ivanovna, 355–56

Valéry, Paul, 163, 481–82; *De l'enseignement de la poétique au Collège de France*, 432
Vallin, Ninon, 141
Valois, Ninette de, 389
Van den Toorn, Pieter C., 86–95, 97, 104, 109–13, 117n50, 364–65; on *Le Sacre du printemps*, 415–16. WORKS: "Some Characteristics of Stravinsky's Diatonic Music," 86; *Stravinsky and The Rite of Spring: The Beginnings of a Musical Language*, 92, 396
Van Vechten, Carl, fake memoir of *Le Sacre du printemps*, 423n13
Varunts, Viktor Pailakovich, 163
Vasilenko, Sergey Nikiforovich: *Buran*, 268
Vasilyov, Vladimir Viktorovich, 418
Vaughan Williams, Ralph, 34
Vedel', Artemiy, 201
Vega, Lope de, 75n16
Veprik, Alexander Moiseyevich, 286, 317
Verdi, Giuseppe, 34, 238–43; *Battaglia di Legnano*, 243; *Cantica (Inno delle nazioni)*, 238–45, 248; *La forza del destino*, 239, 244; *I Lombardi*, 244; *Nabucco*, "Va pensiero," 243–44; *Otello*, 246; *La Traviata*, 244
Verlaine, Paul, 506
Viadana, Ludovico Grosso da, 230–31n162
victim card, 96, 113
Vishnevetsky, Igor Georgiyevich, 149, 187, 189, 196, 200, 204, 225n80, 231n172, 341, 346n13
Vishnevsky, Ivan Sergeyevich, 311–13
Vittorio Emanuele II, King of Italy, 233
Vittorio Emanuele III, King of Italy, 240
Viyelgorsky. *See* Wielhorski
Vladimir Alexandrovich, Grand Duke, 386, 388
Vlasov, Vladimir Alexandrovich, 268
voice production ("trained" vs. "ethnic"), 297n107

Volkonsky, Andrey Mikhailovich, 157, 318, 352–53; *Musica stricta*, 352; *Les plaintes de Chtchaza*, 352
Volkov, Solomon Moiseyevich, 1, 13–16, 319, 327. 480
Voltaire, 167
Volya Rosii (journal), 153
Voroshilov, Klimentiy Yefremovich, 312
Vovsi, Miron Semyonovich, 286
Vovsi-Mikhoels, Nataliya Solomonovna, 282
vseyedinstvo, 170–71
Vuillemin, Louis, 403–4
Vuillermoz, Émile, 382n28
Vyorstï (journal), 153, 172, 180–81, 445
Vyrypaev, Ivan Alexandrovich, 23n9

Wagner, Richard, 15, 34, 46, 128, 240, 466; *Tristan und Isolde*, "Prelude and Liebestod," 135–36
Waldorf Peace Conference, 331n39
Walsh, Stephen, 9–12, 98, 126, 431, 437, 468n27; on Lourié, 183, 227n96
Waltz, Sascha, 9, 420
Warlikowski, Krzysztof: "Broke Back Onegin," 2
Webern, Anton, 97; *Six Pieces for Orchestra*, 400
Weill, Kurt, 140
Weinberg, Mieczysław (Moisey Samuilovich), 14, 281–86; compared with Khachaturyan, 284–85. WORKS: Jewish Songs, op. 13, 282; *Sinfonietta*, op. 41, 282–86
Werfel, Franz: *Song of Bernadette*, 476
Whittall, Arnold, 98, 101, 106, 113; on *Le Sacre du printemps*, 416
whole-tone scale, 91
Wielhorski, Michal, Count, 288n9
Wigman, Mary, 419
Wihtol, Joseph (Jāzeps Vītols), 43
Williams, Patricia, 16
Wilson, Elizabeth, 340
Wimsatt, W. K., and Monroe Beardsley: "The Intentional Fallacy," 498n28
"Winter War" with Finland, 256–57
Wolff, Christoph, 309
Wolff, Larry, 166
Woolfe, Zachary, 19–21
Works Progress Administration, 324
Worringer, Wilhelm, 164
Wortman, Richard, 54
Wyschnegradsky, Ivan Alexandrovich, 145, 147

Yakovleva, Elena Alexeyevna, 370
Yakulov, Georgiy Bogdanovich, 186
Yanukovych, Viktor Fyodorovich, 3

Yasser, Joseph, 137–38
Yastrebtsev, Vasiliy Vasilyevich, 87, 102, 367–68
Yeltsin, Boris Nikolayevich, 307
Yevraziya (journal), 148, 178, 180, 185, 187, 189
Yiddish, as official language in Belorussian SSR, 344

Zakharov, Vladimir Grigoryevich, 340, 345; "At dusk," 346n13
Zander, Benjamin, 421, 485
Zaslavsky, David Iosifovich, 464
Zbikowski, Lawrence, 103, 106, 110–11
Zemtsovsky, Izaly Iosifovich, 157, 308–9
Zetkin, Klara: *Erinnerungen an Lenin*, 318

Zhdanov, Andrey Alexandrovich, 276, 313
Zhdanov, Vladimir Alexandrovich, 8
Zhdanovshchina, 48, 254, 164, 275–70, 317, 319–20; and re-canonization of Stasov, 370
Zhegin, Nikolai Timofeyevich, 8
Zhubanov, Akhmet Kuanovich, 269
Zieleński, Mikołaj, 201
Zindels, Boris, 339, 341
Zirato, Bruno, 473
Zola, Émile, 47
Zolotaryov, Vasiliy Andreyevich, 284
Zoshchenko, Mikhaíl Mikhailovich, 198
Zukofsky, Paul, 494

www.ingramcontent.com/pod-product-compliance
Lightning Source LLC
Chambersburg PA
CBHW030513230426
43665CB00010B/603